Digital Photos, Movies, & Music
GIGABOOK™
FOR DUMMIES®

Digital Photos, Movies, & Music GIGABOOK™ FOR DUMMIES®

by **Mark L. Chambers**

**Tony Bove, David D. Busch, Martin Doucette, David Kushner,
Andy Rathbone, Cheryl Rhodes, Todd Staufer, Keith Underdahl**

WILEY

Wiley Publishing, Inc.

Digital Photos, Movies, & Music Gigabook™ For Dummies®

Published by
Wiley Publishing, Inc.
111 River Street
Hoboken, NJ 07030-5774

Copyright © 2004 by Wiley Publishing, Inc., Indianapolis, Indiana

Published by Wiley Publishing, Inc., Indianapolis, Indiana

Published simultaneously in Canada

For general information on our other products and services or to obtain technical support, please contact our Customer Care Department within the U.S. at 800-762-2974, outside the U.S. at 317-572-3993, or fax 317-572-4002.

Wiley also publishes its books in a variety of electronic formats. Some content that appears in print may not be available in electronic books.

Library of Congress Control Number: 2004111384

ISBN: 0-7645-7414-0

Manufactured in the United States of America

10 9 8 7 6 5 4 3 2

1B/RY/QY/QU/IN

WILEY

Acknowledgments

Wiley Publishing, Inc. gratefully acknowledges the contributions of these authors and contributing writers: Mark L. Chambers, Tony Bove, David D. Busch, Martin Doucette, David Kushner, Andy Rathbone, Cheryl Rhodes, Todd Staufer, and Keith Underdahl.

We would like to thank Mark Chambers for editing this book, Kim Darosett and John Edwards for copy editing it, and Nicole Sholly for serving as project editor. Thanks as well go to Keith Underdahl for his technical edits, Joan Griffitts for her index, and Rich Tennant for the witty cartoons you will find in this book. Thanks are also due to the many page layout technicians, graphic artists, proofreaders, and others in Compositions Services who worked to bring this book to fruition.

From Mark Chambers: When I was asked by Wiley to take on this project, I had no idea of the truly epic proportions of a Gigabook — sure, I've written several books of 700 to 800 pages, but nothing had prepared me for the sheer number of chapters and the organization involved in this project. Without the help and support of a large number of folks, I would never have been able to meld together several *For Dummies* books into one comprehensive, cohesive whole! It's time I thank everyone involved.

As with all my books, I'd like to first thank my wife, Anne, and my children, Erin, Chelsea, and Rose, for their support and love — and for letting me follow my dream!

The Wiley Production team is the best in the business — hands down — and I applaud the work of project coordinator Adrienne Martinez. Again, the Composition Services team took the raw material I provided and prepared the beautifully-finished work of publishing art you hold in your hands. Thanks to each of the team members for yet another job well-done.

Next, I owe a debt of gratitude to my editorial manager, Kevin Kirschner, my copy editors, Kim Darosett and John Edwards, and my technical editor, Keith Underdahl. All of these folks worked together to check the technical accuracy of every word, investigate every silly acronym and straighten out my logical mishaps — ensuring that my work is the best it can be.

Finally, I send my appreciation across the pages to my acquisitions editor, Tiffany Franklin, and my project editor, Nicole Sholly — two wonderful, hard-working individuals who decided (yet again) to add me to their team! The two of them provided all the help and support any technology author could ask for . . . even with a book so large that I often wondered if any bookstore had a shelf that would be strong enough to bear all this weight. Thanks to both of you for yet another chance to put pen to paper — well, actually, fingers to keyboard!

Publisher's Acknowledgments

We're proud of this book; please send us your comments through our online registration form located at www. dummies.com/register/.

Some of the people who helped bring this book to market include the following:

Acquisitions, Editorial, and Media Development

Associate Project Editor: Nicole Sholly

Acquisitions Editor: Tiffany Franklin

Senior Copy Editor: Kim Darosett

Copy Editor: John Edwards

Technical Editor: Keith Underdahl

Editorial Manager: Kevin Kirschner

Media Development Manager: Laura VanWinkle

Media Development Supervisor: Richard Graves

Editorial Assistant: Amanda Foxworth

Cartoons: Rich Tennant (www.the5thwave.com)

Composition

Project Coordinator: Adrienne Martinez

Layout and Graphics: Andrea Dahl, Lauren Goddard, Denny Hager, Michael Kruzil, Lynsey Osborn, Jacque Roth

Proofreaders: Laura Albert, Kathy Simpson

Indexer: Joan Griffitts

Publishing and Editorial for Technology Dummies

 Richard Swadley, Vice President and Executive Group Publisher

 Andy Cummings, Vice President and Publisher

 Mary Bednarek, Executive Acquisitions Director

 Mary C. Corder, Editorial Director

Publishing for Consumer Dummies

 Diane Graves Steele, Vice President and Publisher

 Joyce Pepple, Acquisitions Director

Composition Services

 Gerry Fahey, Vice President of Production Services

 Debbie Stailey, Director of Composition Services

Contents at a Glance

Table of Contents

Introduction

*L*ife used to be so simple.

In the old days — that's 1983 for you computing youngsters — data came on disks. Just plain disks. There were two kinds of floppy disks (high density and low density), and you couldn't afford a hard disk subsystem for your TRS-80 Model III or your Atari 800, so why even worry about it? And data? Data was data . . . files and programs. That was it. Life was simple, and everyone was happy.

Just look at us now: We've got digital audio, and digital video, and digital photographs. Heck, we've even still got good old-fashioned files and programs to contend with as well. And who knows what all these different fancy formats are stored on? Is it a hard drive, or a USB flash drive, or a memory card, or a CD-ROM, or a DVD-ROM? From what my friends tell me, this stuff can even be stored on the Internet and retrieved online!

Fellow computer owners, this is a book with a *purpose* . . . a book that was specifically written to answer your questions on all forms of digital media. Whether you watch it, listen to it, load it, open it, burn it, or download it, this book will explain what you can do with your data and your digital media. And it doesn't matter whether you have a PC running Windows or a Macintosh running Mac OS X — I've got 'em both, and this technology author doesn't play favorites.

What's in This Book, Anyway?

As if the size of this book and the Table of Contents doesn't give away the secret, this one volume is really four different books — but my editors believe in convenience. (I hope you don't strain your back lifting it.) Anyway, I've tried to squeeze every last tip, shortcut, step-by-step, and personal recommendation I could fit between these covers.

Although you can certainly read this majestic tome from cover to cover in a linear fashion, it's really not meant to be consumed like a novel. (Here's a spoiler — Steve Jobs and Bill Gates both did it.) Instead, this Gigabook is a reference book, organized to make it easy for you to solve problems, read about new technology, and apply what you've learned to your computer.

Here's a quick rundown on the four minibooks that make up the *Digital Photos, Movies, & Music Gigabook For Dummies*:

✦ **Book I: Digital Photography:** This is a guide to the entire spectrum of digital photography. Sure, you find out about your camera and how to download your photos — any book on this topic will tell you that — but this minibook delves into serious amateur and professional Digital Photography, including lighting, composition, studio and on-site work, and sports and portrait photography. Plus, I demonstrate how to restore and improve your photos and scanned images by using Adobe Photoshop Elements.

✦ **Book II: Digital Movies:** Analog video is fast disappearing from the face of the planet, and this minibook introduces you to the new king, digital video. Here you discover what to look for in a DV camcorder, and I provide tips and tricks to help you use today's digital-video-editing software — both the low end (iMovie) and the high end (Adobe Premiere Pro). If you've always dreamed of handling a camcorder like a true film-maker, you'll flip over the chapters on storyboarding, lighting, and post-production.

✦ **Book III: Digital Music:** I'll be honest — separate me from my iPod portable jukebox for too long and I get . . . well, rather cross. If you love music like I do, you won't be disappointed with this comprehensive minibook on digital audio. It covers portable players, computers, and streaming Internet radio, and even includes instructions on connecting your computer to your home stereo system. Separate chapters on the latest versions of iTunes, Winamp, and Musicmatch Jukebox keep the jams flowing. (And yes, I lead you step by step through the process of setting up your own Internet streaming radio station. You *know* you want to.)

✦ **Book IV: CD & DVD Recording:** Finally, I wrap things up with a mini-book on a topic that crosses all the previous three minibooks: recording all these great images, films, and songs onto CDs and DVDs so that you can enjoy them for the next 100 years or so! Talk about comprehensive: Burn DVD-Video, audio CDs, MP3 discs, digital photo albums, and more.

What Makes This Book Special

So why is this book so different? Besides its sheer size and scope, my editors have designed it to be a breed apart from other books that cover digital audio, video, images, and optical recording. Read on to see why.

Information that's easy to find

If you're like me, you reach for a reference book to find a specific piece of information or a specific procedure, and you want that information *fast*. That's why both the authors and editors responsible for this book have worked overtime to make sure that everything between these covers is well organized and answers the questions you're likely to ask, quickly and concisely.

Specifically, I like bulleted and numbered lists, lots of tables, and headings that immediately communicate what's covered in a section. Sure, you'll find humor here too — after all, today's digital art, both visual and audible, is all about entertainment — but the humor never gets in the way of the information you need. (Believe me, my editors wouldn't let that happen.)

A task-oriented approach

Oh, and don't forget the step-by-step, hands-on approach that has made the *For Dummies* series so popular over the years! Instead of just describing

software, most of the chapters in this book show you how to *do* something — burn a disc, set up a portrait studio in your garage, or export a finished movie for distribution on your Web site. You came to the right place if you like to get things done.

The author's opinion

Oh, one more thing: I wouldn't write a book if I wasn't allowed to speak my mind and recommend what I think is best in the world of computers. (I steer you clear of the worst, too.) In fact, all the authors of the material in this book pull no punches — these experts give you the benefit of their experience and the recommendations that readers expect from a *For Dummies* book.

A Greatest Hits Collection

The material in this book was culled from nine *For Dummies* books published by Wiley. You can think of this book as a kind of greatest hits collection of computer books about digital media. If you stumble upon a topic in this book that intrigues you and you want to know more about it, I suggest looking into one of the nine books from which this book was created:

✦ *Digital Photography All-in-One Desk Reference For Dummies,* by David D. Busch

✦ *iMovie 2 For Dummies,* by Todd Stauffer

✦ *Adobe Premiere Pro For Dummies,* by Keith Underdahl

✦ *Digital Video For Dummies,* 2nd Edition, by Martin Doucette

✦ *Digital Video For Dummies,* 3rd Edition, by Keith Underdahl

✦ *MP3 For Dummies,* 2nd Edition, by Andy Rathbone

✦ *iPod & iTunes For Dummies,* by Tony Boves and Cheryl Rhodes

✦ *Music Online For Dummies,* by David Kushner

✦ *CD & DVD Recording For Dummies,* 2nd Edition, by Mark L. Chambers

Foolish Assumptions

Please forgive me, but I made two foolish assumptions about you, the reader of this book. I assumed that

✦ You have a PC or Macintosh computer.

✦ You're reasonably familiar with your operating system, whether it be the latest flavor of King Windows or one of the "big cats" that lend their names to Mac OS X.

Believe it or not, that's the whole list — this book assumes nothing else about your level of hardware or software experience. After all, computers are *supposed* to be getting easier to use, right?

Conventions Used in This Book

This is a hands-on book, and the procedures you encounter sometimes require techno-verbiage and typed commands. Therefore, I've adopted a few conventions.

To show you how to step through command sequences, I use the ⇨ symbol. For example, you can choose File⇨Save to save a file. The ⇨ is just a shorthand method of saying, "From the File menu, choose Save."

Where you see boldface letters or numbers in this book, it means to type the letters or numbers. For example, "Enter **25** in the Margin text box" means to do exactly that: "Enter the number 25."

Icons Used in This Book

To help you get the most out of this book, I've placed icons here and there. Here's what the icons mean:

Next to the Tip icon, you can find shortcuts and tricks of the trade to make your visit to the digital world more enjoyable.

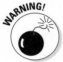

Where you see the Warning icon, tread softly and carefully. It means that you are about to do something that you may regret later.

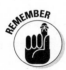

When I explain a juicy little fact that bears remembering, I mark it with a Remember icon. When you see this icon, you'll discover something that you need to remember throughout your computer adventures.

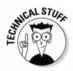

When I am forced to describe high-tech stuff, a Technical Stuff icon appears in the margin. You don't have to read what's beside the Technical Stuff icons if you don't want to, although these technical descriptions often help you understand how a software or hardware feature works.

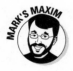

If you had a highlighter handy, you'd likely pick this stuff to underline. My maxims are tips and recommendations that you should commit to memory — they'll save you money, time, and effort. (This way, you won't make the mistakes the rest of us have already made.)

CHECK IT OUT

For Further Fun Factoids . . .

Check It Out sections appear at the end of some chapters and suggest a cool task or an entertaining project that you might be interested in, so Check It Out!

Book I

Digital Photography

The 5th Wave By Rich Tennant

@RICHTENNANT

"Well, well! Guess who just lost 9 pixels?"

Book 1: Digital Photography

Chapter 1: Becoming a Digital Photography Maven

In This Chapter

✔ **Choosing equipment**

✔ **Making great digital photos**

✔ **Converting other photos to digital format**

✔ **Making hard-copy prints**

"**I**s digital photography all that different from film photography?" I hear that question all the time, and there's a definitive answer: yes and no. (So much for absolutes.)

Perhaps I should explain: The equipment you'll use and the procedures you'll follow in digital photography are indeed very different from your venerable 35mm camera. Forget film and traditional film processing — and, if you're a photographer with experience in the darkroom, you can also cast off all those chemicals. If you have an inkjet or laser color printer, you can produce all the prints you need right from your computer. Plus, you can use an image editor like Photoshop Elements or Paint Shop Pro to modify your images and repair problems, or add all sorts of artistic effects.

On the other hand, digital cameras look and operate very much like their film cousins, and they share many of the same accessories: lenses, flash units, tripods, and the like. The basic rules of photo composition are the same no matter which kind of camera you're using, and you'll find that you still need to plan ahead when buying supplies and outfitting your camera bag for a trip.

In this chapter, I outline the guidelines you should follow to reach that hallowed summit we all crave — the title of *Serious Digital Photographer!*

Knowing What Equipment You Need

I realize that not all of you are curled up with this book in one hand and a digital camera in the other. You may already have a digital camera and have just purchased this book to find out exactly what you can do with it. However, I'm guessing that quite a few of you haven't taken the plunge yet. You bought this book to find out more about digital photography before spending your hard-earned money on the equipment you need. You have questions that need answers first: Can I afford a camera that does the things I need it to do? Can a computer fumble-fingers like me really jump into digital photography? What's the best camera to buy? Still others are

digital camera veterans who are already thinking of upgrading. You, too, need some advice about equipment, which you can find in this book.

Choosing a digital camera that's right for you can be tricky because a lot more goes into your selection than simply the specifications. Two cameras with identical specs can perform quite differently. One may exceed your expectations while another one frustrates the heck out of you. I explore some of the subtleties of camera selection in Chapter 2 of Book I.

However, if you want to get the most from this book, your digital camera (or *digicam* for short) should have certain minimal features and capabilities. For example, if your digital camera is one of those Web cams that can capture stills measuring 320 x 200 pixels, or maybe 640 x 480 pixels, you probably don't have what you need to take serious or semi-serious digital photos.

One of those $59 digicams with a lens that can't be focused, no exposure controls, and no removable storage probably won't do the job for you either, other than as a fun toy. If you believe the adage, "Any camera is better than no camera," go ahead and slip one in your pocket and be ready to take a snapshot anytime, anyplace (as long as you have enough light, your subject holds still, and a wallet-sized print will suffice). Such a minimalist digital photo system, however, won't enable you to do much.

Any digital camera costing a couple hundred dollars or more will probably do a fine job for you. Even the least expensive, true digital cameras boast resolutions of at least 1 megapixel. (That is, at least 1 million pixels of information, usually 1024 x 768 pixels or more.) Typical digital cameras have automatic exposure, a color LCD viewing screen for previewing or reviewing your photos, and removable storage so you can take out your digital film card when it's full and replace it with a new one to keep shooting. Most have a zoom lens so that you can magnify an image without moving forward, which is invaluable when you want to take pictures of different subjects from one spot.

Those minimum specs give you everything you need to take great photos. After all, it's the photographer, not the camera, that produces the best images. I once wrote an article for *Petersen's PhotoGraphic Magazine,* in which I presented photos of the same subjects, side by side, taken with an inexpensive point-and-shoot camera and a full-blown professional system that cost 100 times as much. After both sets of photos had been subjected to the vagaries of halftone reproduction, it was difficult to tell them apart.

Spending a lot on a digital camera buys you a few new capabilities from better zooms, enhanced resolution, or a more sophisticated built-in flash. If you have a full-featured model, you can find lots of information in this book on how to get the most from your camera's capabilities (as well as workarounds for those owning more modest equipment).

You can find digital cameras suitable for the most exotic of photographic pursuits, such as the underwater setup shown in Figure 1-1. It's a Canon WP-DC300 waterproof case for the Canon PowerShot S40 digital camera. It provides full access to all your camera's controls, while letting you photograph those colorful coral reefs in Tahiti at depths up to 100 feet!

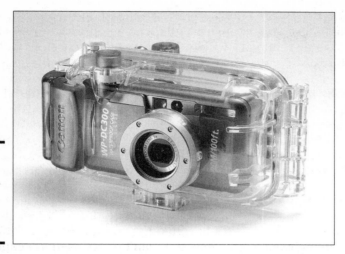

Figure 1-1:
A typical underwater case for shooting marine life.

Minimum and Maximum Specs

For most of this book, I assume you have a digital camera with a resolution of at least 2 megapixels. (If you don't understand resolution right now, see Chapter 2 of Book I, for an explanation.) A camera with a 2-megapixel sensor corresponds to about 1600 x 1200 pixels, which is enough detail to give you decent 6-x-8-inch prints or larger at 200 dpi printer resolution. A 2-megapixel camera also can capture enough information to allow some cropping, especially if you plan to use the image on a Web page, where high resolution isn't necessary. A 4-megapixel resolution was a standard midrange spec as I wrote this book.

However, if you have a 1.0- to 1.3-megapixel camera, you can still do plenty of things. You can prepare images for dynamite Web pages and make sparkling 4-x-5-inch prints. I still use an ancient Epson digital camera that maxes out at 1024 x 768 resolution to take pictures for eBay auctions, and most of the time, I take the snaps at a lower 640 x 480 setting that's plenty sharp enough for photos shown at small sizes.

Cameras with up to 6 megapixels of resolution have dipped into the $1,000 range and will probably become common during the life of this book. If you own one of these babies, you can do even more. You can make tack-sharp 8-x-10-inch prints (and even larger prints if your printer supports them), crop out the center of an image, and still have sharpness to spare. Your camera will have loads of automated features, such as automatic bracketing (taking several exposures at different settings to make sure one is ideal) or a very long zoom lens (to reach way out and capture distant objects).

Although I seem to focus on the number of pixels a camera has, other considerations, such as the zoom lens I just mentioned, may also be important to you. Even the least expensive cameras may have a 2:1 to 3:1 zoom, which can magnify an image 2x and 3x (respectively). Better cameras have 4:1 or longer zooms, up to 10:1 or more. Your camera probably has *macro,* or close-up, capability, which lets you grab images from inches away from your subject.

Most of the other components (such as the amount and type of memory storage, manual/automatic exposure and focusing options, built-in flash capability, and so on) can vary widely. You can find discussions of these in Chapter 2 of Book I.

Although I've been using single lens reflex (SLR) cameras, both digital and conventional, for more years than I care to think about, very little in this book actually requires a digital SLR to achieve. Those of you with high-end cameras should still find lots to like in this book because one of my goals has been to present pro-level techniques in ways that can help beginners, too. If you have a digital SLR, you'll find these techniques even more useful.

One thing I avoid in this book is mentioning the names of specific camera models, except as a matter of interest from time to time. My oldest digital camera in regular use is a 4-year-old (plus) Epson PhotoPC 600. Its capabilities still compare favorably with the least expensive 1-megapixel models, and that's what's important. When camera model matters, I may mention 6- or 3.3- or 2-megapixel models in a generic sense. You won't find any discussion in this book about the relative merits of the latest Nikon or Fuji cameras, or other references that will be hopelessly outdated in a few months. (Those of you reading this in the year 2005 with your $500 10-megapixel cameras should refrain from laughing.)

Taking Great Digital Shots

So, when you have a camera in hand, what do you need to know to take great digital photos? In this section, I discuss the knowledge that needs to reside in your brain (or be otherwise available) to take great pictures.

Understand how your camera works

No digital photography book can tell you how to turn on your camera, how to adjust the auto-exposure settings, or how to use your model's self-timer to take a picture with you in it. Those are things found only in your camera's instruction manual. Read it. I promise that the information you seek is in there; it may just be hard to find. The instructions for my own Nikon digital camera are so cryptic that I found myself creating a cheat sheet with lists of steps, such as, "To turn off the auto-sharpening feature, press the Menu button, and then. . . ."

Some of the techniques in this book call for using a specific exposure mode or lens setting. I may ask you to switch to your camera's close-up mode to take photos a few inches from your subject. You may need to use your camera's built-in flash. Find out how to do these now so that you can add some simple but effective tools to your shooting repertoire.

Know some photography fundamentals

Certainly, you can point your camera and snap off a picture that may turn out great. Some prize-winning shots were taken in an instant as a fast-breaking news event unfolded without warning. Amateur photographers took more

than a few of those photos, such as the famous Pulitzer Prize winner of a woman falling from a burning hotel captured by a 26-year-old Georgia Tech student. However, whatever part instinct and luck take in the production of great pictures, a little knowledge can be much more important.

✦ If you know a little about composition, you can nudge your images into a more pleasing arrangement. (See Book I, Chapter 7, for a full course in photographic composition.)

✦ Understanding how focus can make parts of your image sharp or blurry gives you the freedom to use focus selectively to isolate or emphasize subjects (Book I, Chapter 8).

✦ Having some background in how shutter speeds can freeze action can improve your sports photography (Book I, Chapter 11).

✦ You don't need to become an expert in lighting effects, but understanding how light works can improve your people pictures (Book I, Chapter 9).

Find out how to use an image editor

In digital photography, the pseudo-snap of an electronic shutter is only the beginning. You can do lots of things after the shot to improve your photo — or transform it into an entirely new one. Simple image editors enable you to crop pictures, fix bad color, or remove defects such as those glaring red eyes found in many flash photos. However, you can find even more creative freedom in more advanced image editors that let you do anything from eliminating trees that appear to be growing out of your subject's head to bringing seriously damaged photos back to life. If you want to polish your reputation as an all-around digital photographer, plan on developing at least a modicum of skill with a decent image-editing program. You'll find general information on a broad range of image editors in Chapter 13 of Book I, as well as specifics on Adobe Photoshop Elements in Chapters 14 through 18 also in Book I).

Master a scanner

Digital photographers don't *have* to own a scanner, but you don't *have* to own a camera bag or an extra digital film card, either. Like other digital accessories, a scanner provides you with some supplemental techniques that let your scanner complement or substitute for your digital camera. For example, a scanner can be used for producing close-up images of relatively flat three-dimensional objects, such as coins. A scanner can grab pictures of very small objects (less than 1 x 1 inch) that are difficult to capture with a digital camera.

I won't be going into scanners in any depth in this particular tome — I've got a lot of ground to cover just by focusing on digital cameras! However, I can recommend an excellent book with comprehensive coverage of all types of scanners: *Scanners For Dummies,* 2nd Edition, written by Mark L. Chambers (Wiley). You find out everything you need to know about scanning hardware and application software, as well as tips and tricks for improving your scanned images with Paint Shop Pro or your favorite image editor. Check it out!

Making Any Photo Digital

In this book, you can find out how to transform any photo you happen to have into a digital image. As I just mentioned, scanners are one way to do this: Slap an existing photo down on the scanning bed and scan it into your image editor, and you have a digital image that's the equal of anything you might capture with your digital camera — except it's likely to have dust spots!

Or, drop off your film at your local photo lab and request a Photo CD along with (or instead of) your prints. Photo CDs can be produced from slide film, too, or even stacks of existing prints. What you receive for your money is a high-resolution scan of your images, perfect for manipulating in your image editor and printing on your own color printer. You don't even need to own a scanner: Your photo lab does all the work for you.

Another option is using a local or mail-order service that processes your film and puts the finished images on the Internet. You can download your photos to your computer or make them available for viewing by family, friends, and colleagues on a Web page. What could be easier? You can find more information on this topic in Chapters 20 and 21 of Book I.

Printing Your Final Pictures

The final piece of the digital photography puzzle is the hard-copy print. You may create photos electronically, view them on your computer, post them on your Web site, and send them to others as e-mail, but nothing beats having a stack of prints to pass around or an enlargement to hang over the fireplace.

So, in Chapter 20 of Book I, you can find basic information on making prints. The good news is that the equipment you need is inexpensive and easy to use. A photo-quality inkjet printer can set you back $100 or so. It probably plugs directly into a USB port on your computer and requires little or no setup. Making the prints can be a point-and-click operation, and a variety of printers can do the job for you. Today's models can produce prints directly from your digital camera, with no computer required at all!

The bad news, if it can be called that, is that the cost of materials can seem a little high. You can pay $1 or more just for the paper and ink for a single 8-x-10-inch print. The best news is that, unlike a photofinishing lab, you don't make a print of every single photo you take. You can view your prints on your computer display and make hard copies of only the best images. From that viewpoint, making your own prints isn't expensive at all. You're printing only the pictures you want and, in the long run, probably paying a lot less overall than you used to spend on those prints that end up in a shoebox.

Chapter 2: Choosing the Right Camera

In This Chapter

✔ Selecting a camera category

✔ Evaluating lens requirements

✔ Understanding sensors and resolution

✔ Choosing exposure controls

✔ Selecting exposure options

✔ Finding a camera that's easy to use

Choosing the right digital camera isn't as daunting a task as it might appear to be on the surface. Most of the leading digital-equipment vendors produce fine products that take great pictures. All you need to do is a little homework so that as you make your purchase, you're aware of the features you need — and the features you *don't* need. The vendors write their brochures and ad copy so that those who don't sort out features and benefits ahead of time may think that every feature is essential.

I can tell you from personal experience that not even the most serious digital photographers use every control and space-age feature on a high-end, high-tech camera. For example, the ability to shoot several pictures consecutively, each using different color settings, to make sure that one picture is perfectly color balanced may sound cool, but it's not something many people need every day. But if you find yourself constantly taking pictures under varied lighting conditions and color accuracy is important to you, a feature like that may be a lifesaver. Only you can decide for sure.

The key is having the information you need to buy the camera that has the largest number of your must-have features — and a nice sprinkling of good-to-have features — at a price you can afford. So this chapter looks at each of the following considerations in detail:

✦ Lens requirements

✦ Viewfinder options

✦ Sensor resolution

✦ Exposure controls

✦ Storage options

✦ Ease of use

Although much of this information can help you select a camera, you can also find some basic explanations of digital camera nuts and bolts that will be helpful as you take pictures. If you ever wanted to know what shutter speeds and lens openings do, this is your chance.

Choosing a Camera Category

Digital cameras fall into several categories, each aimed at a particular audience of buyers, as well as particular kinds of applications for them. The major types of camera categories include

+ **Web cams:** These are cheap DV (digital video) cameras that also offer low-resolution, full-motion video and still images. They're generally tied down by a cable and sit on top of your computer, and they aren't covered in this book.

+ **Point-and-shoot models:** These entry-level digital cameras, priced anywhere from $50 to $200, offer 1.3 to 2 megapixels of resolution, simple lenses (frequently with digital zoom), and autoexposure.

+ **Intermediate models:** Priced in the $200 to $500 slot, intermediate digital cameras have 2- to 4-megapixel resolution, a 3:1 or better zoom lens, and CompactFlash or SmartMedia storage. Many have close-up focusing and some manual controls.

+ **Advanced consumer models:** In the $500 to $900 range, you can find deluxe digital cameras with roughly 5 to 6 megapixels of resolution, decent 4:1 to 6:1 zoom lenses, lots of accessories, optional exposure modes, and a steep learning curve.

+ **Prosumer models:** Serious amateur and some professional photographers use these. They cost $1,000 to $3,000 and have all the features you could want, including 6 or more megapixels of resolution, the highest quality lenses, and every accessory you can dream of. Expect automatic and manual focus, multiple automated exposure modes, and "motor drive" multishot capabilities.

+ **Professional models:** Professional quality digital cameras cost $5,000 and more, with 8 to 10 million pixels of resolution (and up), and operate much more quickly, allowing the pro to grab shot after shot without pausing for breath. They're rugged, too, which means they can withstand the harsh treatment pros often dish out to equipment — not because professional photographers are mean, mind you, but because they're *busy*. (Heck, even Ansel Adams accidentally dropped a camera from time to time.)

Hence this chapter: The following sections should give you everything you need to decide what type of camera fits your needs.

Evaluating Your Lens Requirements

The lens and the sensor (or film, in the case of a conventional camera) are the two most important parts of any photographic system. The lens gathers the light from your scene and focuses it onto the capture medium, digital or analog. The sensor or film transforms the light into something that can be stored permanently and, after digital or chemical processing, viewed as a picture.

Sharp lenses and high-quality sensors (or film) lead to technically good images; poor lenses and bad sensors lead to poor photos. Indeed, in one sense, most of the other components of a camera are for your convenience.

Theoretically, you could mount a simple lens on one end of an oatmeal box, focus it on a piece of film or a sensor affixed to the inside of the other end of the box, and make an exposure by covering and uncovering the lens with a dark cloth. Of course, the digital version of this science fair project would require some additional electronics to handle the captured signal, but such a system *could* work.

So, when you're choosing a digital camera, the first thing to concentrate on is the lens furnished with it. You probably don't need to go into as much detail as I provide, but understanding the components of a camera lens does help you use your optics as much as it helps you choose them. The major things you need to know fall into four simple categories:

✦ **The optical quality of the lens itself:** Just how sharp a piece of glass (or, these days, plastic) is it? The better the lens, the better it can capture, or *resolve,* fine details. In most cases, the optical quality of digital camera lenses marches in lockstep with the price of the camera and the resolution of the sensor. At the low and medium ends of the price spectrum, digital cameras have good quality lenses that usually can resolve a lot more detail than the 1- to 3-megapixel sensor can capture. *Remember:* Camera vendors have been mass-producing lenses like these for film cameras for decades, and any film camera can capture a *lot* more detail than an inexpensive digital camera. At higher price levels, lenses have better quality optics, which are necessary to keep up with the detail-capturing capabilities of 6- to 8-megapixel (and higher) sensors.

✦ **The amount of light the lens can transmit:** Some lenses can capture larger amounts of light than others, generally because they have a greater diameter that can transmit more light. This factor, called *lens speed,* is a bit more complicated than that, but if you think of a 1-inch-diameter pipe and a 2-inch-diameter pipe and visualize how much more water (or light) the wider pipe can conduct, you'll be thinking in the right direction. Lens speed, in part, controls how low a light level you can take pictures in. So, if you take many pictures in dim light, you'll want a *faster* lens. I look at this factor in greater detail later in this chapter.

✦ **The focusing range of the lens:** Some lenses can focus closer than others. The ability to get up close and personal with your subject matter can be very important if your hobbies are stamp or coin collecting, for example, or if you want to take pictures of flowers or bugs. Indeed, close-focusing can open whole new worlds of photography for you, worlds you can explore in more detail in Chapter 8 of Book I. Figure 2-1 shows what you can do if you can focus close enough.

✦ **The magnification range of the lens:** Most digital cameras, except for the least expensive, have a zoom lens, which allows you to vary the magnification of the image. You may be able to take your basic image and double it in size (a 2:1 zoom ratio), triple it (a 3:1 zoom), or magnify it 10X or more (a 10:1 zoom). The zoom range determines how much or how little of a subject you can include in an image from a particular shooting distance. As you might expect, the ability to zoom enhances your creative options significantly. At the widest settings (called *wide-angle* settings), you can take in broad sweeps of landscape, whereas in the narrowest view (called *telephoto*), you can reach out and bring a distant object much closer.

15

Figure 2-1: Macro photography brings the world in close.

Understanding How Lenses Work

You don't need to have a degree in optical science to use a digital camera, but understanding how lens openings (called *f-stops*) and some other components work can help you use those components more effectively.

Lenses consist of several optical elements, made of glass or plastic, that focus light in precise ways, much like you focus light with a magnifying glass or with a telescope or binoculars. The very simplest lenses, like those used on the least expensive digital cameras, are fixed focal length lenses, usually comprised of just three or four pieces of glass. That is, the elements can produce an image at only a single magnification. You find these in the simplest point-and-shoot cameras that have no zooming capabilities.

Most digital cameras have zoom lenses, which have very complex optical systems with 8, 10, 20, or more elements that move in precise ways to produce a continuous range of magnifications. Zoom lenses must be carefully designed to avoid bad things, such as stray beams of light that degrade the image bouncing around inside the lens. For that reason, when choosing a digital camera with a zoom lens, you need to pay attention to the quality of the image. All 4:1 zooms are not created equal; one vendor may produce an excellent lens with this range, whereas another may offer a lens that is less sharp. Among digital cameras with similar or identical sensors, lens quality can make the biggest difference in the final quality of an image. You find out how to select the best lens for your needs in the next few sections.

Optical zoom versus digital zoom

Digital cameras have two kinds of zooming capabilities: optical and digital. *Optical zoom* uses the arrangement of the lens elements to control the amount of magnification — this is the type of zoom that conventional film cameras use. Usually, optical zoom is the specification mentioned first in the camera's list of features. *Digital zoom* is a supplementary magnification system, in which the center pixels of an image are enlarged using a mathematical algorithm to fill the entire image area with the information contained in those center pixels. Digital zoom doesn't really provide much in the way of extra information; you could "zoom" in on an image in your image editor if you like. However, digital zoom is a (clumsy) way of turning a 4:1 zoom into an 8:1 (or even higher) zoom lens, even if the results aren't as good as those you'd obtain with a true optical 8:1 zoom. I recommend that you discount digital zoom capabilities when buying a camera; I want the sharpest picture possible, and many cameras make switching to digital zoom a clumsy procedure anyway.

Magnifications and focal lengths

Comparing zoom ranges of digital cameras can be confusing because the exact same lens can produce different magnifications on different cameras. (Keep in mind that I'm talking about optical zoom throughout this section; for the lowdown on optical zoom, see the nearby sidebar "Optical zoom versus digital zoom.") That's why you usually see the zoom range of a digital camera presented as absolute magnifications, or in the "equivalents" of the 35mm camera lenses that the zoom settings correspond to.

Zoom range doesn't relate to lens quality. You'll find excellent 4:1 zooms and other 4:1 zooms that are only average in quality. However, the longer the zoom range, the more difficult it is to produce a lens that makes good pictures at all zoom settings. You should be especially careful in choosing a lens with a longer zoom range (8:1 or above); test the camera and its lens before you buy. However, lenses from the major manufacturers (Canon, Nikon, Fuji, and so forth) are all generally quite good.

Until the advent of digital cameras, figuring the magnification of consumer camera lenses was relatively easy because in recent years, most consumer (and the workhorse professional) film cameras used a standard film size — the 35mm film frame — which measures a nominal 24mm x 36mm. You can easily calculate the magnification of any particular lens with that standard film size by measuring how far from the film the lens must be positioned to focus a sharp image on the film. (This is called the *focal length* of the lens.)

By convention, a lens with a 45mm to 50mm focal length is considered a *normal* lens. (The figure was arrived at by measuring the diagonal of the film frame; you can calculate the focal length of a normal lens for any size film or digital camera sensor by measuring that diagonal.)

Lenses with a shorter focal length, such as 35mm, 28mm, 20mm, or less, are described as *wide-angle* lenses. Those with longer focal lengths (such as 85mm, 105mm, or 200mm) are described as *telephoto* lenses. We've lived happily with that nomenclature for more than 75 years, since the first 35mm camera was introduced. Wide-angle and telephoto images are shown in Figure 2-2.

Then came the digital camera, and all the simple conventions about focal lengths and magnifications went out the window. For good and valid technical reasons, digital camera sensors do not measure 24mm x 36mm. You wouldn't want a sensor that large (roughly 1 x 1½ inches) anyway, because the digital camera would have to be large enough to accommodate it. In addition, as with all solid-state devices, the larger a device such as a sensor becomes, the more expensive it is to manufacture. Sensors that are as large as the full 35mm film frame are just beginning to arrive for professional cameras, which means the magnification effect doesn't apply for these digital cameras.

Most sensors are more likely to measure, say, 16mm x 24mm or less. Even the very largest digital camera sensors — currently a 16-megapixel (or more) monster made by Kodak — might be no larger than about 38mm x 38mm. So, a normal lens on one digital camera may be 8mm, whereas another normal lens on another camera may be 6mm. A 4:1 zoom lens can range from 8mm to 32mm, or 5.5mm to 22mm. What a mess! How can you compare lenses and zoom ranges under those conditions?

Figure 2-2:
Is it wide-angle or telephoto? It's all in the lens.

Camera vendors have solved the problem by quoting digital camera lens focal lengths according to their 35mm equivalents. If you're already familiar with 35mm camera lenses, that's great. If you're not, at least you have a standard measurement to compare to. That's why you often see digital camera zoom ranges expressed as 35mm to 135mm equivalent (roughly 4:1) or some similar expression. You can safely use these figures to compare lenses in your quest for the perfect digital camera.

Because digital camera lenses have such short focal lengths in the first place, most models tend to be deficient in the wide-angle department. Expect to see most digital cameras with no better than a 35mm to 28mm wide-angle equivalent. That's barely acceptable because 35mm isn't very wide. If you really need a wide field of view, consider a wide-angle attachment that fits on the front of your lens.

Lens apertures

The *lens aperture* is an adjustable control that determines the width of the opening that admits light to the sensor. The wider the aperture, the more light

that can reach the sensor, making it possible to take pictures in dimmer light. A narrow aperture reduces the amount of light that can reach the sensor, letting you avoid "overloading" the imaging device in very bright light. (Go figure.) These lens openings are used in tandem with *shutter speed* — the amount of time the sensor is exposed to the light — to control the exposure. (I explain more about exposure later in this chapter.) Your digital camera needs a selection of lens apertures (called *f-stops*) so that you can take pictures in a broad range of lighting conditions.

F-stops aren't absolute values; they're calculated by measuring the actual size of the lens opening as it relates to the focal length of the lens using a formula that I won't repeat here. (Some things are just plain unnecessary for normal human beings.) Anyway, the easiest way to visualize how f-stops work is to imagine them as the denominators of fractions. Just as ½ is larger than ¼ or ⅛, so is f/2 larger than f/4 or f/8. The relationship is such that, as the amount of light reaching the sensor is doubled, the f-stop increases using an odd-looking series of numbers: f/2 is twice as large as f/2.8, which is twice as large as f/4, and so on through f/5.6, f/8, f/11, f/16, and f/22 (which is the smallest f-stop you'll encounter in the digital realm). Figure 2-3 shows lens openings of various sizes.

Figure 2-3: F-stops control the size of your lens aperture.

If you're taking photos in automatic mode, you don't need to know what f-stop you're using; the camera selects it for you automatically. Your digital camera probably displays the f-stop being used, however, either in the viewfinder or on an LCD panel, and the information can be helpful. Just remember these things:

✦ The larger the f-stop (and the smaller the number), the more light that's admitted. An f/2 lens (small number, large f-stop) is a "fast" lens, whereas one with a maximum aperture of f/8 (larger number, smaller f-stop) is "slow." If you need to take photos in dim light, you want to buy a camera with a fast lens.

✦ The smaller the f-stop (the larger the number), the more of your image that is in sharp focus. (More on this later.)

✦ As the f-stops get smaller (larger number), exposure time must be increased to let in the same amount of light. For example, if you took a photo at f/2 for ½ second, you'd need to double the exposure time to 1 full second if you "stopped down" to f/4. I discuss exposure a little later, too.

Focus range

A digital camera's *focus range* is simply how close it can be to a subject and still create a sharp image. Digital cameras vary in their close-focusing (also called *macro*) capabilities. If you want to photograph anything up close — flowers, hobby collections, items for sale on eBay, or your big toe — make sure that your camera is up to it. Close focus can vary from model to model. Some vendors deem anything less than about a foot as macro capability. Other cameras take you down to ½ inch from your subject. Here are some things to consider when evaluating focus range.

+ **There's such a thing as *too* close.** When you get to within a few inches of your subject, you'll find that the subject is difficult to light. The camera itself may keep sufficient light from reaching your subject. You find out more about lighting close-ups in Chapter 8 of Book I.

+ **Some lenses don't allow close focus at all zoom settings.** You might want to step back a foot and zoom in to get the best view of your subject. However, some lenses don't allow automatic (or even manual focus) at longer zoom settings. Some restrict macro capabilities to midrange or wide zoom settings.

+ **Close focusing is tricky.** Make sure your digital camera includes automatic macro-focusing capabilities so that you don't have to focus manually when shooting close to the subject.

+ **Keep attachment friendliness in mind.** If your favored digital model doesn't have sufficient built-in macro options, see if you can attach close-up lenses to the front of your lens. Not all digital cameras can accept screw-on attachments of this type.

Exposure controls

Because light levels vary, digital cameras must vary the amount of light reaching the sensor. One way to do that is to change the f-stop, as described earlier in this chapter. The second way is to alter the amount of time the sensor is exposed to the light. This is done either electronically or with an actual mechanical device called a shutter, which opens and closes quickly to expose the sensor for a period known as *shutter speed*.

Like f-stops, shutter speeds are the denominators of fractions, and the larger the number, the less light that's reaching the sensor. Typical shutter speeds include $\frac{1}{60}$, $\frac{1}{125}$, $\frac{1}{250}$, $\frac{1}{500}$, and $\frac{1}{1000}$ of a second. Your digital camera readout probably shows them as 60, 125, 250, 500, or 1000 because the numerator is always 1.

Cameras (chiefly film models) using mechanical shutters may have only exact intervals like those available. Electronic shutters aren't limited to those values and can provide you with any actual interval from a few seconds through $\frac{1}{2000}$, or sometimes $\frac{1}{4000}$, of a second. The traditional shutter speed values are useful only when calculating equivalent exposures.

For example, suppose a basic exposure were $\frac{1}{250}$ of a second at f/16 (which is a typical exposure for a digital camera in bright daylight). If you wanted to stop some fast-moving action, you might want your camera to switch to $\frac{1}{500}$ of a second to freeze the movement with the shorter exposure time. (You can find out more about stopping action in Chapter 11 of Book I.)

Because you've cut the amount of light in half by reducing the shutter speed from ⅟₂₅₀ to ⅟₅₀₀ of a second, your camera needs to compensate by doubling the amount of light admitted through the lens. In this example, the lens is opened up from f/16 to f/11, which lets in twice as much illumination.

Usually, this all happens automatically thanks to your digital camera's handy autoexposure modes, but you can set these controls manually on some models if you want. It's probably a better idea to choose a different autoexposure mode (described later) that gives you the flexibility you need. Sometimes, you'll look at an image on your LCD review screen and decide the picture is too dark or too light. A digital camera's autoexposure modes can take care of this, too. When shopping for a digital camera, look for the following exposure options:

✦ **Plus/minus or overexposure/underexposure:** With these modes, you can specify a little more or a little less exposure than the ideal exposure that your camera's light-measuring system determines.

✦ **Full autoexposure:** With this option, your digital camera selects the shutter speed and lens opening for you, using built-in algorithms that allow it to make some intelligent guesses about the best combination of settings. For example, on bright days outdoors, the camera probably chooses a short shutter speed and small f-stop to give you the best sharpness. Outdoors in dimmer light, the camera may select a wider lens opening while keeping the shutter speed the same until it "decides" to drop down to a slower speed to keep more of your image in sharp focus. Some digital cameras have several autoexposure program modes to select from, so if you are taking action pictures and have chosen an action-stopping mode, the camera tries to use brief, action-stopping shutter speeds under as many conditions as possible. These program modes are different from the aperture/shutter-preferred modes described next.

Naturally, no "algorithm" will ever be as savvy as a professional photographer, but I've found that the autoexposure mode on my cameras produces better results if I'm in a hurry or I have only a couple of seconds to compose the shot.

✦ **Aperture-preferred/shutter-preferred exposure:** These options let you choose a lens opening (aperture-preferred) or shutter speed (shutter-preferred) and then set the other control to match. For example, by choosing shutter-preferred, you can select a short shutter speed, such as ⅟₁₀₀₀ of a second, and the camera locks that in, varying only the f-stop. Unlike the programmed modes described in the preceding bullet, if your camera finds that the selected shutter speed, for example, can't be mated with an appropriate aperture (say, it's too dark or too light out), it may not take a photo at all. I've run into this at soccer games when I've set my camera to an action-stopping shutter speed and clouds dim the field so much that even the largest lens opening isn't enough to take a picture. Figure 2-4 shows an action shot taken with the camera set on shutter-priority.

✦ **Full manual control:** With this option, you can set any shutter speed or aperture combination you like, giving you complete control over the exposure of your photo. That means you can also completely ruin the picture by making it way too dark or too light. However, complete control is good for creative reasons, because seriously underexposing, say, to produce a silhouette effect, may be exactly what you want.

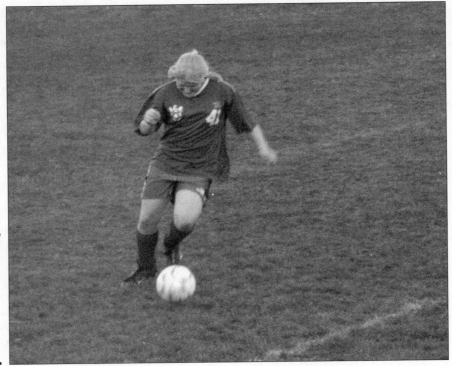

Figure 2-4:
If sports photography is your game, shutter-priority is important.

Keep in mind that the need for full manual control is somewhat less important with a digital camera: That's because you can always experiment after you've taken the shot, using your trusty image editor. Changes you can make in your digital darkroom include lighting, brightness, contrast, and even focus.

In addition to exposure options, you must consider other factors when evaluating the exposure controls of your dream digital camera. Here's a quick checklist of those you should look out for:

✦ **Sensor sensitivity:** Like film, sensors have varying degrees of sensitivity to light. The more sensitive the sensor is, the better it can capture images in low light levels. Most digital cameras have a sensitivity that corresponds roughly to that of ISO 100 to ISO 200 film, and the specs often use that terminology. Many cameras let you specify the sensitivity, increasing from the default value of, say, ISO 200 to ISO 400 or even ISO 800 to give you a "faster" camera. Unfortunately, upping the ISO rating usually increases the amount of random fuzziness, called *noise,* in the image. It's like turning your radio up really loud when you're driving a convertible with the top down. The wind flying past your ears tends to cancel out some of the audio information that your too-loud radio is producing. Increasing the ISO boosts image information while at the same time increases background noise.

✦ **Measurement mode:** Just how does your digital camera's exposure system measure the light? Sometimes, it measures only the center of the picture (which is probably your subject anyway), and sometimes, it may measure the entire frame and average out the light that the sensor sees.

You don't always want the camera to measure the light the same way. Sometimes, measuring a center spot produces the most accurate reading. Other times, such as when the scene is evenly lit, an averaging system works best. On still other occasions, say, when the photo includes a lot of sky, you might want the camera to measure only the light in the lower half of the picture. Many cameras have multiple exposure modes that allow you to choose what part of the image is measured.

✦ **Compensation systems:** Many exposure systems can sense when a picture is *backlit* (most of the light is coming from behind the subject) and add exposure to make the subject brighter. Sophisticated cameras can analyze your scene and choose an exposure mode that best fits each individual picture, compensating for potential trouble spots in the photograph.

✦ **Manual exposure:** If you're seriously interested in photography, you'll want at least the option of setting exposure manually (both f-stop and shutter speed) so that you can customize your exposure to the artistic effect you're trying to achieve.

Choosing Your Resolution

The best lens can't produce any more sharpness than the sensor used to capture its information. For that reason, the resolution of most digital cameras is the specification most people use to choose their equipment. They want a 3.3-megapixel camera, or a 5.1-megapixel model, or maybe a 6- to 8-megapixel camera. They figure (with some justification) that the more pixels they have, the more features the vendor packs into the camera. After all, you can expect a 6-megapixel camera to have a decent zoom lens, lots of exposure control choices, close focusing, and all the other goodies, right?

Most of the time, that's true. The sensor is usually the most expensive part of any digital camera, so if you're building a camera that's going to cost $1,000 anyway, you might as well load on the other goodies to justify the price.

However, all pixels are not created equal. For one thing, the *true* resolution of a sensor is likely to be somewhat less than you might think. Take, for example, a sensor measuring 2048 x 1536 pixels. You'd think that such a sensor could image about 3.1 million different details. Bzzzt. Wrong answer! That would be possible only if the image were captured in black and white.

In practice, the sensor has to capture red, green, and blue pixels. With current sensors, each pixel can capture only one particular color, so those 3.1 million pixels are actually divided up into red-sensitive pixels, green-sensitive pixels, and blue-sensitive pixels. If the pixels were divided up evenly, you'd wind up with three 1-megapixel sensors, one each for red, green, and blue, rather than the 3.1-megapixel sensor you *thought* you had.

However, the pixels aren't divvied up in that way. Because our eyes are more sensitive to green light than to the other colors, sensors typically divide up their pixels unevenly: 50 percent are green, 25 percent are red,

and 25 percent are blue. That's done by alternating red and green on one line, and green and blue on the next, as shown here and also in Figure 2-5:

RGRGRGRGRGRGRGRG

GBGBGBGBGBGBGBGB

RGRGRGRGRGRGRGRG

Figure 2-5: All is not even when comparing sensors.

Your camera's brain examines the picture and calculates (or *interpolates*) what the red and blue values probably are for each green-sensitive pixel position, what the green and blue values are for each red-sensitive pixel position, and what the green and red values likely are for each blue-sensitive pixel.

In addition, some sensors are more sensitive than others, and other factors make a particular sensor not perform as well as another one with the same number of pixels. For example, some sensors don't register some colors well or have pixels that bright light can easily overwhelm.

When buying a digital camera, you want to choose one with the resolution you want and, if possible, compare the pictures taken with each camera under consideration to see if that resolution is being put to good use.

When it comes to megapixels, you can estimate the resolution you require with these guidelines:

✦ **Low res:** If you're shooting pictures intended for Web display, for online auctions, or for pictures that either won't be cropped or enlarged much, you can get by with a lower-resolution camera in the 1-megapixel range.

✦ **Medium res:** If you often need to crop your photos, want to make larger prints, or need lots of detail, you want at least a 2-megapixel camera, and more likely a 3.3- to 4-megapixel model.

✦ **High res:** If you want to extract small portions of an image, make prints 8 x 10 inches or larger, or do a lot of manipulation in an image editor, you want a 5- to 8-megapixel (or more) camera.

Keep in mind that most digital cameras allow shooting in a reduced mode, so if you own a high-resolution camera, you can still shoot in low resolution to pack more images on your digital film or to reduce file sizes on your hard disk. Resizing images is rarely a good idea, even with a good image-editing program, so you usually want to shoot at the resolution you intend for your finished photo.

The mode in which your camera stores the image on your digital film can also affect the final resolution of your image. Digital cameras usually store photos in a compressed, space-saving format known as JPEG (taken from

the tongue-twisting Joint Photographic Experts Group). The JPEG format offers reduced file sizes by discarding some information. In most cases, a JPEG file is still plenty good, but if you want to preserve all the quality of your original image, you may want to set your camera to store in a lossless image format (that is, one that doesn't discard any image information when compressing the file), such as TIFF, RAW, or EXIF. You may be able to choose from different JPEG quality levels, too.

Expect these alternate formats to eat up your exposures quickly. One of my digital cameras can store 32 images on a particular film card in JPEG format but only 5 in TIFF.

Some cameras generally label their resolution choices with names such as Standard, Fine, Superfine, Ultrafine, and so forth. These terms can vary from vendor to vendor. A typical range in a megapixel model might look like Table 2-1.

Table 2-1	Typical Resolution Names and What They Mean
Resolution Name	*Typical Resolution*
Economy/VGA	640 x 480 pixels
Standard/SVGA	1024 x 768 pixels
Fine/SXGA	1280 x 960 pixels
Superfine/UXGA	1600 x 1200 pixels
High/Full	2048 x 1536 pixels

Choosing Your View

Generally, you want what you see to be what you get, but that's not always the case with digital cameras. That's because the viewfinders available are usually a compromise between what works best and what can economically be provided at a particular price level. In the digital photography realm, the solution has long been to provide you with *two* viewfinders per camera, each with its own advantages and disadvantages. You usually find both an optical viewfinder, which you can peer through to frame and compose your image, as well as a color LCD display screen on the back of the camera, which you can use to preview and review your electronic images. Neither is ideal for every type of picture-taking application.

LCD viewfinders

The liquid crystal display (LCD), usually measuring about 2 inches diagonally, shows an electronic image of the scene as viewed by the sensor. On the one hand, that's good because you can view more or less the exact image that will be captured. It's also not-so-good because the LCD display is likely to be difficult to view, washed out by surrounding light, and so small that it doesn't really show what you need to see. Moreover, the backlit LCD display eats up battery power. I've used digital cameras that died after 20 minutes when the LCD had depleted their rechargeable batteries. Luckily, some digital cameras let you specify that the LCD is turned on only when composing a picture, or only for a few seconds after a picture is taken (so that you can quickly review the shot).

Although often not usable in bright daylight, LCDs, such as the one shown in Figure 2-6, are better in more dimly lit conditions. If you mount your camera on a tripod and make sure that all the light is directed on your subject, an LCD is entirely practical for framing, focusing, and evaluating a digital image. As you shop for a digital camera, check out the LCD display under a variety of conditions to make sure it passes muster.

Optical viewfinders

Most of the time, you use an optical viewfinder, which is bright and clear, uses no power, and lets you compose your image quickly. However, optical viewfinders have problems of their own, most notably a problem called *parallax.* Parallax is caused by the difference in viewpoint between your camera's lens and the optical viewfinder. They don't show the same thing.

If the optical viewfinder happens to be mounted directly above the camera lens, its view will be a little higher than that of the lens itself. This becomes a problem chiefly when shooting pictures from relatively close distances (3 feet or less). Such a viewfinder tends to chop off the top of any subject that is close to the camera. Optical viewfinders usually have a set of visible lines, called *parallax correction lines,* that you can use to frame the picture. If you keep the subject matter below the correction lines, you can avoid chopping off heads. Of course, you get *more* of the lower part of your subject than you can view.

Parallax becomes worse when the optical viewfinder is located above and to one side of the lens, as shown in Figure 2-7. In that case, a double set of parallax correction lines is needed to help you avoid chopping off both the top and the side of your subject. Yuk!

Figure 2-6: The LCD is a great help when composing shots.

Figure 2-7:
Beware the
specter of
parallax!

Hybrid viewfinders

Recently, some affordable cameras have been introduced with hybrid viewfinders that work like optical viewfinders (that is, you put your eye up to a window to view your subject) but that use an electronic display to show you the image.

And there's always the high-end, digital, single lens reflex camera, which shows you the exact image the sensor sees through the taking lens, using an optical system. It's done with mirrors — although somewhat tired, the pun is still intended. In the most common configuration, you view the subject through the lens using an image bounced off mirrors and (sometimes) a glass prism. Then when you take the picture, the mirror moves out of the

way to expose the sensor. You lose sight of the image for a fraction of a second, but film SLR users have been tolerating that inconvenience for decades.

Viewfinders with vision correction

Regardless of what optical or SLR viewing system you use, you want to make sure your camera either has built-in eyesight (diopter) correction to adjust for your near- or far-sightedness, or can be fitted with corrective lenses matched to your prescription. This vision correction enables you to get your eye close enough to the viewfinder to see the whole image. Some viewfinders make it difficult for those wearing glasses to see through the optical system, because a bezel or other part of the viewfinder prevents the glasses from getting close enough.

Considering Your Storage Options

The kind of storage your digital dream camera uses will never be a factor in making your selection, unless it's a truly odious choice, and that's a matter of personal taste. The days of the digital cameras that used floppy disks and other oddball media are long gone. Today, all digital cameras use one of the following options:

✦ **SmartMedia:** These digital film cards are more popular in Japan than in other countries, chiefly because of their very small size. Because so many digital cameras are made in Japan, you can expect to see lots of cameras using SmartMedia. In the past, SmartMedia cost more than its chief competitor, CompactFlash, and had lower capacity to boot. Today, the most common sizes, 128MB and 256MB, are available in both formats and at comparable prices.

✦ **CompactFlash:** CompactFlash is the favored format in the United States. Although slightly larger in size than SmartMedia, CompactFlash cards are still very small and convenient to carry and use. As larger capacities are introduced, they usually appear in CF format first. As a bonus, the CompactFlash slot can also be used for mini hard drives, such as those from IBM, with capacities of a gigabyte or more.

✦ **Mini hard drives:** Until silicon technology catches up, mini hard drives are your only option when you need more than a gigabyte of storage. If you're using a 6-megapixel or better camera and like to save your images as TIFF files or in another lossless format, you need more than a gigabyte of storage.

✦ **CD-R/R:** Sony, in its never-ending quest to change its digital camera media options annually, seems to have abandoned floppy storage in favor of mini-CD-Rs and mini-CD-RWs. Although not really a bad idea, because the media is relatively inexpensive (a 240MB mini-CD-R is a lot cheaper than a 256MB CompactFlash card), this option hasn't caught on yet.

✦ **Sony Memory Stick:** About the size of a stick of gum, Sony's Memory Sticks are useful because you can also use them with other devices, such as MP3 players. They're not going to replace CompactFlash, though.

No Flash in the Pan: Determining Your Lighting Needs

Your digital dream camera's electronic flash capabilities (or lack thereof) should be on your list of things to evaluate before you make a purchase decision. Not every photo is possible using existing light. Even if plenty of light is available, you may still want to fill in those inky shadows by using an electronic flash. So, your camera's built-in flash features are something to look at.

Most digital cameras have a built-in flash unit that can be turned on or flipped up or swung out or otherwise activated when you want to use flash — or when the camera decides for you that flash is required. (Usually a tip-off is a flashing red light in your viewfinder. Time to flip up that flash!)

You should be aware that most flash units are good only over a particular range. If you've ever seen a fan stand up in the balcony at a Bruce Springsteen concert and take a flash picture of the Boss from 100 feet away, you'll understand just how limited flash is at long distances. Some units may be so feeble that they can only illuminate subjects between 2 and 12 feet away. Others may have special settings to spread the flash illumination for wide-angle shots or tighten it up for telephoto pictures.

Here are some features to look for in electronic flash:

✦ **Auto-on:** It's useful to have a flash that can be set to flash only when it's needed. Some cameras may require you to flip up the flash to use it. Others build the flash in to the camera's body in such a way that the flash can be used anytime.

✦ **Autoexposure:** An electronic flash can sense the amount of light reflected back from the subject and turn itself off when the exposure is sufficient. See if your camera's electronic flash uses a sensor built in to the camera's body or whether the sensor measures the light actually being used to take the photo.

✦ **Red-eye prevention:** Some flashes can be set to produce a short pre-flash just before the picture is taken. That causes the subjects' irises to contract, reducing the possibility of the dreaded red-eye effect.

✦ **External flash capabilities:** At times, you want to use an external flash, either in concert or instead of your camera's built-in flash. See if your camera has a built-in flash-synch socket or a *hot shoe* that you can use to mount an external flash *and* connect the camera to the flash. Keep in mind that many digital cameras require that you use only a particular brand of flash to retain the automated exposure features or, in some cases, to avoid frying your camera's flash-triggering circuit with too much voltage.

Checking Out Ease of Use

I've saved the best for last because I want this topic to sink firmly into your mind as you put this book down and continue to think about what you're looking for in a digital camera. Usability is one of the most important factors to keep in mind when choosing a camera. The sharpest lens, the most

sophisticated sensor, and the most advanced features are all useless if you can't figure out how to operate the stupid camera! I've owned digital cameras that absolutely could not be used without having the manual at hand. Even common features were so hard to access that I sometimes avoided taking certain kinds of pictures because activating the feature took too long.

Ease of use is not limited to digital cameras, of course. Difficult-to-operate cameras have been creeping up for 15 or 20 years. This was not always so. When I began my photographic career as a newspaper photographer, film cameras had a limited number of controls — a shutter speed dial, f-stops to set on the lens, focusing, and maybe a rewind knob to move the film back into the cassette when the roll was finished. Over the years, electronic exposure controls were joined by exposure modes and a ton of other features as film cameras became more and more computerlike.

Today, even digital cameras that most resemble their film counterparts bristle with buttons, command dials, mode controls, menus, and icons. That's not necessarily a bad thing. What is evil is an interface that's so convoluted that even advanced users may have problems. You may have to wade through nested menus to change the autofocus or exposure control mode. Switching from aperture-priority to shutter-priority may be a pain. Something as simple as changing from automatic focus to manual focus can be difficult, particularly if you don't make the switch very often and forget which combination of buttons to press.

Ease of use varies greatly, depending on which features are most important to you. A camera that one person may find a breeze to use may be impossible for another person to manage, simply because a particular must-have feature is hard to access.

So, I urge you to try out any digital camera you're seriously considering buying before you plunk down your money. A camera's feature set, or the vendor's reputation, or recommendations of a friend won't tell you how the camera will work for *you*. Hold the camera in your hand. Make sure it feels right, that its weight and heft are comfortable to you. Be certain your fingers aren't too large or too small to handle the controls. Can you see through the viewfinder?

If possible, take the camera for a test drive, borrow a similar camera from a friend or colleague, or at least shoot some photos in the store. Can you find the features you use most? Can you figure out the menus and buttons? Is the camera rugged enough to hold up under the kind of treatment you'll subject it to?

As much as I like buying by mail order or over the Internet, a digital camera is too personal a tool to buy from specifications lists and photos. If you're reading this book, you're probably serious enough about digital photography that you'll be spending a lot of time with your camera — and probably will spend more money than you expected to get the camera you really want. Make sure it really is the one you want by giving it a thorough workout.

Chapter 3: Solving the Computer Side of the Digital Equation

In This Chapter

✔ **Choosing between a Mac and a PC**

✔ **Understanding your memory and storage needs**

✔ **Selecting a microprocessor**

✔ **Doubling your display pleasure**

✔ **Pointing with a pen**

You may be ready for digital photography, but is your computer up to the task? The good news is that virtually any computer of recent vintage probably has the horsepower and features needed to work with the digital images that you capture with a camera. A Windows PC with a Pentium or an AMD processor that operates at 800 MHz or faster — or, on the other side of the street, any G3-, G4-, or G5-based Macintosh — has what it takes to import, process, and output digital images.

Even so, the differences between a computer that's good and one that's only "good enough" can be significant. Your system may be exceptional, or it may be the exception. You probably don't want to be working with the minimal system possible, even if you'd rather invest your money in a better digital camera. (I know if faced with the choice of a new, 3 GHz Pentium III computer and an 8-megapixel digital single lens reflex, I'd choose the camera every time. Unfortunately, I don't get to make such choices.)

This chapter helps you develop your own checklist of recommended hardware, shows you how to upgrade to make your work even easier, and offers tips on setting up your computer to make working with digital images a breeze.

I cover only the main equipment options for setting up a computer for digital-photography editing and storage in this chapter. You can find information on equipment used to transfer images between your camera and computer in Chapter 4 of Book I.

Hardware Wars Revisited

Macs versus PCs. Why are we even having this conversation?

Digital photography, graphics work in general, music composition, and video production are the key arenas in which the Macintosh versus PC battle is still being waged. In most other areas, Windows-based systems have taken

over the desktop, with Macs relegated to specialized applications. Apple keeps coming up with compelling hardware, interesting computer designs, and lots of cool applications, but even the world's first prime-time 64-bit system — the Apple G5 Power Mac, teamed with Mac OS X — barely attracts the attention of those in the Windows camp.

But in the digital photography world, that's not the case. Visit any newspaper or magazine relying on digital cameras, and you'll find Macs. Drop in to any professional digital photographer's studio, and you'll see a brawny Macintosh perched on the desktop. Talk to the top Photoshop users in the country, and you'll find that most of them are using Macintoshes, too, either exclusively or in tandem with a Windows box.

Indeed, for a long period of time, the only logical choice for most photographers has been the Macintosh. The decision was along the lines of selecting a 35mm Nikon or Canon SLR for photojournalism, or a Sinar view camera for studio work: a no-brainer. Although I don't have hard figures, my gut feeling is that Macs outnumber PCs in imaging environments by at least 8 to 1. In the rest of the business world, the figures are reversed.

By and large, the latest G4 Macintoshes provide enough muscle for virtually any still-image work, particularly when equipped with at least a gigabyte of memory. (Of course, a Power Mac G5 is the ultimate in performance, producing results like the '60s muscle cars of old Detroit.) No photographer needs to be ashamed of driving a properly equipped Mac.

In the digital photography world, Macs are not only viable but also usually the system of choice. However, in some cases, you may not *have* a choice because you already own a computer or prefer to use a particular system that you're already familiar with.

Yet, if you aren't locked into a particular platform and operating system, should you be using a Macintosh or a Windows computer? If you want a definitive answer, I'd say, "It depends." (Which isn't very definitive, is it?) Each platform has its pros and cons. Here is a summary of some factors you should consider:

✦ **The bandwagon effect:** If you plan to make your living, at least in part, from digital photography, you need to learn two things: how to use a Mac and how to perform image magic with Photoshop. Both skills are expected to be part of your résumé. Jump on the bandwagon while you can. On the other hand, Windows proficiency is expected for most jobs outside imaging. Unless you're a full-time graphics professional, you may have to wear two hats (and, like me, own both Macs and PCs).

✦ **Sheer seat-of-the-pants horsepower:** Hands down, the Mac's 64-bit G5 processor is the fastest desktop on the planet at the time of this writing. Of course, that may last as long as a snowball in Florida, but until 64-bit processors are in common use in the PC world (and Windows fully supports 64-bit processing, which Windows XP doesn't), the Mac will be the King of the Digital Racetrack.

✦ **Ease of use:** The Macintosh is generally acknowledged to be a bit easier to learn and somewhat easier to use for many tasks. Of course,

the Macintosh system's vaunted ease of use has been subverted over the years as Apple has tried to catch up with Windows systems. (For example, the Mac's sublimely simple single-button mouse must be augmented by holding down the Control key while clicking to reproduce the Windows mouse's right-click option.) If you're just starting out in computing and don't want to climb a steep learning curve, the Mac is your computer.

✦ **Software compatibility:** Not all applications are available for both Mac and PC. Most key applications are offered for both, including the Photoshop image editor (shown in Figure 3-1 in both Mac and Windows incarnations), the StuffIt archiving tool, browsers such as Netscape and Internet Explorer, and word processing applications such as Microsoft Word. But if you must be totally compatible with Windows, you need Windows . . . or *do* you?

Figure 3-1:
The powerful vista that is Photoshop.

"Okay, what did you mean by that?" Here's the trick: You *can* run Windows XP on your Macintosh! If you're not interested in playing the latest games, a late-model G4 or G5 Macintosh can do double duty by using Microsoft's Virtual PC for Mac (www.microsoft.com/mac). Virtual PC for Mac emulates a typical Windows PC in software, allowing you to run just about any Windows program (complete with an Internet and network connectivity, USB hardware, and access to your Mac's CD-ROM or DVD-ROM). Naturally, things run somewhat slower — hence my recommendation not to try playing Windows games — but I use this great application every day, and on a 1 GHz (or faster) G4 or a G5, I think you'll be impressed by how well Virtual PC for Mac performs.

✦ **The cost factor:** Macs have generally been more expensive than PCs although the cost difference has decreased over the years. Even so, with powerful Pentium 4 systems available in barebones configurations for $500 or so, even the least expensive Mac still costs a bit more. In the Mac's favor, however, most peripherals and add-ons such as memory, hard drives, DVD devices, monitors, and so forth cost the same whether you're purchasing them for a Mac or a PC.

✦ **Hardware reliability:** Reliability is a two-edged sword. Macs are wonderfully crafted machines, a beauty to behold when you dismantle one, and filled with high-quality components. The insides of some of the assembly-line-built PCs have a decided industrial look, and if you examine the parts, you may find a mixture of known brand-name pieces and whatsis components. On the other hand, if something breaks on your PC, you can run down to the local MegaMart and buy a new floppy drive, a CD burner, and maybe some memory off the shelf next to the cell phone batteries. My local *grocery store* carries these items. Parts for your Mac may be harder to come by, and it's unlikely you'll know how to replace them anyway. So, even assuming the Mac is more reliable than the average PC, is that always an advantage?

✦ **Operating system reliability:** Trust me, Mac OS X 10.3 (affectionately nicknamed Panther) is just plain hard to crash, and I count Mac OS X as a definite advantage over Windows XP — after all, Panther is built on a UNIX foundation. Plus, Mac owners avoid applying the daily patches that Microsoft issues for its software and OS and doing other fiddling that can lead directly to the Blue Screen of Death (BSOD). Oh, and don't forget that virtually all viruses and worms that regularly plague Windows users are unknown in the Mac universe. By any measure, Windows has to be considered inherently less stable than Mac OS. (And I won't get into the frequent horrifying discoveries that things such as the Windows Help system have bugs that let a hostile user invade your system. No, I'm not making that up.) If no crashing is on your holiday gift list, the Mac still has the edge.

✦ **Technological superiority and coolness:** If owning a computer that looks like a Tensor lamp is your cup of tea, and you like the idea of having cool stuff before anyone else, you really, really need a Macintosh. The most exotic hard disk interfaces (from SCSI in the '80s to FireWire in the '90s) came to the Mac first, along with flat-panel displays, DVD burners, and other radical innovations that turned out to be a little (or a lot) before their time.

Windows has its advantages and disadvantages. One advantage is that it's almost universally available and has the broadest range of widely used applications written for it. One disadvantage is that Windows still forces you to do things the Microsoft way when you'd really rather do them your own way. For example, Windows XP is fond of setting up your network the way it likes, bludgeons you into using Internet Explorer even if you prefer Netscape, and has a tendency to coerce you into using the Windows Media Player for everything and anything.

Mac OS 9 and Mac OS X, on the other hand, let you do things your own way quite easily. Would you prefer that your digital-camera application be installed on your secondary hard disk rather than the one you first installed it on? Just drag it to the new hard drive; you don't need to uninstall it and reinstall it as you must do with Windows.

Although you probably won't choose a computer based on the operating system, these things are nice to know.

What Equipment Do You Need?

Digital-cameras themselves make few demands on a computer system, of course. The real drain on your system is running your image-editing program and storing your images for editing or archival purposes. Make no mistake, image editing is among the most demanding types of work you can lay on a computer, so before you start down this road, you'll want to know about the minefields that lie along the way. If you want the flying short course, here are the ten most important things you need to consider:

+ Memory

+ More memory

+ Even more memory

+ Adequate local storage (a fast, big hard disk)

+ A fast microprocessor

+ Archival storage (usually a CD or DVD recorder)

+ Advanced video display capabilities

+ Other peripherals, such as digitizing tablet-and-pen devices

+ A little more memory

+ More RAM than you thought you'd ever need

Determining how much memory you need

If you noticed that I've listed memory five times on my top ten list, there's a reason for that. Memory makes everything else possible. A fast, big hard disk is also important because it gives you room to work with your current project's files and can a substitute for RAM (random access memory) when you finally do run out. But nothing can replace memory when decent performance is your goal.

I can't emphasize this point enough: When you're working with images, you must have, as a bare minimum, at least six to ten times as much RAM as the largest image file you plan to work with on a regular basis. Many digital photos can amount to 18–60MB, which translates into 180–600MB of RAM for *each* image you want open at once. If you're working with more reasonably sized 4MB images but need to have ten of them open at one time, you still need tons of memory to do the job.

Without sufficient RAM, all the bucks you spend on a super-speedy microprocessor are totally wasted. Your other heavy-duty hardware will come to a screeching halt every time you scroll, apply a filter, or perform any of a number of simple functions with an image. That's because without enough RAM to keep the entire image in memory at once — plus your image editor's Undo files (basically copies of the image in its most recent states) — your computer is forced to write some or all of the image to your hard disk to make room for the next portion it needs to work with (a process that software technowizards call *virtual memory*). If you're working with a serious camera in the 6-megapixel range and choose to save your files in the highest-quality mode, you're a candidate for maxing out your computer's memory. An 18MB image is fairly common these days, so you should be prepared with as much RAM as you can cram into your computer.

Most systems have three to four memory slots, which can each hold a 256–512MB memory module, for a total of 2GB. (The exception is Apple's Power Mac G5, which can hold up to a whopping 8GB of memory.) Loading your computer with 2GB of memory is not at all outlandish and is relatively inexpensive. You can purchase that much memory for a few hundred dollars. Any Mac or PC with 512MB or less of RAM is hopelessly underequipped for digital photography. Beefing up your memory can be the least expensive and most dramatic speed enhancement you can make.

Choosing local storage

Your graphics powerhouse is only as fast as its narrowest bottleneck, so you should pay special attention to the biggest potential roadblock: your mass storage subsystems. You need one or more big hard disks for several reasons:

✦ **To keep as many images as possible available for near-instant access:** A large hard disk enables you to store all your current projects — plus many from recent months — all in one place for quick reference or reuse. With a large hard drive, you can store a vast library of your own photographic clip art, too, and avoid having to sort through stacks of archive CDs.

✦ **To provide working space for your current projects:** You'll want *scratch space* — space on your hard drive — to store images that you probably won't need but want to have on hand just in case. Alternate versions of images eat up more space as you refine your project. Image editors such as Photoshop also need spare hard disk space to keep multiple copies of each image you're editing.

✦ **To let you store additional applications:** Good bets here would be panorama-generating programs, a second or third image editor for specialized needs, utility programs, extra plug-in programs, and so forth.

In the recent past, your hard disk storage options were limited to internal hard disks in one of two categories: fast, expensive hard disks using a SCSI interface or inexpensive, slow hard disks using the EIDE interface. Today, the technologies have converged. SCSI drives no longer cost that much more than EIDE disks, and EIDE drives have gotten much, much faster. Moreover, new options have appeared, chiefly in the form of external hard disks that link to your computer via FireWire or USB, and a new kind of internal serial drive.

SCSI and EIDE hard disks

You don't see SCSI disks used much outside server environments these days. Their chief advantage is that your computer can transfer information to and from several SCSI disks simultaneously. That's because SCSI is a system-level interface that conveys information in logical terms: Multiple devices can use the same connection in parallel fashion although more intelligence is required to decode requests from the computer. Other kinds of hard disks, particularly EIDE, may have to take turns in talking to your computer, which can reduce performance. Peripherals are so fast these days that the difference in performance between SCSI and other systems is seldom important outside the server environment.

The chief advantage of drives in the EIDE/Super ATA — or whatever nomenclature you care to apply to the category — is that they are almost free. As I was writing this book, 320GB Maxtor hard drives were available for around $1 per gigabyte, and I expect the cost per byte to drop even more dramatically during the life of this book. However, even at $1 per gigabyte, hard drives aren't that much more expensive than CD-R media.

External hard disks

With external hard disks, you're no longer limited to the number of disk drives you can cram into your computer's housing. These disks, such as the one in Figure 3-2, link to your computer using an IEEE 1394 (FireWire) or USB 2.0 interface. (Two types of FireWire ports now exist — the original FireWire 400 and the new FireWire 800, which is twice as fast — and they use two different ports. However, you can get an adapter that allows one type of device to use the other type of FireWire port.)

The advantage of external storage is that you can install and remove FireWire and USB 2.0 drives without opening your computer's case, and you don't need to worry about how to fit them in the case. You can also easily move such an external drive from computer to computer.

Archiving and backing up

Digital photos can fill even the largest hard disk faster than Yankee Stadium on Bat Day. Your graphics powerhouse needs open-ended storage that is relatively cheap and reliable and that provides near-online (permanent storage) access speeds.

Figure 3-2:
External devices like this FireWire drive are great for mass storage.

Zip disks

For a while, Iomega's Zip drives, which were initially available in 100MB and 250MB capacities, seemed to be the answer. However, as file sizes and hard disks grew, a mere 250MB hardly seemed practical as a serious storage and backup option. Can you really back up an 80GB hard drive on 320 Zip disks? Not when the disks cost $5 to $15 each! Even extending the capacity of the Zip drive to 750MB in late 2002 didn't help. Zip drives have become the floppy disk of the new millennium: They're useful for transferring files from one computer to another but not a serious consideration as an archival or backup medium.

CD-Rs and CD-RWs

CD-Rs and CD-RWs have a bit more credibility in this arena because you can cram a healthy 700MB on a CD that can cost as little as a nickel. You still wouldn't want to back up your 80GB drive to 100 CD-RWs (even though the media itself might cost you only $10), but it's entirely practical to archive your digital photos on this media.

DVDs

More likely to emerge as a long-term storage medium is one of the various versions of DVD. Depending on how many layers are used, DVDs can store 5G or more each. The cost of DVD burners is coming down, and this medium should become more popular when the industry settles on a single, standard format. In a world where DVD-ROM, DVD-RAM, DVD+R/W, DVD-R/W, and other options exist, most users are afraid to commit themselves to one . . . hence the popularity of the dual-format DVD recorder, which can read and record both DVD+R/W and DVD-R/W media.

Kodak Photo CD

The Kodak Photo CD is a viable alternative for storing digital images although the writers for this media are not within the budgets of the average digital photographer. (You can't burn a Photo CD on a standard CD or DVD recorder.) However, you can have your images transferred to a Photo CD and take advantage of the unique features of the format.

Photo CDs, originated by the Eastman Kodak Company, are a form of write-once CD-ROM with some special advantages for photographers. Photo CDs store each image in five compressed versions called Image Pacs, each with a different resolution:

Base	Resolution	Size
Basic, or Base	512 x 768	1MB
Base/4	256 x 384	300K
Base/16	128 x 192	74K
Base x 4	1024 x 1536	5MB
Base x 16	Full resolution, 2048 x 3072	18MB

The Pro CD version adds a sixth, Base x 64, 4096 x 6144, 74MB version.

Here are some advantages of using Photo CDs:

✦ Compatible image-editing software can choose which resolution to work with. You can preview the tiny Base/16 images, use the Base version for comps (layouts), edit and release the Base x 4 image for noncritical work, or unleash the full-resolution Base x 16 or Base x 64 images for full-page layouts, posters, or what have you.

✦ You don't need a high-resolution scanner to produce Photo CDs. Photofinishers and pro labs can convert your images to Photo CD format with their own Photo CD equipment.

✦ You can specify either Photo CD Master Discs, which are designed for 35mm photography and hold up to 100 images at the five basic resolutions, or Pro Photo CD Master Discs, which can store images in 35mm, 120mm, 70mm, or 4-x-5-inch format. Up to 25 images can be included with the sixth Base x 64 resolution added.

✦ Also available is the Photo CD Portfolio II disc, which is one you can create yourself by using Kodak Portfolio II authoring software. The Portfolio disc can include photos, stereo audio, graphics, text, and other material. If you have a Photo CD writer ($3,000 and up), you can create your own business presentations, trade show displays, or educational programs.

✦ You can encrypt images on Photo CDs. Photographers can use discs as a portfolio and a stock-photo distribution tool and send out sample discs to clients. The clients can retrieve the unencrypted Base versions to see what your work looks like on their own computer screens. But no one has access to the high-resolution versions needed for reproduction until you supply a password.

Avoiding microprocessor no-brainers

Several times in this book, I note that having the very fastest microprocessor is no longer essential for most digital-photography and image-editing applications. If you have a Windows or Mac system operating at 800 MHz or faster, you can do just fine. Microprocessor speeds have greatly outpaced the requirements of most applications, even for processor-intensive applications such as image editors.

However, if you're buying a new machine, there's no reason not to buy one with the fastest microprocessor available, within reason. The microprocessor is what processes many of your program instructions — everything that isn't handled by a separate digital signal processing chip. So the faster the microprocessor runs, the faster your image-editing software will work, generally speaking.

Each individual element of an image involves from 1 to 4 or more bytes of information. (An RGB image requires 3 bytes per pixel, a CYMK image needs 4, and additional alpha channels take up 1 byte each.) So, even a relatively small 640 x 480, 24-bit image can involve nearly 1MB of data.

If you ask your image editor to apply an image-processing filter to an entire image, your microprocessor must calculate the effects of that filter on every one of those million bytes. That process can take a second or two with a very fast system, or as long as a minute or much more with very slow computers.

And although there are other constraints (such as memory or hard disk speed), the speed of the microprocessor affects nearly everything you do on your system. As you might guess, a fast CPU should be a major consideration when assembling a graphics workstation from scratch. You may not need the very fastest microprocessor available, but, then again, you never hear anyone complaining that a computer is just too darn fast.

Determining what's most important

I buy a new computer every year or two and upgrade most other components more frequently than that. However, I have kept three pieces of equipment for years and years. I lavish all available funds on the original purchases and hang onto them as long as possible. Those three items are my display screen, my keyboard, and my mouse.

This trio comprises the components you work with directly all day, every day, usually for long periods of time. For efficiency and sanity's sake, you should insist that these pieces of equipment be the very best available and don't change them capriciously. I liked the IBM keyboard that was furnished with my IBM PS/2 in 1987 so much that I am still using it a decade and a half later (even on my Macintosh, thanks to a keyboard/video/monitor switch). My ball-less infrared mouse has been serving me well for several years, and I can't recall exactly how long my beloved 19-inch monitor has been a fixture on my desk. I look at or touch these components all day, every day, and they're worth every penny I spent. I know, it sounds a little kinky, but such is the life of a technonerd.

For digital photographers, your display and video card are two of the most important components in your system. You need a video card with at least 64MB of fast memory (or more) so that you can view 24-bit images with 16.8 million colors at resolutions of up to 2048 x 1536 (or more) on a 19- to 24-inch monitor. A combination like that enables you to examine your photos closely, array several large images side-by-side, and view pictures at a size very close to their printed size. Here are some specific recommendations:

✦ Unless you also play computer games, you don't need to spend hundreds of dollars on video cards with video accelerators so powerful that they require their own fans. Instead, sink your funds into a video card with enough RAM to display images at high resolution. Think 2-D instead of 3-D.

✦ Consider buying a dual-head video card capable of displaying separate images on two different monitors. You'll find that most serious Photoshop users and digital photographers work with two monitors (at least). One monitor can contain your image editor, while another can display a Web browser or another application. Or, you can move Photoshop's palettes to the second monitor to make more room for your images. Another trick is to use different resolutions for each monitor, say 1920 x 1440 on one for a high res display, and 1024 x 768 for a larger view on the second monitor. If a Web page is hard to read on my main display, I often just slide it over to the second monitor at 1024 x 768 for a closer view. Figure 3-3 shows a dual monitor setup.

✦ Two video cards can also give you dual monitor capabilities. When I upgraded, I purchased an "obsolete" 32MB PCI video card for about $40 and installed it in tandem with my system's original AGP card. I purchased a 17-inch monitor with multiple rebates for a net cost of $49, and for less than a C-note, I was in dual monitor heaven.

✦ Check out the monitor you buy in the store before you purchase it. You'll be staring at it all day, so you want a sharp image that you can live with.

✦ Until the cost and quality of LCD monitors drops further, don't buy one of these unless you're really cramped for desk space. An LCD monitor might make a good second monitor, but the models worthy of your image-editing workstation are still quite expensive.

Figure 3-3:
Two monitors add up to greater efficiency.

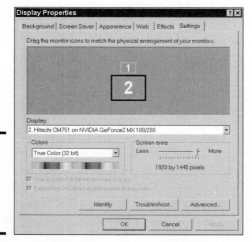

Choosing pointing devices

Can you sign your name with a bar of soap? No? Can you sign your name with a pen? If so, you probably would be more comfortable doing graphics work with a pen-based graphics tablet, rather than a clunky old mouse. Pressure-sensitive tablets with cordless pens are especially cool. Used with applications that support pressure-sensitive pads, such as Photoshop, they enable you to draw thicker lines just by pressing harder. Tablets and pens are a very natural way of working with graphics; if you can draw, you can use them faster and more accurately than you can sketch with a mouse. Trackballs and alternate mice are also choices if you prefer them.

Chapter 4: Connecting the Camera and Computer

In This Chapter

- ✔ Connecting the camera to the computer
- ✔ Using various connections and memory cards or disks
- ✔ Moving images from your camera to a digital darkroom

*W*hen you take pictures with a conventional film camera, you end up with a roll of exposed film that must go to a photo lab or darkroom for processing and printing using special chemicals and equipment. When you get the prints back a few hours or days later, you get to see how your pictures turned out. Often, a fair number of pictures end up in the trash, and you keep the rest. If you want extra prints or enlargements of the good shots, it's back to the lab to order reprints.

One of the great things about digital photography is that you don't have to process and print every image you shoot. Most digital cameras let you preview your images right in the camera, so you know immediately how you did. And you can discard the obvious blunders and bloopers before anyone else sees them. What remains are the pictures you want to keep (and those that you want to print).

With digital photography, you don't need to go to a photo lab to get prints from your pictures. The darkroom and lab are as close and convenient as your own computer. But unlike conventional photography, you don't have a roll of exposed film to send off for processing. Instead, you move your digital pictures from your camera to your computer by copying the image files from one device to the other.

How you do that depends on the features of your camera (and to a lesser extent, your computer). This chapter addresses the various camera-to-computer connections you're likely to encounter.

Making the Connection between Camera and Computer

Before you can use your computer as a digital darkroom to process and print pictures from your digital camera, you must get your picture files out of the camera and into the computer. (Go figure.) After you save the images as files on your computer's hard disk, you can manipulate them with the image-editing software of your choice and print them on your printer.

Some printers are capable of accepting images directly from a digital camera and printing them without going through an image-editing program or other software on your computer. These printers have slots that accept the memory card straight from the camera and usually also have an LCD screen so that you can preview and perform simple editing before you print. *Sassy!*

Several technologies for transferring pictures from your camera to your computer are available. The range of options may seem confusing, but you don't need to worry about most of them because a given camera rarely supports more than one or two options.

In general, the image-transfer technologies fall into two broad categories:

✦ **Wired (and wireless) connections:** A cable, wire, or other connection enables you to transfer picture information from the camera to the computer. The communication between your computer and your camera is similar to that between your computer and other peripheral devices, such as printers, scanners, or external modems. Some cameras also support infrared (or lrDA) connections to laptops and desktop computers with an infrared port.

✦ **Removable media:** The camera stores picture data on a disk or memory card that you can remove from the camera and then insert into a drive, slot, or reader on your computer. This process is much like saving files to a floppy disk and then moving the disk to another computer and accessing the files there.

Getting wired up

When you look at the back of a typical computer, you see a variety of sockets and ports in different shapes and sizes. Some of them probably have cables attached that lead to assorted peripheral devices, such as your mouse and printer. Camera manufacturers can choose from several of these ports in order to connect the camera to the computer. However, you rarely find any one camera with more than one type of wired connection.

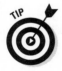

Do you find yourself missing USB or FireWire ports? If your PC doesn't have the ports to connect your new digital camera, fear not — you can add the correct port by installing an adapter card. If you've never installed a card — or, for that matter, you've never removed the case on your PC — then I can heartily recommend *Building a PC For Dummies,* 4th Edition by Mark L. Chambers (Wiley). You'll find everything you need to navigate the mysterious innards of your PC and add the ports you crave.

Serial cable

The serial port is the old standby for connecting miscellaneous peripheral devices to a computer. It's used for everything from external modems to pointing devices and, of course, many digital cameras. Nowadays, all digital camera manufacturers use faster connections instead of the older serial connection, but plenty of older cameras that are still in use rely on a serial cable. (In other words, don't buy a digital camera that has a serial connection, unless you're collecting antiques.)

A typical desktop computer has two serial ports on the back, like those shown in Figure 4-1. Look for a flattened D-shaped connector containing nine small pins. It's often labeled COM1 or COM2. Occasionally, the serial port may be a larger, D-shaped connector containing 25 pins, but regardless of the number of pins, it's always a male connector. (The male connector contains pins arranged to fit into holes in the female plug at the end of a serial cable.) If the serial cable that came with your camera has a plug for the 9-pin connector and your computer has a 25-pin port, you can use an adapter (available in most computer supplies stores) to make the connection.

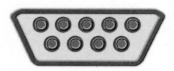

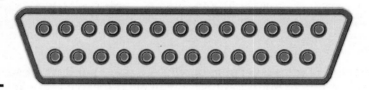

Figure 4-1:
The old standby — a PC serial port.

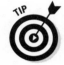

For best results, always shut off your computer before adding or removing cables from the serial, parallel, or PS/2 ports on the back of the computer. USB and FireWire connections, on the other hand, are designed to be *hot swappable* or *plug and play,* which means you can plug them in and unplug them while the computer is running.

After you identify the serial port on your computer, you can use the cable that came with your camera to connect the camera to your computer by following these steps:

1. **Shut down your computer.**

2. **Plug one end of the cable into the serial port on your computer.**

 If two or more serial ports are available, always use the lowest numbered port first.

3. **Plug the other end of the cable into your camera.**

 The plug on the camera end of the cable may look like a small telephone plug or some other special connector. It's a safe bet that this particular plug fits in only one place on the camera. However, the socket may be hidden behind a small door.

4. **Turn on the camera and the computer.**

 Check your camera manual to see if your camera should be turned on before you boot the computer. That often is the case.

5. **Use the camera manufacturer's software to transfer image files from the camera to the computer.**

 Use your camera's AC power adapter to run the camera while you have it hooked up to your computer, transferring files. That way, you don't run down your camera's batteries.

Parallel port

The parallel port is normally used to send information from the computer to a printer; in fact, it's often called the printer port. However, the port itself isn't restricted to printing duty, and it sometimes gets pressed into service to handle data transfers for other devices, such as scanners, external drives, and (rarely) cameras. Nowadays, an external device is more likely to connect to your computer via USB than the parallel port, but you may still find the odd scanner or camera that requires a parallel port connection. (Again, unless you're scavenging, avoid buying a camera with a parallel connection.)

The parallel port is a D-shaped, 25-pin, female connector. (The connector on your computer has two rows of small holes, and the plug on the end of the corresponding cable has two rows of small pins.) The port may be labeled with LPT1 or a printer icon.

After you identify the parallel port on your computer, follow these steps to connect the camera to your computer by using the cable that came with your camera:

1. **Shut down your computer.**

2. **Plug one end of the cable into the parallel port on your computer.**

 You may need to unplug your printer to make room for the cable from the camera. Often, the cable from the camera includes an extra plug into which you can plug the printer cable. This enables both devices to share the same port.

3. **Plug the other end of the cable into your camera.**

 The plug on the camera end of the cable may look like a small telephone plug or some other special connector. It's a safe bet that this particular plug fits in only one place on the camera. However, the socket may be hidden behind a small door.

4. **Turn on the camera and the computer.**

 Again, check your camera's manual to see if the vendor recommends turning on the camera before you boot the computer.

5. **Use the camera manufacturer's software to transfer image files from the camera to the computer.**

USB

The USB (Universal Serial Bus) port is the all-purpose connection that was supposed to replace the older serial, parallel, and PS2 (mouse/keyboard) ports. The older alternatives haven't gone away yet, but USB is increasingly becoming the connection of choice for many computer devices, including digital cameras.

USB connections are capable of moving data much faster than the older serial and parallel connections. USB connections are also *hot swappable* (also called *plug and play*), which means that you can safely plug in and unplug USB cables without shutting down your computer. You can also expand the number of USB ports available by adding a *hub* (a small box containing multiple USB ports) or a device, such as a keyboard or monitor, that has extra USB ports built in. Then you can plug your camera or other USB device in to the added ports, just as you can the USB ports on the back of your computer.

Some older computers may not have USB or FireWire ports built in, and you can upgrade most of those computers with a relatively inexpensive add-in card to provide the needed ports. Another potential problem is that older versions of Windows (Windows 95 and Windows NT 4) or Mac OS (prior to Version 8.5) don't support USB. Upgrading to a newer operating system that does support USB is usually possible, but it's likely to be more expensive than a simple hardware upgrade.

The USB port is a small, flat, rectangular socket approximately ³⁄₁₆ x ½ inch. You usually find at least two of them on the back of your computer, clearly marked with a special symbol. USB ports may also be available on the front of the computer, or on a USB hub (like the one shown in Figure 4-2), or on a keyboard or other device that has a built-in hub. Note that the faster species of USB port, called a USB 2.0 port, is fully compatible with older USB 1.1 cameras, and the ports look the same — your camera will work with either type of port.

Figure 4-2:
USB
connections
are most
common
with today's
digital
cameras.

You can use any USB port to connect your camera to the computer. Just follow these steps (with your computer still turned on):

1. **Plug one end of the cable into the USB port on your camera.**

The USB connector is often hidden behind a small door on your camera. It's usually a squared off, D-shaped socket, approximately ¼ x ³⁄₁₆ inch. If your camera includes a standard USB port, you can use a standard USB cable, which has a rectangular plug on one end and a square plug on the other. However, some cameras use a smaller mini-USB connection to save space. In that case, you need to use the special cable supplied with your camera.

2. **Plug the other end of the cable into the USB port on your computer or USB hub.**

3. **Insert the camera manufacturer's disc into your computer if prompted to do so.**

Windows automatically recognizes when a new device is added to a USB port. The first time you connect your camera to the computer, Windows may need to load drivers supplied by the camera manufacturer in order to access the camera.

4. **Use the camera manufacturer's software (or other file-management software) to transfer image files from the camera to the computer.**

FireWire

FireWire connections (formally known as IEEE 1394) are an alternative to USB connections. Like USB, FireWire transfers data faster than serial and parallel ports, it's hot swappable, and you can connect multiple FireWire-equipped devices to the computer. Because Apple developed FireWire, these connections are a standard feature on all Macintosh computers built in the last few years. FireWire is also available for PCs, but you may need to purchase and install an add-in adapter card for your PC.

Two different kinds of FireWire connectors exist, but unlike USB 1.1 and USB 2.0, FireWire 400 (the original) and FireWire 800 (the much faster new version) are *not* shaped the same. At the time of this writing, FireWire 800 is found only on high-end Macintosh computers, so if your digital camera uses FireWire, it will have an older FireWire 400 port. To connect a FireWire 400 camera to a FireWire 800 port, you need a converter cable.

FireWire is common only on high-end digital still cameras; you encounter it more frequently on all types of digital video cameras. But because some digital video cameras can capture still images as well as digital video, I guess that qualifies them as digital photography devices.

The FireWire 400 port is a small, rectangular socket that looks somewhat similar to a USB port. The FireWire port is a little fatter than a USB port, so you can't mistakenly plug a FireWire cable into a USB port or vice versa.

To connect your camera to the computer with a FireWire connection, follow these steps (with your computer still turned on):

1. **Plug one end of the cable into the FireWire port on your camera.**

The FireWire connector is often hidden behind a small door on your camera. If your camera includes a standard FireWire port like the one on your computer, you can use a standard FireWire cable, which has identical plugs on each end. However, if your camera uses a special cable configuration to save space, you need to use the special cable that came with it.

2. **Plug the other end of the cable into the FireWire port on your computer.**

3. **Insert the camera manufacturer's disc into your computer if prompted to do so.**

Like USB, Windows automatically recognizes when a new device is added to a FireWire port and prompts you for a disc if it needs to load drivers supplied by the camera manufacturer in order to access the camera.

4. **Use the camera manufacturer's software (or other file-management software) to transfer image files from the camera to the computer.**

Riding the (infrared) light wave

An IrDA (Infrared Data Association) port enables you to transfer computer data from one device to another by using pulses of infrared light instead of a physical wire. The process is similar to the way most TV remote controls send channel and volume adjustment instructions to the TV. Infrared connections are slow and not very reliable, but those drawbacks are countered by the convenience of not having to poke around the back of your computer every time you want to make a connection or deal with wires that get tangled and lost.

An IrDA port looks like a small, dark red (nearly black) lens or window. You find these ports on some digital camera models from Kodak and Hewlett-Packard, and on some printers and laptop computers, but rarely as standard equipment on a desktop computer. If your computer doesn't have an IrDA port, you can purchase an adapter that will probably connect via a cable to one of the standard serial or USB ports on your computer.

To use an IrDA port to transfer pictures to your computer, follow these steps:

1. **Turn on your camera and set it for infrared data transfer.**

Use the camera's controls to select the infrared data transfer mode. Each camera model is different, so refer to your camera's instructions for details.

2. **Position the camera's infrared port so that it points toward the infrared port on your computer.**

Although it's possible to make an infrared connection from several feet away, you generally get better results when the two infrared ports are close together (just a few inches apart). Ensure that no obstructions are

between the two IrDA ports and that no bright lights (such as sunlight from a nearby window) are shining on the infrared sensors.

3. Use the camera manufacturer's software on your computer to start transferring picture data.

Memory cards and disks

All digital cameras have some form of built-in memory to store the pictures you shoot. In many cases, the memory medium that the camera uses is a card or disk that you can remove from the camera. Using removable media to store image data has a couple of advantages over fixed, built-in memory:

✦ You can swap out a full memory card or disk and insert another to increase the number of digital photos you can take without erasing some from memory. It's like putting a fresh roll of film in a conventional camera.

✦ You can use the removable memory media to transfer images to your computer for editing and printing. All you need is a suitable disk drive or card reader on your computer, and you can read the image files directly from the disk or memory card without attaching the camera to the computer.

Manufacturers use several kinds of removable memory devices in digital cameras. They range from the standard 3½-inch floppy disk to solid state memory cards, such as SmartMedia or CompactFlash cards, that are scarcely bigger than a postage stamp.

PC cards

The PC card slot found in laptops accepts PC cards, also known as ATA Type II PC cards or PCMCIA cards. PC cards come in many forms. They're typically used to provide plug-in components, such as modems or network interface cards for laptop computers. Memory cards and miniature hard disks also are available in the PC card form. It's these hard disks and memory cards that are used in some digital cameras.

A PC card is roughly the height and width of a credit card, and about four times as thick, with holes for tiny connector pins in one edge. Just about every laptop computer has at least one socket designed to accept a PC card. You can also get add-on PC card sockets that fit into a drive bay in a desktop computer, but it's rare to find a desktop computer that comes with a PC card socket preinstalled. It's more common to attach a card reader through the USB or FireWire port to read PC cards.

Here's the lowdown on using PC cards:

✦ To remove a PC card from your digital camera (or computer), just press the eject button next to the card slot to pop the card loose from its connection. Then you can grab the end of the card and pull it out of its slot.

✦ To insert a PC card into a laptop computer (or digital camera), insert the card into the slot, connector-edge first. Slide the card all the way in, and then press it firmly but gently to seat the connectors along the edge of the card. If the card won't go all the way into the slot, you've probably got it in upside down. Flip it over and try again.

✦ After you insert the card into your computer, you should be able to access it as a virtual disk drive. You can use your normal file-management techniques to copy and move image files from the PC card to your computer's hard drive. See Book I, Chapter 19, for more on managing your digital photo files.

CompactFlash cards

CompactFlash cards, like the one shown in Figure 4-3, are used as removable memory in a few other devices, but their primary application is for image storage in digital cameras. They provide a much smaller and more efficient form of removable memory than PC cards.

At about 1½ inch square, a CompactFlash card isn't much larger than a postage stamp, and it's just a little thicker than a credit card. Still, there's room for two rows of holes for connector pins along one edge. All CompactFlash cards are physically the same size, but they can have various memory capacities ranging from 4MB to 1GB or more. (A higher-capacity version seems to come out every few months.)

Figure 4-3:
A Compact-
Flash card,
caught in
the open.

Card reader attachments are available for your computer. These attachments enable you to read and manipulate the contents of a CompactFlash card. The card reader is usually a small, external device that attaches to your computer via a FireWire or USB cable. Sometimes, a card reader for your computer comes with the camera. If not, you can purchase one from most computer supply stores for less than $50. PC card adapters are also available. The adapters enable you to access your CompactFlash cards via a PC card slot in a laptop computer.

You remove, insert, and access files on CompactFlash cards just like PC cards. See the bulleted list in the preceding section for details.

CompactFlash cards and SmartMedia cards are often called *digital film,* because inserting a memory card into a digital camera is analogous to loading a conventional camera with a fresh roll of film.

SmartMedia cards

SmartMedia cards are similar to CompactFlash cards, but they're in an even smaller package. A SmartMedia card is slightly smaller than a CompactFlash card in height and width, and it's much thinner — only about the thickness of a business card. Like a CompactFlash card, a SmartMedia card has connectors along one edge, but the connectors are metallic foil strips instead of rows of tiny holes. SmartMedia cards come in varying capacities, from 4MB to 256MB or more. SmartMedia cards tend to be one step behind CompactFlash cards in maximum available capacity, but the card capacity keeps marching upward.

You use a card reader attachment — similar to the one you would use to read a CompactFlash card — to access the contents of a SmartMedia card. The only difference is that the slot in the card reader is made to fit a SmartMedia card. Card readers with slots for both SmartMedia and CompactFlash cards are available.

Here's how to use the SmartMedia card:

✦ The SmartMedia card slot on your digital camera is often hidden behind a small flip-up door. To remove the SmartMedia card from your camera, open that door and then press in on the edge of the card to activate a spring-loaded eject mechanism, and then release. When the card pops out part way, grab the exposed edge of the card and slide it out of its slot.

✦ To insert a SmartMedia card into the camera (or card reader), insert the card into the slot, connector-edge first. Slide the card all the way in, and then press it firmly but gently to seat the card into the slot. If the card won't go all the way into the slot, you've probably got it in upside down. Flip it over and try again. If it pops out part way, try pressing in the edge of the card again and then release the pressure slowly and gently so as not to activate the ejection mechanism.

✦ When you insert a SmartMedia card into the card reader attached to your computer, it functions like a virtual disk drive. You copy, move, and erase image files on the SmartMedia card using the same tools you would use to work with files on a floppy disk.

SD (Secure Digital) cards

SD cards are yet another memory card format and are similar to CompactFlash and SmartMedia cards. SD cards are a newer format that hasn't been widely adopted yet; only a few high-end cameras use them. Using an SD card for image storage is essentially the same as using a CompactFlash card except that the card itself is slightly smaller, which means that the sockets in the camera and the card reader must be made to fit the SD card. The Secure Digital format is not interchangeable with the other formats.

Memory Stick

The Sony Memory Stick is one more form of memory card, functionally similar to the CompactFlash and SmartMedia cards. Sony uses the Memory Stick in several of its high-end digital cameras and also in digital video cameras, music players, and so on, which means that you can use your Memory Sticks in various devices and use them for storing pictures, music, and other files.

The Memory Stick is about the size of a stick of chewing gum and comes in capacities of 32MB to 256MB.

Several models of Sony laptop computers include a built-in Memory Stick slot so that you can use the laptop computer to access the contents of your Memory Sticks. You can also use a card reader similar to the card readers for CompactFlash and SmartMedia cards to access Memory Sticks from your desktop computer. The card reader is usually supplied with your camera and attaches to your computer via a USB cable.

Here's the skinny on using the Memory Stick:

✦ To remove a Memory Stick from your digital camera (or card reader), press the eject button next to the slot to pop the stick loose, and then grasp the exposed end of the stick and slide it out of its slot.

✦ To insert a Memory Stick into the camera (or card reader), insert the stick into the slot in the direction of the arrow marked on the surface of the stick. The arrow and a clipped corner help you orient the stick properly. The stick goes into its slot in only one way. Push the stick in firmly but gently to seat it properly.

✦ Like the other memory cards, after you insert a Memory Stick into the card reader attached to your computer, you can access and manipulate the files on the stick as if they were located on a virtual disk drive. Copy, move, and erase the files by using your normal file-management tools.

The Memory Stick includes an Erasure Prevention switch that lets you protect the contents from accidental erasure. Make sure the switch is in the Off position when you want to record images onto the stick in your camera or erase files in the card reader.

Floppy disk

When it comes to removable storage, what could more familiar than the plain old 3½-inch floppy disk? For years, Sony has built a line of digital cameras that use the ubiquitous floppy disk to store and transfer images. A floppy disk drive is actually built into the camera. Because floppy disk drives are standard equipment on almost all computers, you can generally count on being able to access your images from any computer without worrying about cables, card readers, drivers, or special software.

Unfortunately, the floppy disk isn't an ideal storage media. At only 1.44MB, its capacity is puny compared to even the lowest capacity CompactFlash and SmartMedia cards, and the size of a floppy disk makes it an inefficient storage medium. Plus, floppies are notoriously unreliable.

The exceptions to the universal availability of floppy disk drives are the recent Macintosh computers, such as the Apple iMacs, as well as some extremely lightweight laptop computers. These computers are about the only ones that don't come with built-in floppy disk drives. However, even for these machines, add-on external drives that read floppy disks are available.

If your camera utilizes a floppy disk for storage, here's how to use it:

✦ To remove a floppy disk from your camera, press the eject button next to the floppy disk slot. When the disk pops out part way, you can slide the disk out of the drive.

✦ To insert a floppy disk into your camera or the disk drive in your computer, slide the disk into the drive, metal-slide-edge first with the label facing up. Push in the disk until it clicks in place and the eject button pops out.

Mini-CD

To combat the problem of the limited capacity of floppy disk drives, Sony builds some digital cameras with a mini-CD drive in place of the floppy disk drive. The camera actually includes a CD burner to record picture data onto mini-CDs, which are smaller versions of standard CD-ROMs. A standard CD-ROM drive can read the mini-CDs, and because CD-ROM drives are standard equipment on almost all computers, the mini-CD enjoys the same universal accessibility as floppy disks. The downside is that mini-CDs aren't readily available like floppy disks or even memory cards.

Microdrive

The IBM Microdrive is a tiny hard disk drive that's a little thicker than the standard CompactFlash card, but it's otherwise the same. If your camera is equipped with a CompactFlash+ Type II slot, you can use the Microdrive. The Microdrive is a bit pricey, but it provides a lot of storage space for your images. It's available in sizes up to 1GB or more. Using the Microdrive is just like using a standard CompactFlash card except that because it is actually a miniature hard drive, it must be handled with more TLC than a CompactFlash card.

Transferring Images from Camera to Computer

As the previous section shows, different digital cameras offer different tools for connecting the camera to your computer. It may be a direct connection such as a cable from the camera to a port on your computer, or it may be an indirect connection such as a memory card or disk that you can remove from the camera and then insert into a reader or drive attached to your computer.

After you make the connection between your camera and your computer, you may have a few more options available regarding what software you use to transfer pictures from the camera connection to your computer. Most digital camera manufacturers supply a software program with the camera that is designed to handle the task, but you may also have the option of transferring pictures to your computer using image-editing software or your computer's normal file-management utilities.

Transferring pictures using camera utility software

Just about every digital camera on the market today ships with a disc containing a software program designed specifically to transfer pictures from the camera to your computer. Often, the software has a number of other features as well, but its main purpose is to allow you to use your computer to access the pictures you shot with your camera.

The details of the installation and use of the software accompanying the different digital cameras varies as much as the cameras themselves. It's not possible to cover all the programs in detail in this book, but the general process goes something like this:

1. **Make sure that the camera (or card reader) is connected to the computer and is turned on.**

 This ensures that the software can find the camera/card reader connection if the installation searches for it.

2. **Insert the disc that came with your camera into your computer's disc drive and launch the installation utility (if it doesn't start automatically).**

 The software disc is usually a CD-ROM, and the installation routine usually starts automatically a minute or so after you insert the disc into your computer. However, if the installation doesn't start automatically, you can usually get things going by using Windows Explorer to double-click a file icon labeled Setup or Install. You can probably find the file in the root folder of the drive where you inserted the disc, or with Macs, click the program's icon on the Desktop.

3. **Follow the on-screen instructions to install the software.**

 A couple of mouse clicks to accept the defaults is all it usually takes.

4. **Start the camera utility software.**

 Double-click the desktop icon that the installation program added or look for the new addition to your Windows Start menu. If the camera or

card reader is connected and turned on when you start the program, it will usually find your camera automatically. In some cases, you may need to help the program locate the camera by choosing a command such as File⇨Connect and selecting the appropriate location in a dialog box.

5. **Click an icon or menu command to view the image files on the camera (or removable media).**

 Here's where the different software programs really go their own way. You usually use an icon or menu command to display a list of picture files on your computer. You might even be able to preview the pictures as thumbnail images.

6. **Select the picture files you want to transfer and click an icon or menu command to begin moving the files to your computer.**

 Again, the details vary greatly in the different programs, but you usually click a prominent icon to start the transfer process. If you don't see an obvious icon, check the File menu for a command, such as Import.

The same utility program that enables you to transfer pictures from your camera to your computer often includes features that enable you to edit or manage your image files. You can also erase pictures from your camera's memory after transferring them to your computer so that you have room to shoot more pictures with the camera.

After you transfer the images to your computer, you can view, edit, and print them by using any appropriate program on your computer. The built-in Windows utilities are sufficient for basic viewing and printing, but you'll undoubtedly want to use more capable programs (like Photoshop Elements from Adobe Systems or Paint Shop Pro from Jasc Software) for most image-editing tasks.

Copying files to your hard drive

Perhaps the simplest and most straightforward way to move pictures from your camera to your computer is to treat them like any other computer file. In other words, you simply use your standard file-handling utilities to copy, move, and delete the image files. This is the technique you use with most forms of removable media, and you can often use it with direct camera connections via USB or FireWire as well.

The biggest advantage of this approach is that you don't need to deal with a specialized program to access your pictures. Instead, you use familiar tools, such as Windows Explorer (or, on the Mac, the Finder window) and the File Open dialog boxes, in your favorite programs.

For this technique to work, your computer's operating system (Windows or Mac) must be able to access your camera or card reader adapter as an external hard drive. Fortunately, that's exactly how most memory card readers and many cameras (most cameras that connect via USB or FireWire) work. They appear to your computer as virtual disk drives, and you can read, write, and erase the files on those devices just like you can files on your hard drive or floppy disk.

To transfer pictures from your camera to your computer, you can use any of the same techniques you would use to move files from one disk drive to another. The only exception is the extra steps needed to connect a virtual disk (your camera or card reader) to the computer. The following steps summarize the process:

1. **Connect the camera (or card reader) to your computer and turn it on.**

After a moment or so, Windows displays a message box saying that it has found new hardware and is installing the necessary software drivers. An icon appears in the system tray portion of the taskbar next to the clock.

2. **If prompted to do so, insert the manufacturer's disc containing drivers for your camera or memory card reader.**

You only need to do this the first time you attach your camera or card reader to the computer.

3. **Open Windows Explorer or a Mac OS Finder window and navigate to the virtual disk drive representing your camera or card reader.**

Under Windows, you can double-click the My Computer icon on your desktop to open an Explorer window and then double-click the appropriate drive icon to display the contents of the camera memory or the memory card in your card reader. Look for a new drive letter that doesn't correspond to one of the standard disk drives installed in your system. The name of the drive may be the brand name of your computer or card reader. (Macintosh owners can dispense with this foolishness because the drive should automatically appear on your Desktop. If you're using Mac OS X Panther, you'll see the drive listed in the sidebar on the left side of the Finder window.)

4. **Open another Windows Explorer or Mac OS Finder window and navigate to the folder where you want to store the picture files from your camera.**

Be sure to position the two windows on your desktop so that you can drag and drop between them.

5. **Drag and drop one or more files from the first window onto the second window.**

That's all it takes to copy pictures from your camera to your computer.

Of course, after you connect your camera (or the memory card from your camera) to your computer as a virtual disk drive, you can use all the standard tools and techniques to manage your picture files. Under Windows, the default action for dragging and dropping is to copy the files to their new location. However, if you click and drag with the right mouse button rather than the normal left button, Windows displays a context menu that gives you the option to move the files rather than copy them. The Move command lets you copy the files to their new location and erase them from the old location all in one step. You can also return to the first Explorer window and erase the picture files from your camera memory in a separate operation.

You can even copy files from your computer to your camera's memory so that you can view the images in the camera. You're not likely to do that very often, but it's possible.

After you finish transferring pictures from the camera to your computer, don't forget to disconnect the camera properly. To do so, follow these steps:

1. **Right-click the device icon in the system tray and choose the Unplug or Eject Hardware icon from the context menu that appears.**

2. **In the dialog box that appears, select the camera from the list and click the Stop button to tell Windows that you want to disconnect the device.**

 Windows displays a confirmation message, after which you can physically disconnect the camera and its cable from the computer.

With a Mac, you should drag the camera's icon to the Trash before disconnecting your camera.

Importing images into image-editing software

The normal sequence of events is to use your camera's utility software to transfer one or more picture files from your camera to your computer. Next, you launch your favorite image-editing software and open the image file to make some adjustments before finally saving or printing the picture. However, several image-editing programs can do the transferring for you, which shortens the whole process.

If Windows or Mac OS recognizes your camera or card reader as a mass storage device (and most such devices that connect to the computer via USB and FireWire are), then the device and all the files on it appear to Windows just like any other disk drive. Consequently, to open a picture for editing in your image-editing program, you simply select the file in the program's File Open dialog box. Make sure the camera is connected and turned on (and recognized by your operating system) before you attempt to open files in the photo editor.

In some cases, the image-editing software uses the camera manufacturer's software to access images on your camera. You still save time by having the option to access that software with a menu command or button in the image-editing software instead of opening the camera software separately. The process is similar to the way you acquire images from a scanner directly into your image-editing software.

The advantage of this technique is that it not only streamlines and automates the process of using the camera access software, but also often brings the images directly into the image-editing program without making an intermediate stop as a file saved on your computer's hard disk. As a result, you get to view and edit each image before saving it.

To transfer images from your camera directly to your image-editing software, you first need to tell the program what camera you use and where to find it. Make sure that the camera manufacturer's software has been installed and is

operating properly on your computer, and then configure your image-editing software to access images from the camera. The setup process varies depending on the program, but the following steps are typical:

1. **Connect your camera to the computer and turn it on.**

2. **Choose File⇨Import⇨Digital Camera⇨Configure (or an equivalent command) in your image-editing program.**

 The program usually opens a dialog box, but it may also present a sub-menu instead.

3. **Select your camera and (if necessary) the port to which it's connected; then click OK to close the dialog box.**

After you configure your image-editing software, you can use it to access images from your camera. Here's how:

1. **Connect your computer to the camera and turn on the camera.**

2. **Choose File⇨Import⇨Digital Camera⇨Access (or an equivalent command) in your image-editing program.**

 A dialog box appears, giving you access to the images stored on your camera. This is usually a subset of the camera manufacturer's access software.

3. **Select the image or images you want to open in the image-editing program and then click the button or choose the command to begin the transfer.**

 The software transfers the selected pictures from your camera to the image-editing software.

4. **If the image-editing software doesn't return to the foreground automatically, click its button in the taskbar.**

 The selected images appear in the image-editing program window, ready for you to begin working with them.

Chapter 5: Choosing a Printer and Scanner

In This Chapter

↳ **Rationalizing your need for prints**

↳ **Selecting your digital printer**

↳ **Choosing a scanner**

↳ **Evaluating the best scanner features**

*N*othing shows us more dramatically how digital technology has changed the face of photography as the ways in which we use prints. We've gone from the days of the daguerreotype, in which every photographic image was a unique and original hard copy, to the digital age, in which, if we want, a photograph can exist entirely and solely in electronic form and never be transferred to a piece of paper or film that we can hold in our hands. The photographic print has gone from being the normal and expected result of taking a picture to nothing more than an option.

In the digital age, prints have taken on an additional role as a source for digital images. If you have a scanner, the photographic fodder for your image-editing software can come as easily from a hard-copy photograph that you've scanned as from your digital camera. Indeed, some of the happiest marriages of imagery come from mixing and matching photos that originate in digital form with pictures that have been created on film, printed on paper, and then scanned.

Even when you have the choice of viewing your finished photographs on a computer screen, you have so many reasons for making prints. So, a better color printer is probably the first accessory that a digital photographer purchases after upgrading to a digital camera. And a scanner used to convert existing prints and slides into pixels is probably the second accessory that is considered.

This chapter looks into the factors that you need to take into account when choosing a printer and a scanner for your digital photography outfit.

Why You Want Prints

Digital pictures are great when you want to show them on your computer screen, project them on a screen during a presentation, or incorporate them into your Web page. Even old-fashioned color slides have their uses. Professional photographers like prints for their unsurpassed reproduction capabilities. Amateurs have used slides as a tool for lulling neighbors to sleep during a discussion of their last vacation.

Yet, when it comes time to share your photographic efforts seriously, nothing beats a print. You can hang a print in a frame over your fireplace. You can pass around a stack of photos of your kids without worrying whether your captive audience has the right viewing hardware or software. Photo prints are used as proofs that are submitted for approval or as samples in a portfolio. When you open an old shoebox of memories that's tucked away in your closet, you hope to find a slew of old prints inside, not a stack of Zip disks.

Indeed, students of photography have already noticed a dramatic change in how the work of the very best photographers can be studied and evaluated since digital photography became common. The photographic masters of illustration and photojournalism of the past worked with prints and often made proof copies, called *contact sheets,* that contained a rough, uncropped, uncorrected version of every picture they took. We can look at those old prints and see how photographic ideas evolved into the famous photos we know today.

With digital photography, test shots, alternative angles that didn't work out, and other material can be erased and forgotten. A digital camera's Quick Erase feature can obliterate unwanted photos before they ever reach a computer. Only the best images survive, and only the best of the best make it to print form.

This doesn't mean that prints are an endangered species. The same digital technology that has eliminated some of the need for prints has given us whole new capabilities that make them more useful than ever. For example, when shooting pictures on film, you probably let your photofinisher make a print of every single shot on the roll so that you can see which ones are the "good" ones. (In these days of double prints, you probably get at least two copies of every shot, including the blurry ones and the pictures of your shoes.)

With digital photography and inexpensive color printers, you don't need to accumulate stacks of 4-x-6-inch prints that you don't want. You can not only print just the pictures you want but also easily crop them the way you want to see them, fix the color, sharpen the blurry parts, and print them as glorious 5-x-7s or 8-x-10s. Digital photographers may not end up with more prints, but they do have better prints and they like them better, too.

Choosing a Printer for Digital Photography

The good news is that printers that are capable of producing photo-quality images are cheap to buy, and printers from all the vendors are comparable in quality, ruggedness, and image quality. If all you want are a few photos now and then, it's hard to go wrong. All the well-known printer manufacturers and most of the companies that sell cameras are hard at work building faster, better, and cheaper printers for you to choose from.

The bad news is that the vendors have a nefarious purpose behind their industrious efforts. Those who sell printers these days want to make their devices so easy to use and produce hard copies that are so pleasing to the eye that you'll be tempted to make more and more prints. And that's where the money is: The cost of special photo papers and inks can easily exceed

the price you paid for a color printer during the first few months of use alone. So, as you read the descriptions of your printing options that follow, you need to keep foremost in your mind not just how much the equipment costs to buy but how much it costs to *use.* I provide some guidelines and tips as you go along.

The following sections outline your primary options.

Let somebody else do it

If you don't need many prints, you can probably get by quite well without owning a color printer. The color ink cartridges tend to dry out and clog up if allowed to sit for a month or two without being used, so if you really aren't making many prints, you should consider just stopping by your local discount or drug store with your CD and using a standalone kiosk such as the Kodak Picture Maker. You pay $5 to $7 for a sheet of photos, but think of the money you'll save on equipment and dried-out ink cartridges! Many photofinishers will accept your "digital film" and deliver a stack of 4-x-6-inch prints, if that's what you want. You can even send your images to labs on the Internet for delivery to you by mail.

Laser printers

If you have a black-and-white laser printer, you can make quick-and-dirty monochrome prints of your digital images that may be good enough for many applications, such as pasting up in publishing layouts or creating simple posters to promote your rock band's upcoming club date. Color laser printers, at $900 to $3,000 and up, can create fairly decent full-color pictures although these pictures don't have the glossy sheen and true photographic appearance of some of the other options. Color lasers can be fairly economical, too, because their color toners are inexpensive and can be applied to inexpensive ordinary paper stocks. If you have some other use for a color laser printer (say, printing documents, newsletters, or other work that uses spot color), these devices can fill in for you as an output option for the occasional digital photograph.

Ink-jet printers

Ink-jet printers are currently the most popular color output option for digital photography because they cost very little (decent ink-jets can be purchased for $50 to $300 or more) and supplies for them can be purchased everywhere, including your average all-night grocery store. Their output looks almost exactly like a color photograph when printed on special glossy photo papers. Unfortunately, for *each* photo that you print, you can pay as much as 50 cents to $2 for the materials (ink and paper) alone. After paying $35 for a single-ink-tank color ink cartridge that was good for only 20 to 30 8-x-10-inch prints and then repeating the process once a week for a month, I junked a perfectly good ink-jet printer and replaced it with another model that uses separate ink tanks for each color. Now, when I run out of yellow ink, I drop in a new $8 yellow ink cartridge instead of replacing an entire single-ink-tank color cartridge. I tried several ink-jet refilling kits, but the ink seemed to be more easily applied to my hands and clothing than to the cartridge that I was refilling. So I like using separate, replaceable tanks, like those shown in Figure 5-1.

Figure 5-1:
Replacing one-color ink tanks is far cheaper than replacing a whole color cartridge.

Dye-sublimation printers

Dye-sublimation technology is used at the consumer level in small photo printers that are limited to, say, 4-x-6-inch prints. In those sizes, a typical $200-$400 dye-sub printer can be fairly economical even though it uses a fairly complex printing system that involves a roll with a continuous ribbon of color. Each section of the color ribbon is used only once, so you always know exactly how many prints you're going to get before it's time to refill. The quality of these printers is unsurpassed but, unlike ink-jet and laser printers, you can't use these printers for printing documents. Photos are all that they can print.

Other printers

You can also find various alternate printing technologies, such as thermal wax printers, solid-ink printers, and a few other offbeat types, each with its own advantages. Some of them, called *phase-change* printers, for example, can print photo-quality images on ordinary paper, partially offsetting the cost of their solid wax or resin inks.

Choosing a Scanner

In many ways, digital cameras and scanners are two sides of the same coin, each with its own advantages and limitations. Both use solid-state sensors

to capture a digital image of an object, providing you with fodder for your image editor's magic. Cameras are portable and can grab images of three-dimensional objects of virtually any size, at any distance (up to the moon, and beyond!). For the most part, scanners reside on your desktop next to your computer, are limited (for the most part) to two-dimensional originals such as photographs, and can work only with objects that are 8½ x 11 inches or smaller.

Digital cameras capture an image in an instant; a scanner takes a minimum of 20 to 30 seconds to produce a scan. High-resolution digital cameras are expensive; if you want 6 megapixels of information, you can pay $1,000 or more. A scanner that is fully capable of grabbing 135 megapixels of image information (1200 samples per inch over an 8½-x-11-inch photo) can cost less than $100.

Digital photographers carefully select what goes into a digital camera image through use of composition and lighting; scanners pretty much capture whatever is already on the original that you slap down on the glass. The purposes and capabilities of digital cameras and scanners are so different that if you're serious about digital imaging, you'll want both a digital camera and a scanner.

One of the best things about scanners is that you can do a lot of other things with them in addition to scanning photographs. Some highlights of scanners are as follows:

✦ **Turn printed text into editable text.** If you create newsletters and want to convert hard-copy text documents, such as newspaper clippings, into editable text, a scanner can use *optical character recognition* (OCR) to capture the text and, using software that's usually bundled with the scanner, translate the image of the text into text files (often with the formatting and photos preserved). You can also use OCR with faxes that are clear and legible to convert those faxes back into an editable document.

✦ **Photocopy documents.** Most scanners have a Copy button on their front panels. Slap an original down on the glass and press the Copy button, and the scanner captures the image and directs it to your printer. It's almost as good as having a dedicated copy machine.

✦ **Send faxes.** If a scanner can serve as a copier, it also works admirably as half a fax machine. Regardless of whether your work environment has a dedicated fax machine, nothing is quicker (or more confidential) than using your scanner with your computer's fax modem.

✦ **Manage documents more easily than you can with microfilm.** Some types of records must be retained in some semblance of their original appearance, such as documents with signatures, checks, illustrated reports, and so on. Offices used microfilm for this sort of document in the past. Today, you can manage documents using a scanner as an input source and a specialized document-management application to file and retrieve the images.

✦ **Capture nonphotographic images.** You may have some line art, charts, logos, cartoons, or other artwork that you would like to have in digital form. A scanner works as well with nonphotographic images as it does with photos.

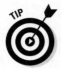

Naturally, this chapter can't cover *all* the specifics of selecting, installing, using, and maintaining a scanner — in fact, the *For Dummies* series includes a popular title that's completely dedicated to scanning. For a comprehensive guide to all things scanner, pick up a copy of *Scanners For Dummies,* 2nd Edition, by Mark L. Chambers (Wiley).

Types of scanners

For digital photography, your choices boil down to one of three kinds of technology — and several categories — based on price and features. The three scanner technologies are as follows:

✦ **Photo scanners:** These small scanners are designed specifically for scanning snapshots and are often used in tandem with equally compact photo printers. You feed in a snapshot and get a digital image for editing. Or, you can skip the editing step and direct your scanned output to a photo printer. You can use such a setup as a sort of photocopier for prints, which is great when your scanning needs are limited to snapshots. These scanners can cost a few hundred dollars.

✦ **Flatbed scanners:** These are the most widely used types of scanners. They look and operate something like a small photocopier. You open the lid, place your original face down on the glass, and scan. Flatbeds are usually limited to scanning 8½-x-11-inch (or sometimes 8½-x-14-inch) material, but the movable cover makes it simple to grab images of thick originals, such as books or even some three-dimensional objects. Larger originals can be scanned in sections and stitched together using your image-editing software. Some flatbeds have an alternate light source built in to the lid or available as an add-on that can illuminate transparencies, giving you slide-scanning capabilities. Flatbed scanners can cost from $50 to $1,000 or more.

✦ **Slide/transparency scanners:** These high-resolution scanners are used for scanning color slides (in 2-x-2-inch mounts) or strips of film in sizes from 35mm to 6 cm in width, or sheet film up to 4 x 5 inches (or sometimes larger). Photographers who use transparency or negative film — or who have archives of these kinds of film — prize the specialized capabilities of slide scanners. These scanners cannot scan reflective copy, such as photographic prints. They can easily cost $1,500 or more.

All three types of scanners use similar components. All have a place to position the original to be scanned. A light source reflects off the surface of the original or *transilluminates* it (in the case of transparencies or negatives). A high-resolution sensor captures the original one line at a time either by moving past the surface of the original or by capturing light that's reflected from a moving mirror. Electronics inside the scanner convert the analog information that the sensor captures into digital form.

Scanner prices and features

Like digital cameras, flatbed scanners fall into several fairly well-defined price and feature categories. You can find point-and-shoot scanners just like you can find point-and-shoot digital cameras. General-purpose and advanced scanners, as well as true professional scanners, are also available.

Unlike digital cameras, the primary criterion that's used to choose a scanner is not the resolution of the scanner. Virtually all scanners on the market claim to have roughly the same resolution, even though in practice, the image quality of these devices can vary widely, even among those with similar specifications. The primary features that you should look for when choosing a scanner are the image quality, speed, and convenience. I address these issues separately later in the chapter; I concentrate on general specifications and features for the main flatbed scanner categories first.

Entry-level scanners

Entry-level scanners are the $50 to $150 scanners that you see on special at your local electronics superstores. They are designed for the casual scanner user, someone who needs to grab an occasional photo or who doesn't have particularly high quality standards.

All you get with one of these scanners are simple scanning capabilities. They're often quite slow and use inexpensive sensors that often can't capture the kind of sharp image that a digital photographer expects. They're typically connected via USB port and they're easy to use, which makes them ideal for scanning neophytes, but they usually aren't expandable with accessories, such as transparency adapters. Don't expect even a "lite" version of Photoshop to be bundled with a scanner like this; many are furnished only with the most basic image-capturing and -editing software.

Entry-level scanners are a good introduction to scanning for people who don't know whether they want to get heavily involved with image editing. These scanners are also good for noncritical applications, such as photocopying, faxing, or grabbing images for Web pages.

Intermediate scanners

Spend $150 to $250, and you can purchase an intermediate scanner with better quality, higher speed, more features, and a great deal more versatility. These scanners have enough quality to please all but the pickiest digital photographers and are fast enough that you won't fall asleep between scans when you're capturing a stack of photos on a lazy afternoon.

Intermediate scanners usually have all the convenience features that you could want (and again, they typically use a USB 1.1 connection). Your new toy will probably have front-panel buttons that let you scan an item, make a photocopy, send a fax, or attach a scan to an e-mail. Some scanners can be augmented with simple attachments for scanning slides and usually include a good selection of software, such as optical character recognition programs, stitching programs that let you stitch together multiple scans into a single image, and image-management programs.

Advanced (or business) scanners

Serious digital photographers will probably be happiest with a scanner in this category. Priced at $300 to $400 and up, these units include everything that you need to scan and manipulate photos and other originals and to produce better quality, and they are faster to boot (using USB 2.0, FireWire, or SCSI connections).

You can find lots of flatbed scanners with slide-scanning capabilities in this group as well as a few models with automatic document feeders so that you can scan whole stacks of originals one after another. The image quality is better, especially when you need to pull detail out of inky shadows or bright highlights. Improved speed can be very important, because owners of these scanners can spend a lot of time using them.

Expect a rich treasure-trove of software with a scanner in this class, including a capable image editor (probably along the lines of Adobe Photoshop Elements), OCR software, document-management software, fax software, and specialized image-manipulation applications, such as applications that let you create panoramas from multiple photos (also called *stitching applications*).

Professional scanners

Actually, I'm not sure whether a professional category exists in scanners anymore. The advanced, or business, scanners described in the preceding category can handle most needs of digital photographers and others who aren't using their scanner professionally. True graphics professionals are really the only people who need to spend $500 to $2,000 or more for a flatbed scanner, and then only if they need some of the special capabilities that these scanners provide. Again, you're in USB 2.0, FireWire, and SCSI territory when it comes to connections.

Scanners in this category have all the features that are found in the advanced category, but these scanners augment those features with the very best optics, sensors, and electronics available. You truly get the very best scans with these models, particularly if you know how to use the features.

These scanners are also very rugged, having what the automakers used to call, euphemistically, "road-hugging weight." You can bang one of these scanners around without throwing anything out of alignment, and you can expect them to scan hour after hour, day after day, without protest.

These are the scanners to consider if you are scanning larger originals. An 8½-x-14-inch scanning bed is a must, and some models have 11-x-17 or larger scanning beds.

Don't expect to get a copy of Photoshop bundled with one of these models. Anyone who can afford one of these scanners undoubtedly already has a copy (or two) of Photoshop on hand. You can expect to receive a high-end scanning program, though, with dozens of controls and adjustments so that scans can be both automated as well as fine-tuned to the *n*th degree.

What scanner features do you need?

You find a lot of overlap in features within and between the various flatbed scanner categories. Some features are more useful than others for the digital photography–inclined. Other features can be deceptive. I spend a little time on the two most misunderstood features, resolution and the number of colors captured, later in this chapter, and I describe the other features briefly in this section.

Scan quality

Scan quality is different from resolution, as I describe in the section "Resolution mythconceptions," later in this chapter. Resolution of the sensor is only one of the factors that affect scan quality. The others include the number of colors, or *dynamic range* of the scanner; the quality of the optics; and the electronics that are used to translate the scanned image for your computer. The most important thing that you want to think about is *How good does the final scan look?* Often, you need to rely on reviews in magazines or at Web sites — or your own testing — to determine this.

Scanner speed

Some scanners operate much faster than others. One scanner may capture an 8-x-10 image at 300 samples per inch in 20 seconds, whereas another may require a minute and a half. You may not care about the speed if you make one scan a day. If you're making 100 scans a day, speed matters. Reviews may tell you how fast a scanner is, relatively speaking, but you still may want to test a scanner before you buy it, using your own documents and a computer that's similar to your own.

Scanning size

Flatbed scanners have a fixed-size scanning bed, usually 8.5 x 11.7 inches to 8.5 x 14 inches. Even though you may rarely scan a 14-inch-long original, the larger size is handy to have. I often slap down a bunch of 4-x-6-inch prints and scan them all at once, cropping and sizing within Photoshop. It's nice to have a larger scanning bed to accommodate more and larger originals when you need to.

Physical size

If your desktop space is limited, you may want a smaller scanner. I favor larger scanners because they tend to stay put without sliding and can better ignore vibrations when heavy-footed colleagues or family members stride past. In any case, even the largest flatbed scanners are likely to be half to two-thirds the size of the behemoths of five years ago, so you don't have to worry about handing over half your desktop to your image grabber.

Bundled software

If you're already well equipped with software, you probably don't need to worry about the bundle that's furnished with your scanner. I have several copies of Adobe Photoshop Elements that came with scanners that I have, but I rarely use this software. Of more interest to me are the advanced scanning programs, such as the versatile Silver Fast application that came with my high-end Epson scanner.

You may be more interested in optical character recognition software (to convert documents to editable text), copy utilities (to let you use your scanner as a photocopier), document-management programs (to let you file document images and retrieve them by keywords), and other software, such as applications that let you stitch images together to create panoramas.

Type of sensor

The kind of sensor that is used in a scanner can affect how you use the scanner. In the past, *Charge-Coupled Device* (CCD) sensors were the most common sensors used in consumer scanners. These solid-state devices capture an image that is conveyed by a sophisticated optical system, often a path measuring a foot or more in length, as mirrors and optics convey the light that's reflected from the original to the sensor itself.

More recently, a less expensive solid-state sensor, called a *contact-image sensor* (CIS), has been used, especially for lower-priced scanners. A CIS moves beneath the glass a few scant millimeters from the original in a much-simplified system that requires no optical path. CIS scanners can be very thin and compact (because there is no need to leave room for an optical path), and they use inexpensive red, green, and blue light-emitting diodes (LEDs) instead of the fluorescent light tubes that are found in CCD scanners. This permits a cheaper scanner, for the following reasons:

✦ CIS scanners often produce poorer quality than the more sophisticated CCD-sensor units produce. Although quality is improving (some $150 to $200 CIS scanners produce great quality), this technology has not been associated with the best overall quality.

✦ CIS scanners typically have very little depth of field, which means that they can scan only flat originals that are held in tight contact with the scanning glass. Even a wrinkle in a paper original can affect the sharpness of some CIS scanners. You can also forget about scanning three-dimensional objects with these scanners.

Until CIS sensors catch up with their CCD counterparts, you should probably stick with a CCD-based scanner when making your purchase.

Scanner interface

The kind of interface that is used to connect your scanner to your computer was once an important consideration. Back in the early '90s, you had to choose between SCSI or parallel port scanners, or even slow serial connections. Some scanners required a proprietary interface card.

Today, virtually all scanners come with Universal Serial Bus (USB) or IEEE 1394 (FireWire) connections, or both; SCSI scanners are still available, but they're a rapidly dying breed. Either USB or FireWire is fast enough for the typical scanner; choose one with the interface that is available with your computer. (I recommend a USB 2.0 scanner if your computer supports this faster version of USB — you'll thank me when producing really large scanned files.)

Color depth

Color depth indicates the number of different colors that a scanner can capture. Color depth, measured in bits, is called the *bit-depth*. For example, a 24-bit scanner can capture 16.8 million different colors, while 30- to 48-bit scanners can capture billions of colors. Most of the vendor-supplied specs about color depth are misleading or false, so I don't advise paying much attention to color-depth specs, unless you're scanning transparencies (which require so-called *deep color* capabilities). Most of what you think you know

about scanner resolution and color depth is wrong anyway. I explain both in more detail in the next section.

Resolution mythconceptions

I've written eight books solely on scanners since 1990, and I've tested and reviewed hundreds of scanners for the major computer magazines and Web sites. During this time, one thing that hasn't changed in the last dozen-plus years has been all the fuss over scanner resolution. I've received scanners for testing that were packed in large boxes with 12-inch lettering on the side proclaiming 2400 x 2400 RESOLUTION in garish tones. A scanner is invariably described as "a 1200-dpi, 36-bit color scanner" or some similar terminology, as if those terms summed up the most important qualities of that scanner. Well-meaning people write and ask me what resolution they should look for in a scanner. All the scanner books that I've seen, including my own, include recommendations on what scanner resolution to use for particular tasks.

I'm about to share a little secret with you: Resolution is not the most important specification to consider when choosing a scanner. It's not even the most important determiner of the scanner's final quality. The optical system and other attributes of the sensor are more important. Even the smoothness of the sensor/mirror transport system can be important. To make matters worse, the resolution figures that vendors quote are likely to be false or misleading. And to top it off, unless you are scanning tiny objects that have lots of detail, you rarely have any use for a scanner's top resolution in the first place. Resolution figures are not only a myth, they're a *dangerous* myth.

Until you've seen a 600-spi (600 sample-per-inch) scanner that produces better images than a 2400-spi scanner, you won't believe this, but it's true. To see why this is true, you need to know how the manufacturers arrive at those figures.

Resolution is calculated from the number of individual sensors in the sensor array that captures an image. This array is a narrow horizontal strip that extends along the width of the scanner. There is one element for each pixel in that width. For example, an 8.5-x-11.7-inch flatbed with "true" optical resolution of 1200 spi has 10,200 elements along the array's width. The sensor itself is less than 8.5 inches wide, of course, because the optical system focuses the image onto the sensor's somewhat narrower width.

The scanner grabs one line at a time by moving the sensor (or a mirror that reflects through the optical system to the sensor) some distance between lines. If the scanner sensor/mirror carriage moves $\frac{1}{1200}$ of an inch between lines in the vertical direction, the scanner is said to have an optical resolution in that direction of 1200 spi. So, your scanner may be described as having a true resolution of 1200 (horizontal) x 1200 (vertical) samples per inch.

Some vendors try to play tricks by moving the sensor a fraction of a full line between scans — say, $\frac{1}{2400}$ inch — so that they can claim perhaps 1200-x-2400-spi resolution. In practice, blurring caused by the motion of the carriage probably wipes out any resolution that is gained through this trick, so the spec that's reported by the vendor is already wrong on at least one count.

True resolution also depends on the sharpness of the optical system that is used to focus the image on the sensor, so unless the optics are top quality, even the horizontal resolution measurement doesn't really mean a lot.

Things get even more confusing when vendors quote *interpolated* resolution, which is a figure that's derived from mathematical algorithms that are used to calculate what pixels would exist if the scanner were capable of capturing them. So, you may have a scanner that boasts 1200-x-1200-spi optical resolution and up to 9600-x-9600-spi interpolated resolution, and neither figure tells you much about the quality of the image.

If resolution is really important to you, the best way to estimate the kind of quality that you can expect from a given scanner is to read the laboratory reviews that many magazines publish or to test the scanner yourself. I've seen 1200-x-1200-spi CIS scanners that were terrible and 600-x-600-spi CCD scanners that were twice as good at half the resolution.

Color-depth confusion

The other misleading specification quoted for scanners is their color depth. Does it really make a difference whether a scanner is a 24-bit, 30-bit, or 48-bit unit? In practice, color depth — which is better thought of as dynamic range — does make a difference. Greater dynamic range lets you capture better-quality images, with more detail in the shadows and highlights. Unfortunately, most of the dynamic range figures that are quoted by vendors are as misleading and inaccurate as their resolution figures.

Why do you need all those colors? A 4-x-5-inch photo that's scanned at 200 spi has only 800,000 different pixels. Even if every pixel were a different color, you would need only 800,000 unique colors to represent them all. Surely, the 16.8 million colors in a 24-bit image are enough, but alas, that's not true. First, scanners lose a lot of information because of noise in the electronic system. Imagine trying to watch TV while a lively party is going on all around you. Conversation, people walking, and even the tinkling of glasses provides extraneous noise that degrade the sounds that you hear from the TV. You're trying to listen to something while surrounded, quite literally, by noise. Scanners are subject to the same interference, but this interference is random electrical noise. Even a 30-bit scanner may barely end up with 24 bits of information after the signal-to-noise factor is included.

Moreover, the greater range of colors in some types of originals, particularly color transparencies, means that more colors must be available from the scanner to represent them accurately. To capture detail in very dark areas (called *D-max areas* by the techies) as well as in the very lightest areas (called *D-min areas*), you need a heck of a lot of information. That's where extra color depth is valuable.

Unfortunately, scanner vendors quote dynamic range figures based on theoretical constraints rather than the real-world performance of their scanners. I've seen 48-bit scanners that actually produced no better than 24-bit scans. I've gotten superior results from scanners from more conservative vendors who claimed no more than 36-bit dynamic ranges.

Scanners that are touted for their transparency-scanning capabilities usually have the best overall color-depth performance. But, as with resolution, if dynamic range is important to you, you're better off relying on independent lab results from the magazines or Web sites, or testing the equipment yourself.

Chapter 6: Accessorizing Your Digital Camera

In This Chapter

✓ Supporting tripods

✓ Lighting up your life

✓ Tucking into camera bags

✓ Becoming a gadget freak

Most digital cameras have everything you need to take great pictures, right? And they're not really very expandable because they usually have a nonremovable lens, a built-in flash, close-up capabilities, and other features that you may normally purchase as accessories for film cameras. What more could you want?

A lot. One of the most diabolic things about photography is that as you use the capabilities of your camera equipment, you always find even more interesting things that you could do if you just had *this* accessory or *that* gadget. A digital camera with a long zoom lens, for example, makes you wish you had a longer zoom. Discovering ways to use your digital camera's built-in flash effectively can make you yearn for a bigger, better external flash.

When the bug really hits you, you start *searching* for previously unknown accessories to help you do things you didn't even know could be done. You'll even think up ways in which having a second digital camera can help you (as a spare, as a smaller camera to keep constantly on hand, and so on). Once you become serious about photography, accessory-itis is sure to strike. I say this from the viewpoint of someone who currently owns more than a dozen single-lens reflex cameras, a clutch of digital cameras, some 15 lenses, eight or nine flash units, and a closetful of close-up attachments, filters, and other add-ons.

Don't fight it. Enjoy your incurable disease. You can have a lot of fun playing with your accessories, and most of them don't cost that much, anyway. They help you shoot better pictures, too. This chapter highlights some of the most common — and most needed — accessories for digital photography.

Getting Support from Tripods

A tripod is a three-legged stand, as shown in Figure 6-1, that is designed to hold your camera steady while a picture is composed and taken. Although a tripod may be a little cumbersome to carry around, it is indispensable at times. A tripod can do the following things for you:

✦ **Hold the camera steady for longer exposures.** You need a slower shutter speed to capture an image in dim light.

✦ **Hold the camera steady for photos that are taken at telephoto zoom settings.** Telephoto settings do a great job of magnifying the image, but they also magnify the amount of vibration, or camera shake. Even tiny wobbles can lead to photos that look like they're out of focus, when they're actually just blurry from camera movement. A tripod can help eliminate this sort of blur.

If your pictures keep ending up fuzzy when the camera is set for its maximum telephoto zoom setting, the problem is more likely to be camera shake than a poor autofocus mechanism. At long zoom settings, most digital cameras often switch to a slower shutter speed. The slower shutter speed, coupled with the telephoto's magnification of the tiniest bit of camera shake, leads to a photo that appears out of focus. The picture is not out of focus; the camera has just been vibrating. Mounting the camera on a good, sturdy tripod is the best cure for this problem.

✦ **Hold the camera in place so that you can get in the picture, too, by using your digital camera's self-timer feature.** This way, you only have to worry about how you look as you make a mad dash to get into the picture.

✦ **Allow precise positioning and composition so that you can get exactly the image that you want.** This is especially important when taking multiple shots from the same spot, and it is useful if you're experimenting with filters or trying different lighting ideas.

✦ **Hold the camera for multipicture panoramic shots that you stitch together into one photo in your image editor.** I discuss panoramas in greater detail in Chapter 12 of Book I.

Getting multiple shots with a tripod

Here's a trick that shows you just how useful a tripod can be. Multiple shots can be merged to solve difficult lighting situations. That's because using a tripod also allows multiple images from exactly the same camera position. This is important because it can help the photographer correct problems with lighting that delivers too much contrast.

Many times, a scene is lit in such a way that the difference between the brightest white and the darkest black is greater than the sensor can handle. When this happens, pictures end up with areas that are solid white or solid black and have no detail in them.

When circumstances permit, pros correct this by taking two or more images of exactly the same scene with the camera mounted on the tripod. The first image is exposed so that the highlights are properly exposed; the second is exposed to let the shadows have detail. When in doubt, take one picture that's a little overexposed and one picture that's a little underexposed. (One setting above what the camera recommends and one setting below what the camera recommends is a good rough estimate.) Some cameras have this capability, usually called *auto exposure bracketing,* built in.

Back at the computer, the two images are merged in an image-editing program such as Photoshop so that the combined image carries detail throughout the picture. Using this technique may stretch your comfort zone with both your computer and your camera, but it can also help you improve many photos, such as scenics, that can be taken with the camera mounted on a tripod. You can always take an extra shot at the setting that the camera recommends so that you still have the shot you would have gotten anyway. That's one of the nice things about digital cameras; you don't have to worry about "wasting" shots!

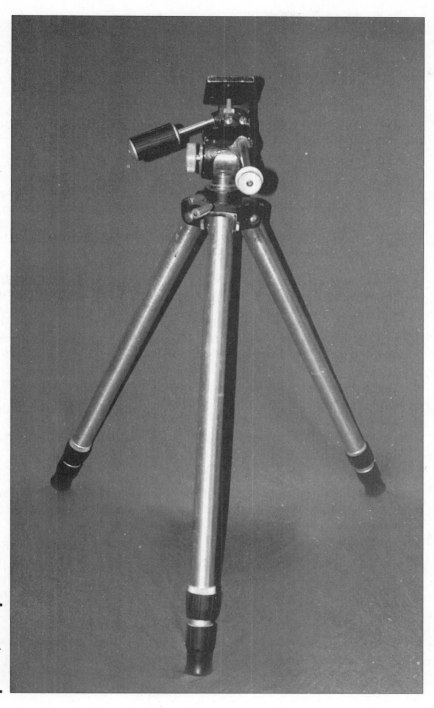

Figure 6-1:
The tripod
is the photo-
grapher's
best friend.

Because most modern digital cameras are pretty lightweight, you don't need to carry a massive tripod like many pros do; just be sure that the tripod is strong enough to keep the camera steady. Beware of models that claim to go from tabletop to full height (roughly eye level at 5 feet or more); odds are, they sway like a reed when fully extended.

Types of tripods

Tripods come in several types of materials, styles, and sizes. Pro units are capable of handling heavy cameras and extending 5 to 6 feet high. These tripods are made of wood, aluminum, or carbon fiber and may cost from a couple of hundred dollars to a thousand dollars or more. You probably don't want one of these pro units. Your ideal tripod is probably a compact model made of aluminum. The common types of tripods are as follows:

+ **Less expensive units:** These may range in size from 1 foot to 5 feet tall and cost just a few dollars to a hundred dollars or more.

+ **Full-sized models:** These range from 4 to 6 feet tall when fully extended and may have from two to four collapsing sections to reduce size for carrying. The more sections, the smaller the collapsed tripod. The downside is that the extra sections reduce stability and provide more points in which problems can develop.

+ **Tabletop tripods, or "minitripods":** These are promoted as lightweight, expandable, and easy to carry, which they are. They're also promoted to be sturdy enough for a 35mm camera, which they probably aren't — unless they're set to their lowest height. However, most can easily handle a digital camera, and they can be small enough to carry around comfortably. If used on a tabletop or braced against a wall with a small digital camera, these units can do a decent job. They can come in handy in places where you don't have enough room to use a full-sized tripod.

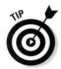

To use a minitripod against a wall, brace it against the wall with your left hand while pressing your left elbow into the wall. Use your right hand to help stabilize the camera while tripping the shutter. Keep your right elbow tight against your body for added stability.

+ **Monopods:** While not exactly a tripod (monopods have only one leg versus three), a monopod can help reduce camera shake. These single-leg, multisegment poles can just about double the steadiness of the camera, compared to simply steadying it by hand.

+ **Hiking-stick monopods:** Another option is a combination hiking stick/monopod. If you do a lot of hiking, these can be very worthwhile. Although not as sturdy or stable as a high-quality monopod, these hybrids can work well with the typical small digital camera. Most of them have a wooden knob on top that unscrews, leaving a ¼-inch screw that mates with the camera's tripod socket. (Check to make sure that your digital camera has a tripod socket; not all models do.) Mount the camera on the hiking stick, brace the bottom of the stick against your left foot, pull it into your body with your left hand, and gently squeeze the shutter-release button.

Scrutinizing tripod features

Not all tripods are made alike, so it pays to take a close look at how the tripod you're thinking of purchasing is put together. I cover what you should look for in a tripod in the following sections.

Locking legs

All collapsible tripods offer some way of locking the legs into position. Most common are rings that are twisted to loosen the legs or tighten the legs in

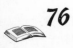

place. Some manufacturers use levers instead. When buying a tripod, check this part closely. Remember, every time you want to fully extend or collapse the tripod, you're going to have six or more of these locks to manipulate. A good tripod lets you open or close all the locks for one leg simultaneously when the legs are collapsed. (It works like this: Cover all three rings at the same time with your hand and twist; they're all released, and then with one simple movement, they're all extended. This procedure is also used in reverse.)

Range of movement

Some tripod legs can be set to a right angle from the camera mount. This feature can be handy if you're working on uneven ground, such as a hiking trail.

Extra mounting screws

Some tripods offer an extra mounting screw on one of the legs. Hypothetically, this is useful, but its use is rare enough that I wouldn't choose one tripod over another just for this feature. A more useful extra is a center column post that can accept a camera on its low end (for ground-level shots) or that has a hook that holds a weight or camera bag. Placing extra weight on a tripod makes it steadier for longer exposures, so this capability is very useful.

Heads

A *tripod head* is the device that connects the camera to the tripod legs. On inexpensive tripods, these heads are frequently permanently attached. On better-quality models (although not necessarily expensive ones), the heads are removable and can be replaced with a different type. Quite a few different styles of tripod heads are available. Many tripod heads that offer a panning capability (the ability to spin or rotate the camera on its horizontal axis) also offer a series of 360 markings (one for each degree of rotation) to help orient the camera for panoramas. Consider the following types of tripod heads:

✦ **Pan/tilt heads:** These allow you to spin the camera on one axis and tilt it on another. These are generally the cheapest and most labor intensive, because you have to make adjustments to multiple levers to reposition the camera.

✦ **Fluid, or *video,* heads:** These usually have a longer handle that extends from the head. Twist the grip to loosen it, and you can pivot and tilt the camera simultaneously.

✦ **Joystick heads:** Similar to the fluid or video head, this type has a locking lever that's built into a tall head. By gripping the lever and head and squeezing, you can pan and tilt the camera quickly and easily. These heads were designed and marketed for 35mm cameras, but they don't work particularly well for these cameras because they're subject to *creep.* Basically, creep occurs when you reposition your camera on a tripod head and lock it, and then notice the camera move a little as it settles into the locked position. Creep can be a very annoying problem with any tripod head, but the joystick models seem to have the most

trouble with it. *Note:* For a smaller digital camera, these heads may be a better choice simply because these cameras weigh so little.

✦ **Ball heads:** These are probably the most popular style with pro photographers because they provide a full range of movement for the camera with a minimal amount of controls to adjust. This type of tripod head, as shown in Figure 6-2, uses a ball mounted in a cylinder. The ball has a stem with a camera mount on one end, and when the control knob is released, you can move your camera freely until reaching the top of the cylinder. A cutout on one side of the cylinder allows the stem to drop low enough for the camera to be positioned vertically. Ball heads range in price from just a few dollars to $500 or more. The best ones don't creep, which is why photographers pay so much for them.

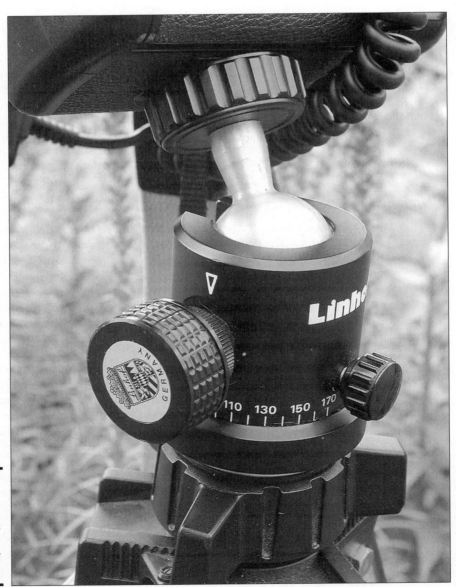

Figure 6-2: A tripod with a ball head allows complete control over position.

Checking out tripod alternatives

Several other items on the market are also worth considering for those who need to travel light. A tried and true classic for supporting bigger camera/lens combinations is the beanbag. Whether you use the basic beanbag that you tossed around as a kid or the one that's specially designed for photography, by putting the bag on a wall or car roof and then balancing the lens on the bag, you can maneuver your equipment easily while letting the wall or car take the weight of the lens.

You can also find a number of clamp-like devices coupled with the ¼-inch screw that's necessary to attach them to your camera's tripod socket. You then clamp the camera to a tree limb, fence post, or other solid object, and voilà! — instant tripod (don't add water).

These camera-holding clamps range from a modest C-clamp device for just a few bucks up to the Bogen Super Clamp system (www.bogenphoto.com). The basic Super Clamp costs around $30. The basic C-clamp style should do the job for travelers who use a shirt-pocket-sized digital camera. Those working with one of the larger, SLR-style digital cameras may want to consider buying a Super Clamp. Your local camera store can help you decide which type is right for you.

Making Good Use of an Electronic Flash

Because available light (more commonly known as *available darkness*) is undependable, digital photographers should consider carrying an accessory flash unit. Although most digital cameras have some sort of built-in flash capability, these flash units don't produce a very powerful light. The built-in flash unit is usually good only for a range of up to about 8 feet, which isn't always enough.

Accessory flash units do more than just provide extra light when it's too dark to shoot without it. Although I cover accessory lighting more thoroughly in Chapter 9 of Book I, make note of the following situations in which an accessory flash is useful:

✦ **Fill flash:** Is your subject standing in the shadows while another part of the scene is brightly lit? Trust your camera's light meter, and you'll either get a properly exposed subject and overexposed area where the light was too bright, or you will end up with an unrecognizably dark subject and an okay scene. Using an accessory flash lets you balance the light throughout the scene by exposing for the bright area and using the flash to light up the shadows.

✦ **Painting with light:** You may want to take a picture of a building or other large structure, and it's, shall we say, pitch dark outside. One technique for handling this situation is known as *painting with light.* Set your camera on a tripod or something equally solid and then pull out your accessory flash unit. Set your digital camera to its bulb or time-exposure setting if it has one; if it doesn't, use the longest exposure possible. While the shutter is open, use your flash to light up sections of the building one section at a time. Here's where the true wonder of the digital camera comes in: You

can check your photo as soon as you're done taking it. Although film photographers have been using this technique for years, they never knew whether they got it right until they got their prints developed.

✦ **Macro, or close-up, photography:** Getting in close calls for lots of light simply because as the camera gets closer to its subject, the area of sharp focus — or *depth of field* — diminishes. Using your external flash helps provide enough light to allow an aperture setting for greater depth of field. The external flash also provides more even illumination for your subject. You should use a setup that allows your flash unit to operate while off the camera because lighting your subject from the side brings out more detail than lighting from straight ahead. Some flash units, such as ring lights, are specifically designed for macro photography. (I take a look at ring lights in the section "Lighting/flash accessories," later in this chapter.)

✦ **Bounce flash:** Many accessory flash units include a tilt/swivel head that lets you point the unit toward a reflective surface instead of right at your subject. By bouncing the flash off the surface and toward your subject, you create softer light and shadows than you would if the flash were directed straight at your subject.

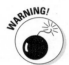

Bouncing a flash unit this way weakens its effective output, because the light has to travel a greater distance to reach the subject. This isn't a problem if the surface is reasonably close, but distance matters. Beware of cathedral ceilings!

✦ **Multiflash:** You can use multiple flash units to create a lighting setup that comes reasonably close to studio lighting. By positioning these flashes properly, you can either create a nicer portrait lighting setup or distribute the lights well enough to evenly illuminate an entire room.

Built-in flash units can also speed the camera's battery drain tremendously. Because they're positioned right above the lens, the built-in strobes are also a prime cause of *red-eye.* This is a reddish tinge in human pupils (it's greenish or yellowish in many animals). Red-eye is particularly difficult to prevent when photographing young children with a flash. An accessory flash can help reduce this effect because you can position it farther from the lens than a built-in unit.

Many higher-end digital cameras offer some method of triggering an accessory flash unit, either by a cable connection or via a *hot shoe* — the device on a digital camera that holds an external flash and provides an electronic connection to the camera. Many amateur and entry-level digital cameras, however, offer no such provision. In this case, the answer is to use a "slaved" flash that's specifically designed for digital cameras. (I discuss this in more detail in the next section.)

Types of electronic flash units

As many different electronic flash units are available as there are digital cameras. The following sections give you a quick rundown on the kinds of flash units that you should consider.

Before buying flash equipment of any kind, be sure that it works with your camera. Flash units can be triggered via the camera's hot shoe, by electronic slaves, by wireless radio triggers, and via several different types of cables. Some cameras can use a generic, old-fashioned connection called a *PC cable*. These cables are inexpensive and work with any camera that has a PC connection, but all they do is trigger the flash unit. A camera's manufacturer makes another type of cable that is known by several different designations (for example, TTL and E-TTL). This type is specifically designed for the manufacturer's cameras (and sometimes for just one segment of its camera line) and no other, although these cables work with third-party flashes. The advantage of these types of flash cords (which are much more expensive than PC cords) is that they allow the camera and flash unit to communicate with each other so that the camera can turn the flash's output off when the camera determines that the proper exposure has been reached.

Small, light "minislaves"

These units are designed to help augment the camera's built-in flash unit. They're generally useful for adding a little extra dimension to your lighting and as a way of filling in background areas. These units are slaved to fire when another flash unit goes off. Such photographic slaves are photoelectric sensors that are designed to trigger a flash unit when another flash is fired within the sensor's field of view (in the case of a digital camera, when the camera's built-in flash fires). These slave-triggering circuits are sold as independent units that you can attach to existing flash units, or the circuitry may be built right in to a flash unit.

Small hot-shoe mount flashes

These are more powerful than both the minislaves and the camera's built-in flash units. They may also offer a tilt or swivel capability. Some camera systems (usually higher-end digital cameras) offer a cable that connects to the camera's hot shoe and allows the flash to communicate with the camera's electronics while being positioned in ways that the hot shoe mount doesn't permit. The advantage to these cables over slaves is that they usually permit the camera/flash combo's full range of capabilities. (Some cameras are set to turn off the flash as soon as the correct exposure is reached, whereas a slaved flash continues pumping out light as set.)

Professional models

These units tend to be the manufacturer's most powerful and most advanced flash units. They have lots of features, including built-in slave capabilities and the ability to work with wireless remote systems. In many cases, these units can also take advantage of the digital camera's lack of a true shutter. This means that the flash can be used with faster shutter speeds than those used with film cameras. In addition to the manufacturer's flash models, dedicated flashes that are offered by third-party manufacturers also work with many existing camera systems, like the one shown in Figure 6-3.

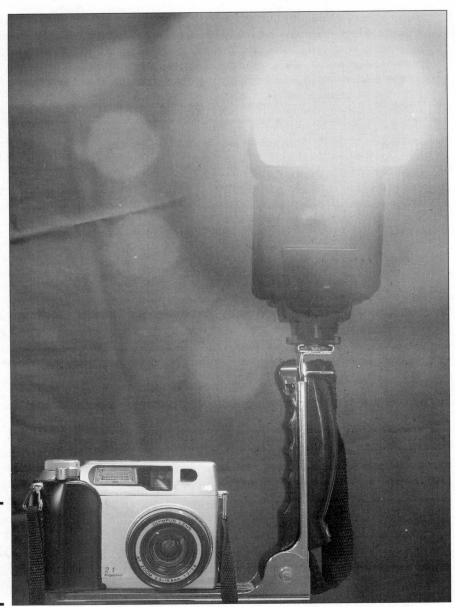

Figure 6-3:
This external flash packs real lighting power.

WARNING! Many third-party flash units and lenses are reverse-engineered to work on major brand-name cameras. Sometimes, this equipment may not work with newer equipment from your camera's manufacturer. If a third-party flash causes damage to your camera (and today's highly electronic cameras can be susceptible to damage from improper voltage discharge), the camera manufacturer may not repair the damage under warranty.

Portable studio lighting

Portable studio lighting kits are available that enable a photographer to carry a complete set of lights with lighting stands and reflectors or umbrellas. These kits usually offer from two to three lights or more and may also include a backdrop setup. Although these sets are fine for local or cross-country trips, you may want to rent such a kit while traveling overseas

rather than pack one along with all your camera equipment while flying. The flash units in these kits often have built-in slaves as well; these slaves are triggered either via a connection to the camera or via a flash unit on or in the camera.

What to look for in a photographic slave flash

A basic slave unit is a small device that's designed to mate with the flash unit's hot shoe. The slave (good ones have on/off switches) triggers the flash when another flash unit is fired. These slaves have their own hot shoe foot to mate with stands that are designed for such things or with the L-bracket that I describe in a few paragraphs. The slaves also have ¼-inch tripod sockets in their base so that you can screw them onto an extra tripod.

Wireless, or radio, slaves are also available. These are significantly more expensive than their wired counterparts, but they are worth the cost when other photographers and their accompanying flashes are in the vicinity. A regular photoelectric slave doesn't care that it's been triggered by the wrong photographer's flash unit; it has simply done its job. Wireless triggers work via radio signals, not light signals. These devices generally offer multiple frequencies to minimize the likelihood of another photographer triggering them.

A standard photographic slave won't work properly with a digital camera because most prosumer and amateur digital cameras emit a preflash (to help the camera make some internal settings) that triggers earlier slave designs prematurely. So, if you're interested in buying a slaved flash unit, make sure that it's designed to work with a digital camera. Nissin, an electronics firm, makes a flash unit known as the Digi-Slave Flash. You can find about a half-dozen different units, ranging from basic slaves to pro units. Check out SR Inc. (www.srelectronics.com) for pictures and descriptions of the models that are available.

Although the slaved flash doesn't help reduce the drain on the camera's battery, the more powerful light still helps improve photos. The photographer also gains the ability to position the light higher up from the lens (usually slightly to the right or left as well) to reduce the likelihood of red-eye and to provide a more pleasing effect. Setting the camera's exposure system to automatic can generally handle the increased flash without a problem; if you're not satisfied with the result, switch to aperture-priority and experiment! The exception is with close-up photos, where overexposure is likely. Dialing in a correction (usually about two f-stops) through the camera's exposure-compensation system solves this problem.

An electronic flash unit without power is an expensive paperweight. With the exception of the portable studio lighting kits, which require electrical outlets, electronic flashes usually require AA batteries, although the smallest may take AAAs instead. Rechargeable batteries generally provide an inexpensive option although they tend to recycle (recharge the flash unit) more slowly than alkaline batteries do. PC cables and manufacturer flash cords can malfunction (take care not to crimp them), so for important trips, carry extra cables (especially if you're going overseas, where it may be hard to find a replacement).

Lighting/flash accessories

Depending on your shooting requirements and how much weight you can afford to carry, some accessories can help improve your photography. My list of possibilities is as follows:

✦ **Brackets:** A nice complement to the accessory flash route is an L-bracket flash holder. This device mounts to the camera via the tripod socket and has a flash shoe at the top of the L, where you position the flash. In addition to providing a secure hold for the flash unit, the L-bracket provides a steadier grip for the camera. You can even find models that are designed for the shorter, thinner digital cameras, such as the earlier Nikon Coolpix series.

✦ **Background cloths or reflectors:** Garden enthusiasts who are interested in photographing flowers can bring swatches of colored cloth that are large enough to serve as a background for your shot of a plant or bloom. Black is a good all-purpose color, whereas red, green, and blue complement common flower colors. Another helpful item is a collapsible reflector. (Camera stores sell small reflectors, or you can pick up sun blockers that are designed for car windows.) These reflectors can kick some sunlight back into the shadow areas to help create a more pleasing image. For the most serious flower photographers, a *ring light,* or circular flash unit that mounts in front of the camera lens, provides an even, balanced light for flower close-ups. A Digi-Slave Flash ring light unit can be configured for many amateur- and pro-level digital cameras.

Choosing a Camera Bag

Depending on the size of a digital camera and the accessories that accompany it, a camera bag or pouch may be a necessity. For just the basics — a small camera, extra batteries, extra memory cards, and a lens cleaning cloth — a simple fanny pack does the job and leaves room for hotel keys, money, and identification.

A more serious photographer who is carrying a larger digital camera needs more space. A larger camera bag may be the answer, but for the active traveler, some interesting options are available. Because camera bags are especially useful for traveling photographers, I've included a longer description of the options and features in Chapter 12 of Book I, where I discuss travel photography.

Acquiring Other Useful Devices

Gizmos. Gadgets. Thing-a-ma-jigs. Many of these items don't fall into any particular type of category, but they often do something useful. I discuss some of these gadgets in the following sections.

Filter holders

A helpful device that I especially like is a filter holder, sold by Cokin (www. minoltausa.com/cokin/about.htm), that also mounts to the base of the camera via the tripod socket. This adapter allows you to use Cokin's square

filters, which slide right into the adapter to provide a variety of effects and corrections. Note, however, that you could achieve many of the same results in an image-editing program. To those who are more comfortable tweaking things on the computer, filters aren't important. On the other hand, if you're new to computer photo editing, relying on traditional filters may be easier. You can always take one shot with a filter and one without, and then try to tweak the filterless shot to look like the filtered one. This process may help you figure out how to get the most from your image-editing software.

A second camera

At some point, you'll consider buying a second camera — say, when you're ready to leave on that vacation of a lifetime. A small, inexpensive digital camera may not cost much, but if your primary camera fails, this second camera may be worth its weight in gold, photographically speaking. Shop for — or borrow — one that uses the same type of batteries and storage media as your primary camera, if possible. The extra camera can also entice a spouse or child into sharing your love of photography.

Cleaning kits

You'll also frequently need a good cleaning kit. An inexpensive microfiber cleaning cloth is great for cleaning optics, but first use a blower to remove any dust particles from the lens. You can then hold the lens near your head, fog the lens with your breath, and gently (very gently) wipe the lens with the cloth. "Canned" air also does a good job of blowing dust and dirt off the camera, but make sure that the can is held level, or solvents from the aerosol may contaminate the lens.

Damp or dusty conditions call for more serious efforts. The camera can be protected inside heavy-duty plastic freezer or sandwich bags while inside the camera bag, thus reducing exposure to dust and moisture. Keep the small packets of silica that come with electronic equipment, and place one or two of these packets in the camera bag to absorb moisture. The following section provides more detailed information about dealing with extreme weather conditions and discusses bags and containers for protecting gear. (Call it the difference between shooting at a dusty ball field on a windy day versus shooting in a windstorm in the desert.)

Waterproof casings and housings

Extreme conditions call for better protection for your camera. Better yet, photography in wet weather, or even underwater, can be fun, too. Waterproof casings that allow photography are available from several companies, including Ewa Marine (www.ewa-marine.de). These are useful for both underwater photography (careful on the depth though) and above-the-water shots if you're sailing or boating. Keep in mind that salt spray may be the worst threat to camera electronics. Make sure that your camera casing provides good protection against wind and salt spray.

Another option for those who want to shoot in wet conditions is a new underwater digital camera. The SeaLife Reefmaster Underwater Digital camera (www.sealife-cameras.com) comes in a waterproof housing and works both on land and underwater. This camera, which retails for under

$400, only produces a 1.3-megapixel file but saves you the trouble of trying to find a housing to fit an existing digital camera. The camera also has a liquid crystal display (LCD) that works underwater and a fast-delete function to make it easier to operate underwater.

For serious underwater enthusiasts, heavy-duty Plexiglas housings are now available for small digital cameras. You can buy these housings for a wide range of digital cameras for as little as a couple hundred dollars.

Filters

Filters, those glass disks that can be screwed onto the front of your camera's lens, are popular accessories. The following are popular types of filters:

✦ **Warming:** Some filters produce what photographers refer to as a *warming effect.* This filter can make up for the lack of color in midday light by adding some reddish-orange color to the scene. These filters are usually coded in the 81 series: for example, 81A, 81B, 81C.

✦ **Cooling:** These filters do just the opposite of the previous type. They add blue to the scene to reduce the reddish-orange color. These fall into the 82 series for daylight conditions.

✦ **Neutral-density:** Another type of filter is used to reduce the amount of light that's available. These neutral-density filters (*neutral* because they have no color and *density* because they block light) come in handy for things such as achieving the spun-glass effect of moving water. The filter blocks one f-stop's worth of light or more, making a slower shutter speed possible and increasing the blur of the moving water.

✦ **Neutral-density, Take II:** You may want to photograph a street scene without having cars driving through the photo. By stacking neutral-density filters, you can create such a long exposure that no cars are in the scene long enough to register in the image. Obviously, a camera support of some sort is required. (*Hint:* The ground must be pretty stable too, unless of course you're visiting California.) You must also have a camera that is capable of extremely slow shutter speeds.

✦ **Split-neutral-density:** Another version of the neutral-density filter is a split-neutral-density design. This filter provides half neutral density and half clear filtration, preferably with a graduated transition from the light-blocking half to the clear half.

You primarily use a split-ND filter when half the scene is brighter than the other. The most common example of this is a bright sky against a significantly darker foreground. This condition is typical of midday lighting conditions.

✦ **Polarizers:** Polarizing filters can reduce the glare that bounces off shiny surfaces in your photos. Simply attach the filter and view the image through your LCD. Rotate the polarizer until the glare disappears. Polarizers can also help increase the contrast of the sky from certain angles.

Chapter 7: Understanding Photo Composition

In This Chapter

✔ Developing a picture concept

✔ Centering on your main subject

✔ Selecting vertical or horizontal orientations

✔ Mastering the Rule of Thirds

✔ Using lines to draw interest

✔ Balancing and framing your image

✔ Avoiding unintentional mergers

*R*andom snap-shooting can sometimes yield lucky shots — happy accidents that look good and prompt you to say, "Actually, I *meant* to do that" (even if it wasn't the case). Some Pulitzer Prize–winning photos have resulted when the photographer instinctively squeezed off a shot at what turned out to be a decisive moment in some fast-breaking news event. However, lacking a Pulitzer-winner's intuition, most photographers end up with a larger percentage of pleasing photos when they stop to think about and plan their pictures before putting the viewfinder up to their eye.

In this chapter, I tell you about the essentials of photo composition that set you on the road to taking great pictures. I introduce all the basic elements of good composition, such as selecting what to include in a well-designed photograph and what to leave out. You find out some basic rules, such as the Rule of Thirds, and most importantly, when you should ignore the rules for dramatic effect.

Photo Composition: The Big Picture

One difference between good photojournalists and superior photojournalists is the ability to take a newsworthy picture quickly when circumstances don't allow much time for preparation or thought. If you examine the work of these professionals, you find that even their grab shots are well composed. With scarcely an instant's notice, they can line up and shoot a picture that commands your attention.

The very best photos are usually not accidents; they are carefully planned and composed. That is, such pictures display good *composition,* which is the careful selection and arrangement of the photo's subject matter within a frame. I'm not suggesting you set up your camera on a tripod and wait hours — à la Ansel Adams — in anticipation of the universe settling into exactly the right arrangement. Instead, simply understanding how good composition works and keeping that in mind as you plan your photos can

make a world of difference. The following list gives you an overview of how to plan and execute good photo composition:

✦ **Visualize a concept for your picture:** It's important to know what you want your picture to say and who your audience is.

✦ **Choosing your subject matter:** This isn't as easy as it appears to be. A picture may be filled with interesting things to look at, but you must select which one should be the subject of the picture.

✦ **Deciding on a center of interest:** One point in the picture should naturally draw the eye, a starting place for the viewer's exploration of the rest of the image. With a center of interest, the photo becomes focused and not simply a collection of objects.

✦ **Picking the picture orientation:** Some subjects look best when shown in a tall, vertically-oriented frame. Some look best in a wide, horizontal format. A few need a square composition. To make the most of your camera's resolution, choose an orientation when you take the photo instead of cropping it in an image editor.

✦ **Establishing the distance and point of view:** These elements affect your photo's composition and are sometimes difficult to control. For example, when you're attending that World Series game, you can't easily substitute your upper-deck seats for a choice position next to the dugout (although it's worth a try).

✦ **Planning for action:** If your subjects are moving, you need to anticipate where they will be and how they will be arranged when you take the picture.

✦ **Working with the background:** Objects and textures in the background can work for you or against you. The area behind your main subject is an important part of the composition.

✦ **Arranging all within the frame:** The way you accomplish arranging within the frame depends on the situation. In some situations, such as at sporting events, you can't dictate how the subjects are arranged. For example, no matter how much you want an action shot of Ichiro Suzuki, the Seattle Mariners' star isn't likely to relocate to center field to accommodate your photo.

Although these guidelines for composition can help you, remember that they are only guidelines. Your instincts and creative sense will tell you when it's a good time to break those rules, grind them up into tiny pieces, and stomp them under your feet in your quest for an unusual, eye-catching picture. If you examine Picasso's earliest art, you'll see he knew how to paint in the classical style. His legacy is based on knowing when *not* to paint according to the time-honored rules.

Visualizing a Concept for Your Picture

Take some time to visualize your photo before you begin the actual picture-taking process. You don't need to spend hours dwelling over your photo, but you need to have at least a general plan in mind before starting to shoot. The following sections ask — and then answer — the questions that lead you through the process of visualizing a concept for a picture.

What do you want your image to say?

Will your photo be a portrait, a sports action shot, or a scenic masterpiece? The kind of picture you want to take can affect the composition. For example, portraits of teenagers frequently include them within the composition props (from skateboards to pigskins) that reflect their lifestyles. For a sports picture, you may want to get a high angle or one from a particular location to include the field of play or other elements that say, "Action!"

A scenic photo may be composed in different ways, depending on what you want the image to say. For example, a photo taken in a national park can picture the grandeur of nature with a dramatic skyline with purple mountain majesties and amber waves of grain. On the other hand, you may be tempted to make a statement about the environmental impact of humans by focusing on trash left behind by careless visitors or, at worst, desiccated amber mountain majesties and chemically tainted waves of purple grain. Some of the best photographs use composition to take a stand or say something beyond the photo itself. Figure 7-1 is an example of a photo that makes a subtle statement, juxtaposing the idyllic academic setting of Kent State University in Ohio today with a stark memorial that shows where the body of a slain student fell.

Where will it be used?

How the photo will be used can affect composition. If you plan to print the picture in a publication or enlarge it for display in a frame, you want a tight composition to maximize sharpness. If you want to use the shot on a Web page, you may want to step back to take in a little extra and crop later with your image editor because the resolution lost from cropping pixels isn't as critical for Web graphics.

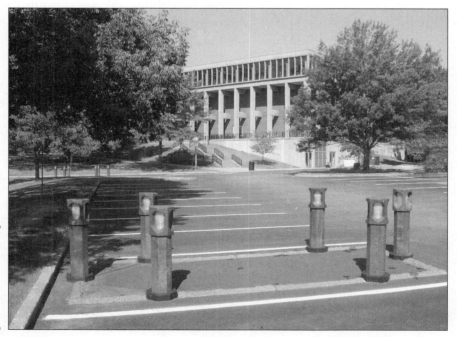

Figure 7-1: Merging a memorial with a campus background.

Who are you creating the image for?

You compose a photo for your family differently from a photo that your colleagues or strangers will view. Your family may like a picture better if the composition revolves around that cute new baby. Create a photo that says, "I've been to Paris," and you'll want to include the Eiffel Tower somewhere in the picture. Colleagues may want to see a product highlighted or the CEO shown in a decisive pose. Subject matter that's extraneous for one application may be important for another.

Selecting a Center of Interest

Photographs shouldn't send the person looking at them on a hunting expedition. As interesting as your subject may be to you, you don't want viewers puzzling over what's the most important part of the image or perhaps conducting a vote by secret ballot to see who has successfully guessed your intent. Every picture should have a single, strong center of interest. You want to narrow down your subject matter: Rather than include everything of interest in a photo, choose one main subject. Then find secondary objects in the picture that are also interesting (this gives the photo depth and richness), but that are still clearly subordinate to the main subject.

Narrowing down your subject matter

Narrowing your subject matter means eliminating everything from your photo that doesn't belong there and concentrating on fewer objects that can form an interesting composition.

Find something in the photograph that the viewer's eye should focus on, forming a center of interest. Usually, your center of interest is a person, a group, or the object you're seeking to highlight. You don't want viewers' eyes roaming around your photo searching for something to look at. Some aspect should jump out and grab your viewers' attention. If other portions of the photo compete for attention, look for ways to eliminate or minimize them.

For example, you can crop more tightly, move to one side or change your angle, ask the extraneous person to leave (your brother-in-law is a good guy; he'll understand), or physically move something to delete it from your composition, as shown in Figures 7-2 and 7-3.

One good technique is to plan several photographs, each using a different part of the subject matter in view. That way, each person or object can take a turn at being the center of interest, and you won't be looking for ways to reduce the competition between them.

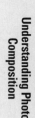

Figure 7-2:
Too many
subjects
spoil the
shot.

Figure 7-3:
Moving
the girl
improves
the
composition.

Choosing one main subject

You can use several compositional techniques to ensure that the main subject you've selected is, in fact, the center of interest. Here's a quick checklist you can follow:

✦ **Make sure your center of interest is the most prominent object in the picture.** You may think Aunt Mary is a worthy photo subject, but if she's standing next to a '60s-era minibus with a psychedelic paint job, she

may not even be noticed. Large, distinctive, highly unusual, or controversial objects are likely to take on a life of their own and seize the focus of attention in your photograph.

✦ **See that the center of interest is either the brightest object in the photo or, at least, not overpowered by a brighter object.** Gaudy colors or bright shapes in the background distract viewers from the main subject. Some elements, such as spotlights at a rock concert or a reflection of the sun on water, become part of the environment and aren't necessarily distracting. Other parts of a photo, such as a bright sail on a boat or a white automobile located behind your subject, can interfere with your carefully planned composition. Eliminate such objects, move them behind something, or otherwise minimize their impact.

✦ **Make sure only one center of interest is in your composition.** Other things in a photo can be interesting, but they must clearly be subsidiary to the main center of interest. A child seated on the floor playing with a puppy would be interesting. But other puppies in the photo should be watching or vying for the child's interest, not off somewhere else in the photo engaged in some distracting activity.

✦ **Avoid putting the center of interest in the exact center of the photograph.** Move the important subject to either side and a little toward the top or bottom of the frame. Don't take "center" literally. See Figure 7-4 for an example of a center of interest moved to one side, but still somewhat centrally located. I explain how to locate your "center" in interesting spots later in this chapter.

Figure 7-4: Move the center of interest away from the center.

Using secondary subjects

Having more than one center of interest is confusing. If you really have several things of importance in a single picture, consider taking several separate photos of each and using them to tell a story. Or, group them together to form a single, new center of interest.

However, you can easily include (and should, in many cases) secondary points of interest that give the photograph depth and richness. A portrait of a child should concentrate on the child's face, but a favorite toy can speak volumes about what this youngster likes to do. A rock singer on stage can command your attention, but a view showing the adoring fans in the front row tells the viewer how popular the performer is. (Conversely, having a scant few bored spectators as a secondary subject can make another statement, and turn the picture into a bit of visual irony.)

To successfully use secondary subjects, they should clearly be subordinate to your main center of interest. You can indicate what's secondary in your image through location, brightness, or even degree of sharpness (a bit of image editing can help you after the fact).

Choosing an Orientation

The *orientation* of a photo — whether it is a wide or tall picture — affects the way we look at the image. When we see a landscape-oriented photo, we tend to think of panoramas and horizontal sprawl. A vertically oriented photo, on the other hand, provides expectations of height. Most subjects fit into one of these orientations, so very few photos are actually composed within a perfectly square frame. Square photos are often static and uninteresting and are usually put to work only with subject matter that suits them, such as circular objects or images that have important horizontal and vertical components.

Digital cameras, like most of their conventional, film-camera brethren, are built using a horizontal layout because that configuration is best suited for holding in two hands positioned side by side. Unfortunately, many photographers unconsciously slip into the trap of viewing every potential photo in a horizontal mode. They turn the camera 90 degrees only when confronted by subject matter that simply can't be photographed any other way, such as the Eiffel Tower, a rocket headed skyward, or any NBA player taller than a guard.

Here are some tips that will help you decide when it's appropriate to use a vertical composition, and when you should think horizontal instead:

✦ **If you're taking pictures for a slide show or, more likely, for a computer presentation, stick with horizontally composed pictures.** Slide show images are seen sequentially and should all have the same basic frame that is often sized to fill up the horizontal screen as much as possible. Inserting a vertical picture may mean that the top and bottom of your photograph is cut off or appears odd on-screen.

You can still have a vertically composed picture in your slide show; just mask off the right and left sides in your image editor to produce a vertical image within the fixed-size horizontal frame. The key is to make your vertical image no taller than the short dimension (height) of a horizontal picture in the same show.

✦ **If your subject has dominant horizontal lines, use a horizontally composed image.** Landscapes and seascapes with a prominent horizon, photos of sprawling buildings or bridges (like the one shown in Figure 7-5), many sports photos focusing on more than one team member, and the majority of four-legged animal pictures look their best in horizontal mode.

Figure 7-5: This landscape proved better as a horizontal image.

✦ **If your subject has strong vertical lines, use a vertical composition.** The Eiffel Tower, trees, tall buildings, pictures of individuals (whether full-length or portrait photos), and similar compositions all call for a vertical orientation, as shown in Figure 7-6.

✦ **Use a square composition if vertical and horizontal objects in your picture are equally important and you don't want to emphasize one over the other.** A building that is wide but has a tall tower at one end might look good in a square composition. The important vertical element at one end would keep the image from being too static. Circular images lend themselves to square compositions, as the round form fits comfortably inside a square "frame," as shown in Figure 7-7.

Figure 7-6:
A vertical
orientation
is great for
showing
height or
vertical
movement.

Figure 7-7:
A square
presentation
often works
with round
subjects.

Arranging Your Subjects

A basic skill in composing great images is finding interesting arrangements within the frame for your subject matter. You need to position your subjects, make sure they're facing an appropriate way, and ensure that they are well-placed in relation to the horizon and other elements of your image. Your first consideration in arranging your subject is to choose the subject's distance from the camera.

Choosing subject distance

Choosing the distance to stand from your subject is one of the first things to do, but it's not something you do once and then forget about. As you take pictures, constantly examine your distance from the subject and move closer or farther away if adjusting your position will improve the composition. Here's how to choose a subject distance:

✦ **To convey a feeling of space and depth, move back a bit or use a wide-angle lens.** Standing back from your subject does several things. The foreground area becomes more prominent, adding to the feeling of space. You'll also take in more of the sky and other surrounding area, giving additional depth.

✦ **Make sure your subjects don't appear too small when you're moving back; they should still be large enough to be interesting.** Moving too far back is the most common mistake amateur photographers make, as shown in Figure 7-8. If you're showing wide-open spaces in your picture, be certain that it's because you *want* to.

Figure 7-8: Whoops! Shot this one too far back.

✦ **For photos that emphasize a person, group of people, or particular object, move in as close as you can.** A close-up viewpoint adds intimacy and shows details and textures of a subject that can't be seen at greater distances, as shown in Figure 7-9. A short telephoto setting is often the best route to getting closer; with a normal or wide-angle lens, you may get some apparent distortion of objects that are very close.

Figure 7-9: Mother Nature provides some backgrounds at no extra charge.

✦ **Move so you fill the frame completely with interesting things.** Whether you're shooting close up to your subject or at a distance, your composition should not include anything that isn't needed to make the picture. Full frames mean less enlargement and sharper pictures, too!

Optimizing backgrounds

Unless you're taking a picture in the dead of night or on a featureless sand dune or snow field, you'll have some sort of background to contend with. A background can be a plus or a minus, depending on how you use it in your composition. Here are some tips for making the most of your background:

✦ **Check your background to make sure it's not gaudy, brightly colored, or busy.** The background should not be more interesting than the subject, nor should it be a distraction.

✦ **For portraits, a plain background, such as a seamless backdrop, can be effective.** A plain, featureless background can work for portraits, as long as it isn't totally bland. Notice how pro photographers who pose subjects against a seamless background still use lights to create an interesting gradient or series of shadows in the background.

✦ **Outdoors, trees, grass, cloud-studded skies, plain walls, and other textured surfaces can make good backgrounds.** Such backgrounds are interesting, without overpowering your subject.

✦ **Watch for strong lines or shapes in the background that don't lead the eye to your subject.** Straight or curved lines are good for compositions, but not if they distract the viewer from your subject.

✦ **Consider using depth of field (the amount of the image that's in sharp focus) to make your background blurry.** Figure 7-9 uses this technique to make the foliage background less distracting.

Because of the way their lenses are designed, consumer digital cameras often show *everything* in sharp focus. Workarounds include using longer lens zoom settings and wider lens openings.

The Rule of Thirds

The position of your subject matter within a picture is one of the most important decisions you make. Whether you can move the subject or objects around, change your position, or wait until everything moves to the right spot, you should constantly be aware of how your subject matter is arranged. Photographers often consciously or unconsciously follow a guideline called the *Rule of Thirds,* a way of dividing your picture horizontally and vertically into thirds, as shown in Figure 7-10. The best place to position important subject matter is often at one of the points located one-third of the way from the top, bottom, and sides of the frame.

Figure 7-10:
Dividing an
image into
thirds.

Placing important objects at imaginary junction points

Follow these steps to compose your pictures effectively using the Rule of Thirds:

1. **Divide the frame into thirds horizontally and vertically.**

 Above all, you want to avoid having your subject matter centered. By imagining the frame in thirds, you automatically begin thinking of those ideal, off-center positions.

2. **Try to have important objects, particularly your center of interest, at one of the four intersections of the imaginary lines that divide the picture (refer to Figure 7-10).**

 Dividing a composition in this way is called the Rule of Thirds, and following this guideline typically arranges objects in a pleasing way.

3. **Avoid having objects at the edge of a picture unless the part that isn't shown isn't important.**

 If you're taking a picture of a group of people, cropping out part of the building they're standing next to or trimming off half a tree that's not an important part of the composition is okay. But don't cut off heads!

When to break the rule

Sometimes, you'll want to break the Rule of Thirds. There are almost as many exceptions to the rule as there are good reasons to apply it, which is why the rule should be considered only as a guideline. Think of the Rule of Thirds as a lane marker on a highway. Sometimes, you'll want to stay within the markers. Other times, like when you see an obstruction in the road, you'll want to wander outside the lines. If you happen to move from the United States to the United Kingdom, you'll find that it's wise to swap sides and use the lane markers on the opposite side of the road.

You might want to ignore this handy rule in some of the following cases:

✦ **When your main subject matter is too large to fit comfortably at one of the imaginary intersection points:** You may find that positioning an object at the "correct" location crops it at the top, bottom, or side. Move it a bit to another point in your composition if you need to see the whole thing.

✦ **If centering the image would help illustrate a concept:** Perhaps you want to show your subject surrounded on all sides by adversity or a threatening environment. Placing the subject at one of the intersection points implies motion or direction, as if the subject were about to flee the picture entirely. However, putting the center of interest in the very center of the picture gives the subject nowhere to hide.

✦ **When you want to show symmetry:** Centering a symmetrically oriented subject that's located in a symmetrically oriented background can produce a harmonious, geometric pattern that is pleasing, even if it is a bit static. If the subject itself makes you think of motion, a square image can even boast a bit of movement, as shown in Figure 7-11.

Figure 7-11:
A square photo with an interesting geometric arrangement.

Some corollaries

A photo composition creates an entire world for the viewer to explore. You won't want to destroy the illusion by calling attention to the rest of the universe outside the frame. Here's how to orient people and other objects in a picture:

✦ **If your subjects are people, animals, statues, or anything that you think of as having a front end and back end, make sure they are either facing the camera or facing into the frame rather than out of it.** If a person seems to be looking out of a picture, rather than somewhere within it, viewers will spend more time wondering what the person is looking at than examining the actual person. The human doesn't actually have to be looking at any object in particular as long as he or she is looking somewhere within the picture.

✦ **If objects in the frame are moving or pointed in a particular direction, make sure they're heading into the frame rather than out of it.** A stationary automobile, a windmill, a palm tree bent over by a strong wind, anything with a sense of direction to it should be facing into the frame for the same reason that a person should be looking into it, as you can see in Figure 7-12.

✦ **Add extra space in front of any fast-moving object (such as a race car) so that the object has somewhere to go while remaining in the frame.** It may seem odd, but if an object is moving, having a little more space in the frame in front of it is best so that the viewer doesn't get the impression that it's on its way out of view. In Figure 7-12, for example, you wouldn't want to crop the image any more tightly on the left because you need to leave room for the speeding ball.

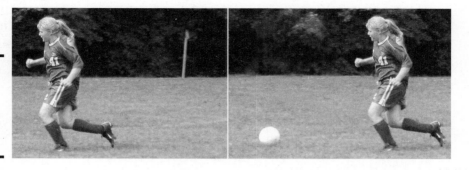

Figure 7-12: Which sports photograph looks better?

Using Straight Lines and Curves

After you have the basics out of the way, progressing to the next level and creating even better compositions is easy. All you need to know is when to apply or break some simple rules. Just remember that one of the key elements of good composition is a bit of surprise. Viewers like to see subjects arranged in interesting ways, rather than lined up in a row.

Lines within your image can help your compositions by directing the eye toward the center of interest. The lines don't have to be explicit; subtle shapes can work just as well. Try these techniques:

✦ **Look for straight lines in your image and try to use them to lead the eye to the main subject area.** Some lines are obvious: fences, or a seashore leading off into the distance, for example. These kinds of lines are good when you want a dramatic composition, like Figure 7-13.

✦ **Find diagonal lines to direct the attention to the center of interest.** Diagonal lines are better than straight lines, which are static and not particularly interesting.

✦ **Use repetitive lines to create an interesting pattern.** Repetitive lines can be multiple lines within a single object, such as the grout lines in a brick wall. Or repetitive lines can be several different parallel or converging objects, such as a road's edges, the center line of the road, and the fence that runs along the road. Strong repetitive lines can become a pleasing composition themselves, like in Figure 7-13.

✦ **Curved lines are more graceful than straight lines and can lead the viewer gently from one portion of the composition to another.** Curving roads are a good example of arcs and bends that can contribute to a composition. Other graceful curves include body parts of living things, such as the necks of flamingos, as shown in Figure 7-14.

✦ **Look for shapes within your composition to add interest.** Three objects arranged in a triangle make a picture inherently more interesting than if the objects formed a square shape. That's because your eye naturally follows the lines of the triangle towards each of the three points or apexes, whereas squares or rectangles don't "point" anywhere. Instead of posing groups of people in rows and columns, stack them in interesting arrangements that make shapes that the viewer's eye can explore.

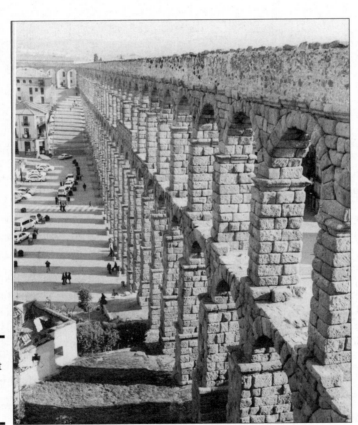

Figure 7-13:
The straight lines in this shot lead the eye.

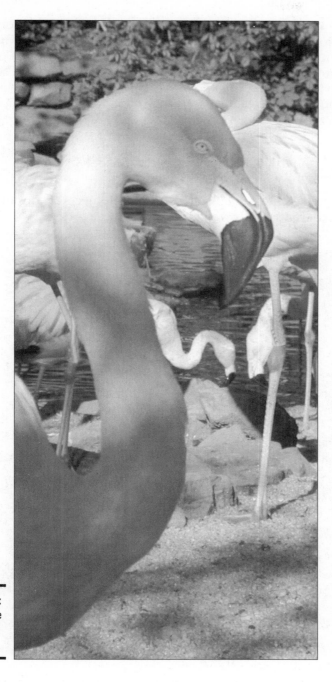

Figure 7-14:
An example
of a curved
line.

Balancing an Image

If you place every element of interest in a photograph on one side or
another, leaving little or nothing to look at on the other side, the picture is
imbalanced, like a see-saw with a large child at one end, and nothing on the
other. The best pictures have an inherent balance that makes them graceful
to look at.

To balance your image, arrange objects so that anything large on one side is balanced by something of importance on the other side. This is not the same as having multiple centers of interest. You can balance out a group of people arrayed on one side by simply having a tree or building on the other. The people are still the center of interest; the other objects simply serve to balance the composition, as shown in Figure 7-15.

You can balance objects in two ways:

✦ To create a symmetrical balance, have the objects on either side of the frame be of roughly similar size or weight.

✦ To create a nonsymmetrical balance, have the objects on opposing sides be of different size or weight.

Figure 7-15:
Extra
elements in
a photo
can add
balance.

Framing an Image

Photos are frequently put in frames for a good reason: A border around a picture defines the picture's shape and concentrates our attention on the image within the frame. You can use framing to provide an attractive border around your own pictures by using these tips:

✦ **In the foreground, look for obvious framing shapes in which you can place your composition.** You won't easily miss the most readily apparent frames: doorways, windows, arches, and the space between buildings, for example. These have the advantage of being a natural part of the scene and not something you contrived in order to create a frame, as you can see in Figure 7-16. In this illustration, the cliffs at the left side of the image partially frame the ocean inlet at right.

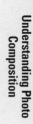

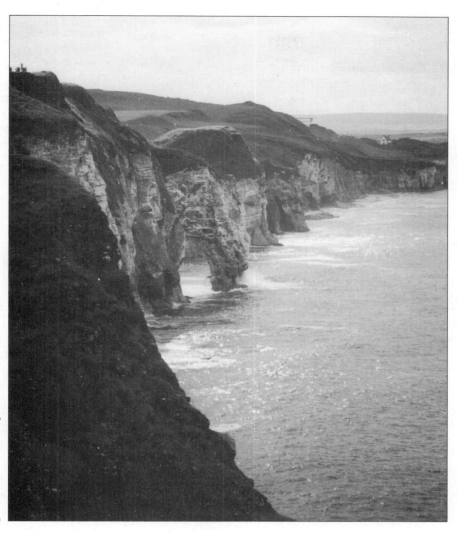

Figure 7-16:
Here an existing object helps frame the subject.

✦ **Make your own frames by changing position until foreground objects create a border around your image.** Find a curving tree branch and back up until the scenic view you want to capture is wrapped in its leafy embrace. Climb inside something and use an opening as a frame.

✦ **Place your frame in the foreground.** Shapes in the background that delineate your image don't make an effective frame. You want something that appears to be in front of your subject matter, just as a real frame would be.

✦ **Use a frame to create a feeling of depth.** A flat-looking image can jump to 3-D life when it's placed in a frame. Usually, you want to have the frame and your main subject in focus, but you can sometimes use an out-of-focus frame to good effect.

✦ **Use a telephoto lens setting to compress your frame and your subject; use a wide-angle lens setting to add distance between the frame and your main subject.** With a telephoto lens, however, you have to be especially careful to keep the frame in focus.

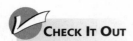
CHECK IT OUT

What's That Tree Doing Growing Out of My Head?

Mergers are the unintentional combining of portions of an image. With our stereoscopic vision, our eyes and brain distinctly separate objects that are farther apart. Other visual clues let us keep objects separate, such as the relative size of the objects compared to our knowledge of their actual size. For example, we know that a tiny human is located in the distance, whereas another one in our field of view that's four times as large is simply closer. However, viewed through the one-dimensional perspective of a camera lens, objects that we know are distinct easily become merged into one.

We've all seen photographs of hapless photographic subjects posed with what looks like a telephone pole growing out of their heads. Sometimes, the merger is with a border of the image — this mistake is easier to make than you may think, and easier to avoid than you realize. Follow these steps to avoid an unwanted merger:

1. **When composing an image, look behind the subject at the objects in the background. Then examine the borders of the image to look for things "attached" to the edges.**

 By concentrating, you can see how the background and foreground will appear when merged in your final photograph.

2. **If an unwanted merger seems likely, move the subject to either side, or change your position slightly to eliminate the juxtaposition.**

Like all the other rules discussed in this chapter, you can ignore the antimerger guideline, even if you aren't a captain of industry looking to build a giant conglomerate. Keep in mind that you can creatively use mergers to make photographs that are humorous. You just might want that forest ranger to appear to have a tree growing out of his or her head.

Chapter 8: Moving into Close-Up Photography

In This Chapter

- Learning the jargon
- Previewing the fun of macro photography
- Choosing your location
- Assembling the necessary equipment
- Taking that photo

Close-up, or *macro,* photography can be one of the most satisfying forms of digital photography. Any intermediate digital camera has all the features that you need to take great close-ups to astound your family, friends, and colleagues. A beautiful scenic photo or an attractive portrait can elicit praise and appreciation, but a well-crafted, close-up photo is guaranteed to generate *oohs* and *aahs* as well as the question that photographers love to hear: "How did you ever take that picture?" Close-up photography takes us into fascinating new worlds (without the time or expense of a trip to Europe).

If you're a collector of coins or stamps, toy cars, porcelain figurines, model trains, or nearly anything smaller than a breadbox (unless you collect breadboxes), you'll love the ability to document your collection. Have a garden full of prize roses? Display them even in the dead of winter through digital photos. Have a thing for insects? Grab a picture of the little beasts in their natural habitat. Some of the best applications of close-up photography involve crafts and hobbies.

You don't have to be a forensic expert specializing in crime scene investigations to find interesting photos in the macro world. Just about any household object, if photographed from an inch or two away, is transformed into an abstract scene worthy of the most artsy photographic expression.

If you haven't tried close-up photography, I hope this chapter encourages you to do so. I show you how to set up a close-up "studio" and take macro photos the painless way.

What's Macro Photography?

The first thing to do as you begin your exploration of close-up photography is to get some jargon out of the way first. There's nothing wrong with calling up-close-and-personal pictures *close-ups,* but within the photography realm, you'll commonly find some other terms in frequent use (and misuse). Some of them are as follows:

✦ **Close-up photography:** This term has been co-opted by the movie industry (as in "Mr. DeMille, I'm ready for my close-up" in the classic film *Sunset Boulevard*). A close-up is generally considered to be a tight shot of a single person (say, only the face and shoulders) or another object of similar size. It's okay to refer to close-up photography for what you do with your digital camera, as I've done in the chapter title. That's a term that most people, even photographic neophytes, understand.

✦ **Microphotography:** Microphotography results in microphotographs: that is, microfilm images. You wouldn't apply this term to pictures that are taken through a microscope, although it is sometimes (incorrectly) used that way.

✦ **Photomicrography:** This is the correct term for taking pictures through a microscope. Although photomicrography is chiefly within the range of scientists and researchers, it can also be a fun activity for digital photographers if you have the special equipment that's needed to connect a digital camera to a microscope. Everything from microscopic animals to human hairs can make fascinating photographs, but you generally need a higher-end digital camera and some specialized gear to capture the images. Photomicrography is beyond the scope of this book.

✦ **Macro photography:** *This* is the brand of close-up that is the focus of this chapter. Generally, *macro photography* is considered to be any picture that is taken from about 12 inches from the subject down to half an inch or even closer. *Macro* is derived from the Greek word *makro,* meaning "long," but the term has come to mean "large" and the opposite of *micro.* However, that's not exactly the case in photography. A macro photograph is not a huge picture (the opposite of a microphotograph) but rather a normal-sized photo of a tiny object that has been made to appear large, as shown in Figure 8-1. You may not even be able to recognize common objects when they are blown up in a macro photograph.

Figure 8-1:
Remember, macro photographs are normal size.

Why Digital Macro Photography Is Cool

Digital cameras and macro photography were made for each other. In many ways, digital cameras can be far superior to an ordinary film camera when it comes to taking close-up pictures. Consider the following advantages:

✦ **Close-focusing lenses:** Digital camera lenses are ideal for focusing up close. Without getting too technical — too late — macro photos are made with any camera by moving the lens farther away from the film (or sensor, in the case of a digital camera). Film cameras require moving the lens quite a distance out to get a decent macro effect. For example, a 50mm lens on a 35mm single-lens reflex camera must be moved *4 inches* out from the film to get a life-size (1:1) image. In contrast, an 8mm lens on a digital camera (which may be roughly the equivalent of the 50mm lens on the SLR) needs to move out only about ⅜ *inch* to provide the same magnification. Clearly, close focusing is much easier to incorporate into a digital camera.

In the macro photography arena, you'll see close-focusing capabilities described in terms of magnification rather than the distance from the subject. As a beginning macro photographer, you may be more interested in how close you can get, for example, 6 inches, 3 inches, and so on. However, realize that the size of the final image at any given distance varies with the zoom setting of your lens (that is, an image taken from 6 inches away at the wide-angle setting may be one-fourth the size of one taken from the same distance at the longest zoom setting). It's more useful to compare the amount of magnification. A 1:1 image is exactly the same size in your camera whether it is taken from 1 inch away with the wide-angle setting or 6 inches away with the zoom setting. (Although the size is the same, the way the image looks is quite different, but that's something I discuss in the section "Close-up lenses," later in this chapter.)

✦ **Easy framing of your image:** Virtually every digital camera features an LCD that shows almost exactly what you'll get in your finished photograph. (The LCD may trim a bit of the edges from the image, but getting *more* than you expected is far superior to getting *less*.) Inexpensive point-and-shoot film cameras, if they have macro capabilities at all, don't show you exactly what your image will look like. You need to get a single-lens reflex film camera if you want the capability that's built in to many of the least expensive digital cameras.

✦ **Immediate results:** Close-up photography can be tricky, and the last thing you want is to have to wait for your film to come back from the photofinisher before you know whether your pictures are good. With a digital camera, you can review your results on the LCD immediately, delete bad shots, and keep taking pictures until you get exactly what you want.

Picking a Place to Shoot

Where you shoot your macro photos can be as significant as what you shoot. You may want to take your photographs in the tightly controlled environment of your kitchen, using a tabletop as your platform for your model trains or other objects. Or, you may want to venture out into the field to stalk the creatures of nature.

Sometimes you have a choice of where you shoot, and sometimes you don't. For example, to photograph sea life on the beach, you pretty much have to take your pictures at the beach. You can photograph a tree frog on a tree, or you can pop him in a mayonnaise jar and take him elsewhere.

Table 8-1 shows some of the advantages and disadvantages of location versus studio shooting.

Table 8-1	Location Shooting versus Studio Shooting	
Factor	*Location Shooting*	*Studio Shooting*
Setting	Natural environment.	Studio environment.
Transport	Equipment such as tripods and reflectors must be carried. Some items may not be available.	All equipment is at hand.
Background	No control over background.	Background can be chosen to complement the subject.
Lighting	Realistic natural lighting, but less control.	Lighting may look artificial, but perfect control is available.
Environment	Bad weather can be a problem.	Weather not a factor.
Set up	Setting up picture may be tedious. Settings may be transitory and impermanent.	Setups can be left in place as long as desired.
Consistency	Difficult to take groups of pictures with similar look.	Control over lighting and backgrounds means a consistent look that's useful for photographs of collections, for example.

Setting Up Your Macro Studio

You don't need a real studio for macro photography, of course. That's one of the cool parts of taking close-ups. Any nook or cranny that you can spare in your home or work environment can be designated as a studio area. All you need to do is keep the area reasonably neat and free of clutter so that you can set up and take macro photos with a few minutes' notice. You can also keep a semipermanent close-up studio, like I do, for stuff that my wife sells on eBay. I've put a seamless backdrop up in a little-used corner, so an item that's destined for sale can be set up and photographed anytime. A macro studio, such as the one shown in Figure 8-2, requires so little space that you won't hesitate to dedicate a small portion of your living space in exchange for the convenience of having a special area that you can use anytime.

Of course, you're free to create little macro studios on an ad hoc basis, using your kitchen table, hearth, or any convenient location as you need to.

Many of the close-up photos in this book were taken on impulse right at the desk where I work. I grab a piece of white paper from my ink-jet printer, lean it against a convenient support, and drop the object I want to photograph on my miniature, seamless backdrop. I often use the built-in flash of my digital camera with one or two other pieces of printer paper strategically located to reflect the light onto my subject. Less than a minute after I started, I plug my camera into the USB cable that rests by my keyboard and watch my photos appear on the screen.

Figure 8-2: Can you spare a few feet for a macro studio?

Of course, you can get better results than I get with my quickie photos if you collect the right equipment and gear for your ministudio. The next section explains exactly what you need.

Background check

In many cases, you'll want close-up backgrounds that are plain and unobtrusive and that allow your subject matter to stand out without any distracting extraneous material. That generally means a light background for darker objects and a dark background for light objects. You do not need to stick with stark white or inky black backgrounds unless your plan is to drop out the background in Photoshop or another image editor so that you can combine the subject with some other photograph. Often a light pastel color background works well for dark objects, and a medium-dark shade looks good with very light objects.

The amount of light that falls on the background helps determine its lightness or darkness. A soft gray background can appear to be almost white or fairly dark, depending on the amount of illumination that reaches it. Don't be afraid to experiment.

So-called "seamless" backdrops are very popular. They provide a continuous (seamless) surface on which the subject can rest, while blending smoothly into a vertical background. Depending on how you light the seamless backdrop, it can appear to be a single shade, or you can provide varying amounts of separation between the foreground and background, as shown in Figure 8-3.

Figure 8-3:
With the right lighting, you can add considerable depth.

The following types of backgrounds are the most popular for macro photography:

✦ **A few yards of cloth:** I really like plain, solid-colored cloth as a backdrop. It's rugged and versatile, and if it gets dirty, you can usually just throw it in the wash. I buy pieces that are 45–54 inches wide and 8 or 9 feet long in several different colors, including pure black and pure white as well as soft pastels and bright colors. The longer lengths let me use the cloth as a portrait background if I need to.

Artificial velour is extremely useful. One side has a soft surface that really soaks up light. A black velour cloth can make a perfectly black background that's almost guaranteed not to show shadows. The other side of velour has a shinier texture that you can use for some types of photos. Leave the cloth smooth.

✦ **A roll of seamless paper:** Rolls of true photographic seamless paper can be expensive (around $40 for a 9-x-36-foot roll) and hard to find (you need to seek out a camera store that sells to professional photographers). Take a hacksaw and cut the roll in half to make the size a little more manageable for ministudio work. Seamless paper eventually gets torn and dirty, so it's nice to be able to unroll a little more so that you always have a fresh background.

You may want to check out craft and packaging stores for large rolls of sturdy wrapping paper as an alternate source for seamless backgrounds. Avoid the paper with mistletoe and bunnies, and look for plain colors. However, don't be afraid to experiment. A smooth section of kraft paper can make a handsome backdrop for some subjects.

✦ **Posterboard:** I've used a *lot* of posterboard as seamless backgrounds for close-up photos of smaller objects. Use duct tape to curve it into place. At a few cents a sheet, you can afford many different colors. However, posterboard may have a slightly shiny surface. If you use it with soft, diffuse lighting, you shouldn't have a problem.

Visible means of support

You have to provide support for your background material, your lighting equipment (if you use some), and your camera. Fortunately, the same supports that work for close-ups serve admirably for other types of photography. (See Book I, Chapter 9 for a discussion of gear for people pictures.) If you plan to take a lot of studio-type photos, buying some good-quality equipment of this type can be a shrewd move. I'm still using the same tripod and light stands that I purchased while in college. A few hundred dollars for that stuff seemed like a lot of money at the time, but I haven't had to spend a penny since then, even though I've gone from large professional cameras to tiny digital cameras in the interim.

You can buy tripods, light stands, and other equipment relatively inexpensively; you may have to do so if your budget is tight. However, I can tell you from personal experience that a $100 tripod is a lot more than twice as sturdy and twice as useful as a $50 model. If you're going to spend the money replacing a flimsy tripod or two, why not start out with a good one?

You can find the following supports:

✦ **Background supports:** You'll find that cloth backgrounds are so lightweight that you can support them with almost anything. Duct tape can suspend a piece of cloth from any piece of furniture. I tend to use 7-foot light stands, which are aluminum supports that telescope down to a compact size and have tripod legs at the bottom to keep them upright. Set up a pair of light stands and suspend a wooden dowel between them as a horizontal support for your cloth, and you're all set.

Light stands can also support some rolls of paper if you substitute a wood closet pole or metal pipe for the wooden dowel. You can also build a simple background stand out of lumber or, if you do a lot of shooting in a basement area (as I do), use metal supports that are fastened directly to the ceiling joists, as shown in Figure 8-4.

Figure 8-4:
What works to hang a bicycle can also hang a background roll.

✦ **Lighting supports:** Light stands are good but may be a bit too large to position effectively for close-up photography. In many cases, you can skip light stands or special lights altogether and use household desk lamps that rest right on your background setup.

✦ **Camera supports:** A tripod is essential for macro photography. You need to be able to fix your camera in one position and lock it down while you take your photos. That's particularly true if you use your digital camera's LCD to compose or focus your image. It doesn't matter whether you're relying on your camera's automatic focus or are focusing manually — a tripod can give you the fixed position that you need. A tripod also allows you to photograph several subjects from the same distance and angle, adding an important measure of consistency.

You can find more information on choosing a good tripod in Book I, Chapter 6.

Lighting equipment

Unless your subject is a candle or a glow-in-the-dark Halloween skeleton, you need some sort of lighting to illuminate the scene. Your choices include the existing light in the room, an electronic flash, and incandescent illumination, such as desk lamps or photoflood lights. The following sections explain what you need to know about each option.

Existing light

Photographers used to refer to existing light by the term *available light* until someone pointed out that a 400-pound Klieg light is *available* if you happen to have one left over from the last motion picture that you shot. (Insert chuckle here.) Today, we refer to ambient light as *existing light* on the presumption that lighting doesn't exist if it isn't already available on-site. Some tips for using existing light are as follows:

✦ **Use with modulation:** You can modulate existing light, of course, if you have reflectors or other gadgets handy. If existing light is too harsh, you can soften it by using a piece of white cardboard as a reflector (avoid other colors unless you really want a color cast in your photo). Foam board also works and is stiffer and easier to position than cardboard.

✦ **Foiled again:** A piece of aluminum foil can make a brighter reflector, with more contrast. Crinkle it up so that the light it reflects is more diffuse. Otherwise, foil behaves a lot like a mirror, which is something you don't want. Mylar "space blankets" also make a good lightweight, portable metallic reflector.

✦ **For all in tents:** Pros often use miniature white tents when photographing a shiny object. Place your subject inside the tent, apply plenty of light from the outside of the tent, and then shoot through a hole in the top or side. You end up with a beautiful soft lighting and no reflections of the surrounding room on the shiny subject matter. (Make sure that the camera lens itself doesn't reflect on the object!)

✦ **Block that light:** Sometimes, you want to subtract light rather than add it to your subject. Place black cloth or cardboard outside the subject area to absorb light and darken shadows for a dramatic effect.

When using incandescent lights, make sure that your camera's white balance control has been set for interior illumination. Many digital cameras can be set to automatically recognize and adjust the white balance for various lighting conditions. Fluorescent lighting often requires a different setting, and some cameras have adjustments for both warm and cool fluorescent bulbs.

Electronic flash

Electronic flash is often useful for quickie shots like those that I take right at my desk, but flash is often not the best choice for close-ups. The reasons for this are as follows:

✦ Flash is often too powerful for close-up pictures that are taken inches away from the camera. Flash is intended for shooting from a distance of several feet or more.

✦ The effect of the lighting isn't easy to visualize with electronic flash because the subject is illuminated for only a fraction of a second. After you've taken your photo and reviewed it on the LCD, you may find that the light is too harsh, is placed incorrectly, or illuminates the wrong part of your image.

✦ One of the major advantages of electronic flash, stopping the action of moving subjects, doesn't really apply to close-up pictures, which are usually taken of stationary subjects at a fixed distance.

You can use four kinds of electronic flash when taking close-up photos. I provide a more thorough discussion of these flash options in Book I, Chapter 9 (where I discuss photographing people). However, a quick summary of your choices of electronic flash is as follows:

✦ **Your camera's built-in flash:** This is usually your worst choice for illuminating your subject. For one thing, the flash is likely to be aimed quite a distance past your area of interest or, in many cases, is blocked by parts of the camera or lens. When I use my camera's built-in flash for close-ups, I always include several pieces of white reflective material outside the field of view to bounce the light back onto the subject. Your flash is likely to be too harsh and will wash out the details of your subject. (Light that is placed at an angle, rather than straight on, can often produce better close-up illumination.)

✦ **External flash:** You can find a connector on many digital cameras for linking to an external flash unit. These units range from more powerful versions of your camera's built-in flash to expensive studio flash units.

✦ **Slave flash:** These are a kind of external electronic flash that includes a photocell that triggers the unit automatically when another flash unit is fired. Slaves let you use several flashes at once.

✦ **Ring lights:** These are circular flash units that can be fitted around the circumference of your camera's lens. They provide even lighting that is designed especially for close-ups. Usually, only professionals who do a great deal of macro photography can justify buying a ring light.

Incandescent lights

Incandescent lights (including gooseneck desk lamps, which I use; high-intensity lamps; or photographic flood lights) are great for lighting close-ups. Their advantages are as follows:

✦ **Easy preview:** You can see exactly what your lighting effect will be.

✦ **Flexibility:** Use as many lamps as you need, and arrange them as you like. Create backlit effects or soft lighting. Use a high-intensity lamp when you want a high-contrast quality to your illumination. Turn to a soft-white desk lamp when you need diffused light.

✦ **Inexpensive:** I buy desk lamps for less than $10 and use them in various combinations to get well-lit close-ups. What other photographic equipment can you buy that cheaply?

Their disadvantages are as follows:

✦ **Heat:** Don't let your high-intensity lamps burn your subject. And forget about using them to photograph ice cream sundaes.

✦ **Color of their light:** Make sure that your camera's white balance is set correctly for the reddish hue of incandescent lights.

✦ **Burnout:** Have some extra bulbs available in case one of your lamps burns out during a shooting session.

Other equipment

You may find some other equipment handy when shooting macro photos. For example, slide-copying attachments are available for some digital cameras. These attachments let you make high-resolution digital grabs of 35mm color slides without using an expensive slide scanner. Even if your digital camera focuses close in, special close-up lenses let you get even closer. This section gives you a rundown on some of the most popular add-ons for close-up photography.

Slide copiers

Slide copiers are great for converting your existing collection of color transparencies to digital form. All you need is a close-focusing digital camera and a copier attachment. (This attachment consists of a holder for the slide and a diffusing panel that sits behind the slide to soften the light that you use to illuminate it.) You may be able to get good quality with such a device — note, however, that you'll get better results with a typical flatbed scanner that offers a slide (often called a negative) attachment.

Single-lens reflex add-ons

If you own a digital camera with removable lenses (with basic SLR digital cameras finally dipping below $2,000, that's not altogether unlikely), you can use accessories that are similar to those offered for film-oriented SLRs, such as bellows, extension tubes, and reversing rings. Brief explanations of these accessories are as follows:

✦ A **bellows,** such as the one shown in Figure 8-5, moves your camera's lens farther from the sensor, enlarging the image over a continuous range. The downside is that the farther the bellows is extended, the less light that reaches the sensor, producing long exposure times. Bellows attachments are also expensive.

✦ **Extension tubes** do much the same as a bellows, but over fixed distances.

✦ **Reversing rings** let you mount your camera's lens on a bellows so that the front of the lens faces the sensor. With removable lenses that weren't designed for macro photography, reversing the lens can produce sharper results *and* increase the magnification.

Close-up lenses

Even if your digital camera focuses very close, you may want to get even closer. That's where close-up lenses come in. Although they are called lenses (because they function as one), close-up lenses look more like clear glass filters with a curved surface. These lenses fasten to the front of your digital camera's lens using a screw mount or other arrangement. Labeled with designations such as #1, #2, or #3 (these numbers refer to a measurement of magnification called *diopter strength*), these lenses can be used alone or in combination to produce varying amounts of magnification. The amount of magnification that a particular close-up lens or combination provides depends on the zoom setting of the lens and its normal close-focusing ability.

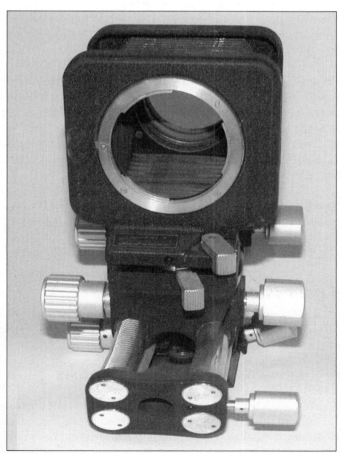

Figure 8-5:
A bellows helps produce the best macro photographs.

For example, if you have a lens that focuses as close as 1 meter, a +1 close-up lens enables you to focus down to ½ meter, a +2 diopter allows focusing down to ⅓ meter, and a +3 diopter permits focusing down to ¼ meter (slightly less than 10 inches for the nonmetrically inclined). As you can see, these close-up lenses can bring macro capability to optics that aren't able to focus very close (from a close-up standpoint, 1 meter is the pits). These lenses can bring super macro capability to lenses that can already focus very close to your subject.

Serious macro photographers purchase a set of several close-up lenses and use them in combination to get the magnification that they want.

Shooting Tips for Macro Photography

The first part of this chapter helps outfit you for macro photography. Most of the equipment and gear that I discuss can be used for location shooting or for home or office studio shooting (although outdoor close-ups may make some of the tools, such as cardboard reflectors, tricky to use).

This next section provides you with tips for shooting good close-up photographs, using common techniques that the pros take advantage of all the time — plus a few things I learned myself, the hard way.

Setting up your subject and background

You've chosen your subject to photograph, whether it's a pewter soldier from your collection or a terrified tree frog. You've selected a background to isolate and/or flatter your subject. What's next?

Set up your subject on its background so that it can't move. Although this can be tricky with the tree frog, it's less of a challenge with an inanimate object, such as the pewter soldier. I often use bits of modeling clay that can be hidden underneath an object to hold it at the correct angle. I also use pieces of wood, bent paper clips, or inexpensive clamps. One of the advantages of digital photography is that you can easily remove any supporting device in an image editor.

In the studio, positioning your subject may be all you have to do. On location, it's more likely that you'll have to remove unsightly leaves, ugly rocks, or maybe some bugs that wander through your frame. Clean up any dirt, dying stems, or other objects that you don't want to photograph.

Setting up your camera

In the studio, it's fairly easy to set up your camera on a tripod or other support and not have to worry about it shifting. On location, you may need to make sure that the ground underneath your tripod is firm and solid. Put a rock under one or more legs, if necessary. If you're shooting on a slope, you may want to lengthen one or more legs of the tripod and shorten others.

Set the tripod a little shorter than the height that you actually want to use. You can use the center pole to raise or lower the camera a bit. Don't make the common mistake of setting the tripod too low. If you really crank up the center column, the tripod can become top-heavy and unstable. You can tie a

weight on the center pole to give the tripod a bit of ground-hugging heft. I use the mesh bags that oranges are sold in as a receptacle for rocks. (Mesh bags tend to be strong but lightweight, which makes them ideal for this particular task.)

You can reverse the center pole of many tripods so that it extends down between the legs of the tripod, letting you shoot at an angle down on your subject. That's often the only way to get the viewpoint that you want without interference from the tripod's legs.

Lights, please

Use your lighting equipment or the existing light to illuminate your subject. In the studio, position two or more lights so that they light up the subject evenly. In the studio or on location, work with reflectors to fill in dark shadows, darken spots that are too bright, and even out your illumination.

The light that falls on the background can be just as important as the light that you use to illuminate your subject. The background light can separate your subject from the surroundings and provide a more attractive photo. See Book I, Chapter 9 for more information on lighting backgrounds.

Remember, the more light that you are able to use, the smaller the lens opening needs to be and the better the depth of field (the more of your subject that is in focus). If you want a really sharp picture with lots in focus, pump up the light as much as possible (although if you're an using electronic flash, having enough light is rarely a problem). I explain more about depth of field in the next section, "Ready . . . aim . . ."

The quality of the light is as important as the quantity. If you're using electronic flash, you should avoid the harsh illumination that flash typically provides. I often drape a handkerchief over my camera's flash. This reduces the flash illumination to a more reasonable level while softening the light.

If the electronic flash is still too strong, move back a step or two and zoom in closer. (But remember that not all digital camera lenses can focus closely at all zoom settings.) Because of the perverse-square law (er, I mean *inverse square* law), a light that is 12 inches from a subject generates only *one-quarter* as much illumination as it does from a distance of 6 inches.

Ready . . . aim . . .

You're all set to frame your photo and press the shutter release. But first, a few words from your sponsor. Keep the following final advisories in mind as you take your best shot:

✦ Remember that when shooting up close, for any particular magnification, the closer you get, the more emphasis is placed on the objects that are very close to the lens. Photograph a figure of a clown's head from 2 inches away, and his nose will be very large in proportion to the rest of his face. Move back a few inches and zoom in to produce the same size image, and the proportions are much more realistic.

✦ Don't forget focus and depth-of-field considerations. When shooting up close, only a small portion of your image may be in focus. Make sure

that's the most important part of your subject! If your camera lets you lock in a focus setting by pressing the shutter release button part way, make sure that you've focused on the right area before locking. Depth of field is a range, extending one-third in front of the plane of sharpest focus and two-thirds behind it, as you can see in Figure 8-6. In this figure, very little in front of the blossom is in focus, but the blossom itself is fairly sharp. The background, of course, is too far away to be in focus, which is how the picture was conceived.

✦ Crop out extraneous material, and center your subject in the frame (most of the time). Good composition, as described in Book I, Chapter 7, usually calls for an off-center subject, but that rule may not apply when shooting close-ups. It may be best to feature your main point of interest right in the center of the frame.

✦ Use your camera's close-up features effectively. That includes double-checking to make sure that the camera is in macro mode and keeping close tabs on the in-focus indicator (usually an LED) that may appear in your viewfinder.

✦ Make sure that you've framed the subject correctly, without accidentally chopping anything off. You often have to use the camera's LCD to examine your composition because the built-in optical viewfinder doesn't show the image 100 percent accurately. (Flip to Book I, Chapter 2 for a basic discussion of viewfinder *parallax* error.) You don't want to chop off the top or sides of your image.

Figure 8-6: Depth of field is very important in macro photography.

If your digital camera has a connector for linking the camera to a monitor or TV, you can often use that capability to frame your photo.

Fire!

When you press the shutter-release button, a lot of things happen. One likely (and none-too-happy) event is that you press the button too hard and produce a blurry picture. Another possibility is that you see something wrong with your composition in the last ohnosecond. (An *ohnosecond* is that interval between the time when you press the shutter release and the instant when you realize that you've made some sort of serious error. An ohnosecond also occurs as you're slamming your locked car door closed and notice your keys in the ignition.) But it's not too late!

Avoiding blur

First, avoid human-caused blur by using your camera's self-timer to trip the shutter after a few seconds, rather than using your big fat finger. In self-timer mode, you set up your composition, make sure that everything is okay, press the shutter button, and then step back and take a few deep breaths until the camera actually takes the photo (blur-free).

An alternative is to use an electronic or mechanical remote shutter-release control to trip your camera's shutter without touching it. A remote release may be a cable that attaches to your camera or an infrared remote control like the one that operates your television, VCR, and virtually everything else in your household. Unlike a self-timer, a remote release lets you take the photo at the instant you want — say, when the tree frog has a cute expression on his face.

Making sure the camera is done

For heavens sake, don't *do* anything after you press the shutter button until you're positive that the camera has finished taking the picture. If your camera has an optional shutter-release sound, turn it on so that you know when the picture is being taken. (Learn to differentiate between the sound that the camera makes when the shutter opens and the sound that's made when it closes again.)

If your camera has a flashing LED that shows a photo is being saved to your digital film, look for it to begin flashing as an indication that the photo has been taken. The automatic-exposure mechanism of your camera may need to use a long exposure (several seconds or more) to take the picture, and you certainly don't want any sudden movements or grabs at the camera to ruin your shot. Wait a few seconds after you hear the camera's shutter click before doing anything, until you are sure that your camera is not making a lengthy exposure or time exposure. That click may have only been an indication that the shutter was opening, and the camera may still be capturing the picture.

Reviewing your shot

After the photo has been taken, take the time to review your picture on the LCD for defects. Look for the following common problems:

✦ **Poor focus:** Correct and reshoot.

✦ **Bad exposure:** Make adjustments using your camera's available exposure-compensation modes. (Check your camera manual.)

✦ **Bad reflections that you didn't notice before:** Move your lights or move your camera until the reflections go away.

✦ **Tree frog that has departed the scene:** You know, quite realistic-looking plastic tree frogs are available these days. (Doggone those unpredictable models.)

Chapter 9: Photographing People

In This Chapter

- Making satisfying portraits
- Shooting on location or in the studio
- Building an informal portrait studio
- Discovering the basics of lighting
- Arranging multiple lights
- Creating your first portraits

Although the first successful photograph, a scene taken from a Paris rooftop by Nicéphore Niépce in 1827, was a scenic photo unpopulated by humans (largely because the exposure took eight hours!), the most memorable pictures since then have included people. Indeed, the desire to photograph family, friends, and colleagues is the reason that many people own a camera.

When you think of the daguerreotype, Civil War–era portraits probably come to mind. When you imagine a prize-winning photograph, images such as Dorothea Lange's *Migrant Mother* leap into your thoughts more quickly than, say, Ansel Adams's "portraits" of the U.S. national parks. And when you photographed an architectural treasure such as the Eiffel Tower, didn't you include a family member in the picture?

We're fascinated by photographs of people, so we take lots of them. However, people are the most difficult of all subjects to photograph because of the complexity of human ego, awareness, and opinion. When was the last time the Eiffel Tower complained that your picture made it look too fat? Has anyone ever told you that your photo of the Grand Canyon "didn't really look like the Grand Canyon?" Has anyone worried that the presidents on Mount Rushmore would blink during an exposure?

This chapter is an introduction to the many facets of people photography. You find out how to take great portraits, capture vivid candid photos, and manage unruly group pictures. If you can handle those, all other forms of digital photography are a snap.

Capturing Satisfying Portraits

There are two basic categories of people photography: portraits and candids. *Portraits* are posed photos that are taken in a controlled environment; *candids* are unplanned pictures that are taken of people in the act of being themselves. Portraits show people as they would like to be seen; candids portray them as they really are.

Each category can produce images that range from the mundane to the sublime. To make the step up from mundane isn't hard. In fact, the average novice can achieve significant improvement just through better composition and lighting alone.

You don't need a lot of training to shoot candid photos after you've mastered the features of your digital camera and the rules of composition. Just go out and take pictures. Portraits, on the other hand, demand some special skills if you want the images to "look" like portraits. The techniques that you need to capture satisfying portraits are the emphasis in this chapter. The good news is that these capabilities are within the range of the average photographer; he or she just needs someone to outline the tools and techniques that work. That's what this chapter is for.

But first, a few ground rules. Take care of the following simple aspects, and you can't go wrong:

+ **Make it possible for your subjects to look their best.** Suggest that they wear suitable clothes. Encourage them to use a friend or family member to help them prepare. Provide access to a good-sized mirror so that they can check their appearance. A portrait subject that knows he or she looks good will photograph well!

+ **Get to know your subject's personality.** Be careful about trying to make a somber, serious type individual look cheerful and gay; the picture can look forced and fake. Getting a happy type to look serious is easier, but why do that? Unless you're taking an executive portrait (where serious is good), go for the smile. Use what you know about the subject to create a portrait that reflects his or her personality.

+ **Provide comfortable surroundings to help people stay relaxed.** A clean, organized shooting area puts your subjects at ease, as can some soft mood music. If your subject doesn't feel that he or she is standing in front of a firing squad, your photos turn out much better.

Successful portraiture begins with getting your subjects in the right frame of mind. Relaxed, confident people pose better than nervous, tense ones, so make every effort to start things off right. If you are successful, you get a portrait like the one shown in Figure 9-1.

Figure 9-1: A confident photographer helps produce a portrait like this one.

Shooting on Location or in the Studio

Because portrait "sittings" are generally carefully arranged, these kinds of shoots offer the photographer the advantage of being able to exercise a great deal of control over creation of the image, both in location and lighting. You can choose to shoot *in the studio* (which can be any indoor room, including your living room or garage) or *on location* (which can range from your backyard to a park or other site).

You don't need to have a "real" studio to shoot studio portraits. Indeed, most of you don't have dedicated studio. At best, you may have a place that serves double duty as a studio as well as some other function. I took some of my favorite portraits in an attic "studio" that was little more than a large space hung with multiple rolls of seamless backdrop paper, a few painted backgrounds, and lots of room to arrange lights. At worst, your studio may be an area that can be temporarily reconfigured to serve as a photographic environment. Back the car out of the garage and hang a backdrop, and you have a studio.

So, in this chapter, when I refer to a *studio,* I mean any indoor location that can be used to take posed photographs. I don't mean to imply that you have to build a home studio to use any of the techniques that I describe here.

Deciding whether to shoot in your studio or on location must be based on the kind of photos that you want to take. Shooting in the studio offers the utmost in control for a photographer, particularly when you're working in a studio that you've set up and become comfortable in. Your studio can become a warm, comfortable cocoon that nurtures your creativity and talent.

Of course, sometimes, we all have to leave our comfortable surroundings and brave the outside world. Location photography may pull us out of our comfort zone, but it also gives us something hard to find in the studio — scenery. Such honest-to-goodness great outdoors beauty is shown in Figure 9-2.

Think of location shooting as your outdoor studio. Most of the techniques that I describe later in this chapter apply to location photography although you may have to use reflectors instead of external flash units, and you have less control over your backgrounds. The chief requirements for location shooting are as follows:

✦ **Portability:** If you plan to regularly shoot on location, you need to assemble a versatile kit of equipment that you can set up and break down quickly.

✦ **Flexibility:** Because no two location shoots are identical, try for a portable location kit that provides the greatest flexibility for lighting both your subject and, if need be, elements of the location that appear in the shot.

✦ **Creativity:** Put together a portable studio system that lets you create different shots and moods. Consider props that are portable and versatile. Make sure that your kit includes a good set of posing blocks (structures, often of wood or plastic, that can be sat or stood on) so that you can adjust the height of various posers.

Location shoots give you the chance to provide your clients with something different from the typical portrait sitting. Every area has a special site of some sort that can serve as a backdrop for memorable images — for example, a gorgeous hotel lobby, a public park, a forest, or a lake.

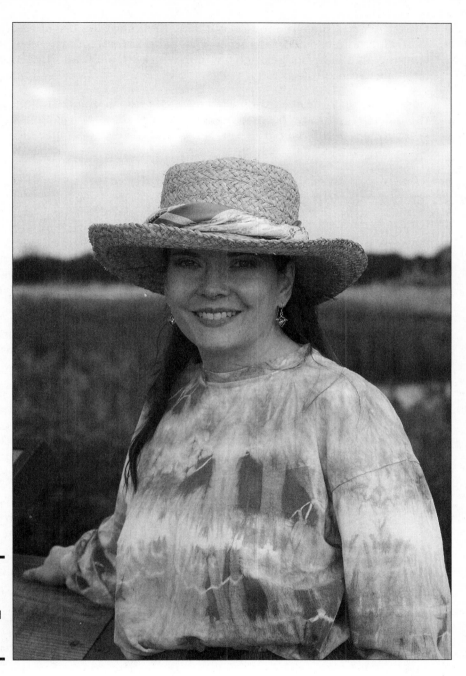

Figure 9-2:
You can't
create a
background
like this in
the studio!

Setting Up an Informal Portrait Studio

Many photographers who pursue their art as a hobby or sideline like a simple, informal home studio that can be set up easily and broken down when the shoot is done. Such a studio fills their needs without taking over part of their house.

Others want to have the option of taking their show on the road. A simple portrait studio can also be a transportable portrait studio. Even if you're working on a tight budget, you can come up with a lighting system that improves your photography.

Depending on your needs, a pair of accessory flash units can help give you the balanced lighting that you need to capture that natural-lighting look. If your budget permits a better system, you can build to a more powerful, semiprofessional system.

Choosing Backgrounds

Sometimes, you want to pose people in their natural environment, even for "formal" portraits. A family can be posed in their living room seated on a couch. An attorney can be pictured in front of a wall of law books. (This is almost a tradition. Don't forget to include a flag!) If you apply the same rules of posing and lighting to such a portrait as for more traditional studio portraits, the results will be quite good.

However, most formal portraits call for a "real" portrait background. For an indoor studio, you need to have something more attractive than just a bare wall for a background; fortunately, a wide variety of choices are available for every budget. Samples of these choices are as follows:

✦ The simplest choice is a roll of seamless background paper, like that shown in Figure 9-3. These rolls are available in a wide variety of colors and are easy to use (and yes, you're allowed to laugh if you're reminded of a roll of Christmas wrapping paper). You usually just hang up a roll on some kind of support and unroll as much as you need for a shoot. (Bring enough down to cover a couple of feet of the floor, and have your subject stand on it.) As a section of the backdrop paper becomes dirty or wrinkled, just roll down some more. Cut off the damaged part, and throw it away. You can keep a selection of three to five different rolls and switch among them as needed.

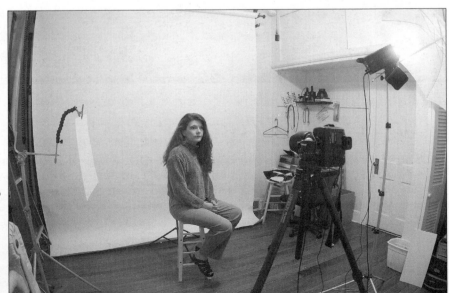

Figure 9-3: Shooting a subject with a seamless paper background.

✦ More complicated choices include painted linen backdrops, which provide a more interesting texture and color gradient. These backgrounds are more expensive and weigh more than the seamless paper, so they may not be a great choice for a portable setup or for the home enthusiast, who may need the studio for family use when not doing photography.

✦ For those making their living doing portraits, a higher-end system offers a multiple-background setup that can be used for either a permanent studio or a traveling one. Such a rig has multiple rollers with different backdrops on it. The portrait photographer creates one set of portraits with one background and then another set with a second or even third background. Often, the backgrounds and poses complement each other — say, an athletic field for a sports-type portrait, with props such as a football in the child's arm. This way, you can create a combination of both formal and informal images, making multiple sales more likely.

Nothing is more distracting than a cluttered wall as a background. Even a simple roll of seamless paper as a backdrop can do a lot to make your portraits look more professional.

Selecting supports for lights, camera, and subjects

Good portraits require lighting beyond the flash that's built in to your digital camera. In most cases, you need two or more external lights. And because lights, cameras, and subjects all need to be moved from time to time, how you support the lights is important. Supports need to be light enough to move around easily and collapse small enough to be portable, and yet they must be sturdy and solid enough to safely hold your gear.

You need different supports for lights, backgrounds, camera, and people. As usual, the choices span all budgets and setups. Try to build a system that allows future upgrades or studio expansions.

When planning your support system, such as the one shown in Figure 9-4, aim for versatility and portability. Consider the following items:

✦ **Lighting support:** Your lighting supports should be strong enough to support an external lighting unit, up to and including a relatively heavy flash with soft box or umbrella reflectors (more on these later). The supports should be capable of raising the lights high enough to be effective. Look for light stands that are capable of extending 6 to 7 feet high.

✦ **Camera support:** A good, solid tripod that's sturdy enough to support your camera represents the starting point. If your setup is likely to call for a lot of back-and-forth movement as you shift from individual to group portraits, you may want to consider a camera dolly device — a kind of wagon on wheels — that lets you slide your camera/tripod rig back and forth as needed.

✦ **Subject support:** Posing your subject is easier if you can have her sitting rather than standing. (This is why portrait sessions are usually known as *sittings*.) The tool of choice for this sort of thing is the pneumatic posing stool. These stools are much easier to operate than older-style corkscrew-type chairs, which have to be spun to raise or lower them to

the right height for portraiture. With a pneumatic stool, you simply press a lever to control an air-driven piston that raises or lowers the chair. At under $100 each, these stools are reasonably affordable. A posing table is also a useful option, particularly if you need to take a shot of a baby in his or her carrier. However, you don't always need to buy these devices. You can find stools and tables around the home that can serve your purpose.

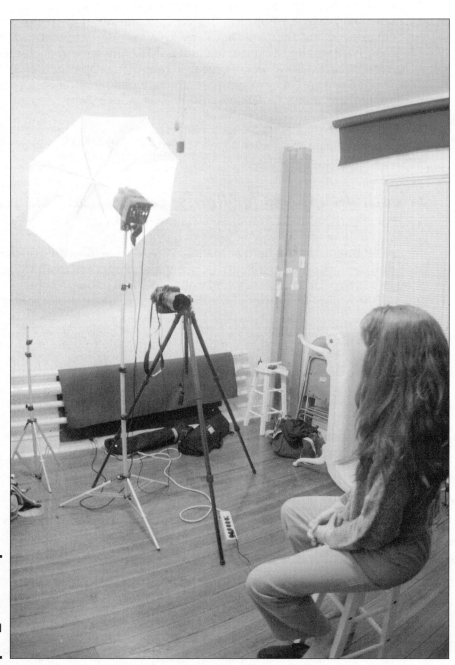

Figure 9-4:
This basic studio setup is both portable and versatile.

If you want to use photo gear, you can find lots of options at most camera stores or in many camera magazines. A good basic setup includes at least one posing chair (preferably two), three light stands (two capable of reaching 6 or 7 feet high and a third, shorter one), a mobile tripod, a posing table, and posing blocks. *Posing blocks* are nesting wooden blocks made in varying heights that are big enough for people to stand on. Using these blocks helps you make people taller as needed to get the proper posing relationships.

Basic lighting equipment

Properly lighting your subject is one of the most challenging aspects of portrait photography. Many different approaches to lighting and many different types of lighting resources are available.

Choosing a lighting system and approach is a function both of the type of people photography that you want to do and the budget that you have to spend. Even a beginning photographer can create a basic, inexpensive lighting system that's capable of delivering high-quality results.

Putting together a lighting kit depends on how big your budget is, what kinds of portraiture you hope to do, and how big a percentage of your photography this kind of shooting represents. Obviously, the photographer who needs to shoot only the occasional portrait can get by with a less sophisticated setup than someone who plans to focus mainly on portraiture. Lighting choices fall into several different categories, as discussed in the following sections.

Existing light

Also known as available darkness, existing light is whatever lets you see your way around. It can be sunlight, room lights, or a combination of different light sources. Sometimes, though, you can give Mother Nature some help with the following tools:

+ **Reflectors:** Reflectors enable you to bounce light into areas of the scene that need it. Any material that can bounce light into areas of heavy shadow can help make existing light work more in your favor. Whether it is an assistant holding a piece of foam board or a reflective disk held in place by a clamp and stand, this can be an inexpensive and portable way of making your lighting better. Although some pretty fancy (read expensive) reflectors are on the market, spending a lot isn't necessary. A simple piece of white foam board can do the job beautifully. Use your main light source (the sun) to light a three-quarter section of your subject, and then position the reflector to bounce sunlight onto the remaining quarter. This lightens the shadows and gives a greater sense of dimension to your photo.

+ **Room lights:** Sometimes, your goal is to give the most natural possible setting and feel to an image. If this means working without accessory lights, managing the room's lights properly can be a big help. If you can position a lamp to throw a little more light to a shadow area, you can clean up a heavy shadow, or depending on the mood that you're aiming for, you can bring your lights all to one side and have your subject emerging from the shadows.

Working with available darkness is one of photography's greatest challenges. Yet if you can use it successfully, you can produce exceptionally natural-looking images. Look for ways to control the impact of the building's lights, and remember, you don't have to accept what's there. It's okay to shift a lamp closer to or farther from your subject. You can also unscrew some light bulbs while leaving others on or even mask lighting fixtures with cardboard or *gaffer's tape* (a special kind of tape that doesn't leave a residue when pulled off the lights). Yep, that's the same "gaffer" that you've noticed in film credits — they specialize in movie lighting.

Electronic flash

Accessory flash units are your first tool in the battle to correct undesirable lighting conditions. These small, portable light sources provide you with a lot of options and can be used to produce some amazing results. Photographers who use a multiple flash setup can produce lighting results that are similar to those found in the studio. You can put together a small, three-flash lighting kit that can fit in a small suitcase or carrying case. If you're planning to put together such a flash kit, consider the following things:

✦ **Supports (again):** You definitely need some sort of system for holding your flash units in position. Lightweight minitripods that can be set on tabletops or other elevated surfaces and positioned as needed work well. The marketplace has also produced a wide variety of clamps with standard ⅜-inch tripod threads that can also hold a flash and be used to position it high enough to work effectively. Some tripods also come with feet or stands for mounting so that they can be stand erect on a flat surface.

✦ **Light modifiers:** After you've positioned your flash units, it's time to make the quality of your light as pleasing as possible. When used head on, direct flash is harsh, showing every flaw and imperfection. Experienced photographers have a number of different ways of solving this problem. One solution is called *bounce* flash. Here, the flash units are pointed toward the ceiling, and the light is reflected down to the subject, spreading and softening the light and making it more pleasing. Other tools that improve the quality of light are as follows:

 • Devices that attach to the flash head and reflect light (such as white cards)

 • Devices that cover the flash head and soften the light as it comes through the device (such as the Sto-Fen Omni Bounce)

 • A small soft box, which is essentially a piece of white cloth or other material that's stretched over a frame, as shown in Figure 9-5

✦ **Power:** Keeping your flashes firing during a long shoot can be a daunting task if you're just relying on AA batteries. Devices such as Quantum rechargeable batteries can provide enough juice for your flash units to keep pace with even your most frenetic shooting. Many of these units can provide power to a pair of flashes simultaneously.

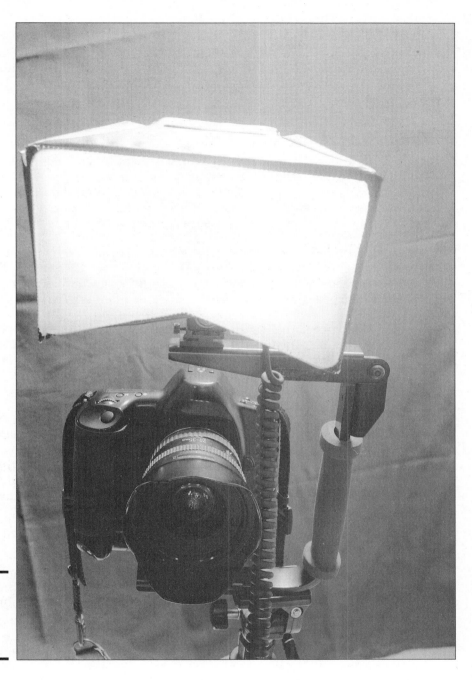

Figure 9-5:
Why, that
light looks
positively
soft!

Two or three good flash units with some form of supporting gear and the
appropriate light modifiers can give you a very effective portable lighting
setup. Such a kit can give significantly better results than just a single flash
unit and is versatile enough to be useful in a variety of situations.

Photographic slaves — electronic units that trigger multiple flashes that are
not connected physically to the camera — are needed to fire the flashes
with either a photoelectric trigger or a wireless radio transmitter.

Incandescent lights

Incandescent lighting is the same lighting that most of us use to light our homes. Enterprising manufacturers have created inexpensive photo lighting kits that use regular light bulbs instead of the more expensive tungsten lighting setups.

Professional studio lighting

If you're serious about portraiture, you may want to consider professional studio lighting, which isn't too expensive for a photo hobbyist who spent a thousand dollars or so on a camera alone. Many digital cameras are capable of firing expensive and high-quality studio lighting kits. These kits, which use very powerful flash heads, provide a predictable, steady light source.

Several differences exist between these flash heads and the more common accessory flash units that I discuss earlier. For a start, the power output of these flash heads is measured in watt-seconds (ws), whereas the output of on-camera flashes is usually measured in guide numbers (gn).

Another difference is that these professional units draw too much power to get by on either batteries or portable power packs. Instead, an electric outlet feeds them either directly or via a separate power supply (which can usually feed two or more lights at a time).

The advantages to using such a high-power system are as follows:

+ The nearly unlimited power supply means that you can get greater light output. This enables the photographer to shoot at smaller apertures (larger-numbered f-stops). The resulting greater depth of field that's provided by smaller apertures means that you can shoot larger groups of people and have them all in focus, plus it allows sharper overall images.

+ You don't have to wait for your lights to recycle. This means that you can blaze away, taking shot after shot without having to wait for the flash heads to recharge.

+ You can take advantage of *modeling lights,* the incandescent lamps that are built in to the studio flash that show exactly how the light from the flash will look. Many of the higher-quality studio lights have built-in modeling lights that stay on the whole time you're working. These lights aren't as powerful as the main flash heads, but they show you where shadows will fall on your subject and can help you check for hot spots on eyeglasses.

+ You have more control over lighting. This means that you can set one light for full power and another for a lower percentage of power output. In this way, the full-power light acts as a "main" light while the second, less powerful light simply fills in the shadows.

Studio lighting kits can range in price from a few hundred dollars for a set of lights, stands, and reflectors to thousands of dollars for a high-end lighting system that includes all the necessary accessories. The good news is that you don't need a top-of-the-line system to produce top-of-the-line results.

Lighting gadgets

A huge assortment of lighting gadgets is on the market, and all of them promise to be easy to use and to produce a higher quality of light. The good news is that for the most part, these claims are reasonably true. In the following sections, I give you a quick summary of what's out there, ranging from useful and just about free up to high-tech and pricey.

Inexpensive (or free!) gadgets

No such thing as a free lunch . . . or, perhaps more appropriately, free equipment? Guess again — here's a list of accessories that you can make for pennies that deliver professional results!

✦ The all-time classic is something called The White Card Trick. Set your flash to bounce mode (point it at the ceiling!) and take a 3-x-5-inch index card and attach it to the flash with a rubber band, as shown in Figure 9-6. Have the card extend 3 or more inches up the flash head. When you fire the flash, some of the light bounces off the ceiling, while more light kicks off the white card to throw some light into your subject's face, as shown in Figure 9-7.

✦ If your supply of index cards has been depleted, you can always try using The Spoon Trick. Similar to the preceding method, this trick involves having the photographer use a cheap plastic spoon in much the same way as the card. Some photographers maintain that the curvature of the spoon throws the light out in a curve to provide a more pleasing effect. I've used both methods, and they both work pretty well. It's also pretty easy to carry some rubber bands, plastic spoons, and index cards in your camera bag, or you can find the stuff at most shooting locations.

✦ For those with a hint of mechanical ability, a third version is to take a piece of aircraft aluminum (white or copper-colored) and cut it in a square or 3-x-5 shape. Use hook and loop tape on the square and the back of your flash head. Store the card by attaching it upside down when not in use and then just pull it off, flip it, and reattach it for use. Although white is pretty standard, using a copper-colored piece can slightly warm the color of your light.

✦ Just so it doesn't look like all I know is different versions of the White Card Trick, here's one that's a little different. Get one of those white frosted plastic bottles of rubbing alcohol (one whose waist is about the same diameter as your flash head). Remove the alcohol (this is important), and then cut the bottom of the bottle about 2 inches down the waist. Then snug the waist (the end with the bottom) over the flash head. You can now shoot with the flash head angled almost vertically and get a much softer light. (The Alcohol Bottle Trick creates an inexpensive alternative to a product known as the Sto-Fen Omni-Bounce, which I describe in the next section.) You can also use a spoon as a reflector, as shown in Figure 9-8. Funny how those utensils come in so handy, isn't it?

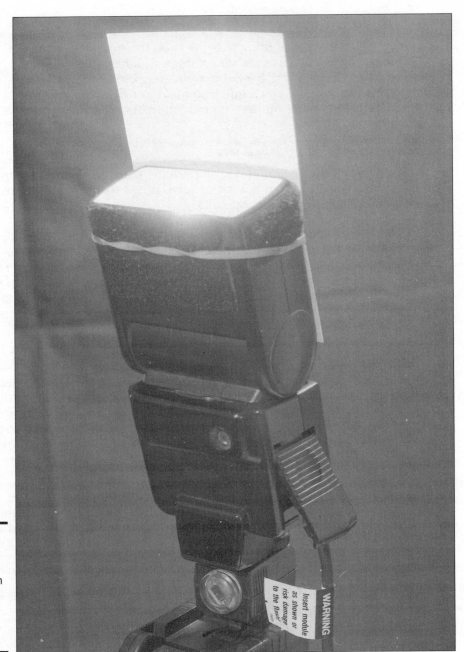

Figure 9-6:
Need fill
lighting?
Just use an
index card
and a
rubber
band.

Figure 9-7:
Using a
white card
(right), the
subject's
face is
illuminated.

✦ If you have only a small, fixed flash — fixed as in it can't pivot or tilt, not fixed as in repaired (but this doesn't work if the flash is broken either) — there's another way to soften and spread the light from it. Take an old, clear 35mm film canister (see if one of your less technologically advanced friends has one or visit a camera store) and tape it over the flash head. Variations of this trick involve placing a sheet of tissue inside the film canister to diffuse (soften) the light a bit or using colored tissue papers to change the color of the light that the flash produces. This isn't as big a deal these days, when you can produce all sorts of similar effects in an image-editing program. Still, if you're not real comfortable trying effects on the computer, this method lets you experiment while taking the shot.

✦ Many department stores carry cheap, L-shaped flash brackets. Your camera mounts onto the flash bracket, while your flash fits into a flash mount at the top of the L. To use a setup like this, you must have some way of triggering your flash when it is not attached to the camera. You can do this in several ways. If your camera has a PC connection (and I don't mean the way to connect it to your computer or being politically correct; I'm talking about a small circular electrical linkage), you connect your flash via a PC cable. A second method is to use a photoelectric slave to trigger your accessory flash unit. To do this, you use your camera's built-in flash unit, perhaps blocking most of its light output with gaffer's tape or masking tape.

You have many inexpensive ways of improving the quality of your artificial light. Even the simple White Card Trick combined with bounced flash gives you much better results than bombing away with direct flash. Keep this method in mind even when your available light is enough for a good exposure. The light that's kicked forward from the white card is a great way to fill in shadows from ball caps and other similarly billed haberdashery items.

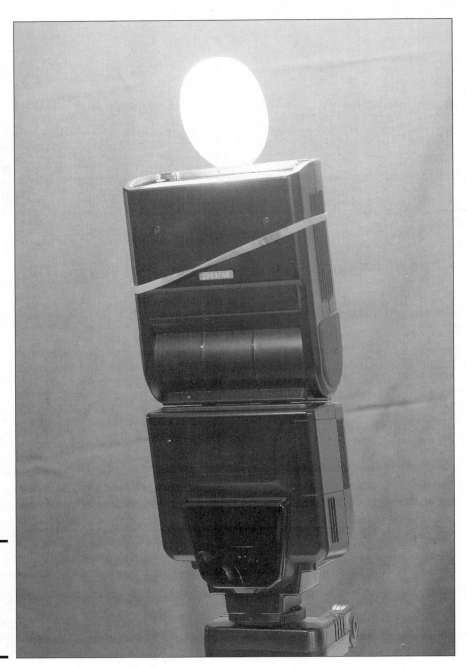

Figure 9-8:
Yes, that is a plastic spoon. No, I'm not kidding. It works.

Moderately priced gadgets

For just a few pennies (well, maybe dollars) more, you can add the following items to your lighting toolbox:

✦ **Omni-Bounce:** Sto-Fen (www.stofen.com) makes several inexpensive light-modifier devices. Best known is the Omni-Bounce, a frosted plastic attachment that fits over the flash head and softens the light considerably. The device is used by setting the flash head to a 45-degree angle. If your subject is more than 15 feet away, set the flash to fire straight on.

The price is about $20. The company also makes colored versions of the Omni-Bounce, which cost a few dollars more.

✦ **Two-Way:** Sto-Fen also makes a product called a Two-Way. This is a sturdier approach to the White Card Trick, and it works in a similar manner. Its price is also about $20.

✦ **Lumiquest attachments:** Another company, Lumiquest, (`www.lumiquest.com`) makes a whole range of flash attachments that offer a bunch of different capabilities. These range from simple bounce hoods that kick the flash's output forward and spread it out to ones that perform very specialized functions. Variations of the basic bouncer include attachments to allow some light to bounce off the ceiling while the rest is kicked forward. Another version sends the light through a frosted panel to soften it even more. A third variation permits the insertion of colored panels to change the color of the light that the flash produces while bouncing it.

✦ **Soft boxes:** A *soft box* is an attachment that mounts on the head of the flash and extends out 6 to 8 inches, with a frosted white panel at the end. This attachment lets the light from the flash spread out a bit inside the soft box, softening the light as it passes through the frosted end. (Pro portrait studios often sport a similar but much larger version on their studio flashes.) Lumiquest, as well as several other companies, also make soft box attachments for portable flash units.

✦ **Snoots:** Lumiquest also makes a snoot. Please restrain your mirth: A *snoot* is a tube-like device that focuses the flash's light to a very small area. For example, a snoot can be used to create a highlight on someone's hair.

✦ **Barn doors:** Lumiquest's barn doors attachment fits several of its bounce flash attachments. Barn doors are flat panels that can be swung open and closed to more finely tune light output.

✦ **Flash brackets:** Moderately priced flash brackets tend to be sturdier than their inexpensive counterparts, plus they usually tend to lift the flash higher above the camera. Otherwise, these brackets work the same way as the inexpensive ones.

A decent light modifier can be a pleasure to work with, can significantly improve your photos, and doesn't have to cost you an arm and a leg. Many are available for less than $50. You have a wide variety of choices, depending on your needs. For photographers who work mainly out of a camera bag, a small, collapsible light modifier is a better choice than one of the bigger, more cumbersome units. Those who work from a home studio are better off with one of the bigger soft boxes that give a nice-quality light.

Higher-priced gadgets

I'm not talking thousands of dollars here, but costs for the following items may still add up a bit. The quality, however, rises with the price.

✦ **Soft boxes:** Some companies make a fancier soft box attachment that mounts on the flash head via spring-loaded clips. These devices are bigger and feature a deeper well for the light to spread out before hitting the frosted panel. These units also tend to be sturdier than the less expensive versions.

✦ **Umbrella units:** Another option is to mount your flash on a combination flash stand with a photographic umbrella. This kind of rig lets you set up a multiple-flash lighting system that produces very pleasing lighting without the expense of buying portrait studio flash heads. These devices are usually triggered via some form of slave. The price is about $100.

✦ **Flash brackets:** Examples in this category tend to be very sturdy and may extend the flash as much as 1 foot or more above the camera. Some offer expanded capabilities — such as the ability to accept a flash umbrella, making for a heavy, but versatile, rig. Many of the more expensive units, such as several made by Stroboframe (`www.saundersphoto.com/html/body_strobo.htm` has information about these products), offer the ability to rotate the camera and/or flash for vertical orientation.

If you're serious about using your digital camera for portrait photography, the equipment that I mention here adds a lot of bang for your buck. The umbrella rigs tend to be better for studio setups, whereas the soft boxes and heavy-duty flash brackets stay manageable for photographers who do most of their work on the road.

Choosing power sources

Keeping your portrait flash units supplied with power is a key to effective flash photography. You have several ways to get juice to your flash heads, and they vary in both price and effectiveness. Don't skimp here if you expect to rely on your flashes. The wrong choice will cost you images and make you miserable. Some flash unit power sources are as follows:

✦ **AA batteries:** These are the standard power source for your average accessory flash unit. The advantage is that they're inexpensive and can be found almost anywhere. There's a choice among alkaline, lithium, and standard types. Alkaline and lithium are better choices because they recycle faster than the standard type. Rechargeable types are also available in several different versions, including nickel-cadmium (NiCad), alkaline, and nickel metal hydride (NiMH). The big disadvantage to all of these is that they drain fairly quickly, leaving you to frantically change batteries while hoping that you don't miss a shot.

✦ **Portable battery packs:** Several different manufacturers make high-capacity portable battery packs that can provide power for a wide variety of flash units. The best-known manufacturer is Quantum Instruments (`www.qtm.com`), which makes several different styles, along with adapters for most current flash units. While these rigs are much more expensive than AA batteries (plan to spend from $150 to $200 for a new battery pack and flash module), they can power tons of flash cycles before running out of juice. They also keep your flash firing longer during motor-drive bursts (although not indefinitely).

A good portable power pack can provide enough juice to power a couple of flash units through a wedding, prom, or public affairs event. Having one available can really make your life easier.

Lighting Basics

The idea behind using artificial light is to provide enough illumination to adequately light your subject in a pleasing manner. The simplest, most basic method is to use a single flash — preferably with some form of light modification or by bouncing — with the flash unit raised higher than the camera.

You can maximize the effectiveness of a one-light photographic system in several ways. First and foremost is to get the flash up off the camera. The closer the flash is to the lens, the greater the likelihood of *red-eye* — that nasty red glare that appears in the eyes when light bounces off the subject's retina. Extending your flash unit's height helps your photography quite a bit. You can do this in several ways:

✦ **The old "Statue of Liberty" play:** Use an *off-camera shoe cord* (an intelligent cord that communicates between the camera and dedicated flash unit to retain the camera's ability to meter light through the lens) or a PC cord to lift the flash high above the camera, and either point the light directly at your subject or bounce it off the ceiling.

✦ **L-Brackets:** Use an L-bracket — or something based on an L-bracket design, such as a Stroboframe grip — to raise the flash above the camera.

✦ **A flash stand with an umbrella reflector:** This either requires a long PC cord or a wireless transmitter to trigger the flash unit.

One advantage of getting the flash up off the camera is that it re-creates the single high light source that you're used to seeing naturally — the sun. A second advantage is that by getting the flash off the camera and at a higher angle, you reduce the likelihood of red-eye.

Using multiple light sources

A more advanced, but still basic, lighting system calls for multiple lights that are arranged in one of several ways. Although a multiple-light system doesn't re-create the natural light of the sun, it allows you to create a very pleasing and effective lighting package.

Advantages of a multiple-light system include the following:

✦ **Precise control over how much illumination you provide for a scene:** Even if your lights are more powerful than you want, you can add screens to reduce output or shift your lights farther back.

✦ **More control over the mood of the image:** You can control the location and intensity of shadows and highlights.

✦ **An adaptable lighting kit:** You can adapt your lighting kit to a wide variety of shoots and to any number of subjects. Some lighting kits are even versatile enough to be brought on location.

Multiple lighting setups, like the equipment shown in Figure 9-9, can mean the difference between an adequate portrait photo and a good one. While a multilight setup doesn't guarantee better quality, getting the hang of such an arrangement can do a lot to improve your portrait photography.

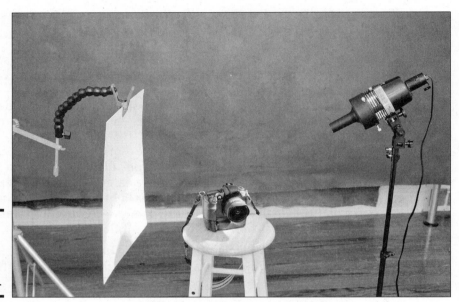

Figure 9-9: Multiple lights often deliver the best results.

Arranging a multiple-light setup

After you decide that you want to use a multiple-light setup, you need to know where to put it. Setting up a multiple-light system isn't very hard; it's just a question of positioning your lights to illuminate your subject in an attractive manner.

With a multiple-light setup, each light has a different role to play. Understanding the basic arrangement helps you get started down the road to good portrait photography.

Main light

This is your primary light source. (Go figure.) The main light provides most of the illumination for your subject. An effective two-light studio system can be set up with a big main light firing straight on your subject through a big soft box (not the kind that mounts on an accessory flash, but a big studio model that's about 18 inches tall and 36 inches wide), with a second back light to separate your subject from the background (more on back lights in a minute).

This principle also works with a smaller shoe-mount flash and soft box, but the quality of the light doesn't compare to that of the studio system. Generally, the difference is noticeable when you're trying to shoot larger groups or doing a lot of sittings. For an occasional small group and a limited number of exposures, the small portable system does the job pretty well.

The following list gives you some ways to maximize the effectiveness of your main light:

✦ Get it up high. Your main light should be higher than your subject. You don't have to be ridiculous here; keeping the light about a foot or so higher than your tallest subject does the trick.

✦ Make an effort to improve the quality of your light, either via a soft box or by using an umbrella system.

✦ Provide enough power to shoot at a small aperture, thus giving you greater depth of field. Because shooting through a soft box or off an umbrella costs you some light, you need a lot of power to shoot a big group at f/11 or f/16.

✦ Recycle quickly. How quickly your main light *recycles* (recharges so that it can be ready to fire again) is very important. You want your lights to keep pace with your workflow, not the other way around. During a sitting, it's important to develop a rhythm with your clients while posing and photographing them. A break in that rhythm, particularly one caused by your lights not being ready, can make your life difficult.

Your main light should provide a soft, even illumination with enough power to keep your subject in focus from front to back. Most often, the main light is set up a couple of feet to the right or left of your subject's centerline and angled toward that center. Figure 9-10 shows a portrait subject illuminated only by a main light.

Fill light

The *fill light* is the light that's used to fill in the shadow areas that are created by the main light. For the most versatile system, plan on using the same model flash head for your fill light as you do for your main light. This gives you the option of setting the same power ratios — the settings on your flash that reduce or increase the amount of light emitted — for each light. Such a lighting system, with two comparable lights about 6 feet apart angled toward the center point of your sitting, enables you to build your group size without having to reconfigure your lighting. This is a huge advantage if you're doing a large number of sittings during the course of a day.

Just because you can bomb both flash heads away at their highest power settings and create an even light doesn't mean that you have to. You can always dial down the power setting on your second flash head and create a more interesting lighting effect for your subject. Experiment with 2:1 and 3:1 power ratios, and see which you prefer.

If you have a fill light that doesn't let you reduce or increase the power, try moving the flash back a bit or try placing a diffuser such as a handkerchief over the flash. Thanks to your digital camera's review feature, you can quickly see whether you've reduced the amount of light enough.

Some tips for setting up your fill light are as follows:

✦ Your fill light should be roughly the same height as your main light, although slightly lower is okay.

✦ The fill light should receive some kind of modification, via an umbrella, soft box, or diffusion screen (a thin screen-like material that diffuses or softens the light).

The fill light helps balance your portrait lighting and creates a sense of depth for your image. Used properly, it can also create a moody or romantic image through the carefully controlled play of shadows. Figure 9-11 (the same subject as Figure 9-10) shows the photo with a fill light added.

Figure 9-10: A portrait that was captured using only a main light.

Figure 9-11:
Notice how
the fill light
reveals
clothing
details.

Hair light

The *hair light* is a small, carefully controlled light that's used to put a high-light on the subject's hair. This type of lighting can also be referred to as *rim lighting*.

Most often, the hair light is controlled via either a snoot or through a barn doors attachment on a flash head. The light itself doesn't need to be particularly powerful, because it's responsible for lighting only a small area. Most

often, the hair light is positioned closely to the subject (just out of the camera's view) via a boom (a raised arm that's attached to a lighting stand) that allows the hair light to reach into the portrait area from up high.

To use a hair light, position it so that the light is directed almost straight back into the camera, raking across the top of the subject's head, to produce an effect like that shown in Figure 9-12.

Figure 9-12:
A hair light
can add real
impact to a
portrait.

Background light

The *background light,* as its name suggests, is used to light up the background as well as to create some separation between the subject and background.

This light is generally mounted on a small lighting stand and is pointed upward at the background; a small screen is usually mounted on the light to help spread the light over the backdrop. Be careful to position the light so that the lighting stand stays hidden behind your subject.

When using the background light, keep the following tips in mind:

✦ Set the background light about 2 feet from the backdrop and 2 to 3 feet off the ground.

✦ Try to keep your background light on a separate power circuit than your main and fill lights. Because the main, fill, and background lights are usually the most powerful lights in your setup, having them on the same power supply or circuit can place excessive stress on your power source.

✦ Angle the background light upward about 45 degrees so that the light spreads upward and outward from below your subjects.

✦ Mount a diffusion screen (which can be as simple as a handkerchief or any other diffusing material) on the light head to soften the light as it spreads up the backdrop. Using the screen helps prevent the light from creating *hot spots* — those annoying bright areas that can crop up in a background if the light isn't spread evenly.

Adding a background light to your portrait setup makes for a cleaner, more pleasing portrait — like the one shown in Figure 9-13 — because it helps separate your subjects from the background. While the background light is hardly the most important light in your setup, without this light, your subjects can get lost in a dark background.

Additional light sources

The four lights that I discuss in the previous sections can take care of the majority of lighting situations, but they're certainly not the only way to create interesting lighting. For some neat alternatives, try one (or more) of the following:

✦ **Reflectors:** Sometimes, rather than using a fill light, the photographer bounces light from an angled main light into a reflector that's positioned near the model but still outside the picture area. This can be a good solution if you don't own a second electronic flash.

✦ **Window lighting:** Another charming source of light can be the nearest window. Window-lit portraits require a bright, sunny day with sunlight pouring in through the window. Position your subject on a chair near the window, and make sure that your digital camera takes its exposure reading from the portion of his or her cheek that's illuminated by the sunlight. If done properly, your subject appears to emerge from the shadows bathed in a golden glow. A variation of this lighting technique

is to use a reflector to kick some light back into the shadow area so that some detail is returned to the side that doesn't receive sunlight.

✦ **Sun and fill:** A typical example of this form of lighting is the swimsuit model at the beach. The model is positioned so that the early-morning sunlight acts as the main light, and a reflector is positioned to direct some light into the shadow areas. This is a very nice style of lighting; unfortunately, it requires you to get up early!

The last two methods can produce some beautiful lighting but are hard to use for groups or a large number of sittings. It can be hard to schedule a sitting for this kind of lighting technique, too.

Figure 9-13:
A background light accentuates and defines the subject.

Basic Lighting Techniques

If you understand the basic lighting equipment and how it is used (which I describe in the previous sections), you're ready to become familiar with common techniques that can be applied with main, fill, background, and hair lights. In this section and the next, I describe several different lighting techniques, each with its own advantages and disadvantages. Although you can set up a basic lighting style that produces an even, acceptable light that works for a variety of situations, this doesn't necessarily bring out the best in your subject. Still, you may find yourself in a situation that calls for you to photograph a large number of setups as efficiently as possible. Such jobs — weddings, church directories, and proms, to name a few — come up quite often and call for photographers to shoot lots of different setups (called *sittings*) quickly.

Keep the following basic lighting setups in mind for those times when you have to shoot a lot of sittings as efficiently as possible:

✦ Set up your main light straight down the center, and use a big soft box to spread and soften the quality of the light. Set up a second light as a background light, and you're good to go. Depending on the size of your soft box, the power of your main flash head, the size of your backdrop, and your posing resources, you can easily illuminate a 15- or 16-person group. You don't have much flexibility in this setup, though.

✦ Use a three-light arrangement with a pair of identical flash heads firing into umbrella reflectors as your main and fill lights. Set both flash heads for the same power output so that you don't have to worry about rearranging your subjects according to shadows. Set your lights up about 6 feet apart (horizontally), with each pointed toward the center posing spot, and 4 or 5 feet away from your subject.

These basic lighting setups can get you started. You can take a nice, professional-looking portrait with either of these lighting arrangements, but your portraits won't look much different from those of the photo studio at your local department store.

Advanced Lighting Techniques

The technique that you choose depends on your subjects' features. One style of lighting can flatter a person's face while showing another's poorly. Each technique can be created with a basic three-light lighting kit.

As you increase your photographic capabilities, learning to use more advanced lighting techniques helps you stand apart from the Opti-Mart down the block.

Two forms of advanced lighting techniques rely on turning your subject's head so that his or her face isn't staring directly into the camera. These techniques are called *short lighting* and *broad lighting*.

Short lighting

Short lighting is a technique in which the main light source comes from the side of the face that's directed away from the camera, as shown in Figure 9-14. Short lighting is a valuable lighting style because it tends to narrow overly broad faces. It's also sometimes referred to as *narrow lighting*.

Figure 9-14: The effect is thin — the result of short lighting.

To set up a short lighting arrangement, do the following:

✦ Turn your subject's face so that it is angled somewhat to the right or left of the camera (not too much though; this isn't supposed to be a profile shot). When you do this, the side of the face that you can see more of is called the *broad* side of the face, while the side that you see less of is known as the *short* or *narrow* side of the face.

✦ In short lighting, you set up your main light to illuminate the short side of the subject's face and then add a fill light or reflector to fill in some light on the broad side of the face. Add a fill light to separate your subject from the background for a good three-light setup and a hair light for a four-light configuration.

Short lighting is a particularly nice form of lighting for the female face, because it accentuates the eyes, cheeks, nose, and mouth in an attractive way. This style of lighting can also be used to make a broad male face look thinner.

Broad lighting

Broad lighting, shown in Figure 9-15, is essentially the reverse of short lighting. It widens narrow or thin faces by emphasizing the side of the face that's turned toward the camera. Here the subject's face receives the main light on its broad side, with a fill or reflector used to lighten or eliminate the shadows on the short side.

This is a useful lighting technique for thin faces, but it should be used carefully with women.

To set up a broad lighting arrangement, do the following:

✦ Turn your model's face so that the main light illuminates the broader side of the face.

✦ Use your reflector to bounce some light into the shadow areas of your subject's face. Be careful with this lighting technique, because it can make a normal face seem very full.

Butterfly lighting

An even more glamorous style of lighting that works well for posing women is called butterfly lighting, as shown in Figure 9-16. This type of lighting creates a subtle butterfly of light; the bridge of the nose is the axis for the "wings" of light that spread over the eyes and cheeks.

This style of lighting does not work as well for men because it tends to throw too much light on the ears.

Figure 9-15:
Our portrait subject is illuminated by broad lighting.

To set up for this type of lighting, configure your lights as follows:

✦ Position your main light straight on to your subject, high above his or her eyes, with the light pointed directly on the nose. This is what enables the light to spread out in the butterfly pattern.

✦ Use a background light to separate your subject from the backdrop.

Butterfly lighting should always be considered for a female subject, although that doesn't mean that you always need to choose this style. If you use it with a girl or woman who has short hair, the same problem of throwing too much light on the ears can occur.

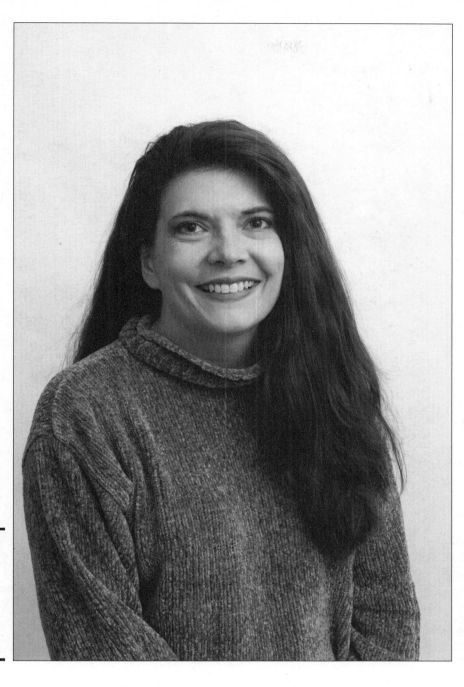

Figure 9-16:
Butterfly
lighting
was often
used in
Hollywood
glamour
portraits.

Backlighting

Backlighting, also known as *rim lighting,* can create an almost magical glow or halo-like effect for your subject. (Think of the Elvish princess Arwen from *Lord of the Rings.* Can you tell that this is a big hit with both clients and yours truly?) An example of backlighting is shown in Figure 9-17.

This lighting style calls for your main light to be placed behind the subject while a fill light prevents the face from falling into shadow. The result is a rim of light that highlights your subject's form.

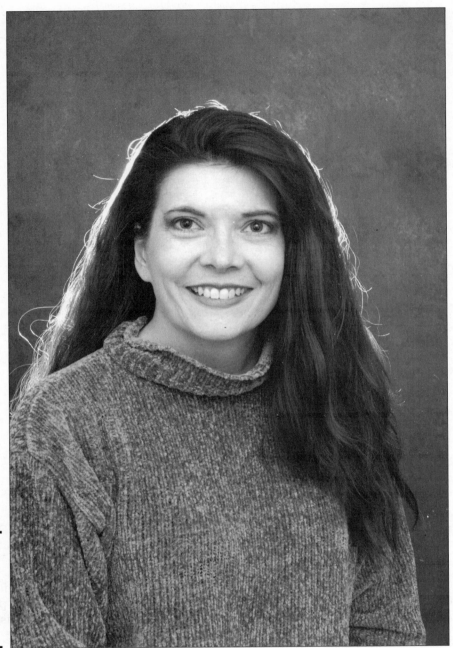

Figure 9-17:
My favorite lighting effect for portraits — backlighting — rocks!

You can use this lighting style in the following ways:

✦ **Full backlighting:** In this technique, the main light is positioned directly behind the subject, about even with his head. Check your composition carefully to make sure that the light is hidden from the camera's view.

✦ **Side rim lighting:** Here you're trying for just a hint of backlighting to add some glow to one side of the head. This is similar to hair lighting. In this case, though, use a small light rather than your main light. Set up a small light with a snoot (a conical light modifier that I discuss in the section "Moderately priced gadgets," earlier in this chapter) on a boom

that's pointed at the side of the head, away from the camera. If you don't have a boom arm, try placing a light stand as close to your model as possible while keeping it out of the shot.

Practice this technique to get the hang of it. Rim lighting and backlighting are valuable lighting techniques for many types of portraiture, such as when photographing a bride or a mother and child. (Just be careful not to overdo it.)

Taking Your First Portraits

Studio portraiture is about making your subjects look as they would *like* to appear, not necessarily as they really are. So when you're setting up your poses, reflect on how to make people look their best.

A good portrait photographer inspires confidence, not only in himself but also in a client. The better you can make a person who's posing for you feel about how she looks, the better her pose and the better her feeling about the whole portrait experience. This works in your favor, because your subject will be more likely to buy your photographs.

People pose for portraits for different reasons and in different situations. If you're working on a tight schedule with a lot of sittings in a relatively brief period of time (say a wedding or church directory shoot), you don't have a lot of time to get to know your subjects or establish a rapport. Instead, consider a routine that works something like this:

✦ Pose the family first, with Mom seated and Dad as one of the side elements in the diamond pose (see the sidebar "The diamond pose," in this chapter). Then build the rest of the pose with other family members. Shoot the family portrait.

✦ Pull the kids from the family pose. Keep Mom and Dad in place, and photograph their portrait.

✦ Pull Mom and Dad from the sitting and place the kids up in a new diamond pose (depending on how many kids you're photographing). It's usually best to pose a group of male children in a line from tallest to shortest. If a sister or two is present, seat the oldest boy and pose the oldest girl as the next diamond element, with her hands on his shoulder.

✦ Ask the parents if they would like any special poses. (Don't be afraid to take special requests; they're usually very likely to sell.)

✦ With most families, Mom is usually the decision maker when it comes to things such as family portraits. Make sure to keep her happy. Have brushes and combs on hand, as well as lint brushes, so that everyone can make sure to look his or her best. It also doesn't hurt to have some conservative ties and scarves on hand, just in case someone has an accident on his way to the sitting.

When you're doing large numbers of sittings, strive for the most efficient posing setup and flow possible. People who are sitting around in their wedding finery waiting to be photographed can get pretty grumpy, particularly if more than one group is waiting. A typical pose, using the diamond configuration discussed in the upcoming sidebar, is shown in Figure 9-18.

Figure 9-18:
The bride is the focus of this pose.

Try to be flexible enough for a special request because these can be very profitable. I was once part of a team that was shooting portraits for a church directory when a husband mentioned that he and his new wife had never had a wedding portrait taken. We suggested that they come back after our shooting schedule was done in their best suit and wedding gown, and we would do a series of portraits for them. The couple loved the idea, and we spent an hour creating different poses and portraits — and ended up with a huge order! Most importantly, we accomplished this without inconveniencing other members of the church, and we gained a reputation for enthusiasm and service among that particular church's members.

If you're working under a more generous time schedule and aiming for a higher-end product, take the time to make your subjects comfortable and to see what they're looking for in a portrait sitting.

Although you may still be looking at the basic family portrait package (family, couple, and children), each family member may need individual portraits as well. This may be the time to bring out more specialized types of lighting, such as the broad lighting and short lighting that I discuss earlier in this chapter.

Be sure to offer your clients some extra poses for each family member, particularly for those kids who may go for a variety of sports images. Have props on hand, such as soccer balls, baseball gear, footballs and helmets, and so on.

Here are some standard combinations for portraits with multiple subjects and/or props:

✦ **Husbands and wives:** Offer husbands and wives the basic couples pose, but also suggest a second pose that illustrates their love and commitment to each other (standing close, gazing into each other's eyes). Depending on their age and demeanor, a more whimsical pose may also be in order. If so, having the husband get down on one knee to re-create his marriage proposal while the wife "thinks" about it can be cute.

✦ **Kids:** A brother and sister can be posed in a diagonal, with the boy seated and the girl angled behind him with her hands folded on his shoulder. This is a basic couples pose, but the relationship issue isn't important. If you have two posing stools, you can seat both people diagonally, one behind the other. A pose that works with two boys is to have them sit back to back with their heads turned toward the camera.

✦ **Mothers and daughters:** I would seat Mom and have her daughters arranged in the appropriate number of elements for a diamond pose. Another option — if you have the posing boxes to do so — is to seat Mom on a posing stool and have a daughter or two seated at her knee. A third daughter (the oldest) would be diagonally behind Mom with her hands on Mom's shoulder. If I had flowers, I would load the scene with them.

✦ **Fathers and sons:** A simple pose would be to seat Dad and build a diamond around him. A more adventurous pose would be to have Dad standing slightly sideways, with his off-camera hand in his pocket, looking at his son(s) posed about a foot away (one diagonally behind the other). Have one son toss a ball in the air, let the sons watch the ball, and have Dad watch the sons. A simpler variation would be to have the sons remove their suit jackets (if this is a "dressy" portrait) and sling them over their shoulders (the off-camera side), while Dad regards them with arms folded across his chest (still properly attired).

✦ **Infants:** For a fancy pose, look for an old-fashioned baby buggy or some other such prop. A lot of choices are available, including seashells for the baby to sit in or bearskin rugs for him to lie on. Generally, how you pose an infant depends on his or her age and physical abilities (such as whether the infant can sit up unsupported). Babies who are younger than 6 weeks old usually can't focus their eyes on a specific point, so they present a special challenge. It's usually best to leave someone in this age group in her carrier and go for a reasonably tight shot.

The diamond pose

Diamonds are a photographer's best friend. Professional portrait photographers use a diamond formation as their basic foundation for a group photo. Establish your anchor person (usually the mother in a family portrait), and seat that person. Place the father (or second individual) behind the anchor and halfway to the side. Elevate the seated person so that the top of his head is level with the nose of the standing person. Have the standing person place his or her hands one on top of the other slightly angled on the seated person's shoulder. (By the way, this is the basic pose for a couple.) Now do the same with the third person to balance the trio. (This gives you a basic pose for three people.) Place the fourth person directly behind the first person and positioned so that the heads of subjects two and three come up to the nose of the fourth person. (Have sturdy wooden boxes or blocks of varying sizes for people to stand on.) Have subjects two through four lean slightly forward from the waist so that their faces are as close as possible to being on the same plane as the first person. Then, everyone is on the same plane of focus. You should not have gaps between bodies. Now you have a basic posing system that's expandable to fit 20 people or more.

As a general rule, pose multiple people closer together than they would normally stand if left to personal-space comfort levels. Your goal is to maximize the use of space by filling the frame as effectively as possible with people, not backdrop or props. This doesn't that mean you're doing nothing but headshots, though. If you're doing a wedding or prom shoot, people will be in their finest clothes, and showing that clothing may be appropriate. Certainly the bride in her wedding gown deserves at least one photo that shows her entire wedding dress, including the train.

Shooting the Portrait

Your first family enters your studio, ready to have a portrait taken. After you've exchanged pleasantries, be sure to point them in the direction of the mirrors and touch-up hairbrushes for any last-second adjustments.

When everyone's ready, it's time to begin arranging the sitting. Start by seating the mother, and build your diamond around her. Make sure that each person is sitting or standing up straight. (Place your hand on the front of a shoulder and two fingers at the base of the spine and apply gentle pressure to straighten them up.)

Have your subjects focus their eyes slightly to one side of the lens. Have them bring their chins up slightly so that they're looking slightly up and away from the camera.

Be aware of the following things while seating your subjects:

+ Make sure that your subjects are sitting up straight.

+ Check to make sure that clothing is as wrinkle-free as possible. If necessary, tug suit jackets to straighten out wrinkles.

+ Use your modeling lights (if you have them) to make sure that you've minimized the glare from eyeglasses.

+ It's often a good idea to give the subjects a mirror so that they can check themselves over just before you take the picture. Knowing that they look good can help them relax — and that, my friend, is A Good Thing indeed.

Use this time to get your subjects in position and into the right mood for the portraiture. Remember to stay positive and encouraging. Be sure to tell them that they look good. Crack a few *tasteful* jokes or discuss current events while positioning people to keep them relaxed, too.

Posing your subjects

To properly pose your subjects, keep in mind that you are dealing with two separate tasks: positioning them in such a way to make them look their best and simultaneously creating a pose that's not too unbearable to maintain for several minutes.

Start out by posing the lowest seated person, as follows:

1. **Pose the bottom person in the diamond so that he or she is comfortably seated on a posing stool; elevate the person's legs so that they are at a right angle to his body.**

2. **Allow the person to place her feet on a small posing box for comfort while holding the pose.**

3. **Angle the person so that she is at about a 45-degree angle to the camera lens.**

Make sure that this person is comfortable in the basic pose because he or she must hold the pose longer than anyone else. I usually put the mother in this position for several reasons. First, she looks natural as the base of the diamond; second, she's usually trying to set a good example for the rest of her family; and third, if she's already in the pose, she can't meddle with your work with the rest of her family. (Don't underestimate this reason, whatever you do.)

With your first person in place, it's time to move on to person number 2. Follow these steps:

1. **Place the second person on a posing stool, angled behind the first person.**

 Normally, this would be the father, but no hard-and-fast rules apply here. Position the individual so that his or her head is properly positioned in relation to the mother within the diamond pose.

2. **Have your subject place his on-camera hand (the hand that faces the camera) on his hip.**

 Be forewarned: Couples are always trying to put their arms around each other's waists. Don't let them; it's touching, but it doesn't photograph well. If you are dealing with spouses or a couple in a relationship, let them put their off-camera hand on their partner's hip, out of sight of the camera.

3. **Have the second subject lean slightly into the first person so that you don't have any gaps between their bodies.**

 Make sure that both persons are still sitting up straight. If a gap exists, you can turn the stools slightly to bring the shoulders a bit more square to the camera and close the gap. You may also have to slide the chairs a little closer together.

Keep in mind that the pose you're setting up with the husband and wife (or whatever significant pair you're posing) can also make an excellent pose for when you do the couple's portrait. So don't let them get up when the family/group shot is done, or you just have to re-create this pose all over again.

Now that you've got Mom and Dad posed, start adding the kids. You can start with child number 1 by following these steps:

1. **Take the smallest child, and place her on the bottom person's other side, using a posing box to raise her to the right height.**

159

2. **Turn the third subject toward the bottom person (roughly at the same angle as the second subject).**

3. **Move the third subject so that she is about halfway behind the bottom sitter.**

 The second and third subjects should be close together, but their shoulders don't have to touch. Just make sure that no gap exists between those two posers and the bottom subject.

You've now set the base for a diamond pose and created a good three-person sitting that can work for posing a trio. Remember to keep the relationship between the three heads consistent so that a line drawn across person number 2's face and person number 3's face travels over their eyes. Their mouths should be even with the first poser's eyes.

Now add person number 4, as follows:

1. **Place your fourth person behind person number 2 and number 3, and raise him (if necessary) by using a posing box.**

2. **Person number 4 fills any gap between persons two and three, which is why it wasn't that important to squeeze them in tight.**

 Square person number 4's shoulders toward the camera.

3. **Adjust the height of person number 4 so that his mouth is on a line with the eyes of person number 2 and 3. Have person number 4 lean slightly into the others.**

That last little part about leaning is important. Ideally, you want all the faces in the same plane for the best possible focus. Even when shooting at f/11 or f/16, it's still better to have all faces on a line for best appearance. After you have everyone lined up properly, check your modeling lights to make sure that no one is casting shadows where they shouldn't be.

If you have more than four individuals that you need to pose, take the following guidelines to heart:

✦ Use the topmost person in your original diamond as the base person for another diamond group.

 This lets you add three more people in the same way that you added posers two through four.

✦ If you have more than seven sitters, start building diamonds outward by using the leftmost or rightmost person in the lower diamond as the side anchor of a new diamond.

✦ As you build your additional diamonds, take care to make sure that everyone's faces are lining up properly in the same focal plane. Also, make sure that everyone is on steady ground. As you have more people standing on posing blocks, your group's inherent stability suffers. You don't want to see them collapse into your backdrop and lights. (This could affect future business with this family.)

Working with a large group is a challenge because the number of variables increases significantly. Take a moment before setting up the pose to do a little planning.

Visualize the group pose before you start assembling it. This way, you waste less time and effort once you get started. Take a moment to explain to the group that you're going to take a lot of shots of the group pose to maximize your chances of getting an exposure with as many good expressions as possible.

Arranging your lighting

Create a triangle with your base posing stool as its apex. Set up your main light and fill light about 6 feet apart and 6 feet from the posing stool.

Position your background light about 2 feet behind the posing stool, and then position the background 1 to 2 feet from the background light.

If you're using a hair light, position the light angled about 45 degrees behind the subject's head and pointed toward the camera. Take a moment to check your viewfinder to make sure that no part of the hair light protrudes into the photograph.

Taking the picture

Now that you've set up the lights and arranged your subjects, it's time to start thinking about taking the picture.

I recommend triggering the camera via a remote so that you can maintain eye contact with your subjects. Many digital cameras, both professional and point-and-shoot types, offer some method of triggering the shutter without physically tripping the shutter button. If your camera doesn't have this feature, you can still fire the camera via the shutter-release button while looking over the camera at your subjects.

Before tripping the shutter, go through this quick checklist:

✦ Is everyone standing up straight?

✦ Are their heads properly arranged so that their faces are directed toward the camera?

✦ Is everyone looking either directly toward the camera lens or in the direction that you've designated? (Some poses may look better if you have your subjects looking slightly past the lens.)

✦ Is everyone smiling?

Be ready to work fast. Holding a pose is a tiring chore. People lose their patience if you take too long to trip the shutter, so be ready to run through the checklist quickly.

Don't be afraid to stop and correct someone who has relaxed his pose. It doesn't do you any good to trip the shutter if someone doesn't look good.

I usually hold the remote behind my back when tripping the shutter during a portrait session to keep people from realizing that I'm about to take the picture. This is important for the following reasons:

- ✦ I don't want to give people a reason to shift their eyes in the direction of my hand as I'm taking the shot.

- ✦ Many people anticipate the flash firing and blink their eyes as the lights are firing.

Remember to keep watching your subjects as you trip the shutter. You can usually catch the blinkers, if have any, and you know that you need to take another shot.

Advantages of Digital Cameras

Digital cameras offer you many advantages in portrait photography. Most important is the chance for the photographer to review the pose before the clients leave. This way, you can spot problems and have a chance to correct them while everyone is still there.

Another huge advantage of the digital camera is that it gives you a chance to make sales while your customers are still excited from their sitting and are still in high spirits after all that positive feedback you've been giving them. (You *have* been giving them positive feedback, haven't you?)

Film photographers have to factor the cost of film, processing, and making proofs into their costs of doing business, driving up their margins. As a digital photographer, you can afford to take all the shots you want without damaging your bottom line (provided that you have enough media to get you through a long shooting session).

Learn to use your digital camera's review feature to its best effect. You should be analyzing the following things as you play back your shot:

- ✦ **Make sure that the photo is properly focused.** Although you can't be sure while reading your camera's LCD screen, you can at least eliminate really poor shots. If you have a digital camera that can be hooked up to a television to play back images, by all means do so! This can help you get a better look at your images and, when the time comes, you can show the images to your clients while at the same time taking their order. (If they're not satisfied, you can also offer to reshoot the sitting while they're still dressed for it.)

- ✦ **Check for obvious errors.** These errors could be gaps that appear between people, bad expressions, or wrinkled clothes. Straighten out the clothing, as shown in Figure 9-19. Also make sure that everyone's hair looks good and that the image is properly exposed.

- ✦ **Check for lighting errors.** These would include lights that shine where you don't want them to, unwanted shadows, and so on.

- ✦ **If your subjects are wearing glasses, check for hot spots that may be too difficult to clean up in an image-editing program.** It's easier to reposition someone's glasses than it is to do heavy computer retouching, so make your job easier when you can.

- ✦ **Check for people who blinked.** This can be pretty tough with small LCD screens; a TV monitor makes this easier.

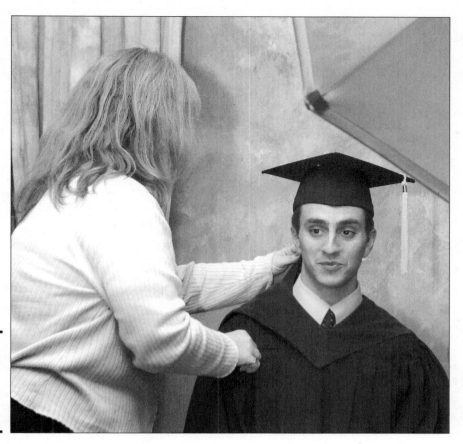

Figure 9-19:
You always
have time
for a quick
clothing
adjustment.

I once worked for a portrait firm (before the digital revolution hit its stride) that spent quite a bit of money to develop a portrait system that simultaneously exposed a piece of film and captured a low-resolution digital image. The photographer would then hand the salesperson a floppy disk with the images, and he or she would then show the images to clients while giving the sales pitch.

Such a system made portrait sales much more effective because people were seeing the results of their sitting while they were still excited and upbeat about the process, and they were more likely to buy prints.

Many of today's digital cameras offer a similar capability via an RCA- or video-out port that allows you to connect to a TV monitor. Then, you (and your clients) can view images on a larger screen.

Chapter 10: Shooting for Publication

In This Chapter

✔ **Finding outlets for print publication**

✔ **Shooting for local newspapers**

✔ **Publishing in magazines and similar markets**

✔ **Photographing for company newsletters**

✔ **Shooting for effective public relations**

✔ **Taking photos of products**

For some readers of this book, becoming a published photographer may be a lifelong goal. Many avid photographers hone their skills, trying to reach professional levels in a quest for a published credit line.

However, it's far more common for your average digital camera buff to end up shooting for publication for more practical reasons. Perhaps your parent–teacher association drafted you to publicize school events. Maybe your small company doesn't have a full-time photographer, and you, with your digital camera wizardry, seem perfect to snap a portrait of the founder for the organization's newsletter. Or, you may be a recognized expert in your hobby, customizing vintage Atari game consoles, and you would like to have a few photographs published in one of the technical magazines that are devoted to '80s-era games.

Digital photography lends itself to all these situations because you can take a picture on a moment's notice, review your results on your camera's LCD, take *another* picture if you need to, and then produce a digital file or print that's ready for publication in a few minutes. Most professional photographers who shoot for newspapers, magazines, catalogs, and other publications now use digital cameras, and you can, too.

In all these cases, your digital pictures are going to end up in print, and you need to know some things so that you can shine when shooting for publication. This chapter explains the differences in taking pictures for print — as opposed to photography that's destined for Web sites, desktop presentations, or a personal photo album. You can also find some tips on how to get published and advice on preparing your work for publication.

Finding Outlets for Print Publication

Whether you simply want to get published to satisfy yourself or you need to have your photos published to satisfy the expectations of your friends, boss, or colleagues, many outlets are available for your digital work. I describe the most common in the following list, and I look at each one in more detail later in the chapter:

✦ **Local newspapers:** Although larger newspapers may rarely publish photos from readers, smaller local papers may welcome submission of photos on behalf of your school, club, or even business. Or, you can make a habit of showing up at public meetings or fast-breaking news events. Supply enough good shots in a variety of situations, and the paper may take you on as a part-time stringer. Because digital pictures can be snapped and transmitted to a newspaper over phone lines minutes after an event takes place, electronic photos are especially appropriate.

✦ **Trade magazines:** These are the unseen publications that nobody knows about, except for the millions of people within a particular industry. You may have never heard of *Repro Report* magazine, unless you're a member of the International Reprographics Association, but that publication and hundreds like it are constantly looking for photos that are taken at member businesses, conventions, and other venues. These trade publications are good outlets for digital photography.

✦ **Company publications:** Companies of any size can never have enough photographers. If your organization is a small one, management may be delighted to find a photographer who is outfitted with fast and flexible digital gear and who is ready, willing, and able to snap photos for company newsletters, annual reports, and other official publications. Larger organizations with a full-time photographic staff may still be receptive to photos that you take at events that their pros are unable to cover.

✦ **Special-interest publications:** Every hobby or special-interest group, from collecting Seat Occupied signs from defunct airlines to protecting your right to arm bears, probably has some type of publication. If you share that interest, you can easily get your digital photos published.

✦ **External PR and advertising:** Most organizations can use photos for public relations or advertising purposes. If you're good, your work can accompany news releases or be incorporated into less formal advertising layouts. Digital cameras are good for these applications because you can create a photo in a few minutes, ready for review and approval by the big shots in an organization.

✦ **Self-publication:** The fastest route to getting your digital photos printed is to publish them yourself. Whether your interests stem from a favorite hobby or from the most arcane conspiracy theories, if you have a computer, you can create a newsletter, fanzine, or other publication and spice it up with your own photos. The best part about self-publication is that you have absolute control over which images are used, how they are sized and cropped, and who gets to see them. And who knows? If your work is good, you may get paying subscribers to cover part of your costs. In my case, I knew that no publisher would possibly want to print my illustrated guidebook to repairing vintage video games. So I took the photos, laid out the manual, and published it myself (see Figure 10-1). I've sold thousands of copies at eBay of something that I put together just for fun.

✦ **Product photographs:** Your company probably needs photos of its products for use in advertising, PR, and so on. You can take these photos with your digital camera.

Figure 10-1:
Publishing
your own
book is now
easier than
ever.

Shooting for publication isn't as hard as many people think, provided you remember that, just like an athlete, you don't start out shooting for slick, nationally distributed magazines any more than aspiring ball players begin by playing shortstop for the New York Yankees. If *National Grocer* is your target rather than *National Geographic,* you have a shot.

Local Newspapers

Your local paper is probably willing to consider your digital photos of a local event, particularly if it's a small paper. Larger newspapers prefer to use their own photographers not because they don't think your photos are good enough but because of journalistic ethics reasons. Big papers frequently face charges of journalistic bias and must be able to vouch that a given photograph hasn't been manipulated in ways that would make it misleading. Photographs that are supplied by businesses can't be used unless they are clearly labeled as a photograph that originated within that organization. However, bear in mind that even big cities have small, special-interest papers that can be a market for your pictures.

Also, remember that you don't have to limit yourself to just one community newspaper. More often than not, neighboring newspapers have circulation areas that overlap. If you know your neighboring communities well, you can also market your talents to their newspapers.

Newspaper photography is fun and challenging. This type of shooting isn't especially rewarding financially, but it provides valuable experience because you learn to adapt your photographic ability to the environment. No other type of photography offers the shooter as little control over the shooting conditions as photojournalism. For some of us, that's the best thing about it.

Understanding what newspapers need

The key to getting published in your local paper is understanding what the paper does and doesn't need from you. Newspapers have small photo staffs and can't be everywhere at once. They may send a photographer (*shooter* in the lingo of photo editors) to a major event, fire, or accident, but if several events happen at the same time, the shooters probably have to cover one or two events and let the others slide. I regularly cover events at my kids' school and submit them to the newspaper. Our paper even prints the articles that accompany the photos, as shown in Figure 10-2.

Smaller newspapers would love to receive the following types of photos:

✦ **Events:** Your club or fraternity is having its annual barbecue, banquet, or get-together. It's not a big enough deal for the local paper to send someone to cover. If you can produce some useable images, along with enough information to caption them properly, you may get at least one of them published. Newspapers are willing to run photos like these because people like to see their pictures in the paper — that helps sell newspapers.

✦ **Sports:** The paper's shooter(s) get the big ones, such as football, basketball, baseball, and so on. Your opportunity comes with the sports that don't quite get their due. For example, you can shoot track-and-field events (not necessarily the big weekend meets with 50 schools and a thousand athletes but perhaps the local dual meet). Sports such as tennis, field hockey, or lacrosse seldom get as much coverage as the big three (football, basketball, and baseball). Study your local paper to see what sports it seems to favor, and then try submitting shots for the sports that it doesn't seem to cover. Good action photos are particularly important. If you can regularly capture peak action well, your photos will be used. See Book I, Chapter 11 on sports photography for more information on how to take good sports photos with a digital camera.

✦ **Spot news:** Spot news includes things such as traffic accidents, fires, and robberies. It can be tough to succeed at selling this kind of photo unless it's your main focus. If so, a police/fire scanner is a must. Remember though, that it doesn't do you any good if you're covering the same news as the paper's staffer. Small-town papers tend to need this kind of material most and are sure to send out their own staffers at the first hint of a big story, but you may have a shot at publication if you're in the right place at the right time to take a photo of something that no one else managed to grab. (Some spot news opportunities don't last very long, which is why they're called *spot news*.) And because your digital camera film doesn't need processing, your photos are timely.

*Life*Times

RAVENNA

Teacher makes science 'egg'citing

Students motivated by newly implemented hands-on activities

Just how much does a larger parachute slow the fall of a plummeting egg? What is it like to go on an archaeological dig? Is it really possible to predict the weather? Lively experiments and creative projects are providing the answers to questions like these at Immaculate Conception School in Ravenna.

New science teacher Monica Thornton is helping elementary and middle school students discover the exciting practical applications for the dry theories and statistics found in most science books.

"Hands-on projects are a way to get all the kids interested in science," Thornton said. "Many of the students who aren't as good at traditional book-learning excel when they're asked to put what they're learned to work. I'll explain what happens to the calcium in an eggshell when the egg is left in vinegar, and the next day two or three kids will come back with the 'rubberized' egg."

Although she's been teaching at ICS for only two months, Thornton has already taken her

Figure 10-2:
Your local newspaper is fertile ground for your digital photographs.

Although dramatic photos of spot news events can produce eye-catching portfolio shots, don't forget that human emotion creates the most memorable images. This is perhaps the most difficult part of photojournalism — intruding upon the tragedy of others and recording it for the world to see. Pros don't really have a choice in this matter — it's part of the job. Freelancers, however, can choose either side of the deal.

You may run across organizations that claim that as part of their membership fee, you'll receive a press pass that can get you across police lines or into events. Be very skeptical of such claims. Usually, an organization, such as the state police (in some states) or event organizers, issues the press pass. No universal press pass exists to get you into an event. In fact, even working news photographers with state-issued press passes don't get into many events (for example, pro sports and rock concerts) unless they're specifically cleared for that event by the event organizer as well.

✦ **Hard news:** These are major news events: a speech by the mayor, a visit by the governor, certain press conferences, demonstrations, and political rallies. They're frequently open to the general public, although "official" photographers may be given a special area to shoot from.

✦ **Feature news photography:** There's a difference between a feature photo and a news feature photo. The news feature image accompanies a legitimate story with a feature edge — say, an article on family TV watching habits or a story on Civil War re-enactors.

169

✦ **Feature photography:** This part of the paper deals with its lighter side. It may involve shooting a feature package on Elvis impersonators or pictures of a local restaurant for a review. This is the one section of the paper where you frequently see *created images,* or what are sometimes called *photo illustrations.*

Working as a professional newspaper photographer

Whether you submit photographs to newspapers as a representative of your organization, as a freelancer for pay, or as an official stringer for the newspaper, you should conduct your business in a professional manner. You should consider many points. For example, do you want to be a freelancer or a stringer?

Freelancing versus being a stringer

You find two different types of affiliations for a nonstaffer: being a freelancer or being a stringer. The difference is in just how attached you and the newspaper are to each other.

Being a stringer involves the following things:

✦ **Pseudostaffer status:** Still considered an independent contractor, stringers are generally issued a newspaper press pass, or the paper gets a state credential for them (if the state issues them).

✦ **Free supplies:** Stringers frequently receive free supplies (film in the old days, notebooks, pens, and pencils). You may be able to get your newspaper to chip in for some extra digital film (that is, another memory card). That could be handy if you're rushed to get a shot published and you need to hand over your memory card.

✦ **Regular assignments:** Stringers receive assignments from the paper that they're affiliated with, frequently with a guarantee of pay, even if a shot isn't used.

✦ **Remaining loyal:** Both the stringer and the newspaper are expected to show some level of loyalty to each other, although it may not be a lot. Generally, a paper has a specific number of stringers and a rotation policy to have some fair manner of distributing assignments. By the same token, the stringer doesn't shoot for the paper's competition. (You are expected not to shoot for a newspaper that is sold in your paper's distribution area.)

Stringers are generally considered independent contractors for tax purposes and are occasionally a point of contention between newspapers and state employment officials, who scrutinize such arrangements carefully to see whether such relationships should be considered employer/employee instead of contractor/client. You should be aware of tax responsibilities in this situation, too.

Working as a freelancer has the following advantages and disadvantages:

✦ Freelancers have no affiliation to a particular newspaper, so they receive no support from any paper. However, they are free to work for any newspaper and to sell pictures to the highest bidder if they stumble on a potential Pulitzer Prize winner.

✦ Because freelancers are unaffiliated, they either don't get assignments or are at the very bottom of the list of those who do. This means that freelancers have to develop their own opportunities, which can help sharpen their news sense.

Freelancers don't have to worry about employee/employer relationships because they're free agents as independent contractors, but the same tax responsibilities apply. In the case of both a stringer and a freelancer, you can deduct the cost of your equipment and expenses that are involved in doing business. You may also have to make quarterly tax payments if this is your primary source of income.

Special considerations for news photography

Consider the following things when photographing news events:

✔ **Be aware of emotions.** Tempers can run high at both spot and hard news events. Sometimes, law enforcement personnel can overreact when things go wrong. Cameras can be broken, film can get confiscated, and photographers can be threatened. More frequently, police try to stop press photographers from working, First Amendment considerations be damned (although to be fair, this still doesn't happen that often). In such situations, newspaper photographers tend to have their newspaper's resources behind them, whereas a freelancer probably doesn't. It's best to accept that you're not on a level playing field in such circumstances. I've heard stories of photographers who have played sleight of hand with their film and turned over an unexposed roll of film when someone demanded their images. I've been ready to do so myself once or twice, but it's a judgment call for each photographer to decide the risk that he or she is willing to take.

✔ **Be different.** Your best bet as a freelancer is to deliver something different from what everyone else is doing. One of the best news shots that I've ever seen came from a presidential campaign several decades ago. The photo is of a president answering questions with a mountain of photographers pressed together, shooting away. One enterprising shooter had enough of a sense of the moment to take a few steps back and recorded the insanity of the situation. In the process, he got a timeless photo that far exceeded the images that his counterparts created.

✔ **Look for unusual angles.** Shoot from up high and down low. Try and get the shot with several different focal lengths, too.

✔ **Be careful not to get locked in on the main event.** Sometimes, the best shot comes because you look beyond the setting and uncover human nature at work. Young children can offer interesting opportunities because they don't hide their reactions or feelings as much as adults do. A sleeping child at a political event or a wedding can show humor and make a comment about how adults sometimes take themselves too seriously.

✔ **Look at the participants who aren't center stage.** Is there a clandestine conversation going on? Do they look bored? Are they looking in the opposite direction of everyone else?

✔ **Avoid the Grip 'n' Grin shot.** One person is giving an award, and one person is receiving it. The two individuals stand there gripping the award and each other, looking right at the camera and grinning. Instead of the mundane, provide a sense of what the event is about. If it's a barbecue, get behind the grills and take a shot of somebody getting a hot dog through a haze of smoke with a big smile on his or her face (hopefully wearing a cap or t-shirt with the name of the organization on it). You can mention the award that was presented at the event in the cutline (caption), but you really don't need to show it.

News photography strives for impact. Eye contact and emotions are key ingredients. Don't be afraid to compose your shot tightly. The image should have a single focal point, not multiple ones. Whether you're shooting for a newspaper or the World Wide Web, space is valuable, and images should be tightly cropped and easily understood.

Newspaper Web sites have created a new concern for freelance photographers. Many papers now require freelancers to sign over more rights or all rights to any images that are used in the paper as a result of some recent court decisions. These rulings have indicated that freelancers still retain the other rights to their images, even if a photo appeared in the paper. Because many newspapers were making their entire issue available online, the decisions meant that the papers were violating the freelancer's copyrights. Most of the time, the loss of the additional copyright doesn't get you additional compensation. Only you can decide whether giving up all rights to a particular image is worth the chance of getting your work published.

Getting your foot in the door

How do you become a stringer or freelancer? It's usually best to make initial contact by mail. A simple introductory letter that identifies you as a photographer who is interested in working as a stringer or freelancer, plus some samples of your work, should be enough. Don't overdo it on the number of samples that you send. Two or three shots that demonstrate your ability should suffice.

Then, follow up. In your letter, say that you're going to call in a day or two to discuss how you may be able to help the paper. At this point, all that you're aiming for is a chance to meet the editor, show him or her your portfolio, and sell the idea of your contributing. The smaller the newspaper, the better your chances (although the smaller the pay, too).

Be thorough in your examination of the potential marketplace. Many areas have more than one newspaper and thus more than one opportunity for freelancing.

Magazines and Magazine-Like Markets

Breaking into magazine, book, or stock photography presents a different set of challenges and opportunities. Magazines offer the most opportunities. You can find many different types of magazines that target a variety of audiences. These magazines include the following:

✦ **Trade journals:** These are specialized publications that although perhaps not glamorous, are potential sources of sales for enterprising digital photographers. A *trade journal* is a magazine that covers a specific industry or profession. These magazines are seldom found on newsstands and are instead distributed mainly via subscriptions. Although they may not pay very well, if at all, they tend to be the easiest magazine market for novices to break into. If you know of a trade journal for your particular profession or trade, you probably have a good place to start because you already have knowledge and experience in the industry. Your chances of acceptance improve even more if you can package a story with your photos. This is also a good market for event photos within your industry, particularly if you can produce interesting images.

✦ **Special-interest magazines:** These are mass-market publications that are geared toward a specific interest. These include magazines such as *Tennis, Popular Photography, Cat Fancy,* and so on. This market is harder to break into than the trade journal market because these magazines

tend to pay better than trade journals and because more writers and photographers want to be published in them. Read the guidelines, study the magazine thoroughly, and query the editor before submitting anything. In many cases, these magazines are more receptive to photo-only queries. Regional travel magazines may be a good bet. If you get a good photo of an unusual or out-of-the-way travel destination, like the one shown in Figure 10-3, you may have a sure sale.

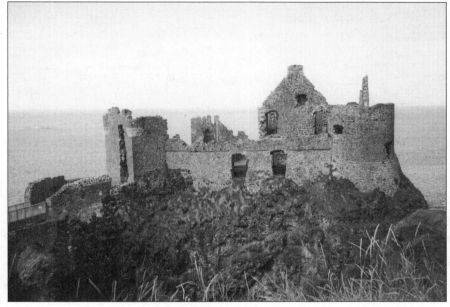

Figure 10-3:
If it's off the beaten path, you have a great chance to sell a photo.

- ✦ **Mass-market major magazines:** Examples of these magazines are *Time, People, and Cosmopolitan.* These are the heavy hitters of the magazine world. They're also incredibly difficult publications for beginners to sell to. Many times, these magazines don't consider unsolicited submissions and probably won't take your query letter seriously, either — unless you have some kind of established track record as a professional photographer. An amateur photographer generally needs a remarkably newsworthy image to have a chance to sell to one of these magazines.

Other markets include the following:

- ✦ **Books, textbooks, and photo books:** The good news is that this market can be a reasonably easy one to break into. The bad news is that book editors are notoriously cheap, grumpy, and hard to deal with. (Just kidding! They're actually kind, supportive, and generous; plus they edit books such as this one.) Unfortunately, the book-publishing industry is extremely competitive, and the sad truth is that many books don't turn a profit. (Please buy an extra copy of this one! It can make a great gift.) So, although there is a need for good photography, you seldom find a lot of money in it. Find a publisher whose line of books appeals to you and query about its photographic needs and policies, or check the appropriate market guide book. A coffee table or photo book is a tough sell, even for established pros, and requires the highest-quality photographic images to support the higher resolution that these books demand.

✦ **Stock photography:** The concept sounds great: Sell the same image over and over, and make lots of money. No, it's not a telemarketing scam or multilevel marketing scheme; it's the world of stock photography. You deal with stock photo agencies, which keep carefully categorized images in a database that they can access to provide virtually any sort of picture (including yours) at the request of a client. To break into this business, you need *lots* of photos (thousands) to make taking you on worth the agency's time. Figure 10-4 shows an example of a generic photo that *may* be useful as a stock picture.

✦ **Web stock agencies:** A number of small stock outlets have sprung up on the Internet thanks to its worldwide reach, easy accessibility, and relatively low cost compared to the prime zip-code real estate that's used to house the big agencies. The problem facing the small Web outlets is that they seldom have enough images to make photo buyers happy. The advantage to them is that they can provide a starting point for photographers whose portfolios are too small to interest the big agencies. Of course, if your stock of images is that small, the odds are against your having much success. Still, most agencies operate on a 50/50 split arrangement, with no charge for displaying your images, so it's an opportunity for you to get a lot of images online without the need to have your own Web site or server.

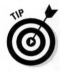

Shooting stock pictures is one area in which having a spouse and kids may pay off. Photos of family interaction, pensive teens, and children at play are all marketable stock images. How about a boy and his dog? A girl and her cat? Study advertisements and brochures. Although teams of professional artists, designers, and photographers sometimes create images specifically for an ad or brochure, more often than not, these pictures have been assembled from stock images. Advertisers sell products by showing normal, everyday people whose lives are enriched by their products. Theoretically, your family qualifies as normal. (Heaven knows, I wish mine did!)

Remember the basic tenets of photography: The picture must be in focus and properly exposed. I find it amazing just how often these basics don't get met when people are submitting photos to their local newspaper. I know — at one newspaper I worked for a few years ago, I was the one who had to weed through all those pictures trying to find something that we could use.

Start by sending your best work. Publishable photographs are different from fine art. The purpose of publishable photos is to communicate as simply and effectively as possible. Because you can do that, follow these guidelines to take the next step toward seeing your work in print:

✦ **Plan to be organized.** Have a filing system that enables you to identify and locate a particular image.

✦ **Be ready to do some research.** Your local library is sure to carry references, such as the *Photographer's Market,* but it may pay to invest in your own copy because *Photographer's Market* provides information on a wide range of possible markets.

✦ **Consider ordering your own business cards and stationery to best present a professional appearance.** If your budget allows, consider a promotional piece, such as a four-color postcard or a print that shows some samples of your best work.

Figure 10-4:
A good
stock photo
can be a
real money-
maker.

Making the leap to published photographer is within the reach of many talented amateurs. It's just a question of understanding what markets are out there, how to make contact, and what the markets need.

Making contact

The magazine industry does not respond well to unsolicited photographs and manuscripts. Although you have a better chance of getting published with a trade journal than with most others, you improve your chances by sending the publication's editor a carefully worded missive indicating what he or she can expect.

Sometimes, a publication accepts unsolicited photos or manuscripts. (This is usually noted in the magazine's masthead.) If so, be selective. Don't bombard an editor with a submission or more per week. (Editors can get restraining orders, too.) Instead, send only your best. Either include an SASE (self-addressed, stamped envelope) with enough postage for the editor to return the photos to you, or attach a note saying that they don't have to come back. (In the days of typewritten manuscripts or hand-printed photos, this whole issue used to be a much bigger deal than it is now.)

Write a query letter to introduce yourself. Talk about your experience in the industry, plus your experience as a writer and photographer if you think it will help. Let the editors know what your photo or story idea is and how you plan on approaching it. Indicate that you're familiar with the publication's guidelines for writers.

Writer's and photographer's guidelines are frequently available on the Web or by mail and are sometimes even noted in the publication itself. Books such as the *Writer's Market* and *Photographer's Market* appear yearly, providing useful information on many publications. Generally, this information tells you how publications want materials to be submitted. (Do they accept digital photos? Should you submit prints with them? How should prints be packaged? Do the publications accept work from freelancers?) Publications such as trade journals are more forgiving if you violate their writer's guidelines than other magazines are, but it's still best not to do so. (Remember, you're trying to convince them that you're a professional.)

Regardless of the individual guidelines that a publication may have, you would be wise to keep the following points in mind:

+ **Be enthusiastic!** You can't expect editors to get fired up about your idea if it sounds like you find it dull. Tell them why you think their readers will want to read your story.

+ **Submit on spec.** It's important to mention that if the editor is interested in your work, you would be willing to submit it on speculation. This means that you prepare the work at your own risk, with no guarantee that the publication will use it. This kind of thing lets the editor know that he can encourage your submission without having to worry about what will happen if you're rejected. (Editors have nightmares about beginning contributors threatening lawsuits because they expected to be published, even though the editor only agreed to look at a submission.)

+ **Send in your tear sheets.** If you have samples of published work (usually referred to as *tear sheets*), submit the best one or two (three at the most) pieces that you've done. Quality is much more important than quantity here. If you don't have something good to submit, don't submit anything unless the editor or guidelines ask for it. Frequently, editors take on mediocre writing with good photography simply because they can improve poor writing but may have trouble finding good photography.

Trade journals are the best place to start if you're interested in expanding beyond newspaper work. They tend to be receptive to freelancers, and they provide the opportunity to contribute both photos and text. If writing isn't your thing, consider teaming up with a newspaper staffer or stringer who is also looking to expand his or her reach.

Editors hate submissions and query letters that make it obvious that the person who is contacting them hasn't even looked at their magazine. Most publications offer copies at a reasonable rate for would-be contributors, or your local library may have back issues available. Get to know the magazine before you propose a story idea. Studying back issues tells you if you've been beaten to the punch by another contributor, or you may find out that a publication is the wrong market for your submission.

Submitting photos

Quite a few publications remain cautious about accepting digital submissions for final publication (perhaps accepting CD submissions for portfolio samples) and may not even be willing to consider them. If the fact that your images are digital is the only thing preventing them from acceptance, consider converting them to analog artwork. A few publications accept prints,

but these are in the minority. Generally, the hands-on favorite for submission, even now, is transparencies, or *slides*. The good news is that you have a couple of ways to get 35mm slides made from digital files, as follows:

✦ Online photo labs frequently offer this service. One such lab is `www.slides.com`, which charges about $4 per slide.

✦ Get a 5-x-7 or 8-x-10 print made from your digital file and load up your film camera with a good-quality slide film. Then, either set up a copy stand (the camera is placed parallel to print with two lights placed at 45-degree angles to the print) or your tripod, and photograph the print.

As time goes by, more publications are accepting digital images. Odds are that your local newspaper will. It's a nice feeling to discuss an image with an editor, e-mail him or her the image, and find out that it's been accepted, all in a single afternoon! (This is particularly true when you're selling a shot for the second or third or fourth time.)

Getting model releases

A *model release* is a written permission to use a person's likeness. These documents are popular with publishers because they help protect the publisher from nuisance lawsuits. The need for model releases depends on how the images are to be used. Newspaper photographers, for instance, seldom bother. "Editorial" use is generally recognized by the courts to support the public good and provides some protections to such publications that are expected to meet that need. Newspapers, news magazines, and books are usually considered to meet the editorial-use standard although most book publishers desire model releases anyway. Advertising photography, on the other hand, receives no such help. If your photo is going to help sell a product, have a model release for every *recognizable* individual in the shot.

Even as a newspaper photographer, I still tried to be careful when it came to photographing children. I would usually look for the adult caretakers first, introduce myself to them, explain my purpose in taking pictures of the kids, and give them one of my business cards before asking their permission to shoot. It was perhaps more than I needed to do, but parents rarely objected after they knew who I was and why I was taking pictures of their kids. Skip this approach, and you may end up explaining yourself to a state trooper instead. Also, a parent or guardian must sign model releases for minors if you want those releases to count.

A model release doesn't give you carte blanche to play with a person's image, which is something that's very easy to do with a digital photograph. Taking someone's image under innocuous circumstances and then placing the image into what could be considered an embarrassing photo composite could leave you open to a lawsuit. When in doubt, be careful and consult with a lawyer or discuss the potential use with your subject (making sure that your model release reflects the potential use and the subject's awareness of it). Model releases are particularly important for stock photography, where the image could end up being used for just about anything.

In some cases, public figures receive less privacy protection than private citizens when it comes to editorial photography. (Think of how the paparazzi chase celebrities. If you followed your private-citizen neighbor around that

way, your future cellmate would no doubt be amused to hear how you ended up in jail.) No such leeway exists for advertising-related uses, particularly because celebrities can argue that their likeness has a monetary value and that your image is lowering its value.

Taking Photos for Publication

This section details the special needs of each of the most common types of photography for publication, such as group and PR photos. In each section, you can find suggestions for taking great photos in a variety of situations. These photos can fit in with many different types of publications, from newspapers to trade magazines or company in-house newsletters or magazines. The tips in this section can be applied to many different types of print destinations.

Understanding group photography basics

Photographing groups can be an interesting challenge, one that calls for more skill as the number of people in the shot grows. As you add more people to the frame, it becomes more difficult to catch a moment where everyone has a pleasant expression. As the numbers increase, faces get smaller, making it increasingly difficult just to make sure that everyone is visible in the shot.

Group shots are popular and, for the photographer who can do a good job, rewarding. As souvenirs of large events, they're a well-accepted and comparatively easy way to commemorate a gathering. People have also become so trained to expect a group shot that trying to get through an event without taking one is almost a sacrilege. Thankfully, taking good group photos isn't impossible; you just need some planning and the right tools. These photos are perfect for trade publications that are looking to publicize member groups, or for your local newspaper.

Pose your group to conform to your camera's image area. For virtually all digital cameras, this means a horizontal rectangle that conforms to roughly a 2:3 aspect ratio.

How you pose a group depends on how many people you're working with. For more about the diamond formation for groups — and more information about composing group shots — refer to Book I, Chapter 9.

Managing the group

People tend to get impatient in such situations, especially if they're among the first to get posed. Staying enthusiastic and cheerful buys you time and patience from your subjects. Some of the following ideas have proven to work in the past:

✦ **Don't worry, Mon.** It helps to explain to your subjects not to worry about posing until everyone is in place. Keep them relaxed as long as you can, because posing is tiring and stressful for most people.

✦ **Please, stay put.** I usually stress to people that I'm going to take more than one photo and ask them not to flee like startled deer the first time my flash goes off. (Every time they laugh at one of your jokes, you've gained a couple more minutes of patience from them.)

✦ **Flashers.** If your digital camera uses a preflash or red-eye reduction of any sort, either turn it off (if possible) or alert your subjects to ignore the preflash. Otherwise, they will release their poses just as the main flash fires. When you're ready to shoot, tell everyone to look directly into the camera lens. Look carefully through your viewfinder and quickly check each person to make sure that you can see everyone's face. If you can't, stop and correct poses. If you can, start shooting!

Keep your sense of humor, no matter how challenging the group shot may get. If you can keep everyone smiling and relaxed, you'll get a good shot sooner or later.

Having people say "Cheese" is a no-no. Every portrait photographer has a bag of phrases to get his or her subjects to smile.

PR photography

Public relations photography frequently looks like photojournalism, but there's an important difference. Newspaper photography tries very hard to be balanced, objective, and unbiased; PR photography doesn't.

Lighting groups

Follow these general tips when lighting photos that you hope will be publishable (see Book I, Chapter 9 for more information on lighting):

✔ **The pro way:** To light this setup, use a pair of studio lights that are firing into umbrellas or soft boxes about 6 feet apart and angled toward the center of the group. A third light is positioned behind the group and pointed at the backdrop to provide some separation from the backdrop. Set your light's power output to maximize your depth of field. If you're doing multiple sittings, use masking tape or gaffer's tape to restrain your cables so that people don't trip over them.

✔ **The serious amateur way:** A less professional setup that can still deliver good results is to use multiple slaved portable flashes (see Book I, Chapter 6 for an explanation of photographic slaves) without the backdrop. You find three problems with this approach: The flashes don't recycle as quickly as the studio lighting setup, the flashes don't put out as much

light — meaning that you have to go with a shallower depth of field — and the lack of a backdrop means that the photo's background may detract from the overall image quality. Few publications will use a photo that has a distracting background.

✔ **The not-so-serious amateur way:** One flash, straight ahead. It's not elegant, the light's kind of harsh, and you risk getting red-eye, especially with kids. Getting your flash up higher helps prevent red-eye and gives you a nicer light, but even one flash can do you some good because it helps clean up shadows on your subjects' faces.

✔ **The "Oh My God, What Were You Thinking?" way:** The camera's built-in flash. You've got to be kidding. Most built-in flash units have a range of about 8 feet. This flash may do some good with a small group, but it's useless with a big one. Publications will reject large group photos that are poorly lit with a puny flash unit.

The goal in PR photography is to present your client in the best possible light. This kind of photography calls for a good sense of diplomacy and the ability to work as a member of the team with the company's public relations personnel. Generally, the PR department has some specific ideas of the message that they want like the image to convey.

PR photography can take many forms. It may range from creating executive portraits for senior company personnel to special-event photography to taking photos for the company newsletter or a sales brochure. The next sections cover these particular varieties of PR photography in greater detail.

Executive portraits

Executive portraits can vary and include basic head-and-shoulders portraits, commanding-executive-in-charge-at-the-helm/desk photos, and leader-with-his (her)-troops pictures. You can find more on shooting portraits in Book I, Chapter 9, but for now the following points outline the basic kinds of executive portraits that you may be asked to shoot:

✦ **Head-and-shoulders:** This is a basic portrait. Use a portable studio lighting setup, and take a variety of shots and poses, including smiling, visionary, and serious. Don't be surprised if an executive has some very clear ideas about how he or she wants to look. You and the PR staffer should look the execs over carefully to make sure that they look their best. If they don't, offer them a mirror and a comb (if their hair is out of place) or a lint brush (if their clothes need it). Use an appropriate backdrop. The PR types in your organization can suggest the best backdrop for a particular executive.

✦ **Desk:** This portrait shows the captain of industry hard at work at his or her desk. Skip the backdrop, but check the background thoroughly through your viewfinder. Some honors and photographs are fine, but if the backdrop is too cluttered, consider changing camera angles a bit to clean things up. Because you're shooting the exec at his or her desk, you photo should indicate that it's a working space. A neatly arranged pen set and a single document on the gleaming mahogany desk is plenty. In any case, don't show a messy, cluttered desk.

✦ **Confab:** This shot is a bit trickier. The idea is to show the exec as an "in-charge" leader. This is usually done with the standing exec giving instructions to a pair of underlings. The exec is turned toward the camera (slightly angled), with the underlings posed mostly away from the camera. Underlings should be carefully selected (this is the PR department's job) because it's an opportunity for the company to show that it is an equal opportunity employer, or minority employer, for example.

✦ **Setting:** The setting is usually taken in a nicer section of the company headquarters, but it could also be in a location that showcases something about the firm. Location could be anything, including a shipyard, an oil field, a factory assembly line, or a restaurant.

✦ **One of the gang:** This shot is for the charismatic executive whose rapport with the troops is legendary. Forget the suits, mahogany desk, and rich carpeting. Instead, he or she is dressed casually. In fact, it should be hard to tell the executive from the employees, except for the fact that everyone in the photo is hanging on his or her every word.

✦ *Really* **one of the gang:** From time to time, you need to take a head-and-shoulders shot of someone who really is one of the gang: a nonexecutive, nonmanager, ordinary star-of-the-warehouse type. Maybe he or she had a great bowling score on behalf of the company team or perfect attendance for ten years. In such cases, a formal portrait would be inappropriate. You need to be prepared to grab a simple, flattering head-and-shoulders shot, like the one shown in Figure 10-5.

Being able to produce a wide range of executive photos is a good skill for a PR photographer because a place always exists for these images, whether in the company newsletter or the latest annual report.

Company events

Shooting company events usually revolves around documenting activity for outside company publications and for distribution among employees. This usually means that the photographer is expected to take a lot of pictures, and the biggest challenge is in being thorough enough.

You may be called on to capture the following company events:

✦ **Dinners:** A company can hold a dinner for a lot of reasons. Plan on getting photos of the speakers, award recipients (if any), company executives, and as many attendees as possible. Special-event dinners (fund-drive events, seasonal parties, and recognitions of company accomplishments) should also include photos that show why the event is being held.

✦ **Outings:** An organization may hold a retreat or conference. These gatherings feature a variety of events, some meant for fun and some for training. Plan on taking lots of shots of the individuals who are participating in these events. Start by making sure that you get the bigwigs. While you're looking for good photographs, also make sure that your shots are positive and present the employees in a good light.

✦ **Company-sponsored sporting events:** Book I, Chapter 11 — the one on sports photography — applies here, with the added reminder that you're still shooting a corporate event first and an athletics meet second. Document elements that show the company relationship to the sports event (banner or logo, for example), and get good souvenir photos for the amateur athletes (particularly if they are company employees). Posed shots and camaraderie photos are good, too.

✦ **Family events:** A company may hold an open house for employee families so that they can see what their family members do and where they work. Get plenty of shots of employees demonstrating their jobs for their families.

✦ **Community relations events:** Many companies work hard to be good corporate neighbors. Employees are encouraged to volunteer as mentors or to give time to public service efforts, such as Habitat for Humanity. If you're asked to shoot a community relations event, plan on getting newspaper-type photos for use in the company newspaper or newsletter (and remember, accentuate the positive results of the event). You should also take pictures for the company to hand out to its workers. (Companies motivate and reward employees for doing things like this in many ways. T-shirts, coffee mugs, and souvenir photos are the top three.)

Figure 10-5:
Look, a quick portrait of a regular guy!

Arranging a PR event that's worth photographing

If you're shooting for your own company and your company is a small one, as you take more photos for company purposes, you may find yourself as the in-house PR "expert" and be asked to help put together events that are covered by photographers other than yourself. You really understand the needs of other photographers, too! That's great because putting together a photo-worthy event calls for an understanding of the needs of the photographers that you're inviting and for optimizing your own chances to get good photos alongside them. Press photographers are paid to create strong, exciting visuals.

You can do the following things to make an event more successful:

✦ Choose a location that provides a strong backdrop for the speaker or ceremony.

✦ Include elements that reinforce the purpose of the event. For example, if it's a groundbreaking or building dedication, try to get some construction equipment in place to frame the podium or platform. Hang banners off the buckets of front-end loaders that identify your company and project.

✦ Give the other photographers handouts that make it easier to identify each person who is participating in the event. This should include a photo of each person, with his or her name and title securely attached to the picture. (It can also be a printed sheet with a bio. It doesn't have to be an actual print.)

✦ If you are holding an outdoor event, be prepared for bad weather by having an awning available on-site. Try to set up things so that photographers can still get a good backdrop for their photos.

On the day of the event, check on all the small details that can come back to haunt you, such as confirming the presence of equipment, banners, handouts, and so on. Next, check the weather forecast. Have some people available to help answer questions from the photographers or provide extra handouts.

Refreshments for the press and guests are a good idea, but you don't have to go to extremes. You should probably worry more about having the appropriate refreshments for the company bigwigs than for the media.

Other photo-worthy events

Your company may welcome members of the community inside its doors. This can be a good opportunity for creating images that you can place in your local papers.

Consider these proven winners for enhancing the image of a company through . . . well . . . images:

✦ **School tours:** Does your company do something that may make a good tour for the local school? If so, bringing a group of school kids in can provide tons of photo ops. Some typical images include an employee demonstrating a piece of equipment to the kids or one of the kids learning to use a piece of gear (keeping safety in mind at all times). Be sure to have your company's name or logo on the equipment so that it shows up in the photo.

✦ **Mentors:** Does your company have a mentor program? If so, the interaction between your employees and their protégés can also make a good image. In this case, you're shooting at the school instead of your facility, so you don't have as many opportunities to get your company's name in the shot. At least make sure that the name is in the photo's caption.

Producing placeable PR photos

Successfully placing images that were taken specifically for PR purposes with your local media is both an art and a science. Remember that you're trying to meet your needs (placing your company's photos) as well as those of the newspaper (strong images).

Newspapers know what you're trying to do: That is, get your company some free publicity and credibility. They also know that they have an advertising department that exists to help pay the bills. They're not giving away free space, but if you supply a good image, it may be used.

Understanding your markets is important. Many local newspapers are willing to consider photo submissions, but each paper has its own criteria for acceptance. Newspapers use PR photos for a variety of reasons. Some of these reasons are as follows:

✦ The images are of high quality and show members of the community doing something newsworthy (like building homes for Habitat for Humanity, running a dunk tank to raise money for charity, and so on).

✦ The images fill a need that the newspaper couldn't fill on its own because it was understaffed, or the event occurred over a weekend and the newspaper staff couldn't cover it.

✦ The newspaper is willing to "sacrifice" a couple of pages to run photos from groups and organizations that want publicity. You can easily determine whether your newspaper does this: Look for the section near the back that has a couple of solid pages of Grip 'n' Grins (those trite photos of two people shaking hands and grinning at the camera).

Many newspapers also run a Neighborhood or Region section. (Lots of names are used for this part of the paper.) Such a section is geared toward the local community. In fact, when a newspaper hits a certain size, it will probably print a different section for local communities as a special insert. This means that you have even more opportunities to place photos! Even if your company isn't located in a community that the paper covers, some employees who work for your company probably live there.

Printing your PR photos

After you've created your publishable PR images, give yourself the best chance you can to get them used. While Book I, Chapter 20 covers printing digital images in more detail, I discuss some general observations in the following paragraphs.

As a bureau chief for one publication that I worked for, I was frequently amazed at the number of low-resolution ink-jet prints that I used to receive from PR and marketing people. To make matters worse, these images were frequently printed on cheap typing paper. Needless to say, they weren't used. (I'm not referring to "proof" images that accompany a digital file here; those are okay.)

Instead, you should use one of the newer high-resolution ink-jet printers (1400-dpi or higher) that can produce photos that are as good as those you get from conventional film finishers and photofinishers. If you don't have such a printer, your local pharmacy or department store may have a stand-alone kiosk or an in-house digital minilab that can produce high-quality photos from your digital files.

Writing cutlines

Cutlines, or captions, are vital to getting your photos used. Newspaper editors know that nothing infuriates a reader more than seeing his or her name misspelled or being misidentified in a newspaper photo. As a result, most papers set very strict policies for their own staff on this kind of thing. (Three strikes and you're usually out of a job.)

Good cutlines provide the basic information and get it right. Include the following information in your cutlines:

✦ Make sure that you have the correct spelling for the names of everyone who is appearing in the picture, and triple-check to be sure that no typos sneak through.

✦ Make sure that each name is identified with the proper person — usually by designating "from left to right" or "l to r."

✦ Now that you've made it clear who the people in the photo are, describe what they're doing and why it's important. Make sure that you also identify your company or client.

✦ Provide your photo credit ("Photo by John Doe"). Include your contact information.

Cutlines need to be accurate, concise, and informative. Plus, the cutline is your chance to mention your organization's name in the publication.

Preparing the cutline for submission

After you've written your cutline, it's time to affix it to the print. You must do this so that the print and cutline can't be separated by accident.

The standard method of preparing a cutline is as follows:

1. **Set your margins so that they're narrower than the print's horizontal dimension, and give your cutline a top margin of about 1½ inches.**

2. **Print the caption, and trim the sides and bottom to about ¼ inch from the text, while leaving the top margin alone.**

3. **Turn the print face down, and position the facedown cutline on top of it.**

 Line up the cutline so that the top line of text is slightly below the bottom of the print, and use a small piece of tape to affix the cutline to the back of the print.

4. **Turn the print and cutline back face-up, and fold the cutline sheet up and over so that it covers the photograph.**

 Now your picture and cutline, as shown in Figure 10-6, should fit neatly into an envelope, with the cutline sheet offering some protection for the face of your print.

5. **Before placing your print in the envelope, though, sandwich it between two pieces of corrugated cardboard, and rubber-band the sandwich together to keep it from being damaged in transit.**

Professional packaging and presentation can help you put your best foot forward and improve your chances of getting your photos accepted.

Submitting the photo

You have a nice, professional package now, but you're not done yet. Now you have to prepare a cover letter that tells the editor why you're sending her these photos. Follow these guidelines when writing your cover letter:

✦ Be brief. You need only a few paragraphs to explain what the event was about, when it was held, and where.

✦ Make sure that the appropriate contact information is provided in your letter.

✦ Check the newspaper's masthead, and address the envelope to the photo editor (if the paper is big enough to have one), the Neighborhood section editor if the paper has a Neighborhood section, or just the editor if it's a really small paper.

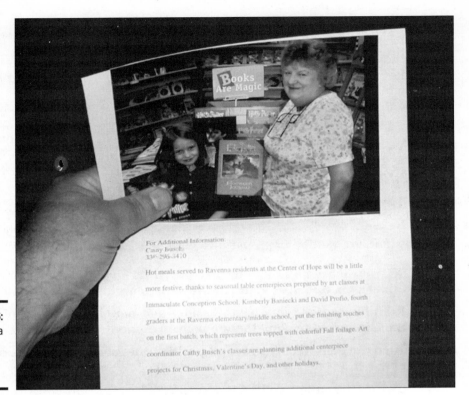

Figure 10-6:
Preparing a
photo and
cutline for
shipping.

✦ Keep a log that identifies the image (something like 20020821.03 to indicate 2002, August 21, third photo release of the month), the newspaper(s) that you've sent the photo to, and the date you mailed it. Make sure that your cutline includes this release number. Also identify whether the photo is for immediate release or for use on a future date.

Follow up

A few days after mailing your photo submission, call the newspaper and ask to speak with the appropriate editor. Say that you're calling to follow up on a photo submission. When you're connected, identify yourself and say that you're checking to see whether the editor needs any additional information.

Be sure to check the appropriate papers to see whether they've run your image. If so, buy a couple of copies for tear sheets for your files. Note the log number on your file copy so that you can match it with the appropriate photo. Get in the habit of comparing your successful and unsuccessful images so that you can see what kinds of images your local paper favors.

Product Photography

Product photography is a specialized type of photography, but it is one that offers good opportunities for the enterprising photographer. This type of photography is all about making your clients' products look as good as possible. You can do this in several ways, and you can find more information on photographing objects close-up in Book I, Chapter 8.

If you think that this type of photography is the exclusive preserve of the big-name advertising photographers, agencies, and art departments, you'll be happy to know that the reality is far different. Opportunities for this type of work are very open to talented, freelance photographers.

Product shot opportunities

Lots of manufacturers make product lines that are sold through catalogs. These manufacturers constantly need fresh images, because these catalogs are issued as frequently as once a month. Success in this type of photography calls for the following skills:

✦ **Speed:** Be prepared to work quickly and efficiently. Set up a standard lighting package that provides clean, even lighting. This generally means setting up a tabletop station with a pair of lights that rake across the product at 45-degree angles and that are positioned at a right angle to the camera.

✦ **Simplicity:** Your tabletop setup should be as simple as possible. Plan on using seamless paper that you can advance on a roller. Then, when one section gets dirty, just advance the paper to another stretch where it is clean. Your close-up photography skills should be well honed, too, because many product shots are close-ups of components, like those shown in Figure 10-7.

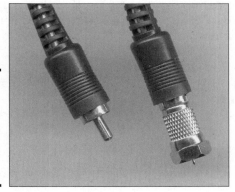

Figure 10-7: They may not be exciting, but product shots can pay the bills.

✦ **Flexibility:** Your digital camera and tripod rig should be versatile enough so that you can change its position quickly and easily. Some tripod manufacturers offer dollies (a small platform with rollers) that the tripod can be mounted on so that you can reposition it easily.

✦ **Recordkeeping:** Be sure to have a workable recordkeeping and indexing system in place so that you can keep track of what you've shot and when, because clients frequently need this info.

Product demo shots

These photos are designed to either show what the product can do or how it is correctly used. The idea is to create an image that shows a typical person successfully using the product for its designed purpose. Some examples of product demo photos are as follows:

✦ **An attractive person reclining on a pool float, looking relaxed and happy (selling the pool float).** Shoot this scene from a variety of angles, including getting up on a ladder to shoot down on her. Use an image-editing program to tweak the pool water's color to be a nice, rich blue. Be careful in your choice of lenses here. Longer focal lengths are more flattering. You probably need flash here to clean up any shadows, too.

✦ **Cyclists standing with their bikes, happily discussing their planned ride (selling the bicycle).** Use a long telephoto lens for this image. The couple and the bikes should be in focus, not the background. Use late-afternoon light to add a rich glow to the scene.

✦ **A woman stroking her pet cat while it laps up a saucer of milk that's not just any milk, but a specially formulated milk just for cats (the product box can be in the photo or be composited in later).** Use your portable studio lighting setup here and a short telephoto or modest wide-angle lens, depending on how much space you have to set up your photo.

✦ **A businessperson working on a portable computer (selling the computer).** If the shot is outside, use fill flash and a medium telephoto lens. If it's inside, use your portable studio lighting kit and the medium telephoto lens. Set your aperture based on your background. For the outside shot, a wide-open lens that throws the background out of focus generally works fine. Inside, if you have a particularly good background (say, a nice study), take advantage of it and reduce your f-stop to increase your depth of field.

✦ **The product placed as it is set up for use.** Figure 10-8 shows a shot that's arranged to show how a product is used. All the extraneous information has been excised, making the final photo abundantly clear.

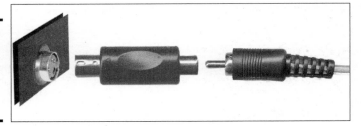

Figure 10-8: A shot like this helps the reader follow a procedure.

The idea is to sell viewers on the idea that buying this particular product can enrich their lives in one way or another.

Of course, sometimes you don't want to show the product being used. When that happens, the photographer must invoke a mood that the product manufacturer finds desirable. For instance, I would never show a sample of kitty litter being used. Instead, I would create an image of a cat bathing itself in the foreground, with a dinner party in the background. The text for the ad could then read "Brand X Kitty Litter: You'll never know it's being used."

Chapter 11: Sports and Action Photography

In This Chapter

↳ Choosing your equipment

↳ Taking outstanding sports pictures

↳ Choosing your spot

↳ Capturing your first action photo

↳ Shooting sequences

Digital cameras offer at least one advantage and one disadvantage when used for sports and action photography. The big advantage lies in the ability to shoot an almost unlimited number of pictures in your quest to capture the peak moment of action, but without burning up dozens of rolls of film. In times past, professional photographers had an edge in this department because they could justify using tons of film at a single event. Today, you can "erase" mistakes and bad shots from reusable digital film, so your errant photos aren't necessarily captured for eternity.

The chief disadvantage to digital cameras is that many models don't respond as quickly as you like when the shutter release button is pressed. Even a pause of half a second is too long when the decisive moment in a contest is framed within your viewfinder or LCD screen for an instant.

Fortunately, the advent of affordable digital cameras allows photographers who don't have a newspaper or magazine paying for film to shoot enough to create high-quality sports images. And, you can work around the digital camera's main drawback lots of ways. This chapter focuses on ways to use the strengths of digital photography to get great sports and action photos and offers tips for minimizing the technology's weaknesses. Read on and see what pros and amateurs alike can do to get the picture.

Choosing Your Weapons

Sports photography calls for a range of tools that can help put you in the best possible position to get the shots you need. This doesn't mean you need to break the bank to get good images, though. Many of the current crop of digital cameras — from digital SLRs to point-and-shoot versions — offer powerful capabilities of their own.

Sports photography does have specific requirements, and you should consider a number of things when assembling your sports photography arsenal. I explain these key needs in more detail later in this chapter, but this summary will get you in the proper equipment frame of mind:

✦ **Go long with telephotos.** To get the best sports photos, you want to get as close to the action as possible. That's enough of a challenge for pros equipped with press passes and access to areas set aside for their use. Imagine how tough it is for someone who has to get shots from the stands. If you can't get close, your digital camera's telephoto zoom setting or add-on telephoto attachment is your best friend. For sports photos, a camera with a 3:1 or 4:1 zoom lens is almost essential. You can find pro-sumer digital cameras that take you even closer with 10:1 zoom ratios.

✦ **Go wide.** Wide-angle capability also comes in handy for sports photography. Certain sports, such as skateboarding and rollerblading for instance, photograph quite well from a low position using an extreme wide-angle view. A wide-angle capability is also great for getting an overall view of a sports venue or crowd, as shown in Figure 11-1.

Figure 11-1: Do you think they have a phone we can use?

✦ **Light up your sports life.** If you want to shoot sports at night, an accessory flash unit can greatly improve the quality of your photography because that brief flash of light can freeze action. External flash units can even be a big advantage during the day if you're photographing outdoor sports such as baseball — the flash lights up those inky shadows on the upper face caused by the caps many athletes wear to shield their eyes. Of course, you have to be close enough for the flash to be useful.

✦ **Take along lots of digital film.** Sports photography can fill your digital storage media faster than most other photographic enterprises. At an exciting game or match, you may find yourself shooting more photos in two hours than you took during your entire vacation. Yet, other than timeouts or halftime, you have very little time to review your photos and erase the duds to free up storage space. The solution is to take a lot of digital film with you and use it freely.

Digital camera features and action photography

This section reviews how some specific camera features can be best applied to action photography.

Viewfinder

Most digital cameras have an optical viewfinder and a color LCD panel. You need to know when to use each of them when taking sports photos. Some general rules to keep in mind:

✦ Use the optical viewfinder to follow action prior to squeezing off a shot. You can view the subjects continually through the viewfinder under just about any lighting conditions. Although optical viewfinders can be difficult to use under very low light levels (when you need to use a flash instead of existing light to take the picture anyway), optical viewfinders are still a better choice than the LCD panel for following fast-moving events.

✦ Sometimes, it helps to keep your other eye open while looking through the optical viewfinder, giving you some peripheral vision that will alert you when the action is about to enter the frame.

✦ The LCD screen is invaluable for reviewing your images immediately after creating them. Most cameras can be set to display an image on the LCD for a few seconds while the image is being saved to your digital film. Take the opportunity to review the image. Even if it's great, you may learn something that will enable you to do better on the next shot!

Using your camera's LCD review feature

Here are some things to look for when reviewing your action shots:

✔ **Composition:** One of the most valuable things your LCD screen can do for you is to confirm that your composition is what you want it to be. Considering that, with sports photography, you're dealing with athletes moving quickly and sometimes (seemingly, to the lay person) at random, being sure they're where you want them to be in the frame is a good thing.

✔ **Sharpness:** LCD screens aren't necessarily an accurate way to judge image sharpness. However, some cameras offer the ability to magnify a portion of your image, which can help you see whether your camera's autofocus or your manual focusing is close. If not, you can switch autofocus modes (some cameras let you choose which area of the frame to focus

on, or whether or not the camera *locks* the focus when you press lightly on the shutter release) or switch to manual focus.

✔ **Exposure:** Your camera's LCD screen can help you determine whether your exposure is on target. Some cameras let you call up a *histogram,* which is a kind of scale that shows the distribution of brightness values throughout the image. The histogram can help you judge your exposure. If your exposure is not spot on, you can make changes immediately so that subsequent action shots are better.

It can be hard to use your LCD screen effectively when you're shooting outside in bright sun. A company by the name of Hoodman (www.hoodman usa.com) makes a variety of hoods that offer some shade for the LCD screen and make it easier to read in the sun.

Electronic flash

An electronic flash unit can be a big help to your action photography whether it's day or night. You can use flash for good photos in a number of ways. Here are a few:

+ **Let there be light.** An accessory flash unit can provide enough light for you to shoot by when it gets too dark for even your highest ISO setting to be usable.

+ **Freeze your frame.** Accessory flash units produce an incredibly brief burst of light (somewhere on the order of up to $\frac{1}{10,000}$ of a second in duration), and because the flash unit provides the main source of light, it has the ability to stop action. You should be careful, however: When using flash at a slow shutter speed setting, the ambient light (the available light other than the flash itself) can register a ghost image trailing the image captured by the flash. This can sometimes be a cool effect, but only if it's intentional.

+ **Cleaning up the shadows.** Even when you have more than enough light for good sports photography, many times even the brightest conditions can't change the fact that athletes wear ball caps or tree limbs cast shadows. An accessory flash unit can help get rid of those shadows.

Tripods

Sports photography usually calls for such high shutter speeds to stop action that no photographer would use a tripod to prevent blurry photos from camera shake unless you're using a high-end digital camera with a huge telephoto lens (which isn't something the average digital photographer needs to worry about). Instead, sports photographers use a tripod to simply help support the camera. Here are some "tripodic" considerations specific to sports photography for you to ponder:

+ **Great support:** A good sturdy tripod can be invaluable for holding and steadying your camera, particularly at telephoto lens settings. Some sports, such as football, call for too much movement on the photographer's part for tripods to be useful (you'll constantly be running up and down the sidelines). When photographing sports, such as track and field, baseball, and softball, however, you benefit greatly from having a tripod to support your camera.

+ **A second camera rig:** When shooting baseball and softball games, I frequently set up a second camera that's prefocused on a key spot, such as first base, second base, or home plate. A tripod enables you to switch back and forth between two cameras easily and quickly.

+ **Panning:** This technique involves following the action as it moves across your image frame. I discuss panning in greater detail later in this chapter, but a tripod with a panning head can greatly improve your efforts at this technique because it allows free horizontal movement while keeping the camera steady vertically.

+ **Monopods:** For sports that call for photographers to be active, a monopod (which looks like a walking stick) frequently works better than a tripod because it's easier to pick up and carry around (while still providing a steady base). A good monopod is fairly thick and heavy, both to

be strong enough to support the weight of a big telephoto and also so that you can brace against it. A lot of inexpensive units on the market promise all sorts of capabilities; make sure you hold out for a good solid monopod and not one of the flimsy ones.

✦ **Shoulder stocks:** These devices are modeled on rifle stocks and work on the principle that, by bracing the lens into your shoulder, you can hold it steady.

Lenses and attachments

Because sports photography calls for the ability to cover large swatches of field and fast moving athletes, long lenses or attachments to extend the reach of your point-and-shoot camera's built-in zooms will really help improve your results. Your choice of lens or zoom settings is in part dependent on what sports you plan on shooting:

✦ **Wide-angle settings:** Unless you're very close to the action, wide-angle settings won't be a big part of your sports photography. For example, wide-angle lenses are currently in vogue for skateboarding photography. These lenses can give your sports shots a very different look, if you can get close enough to your subject to fill the frame.

✦ **Short telephoto settings:** Telephoto settings equivalent to a 35mm camera's 85mm to 135mm lengths (which is how digital camera manufacturers measure their optics' magnifications) have a lot of uses in sports photography. These are great for indoor sports, such as basketball and volleyball, and can also be handy for nighttime sports under the lights. If your digital camera has a maximum aperture of f/2.8 or larger, you can take photos in lower light levels. Make sure your camera doesn't use a smaller lens opening, which would defeat your ability to take indoor shots.

✦ **Medium telephoto settings:** These are usually in the 180mm to 200mm range. This is a very versatile setting that can come in handy when you're shooting almost any type of sport.

✦ **Long telephoto settings:** Some digital cameras have long telephoto settings that are the equivalent of 300 to 400mm on a 35mm film camera. These are the lenses of choice for both football and baseball photography because they allow great reach and the ability to keep shooting even when you're outdoors under lights. Be careful that your long lens doesn't reduce your shutter speed beyond the ability to capture the action.

✦ **Super telephotos:** You probably won't have access to super telephotos unless your digital camera has interchangeable lenses. I'm talking about the really big guns here, the 500mm and 600mm telephotos. These lenses are almost too big for sports photography and are almost the exclusive reserve of nature and bird photographers. They can be useful for times when you just can't get very close to the action and have a pretty small subject (gymnastics events come to mind).

✦ **Add-on lenses for point-and-shoot digital cameras:** Many point-and-shoot digital cameras can accept lens converters that attach to the front of the camera's built-in zoom lens. These converters may screw into the lens filter mount, clip onto the lens barrel, or attach via an ingenious adapter barrel and are frequently available in both wide-angle

and telephoto flavors. It's generally best to go with the manufacturer's version, which is specifically designed for your camera, but if your camera's manufacturer doesn't offer the accessory lens you need, look at third-party options. Be very careful if someone tries to sell you an add-on lens for a video camera. Video cameras get by with much lower resolution than digital still cameras. A lens designed for a video camera probably won't produce very good results on a digital still camera.

Digital cameras and latency

Before you move into tips for taking great digital sports photos, you probably should spend a few minutes considering the deep, dark secret that digital camera manufacturers don't want you to think about: When you press that shutter release button, many cameras have a noticeable time lag before the picture is actually taken. Although a minor inconvenience if you're taking a photo of the Eiffel Tower, that delay can be fatal when photographing sports. Fortunately, you can do some things about the phenomena known as *latency* and *shutter lag*.

Once upon a time, you pushed the shutter release button, and the camera took the picture. As cameras have gotten more and more sophisticated, more and more things have to happen before an image is created.

Dealing with latency

Latency is the time required to write the image you've just taken to your storage media. When you take a picture with a film camera, the shutter releases, and the image is immediately registered on the film at the speed of light, so to speak. When you take a picture with a digital camera, the image has to be captured and then recorded onto your memory card. The image capture and storage process can take a second or two, or even longer. How long the process takes and whether or not your camera will continue taking additional photos while writing to the card are important questions.

Some digital cameras use buffers (built-in memory) to temporarily let you keep shooting while the buffer contents write to removable memory. If you keep shooting, eventually the buffer fills, and you have to stop until it's made enough room for you to resume shooting. Other cameras may not be able to use their buffers for their highest resolution files but will let you keep shooting if you chose a lower resolution setting. It's a tough choice, but sometimes, the ability to keep shooting overrides the desire for the highest possible resolution. Here are some things that affect latency and that you can control:

✦ **Media:** Some forms of media accept data faster than others. CompactFlash cards tend to write information faster than Microdrives (which are tiny hard disk drives). Some CompactFlash cards write data faster than others. Look for ones rated for faster write times (frequently marked 4x, 8x, or 12x).

✦ **Resolution:** The more data the camera has to write to the card, the greater the latency period. If you know you can get by with a lower resolution setting, you can speed up things considerably by going with the lower resolution. This can be a tough decision because after you give up

quality, you can't get it back. On the other hand, missing a shot because you're waiting for your last few images to write to your memory card is one of the more frustrating experiences a photographer can enjoy. Film photographers miss shots while changing rolls of film, and digital photographers miss them due to latency. It's not a perfect world, but it is a great reason to get a second camera.

Understanding your equipment, its capabilities, and its limitations, is important for the digital photographer interested in making winning sports photographs. If sports photography is your overriding concern, several cameras on the market are geared toward the sports shooter. Both Canon's and Nikon's top-of-the-line digital SLRs are highly capable photographic tools well designed for this kind of work (but not cheap!). For those of us on a tighter budget, Olympus makes a lower-resolution digital camera — the E-100RS — capable of 15-frame-per-second bursts (for a max of 10 frames). It may be worth considering.

Dealing with shutter lag

Latency isn't the only thing that can slow down your picture taking. A long list of things happen as you press the shutter. That list includes such things as activating light-sensing features and bringing autofocus up to speed. If you have a Microdrive hard disk storage device, the time it takes for its drive platters to start spinning is a factor as well. The result is something known as *shutter lag*. What it means is there's a delay between the moment when you squeeze the shutter and when the camera actually fires. This means you have to anticipate the decisive moment and trigger the shutter early enough to cause the image to be created at the best possible moment.

Just like top baseball pitchers study the habits and preferences of the hitters they face, sports photographers need to become familiar with the specifics of the sport they're shooting. Being ready to shoot and looking in the right direction can give you enough of a head start to compensate for the delay in firing time.

Timing your shot properly

Here are some ways to time your shot so that you can take a great picture even when shutter lag delays capture of that decisive moment:

✦ **Anticipate.** Many sports have a particular rhythm. If you can become sensitive to that rhythm, you can anticipate that peak moment of action and gauge how far in advance to trigger the shutter. If you're shooting a baseball or softball game, you can position yourself down the third base line and wait for a play at first. It takes a certain amount of time for a throw to make it across the field to the first baseman, so you can trip the shutter in time for the ball to reach the mitt. Or, wait until just before the soccer player kicks the ball to snap the shutter, as shown in Figure 11-2.

✦ **Go with the flow.** Follow the action with your camera and gently squeeze the shutter as you keep your eye on the ball (or athlete). In sports such as basketball or soccer, you can track the person bringing the ball down the field.

Figure 11-2: Freezing the action by timing the shutter release.

✦ **Pick your spot.** Many sports direct action to a particular location. For instance, long jumpers are headed toward the landing pit, so you can know within a couple of feet where the athlete will land. Be prepared to trigger the shutter as the athletes launch themselves and stay with them until landing. Some sports have goals, some bases, some baskets; sooner or later, every sport has a spot that you just know will see action.

✦ **Use manual focus.** Some digital cameras allow more control over their capabilities than others. If your camera lets you deactivate autofocus, for instance, you can prefocus on the expected action spot and reduce your camera's shutter lag time. A similar technique works for cameras that let you lock focus. Lock focus on the spot you're keying on just before the play starts, and you give yourself a head start on the action.

✦ **Lock in your focus.** If your digital camera requires you to press the shutter halfway to activate autofocus and start your Microdrive spinning, you can do this in advance and have it fully up to speed at just the right time. The problem with this technique is it can drain your camera's batteries in a hurry, so plan on having lots of extra juice if you want to do this.

✦ **Use autofocus selectively.** Does your digital camera let you pick a different button to activate autofocus instead of the shutter button? If it does, then you can combine this feature with the previous technique to decrease battery drain (autofocus uses lots of power). Keep the shutter pressed halfway while awaiting the next event and then, as soon as you need to, press the second button to activate autofocus. (This takes a little practice, but it does work.) It also works well for the prefocusing suggestion made a couple of paragraphs ago. Some cameras have a continuous or single autofocus setting. Switching to the single setting can save power because your camera doesn't constantly refocus each time you move it a little.

Taking Great Sports Photos

This section deals with tips for taking great digital action photos in a variety of sports situations. That's the great part about sports photography: There are so many different sports that, when you think you've explored everything that can be done for, say, soccer, then soccer season is over, and it's time to grab some basketball shots!

Elementary, middle school, and high school sports are great training grounds for people who want to become good sports photographers for several reasons:

✦ **Speed:** Because the players aren't as fast and as skilled as those at the college level (and up), the excitement generally unfolds at slower speeds, making life easier for the novice sports photographer who's trying to follow the action.

✦ **Access:** School athletic events are much more accessible than college or the pros. Return the favor by offering the coach or the boosters a copy of your shots from their awards dinner.

Don't be afraid to experiment, either. There are always elements of an event that provide dramatic imagery, even if it's not the typical sports action shot. Think about close-ups of equipment, low-angle shots of the playing field, and portraits or studies of spent, exhausted athletes at the end of the game. Look for shots that show the emotion and intensity the athletes bring to the sport.

Choosing your sport and your spot

Knowing where to position yourself can be a real challenge for novice sports photographers. It's also vital to give yourself the best possible opportunities to get great shots.

Most events are accessible at all but the highest levels of play. Even high school and junior college sports cut serious amateurs some slack if they want to get closer to the action (on the sidelines or behind the baseline).

Starting with NCAA play, that starts to change. Even minor league ball has restrictions on what you can do and what equipment you can use. Pro-level events are even more restrictive. Plus most professional organizations only grant access based on your agreement to use your images only for editorial purposes. Sports organizations like Major League Baseball, the National Football League, and National Basketball Association, to name a few, guard the marketing potential of their sport and athletes very closely.

Your goal is to be in position to capture peak action in the right direction (getting that great catch with the athlete's back to you doesn't do you much good). Generally, this means you want to be far enough in front of the action to be effective, yet close enough to fill the frame.

Determining the right spot is largely dependent on the sport you're shooting. Your choice of available zoom settings can also play a role.

Football

If you're photographing high school or peewee football, you can often get right down on the sidelines to take your photos. At the lowest levels of the sport, you can pretty much get whatever access you want. Even at the high school level, you can probably get on the sidelines if you explain you're trying to build a sports portfolio. For most college and professional games,

you need some form of accreditation from the team itself. Still, sometimes even a small, local newspaper can secure such access for its photographers, so working for such a publication may get you in. Here are some tips for photographing football:

✦ **Keep your distance.** Photographers generally stand about 8 to 15 yards up field from the line of scrimmage. Don't get much closer than this, or the line officials will block your view. This puts you in place for a shot of a running play or quarterback sack in the backfield, while still giving you a chance to turn and lock on to a receiver in case of a pass play to your side of the field.

✦ **Use a second camera — if you have one.** A second digital camera set to its wide-angle setting can also be a good idea. You can quickly grab this camera and bring it up to shooting position if a play comes right at you. (Be careful to avoid being run over.)

✦ **Keep other spots in mind.** As teams approach the goal line, you can move to the area behind the end zone and shoot straight at the quarterback or running back attempting to leap over the defensive line. Because the team's players sit near the midfield, you can't shoot around this area. Also, plan on getting some shots of the coach yelling from the sidelines and players on the bench. Cheerleaders are good for a couple of shots, and if it's a particularly cold day, some shots of the fans bundled up in the stands are worth taking.

✦ **Be patient.** Football demands patience and determination on the part of the sports photographer simply because so much of the sport takes place too far away from where you're standing for you to be able to shoot it effectively. Just stay with the game and be prepared for the action when it finally does head toward you.

Football is one sport where the more you know about the game and the particular teams that are playing, the more effective you can be. Understanding that one team favors short, quick passes while another favors a more conservative ground game helps you predict where the next bit of action will take place.

Baseball and softball

A photographer can work from several likely places for shooting baseball and softball games. One of my favorite spots is directly behind the backstop, shooting through the links to get a shot of the pitcher just as he or she releases the ball (ideally framed between the batter and umpire). Here are some other tips for shooting ballgames:

✦ **Get behind the plate.** Many times, I start behind the plate to make sure I get a usable image as quickly as possible before moving on down either the first or third baselines. Usually, I head down until I'm about 5 or 10 feet below the base. From this spot, I can get good shots of the batter, a side view of the pitcher, and a good angle for plays at second base.

✦ **Move down the baseline.** After that, I continue on down the line until I'm as much as 15 or 30 feet past the base. This position gives me a shot at the runner racing to first or third.

✦ **Watch that runner on first.** If a runner is at first base, sometimes I pre-focus my tripod-mounted camera on second base in case there's a close play there. Here's where knowledge of the sport and the teams involved can give you a big advantage. The stolen base is one of the more exciting plays in baseball or softball. If you're ready before the play begins, you have a much better chance of getting a good shot of the action.

Much like football, baseball's lowest levels of skill are wide open to any photographer who cares to shoot them. College and the pros are much harder to gain access to, although once again, a newspaper job may give you a chance. Softball tends to be easier to gain access to. Sometimes, a one-sided game is easier to shoot than a close one. There tends to be lots of scoring, including plenty of people stealing home.

Basketball

Hanging out behind the backboard is a great place for getting good shots. I probably spend 80 percent of the game here. Rebounds, scoring, fights over the ball — it all happens under the boards. Here are some other good locations for shooting hoops:

✦ **Take to the bleachers.** I take some shots from up in the bleachers with a telephoto prefocused on the rim. This is a good location for getting the rebounder pulling the ball off the rim and a good look at the player's face. Try to find a spot a little higher than the rim. This generally calls for a longer zoom lens setting, about 100mm to 135mm for a digital camera.

✦ **Head for the sidelines.** I also shoot along the sideline with a longer zoom setting to get a shot of a ball handler bringing the ball up court. From this position, I can also look for a shot of the coach yelling instructions to the players and pivot to grab some crowd intensity shots. Sometimes you can catch a tense moment as the ball is thrown back into play.

✦ **Don't forget halftime.** Now's the time to look for shots of the coach and players talking strategy. A wide-angle lens gets you in close when possible (easy for high school ball and younger, but you probably won't be able to get that close for college and the pros).

Basketball is a great sport for a novice photographer who's looking to build a sports portfolio. It's possible to get good photos without having to break the bank on a camera with an ultralong telephoto lens zoom setting.

Soccer

Soccer is a little like football in terms of the field and sidelines action, but this sport has lots of unique aspects, as well. Here are some tips:

✦ **Get behind the net.** Behind the net and to one side of it are good locations to catch scoring attacks, but you spend long periods of time counting blades of grass when the action moves to the other side of the field.

✦ **Take to the sidelines.** Positioning yourself on the sidelines puts you in place for good ball-handling shots, and if you move down the sidelines closer to the net, you'll be in position to get the goalie in action.

✦ **Reach out and grab someone.** If you have a digital camera with a long zoom lens, you can try to reach from one end of the field to the other to get the goalie straight on. Or, you can even grab a shot from way up in the stands!

✦ **Go for the wide look.** For variety's sake, try a shorter focal length while lying on the ground. This will give you a second shot, but not a main photo.

Soccer can be a difficult sport for the point-and-shoot digital camera simply because of the size of the field. The best place to work from is the spot behind the net and to one side. An occasional shot through the net works too, but becomes a cliché if this is the only image you ever capture.

Other sports

You may be interested in other sports, too. All of them have their own special challenges and opportunities. Here's a brief rundown on some other popular action opportunities:

✦ **Hockey:** Stand behind the goalie or on the sidelines just above the goal. Players tend to make a lot of contact behind the net trying to control the puck, so there's some good action there. Another place where big hits happen is the area between the blue lines, the neutral zone. If your lens is long enough, get some shots of the face-offs. Don't forget about reaction shots either. Hockey is tough simply because your movement can be so restricted.

✦ **Tennis:** You can stand behind the court shooting the player on the far side of the net straight on. Don't worry about the fence; if you're using a telephoto setting, you can shoot through the links. On the sidelines, I favor shooting when the player is running from side to side after a ball, but only when the player is moving toward me. Either a monopod or tripod will work for tennis.

✦ **Golf:** Shoot from the side when the player is teeing up (but not during his or her swing), or straight on if the course conditions permit. You can also shoot straight on from a safe distance when a player is putting.

✦ **Track:** So many events, so little time. Whenever possible, I try to shoot track events from as close to straight on as possible, generally as runners are coming around the turn or at the start of a race when the line of runners is beginning its break. For shuttle hurdles (teams of hurdlers shuttling in each direction), I try to position myself at the midpoint of the track so that I can zoom from longest to shortest focal length as I move from runner to runner.

✦ **Field events:** So many events, so many different ways to shoot them. Unlike track, which tends to use the same quarter-mile track surface for its events, the field competition presents more challenges. Fortunately, the shot put, javelin, and discus can all use the same basic philosophy: Namely, get in front of the athlete with a little offset to the side (and far enough away to be out of range) so that you can shoot straight on as the athlete releases whatever it is he or she is throwing. Setting yourself

up behind the landing area is a good strategy for both the long jump and pole vault, while positioning yourself to the side and slightly behind the bar works well for high jumping (the hard part is racing from side to side because jumpers will come from both the left and right).

✦ **Gymnastics:** Any position that lets you shoot the athletes coming directly toward you is a good location. If circumstances allow you to get close to the action, wide-angle lenses can give your images a different look.

✦ **Adventure water sports:** I'm talking white-water rafting, kayaking, and canoeing here. Generally, you have a choice of two good locations. The first is downstream, just below a rapid, so that you can get the boaters in action. The second is from a bridge, looking down on the river, which gives you a nice alternate shot. Don't be afraid to get in tight and compose from the top of the boater's head down to his or her paddle in the water. It's not necessary to show the entire boat.

✦ **Rock, alpine, and speed climbing:** If possible, get on top of the rock and shoot down on the climbers, or get on a ledge that's level with a point the climbers will reach during their ascent. If you're on the ground when they begin the climb, a wide-angle shot from the side and below gives a usable image, and you can play with silhouettes if you want to try something different. Also from ground level, you can try a telephoto shot of the climber against the wall. For a speed climbing competition, a longer telephoto setting gets you in tight and compresses the competitors more closely together. I prefer to shoot speed climbing from the side because it emphasizes the extreme body contortions the climbers go through.

✦ **Extreme sports:** Both straight on and profile shots provide good images for many of these sports. For skateboarding, inline skating, and BMX bike events, shorter focal lengths work well, depending on how close to the event you can get. Wakeboarding calls for very long lenses, a monopod, and a position on the riverbank that gives a good view of as many jump points as possible.

✦ **Motor sports:** These sports are among the fastest growing events from a fan's standpoint. Auto racing is one of the toughest photographic challenges, even with modern professional camera equipment. Those cars are fast! Try to catch them on the curve when they're moving a little bit slower. This may also give you a three-quarter's view of the car. Or, pick a spot where you can get the cars coming at you. This type of action is easier to capture. Fast moving race cars can also present a good opportunity for creative blur shots (more on this topic later). Use a modest shutter speed (say 125th of a second) to keep the starter sharp as he or she waves the flag to begin the race. If you do it right, the starter stays sharp while the cars and flags are blurred. Other good opportunities include shots at the starting line or in the pits. For motocross events, where the motorcyclists are catching big air, you want to be located some distance away from their take-off point. Side shots of the athletes and bikes as they come even with your position are also good.

✦ **Horse racing/dressage:** For horse racing, station yourself at the spot where the track curves so that you can shoot the animals coming straight toward you; then get three-quarter and profile shots as they round the curve. For dressage, study a book on the desired movements and looks that each animal should present. Be ready to shoot the horses head on and in profile and three-quarter pose.

✦ **Swimming:** Shots from head on and from the side are pretty much your only choices here. Start by shooting head on and time your shot to catch the swimmer rising up from the water. You might need an accessory flash unit and a butane powered hair dryer for battling lens fogging. Don't underestimate just how difficult it is to keep your equipment in working condition because of all the moisture and humidity in the air. Keep extra packets of desiccant in your camera bag and a microfiber cloth within easy reach. Try to get to the swim meet site at least a half hour early so that your equipment has a chance to come up to room temperature and humidity. Package your camera and lenses in sealable plastic bags during this warm-up period so that condensation forms on the bag, not the lenses.

Winter sports: a special case

Winter sports such as skiing and snowboarding present a special challenge for the digital photographer because of the amount of contrast inherent in snowy conditions. Such lighting conditions often fool your camera's exposure system. If your digital camera lets you shoot in RAW mode and capture images as linear TIFF files (check your camera's instruction manual to see how), use that option. It gives you the maximum amount of information when you're editing the image later. You'll be glad you did.

Generally, a good image occurs when the skier or snowboarder turns about 15 or 20 feet from your position (try to avoid the snow spray). Another good shot is when the athlete becomes airborne. Be careful that you aren't so busy looking through the viewfinder that you lose track of the skier or boarder coming right at you. (Don't laugh; it happens.)

Increasing dynamic range

High-contrast situations, such as ski slopes, present a special challenge for digital cameras. Because sports photography frequently revolves around frame-filling action with just one or two athletes, the easiest way to deal with high-contrast lighting is to use flash to balance the light between your subject and the background.

✔ **Metering:** Take a meter reading off a midtone (something equivalent to medium gray) and find the correct exposure for the overall scene. Then set your flash to output enough light so that your subjects' illumination matches the background. (This tip probably applies only to those with higher-end cameras and very powerful flash units.)

✔ **Filtration:** Special low-contrast filters have appeared on the market in the past few years. Although sticking another piece of glass in front of your high-quality lens risks degrading image quality, a well-made filter can be worth the investment. Photographs made with low-contrast filters generally require a little extra tweaking in an image-editing program (nothing extreme), but the results can be well worth it.

✔ **Linear TIFFs:** If your camera offers a RAW mode capable of producing what are called 16-bit linear TIFF files, and if your image-editing program can work in layers, then you have another method of dealing with high-contrast lighting. Just capture the image twice — once as a linear TIFF (which will appear underexposed) and once as a regular TIFF. Copy the regular TIFF directly over the linear TIFF (Shift+drag with the Move tool if you're using Photoshop) and then create a layer mask. Activate the layer mask and then drag the gradient tool from top to bottom.

I usually rely on the medium to longer zoom lenses plus an accessory flash. Because these sports take place on snow-covered mountains, I try to travel light and with my equipment balanced in waist pouches or equipment belts rather than a camera bag. A camera backpack works well too, but makes it harder to get at your equipment in a hurry. Having a flash available is very important, because otherwise, you have to choose between overexposed snow or an underexposed subject.

Taking Your First Action Photo

You've got all the background you need. Now, it's time to put what you've learned to work and take your first action photos. This section leads you through the preparation and steps you'll want to take.

Be prepared

As a would-be sports photographer, one of the most important things you can do is become knowledgeable about the sports you want to shoot. The most successful sports photographers are the ones who can anticipate the next play or event and put themselves in position to trip the shutter in time to record the moment.

Many times, you have decisions to make long before the action starts. Is this a situation where you're going to use the zoom on the camera and try to react to what happens? Or are you picking a spot, prefocusing, and waiting for action to reach that location? Both are valid methods, and most photographers alternate between them as the game goes on.

Whenever possible, sports shooters try to analyze the situation to see if they can understand what will happen next. Third and long yardage or first and 10 in football are good examples. In the former, a pass is likely, and in the latter, a running play. You can follow the receiver on your side of the field if you think a pass play is likely or key in on the quarterback to get a shot of the pass or the pass rush. For the running play, you can key in on the backfield and be ready to catch the hand-off and ensuing running play.

Setting your ISO speed

Being able to change the "film speed" or ISO (International Standards Organization) rating of your camera on the fly is one of the great benefits of owning a digital camera. Be sure to check your camera's instructions to see how to change the ISO setting.

When conditions permit, I always try to work at 100 or 200 ISO to get the highest quality images. Most digital cameras are optimized to provide their best quality at those settings. If I'm shooting outdoors under most daylight conditions, a setting at 100 to 200 usually allows me an action-stopping shutter speed of $\frac{1}{500}$ of a second or higher, which is good for the majority of sports. If I have to move indoors or if the sun is getting lower in the sky, I ratchet the speed up to 400 ISO and use a flash unit if circumstances permit. Being able to change ISOs whenever you want is a great help during uneven lighting situations.

Although my digital camera allows me to use ISO settings as high as 800 and 1600, I try to avoid these settings unless it's the only way to keep shooting. Images made at these ISOs tend to need a little more tweaking in an image editor than lower ISO shots and also offer less margin for error when it comes to exposure. Cameras vary and so do photographic tastes. Test out your camera before taking your first action shots so that you can determine whether your camera's ISO choices produce results that meet your standards.

High ISO settings let you use faster shutter speeds, which means sharper images, but higher ISO settings also produce noisier images. *Noise* is the digital film version of conventional film's grain. Still, a sharp, noisy image is preferable to a noise-free, fuzzy one.

Understanding how to stop action

Today's athletes are well trained, well conditioned, and well prepared. As a result, they're faster than ever. This means that, to freeze their movements, you need to use either a fast shutter speed or an accessory flash unit. Another consideration is the relationship between the direction in which your subject is moving and your camera's orientation. Here are some tips to keep in mind:

✦ **If your subject is moving toward you, you can get by with a slower shutter speed than if your subject is moving across your field of view.** It's hard to say generally what a good minimum shutter speed is — because the shutter speed needed to stop action varies from sport to sport — but faster is always better.

✦ **As light levels drop, an accessory flash's quick burst of light can freeze action that a slow shutter speed might not.** Whether or not you can use flash tends to depend on the particular sport you're shooting. I've never had any problems shooting football or basketball with a flash unit. Athletes such as tennis players tend to be more sensitive to flash photography, so I plan accordingly. When in doubt, check with the event organizer to see whether a specific policy is in place or watch what other photographers are doing. Many times, if you're setting your flash for fill lighting rather than as your main light source, the burst of light is brief enough and low enough in intensity that the light won't be a problem. Keep in mind that you have to be within the effective range of your flash's output capability for it to do any good.

Short-duration shutter speeds can often be the key to stopping action. The brief time that the shutter is open registers only an instant of motion. Longer shutter speeds give your subject time to move farther or make more movements while the image is being recorded, which results in blurred photographs.

Generally, your choice is to use the fastest shutter speed possible. For many prosumer digital cameras, this frequently means $\frac{1}{1000}$ of a second. This speed is fast enough to stop any human motion and will freeze many other elements of most sports.

Controlling shutter speed

How do you get your camera to use a short shutter speed to stop action? You may have to check your camera's instruction manual to find the exact controls, but here are the options you should look for:

✔ **Shutter priority mode:** In shutter priority mode, you can choose the exact shutter speed you want to use (such as $\frac{1}{500}$ or $\frac{1}{1000}$ second), and the camera's automatic exposure control will choose the f-stop lens setting appropriate for that shutter speed. Keep in mind that, depending on the lighting conditions, you may not be

able to use the very shortest shutter speeds at all. In dim light, for example, your camera may not be able to take a photo at any shutter speed shorter than $\frac{1}{250}$ or $\frac{1}{125}$ second because there simply isn't enough light.

✔ **Manual shutter speed/exposure settings:** Your camera may let you set both shutter speed and f-stop manually. If you do that, it's up to you to interpret your camera's light meter to provide the correct combination of shutter speed and f-stop for a proper exposure.

Stopping action with slow shutter speeds

You can often stop action using a slower shutter speed, too. Indeed, the effects may be more realistic than the "frozen statue" look you get when sports participants are stopped dead in their tracks. Here are some tips for stopping action at slower shutter speeds:

✦ **Look for momentary pauses.** Many times, a sport has a moment of peak action where the action hesitates before movement returns. Think of jumpers on the ascent. At the top of their leap, there's a moment of stasis where they hang in space before dropping back down, as shown in Figure 11-3. If you're forced to shoot at too low a shutter speed, try to time your shot for that moment. Another example is a tennis player just after tossing the ball to serve. If the server uses a high toss, he or she has to wait for the ball to drop before hitting it. The tennis player up at the net is another example. Although the racket and ball may be moving very quickly, the athlete's body usually isn't traveling very far or fast.

✦ **Try to shoot the action moving directly toward the camera.** Athletes and machines moving toward the camera require a slower shutter speed and faster autofocus to freeze motion than those moving laterally across the camera's field of view.

✦ **Concentrate.** Sometimes, the most dramatic image is in the concentration of the athlete the moment before he or she begins play. Think of the pitcher looking to the catcher for a sign, or a tennis player just before serving the ball. Another example is the linebacker poised for the snap of the ball before rushing the quarterback. There's also the free-throw shooter pausing a moment before shooting.

✦ **Find action in nonaction moments.** Another shot to look for is one that shows the price the athlete pays for his or her sport. This can be football players on the bench with steam rising off their heads, or a spent distance runner leaning on a teammate at the end of a race. A shot of a distraught athlete being consoled by a fellow athlete is a classic sports photograph. Also watch for the emotions of the fans or cheerleaders.

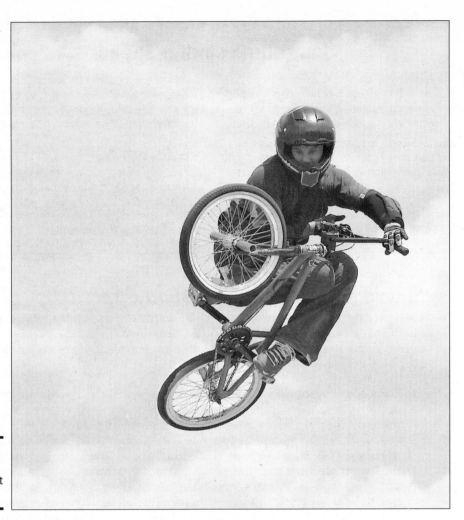

Figure 11-3:
Catching
the action at
its peak.

Panning

Panning (moving the camera horizontally in the same direction of motion as your subject) is a valuable technique that should be part of every serious sports photographer's repertoire. This procedure gives you the best of both worlds: freezing the important part of the scene while blurring the background to show the furious motion of the moment.

The idea behind the technique is to use a slower shutter speed while following a runner or vehicle laterally with the camera. The result is a subject that's in relatively sharp focus while the background is blurred.

Here's how to put panning to use:

1. **Select a moderately slow shutter speed to give yourself a long enough stretch of time for the lateral movement of the camera to register, but not so long as to create overall blurriness from camera shake.**

Don't you just love precise directions like this? But seriously, if I could give you exact numbers, your camera would already be programmed to

do it for you. There's no exact recommendation; you have to experiment to see what works best for you. The speed will vary from sport to sport as well. Start out by trying something in the $\frac{1}{45}$ of a second to $\frac{1}{60}$ of a second for running humans. Work your way to around $\frac{1}{250}$ of a second for motor sports and see how this works.

2. **Begin following your subject with the camera before tripping the shutter.**

 You want a smooth lateral motion here, so beginning the move first and then shooting helps you do that. Your panning movement is steadier if you limit your movement to your waist and hips while keeping your feet planted and your knees together. This also helps reduce camera shake. Also make sure to keep your elbows braced against your body to help turn yourself into a human monopod. Most people find that using an actual monopod generally doesn't work very well, but for a few, it works. If circumstances permit, a tripod with a tripod panning head (one that allows the tilt and yaw controls to be locked while the panning direction swings free) can make for a smoother pan. Certainly a photographer who's just starting to experiment with the panning technique may find that a tripod makes things easier.

3. **Trip the shutter as gently as possible.**

 You're trying to avoid a downward snap in your movement. The old cliché is to squeeze the shutter, not press it.

4. **Continue your lateral panning movement for a second or so after the shutter has closed.**

 This is a case where proper follow-through is just as important for the photographer as it is for the athlete.

5. **Repeat this process at least a half dozen times or more.**

 It seldom works perfectly the first time. (It's okay; you're not paying for film here.) Good panning is something you have to work at. Don't give up on the technique if your first few attempts don't pan out. (Sorry, just couldn't resist the pun!)

This technique gives you dramatic images that accurately convey the sense of motion the sport involves. Sometimes, the photograph of the athlete flying through the air or running down the track with the background blurred does a better job of conveying the speed of the event than a moment of frozen action.

Action approaching the camera

Action approaching the camera is also more dramatic because the camera can maintain eye contact with the athlete or create a sense of power from the approaching machine coming right at the viewer.

Because these images produce such drama, it's important to work on capturing them well. Mastering this aspect of sports shooting will do much to improve your sports photography. Help your camera's autofocus system work its best by prefocusing on a spot a few feet ahead of where you hope to take the picture. Lock on to the approaching athlete and give your camera a

chance to acquire the athlete and bring its autofocus up to speed. If you're working with a digital SLR with a zoom lens, you can give yourself more time and distance for the shot by acquiring your subject at the extreme telephoto end of its range and continuing to shoot while racking the zoom through its full range to its widest setting.

Circumstances don't always permit you to get this shot. Still, photography is about putting yourself in a position to give yourself the best possible chance to catch the action. If you couple that with shooting a large number of images, you can increase the likelihood of success.

Using blur creatively

In some circumstances, you just don't have enough light or a fast enough lens to set the shutter speed as high as you would like. Stopping action can be a good photographic technique when you're covering sports, but it's certainly not the only one. When circumstances don't allow you to freeze motion or when you want to create something that looks different from what everyone else is doing, deliberately trying to blur your image can create something special. Figure 11-4 shows a picture in which the blurring (especially of the ball) creates a photo that says "action!" more clearly than any frozen-in-time photo.

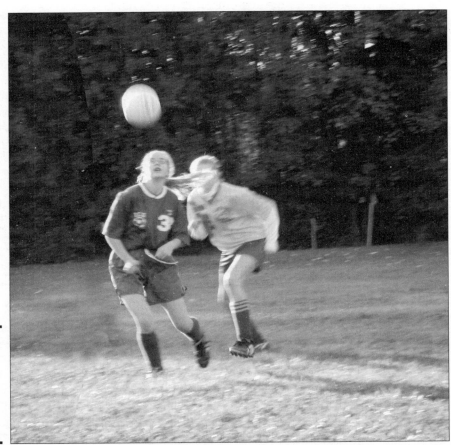

Figure 11-4: In sports photography, blurring can be a good thing.

To create a successful photograph, it's important for the key elements of the image to be in focus, not necessarily every single part of it. Your subjects' eyes and face need to be in focus. If their body or hands or feet are blurred, then that shows just how fast they're actually moving. Some sports, such as tennis, are easy. There's a pretty forgiving difference between the shutter speed you need to freeze the athlete's body and the speed necessary to freeze the moving tennis racket or ball. The same goes for hockey because the player's stick and the puck blur quite easily at shutter speeds that comfortably freeze the player.

When successful, this kind of image can actually be more dramatic than freezing action. Here's how to try this technique.

1. **The first step is figuring out what shutter speed is slow enough to blur the faster moving parts of the body, while also being fast enough to freeze the face.**

 This varies from sport to sport, so be prepared to experiment.

2. **The second part of the process is timing your shot to coincide with a moment of peak action, such as the athlete at the top of his or her leap.**

 Many sports call for the athlete's head to stay still while the rest of the body explodes in action (think of a golf swing where the player's head stays down through the entire stroke). Other sports require the head to travel through a range of movement as the athlete strokes through the ball ("keep your eye on the ball"). For these sports, the head eventually stops as the athlete follows through to complete the stroke. It's at the end of this follow-through where the athlete's body movement is frozen, although the ball or puck and stick or racket may still be moving.

Once you get the hang of using blur creatively, you've added a powerful tool to your photographic arsenal. The essence of many sports is the athlete's ability to move as fast as possible. Blurred hands, feet, limbs, and wheels convey the speed of modern athletes and machines in a way that frozen figures can't. Try to experiment with creative uses of blur each time you're on a shoot. Just manage it the way most of us do: Start out working for an image you know gets the job done. After you've succeeded in getting your "money" shot, start working for something a little more creative. This is the time to try for the panning or creative blur photos.

Taking the Picture

After you've chosen your shutter speed, taken a strategic position, and know what kinds of opportunities may be coming your way (literally!), it's time to take the picture. Watch the action closely, frame the image in your viewfinder, and snap away.

Capturing great sports moments

As you shoot, keep some simple concepts in mind. For example, here are some things to look for in a great sports image:

✦ **Full extension:** The athlete at the top of a leap or in full stride represents one example of the decisive moment in sports photography.

✦ **The coiled spring:** The moment before release when muscles are tense and the body is coiled represents another key moment in sports. This image shows the athlete just before he or she explodes into action. Think of the shot put thrower just before release, the shot still pressed into the chin, or the baseball pitcher, arm reared back ready to reverse direction and fire the ball at the batter.

✦ **Emotion:** It doesn't even need to be a good action shot. Catch the athlete or fan in a moment of extreme emotion, and you've gotten a memorable image. Watch the fans, watch the coaches, and watch the athletes watching the other athletes. There's more to sports than just sports.

Most sporting events are carnivals of colors, patterns, and personalities. They provide a wealth of photographic opportunities not limited to just the playing field. Enthusiastic photographers, curious about the world around them and with an eye to more than just the game, can produce great sports photos no matter what camera they're using.

Setting up for predictable action

Having an understanding of the sport you're photographing can put you in a position to take advantage of your ability to predict impending action. Here are a couple of ways to use that ability:

✦ **Prefocusing:** Sometimes an athlete needs to reach a specific location as part of a play. If I'm photographing a baseball or softball game, and a runner makes it to third, I swing my tripod-mounted camera to cover home and prefocus on home plate. I still follow the action with my hand-held camera, but I also position myself so that I can quickly fire the second camera for a shot of a runner sliding home. Prefocusing on the forward end of the basketball rim is another example. You're now ready to get a shot of the center leaping for a rebound.

✦ **Zone focusing:** This technique takes advantage of the *depth of field* that comes with using a smaller lens opening. (In simple terms, the smaller the lens opening, the greater the range of sharp focus from one point to another on a line from the lens.) The idea here is to choose a lens opening that's small enough to create a zone of sharp focus. The zone should be deep enough to give you about a 5-foot range where everything is in focus. Then instead of worrying about focusing, you can just concentrate on what happens in that zone and shoot as appropriate. Zone focusing works well on a sport such as basketball, where you know you can expect action to take place in a location about 5 to 10 feet from the basket. Using an external flash unit (which many point-and-shoot digital cameras can do) should enable you to shoot at f/5.6 or f/8, which gives you that 5-foot range or greater. In Figure 11-5, the focus was set ahead of time for the ramp, so when the athlete spun around, the camera was already set for the picture.

Shooting action sequences

Sometimes, you need to do more than just capture one good shot of sports action. You need to get the entire sequence of movements that make up an entire run or the execution of a particular move or trick.

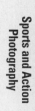

Figure 11-5:
Prefocusing
was all-
important
for this
photo.

Pros get these sequences by using high-speed motor drive cameras that may capture as many as eight or ten pictures per second (usually expressed in frames per second, or *fps*). Although one or two prosumer-level digital cameras are capable of high-speed motor driven photography, most are only good for about three frames per second at best. Even the Canon D30 that I use most of the time is good only for this same slow speed, and that's only if I use a fast enough shutter speed. (A slow shutter speed means the camera has to wait longer before taking the next shot. So a shutter speed of say, $\frac{1}{1000}$ of a second, lets the motor drive function more efficiently than, say, a shutter speed of $\frac{1}{60}$ of a second.)

Even with a limited motor drive capability, a photographer can still create effective photo sequences. Once again, a little planning and foresight can help you get the best possible results. If you can predict the path the athlete is going to take, then you can better follow that path with your camera. Another thing you can do is back out your composition a little to give you some margin for error. You don't want to have a great sequence of shots with your subject ruining it by drifting in and out of the frame.

Here are some tips for getting good action sequences:

✦ Visualize the path you expect your subject to travel.

✦ Prefocus on the point where you expect to start shooting.

✦ Set the fastest shutter speed you can to give your motor drive the best possible chance of advancing at its best speed.

✦ Compose your shot to give your subject some room to move within the frame.

✦ Shoot several sequences to make sure you get at least one usable sequence. Remember that you're trying to get four or five good shots in a row, not just one, so it becomes that much harder to be sure that they're all in focus and well composed. Take lots of shots.

Don't expect to get a good sequence on your first attempt. This is another one of those techniques that you need to practice beforehand. You're trying to understand how your camera works in this kind of situation and determine whether you can tweak your gear to perform better. Some cameras may require you to drop down to a lower resolution in order to shoot fast enough to get a good sequence of images. Because you're trying to get multiple images, the loss of resolution may not be as bad as you think. After all, you'll have the group of images to take the place of one shot.

Some digital cameras don't offer a continuous shooting capability. Others may offer it only at a lower resolution setting than you're really comfortable using. Just because you can't blaze away like the pros, doesn't mean you can't tell a multiple-picture story of a sports event.

A good sequence of photographs tells a story. If you're shooting an event where an athlete makes more than one run or attempt (long jumpers get six tries for instance), work on getting the sequence you want by shooting a different aspect of each attempt. Be careful how you identify the finished result though. There's nothing wrong with showing how each element of the jump works through a sequence of images, but representing it as the individual elements of one jump is the kind of thing that gets photographers in trouble.

Capturing the fans

When I feel I have a good set of strong action images, I like to concentrate on getting reaction shots from the fans. Athletes achieve at least some release through their physical exertion, but fans have no such outlet. Find someone who seems to be particularly expressive and shoot that person through the course of a particularly tense phase of the competition. Use a longer focal length to isolate the fan and to avoid attracting attention to your photography.

Chapter 12: Travel Photography

In This Chapter

✓ **Choosing the right equipment**

✓ **Getting ready to go on the road**

✓ **Mastering the best travel photography techniques**

Taking pictures while traveling can be the most rewarding long-term bene-fit of a trip. While memories of a particular location may fade as the years go by, the images that you created will still be there to remind you of a spe-cial time in your life. Plus, let's face it: Photography is fun! Knowing that you've taken a good picture of that special location gives you a particularly satisfying feeling. Sometimes, lasting friendships can be made during a trip, and being able to send your new friends pictures of the time you shared together can help cement your friendship.

If you've traveled with a film camera in the past, you'll find that vacationing with a digital camera offers some terrific advantages over using traditional picture-taking tools. Digital cameras can be smaller and lighter than their film counterparts, so they take up a lot less space in your luggage. They have no film that airport security X-ray cameras can damage. As you take photos, you can check them using your digital camera's built-in LCD screen.

This chapter offers advice to aspiring photographers who are intimidated by the idea of trying to take good pictures in unfamiliar surroundings.

Choosing Equipment

A photographer on the road needs a selection of gear that's versatile enough to handle the unexpected but doesn't need to be burdened like a Sherpa on an Everest expedition. Carefully considering which key pieces of equipment to take — and which to leave behind — can make the trip less stressful and more productive.

Selecting a camera for your needs

Choosing a camera to use while traveling is an important decision, one that you may have already made long before your trip. After all, most of us are unable to buy a camera specifically for a vacation. You should keep a camera's travel photography capabilities in mind whenever you purchase a digital model. A huge variety of digital choices are out there today, offering a tremendous range of capabilities. Pros may use digital camera backs for medium-format cameras or digital SLRs with interchangeable lenses, whereas serious amateurs have tons of less expensive options. Key deci-sions involve lens versatility (for more options while taking pictures), file size (more megapixels equal bigger pictures), and the amount of control the camera gives you over shooting decisions.

Although the average consumer may never see one, the high-end digital camera is interesting nonetheless. Medium-format cameras (the ones that take the 2¼-inch rolls of paper-backed film) often have interchangeable backs that hold the film. You can sometimes replace the back with a component that has a digital-imaging sensor instead of film, bringing digital photography capabilities to roll-film cameras that weren't originally designed for digital output. Digital SLRs (single-lens reflexes) are cameras that usually allow you to view through an optical viewfinder using the same lens that takes the picture.

When purchasing a camera, most of your decisions involve what kind of photographer you are and what kind of travel pictures you expect to take, as the following sections make clear. No matter which category you fall into, your digital camera should have the basic features that you need to make a broad range of travel photography easy and carefree.

Professional photographers

Pros like to be ready for anything, even when they're not on the clock. You never know when a quick shot that's taken while on vacation can turn into a salable image. If you're a professional photographer, look for the following items:

✦ Compatibility of a digital system with your current film camera's interchangeable lens system, if possible. (Right now this means Canon, Nikon, Fuji in Nikon mount, or maybe Contax.)

✦ A choice of camera bodies offering 4- to 8-megapixel sensors, rapid-sequence shooting ability, and other features, depending on your shooting needs. Travel photography can sometimes be as fast-paced as sports shooting and can require high-resolution images for reproduction.

✦ A choice of flash units and accessories, such as those shown in Figure 12-1, to meet your shooting needs. A professional system needs to be flexible enough to accommodate all the gadgets that you need for top-of-the-line travel photography.

Serious amateurs

The best serious amateur photographers are often professionals in every aspect except monetary reward. They frequently spend a lot on their hobby and may even be looking at the same systems that are desired by pros. Their needs include the following:

✦ A higher-resolution (3- to 6-megapixel) camera with a large-capacity memory (with the ability to accept interchangeable memory cards). These features enable you to grab travel photos that are suitable for printing at large sizes, which you can then display on the wall.

✦ Extreme-zoom lens capabilities, preferably with a 10x range. This range is ideal for reaching out and grabbing a small detail from a panoramic scene.

✦ Add-on accessory lenses to extend a zoom's capability even further.

✦ Rapid-shooting capability to allow taking pictures quickly at festivals or other fast-moving travel experiences. (The running of the bulls at Pamplona comes to mind!)

Figure 12-1:
The best
equipment
delivers the
best travel
shots.

Enthusiastic amateurs

Amateur photo enthusiasts love photography but also have other interests — such as travel! With more limitations on their budgets, they need top-quality prosumer cameras. These cameras are aimed at consumers but have features that please advanced photographers. These include features are as follows:

✦ A medium- to high-resolution (2- to 4-megapixel) camera with decent capacity memory (with the ability to accept interchangeable memory cards). These cameras enable you to print vacation snapshots in sizes as large as 8 x 10 inches.

✦ A versatile-zoom lens (between 3x and 10x) for taking close-up shots of distant scenic features or for capturing locals being themselves.

✦ Add-on accessory lenses to extend range even further or to widen the view to take in monuments, castles, or cathedrals that are penned in by their surroundings.

Vacationers who simply want to take good photos

You know who you are: You want pictures that are sharp and clear, colorful, and good enough to make a batch of 4-x-6-inch prints of your best shots. You like digital photography and want to capture some travel memories, but you can't spend a huge amount for your equipment. These photographers need the following:

✦ Low- to medium-resolution (1- to 3-megapixel) cameras with the ability to accept interchangeable memory cards

✦ A versatile-zoom lens, with at least a 3x zoom capability

Choosing key camera features

Regardless of what kind of travel photographer you are, look for the following key features in a camera:

✦ **Optical zoom range:** A powerful zoom enables you to compose your image carefully and cover a lot of photographic territory on your travel treks.

✦ **Interchangeable memory cards:** Some cameras try to get by with just built-in memory. When the memory is full, you either stop shooting or delete images, and neither is a good option during a once-in-a-lifetime vacation. The ability to change cards enables you to just keep shooting.

✦ **Sufficient megapixels:** The more megapixels, the better the shot. This is true for the following reasons:

 • Higher resolution (more megapixels) allows larger prints of your prized vacation shots.

 • Higher resolution lets you crop down to a smaller view of that monument that you just couldn't get close enough to and still get a good-quality print.

✦ **Interchangeable lenses:** These days, most affordable digital cameras don't use interchangeable lenses. The few that do give a photographer a wide range of choices for high-quality travel photography. Being able to select from a range of different focal lengths, plus being able to control depth of field (the range of image sharpness as it appears throughout the photograph), gives the photographer tremendous power over the photographic image. Sometimes, manufacturers also offer add-on lenses for noninterchangeable-lens cameras.

Think about taking a second camera along with you, particularly if this is more than just a run-of-the-mill vacation. A small, inexpensive digital camera may not cost much, but if the primary camera fails, your backup camera may be worth its weight in gold, photographically. Shop for or borrow one that uses the same type of batteries and storage media as your primary camera, if possible. The extra camera can also entice a spouse or child into sharing your love of photography. Encourage other family members to shoot their own photos on the trip.

Choosing lenses for travel

Look at your camera's built-in capabilities, including the range of magnifications that are available from your zoom, as well as the ability to add supplementary telephoto, wide-angle, or close-up lenses. Travel photographers need the following basic lens capabilities:

✦ **Wide-angle:** Being able to fit more into a picture comes in handy when you're shooting scenics and architecture, like the image that's shown in Figure 12-2.

✦ **Telephoto:** Capturing native wildlife or sports shots without getting dangerously close is an invaluable capability.

✦ **Macro:** Getting close-ups of native insects, signs, or documents can be rewarding.

With at least some capabilities in each of these ranges, you can shoot a broad selection of travel photos without having to physically move closer to or farther away from your subject.

Considering a tripod

A *tripod* is a three-legged stand that's designed to hold your camera steady. Although a tripod may be a little cumbersome to carry along on a trip, this camera support can do several things for you. A tripod is great for holding the camera steady if you are using slower shutter speeds in dim light or using a telephoto lens. If your camera has a timer feature, you can use a tripod to get yourself in the picture.

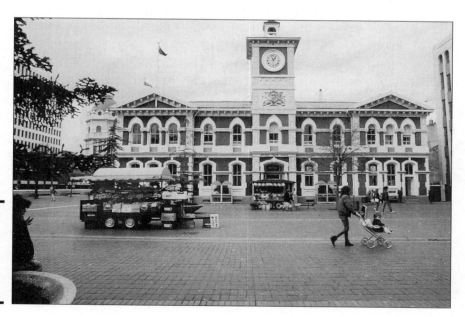

Figure 12-2:
Get everything in the frame with a wide-angle lens.

A tripod definitely leads to better pictures, but only if you use it. If you find the idea of lugging one around too much of a bother during your vacation, plan on using a different tool, such as a beanbag, which I discuss in Chapter 6 of Book I. It's okay — you're on vacation!

Choosing an electronic flash

Although most digital cameras have some sort of built-in flash capability, these flashes are usually good only for a range of about 8 feet, which isn't always enough. Because available light (more commonly known as *available darkness*) is undependable, the traveling photographer should consider carrying an accessory flash unit.

Accessory flash units do more than just provide extra light when it's too dark to shoot without it. The following are reasons why an extra flash can be particularly helpful for travel photography:

✦ **Using fill flash:** If you're planning to shoot a companion in partial shade or wearing a ball cap, an accessory flash can help you clean up the shadows. Because the supplemental light isn't trying to illuminate the whole scene, filling can be accomplished by smaller, less powerful flash units (such as the camera's built-in flash) or even by a reflective surface. A 3-x-3-inch piece of white foam board or a silver-coated auto sunshield, which is held by someone to reflect the sunlight into the area where the sunlight can't reach, provides a nicely lit photo, as shown in Figure 12-3.

✦ **Painting with light:** If part of your trip takes you into a dark place, such as a 13th-century church that doesn't have spotlights inside, an accessory flash can help. You can use the photo technique called *painting with light.* I discuss this technique, oddly enough, in the section "Painting with light," later in this chapter.

✦ **Shooting macro/close-up pictures:** To take close-up shots of typical local jewelry, markers, or insects, you need to provide a lot of light to get enough image sharpness to create a good-looking image.

Many higher-end digital cameras offer some method of triggering an accessory flash unit, either by a cable connection or via a *hot shoe* (the connection that's found on the top of many digital cameras that holds the flash and provides electrical contact with the camera). Many consumer-priced digital cameras, however, offer no such provision. If you have a camera without the means for adding an additional flash, a slaved flash that is specifically designed for digital cameras may be your answer. (A *slaved flash* has a built-in light sensor that triggers the slaved flash when your camera's flash fires.)

Accessory lighting is covered more thoroughly in Chapter 6 of Book I.

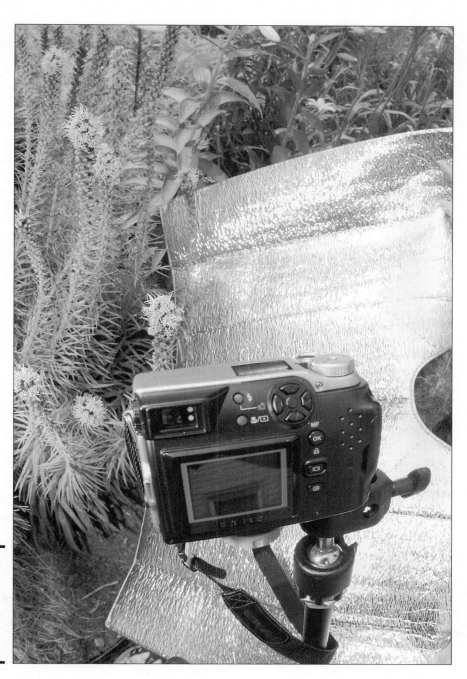

Figure 12-3:
This folding auto sunshield provides great fill lighting.

Selecting a camera bag

Depending on the size of a digital camera and the accessories that accompany it, a camera bag or pouch may be a necessity. For just the basics — a small camera, extra batteries and memory cards, and a lens cleaning cloth — a simple fanny pack can do the job and leave room for hotel keys, money, and identification. If you're a more serious photographer who is carrying a larger

digital camera or an interchangeable-lens digital SLR, you need more space. Although a larger camera bag may be the answer, the active traveler should consider the following factors:

✦ **Size:** Your camera bag should be roomy enough to hold your basic camera setup and leave some room for an extra piece of gear or two that you'll be glad you have when you're hundreds or thousands of miles from home.

✦ **Flexibility:** An ideal bag includes multiple compartments that can be reconfigured (via hook-and-loop tape) so that you can adapt the bag to the different configurations of the camera outfit that you may need. Your equipment needs often vary from place to place on vacation. At one destination, you may need easy access to your extra flash unit. At another, you'll want to be able to grab your add-on wide-angle lens quickly.

✦ **Sturdy strap:** Much travel is done on the run. A travel-friendly bag has a main strap that runs around the sides and bottom of bag and that's securely stitched, not grommetted into the fabric. (Don't underestimate the importance of this one, folks!)

✦ **Toughness:** To stand up to the rigors of travel, a bag should be made of rip-stop nylon or canvas. If you're really into leather though, you don't have to rule this material out — if the bag is well constructed.

✦ **Security and convenience:** The bag should offer multiple methods of closing. A good bag usually offers a fast method of closing (frequently via hook-and-loop tape or clasps) and a more secure method of closure (zippers or clips) that takes more effort to open and close but makes accidental opening less likely.

✦ **Protection from the elements:** The bag needs a top flap that closes over the main compartment in such a way that, if the bag is hit by rain, the water is channeled down the bag's sides. Water shouldn't be able to seep through a zipper channel or closure point, as can be the case with the bag that's shown in Figure 12-4. Although the zippered closure on this leather bag looks secure, it does little to protect the sensitive digital camera equipment inside from rain.

Figure 12-4: This bag is definitely not watertight.

At some point, you can cross over the line that divides vacation photographer from pack mule. Do a dry run with all your gear before leaving. Now ask yourself whether you're comfortable with the idea of lugging that stuff around with you on vacation. The only right answer to that question is the one that satisfies you.

Keeping your camera powered

Modern cameras use batteries like there's no tomorrow, particularly digital cameras with their power-draining LCD screens and built-in flashes. That's not much of a burden when you're shooting close to home. But if you're traveling — far from AC power or a ready source for batteries — power is a prime consideration. If you plan to shoot pictures for more than a couple of hours, it's a good idea to take along spare batteries.

Predicting battery life is a bigger challenge than taking good pictures, simply because the figure varies depending on your particular camera, how often you review your shots on the LCD screen, how many pictures you take, what kind of media you're using, how much you use your internal flash, what type of batteries you're using, and what the temperature is (batteries drain faster in the cold). If you're careful with the LCD screen and flash and keep the camera warm, four AA batteries could last from 30 to 80 shots, depending on the camera.

Use the following tips to maximize your battery life when on vacation:

✦ **Make short reviews:** Most digital cameras let you set how long the LCD stays on for review after a shot is taken. Choose the shortest setting. You can always review an individual shot for a longer period if necessary.

✦ **Flash with care:** Built-in flash units reduce battery life by half. Use an accessory flash if possible.

✦ **Choose batteries wisely:** AA lithium batteries tend to last longer than other battery types, so if you use these, you can extend the life of your shooting session before replacements are necessary. Lithium batteries also handle cold weather better. You should always carry at least one set of extra AA batteries (more if you shoot a lot).

If you're traveling in your home country, you probably already know how easy or difficult it is to feed your camera, but even here in the United States, not every type of battery can be found in the "boonies." If your camera requires one of the less common types, your digital camera can become a paperweight before your trip is half over.

If your camera uses AA or AAA batteries, rechargeable batteries are the best answer (with an extra set of backups) for each device that you bring that needs them. Choose nickel metal hydride (NiMH) rechargeable batteries if you can because they have more power, are safer for the environment, and have several technical advantages over other types. If your camera doesn't use a common battery type, bring lots more batteries than you think you'll need. Remember, if you have to buy batteries at a popular tourist destination, expect to pay a lot more than you would at home.

Of course, rechargeable batteries need to be recharged. If you're going overseas, make sure that you have the proper adapters for the country that you're visiting. Don't automatically assume that you will find plenty of outlets, either. I recently went on a Bahamas cruise and found that our stateroom had only one outlet. Because I had come prepared with a power strip, we could still plug in my laptop, battery chargers, and fan as well as my wife's hair dryer and curling iron. Without such foresight . . . well, my wife and I would surely have ended up fighting over a single outlet.

Another option, especially for those who are headed for a week or two in the backcountry, is a solar-powered battery charger from ICP Solar Technologies (www.icpsolar.com). This unit can charge four AA batteries in 4 hours or so, depending on how bright the day is. (Good luck if you're hiking in the Pacific Northwest.) The hard part may be finding a way to keep the device pointed toward the sun while you're backpacking through the forest. You may also want to consider whether carrying the unit's weight (1.3 pounds) in extra batteries would be more efficient.

Other useful devices

Gizmos and gadgets. Many of these items don't fall into any particular type of category, except that they do something useful. Some of the most popular photo widgets are as follows:

✦ **Cleaning kit:** A cleaning kit includes the following items:

- **Microfiber cleaning cloth:** Useful for keeping lenses and bodies clean.

- **Blower brush:** Use this first, and blow off any dust or small particles.

- **Silica packets:** These soak up moisture that gets into your camera bag. Keep the packets in a plastic freezer bag that can double as a camera raincoat in bad weather.

✦ **Rain poncho:** I always keep a cheap plastic rain poncho in my camera bag, along with a better rain poncho in my car. Add to that a supply of plastic bags of various sizes and some artist's tape that's easy to apply and remove from the camera.

Make a raincoat for your camera from a plastic freezer bag. Draw the end of the bag over the camera's lens barrel, and cut a hole that's large enough for the barrel to shoot through. Wrap the artist's tape around the end of the barrel and bag to hold the bag in place, and you've got a low-cost rain poncho for the camera. Thread the camera strap through the end of the bag that opens, and press as much of the seal together as possible. If it's hard to see through the viewfinder, turn the LCD on and use that to compose the photo. Figure 12-5 shows what this camera raincoat looks like — sure, it's funny-looking, but I've shot some of my best images from the Alaskan rainforest in humid downpours with this setup.

✦ **Towel:** It's a good idea to carry some paper towels so that you can towel off any moisture that gets inside the freezer bag. Toss a silica packet or two in with the camera before closing the bag to help keep the inside dry. You should also have something to dry your hands with so that you're not touching the camera with wet hands. A good choice here is a Pack Towel, which is a lightweight towel that dries quickly and that's sold in many department stores' camping sections.

✦ **A pencil eraser:** Sometimes a thin film of corrosion builds up on the battery and terminal contacts. The cure for this one is to take a pencil and gently rub both the battery and terminal contacts with the eraser. Then reinsert the batteries, making sure that they're right side up.

✦ **Polypro gloves:** Several outdoor clothing companies make lightweight gloves out of polypropylene or some brand-name material, such as Capilene or Thermax. Outdoors enthusiasts prize these synthetic materials because they "wick" (transfer) moisture away from the skin to the outside of the material, making your hands seem warmer because the skin stays dry. Wearing a pair of these gloves in damp conditions can help keep your hands dry. When you need to touch the camera, pull a glove off, and you have a dry hand to work with.

✦ **Artist's or masking tape:** If the conditions are both dusty and windy, protecting the camera can be vital and difficult. Fine-grit sand or dust can blow inside the camera's seals and foul the internal mechanisms. The same plastic bag technique that I described in a preceding bullet is good, but consider taping as much of the bag end as possible shut to get the best seal.

If you're traveling abroad and want to be sure that you aren't hassled on your return, visit a U.S. customs office and ask for a Certificate of Registration (Form CF4457). You have to bring your gear to the customs office, where they can confirm your gear and stamp the form. Having this form guarantees that you won't be asked to pay a duty on your gear. Find the location of your nearest customs office at www.customs.ustreas.gov. Most travelers skip this step and do just fine, but if you have new gear and are going somewhere known for electronics, filling out the form can be a good idea.

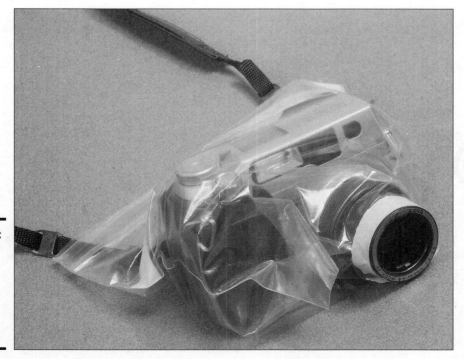

Figure 12-5: This setup may look comical, but your camera is well-protected.

Getting Ready to Go on the Road

You won't like surprises after you leave home and begin taking pictures. One key to successful travel photography is making as many preparations as you can ahead of time so that you can be organized and confident when you begin capturing memories. Use the following checklist of things to do before you leave home:

✦ **Create a packing list:** As you prepare for the trip, put together a packing list for the photographic gear. Plan a dry run to make sure that everything fits in the camera bag or case that you're using.

✦ **Carry your camera onboard:** All but the cheapest camera equipment should be included with your carry-on luggage. If you're taking more than just a basic digital camera and memory cards, make sure that the camera bag is small enough to meet carry-on space limits. Record serial numbers for pieces of equipment that have them, and have a packing list in a separate bag in case the camera bag gets lost or stolen. Check with your insurance company to see whether camera equipment is covered under your policy. If it isn't, determine whether you can add a rider for the trip.

✦ **Have some in-flight reading:** How familiar are you with your camera and accessories? It's a good idea to dig out the instruction manuals and pack them in your carry-on bag so that you can reacquaint yourself with some of your camera's more esoteric features.

Meeting Your Storage Requirements

Just like a film camera, your digital camera needs a steady supply of (digital) film, like that shown in Figure 12-6. Due to the newness of the technology (particularly overseas and in Third World countries), photographers need to make specific plans to ensure that they have enough memory capacity for the trip.

Figure 12-6:
A typical week's worth of digital film for travel outside the country.

Consider the following items when bulking up your storage for a trip:

✦ **Have enough memory:** Can you get an entire vacation's worth of pictures with your current supply of memory? Remember, you tend to shoot a lot more while traveling. If you don't think you're going to have enough capacity, consider whether you need to buy more. Alternatively, you can carry a laptop computer (if you have one) so that you can transfer images and free memory each night. (Test this process before you go to make sure that you have what you need to transfer images.)

✦ **Try a portable hard drive:** In between a pocketful of memory cards and a notebook computer are portable hard drives. These drives can accept CompactFlash cards and other types of removable storage with the proper adapter (floppy disk users are out of luck). For about $200, far less than a laptop, you can get a portable drive with several gigabytes of storage space for fewer dollars per byte than a CompactFlash card. If you go this route, try to acquire the device a couple of weeks before the trip so that you have time to make sure that you can operate it properly.

Even with all the extra memory cards or a portable hard drive, you're still carrying less than the equivalent in number of shots' worth of film.

Tried-and-True Travel Photography Techniques

If you've prepared well, you'll be ready to take great pictures when you reach your destination. This section tells you about some of the most popular types of travel photography and provides tips on getting the best shots.

Shooting scenics

Scenic photos are high on the list of pictures that people try to bring back from their travels. After all, you have to prove that you went someplace nice, don't you? Follow these tips to shoot great scenics:

✦ **Don't hurry.** The effort to record a site's beauty all too often results in quick snapshots that are hurriedly snatched while with a tour group or during a sightseeing drive. Some places are spectacular enough that this approach works; most of the time, it's hit or miss.

✦ **Understand that not all light is created equal.** The best light of the day occurs when the sun is low in the sky. Early-morning and late-evening sunlight produce dramatic shadows and rich warm colors, as the sun's light is more red/orange than at any other time of the day. If a site on your trip is particularly important, plan on being there during the "golden" hours, as photographers call them. Try to do a reconnaissance of the location a day or two beforehand so that you can see whether the sun rises or sets behind what you're shooting.

When the sun is rising or setting behind the scene, it creates the opportunity for a dramatic backlight silhouette. This is a difficult exposure situation because the camera is pointing directly into the sun. Beware of the additional risk for the photographer, who must be careful not to stare directly into the sun.

✦ **Try taking silhouettes.** For a good, solid black silhouette of a building, structure, landscape feature, or person, the camera should be set about

two f-stops smaller than what the light meter indicates for the main scene. Your goal here is a bright, orange-red sun (the most dramatic kind). Depending on your camera, you can either change aperture settings directly or use the exposure-compensation dial to get the exposure that you need. Take several shots at one f-stop increment to make sure that you have a good exposure, like the one that's shown in Figure 12-7.

✦ **Keep the camera steady.** It's best to have the camera mounted on a tripod while doing scenics. The added stability reduces the effects of camera shake and allows a slower shutter speed. Reducing the shutter speed enables you to use a smaller aperture (larger f-stop number), which creates greater overall depth of field for the sharpest possible picture. If a tripod isn't available, try to find something sturdy to brace the camera on or against. Walls, car roofs, wooden chairs, and counter-tops can all make excellent emergency tripods. Bracing the camera vertically against a post or column can also help keep it steady enough to compensate for a shutter speed that's too slow for hand holding.

Figure 12-7: A silhouette is a guaranteed crowd pleaser.

✦ **Take advantage of cloudy skies.** They provide more visual interest than a plain, washed-out blue sky, as you can see in Figure 12-8. When the clouds are in hiding, compose the image so that it has minimal empty sky at the top of the frame.

Figure 12-8: A dramatic cloud bank adds punch to this shot.

Capturing monuments and architecture

The Arc de Triomphe, the Empire State Building, the Golden Gate Bridge. Monuments, architecture, and engineering marvels can provide stunning images and a record of your journey. You can take your photography to a whole new level by following some simple techniques.

Many of the techniques that I described earlier for scenics also apply to photographing these man-made wonders. Some special techniques, however, apply only to man-made objects.

Taking a shot in the dark

Don't put your camera away when the sun sets. Buildings, monuments, and bridges take on an entirely different look at night when they're lit up. Keep the following things in mind when taking pictures of monuments after dusk:

✦ **Support your camera.** Here's another situation where you need to get out your tripod or some other camera support. Many camera manuals suggest using a flash at this point; don't do it. Some cameras automatically set the flash under such conditions; override it if you can. You don't want to overpower the existing illumination with a flat, bright, electronic flash. Most of the time, flash that is used in nighttime scenes spoils the mood or ambiance that exists.

✦ **Go long.** The idea here is to get a long enough exposure to turn the headlights from cars and trucks into long ribbons of color that wrap around the base of the structure, while the structure's own lights help give a sense of its form.

✦ **Use a boat for sea shots.** Finally, if you're photographing in a river or ocean town, a boat can make a fine shooting platform. Just keep in mind that motor vessels' powerful engines cause the decks to vibrate, and a tripod isn't much help in such circumstances.

When the sun goes down, check out the nearest amusement park. Set your camera on a tripod or something solid, and take a long exposure of the Ferris wheel or roller coaster — or any of the other rides that feature bright lights and fast motion.

Painting with light

Sometimes, a building is too big and too dark for normal photographic measures to do the trick. For these situations, the pros *paint with light.* This technique calls for using a long exposure and firing off multiple flash bursts to illuminate the object in sections. Follow these steps to paint with light:

1. **Set your camera on a steady surface.**

 A tripod is good, but so is a short wall or the ground, for that matter. Keep your camera steady — if the camera moves, the illuminated areas move, too, putting them out of alignment.

2. **Adjust the camera for a time exposure.**

 Check your camera manual for the details on setting your camera for a time exposure.

3. **Decide what areas of your subjects need to be painted.**

4. **Trigger a time exposure (or have a helper do it) by using your digital camera's time-exposure controls.**

 Experiment with different times, from 10 seconds to a minute or longer.

5. **Paint by triggering your external flash multiple times.**

 Move the flash around to illuminate the subject in sections. As you move, keep your body between your light source and camera if you don't want the light source to appear in the photo.

Photographers use another technique called *writing with light,* which can be lots of fun. This is another trick that takes advantage of a long exposure and a solid shooting platform, such as a tripod, a wall, or the ground. The idea is to take a pencil torch (a penlight) and point it toward the camera lens while the shutter is open. You can either swirl the penlight around or try to write a specific message. Follow these steps to write with light:

1. **Plan what you want to do. I recommend rehearsing a couple of times, with someone else watching through the viewfinder.**

 This way, you know whether the camera is positioned properly to get everything you want. Besides, you have to write backward — don't you think that takes some practice?

2. **Set the camera to shutter-priority, and give it a long exposure time (long enough for you to do what you want — probably several seconds or more).**

3. **Write with light by pointing the light at the camera lens from your subject position.**

4. **Review the image with the camera's LCD screen.**

5. **If necessary, make some adjustments to your shutter speed based on what you see in the LCD.**

6. **To get really fancy, have a friend or spouse fire off a small flash after you're done writing but before the shutter closes.**

 This helps illuminate you while still allowing your writing to show.

Don't forget that fireworks, like those shown in Figure 12-9, are a kind of "writing with light." You can use the same techniques that I just described, except you let the aerial display create your image for you.

Figure 12-9:
A fireworks display is tailor-made for your digital camera.

Keystoning

Keystoning, also known as *perspective distortion,* happens when the photographer tries to fit an entire building in a photo by tilting the camera up. The problem with this approach is that when the camera is no longer perfectly parallel with the building, any straight lines on the long axis of the image converge until they meet at the top. The photographer ends up with a photo of a building with a wide base and a pinpoint top that appears to be falling away.

How do you avoid keystoning? Because the problem comes from the lens and the building not being perfectly parallel, the easiest way to correct that problem is to align the two. You may be able to do this by gaining some elevation. Sometimes, a nearby hill can provide a distant vantage point, and sometimes another building with an accessible roof is available. Unfortunately, all too often, neither solution is available, and the only option is to point the camera up and take the picture.

Shooting panoramas

One of the most frustrating moments of travel photography comes when you find yourself literally surrounded by the beauty of nature, and you have no way to capture all that surrounds you in a single photo. A digital camera, tripod, and the right image-editing software, however, make capturing a 360-degree panorama possible. Basically, you take a series of shots for your panorama and then stitch the shots together (that is, line up the images into one image) on your computer. Although you can stitch images together in any image editor, specialized stitching applications are easy to use. Follow these steps to take a panoramic shot:

1. **Mount your camera on a tripod, and adjust the camera's appropriate zoom setting.**

 You don't have to adjust the zoom lens to its widest setting. Zooming in a little closer means that you capture more detail per photo. If your main subject is distant, zooming in lets you capture more of the important part of the scene without wasting space on unnecessary foreground details.

 The more shots you take, the more you'll have to stitch together and the greater the chance the software may have trouble creating a seamless panorama. Three to six images are generally the most manageable.

2. **Level the camera.**

 The closer you can come to a perfectly level camera, the better job your software can do with the final image. Buying an inexpensive level (as small a unit as possible) at the local hardware store is highly recommended. Set the level on top of the camera, and adjust the tripod until the camera is level.

3. **When you take the first picture, waste a shot by photographing your fingers in front of the lens (don't worry about focusing or exposure).**

 This makes it easy to see where you began the sequence. (Do the same when you've completed each sequence.)

4. **Make your first shot of the scene at either the left or right end of the panoramic swing that you intend to make.**

If your camera is capable of manual exposure, take several readings throughout the scene and try to come up with an average setting for the entire range.

5. **Take subsequent pictures.**

 Make sure that each shot overlaps the previous one by 20 to 30 percent.

6. **If possible, do a second sequence of images, particularly if the lighting was erratic.**

7. **Stitch all the images together at home, using an image editor or stitching software.**

 Packages such as PhotoStitch for the Macintosh (shown in Figure 12-10) are easy to use and a lot of fun.

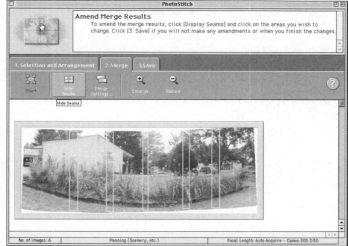

Figure 12-10:
A needle and thread are not required to stitch images together.

Shooting adventure sports

Adventure sports, such as white-water rafting, rock climbing, scuba diving, and similar activities, entail different risks and require different precautions to protect your precious equipment. If you're the adventurous kind, I recommend the following items:

✦ **Dry boxes:** Climbers and hikers need to keep their gear dry using waterproof camera bags or other equipment. Sports such as white water rafting and kayaking call for even greater protection. Usually, these boaters protect their gear in a dry box setup. The best known manufacturer of these is Pelikan, which makes cases with foam insides that can be cut to fit specific camera gear. If using one of these, take very good care of the O-rings that provide the watertight seal for the box. Veteran river runners sometimes rely on Army surplus ammo or rocket boxes, which also provide a watertight container for gear, but without the form-fitting foam. If using one of these, make sure the camera is properly cushioned from the bumps and jolts white water entails. If you protect your camera from water, you can easily take photos like the one shown in Figure 12-11.

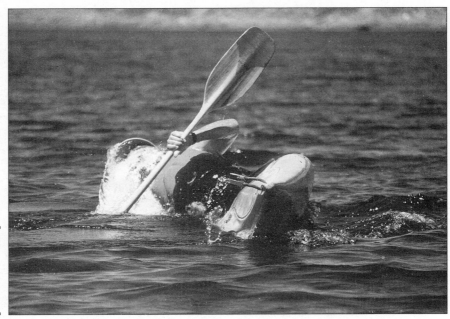

Figure 12-11: A great shot, and the camera remains dry.

✦ **Carabineers:** These are the oval clips that climbers use to secure themselves to safety ropes; you can use them to clip the dry box to your off-road vehicle. If you're immersed in a water activity, the clips can also secure your dry box to the raft or to the inside of the kayak. The boaters will run the rapid, and at the end of the run they'll unpack the camera and start shooting. Once again, placing a silica packet or two in one of these cases can help keep dampness from damaging your equipment.

✦ **Underwater digital cameras:** Another option for those who want to shoot a lot in wet conditions is to buy an underwater digital camera. I've used underwater cameras even when I wasn't *planning* to go in the water. (You never can tell where a hike will end up.) The SeaLife Reefmaster Underwater Digital camera comes in a waterproof housing and works both on land and underwater. The camera, which retails for under $400, only produces a 1.3-megapixel file but saves you the trouble of trying to find a housing to fit an existing digital camera. The camera also has an LCD that works underwater and a fast-delete function, both of which make it easier to operate underwater. Check out the manufacturer's Web site at www.sealife-cameras.com for more information.

✦ **Waterproof casings:** More extreme conditions call for better protection. Waterproof casings that still allow photography are available from several companies, including Ewa Marine (www.ewa-marine.de). These casings are useful for both underwater photography (careful on the depth though) and above-the-water shots if you are sailing or boating.

Keep in mind that salt spray is possibly the worst threat to camera electronics. A camera housing provides good protection against wind and salt spray.

✦ **Deep-diving housings:** For serious underwater enthusiasts, heavy-duty Plexiglas camera housings now exist for small digital cameras. These housings are available for a wide range of digital cameras and may be found for as little as $200.

Photographing people

You have lots of reasons to photograph people while traveling — and some reasons not to. For example, photographing law-enforcement or military personnel without getting their permission first can be a bad idea.

With today's heightened concerns about terrorism, many security forces, including our own, have become much more sensitive about people photographing and videotaping government facilities and employees. While traveling in Israel and South America, it wasn't unusual for me to see armed military personnel walking the streets. Even a decade ago, it wasn't a good idea to grab a snapshot of them, and I wouldn't even consider it these days unless I got their permission first.

When photographing people in other areas of the country or in foreign lands, remember that effective travel photography needs to create a sense of place. Any time the photographer can use lifestyle, surroundings, work, or clothing to show the region or culture involved, he or she has achieved at least one measure of success. The following elements can help your photos convey your location:

✦ **Clothing:** Different cultures have different tastes in clothing and jewelry.

✦ **Design:** Advertisements, homes, and buildings often look different, depending on whether you're overseas or in the United States.

✦ **Products:** Soda cans, candy bars, and other packaging is different in other countries — and sometimes even in the United States.

✦ **The natural world:** Plants and wildlife may be noticeably different in other locations.

In addition to creating a sense of place, the following tips can help you effectively photograph people while traveling:

✦ **Be aware of cultural sensitivities.** Some cultures frown upon photographic images of other human beings (that includes some cultures in the United States, as well). In many Middle Eastern and Third World countries, women wear clothing that's designed to hide their appearance. In some of these countries, photographing these people can be a serious taboo (as can a man speaking to one of them to even ask permission to take a photo).

✦ **Check out the local customs.** Although taboos that have their origins in religious beliefs can stay constant for millennia, official taboos may shift frequently. Check with the U.S. consular office for the country that you're visiting to find out what's okay and what isn't. The following Web site contains information on individual countries and policies:

```
travel.state.gov/travel_warnings.html
```

✦ **Ask first.** As a newspaper reporter and photographer, my philosophy was to shoot first and ask questions later. (You can always talk to people after an event is over; you can't re-create photos, though.) Photojournalists who are working in a newsgathering capacity, though, are afforded some liberties that are considered out of line for tourists. (And that's in this country; the rules vary from country to country.) In

the case of a traveler photographing others without their permission, it's behavior that many would at least consider rude.

✦ **"Pretend I'm not here."** One of the reasons that pros prefer to shoot first and ask later is that people appear more natural when they don't know that they're being photographed. A common way of dealing with this problem is to ask permission and then explain that you would like the picture to look "natural." Ask the person to go back to what he was doing and to forget that you're there.

✦ **Be forgettable.** Although your subjects likely start out being self-conscious, after a few minutes, they tend to become involved in their activity and, in fact, forget that you're there.

✦ **Give your subjects feedback.** Be aware of human psychology. People who are posing tend to wait for some feedback at first, namely the click of the camera that tells them you're satisfied. If a person doesn't hear that click because you're waiting for her to forget that you're there, she can become concerned that you're not happy with what she is doing. Take advantage of the digital advantage (being able to delete bad shots), and take a photo or two at the start. Your subject will relax and begin to forget that you're there.

Another technique works well if you have a camera with a fairly wide-angle lens. Adjust the zoom to the widest possible setting, and hold the camera waist level and as perpendicular to the ground as you can. I usually try to do this one-handed, with the camera strap helping me keep the camera under control. Most people relax even more at this point because they don't expect you to shoot now. At this point, when I see the shot I want, I trip the shutter. This technique works better if you're familiar enough with your camera to have a good idea of what its wide-angle lens covers from a certain distance.

This "shooting from the hip" technique can be a tricky proposition ethically. At least one journalism professor I know feels that it's a violation of trust between a photographer and the subject.

As a photographer, I believe that it's important to be sensitive to your subject's feelings on the matter. Because I'm shooting digitally, I take the shot and then show it to the person who I've photographed. I then let him or her decide whether the photo should be deleted. Most people aren't concerned with the shot, but I've slept better at night by immediately deleting the shot if the person is unhappy with it. This process gets a lot harder if you and your subject don't speak the same language. Sometimes, the combination of pantomime and the preview capability of the digital camera can be enough for you to get by.

Capturing people and their places

Once the issue of getting permission from your subjects is out of the way, it's time to consider how to photograph them. Being able to capture people in their own environment is where you can really feel the advantages of your digital camera. It's lightweight and versatile and can take plenty of photos. Use the following tips to make the most of your camera's advantages:

✦ **Shoot as much as it takes.** If your objective can be achieved in just one shot, so much the better. Still, there's nothing wrong with taking multiple shots to achieve the same thing, provided that the images build on one another.

✦ **Capture the environment.** At least one shot should show the individual within his or her cultural environment. After that image is out of the way, focus on the smaller details. Look for things that would be unusual in your own home.

✦ **Move in close.** Close-ups, like the one shown in Figure 12-12, provide greater intimacy than full-body or head-and-shoulder shots. A well-focused, tight composition of a person's face (cropped in to just the eyes, nose, and mouth, and not much more) packs a lot of intimacy. If your subject wears glasses, try a profile shot (also tightly composed).

✦ **Hands can speak volumes.** Sometimes, a person's hands can reveal his or her work history. Work-roughened, they can speak of years of manual labor and toil. Or, a close-up of hands holding small tools or repairing a watch, for example, can show great dexterity.

✦ **Capture the essentials.** Who is this person? What shows your subject's identity? A new mom cradling her baby, a farmer on his tractor, and a cyclist on her bike are just a few possibilities.

✦ **Think about lighting.** Don't forget to consider lighting. Unless your subject is in direct sunlight, some sort of fill flash is necessary. (The term *fill flash* comes from its use not as a main light source but as an additional light to fill in areas that are hidden from the main light.)

✦ **Go for variety.** Make sure to take a mix of horizontal and vertical photos. For people shots, take lots of verticals (the human body breaks down into a series of elements that are taller than they are wide).

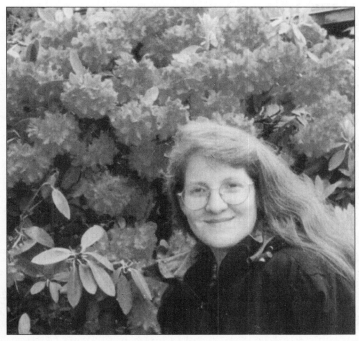

Figure 12-12:
A beautiful woman against a beautiful background.

✦ **Show people working, playing, and relaxing.** Even on a mountain climb, like the one shown in Figure 12-13, quiet moments can reveal another side of your subjects. Social gatherings and religious meetings are also prime opportunities for good photographs. Look for community festivals, too, where you can shoot lots of people, costumes, and events. In such freewheeling settings, people are less concerned about being photographed, and you can probably get away with taking wider shots without having to check with every individual for his or her permission. Performers, in particular, are quite used to being photographed.

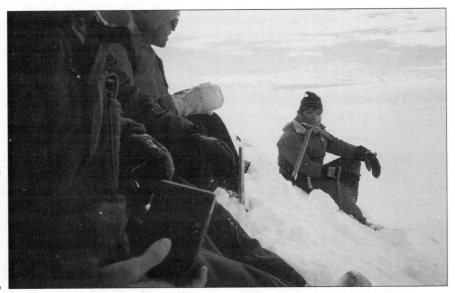

Figure 12-13:
Many photographers climb mountains . . . just don't drop the camera!

Documenting Your Trip

Now, you can pull together everything from the earlier sections and create memorable photos of your trip. Documenting a vacation is more than grabbing some pretty pictures of your travels; it's creating a visual narrative that re-creates the magic of your trip. This section wraps up travel photography with some final tips for getting great vacation pictures.

Varying your shots

Try for a mix of shots and camera angles. Shoot some close-ups, and shoot from far away. You can do a lot of things to avoid having all your photos look alike. Consider the following tips:

✦ **Place the camera on the ground for a worm's-eye view.** Make that church look even more imposing.

✦ **Get a bird's-eye view.** Renting helicopters gets expensive, but you have other ways of getting up high and shooting down. You were going to climb that monument anyway, right? Take advantage of the elevation. Even simpler, climb a staircase and shoot straight down. Take advantage of cable cars. Use a hot-air balloon ride to get some once-in-a-lifetime scenic photos, like the one shown in Figure 12-14.

Figure 12-14:
Take to the air for dramatic photo-graphs.

✦ **Turn the camera vertically when appropriate.** Many scenes lend them-selves to vertical images, yet most people still grip the camera horizon-tally. Monuments, people, and buildings are all taller than they are wide. Turn the camera on its side for these shots.

✦ **Shoot from more than one vantage point.** Do like the pros do: Shoot it high, shoot it low, shoot it horizontally, shoot it vertically, get closer, move back, and walk around it. While doing this, remember to consider what's in the background.

Composing your shots

How you arrange the elements within your photo has a lot to do with how much impact they convey. While I cover this topic in more detail in Chap-ter 7 of Book I, the following things can help improve your photographic composition:

✦ **Leading Lines:** Strong linear elements can be used to pull the eye into an image, as shown in Figure 12-15. Straight lines, diagonal lines, and S-curves all show movement and can depict strength, direction, or grace. For example, the curves of a U.S. flag rippling in the wind com-bine S-curves with the strong lines of the stripes.

✦ **Framing:** Use existing and natural elements, such as window frames or tree branches, to form a natural border along a corner or around the image. Figure 12-15 is an example of this concept.

✦ **Rule of Thirds:** Divide the frame into thirds horizontally and vertically. Where the thirds intersect is a good place to place your subject. You can also use this rule to show a course of movement. For example, put-ting an airplane coming into the frame into the upper-right third con-veys a sense of moving downward through the frame.

✦ **Balance:** Did you ever see a picture of someone sitting on a park bench with one end of the bench missing? Because of the missing support, it seems like the person is going to drop like a rock. Again, you can find examples of photos using balance and these other prime rules of com-position in Book I, Chapter 7.

237

Figure 12-15:
An intriguing image that takes advantage of framing.

Getting organized

Close focusing (or macro capability) is another of the digital camera's best features. By introducing details of the location that you're visiting, you can trigger memories of your experience years after the trip has ended.

On that cruise that I mentioned earlier in this chapter, my wife and I were fortunate to stay in an owner's suite, one of the nicest cabins on the ship. Each afternoon, we received a treat of some sort from one of the ship's staff,

along with a card announcing who it was from. Before enjoying our delicacies, we made sure to photograph the dish and card together (shown in Figure 12-16), and we made sure to keep the card for a scrapbook as well. The photo album from this trip includes many such details and provides a much fuller and richer representation of our trip.

This section has already talked about a couple of documentary techniques, such as photographing the chocolates and card we received aboard ship and getting close-ups of local items or packaging that gives a sense of place.

Now take this technique a step further. Think of your photographic coverage as a series of still images that tell a story, rather than a group of individual pictures that stand on their own (even though they should).

Figure 12-16: The lines draw your eye into this shot.

Opportunities for documenting your trip include:

✦ **Signs, signs, everywhere there's a sign:** Use street and highway signs — or even the one and only South Pole (shown in Figure 12-17) — to show where you are or where you're going. Photograph maps and brochures, too. Don't just settle for snapshots of these images; try to use lighting and depth of field to turn them into interesting images in their own right.

✦ **Cultural and language differences:** Signs differ from country to country. In the United States, a sign can say "End of construction." Years ago, on a trip through New Zealand, I photographed a sign, shown in Figure 12-18, that proclaimed "Works End," with a cemetery in the background.

Figure 12-17: Yep, that's really the South Pole. No kidding.

Figure 12-18: Sometimes, the picture practically takes itself.

✦ **More signs:** Street and road-crew signs are only one type of photographic target, though. Distinctive shop, restaurant, and tavern signs also provide reminders of where you've been.

✦ **Newspapers/newsstands:** Check the local newsstands. In at least some countries, newsstands say something about where you're visiting. For that matter, a close-up of the day's headline during your visit may make a good introductory graphic if you're giving a presentation.

✦ **Trailheads:** If this a wilderness trip, most trailheads are well marked. Photograph the signs. Shoot the trail maps, too. Your packs, supplies, and other gear should also be documented. Follow the same approach if you're on a white-water rafting, skydiving, or ski trip.

✦ **White water:** For white water, shoot as many rapids as possible. (Only my fellow paddlers will get that pun.) It's better to photograph the rapids from the side because that field of view gives a better sense of scale than a head-on shot does. If you can, get a raft or kayak in the photo because that can help show the rapid's size.

✦ **River scenes:** Wilderness rafting trips include many other photo opportunities as well. Photos of swimmers (the white-water euphemism for someone who has inadvertently become one with the river) and their rescue can provide dramatic images. The lunch buffet (if on a commercial trip) provides an opportunity for humor if you get shots of some of the sandwiches that the guides make. (Guides traditionally eat after the paying guests have gone through the buffet. As a result, some of the sandwich ingredients get pretty creative. My guide usually included cold cuts, veggies, chunky peanut butter, and thick slices of onion.)

✦ **River scenes (Part II):** Don't forget, white-water rivers generally offer spectacular scenery, too. Plus, you can take shots of all the preliminaries — inflating the rafts, getting gear together, and putting on wet suits and life jackets.

✦ **Rock climbing:** Scenery, gear, climbers. Oh yeah, don't forget the rocks. Seriously though, mix close-ups, wide-angle shots, and action images of the climbers. Take advantage of the bright colors and patterns of the clothing that rock climbers wear, and the chocks, friends, and nuts (for all you nonclimbers, this is the protective equipment that climbers use to anchor into the rock) are great subjects for close-up shots. So are chalk-covered fingers. Also, get lots of angles: Shoot from below, above, and alongside the climbers.

✦ **Papers, please:** Don't forget close-ups of your travel documents. They're also part of the story that you're telling.

You'll soon discover that good photography is all in the details. Visiting foreign cultures provides a wealth of these details that can help show how different or similar we are. Close-ups of jewelry, magazines, and candy and food packaging help emphasize that you've gone somewhere different.

Chapter 13: Comparing Photoshop Elements to Other Image Editors

In This Chapter

✓ Choosing an image editor that matches your needs and skills

✓ Comparing the capabilities of popular image editors

✓ Using different image editors for different tasks — deciding when you need more than one

*W*hat's the right image editor for you? That's not an easy question, at least, not on the order of something simple, such as choosing a photo lab to work on film from your old-fashioned film camera.

When you take a picture with a traditional film camera, you send the exposed film to a photographic lab for processing and printing. You can change your mind about which lab to use on a whim. In addition to performing the physical and chemical processes required to generate prints from the exposed film, the lab technicians routinely adjust exposure, color balance, and other details to improve the quality of your photographic prints.

With digital pictures, you can use an image editor to perform all the functions of a traditional photo lab, but you can't change editors with each roll of film. When you sign up for an image editor, you're making a long-term commitment (unless you have the resources to buy and use multiple image editors). This chapter compares the features of some leading image editors and helps you decide which is best for you.

Looking at Popular Image Editors: The Basics

There is no one image editor that is right for every digital photographer. Different image-editing programs offer different feature sets and take different approaches to the task of manipulating digital images. The trick is to find the program (or programs) that has the features and approach that most closely matches your needs and working style. Image-editing programs range in capabilities from extremely limited to impressively powerful. And you probably won't be surprised to find a similar range in price, from free or low cost for programs with limited capabilities to several hundred dollars for high-end programs.

A simple image editor was probably included on the disc that came with your digital camera. Dozens of others are available on the shelves of local computer stores or as free downloads from the Internet. Because you're taking the time to read this book to improve your skills, I think it's safe to assume that your interests go well beyond the simplest snapshots and

prints made with the default settings and that your search for an image-editing program will extend beyond the simple, view-and-print utilities. But just because you want more capabilities than the low-end programs offer, that doesn't necessarily mean that you should go all the way to the other end of the spectrum. An assortment of midrange programs might fit your needs very nicely.

You might also find that one image editor doesn't perform all editing tasks equally well. A specific editing task may be easier to perform in one editor and more cumbersome in another. If your main editor is a little awkward to use for some tasks that you perform frequently, I recommend keeping another editor around that can handle those tasks with aplomb.

The available image-editing programs can be roughly grouped into four tiers:

✦ Adobe Photoshop CS stands alone at the top as the de facto standard for professional image editing. If you're working with images professionally, you need to own and use Photoshop CS. You may also find one of the other editors helpful for specialized tasks, but Photoshop CS is your meal ticket.

✦ The second tier is composed of highly capable image editors that, although they may not match Photoshop's every feature, have the power and versatility to meet the needs of many digital photographers — Photoshop Elements falls squarely into this category. The image editors in this tier often provide wizards and dialog boxes to automate common tasks, but the main focus is on direct access to the image with a variety of manual selection, retouching, and painting tools.

✦ The third tier of image editors sacrifices some of the raw power and versatility of the first and second-tier programs in favor of dramatically improved ease of use. Most common image-editing tasks are automated or made more accessible through the use of wizards and dialog boxes that walk you through the steps required to complete the tasks. The programs in this group may also have the ability to access your image for direct manipulation with retouching and painting tools, but the manual editing features are somewhat limited. The main emphasis is on the program's automated editing tasks.

✦ The fourth tier is composed primarily of the simple, view-and-print utilities, although some of the programs also have some limited image-editing capabilities. These programs often feature simple and attractive user interfaces with big graphical buttons for each task. They are easy to use, but offer only a very limited assortment of simple image-editing options, such as cropping and overall color balance. Generally, these programs don't enable you to select and edit a portion of an image with manual retouching tools.

The purpose of this chapter is to give you a brief overview of some popular image editors and assist you in identifying the program that might be right for you. (Unless I specify otherwise, these programs are available for use on both Macs and Windows PCs.) I skip the bottom tier because these programs come and go and don't usually have the level of support needed for serious image editing. The focus in this chapter is on the other three levels.

Adobe Photoshop CS — *Alone at the Top*

Adobe Photoshop CS is the big kahuna of image-editing programs. It is the de facto industry standard, by which all the other image-editing programs are measured.

Over the years, Photoshop has earned a place in nearly every digital-imaging professional's toolbox. In fact, for many graphics professionals, Photoshop CS is their primary tool for everything from resampling image files and changing file formats, through photographic retouching and image enhancement, to creating original illustrations and artwork.

Photoshop is a professional-level tool, but you don't have to work at a major advertising agency, photography studio, or printing plant to use it. Even though buying a copy of Photoshop CS requires a significant investment of money and the time spent learning to use it, it's not beyond the reach of small businesses, serious digital photography hobbyists, artists, and others who need access to its powerful tools and advanced features. You'll need a computer powerful enough to run it, of course. You can find attractive upgrade offers from time to time that let you purchase a full copy of Photoshop CS for a fraction of its regular list price. And when Adobe releases new versions, upgrading is relatively economical.

What's good about it

Photoshop CS didn't attain its stature as the leading high-end image-editing program by accident. It has a well-deserved reputation for delivering a very complete feature set. In short, this is one powerful program. No matter what you want to do with an image, the odds are that Photoshop CS contains the tools that enable you to do it.

Photoshop CS can read, write, and manipulate all the industry-standard file formats (and many not-so-standard formats as well). You can resample images to change the image size, resolution, and color depth. Photoshop CS excels at providing images that are optimized for specialized uses, such as commercial printing and Web graphics, and the application also enjoys close ties with several leading page-layout programs and Web-development programs (especially other Adobe products like PageMaker and InDesign).

Photoshop CS provides a rich set of tools for everything from simple image manipulation (cropping and color balance adjustments, to name two) to selecting complex shapes from an image and applying sophisticated filters and effects to the selected area. Photoshop CS also includes a full set of painting tools that you can use to retouch your images or to create original artwork.

As if this list of built-in features weren't complete enough, Adobe designed Photoshop CS to accept filters and plug-in program extensions provided by third-party suppliers. As a result, a robust aftermarket has evolved to supply a wide assortment of plug-ins that make it quick and easy to apply all manner of textures, edge treatments, special effects, and other image manipulations to the images you edit in Photoshop CS.

What's not so good

Photoshop is undeniably a powerful program, but you pay a price for all that power. Photoshop CS is also an *expensive* program. The price of admission for accessing Photoshop's power is a significant investment in money and learning time.

At a little over $600, Photoshop CS is expensive to purchase initially (later upgrades won't cost you as much). But the cost of the program doesn't stop there. If you're a serious Photoshop CS user, you probably want to add one or more plug-in packages, which each cost as much as a typical midlevel image editor. And then there's the inevitable upgrade costs when Adobe releases the next version of Photoshop CS with all its cool new features. The upgrade price for a new version of Photoshop CS is more than the full purchase price of most other image editors, but it's still reasonable when you consider what you're getting.

In addition to its monetary cost, Photoshop CS is also expensive in terms of the time you need to invest in order to use it. The demands of learning to use this program are probably the most significant barrier for the casual user. Photoshop's power and versatility make it a complex program, and that complexity creates a steep learning curve. It can be challenging to get started working with the program right out of the box, and even after you learn the ropes, performing simple tasks can sometimes be cumbersome in Photoshop CS. The program's breadth and depth make it difficult to master. Often, even the graphics pros who use Photoshop CS on a daily basis haven't explored all its many capabilities.

Photoshop CS is an ongoing commitment, too. It's not the sort of program you can use once a month and pick up where you left off. It works best when used on an everyday basis so that the commands and shortcuts become second nature. Attempt to use a special feature after not working with Photoshop for a month, and you'll probably find yourself diving into the (excellent) built-in Help system.

Oh, and don't forget the hardware requirements. Photoshop CS is one of the most demanding applications for both PCs and Macs, and you'll need the fastest processor and the largest amount of RAM you can afford to maximize the performance of your system.

What you can do with it

What can you do with Photoshop CS? The short answer is, "Almost anything! (Within reason!)"

In fact, it's difficult to come up with anything that you'd want to do to a digital image that *can't* be done in Photoshop CS, unless it's outright impossible in the first place (such as transforming a total train wreck of a photo into a work of art). Oh sure, a few tasks are faster or easier to perform in some other programs. However, it's hard to find a visual effect that can't be duplicated in Photoshop CS if you're willing to invest the time and effort to get acquainted with the program's tools and to use those tools in innovative ways.

Adobe Photoshop CS — *Alone at the Top*

Book I
Chapter 13

Comparing Photoshop
Elements to Other Image
Editors

Here's just one simple example of an image enhancement you can create with Photoshop. Suppose you've taken a beautiful picture of a sailboat on a lake, but you don't like the flat, uninteresting sky in the background. No problem, you can quickly add some clouds by following these steps:

1. **Click the Magic Wand tool and then adjust its settings.**

The Magic Wand tool is the second button in the right column of the toolbox (which is on the left side of the Photoshop window). You adjust the settings for the Magic Wand tool in the Options bar across the top of the Photoshop window. In this case, I used a tolerance setting of 50 and checked the Anti-Aliased and Contiguous options. Those settings tell the Magic Wand to select only the pixels in the sky.

2. **Click the sky with the Magic Wand tool.**

Photoshop selects the sky for editing and marks the selection by surrounding it with a "marching ants" marquee.

3. **Choose Filter➪Render➪Clouds from the main menu.**

Photoshop fills the selection with a cloud pattern. The new sky looks better than the old dull sky, but it's a little too dark to look natural.

4. **Choose Image➪Adjustments➪Variations.**

The Variations dialog box appears, as shown in Figure 13-1. Ensure that Midtones is selected and that the Fine/Course slider is in the middle position.

Figure 13-1:
The
Variations
dialog
box —
impressive,
isn't it?

5. **Double-click the Lighter thumbnail and then click the More Green thumbnail.**

With each click, Photoshop adjusts the color and brightness of the Current Pick thumbnail to preview how the adjustments will look when applied to your image.

6. **Click OK to close the Variations dialog box and apply the adjustments to the selected portion of your image.**

7. **Choose Select➪Deselect from the main menu to remove the selection marquee.**

Enjoy your sunny sky.

Where to get it

Photoshop CS costs about $600 and is available from most computer stores, catalogs, and online software outlets. For more details, or to purchase directly from the manufacturer, go to www.adobe.com.

Second-Tier Image Editors

The second-tier image editors are a diverse lot. They all have the ability to edit and manipulate digital images, and they emphasize direct access to the image over wizards and other automation for editing tasks. They are all less expensive than Photoshop CS. But that's where the uniformity ends.

Some of the programs in this tier are niche products that excel at dealing with particular kinds of images, whereas others are general-purpose image editors with nearly as much versatility as Photoshop. Each of the programs in this tier has its own set of strengths and weaknesses. Depending on your specific needs, the program that is a perfect fit for you might be unsuitable for another digital image maker.

Adobe Photoshop Elements

Photoshop Elements is the little brother to the full Photoshop CS program. Adobe created Photoshop Elements (often shortened to just *Elements*) as a more accessible version of Photoshop CS for the numerous people who want to use Photoshop but don't need some of its more advanced features.

Photoshop Elements, shown in Figure 13-2, shares much of the same user interface with its big brother, Photoshop CS. Compared to the full version of Photoshop, Elements has an abbreviated feature set, but it includes most of the basic image-editing tools that the typical digital photographer needs on a regular basis. That includes image-selection tools, retouching tools, painting tools, a generous assortment of filters, and the ability to expand those filters by accepting the same Photoshop CS plug-ins as its sibling program.

What's good about it

Photoshop Elements is competitively priced at about $100. Elements is considerably less powerful than its big brother, Photoshop CS, but by sacrificing some of the immense power of Photoshop, Adobe created a program that is significantly less complex and is therefore simpler and easier to use than Photoshop CS.

In general, Adobe did a pretty good job of selecting which Photoshop CS features to leave out of Elements. The program's feature set is a reasonably good match for the needs of the typical digital photographer. Most of Photoshop's standard selection, retouching, and painting tools are available in Elements. If your image-editing needs revolve around retouching and manipulating individual pictures one at a time, you'll probably never notice the more advanced Photoshop CS features that are missing from Elements.

Elements isn't just a cut down version of Photoshop CS. The program includes a few interesting features that Photoshop lacks. Elements features a set of

tabs in the toolbar at the top of the main window to provide quick access to many of the program's most-used features, and the automated commands on the Enhance menu make quick work of common image-editing tasks, such as adjusting backlighting or color cast. As a result, an occasional user working with Elements can complete those tasks faster and more accurately than a seasoned graphics pro working with Photoshop CS.

Elements also is a good set of training wheels for Photoshop CS. After you master this program, you can use Photoshop CS much more easily than if you started from scratch.

What's not so good

The similarity of the Elements user interface (the arrangement of menus and floating palettes superimposed on the workspace containing multiple document windows) is a boon to Photoshop CS users and wannabes who might need to switch back and forth between the two programs. However, the Photoshop interface isn't known for its ease of use. Many newcomers to the program don't find the menu arrangements and other details to be very intuitive.

What you can do with it

One very nice feature of Elements is the Fill Flash command. This command enables you to bring out the detail in an underexposed foreground without wiping out the sky the way a simple brightness adjustment would. The effect is similar to using a fill flash when taking the original image. In fact, the Fill Flash command can salvage a picture where the flash failed to fire or the subject was too far away for the on-camera flash to be effective.

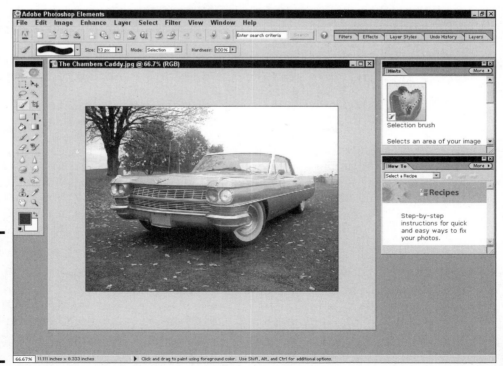

Figure 13-2: Photoshop Elements offers most of the features of Photoshop CS.

Follow these steps to apply the Fill Flash command to an image you're editing in Photoshop Elements:

1. **Choose Enhance⇨Adjust Lighting⇨Fill Flash from the menu bar.**

The Fill Flash dialog box appears. Make sure the Preview box is checked and that the dialog box is positioned so that you can see the effect of the adjustment on your image.

2. **Drag the Lighter slider to the right and observe the effect on your image.**

As you drag the slider, Elements adjusts the image to preview the effect. Adjust the slider as needed to achieve the desired effect.

3. **Drag the Saturation slider to the right and observe the effect on your image.**

Again, adjust the slider as needed to achieve the desired effect.

4. **Click OK to close the Fill Flash dialog box and apply the adjustment to your image.**

The Fill Flash command is one of the features that is available in Elements but not in the full version of Photoshop. You can obtain essentially the same results in Photoshop by using other tools, but the Elements Fill Flash command is much faster and easier to use.

If your image looks muddy and unnatural after applying the Fill Flash command, try applying the Enhance⇨Auto Levels command to restore a more natural tonal range.

Where to get it

Photoshop Elements costs about $100 and is available from most computer stores, catalogs, and online software outlets. For more details or to purchase directly from the manufacturer, go to www.adobe.com.

Corel PHOTO-PAINT

Corel PHOTO-PAINT is the image-editing program that is included in the popular CorelDRAW Graphics Suite.

PHOTO-PAINT, shown in Figure 13-3, is a reasonably full-featured photo retouching and image-editing program. Although its feature set can't match the full version of Photoshop CS, PHOTO-PAINT stands solidly among a second tier of products that deliver a large portion of Photoshop's functionality for a relatively small portion of that program's price. PHOTO-PAINT is far more powerful and versatile than other programs that stress ease of use.

PHOTO-PAINT offers a full set of selection, retouching, and painting tools for manual image manipulations and also includes convenient automated commands for a few common tasks, such as red-eye removal. PHOTO-PAINT accepts Photoshop plug-ins to expand its assortment of filters and special effects.

Figure 13-3:
PHOTO-
PAINT is
Corel's
entry into
midrange
image
editing.

What's good about it

Corel PHOTO-PAINT is a respectable product as a standalone image editor. However, it's greatest strength is its integration with CorelDRAW and the rest of the CorelDRAW Graphics Suite. If you use CorelDRAW to create and edit graphics, then you've probably got PHOTO-PAINT installed on your computer, and you'll feel right at home using the product. All the menus, dialog boxes, and palettes behave just as you've come to expect from your experience with DRAW.

What's not so good

Perhaps the worst thing about PHOTO-PAINT is that it's available only as part of the CorelDRAW Graphics Suite. At a $400 street price, the CorelDRAW Graphics Suite is a good value, provided you need the main CorelDRAW program and any other components of the suite. However, $400 is a lot to pay for PHOTO-PAINT alone, especially when other image editors in this tier are available for around $100.

What you can do with it

You can do many of the things possible with Photoshop cs, except for complex color separation tasks. It's an all-around good editor for the average user and the equal of Photoshop Elements.

Where to get it

To get PHOTO-PAINT, you need to purchase the CorelDRAW 12 Graphics Suite, which costs about $400. The suite includes the CorelDRAW graphics program, PHOTO-PAINT, R.A.V.E. (a Web animation program), CorelTRACE (a bitmap-to-vector conversion utility), CAPTURE (a screen-capture utility),

and a large assortment of fonts and clip art. The CorelDRAW Graphics Suite is available from the usual list of computer software suppliers. For more details, or to purchase directly from the manufacturer, go to www.corel.com.

Jasc Paint Shop Pro

Jasc Paint Shop Pro 8, shown in Figure 13-4, is one of the leading second-tier image editors. It's a general-purpose image editor that has gained a reputation as the "poor man's Photoshop" for providing a substantial portion of Photoshop's capabilities at a fraction of the cost. The program, which runs only under Windows, lists for about $100, but you can often find it for sale at a substantial discount. Paint Shop Pro has been a favorite of mine since the days that I offered it as a shareware download on my dialup BBS!

Paint Shop Pro features a fairly complete tool kit that includes selection, painting, and retouching tools for direct manipulation of your images. It also has a sizable collection of wizardlike commands that automate common tasks, such as removing red-eye and scratches. Paint Shop Pro includes a nice assortment of filters and effects, and you can expand that assortment by adding most any of the Photoshop plug-ins.

What's good about it

Paint Shop Pro has been around for a while, so the program has had time to evolve and mature. Over that time, it has developed a reasonably robust feature set and a refined user interface. Many people rate Paint Shop Pro as the easiest to use of the general-purpose image editors, and it's among the lowest priced programs in its class.

Figure 13-4: Paint Shop Pro has been around since the early days of digital cameras.

Second-Tier Image Editors

Book I
Chapter 13

Comparing Photoshop
Elements to Other Image
Editors

Paint Shop Pro supports layers, which enable you to achieve some fairly sophisticated editing effects. This is a surprising capability in a low-cost image editor.

What's not so good

The breadth and depth of the Paint Shop Pro feature set is a little uneven. The program shows surprising depth in some areas, such as the availability of layers, and shallowness in others, such as the limited choice of selection and paint tools. Also, some tools (such as the Histogram Adjustment command) require more knowledge and experience to use effectively than do the corresponding tools in some of the other editors.

You need to evaluate the program carefully to determine whether its particular strengths and weaknesses are a good match for the mix of work you need to do. Fortunately, you can download a free trial version of Paint Shop Pro so that you can try the program before you buy it. Check out www.jasc.com for the trial copy.

What you can do with it

Paint Shop Pro includes a large number of special effects filters. It also includes a useful little command that helps you select the filter you want to use. Here's how it works:

***1.* Choose Effects⇨Effect Browser from the menu bar.**

The Effect Browser dialog box appears, as shown in Figure 13-5. The dialog box contains a list of effect filters on the left and thumbnail previews on the right.

Figure 13-5:
Time to pick an effect in Paint Shop Pro.

***2.* Click an item in the Effect Name list to preview the effect.**

When you click an item in the list, a short description of the effect appears at the bottom of the dialog box, and the Sample Preview thumbnail shows an approximation of how the effect will look on your image. Continue trying different effects until you find one you like.

3. Click Apply.

The Effect Browser dialog box disappears. This is the equivalent of choosing the corresponding effect from the Effects menu. If no settings are available for the selected effect, the effect is applied immediately. Otherwise, the effect's dialog box appears.

4. Adjust the settings in the effect-specific dialog box as needed.

Depending on the specific effect you selected, you may need to set options to control the intensity of the effect and other attributes.

5. Click OK.

The dialog box disappears, and Paint Shop Pro applies the effect to your image.

Where to get it

Paint Shop Pro started life as a shareware program, but it has since expanded its market presence and gone mainstream. As a result, it now sports the slick packaging and complete documentation that most people expect from a commercial software product. You can buy the boxed version of Paint Shop Pro at all the usual computer software outlets. Or you can order the product from the Jasc Web site at www.jasc.com. A time-limited free trial version is available for download at the site.

Ulead PhotoImpact

Ulead PhotoImpact, shown in Figure 13-6, is a general-purpose photo-editing program with a robust feature set. PhotoImpact features a rich assortment of brushes for painting, retouching, and cloning in addition to the usual selection, cropping, and fill tools. It also has tools for text and vector shapes, as well as tools for creating slices and image maps for use on the Web. Photo-Impact supports layers and includes a generous collection of effects filters, which you can expand with Photoshop plug-ins. Auto-process commands are available to automate many of the most common image-correction and enhancement tasks.

What's good about it

PhotoImpact is one of the most powerful and versatile of the second-tier image editors, and it's modestly priced at less than $100. This combination of high capability and low price makes PhotoImpact an excellent value.

If you frequently perform the same image manipulations on a number of files, you'll appreciate PhotoImpact's batch operations. Using this feature, you can select multiple image files and then apply any one of a long list of filters, enhancements, or auto-process commands to all the selected files. What a timesaver!

PhotoImpact also includes some specialized features for creating Web graphics. The program includes wizards to help you create Web backgrounds, banners, and buttons, and its image optimization features are especially strong.

Figure 13-6:
PhotoImpact is a great bargain for the photographer on a budget.

What's not so good

PhotoImpact's user interface can be a bit quirky and inconsistent in places. Some of PhotoImpact's features, though effective and very useful, feel like they are the result of grafting separate modules onto the program instead of seamlessly integrating the features into the program. Overall, the Photo-Impact user interface is not as polished as Photoshop, Paint Shop Pro, or PHOTO-PAINT. To be fair, however, after you get past the program's quirks and idiosyncrasies, you'll find that PhotoImpact is a very capable Windows-only image editor.

What you can do with it

PhotoImpact is a versatile image editor, capable of most any image manipulation you might want to do. It's hard to pick just one example to show here.

PhotoImpact comes with a generous assortment of effect filters. It's fun to play around with the filters. Here's an example of a filter that gives an image the look of an oil painting:

1. Choose Effect⇨Natural Painting⇨Oil Paint from the menu bar.

 The Oil Paint dialog box appears, as shown in Figure 13-7. The Dual View tab shows two thumbnails: your original image on the left and a preview of the effect on the right.

2. Drag the sliders to adjust the Stroke Detail and Level.

 Adjust the sliders as needed to achieve the desired effect. You can also use the spin boxes to the right of each slider if you want to make more precise adjustments.

Figure 13-7:
Applying
an effect
in Photo-
Impact.

3. Click OK.

The Oil Paint dialog box disappears as PhotoImpact applies the effect to your image.

PhotoImpact's EasyPalette gives you quick access to many of the effects without having to go through the menus and dialog boxes. To apply this same effect from the EasyPalette, simply select Effect Gallery from the Gallery list on the left side of the EasyPalette window. Then scroll down through the thumbnails on the right side and double-click the Oil Paint 3 thumbnail. PhotoImpact applies the effect immediately.

Where to get it

PhotoImpact is available from many of the same software dealers that carry most of the other programs in this chapter. The suggested retail price is about $90. Or you can order PhotoImpact direct from the Ulead Web site at www.ulead.com. The site also offers a time-limited free trial version that you can download.

Third-Tier Image Editors

The third tier of image-editing programs specializes in making the most common image-editing tasks fast and easy to do. Typically, it takes just a few mouse clicks to open an image, make a simple adjustment or two, and then print or save the picture. These are the programs to choose when fast and easy is more important to you than powerful and versatile.

If your image-editing needs are very basic, you might use one of these programs as your main image editor. However, you're more likely to use these programs to complement a more powerful editor. They can make quick work of routine stuff that doesn't require the power of your other editor.

Microsoft Picture It!

Microsoft Picture It! doesn't get the attention that the big-name Microsoft programs get. Despite the Microsoft name, this Windows-only program isn't the dominant program in its class. However, it is a respected player in the field.

Third-Tier Image Editors

**Book I
Chapter 13**

Comparing Photoshop
Elements to Other Image
Editors

Picture It!, shown in Figure 13-8, is a simple program that makes it easy to access your images (whether they are in your camera or scanner, or stored on your hard drive) and then edit and print those images with a minimum of fuss. The image-editing capabilities are limited when compared to first-tier and second-tier editors, but they cover the basics. You can do things such as cropping, rotating, adjusting brightness or color balance, and fixing red-eye and scratches. Picture It! also includes a modest collection of effect filters and edge treatments that you can apply to your images. And the program even includes some basic painting tools as well as tools for adding text and shapes to your images.

Figure 13-8:
Picture It! is Microsoft's entry into the image editor scene.

Picture It! comes in a number of different versions, starting with the Standard Edition at around $50. The Digital Image Pro version adds more filters and retouching tools, including flash and backlight corrections; dodge and burn tools; and the ability to adjust shadow, midtone, and highlight levels independently. Digital Image Pro also accepts Photoshop plug-ins for even more filter effects — it sells for about $100.

What's good about it

Like most Microsoft products, Picture It! has a slick-looking user interface that is well thought out and easy to use. Microsoft can afford to invest time and money in focus groups and usability testing — and it shows.

Picture It! also gives you the ability to select several image files and apply the same adjustment to all the selected files at once. This ability isn't unique to Picture It!, but it's unusual in image editors at this level.

What's not so good

The added features of the Digital Image Pro version of Picture It! are an obvious attempt to give the program capabilities comparable to some of the second-tier image editors. In my opinion, the attempt falls short. However, you may find that Digital Image Pro gives you just enough capability to handle your occasional image-editing tasks without needing a more advanced editor.

What you can do with it

Programs in this tier excel at quick fixes. Here's an example of how to make a couple of quick adjustments in Picture It! to an image that is slightly off in color:

1. **Click the Levels AutoFix button in the left toolbar.**

 Picture It! automatically adjusts brightness and contrast to achieve a full tonal range of blacks, whites, and all the tones in-between.

2. **Click the Adjust Tint button in the left toolbar.**

 Picture It! displays the Adjust Tint panel on the left side of the program window. Make sure the Whole Picture tab is selected.

3. **Click the Eyedropper icon and then click an area of the picture that should be white.**

 Picture It! automatically adjusts the color settings as needed to render the selected area as white. If the image still doesn't look right, you can try clicking another white spot or adjusting the Color and Amount sliders manually.

4. **Click the Done button at the bottom of the Adjust Tint panel.**

 The Adjust Tint panel disappears, and Picture It! returns to the normal display with the changes applied to your image.

Where to get it

Microsoft Picture It! is available in many retail software stores and online outlets. You can also order the program direct from Microsoft. For more information, go to pictureitproducts.msn.com.

Roxio PhotoSuite

Roxio PhotoSuite 7 Platinum, another Windows-only program, is perhaps the best known of the third-tier image editors. (**Note:** Roxio PhotoSuite was formerly known as MGI PhotoSuite.) It's inexpensive (less than $50) and easy to use. The program's opening screen (shown in Figure 13-9) is uncluttered and features big, graphical icons with lots of interactive feedback. This approach is a stark contrast to the multiple toolbars and floating panels that fight for the user's attention in most of the first-tier and second-tier image editors.

Despite PhotoSuite's apparent simplicity, it offers a reasonably good assortment of image-editing tools for this level of image editor. It has basic versions of the standard selection, paint, clone, erase, and fill tools, plus an effect brush and tools for drawing simple shapes (but not text). And, of course, you can crop and rotate the image, remove scratches and red-eye, and touch up the brightness and color balance, among other things.

PhotoSuite also includes tools to help you organize and distribute your pictures. You can gather a set of pictures together into an album and then share an individual picture or an entire album on the Web, show pictures as a slide show, or send pictures via e-mail. You can even install your pictures as wallpaper on your Windows desktop or display an album of pictures as a screen saver.

Figure 13-9:
It doesn't
get much
easier
than using
PhotoSuite.

What's good about it

PhotoSuite's strength is its ease of use. The uncluttered user interface keeps the screen simple and clean. A permanent panel on the left side of the screen contains either buttons that enable you to select a procedure or detailed instructions that walk you through the procedure step by step.

The built-in projects make it easy to create greeting cards, calendars, report covers, and many other items that incorporate your pictures into the design. This nice bonus enables you to use your pictures in fun and interesting ways without needing another program to do so.

What's not so good

The almost stark simplicity of the user interface means that most of the available tools and options are hidden from view at any given time. You often have to drill down through several layers of options to reach a specific tool or apply an effect. The program's constant hand-holding is helpful for new-comers, but after you learn the ropes, you may find yourself getting impatient and wishing you could jump straight to the desired effect with fewer intermediate prompts and clicks.

What you can do with it

Using one of PhotoSuite's project templates, you can create a pretend magazine cover containing a digital image from your collection. Just follow these steps:

1. **Open the image you want to use for the cover and perform any needed enhancements and touchups.**

2. **Click the Projects button in the Edit & Create pane.**

3. **Click the Magazine entry in the Create a Project pane and then click Next.**

4. **Click the cover thumbnail of your choice and then click Next.**

 PhotoSuite displays the magazine cover template.

5. **Click Next to confirm.**

 PhotoSuite displays the Replace Photo panel.

6. **Click Replace Photo and choose an image from your collection, and then click Replace.**

 PhotoSuite inserts the image into the template and automatically sizes it to fit (see Figure 13-10).

7. **Adjust the size and position of the image in the template if needed and then click Print or Save.**

 You can also choose to continue editing the image.

Where to get it

Roxio PhotoSuite 4 is available from most software retailers. You can also order it from the Roxio Web site at www.roxio.com.

Figure 13-10: Hey, is that my Batmobile on the cover of the *CAR* magazine?

Chapter 14: Making Selections

In This Chapter

✓ Making rectangular and elliptical selections

✓ Creating freeform selections

✓ Making polygonal selections

✓ Selecting image content based on colors in the image

Creating selections of the parts of the image that you intend to modify is the key to successful image manipulation. Indeed, the first step in many editing procedures is to focus the software's attention on the stuff you want to edit — an area that needs to be lighter, darker, or a different color, or removed altogether. For this purpose, Photoshop Elements offers a series of specialized tools that allow you to select geometric shapes, rows and columns of pixels, freeform shapes, and polygons. You can also find tools for making selections based on colors and pixel comparisons.

Because each selection method has advantages and disadvantages, the selection tool you choose is based on the kind of area you want to select and the nature of the image itself. I can give you no hard and fast rules for when to use a particular tool over another, but I can show you the basics of the selection tools, which I do in this chapter. I encourage you to experiment with these tools to find out which ones work best for you and in which situations to employ each.

Making Simple Selections with the Marquee Tools

Photoshop Elements has two tools that go by the moniker Marquee: the Rectangular Marquee tool (for rectangles and squares) and the Elliptical Marquee tool (for ovals and circles). Both are simple to use. For example, you can drag the Rectangular or Elliptical Marquee tool to select a rectangle or oval. Hold down the Shift key to select perfect squares and circles. You can select the Marquee tools by clicking them in the Tool palette, or by pressing Shift+M and repeating until the Marquee tool you want is highlighted in the Tool palette.

Figure 14-1 shows a rectangular selection in progress, using Photoshop Elements.

Selecting geometric shapes

When you're ready to make your geometric selection, the procedure is quite simple — it requires only that you've identified the layer that contains the area you want to edit and that you select that layer first. Then you're ready to make the selection, following these steps:

1. **Click the Marquee selection tool in the Tool palette and choose the shape (Rectangular or Oval) that you want to use.**

2. **Move your mouse onto the image and click where you want the selection to begin.**

3. **Drag away from the starting point, and set the size and proportions of your selection by controlling the distance and angle at which you drag the mouse.**

4. **If you want a perfect square or circle, press and hold the Shift key as you drag; release the mouse and then the key when the selection is complete.**

Figure 14-1:
We need only a section of this cat — but the cat won't be harmed.

When using the Shift key to make a perfectly square or circular selection (equal in width and height), be sure to release the mouse before releasing the Shift key when your selection is complete. If you release the key first, the selection snaps to the size and shape it would have been had you not used the Shift key at all.

Both the Rectangular and Elliptical Marquee tools allow you to choose from different Style settings. Your choices are Normal, Fixed Aspect Ratio (Constrained Aspect Ratio on the Mac), and Fixed Size. If you choose either of the latter two, additional options appear on the tool's options bar, through which you can enter the ratio or dimensions, respectively. If you're using Normal, these options are dimmed.

Adding to, reducing, and combining selections

The Marquee tools' Options bars offer four tools for customizing your selections. You can find these same tools, with the same power, in the Options bars for the Lasso and Magic Wand tools, as well. The buttons are descriptively named; here's a brief description of what each does:

✦ **New Selection:** Creates an entirely new selection

✦ **Add to Selection:** Adds more area to an existing selection

✦ **Subtract from Selection:** Removes part of a selection

✦ **Intersect with Selection:** Creates a selection from only the overlapping area of two selections

Each button represents a selection mode and controls whether or not you can add to, take away from, or create a new selection based on the overlapping areas within two concurrent selections. If you're in New Selection mode, each time you click and drag the mouse, a new Marquee selection is created, replacing any other selections currently in place. If you switch to Add to Selection mode, you can select noncontiguous areas on the image, or you can make your current selection larger. The left image in Figure 14-2 shows both a pair of noncontiguous selections (lower right) and a selection that was created by selecting two overlapping rectangles (upper left).

Figure 14-2: Elements provides great flexibility in selecting regions.

A B

The Subtract from Selection mode enables you to cut away from an existing selection or to deselect noncontiguous parts of an initial selection. The right image in Figure 14-2 shows a circular frame created by subtracting a smaller oval selection from within a larger one.

Using the Intersect with Selection mode allows you to create new selection shapes, such as the semicircular selection shown on the left in Figure 14-3. This semicircle selection was formed from the overlapping areas of a circle and a rectangle. You can also move from one mode to another as you build or tear down selections. For example, you can use Subtract from Selection to build a cross-shaped selection (see the right image in Figure 14-3, where a single square selection was cut away on its corners to create the cross shape) and then use the Add to Selection mode to add circular selections to the ends of the cross. This also requires switching to the Elliptical Marquee tool.

Figure 14-3: More examples of complex selection designs.

A B

Snagging Irregular Shapes with the Lasso Tools

The Lasso is a freehand selection tool. You can use the regular Lasso to draw freeform shapes that become selections, or use the Polygonal Lasso to select polygons by dragging around an object with straight lines. You can also select by drawing with the Magnetic Lasso tool: You guide the cursor around an object, and the software selects pixels by comparing them to adjoining pixels and chooses the ones that are different on the basis of color and light. In all its incarnations, the Lasso is a pretty powerful selection tool and probably the one I use most when retouching photos. A Lasso tool selection is shown in Figure 14-4.

Figure 14-4: The Lasso tool can do the irregular selections, pardner.

Selecting freeform shapes

The main Lasso tool is extremely easy to use. Just click and drag, drawing a shape around the section of the image you want to select. It's just a matter of drawing a loop around the area to be selected, as shown in Figure 14-5.

Figure 14-5: Looping with the Lasso — hey, was that a pun?

The other important thing to remember is to *close* your selection by coming back to the starting point. This prevents the software from guessing how you'd like the shape to finish, which usually results in some of the intended selection being omitted. If you don't close the shape, Photoshop Elements does it for you by connecting the start and end points with a straight line.

The Lasso Options bar offers a Feather setting, which allows you to add a number of fuzzy pixels to the selection's edges. This gives a softer edge to any fills you've applied to the selection. The higher the Feather setting, the softer the edge. A higher Feather setting also extends your fill or other edits, such as filter effects, far beyond the actual selection.

A *polygon* is a multisided shape, such as a hexagon, an octagon, and any other three-or-more-sided shape. Triangles are polygons, as are squares and rectangles. The Marquee tool selects rectangles and squares, but what if you want to select a triangular shape or a shape that looks like a big sunburst? You use the Polygonal Lasso. From simple shapes to complex, many-sided stars, the Polygonal Lasso tool gives you freeform selections with the precision of straight sides and sharp corners.

The tool works easily enough, and you can make it select just about any size or shape on your image by following these steps:

1. **Click the Polygonal Lasso tool in the Tool palette to activate it.**

2. **Make sure the layer you want to edit is the active layer; use the Layers palette to make your choice.**

3. **Click the point in your image where you want to begin making the selection.**

4. **Click the point where you want to create the first corner.**

 This creates the first side, and you can now draw the next side. Don't drag the mouse; just click where you want the corners to appear.

5. **Continue clicking until you've drawn all the sides that your selection needs.**

6. **Come back to the starting point, and click (double-click if you're using the Mac) to close the shape and create the selection.**

It's important to note that you can make your sides as small as you want (just a few pixels in length) or as long as you want. You can select the edges of complex shapes by drawing many short sides. You may find this handy when there isn't enough color difference between pixels to use the Magnetic Lasso tool effectively.

Selecting magnetically

If you'd like to select a particular object and if that object is a different color or shade than the objects touching it, you can use the Magnetic Lasso to select it. The Magnetic Lasso works by following the edges of content in your image, comparing pixels as you drag your mouse, and automatically snapping to the edges where pixel values vary enough, based on your settings for the tool's options. The controls on the Magnetic Lasso Options bar allow you to configure the Magnetic Lasso's sensitivity, detail, and the number of pixels it's comparing as you move along your desired path. The Pen Pressure option may be dimmed unless you're using an accessory drawing device.

Before using the Magnetic Lasso, try adjusting the following settings:

✦ **Width:** Sets how far from the mouse path (as you drag) the pixel comparisons will be made.

✦ **Edge Contrast:** Sets the sensitivity anywhere from 1% to 100%. The higher the percentage, the higher the contrast must be between compared pixels before the Magnetic Lasso snaps to pixels to build the selection.

✦ **Frequency:** Changes the number of *fastening points*, or nodes, you see along the line, as shown in Figure 14-6. Fastening points help to direct the line along the edge of the object.

Figure 14-6:
Each tiny block is a fastening point.

To use the Magnetic Lasso tool, you follow a procedure that's similar to the one you use for the Lasso and Polygonal Lasso, with minor variations:

1. **Make sure you have the correct layer selected so that changes you make after creating the selection apply to the right content.**

2. **Click the Magnetic Lasso tool in the Tool palette to select it.**

3. **Make any necessary changes to the tool's settings so that it will work to the best of its ability within the photo at hand.**

 You can adjust the width of the Magnetic Lasso's attraction, how many points it lays down, and the amount of contrast that must be present for the attraction to take hold. The default values work best in most situations.

4. **Click the image to begin your selection.**

5. **Move the cursor and click along the edge of the desired object.**

 A click redirects the line whenever it begins to veer off the path you'd like it to follow.

6. **When your moving and clicking take you back to the starting point, click the starting point to finish the selection.**

Clicking to redirect the Magnetic Lasso's path is especially helpful if you get to a section of the photo where there isn't very much difference between the color and brightness of the pixels and the object you're trying to select. Sometimes, the Edge Contrast setting won't help you, and you have to redirect the selection yourself, or use the other Lasso tools to augment or reduce the selection after using the Magnetic Lasso to make the main selection.

Has your Magnetic Lasso gone crazy, and you can't bring it back into line by clicking and moving? Press the Esc (Escape) key to abandon the current selection and start over.

Abracadabra! The Magic Wand Tool

The Magic Wand tool selects based on color. If you want to select all the flesh tones on a face or all the green leaves on a tree, just turn on this tool and click somewhere on the face or on a particular leaf, and the rest of the face or tree that matches the original pixel's brightness level and color is selected. You can make adjustments to the way the tool works, increasing or decreasing the Tolerance level required for a match, which will increase or decrease the number of pixels that are selected when you click the mouse on the image. The higher the Tolerance level you set, the wider the range of pixels included in the selection.

Making and adjusting selections based on color

You can augment your selection (without changing selection modes) by pressing and holding the Shift key as you click the image.

To reduce the amount of the image that's selected, press the Alt key (Option if you're on a Mac) and click an area that's selected. The pixels in that area are removed from the selection, and you can continue adding to the selection elsewhere, or simply perform whatever edit you'd planned for the color-based selection.

Controlling the magic

To increase or decrease the threshold for the tool's selections, adjust the Tolerance setting on the Options bar. The higher the Tolerance you set, the more pixels that Photoshop Elements sees as a close match for the original pixel that you clicked. If you set the Tolerance to a very low number (15 or less is considered low), you'll find that very few pixels meet the selection criteria.

Another setting that's useful for controlling the selection made by the Magic Wand is the Contiguous option. This option, when checked, limits the selection to those pixels touching the original pixel you clicked, and to the pixels touching those pixels, and so on. If you want to select pixels that aren't touching the original and the first batch selected, uncheck this option, or use the Shift key and click elsewhere in the image.

Using the Selection Brush Tool

Ah, but you're not done yet: Photoshop Elements offers tools that go beyond the normal selection tools that you'd find in just about any image-editing application. By giving you the ability to paint your selections with a familiar tool — the Brush — you can make very fine or very large selections quickly and easily.

In addition, both applications offer a Select menu, which you can use to control the existing selection, no matter which selection tool you used to make it.

Photoshop Elements offers the Selection Brush tool (see Figure 14-7, which shows the tool active, with its Options bar along the top). You can use this tool to select a snaking, freeform line by dragging your mouse in any design you desire.

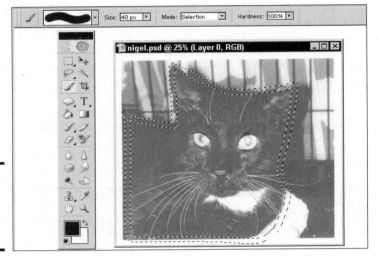

Figure 14-7:
Behold the
Selection
Brush
options.

You can set the size and style of the brush, and you can also set the brush to Selection or Mask mode:

✦ **Selection mode** simply creates a freeform, snaking selection that follows that path of your mouse as you drag. You can paint over and over in an area to select a shape rather than a snaking line, or you can use a very big brush to select a large area with a single stroke.

✦ **Mask mode** places a light red wash over the whole image, except for the places where you dragged the Selection Brush tool. If you made no selection prior to entering Mask mode, your strokes with the Selection Brush create the masked areas. Masked areas are excluded from your selection, and if you revert to Selection mode, your masked areas won't be affected by any subsequent editing in the form of painting, filling, deletion, or the use of the commands Edit, Copy and Edit, Cut.

Using the Select Menu

You use the Select menu to control and manipulate your existing selections, to create selections, and to deselect areas that are currently selected. Many of the menu commands also have keyboard shortcuts.

One of the most convenient commands on the Select menu is the Inverse command, which you can use to turn a mask into a selection, or a selection into a mask. If you selected an area with one of the selection tools, you can invert that selection so that everything *but* that area is selected and editable. Conversely, if you use the Brush Selector in Mask mode to make a mask, you can invert that mask so that the previously masked and uneditable area is now the selected, editable area.

Chapter 15: Brushing Away Your Digital Images' Imperfections

In This Chapter

✔ Mastering the use of brushes and pencils

✔ Customizing the Brush and Pencil tools for specific jobs

✔ Finding third-party brush sets online

The painting tools in Photoshop Elements have many uses when it comes to creating original artwork. You can paint pictures from scratch, starting with a white or transparent background, and paint or draw anything from the realistic to the abstract. These original works of art can end up in print, on the Web, or both. But this is a minibook about working with digital images, so in this chapter, I focus on their use for retouching and editing photographs.

Elements contains four major painting and drawing tools: the Brush tool, the Impressionist Brush, the Pencil, and the Airbrush (which is actually a specialized option for the standard Brush tool). This chapter concentrates on the Brush and Pencil tools — you can find more on the Impressionist Brush (which paints using artsy brush strokes) in *Photoshop Elements 2 For Dummies,* by Deke McClelland and Galen Fott (published by Wiley).

Working with Brushes and Pencils

Elements' brushes and pencils are easy to use and customize and can apply a wide variety of colors, textures, and special effects. Painting and drawing with Photoshop Elements mostly requires a steady hand and the proper view — you want to be zoomed in close enough to see what you're doing if you're retouching a small spot or rebuilding some details lost to damage or fading. Figure 15-1 shows an extremely magnified view of a portion of an image, and the Brush at work filling in a scratch.

Figure 15-1: You can paint away a scratch, one pixel at a time.

You can also paint larger areas, filling in space lost to a tear or to add a colored frame around an image. To create new content where none existed before, paint lines or shapes or simply apply a wash of color to a black-and-white or faded color photo for an interesting effect. Whatever your painting or drawing goal, these two applications offer the right tools for the job.

Painting with the Brush tool

The Brush tool can paint tiny dots, short strokes, or longer lines as small as a single pixel in width or as large as several hundred pixels. Using the tool is easy. Just click it on the Tool palette (or press B) to activate it, and drag or click (or both) on the image. You want to make sure that you're painting on the appropriate layer first, of course.

If you want to control the way the Brush tool applies paint, you can change the following settings before you start painting:

✦ **Color:** The color or tone painted by the brush

✦ **Size:** The size of the brush

✦ **Mode:** How the pixels painted by the brush blend with existing pixels

✦ **Opacity:** The transparency of the pixels

✦ **Airbrush:** Changes any Brush tool to a fuzzy airbrush effect

With the exception of color, you can adjust all these settings from the tool's Options bar. The settings listed here are those that you'd want to adjust whenever you're painting. More elaborate changes would be needed in fewer and more specific cases.

Color is the one setting that you can't set from the Options bar, but you can set it through the Color Picker. You can open the Color Picker by clicking the Tool palette's Set Foreground Color button, shown in Figure 15-2. From within the Color Picker (shown in Figure 15-3), you can choose a color by eye, by setting color levels (RGB, CMYK, HSB, LAB, depending on which application you're using), or by entering a hexadecimal number if it's a Web-safe color from that prescribed palette.

If you want to paint with a color currently in use elsewhere in the image or in another open image, click the toolbar's Eye Dropper tool and *sample* (click) the color you want to use. That color becomes the new foreground color.

Working with the Pencil tool

The Pencil tool works much like the Brush. The only real difference is the nature of the line drawn. Just like you'd expect a paintbrush to apply a relatively soft line, you'd expect a pencil to draw a sharper line, depending on the hardness of the lead. The Pencil tool works just as you'd expect and also offers its own set of adjustments through the Options bar — you can control the Pencil's size and opacity so that you can make whatever large or small edits are required.

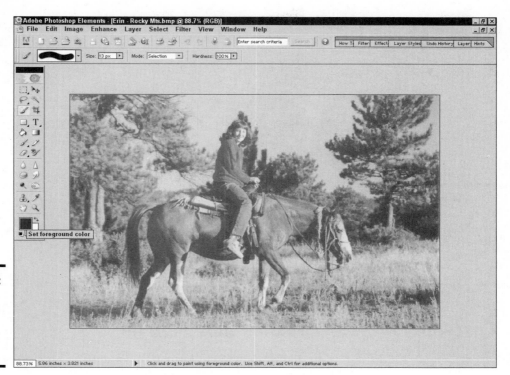

Figure 15-2:
Setting the
foreground
color for
a brush
operation.

Figure 15-3:
Choose your
color from
the Color
Picker.

Use the Pencil's settings to control the size, mode, and opacity of the line
you draw, and choose from a smaller set of styles — most of them solid, fine
lines. The Options bar has an Auto Erase option, which allows you to draw
the background color over any pixels currently colored in the foreground
color and to apply the foreground color only where no color is currently
applied. The name *Auto Erase* is sort of confusing because no real erasing
occurs, but you get the idea. Figure 15-4 shows the Pencil in use, applying a
sketchy fill to a frame around a photo. The frame was created with two rec-
tangular selections, one inside the other.

Figure 15-4:
Using the
Pencil tool
to create a
"handmade"
frame.

Customizing Your Brushes and Pencils

Beyond the basic adjustments that you can make with the Brush and Pencil tools' Options bars, you can work with an additional set of options in Photoshop Elements (see Figure 15-5).

Figure 15-5:
Elements
offers an
impressive
array of
options for
the Brush
tool.

The success of your brush and the direct effect of setting the right size and shape for it are the same. Photoshop Elements offers a list of Brush Presets in the form of a drop-down list, accompanied by a separate Size setting, and the More Options button.

To change the shape of your brush in Photoshop Elements, follow these steps:

1. **Click the Brush tool on the Tool palette to activate it.**

2. **Using the Options bar, set the style and size of the brush, using the drop-down list and slider, respectively.**

3. **Click the brush next to More Options on the Options bar.**

4. **In the resulting dialog box, shown in Figure 15-6, adjust the angle by entering a number or by dragging the arrow in a clockwise or counterclockwise direction.**

You may find that a specific angle is more desirable for painting the kind of strokes you want, and you can use this setting to set that angle.

Figure 15-6:
Setting the angle for the Brush tool.

5. **Adjust the Roundness setting the same way — by entering a number or by dragging the big black dots closer to or farther away from the center of the sample brush shape (see Figure 15-7).**

Figure 15-7:
Should that brush be round and fat or lean and mean?

Obtaining third-party brush sets

The brush sets that come with Photoshop Elements are fairly extensive, but you may pine for more of them. A quick online search will net you several sites where third-party brush sets are available, usually for a small charge. Some sites probably offer brushes for free, but these are not in abundance. Here's a site that I recommend you check out:

```
www.sapphire-innovations.com/
    products/prd_ps_brushes.htm
```

This site is chock-full of interesting new brushes. In fact, you can buy the entire collection on a single CD for $30. (And when I say that the CD collection contains almost 9,000 royalty-free mixed-design brushes, you get an idea of just how much fun you can have customizing the Brush tool in Elements!)

Dragging inward makes for a horizontally flatter brush while dragging outward makes the brush vertically flatter.

6. Tinker, as desired, with other sliders (Spacing, Color Jitter, Hardness), whose names are self-explanatory.

7. Click your image to begin painting or click somewhere on the work-space to close the More Options box.

Chapter 16: Restoring Images

In This Chapter

- Shedding light and casting shadows
- Blending and bringing focus to your images
- Healing wounded photos

Adobe's image-editing applications do a great job of fixing problem images. Some of the most common problems you'll encounter with your photos, both old and new, relate to lighting, clarity, detail, and damage caused by poor storage methods. Even a vintage photo, if it was properly stored, won't show unacceptable signs of age. However, any photo that was stored in a drawer or put in a frame and exposed to direct sunlight for years will start to look a little old, a bit shabby, and probably lose much of its detail and depth. The photo may also have scratches and scuffs, as shown in Figure 16-1, which displays a photo with several problems that require the restorative tools of Photoshop Elements.

This chapter focuses on some of the tools available to you for repairing your digital images.

Figure 16-1:
A wonderful photo, but age has taken its toll.

Adding Light and Shadows

Whether due to fading over time or poor original photographic technique, many of your photos may need more light or more shadows — or more of both — in different areas of the same photo. What to do? The Photoshop Elements Dodge and Burn tools to the rescue!

Using the Dodge tool to lighten tones

The Dodge tool lightens your image. The process is simple:

1. **Click the Dodge tool in the Tool palette to activate it.**

2. **Observe the Options bar and decide whether you need to make changes to the range of tones that will be affected or the exposure (degree of intensity) that the tool will apply.**

 The Range drop-down menu determines which tones the Dodge tool affects: Shadows (the dark areas), Highlights (the light areas), or Midtones (everything in between). Most of the time, you want to stick to Midtones, but if you want to open up some inky shadows or darken areas that are a little washed out, you can do that, too.

 The Exposure menu determines how rapidly the lightening occurs. You may lighten too much, too quickly, if you use a high value. A value between 15 and 35 percent enables you to lighten slowly. You can always return to an area and lighten it some more if you haven't applied enough dodging.

3. **Using the Options bar, set the size of the brush you'll use to apply the light.**

 You can choose the kind of brush you use just as you would the ordinary Brush tool (which I describe in Chapter 15 of Book I). Both use the same Brush palette.

4. **Drag over the area to be lightened, or click a single spot, such as a face or some other distinct area that's suffering from too much shadow.**

 If your image isn't very crisp and detailed and you have no desire to make it that way, use one of the textured brush settings for the Dodge tool. This can apply light in a dappled or mottled way, matching the image's overall look — perhaps a desirable one, in the case of vintage photos.

Burning your image to darken areas

The opposite of the Dodge tool, the Burn tool darkens areas. This can bring out facial features lost to a sunny day, faded details in clothing or a garden, or add depth lost to a photo that's faded with time or exposure to sunlight.

To use the Burn tool in either Photoshop or Elements, follow these simple steps:

1. **Click the Burn tool in the Tool palette to activate it.**

2. **Check the Options bar for any adjustments you'd like to make.**

You can adjust the range and exposure, which respectively control which elements of the image (Shadows, Midtones, or Highlights) are affected by the Burning process and how quickly the darkening process takes place.

3. **Choose a brush size from the Brush palette used for all Photoshop brushlike tools.**

4. **Begin darkening your image by dragging over the areas to be made more shadowy or by clicking a single spot.**

 Figure 16-2 shows a face being darkened by a single click with a brush that's set to the same diameter as the face.

Figure 16-2: Using the Burn tool to darken a specific area.

 Don't go too far with the Burn tool. If your image is color, excessive use of the tool creates a brownish, singed look that literally looks as though the image was burned. If your image is in black and white or grayscale, this won't happen; the worst that can occur is that your burned areas look so dark that their details may be obliterated.

Using Smudging, Sharpening, and Blurring Tools

When it comes to retouching photos with Photoshop Elements, you'll probably use the Sharpen and Blur tools frequently. These tools are good for heightening or diffusing details in some or all of an image or along the edges of content that's been pasted into the picture from elsewhere. The Smudge tool is also a powerful ally, but you may find that good mouse skills are required before you can successfully use it. Figure 16-3 shows these three tools — each of which has its own spot on the toolbox.

Although the Sharpen tool's name clearly indicates what it does, the Blur and Smudge tool names might lead you to believe that the tools essentially do the same thing. In reality, the Blur tool is a more finely grained tool than the Smudge tool is in terms of its results. Whether applied to a small area or painted over a large field, the Blur tool's effects are uniform. The Smudge tool's effects are entirely dependent on the length and direction of your mouse or pen strokes. Figure 16-4 shows side-by-side Blur and Smudge effects. The Blur tool was used on the left eye and cheek; the Smudge tool was used on the right eye and bridge of the nose.

Figure 16-3:
The Blur, Sharpen, and Smudge tools.

Figure 16-4:
This distinguished gentleman has been blurred (on the left) and smudged (on the right).

What the three tools have in common is how highly dependent they are upon their Options bar settings or, rather, how dependent you are on the settings. Without controlling how drastic or subtle an effect these tools have, you may end up with very little blurring or too much sharpening — or perhaps some smudging that makes you look like you were drunk when you tried to retouch the photo. Figure 16-5 shows an image where the Sharpen tool was taken a bit too far. Instead of adding contrast between pixels (to make them all stand out just a bit), the result is a very unpleasant effect — definitely not what you'd want.

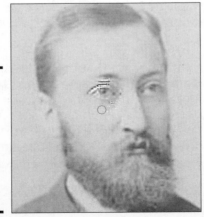

Figure 16-5:
Be careful with the Sharpen tool. If overused, you get results like these.

Finger-painting to blend colors and textures

The Smudge tool is used to drag color from one spot to another spot right next to it. Think of it as working the way your fingertips work if you're blending pastels or chalk on paper. The smudging process can smooth an edge or blend two adjoining colors. You can also turn on a Finger Painting option and bring the current foreground color into the mix, smearing it into the image at whatever point you're dragging the mouse.

To use the Smudge tool, follow these steps:

1. **Click the Smudge tool in the Tool palette to activate it.**

2. **Using the Options bar, change the setting in the Strength drop-down menu to make the smudging more dramatic (a high percentage) or subtle (a low percentage).**

3. **If you'd also like the Smudge tool to adjust the lights, darks, tones, and colors of the area that's smudged, choose an appropriate setting in the Mode drop-down menu.**

 The Mode setting controls how the original pixels and smudged pixels are blended together. Here are your options:

 • **Normal:** This option doesn't change to the quality of the colors or tones where you smudge. They just get smudged.

 • **Darken:** In addition to smudging, a Burn tool effect is applied.

 • **Lighten:** In addition to smudging, a Dodge tool effect is applied.

 • **Hue:** This option smudges only the hue of one area onto another, dragging the shade from your starting point onto another adjoining area of the image.

 • **Saturation:** By smudging with this setting in place, you're smudging the color intensity rather than the image content.

 • **Color:** Smudge color from one area to another without distorting the physical content.

 • **Luminosity:** This option smudges the brightness of your starting point onto the adjoining areas through which you drag the Smudge tool.

4. **Set the brush size using the Brush palette.**

5. **Click and drag to smudge the image.**

 You pull color from the starting point onto the ending point.

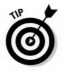 The last four Mode options allow you to adjust the color and quality of the color as you smudge. I recommend that you tinker with the area using other color- and hue-adjustment tools first, and then smudge in Normal mode.

 Don't use the Smudge tool to smudge large areas of your image. Although you can use a large brush size and make a big smudge, you'll regret it, because you'll end up distorting the image instead of blending areas within it. For the best results, use a small brush and use it in small areas.

Using the Sharpen tool to add detail

The Sharpen tool heightens the contrast between adjacent pixels so that each pixel stands out more. This can help you take a blurry or faded photo and improve the apparent detail in the image. You can bring out small features, textures, and the like by making the pixels in and around them more diverse. The Sharpen tool lives all by itself on its own button on the Tool palette in Photoshop Elements.

To sharpen some or all of your image, follow these steps:

1. **To control the area in which the sharpening will take place, use a selection tool — Marquee, Lasso, or Wand — from the Tool palette to select an area within the photo.**

2. **Click the Sharpen tool to activate it.**

3. **Use the Brush palette to adjust the brush size and whether you want a hard-edged or soft-edged brush.**

 A smaller brush enables you to sharpen a very specific area, whereas a larger brush heightens pixel diversity in a wider area, with more generalized results.

4. **Reduce or increase the intensity of the sharpening effect by adjusting the Strength setting from its default of 50%.**

 Be careful not to sharpen too much, or you'll end up with pixels that are so bright and diverse that detail can actually be lost.

5. **From the Mode drop-down menu, choose the Mode setting you want for the Sharpen tool.**

 The Mode setting controls how the pixels are blended. The modes are the same as those for the Smudge tool — described in the preceding section's steps list — and include Color, Hue, Saturation, and Luminosity. Normal mode is good for most jobs.

6. **Click and/or drag over the area to be sharpened.**

 You can go over the same spot more than once, but again, don't go too far. Subtle effects are usually preferable to the overly dramatic.

Sharpen and Blur filters are available through the Filter menu in Photoshop Elements. You can achieve more uniform results with them than with the brush-applied Sharpen and Blur tools because the mouse is removed from the equation. The filter is applied evenly over the selected area or the entire active layer of the image.

Blurring some or all of your image

The Blur tool is the Sharpen tool's opposite. Instead of increasing the diversity between adjoining pixels, the pixels are made more similar, with their color and light levels adjusted so that no individual pixels stand out too much. Obviously, you can blur a lot or blur a little, and the degree to which the tool is applied determines how much diversity is removed from the pixels you brush over with the Blur tool. Figure 16-6 shows an image with

varying degrees of blurring applied. Subtle blurring smoothed blotches on the boy's face and hands; more drastic blurring made surrounding content fade into the background.

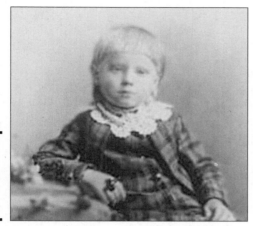

Figure 16-6: An image with varying degrees of blurring.

To use the Blur tool, follow these steps:

1. **If you want to restrict the blurring to a particular area of the image, use the appropriate selection tool (Marquee, Lasso, Magic Wand) on the Tool palette to select that area.**

2. **Click the Blur tool to activate it.**

3. **Observe the tool's options when they appear on the Options bar.**

4. **Adjust the setting in the Strength drop-down menu (it's set to 50% by default) to increase or decrease the amount of blurring that each click or stroke applies to the image.**

 Obviously, a low setting results in very subtle effects.

5. **Set the brush size and type (such as hard- or soft-edged) for the area you'll be blurring using the Brush palette.**

 Use the smallest brush you can if you need to blur a very small or detailed area. If you want to blur a large area, use a large brush so that you can avoid the obvious signs of retracing your steps with the tool.

6. **Click or drag over the area to be blurred.**

 You may find that some scrubbing with the mouse is required if you want to get rid of a very sharp edge between two parts of the image. Figure 16-7 shows the edge of content that was pasted into a photo, and the Blur tool is making the edge disappear so that the pasted content looks like it was always there.

Sometimes, you can use the Blur tool to make another part of the image seem sharper in comparison. For example, if the Sharpen tool is having undesirable effects on your image, use the Blur tool to soften or remove the details surrounding the parts of the image to which you want to draw attention.

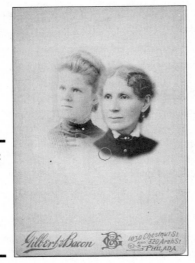

Figure 16-7:
A good example of low-strength blurring at work.

Finding Relief with the Healing Tools

Photoshop Elements has a number of tools that are considered purely restorative tools. They're intended for removing the signs of age, wear and tear, and outright damage in the form of tears, rips, scratches, and missing content.

The Red Eye Brush tool gets rid of that demonic pupil caused by the flash bouncing off the subject's retina.

You can also find a Clone Stamp tool, which copies undamaged content and allows you to paint it over damaged areas. You can do this to replace missing content, cover up damaged content, or simply edit the content of the image by painting over things you don't want. The Clone Stamp obscures any detail being copied over.

The Clone Stamp isn't purely a restorative tool. It has many uses in the creation of original artwork and in images that aren't photographic in nature. Its restorative uses are extensive, however, so I've grouped it here with the healing tools.

Cloning content to cover damage and unwanted content

The Clone Stamp duplicates content from one place and allows you to click and place it one or more times in the image, covering existing content (thus the term *stamp* in the tool's name). Figure 16-8 shows the Clone Stamp used in a very obvious way — if only to show its effect. Unlike the Patch tool, the stamped content is not matched to the surrounding pixels in the target area. If you stamp green grass on a blue couch, you get green grass on a blue couch — you don't get a blue, grassy texture on a blue couch.

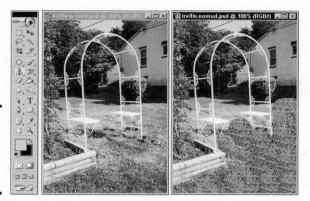

Figure 16-8:
From mud to grass, using the Clone Stamp tool.

To use the Clone Stamp, follow these steps:

1. **Verify the layer you're in, making sure that the layer containing the content you want to clone is highlighted in the Layer palette.**

 You can switch to another layer later when you stamp the content onto the image.

2. **Click the Clone Stamp tool in the Tool palette to activate it.**

 The Options bar appears, offering several settings that you can tweak to control how the tool is applied, including

 • **Brush:** This pop-up palette at the left side of the Options bar contains the brush styles you set for painting, erasing, or using any brush-applied tool. Pick a brush from the palette based on your target area, going for a size that's just a bit smaller than the area you want to stamp over — so that you don't leave an obvious edge to a single stamping of content. With two or more stamps in the area, you can avoid a clumsily pasted look.

 • **Mode:** When the cloned content is pasted, you can choose a mode to control how the pixels are merged. The Mode controls are discussed in the section "Finger-painting to blend colors and textures," earlier in this chapter. Normal works for most jobs, but you may want to experiment.

 • **Opacity:** If you want to see through your stamped content, reduce the opacity from the default 100%.

 • **Aligned:** This keeps the same distance/offset between the sampled spot (where you clicked the Alt key, or Option key on the Mac) and the stamped area. If you leave this check box unchecked (off), by default the cloned location keeps changing as you move your mouse and continue stamping.

 • **Use All Layers:** If you want your cloning and stamping to use and affect your image as it appears when all the layers are visible, check this option. It's unchecked (off) by default, just so you don't make more of an impact on your entire image than you may have intended.

3. **Customize the tool as needed.**

Now you're ready to clone and stamp.

4. **To clone the spot that will be used to cover unwanted content, hold down the Alt key (Option key on the Mac) while you click the spot that you want to clone.**

The mouse pointer changes when you're in clone mode, and a crosshair appears in the center of your brush point.

5. **Release the Alt key (Option key on the Mac), and apply the cloned content by clicking to cover the unwanted content. Feel free to apply multiple copies of the cloned content over a larger area.**

Removing red-eye

Another tool that Photoshop Elements users can call their own is the Red Eye Brush tool. This tool literally allows you to click or paint away those glowing pupils that affect pets, children, or anyone else wide-eyed and close enough to the camera and its overzealous flash. Figure 16-9 shows a poor feline in dire need of red-eye treatment.

Figure 16-9: Time to call in the Red Eye Brush tool.

Using the Red Eye Brush requires use of the Options bar, if only so that you can tell Elements which color you'd like to use in place of the demonic glow. You can allow Elements to pick for you, or you can select the color manually.

To use the Red Eye Brush, follow these steps to customize the tool's effects and apply them to the glowing eyes in question:

1. **Check to see that the layer with the demonic eyes is in fact the active layer in the Layers palette.**

2. **Click the Red Eye Brush tool in the Tool palette to activate it, and consider the following options:**

• **Brush presets:** Choose the brush style you want to use from the first drop-down menu on the left. A solid brush is preferable. If your image is slightly blurry, you might want to choose one with soft edges.

• **Brush size:** Pick a brush size that matches the diameter of the pupil you'll be fixing.

- **Sampling method:** The default is First Click, and the alternative is Current Color, meaning that whatever color is currently showing in the Current Color box is used as the bad pupil color, and any pupil in that shade is replaced with the Replacement color.

- **Tolerance:** This sets the threshold for spotting the sampled color within the pupil when you click to apply the Red Eye Brush tool. A higher number raises the bar and applies the Replacement color less liberally. A lower number lowers the threshold, and more of the pupil is recolored, even the parts that aren't actually glowing.

 Note that the other options (Current, Replacement, and the Default Colors option button) come into play later as you use the brush.

3. **Set your Current color, which is the color of the glowing portion of the pupil.**

 I prefer to set this myself, using the First Click sampling option. With this Sampling mode in place, click the portion of the pupil that's glowing.

4. **Set the Replacement color.**

 If you click the displayed color, you open the Color Picker, from which you can choose the color that the pupil should be.

 If you click the Default Colors button, the Current color becomes red, and the Replacement color is set to black.

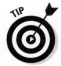

5. **Click the pupil to apply the Replacement color.**

 The glow is removed in favor of the color you selected. If the pupil is larger than your brush or not shaped like your brush tip, you may have to drag to apply the Replacement color to the entire glowing area.

6. **If both eyes are glowing (they usually are), you can repeat this process for the second eye.**

 Figure 16-10 shows both eyes exorcised, with no eerie glow remaining.

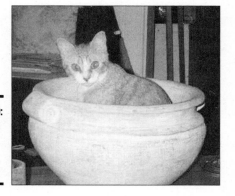

Figure 16-10: Our kitten is no longer a frightening apparition!

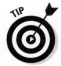

Be careful not to apply the same exact pupil color to both eyes. Usually, the lighting on the individual eyes is slightly different, which affects both the glow you're trying to get rid of and the desired pupil color. If you apply too dark or too large a pupil, the results look fake.

Chapter 17: Correcting Faded, Funny, and Funky Colors

In This Chapter

✔ Mastering the color balancing act

✔ Controlling the intensity of color

✔ Improving color quality overall

*P*hotos displayed on a sunny wall or desk can fade from the exposure to sunshine, even if you live in a rainy climate. You'd be surprised how sunlight can fade a photo if it's exposed for long enough. Time can fade photos, especially those that were shot long ago, with old negatives, printed on old photo paper. You can also have photos that looked a bit odd from the start — perhaps they contained too much red or green, or the colors looked washed out from the minute you had the photo developed or captured it with your digital camera.

Regardless of the cause, color photos present a whole host of color balance, level, and quality issues, and Photoshop Elements is well prepared to deal with them. Photoshop Elements delivers an entire toolbox of photo-retouching features, including a number of ways to manually and automatically adjust color levels and quality.

Adjusting Color Balance

Say a photo has too much red or yellow, or the whole picture is too dark or too light. These problems — problems you might think would require multiple tools and several steps to solve — might be just a couple of clicks away from their solutions. Between automatic color- and lighting-adjustment tools (as well as commands that address specific color levels) you have the power to make sweeping changes to your photos or sections thereof, significantly shortening the amount of time you spend editing and improving your photos.

Adjusting color levels

In Elements, the Levels command is squirreled away under the Enhance⇨ Adjust Brightness/Contrast submenu.

The Levels command allows you to set the highlights and shadows in an image by dragging three Input Levels sliders (in this case a set of three black, gray, and white triangles along the slider axis) to adjust the Levels histogram. A *histogram* is a visual representation of quantities — in this case, levels of tones. The sliders shown in Figure 17-1 allow you to adjust levels of shadows, midtones, and highlights.

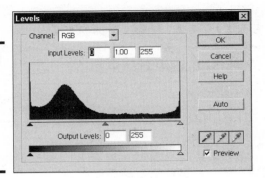

Figure 17-1:
Adjusting shadow, midtone, and highlight levels in Elements.

As you drag the Input Levels sliders (note that only the Midtones slider can be moved on its own), you see the levels of light and dark changing in the photo. You can control the effects by using the Set Black Point, Set Gray Point, and Set White Point eyedroppers to click pixels in your image. As you do this, you see the image change accordingly.

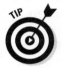

While in the Levels dialog box, double-click each eyedropper in turn to open the Color Picker so that you can choose new colors for these three levels (Shadows, Midtones, and Highlights). Alternatively, you can choose new color levels by clicking existing shades within the image. As you make your selections (using the Color Picker or the image itself) and OK them, you see the results in your image.

Using the Color Variations dialog box

The Color Variations command enables you to view a series of thumbnails, each showing a different color or contrast effect. To access the Color Variations dialog box (shown in Figure 17-2), choose Enhance⇨Adjust Color⇨ Color Variations. Clicking the Darken thumbnail in this dialog box, for example, shows you how adding more black to the image will affect it. If color adjustment is your goal, you can see what will happen if you bump up the Blue component by clicking Increase Blue.

You can view the effects of multiple changes, such as making the image lighter, adding more of one or more colors, or switching between the Midtones, Shadows, Highlights, and Saturation option buttons. No matter what variations you're considering, Elements shows an after version of the image. To return the image to its original tones and colors, click Reset Image.

Equalizing colors

The Equalize command has been christened with a name that clearly tells you what it does. Found on the Image⇨Adjustments submenu, the command evenly distributes color over the range of brightness levels throughout your image (or in a selected area) from 0 to 255. When you issue the Equalize command, Elements locates the brightest and darkest pixels and then adjusts the rest of the colors, making white the brightest value and black the darkest. All the colored pixels that fall between these two extremes are *equalized*, or made to fall between the two extreme shades.

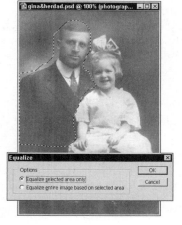

Figure 17-2:
Use the Color Variations command to preview color changes.

If you don't select part of your image before choosing Image⇨Adjustments⇨ Equalize, no dialog box appears, and the changes just take place automatically over the entire image. If you make a selection first, the Equalize dialog box appears, as shown in Figure 17-3.

Figure 17-3:
Time to decide how to equalize a selection.

Use this dialog box to indicate whether you want to equalize the selected area only or equalize the entire image based on the selected area. In Figure 17-4, only part of the image is equalized, and it's easy to spot it. Therefore, be careful that you don't make the rest of your image look shabby by improving just a small amount so drastically.

Remember that the Equalize command affects each image differently. The effect depends on how damaged, faded, and light or dark the image was to begin with. Don't assume that, if equalization was a big problem solver in one photo, it will be as successful with another.

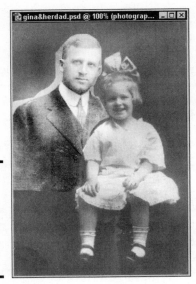

Figure 17-4:
Equalizing part of your image may not be the best decision.

Fixing a color cast

A *color cast* is a tinge — a shade of red or maybe yellow — that discolors your image in whole or in part. Casts occur for a variety of reasons, including the age of the photo, the quality of your scanner (if you scanned a printed original), the print from which you scanned the image, or the film used to take the picture. If a cast appears in an image captured with a digital camera, you need to reset something on the digital camera (what you change and how you change it varies by camera). A digital camera is rarely the culprit, however. Your cast probably came from a print, film, or age problem instead.

So now that you know what a cast is, how do you get rid of it? Use the Color Cast command in Elements to rid an image of any unpleasant preponderance of a single color. To get rid of a color cast, follow these steps:

1. **Open the image with the unwanted color cast.**

2. **Choose Enhance⇨Adjust Color⇨Color Cast from the menu bar.**

 The Color Cast Correction dialog box opens, as shown in Figure 17-5, offering instructions.

3. **Use the dialog box's Eyedropper tool (already activated within the dialog box) to click the gray, then white, and then black points in the image.**

 As you click in the image (about three times — one for gray, one for white, one for black), the color cast in the photo changes.

 Continue clicking different spots until you like the results, or bail out entirely by clicking Cancel.

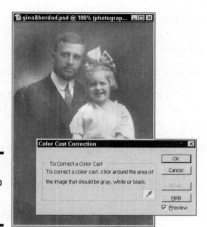

Figure 17-5:
Preparing to
correct a
color cast.

Make sure you leave the Preview check box selected in the Color Cast Correction dialog box. Most applications offer a Preview capability in dialog boxes that adjust visual elements. Leaving this feature on means you don't have to apply the changes just to see them in your image. If you do apply them by clicking OK and then decide you don't like the change, choose Edit⇨Undo.

Working with Color Intensity and Quality

Automatic tools that ask nothing or just a few questions and then make global corrections to color and light may fail you. In these situations, Photoshop Elements can help. It provides targeted tools that you can apply manually to adjust color, lighting, brightness, and contrast. Whatever your photo's color difficulty is, chances are that these tools offer a quick and easy solution:

✦ The Sponge tool for saturating and desaturating color

✦ The Brightness/Contrast dialog box

✦ The Curve dialog box, for adjusting individual colors

Increasing and decreasing color intensity

The Sponge tool adds color (in Saturate mode) or removes color (in Desaturate mode), depending on how you set up the tool.

The Sponge tool can come in handy if you added too much color in a previous editing session, and the edit can't be undone. Or perhaps you simply want a more subtle, faded look to some or all of an image. New photos are often faded to look more vintage or in preparation for the use of an artistic filter that will make the photo look like a drawing or painting.

Regardless of your motivation, the Sponge tool is simple to use.

To saturate or desaturate color, follow these steps:

1. **Click the Sponge tool in the Tool palette to activate it.**

2. **Choose Saturate or Desaturate mode by using the tool's Options bar.**

3. **Adjust the flow — how much saturation or desaturation occurs — by using the Flow drop-down menu. In some Mac versions of Photoshop Elements, Pressure does the same thing.**

4. **From the Brush drop-down menu, choose the right brush size for the area to be sponged.**

 A small brush may give you undesirable results when used in a large area, and a big brush may go too far. Choose a brush size that enables you to fix the problem area with the least amount of clicks or brush strokes.

5. **Apply the Sponge to the image by clicking and/or dragging to add or remove color where desired.**

 Passing over the same spot more than once intensifies the Sponge effect. You wash out or add more color on each successive pass.

Tinkering with brightness and contrast

Although automatic tools can correct brightness and contrast, you may want to control these levels manually. To do so, choose Enhance⇨Adjust Brightness/Contrast⇨Brightness/Contrast in Photoshop Elements. This command opens the Brightness/Contrast dialog box, shown in Figure 17-6, which offers two sliders. One adjusts the brightness, and the other adjusts the contrast.

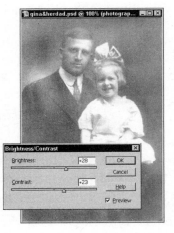

Figure 17-6:
Adjusting brightness and contrast is a cinch in Elements.

Chapter 18: Restoring and Enhancing Photos with Filters and Special Effects

In This Chapter

✔ Understanding how filters work and what they do

✔ Finding third-party filters and other plug-ins

✔ Using Photoshop Elements' special effects for images and text

Filters allow you to apply groups of effects and formats to your images, whether to a selected area or to the entire image on one or more of its layers. You can use filters to change the color and texture of your images or to add patterns. Each filter that you find in Photoshop Elements enables you to control the way the filter affects your image, and most filters give you a preview so that you don't have to apply the filter to your image until you see how it will look.

It's beyond the scope of this book to tell you *everything* you need to know about using filters; however, this chapter certainly gets you started using these fascinating tools.

Working with Filters

For the purposes of a minibook on digital-photo editing, the filters I discuss fall into three categories: corrective, artistic, and special effects. As it just so happens, these are the kinds of filters you're likely to use to retouch photos for personal or professional use. As for the filters that fall outside these categories, you can take your newly found knowledge of the filters covered in this chapter and apply it when you experiment with other filters. Just think of the fun you'll have with the trial and error process!

Understanding how filters work

When you open the Filter menu, you see all the filter categories, each followed by a right-pointing triangle that opens a submenu. Most of the categories have at least four filters in their submenus, and most of them have several filters to choose from.

Just about all the Filter commands work through dialog boxes, enabling you to both preview and customize the filters' effects. Figure 18-1 shows the Smart Blur filter dialog box.

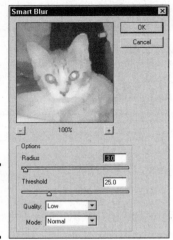

Figure 18-1:
A typical set
of filter
settings.

Before I discuss individual filters, consider these important filtering tips:

✦ You can apply filters only to the active layer and only if that layer is visible. If your photo has only one layer, this is a moot point.

✦ You can limit the filter's effects to a selection by using the various selection tools before applying a filter.

✦ If you don't make a selection before you apply a filter, the filter is applied to the entire active layer.

✦ Certain filters work only with certain file types. If your file type doesn't support a certain filter, the filter command is dimmed in the submenu.

Not all filters have a dialog box. Elements applies these *single-step filters* the instant you click the command in the Filter menu, within a particular category's submenu. The downside is that you have no control over the effects, although you can select a section of your image beforehand. If you don't like the results, you can easily use the Undo command or the History palette to get rid of the effect.

Fixing flaws with corrective filters

Corrective filters improve the quality of the image without distorting it, changing the content significantly, or applying any stylized effect. The three most appropriate corrective filters for a discussion of digital photos fall into three Filter menu categories: Blur, Sharpen, and Noise.

These three categories contain several filters, each performing a relatively subtle effect, depending on the settings you employ in the available dialog boxes.

Blur filters

Use the Blur filters (Blur, Blur More, Gaussian Blur, Motion Blur, Radial Blur, and Smart Blur) to soften the content of your image. The Motion and Radial blurs do a bit more than soften. They actually give the appearance of circular

movement (Radial) or movement through space (Motion). The Blur and Blur More filters don't have dialog boxes; the commands automatically apply a modicum of blurring to your image in its entirety or to a selection made before issuing the command.

Use the Blur and Blur More filters instead of the Blur tool when you want uniform results, as shown in Figure 18-2. When you use the Blur tool, your mouse has the greatest effect on the results. You may be able to see the strokes that you used to apply the blur, or you may miss some spots or apply the effect unevenly. If you use the filter, the same amount of blurring is applied everywhere, with no strokes or places that are blurred more or less than somewhere else.

Figure 18-2:
Consistency is the hall-mark of the Blur and Blur More filters.

In Photoshop Elements, the last filter used is repeated at the top of the Filter menu so that you can access the filter quickly if you want to use it again in the current session. In both applications, the keyboard shortcut to reapply the most recently used filter is Ctrl+F (⌘+F on the Mac).

The specialized Blur filters — Gaussian, Motion, Radial, and Smart — have their own dialog boxes where you can choose the degree of blurring to apply. For the Motion blur, you can also choose the direction in which the object is supposed to be moving. Figure 18-3 shows the Motion Blur dialog box as well as a preview of its effect on an image.

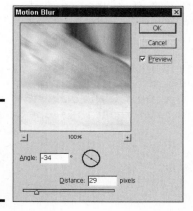

Figure 18-3:
Add action to a photo with the Motion Blur filter.

 The Radial blur completely distorts everything to which it's applied. If you want to create a background that appears to be spinning around or behind parts of the image, select the content that will remain static and copy it to a new layer. Then apply the Radial Blur to the original layer, which should be placed behind the static content layer. Voilà! Your objects are in the center of a hurricane, but they're not moved a bit.

Sharpen filters

Just as the Blur and Sharpen tools are opposites, so are the Blur and Sharpen filters. They're the same in one respect, though — the filters apply the effect in a uniform way, whereas the tools are entirely dependent on your brush size, mouse movements, and selection to control them. Here are the four Sharpen filters:

+ **Sharpen:** This filter has no dialog box. Just choose the command, and Elements automatically applies a uniform, subtle sharpening effect. You may want to repeat it two or more times if you need more sharpening than it applies in one pass.

+ **Sharpen More:** This filter is Sharpen on steroids. It applies more sharpening in one fell swoop than the Sharpen filter.

+ **Sharpen Edges:** This filter makes the edges — determined by a group of pixels varying in color and light levels from an adjoining group — stand out by sharpening the connecting pixels. If you have content in your image that just fades into its surroundings, this might be the filter for you.

+ **Unsharp Mask:** Despite its confusing name, this filter actually *sharpens* images. Very similar to Sharpen Edges, this filter adjusts the contrast of edges. This filter is the only Sharpen filter with a dialog box.

Noise filters

Among the Noise filters, the Despeckle and Dust & Scratches filters are the ones you use to retouch photos. You use them to deal with artifacts, such as dust spots or scratches that are distracting or obscure parts of an image.

The Despeckle filter finds the edges in an image and blurs everything but those edges. Although this filter sounds overly destructive, it can have an interesting effect that blends together parts of an image despite differences in color and texture that existed in the original. Figure 18-4 shows the Despeckle filter applied.

The Dust & Scratches filter eliminates much of the noise (dust, scratches, and small spots) by changing pixels that are very different from their surroundings, making them more similar. You can use the dialog box to adjust the Radius and Threshold settings, which determine the scope and degree of the effects, respectively.

Figure 18-4:
The
Despeckle
filter is
always a
favorite.

The steps in using the Dust & Scratches filter are pretty simple:

1. **Choose Filter⇨Noise⇨Dust & Scratches from the menu bar.**

 The filter's dialog box opens.

2. **Zoom in on the area with the greatest degree of dust and scratch damage by using the Hand tool and the + sign button to get closer. (The Hand tool appears when you mouse over the preview.)**

 Zooming in helps you determine if your settings are doing the trick.

3. **Adjust the Threshold setting by dragging the slider.**

 Watch the preview for the desired result to appear.

4. **Adjust the Radius, again by dragging the slider.**

 Don't go too far with your Radius adjustment. The image can become so blurry that any details in the photo are indistinguishable.

5. **Click the OK button to apply the filter.**

Turning photos into paintings with artistic filters

The filters in three of the Filter menu's categories — Artistic, Sketch, and Brush Strokes — are not truly restorative or retouching filters, at least not traditionally. However, as more people are either capturing images digitally or scanning prints, their needs and desires with regard to those pictures have become more sophisticated and complex. It's not good enough to just scan a wedding photo and enlarge it for a framed copy on the piano. Now, you may want to make the photo look like a drawing done with pastels or a painting created with oils. For gifts, cards, Web graphics, and interesting marketing materials, you can turn any photo into an apparent work of hand-done art, as shown in Figure 18-5. Here, a photo has been filtered to look like a watercolor painting, with soft shapes and a slight texture that mirrors the weave of watercolor paper.

Using artistic filters also performs another important role. If your image is simply beyond repair or beyond your skills or interest level to repair it, you can hide a multitude of sins with the right filter. If your image is scuffed and

scratched and you don't feel like dealing with each individual injury, just clean up the most offensive or extreme of the marks and then apply a filter such as Colored Pencil or Dry Brush. This way, you create something entirely new, while preserving the content and history of the original image by hiding the damage that would have normally relegated the image to a drawer rather than a frame.

Figure 18-5: One click of the mouse, and you get instant watercolor artwork!

When you use these filters, you always get a dialog box, such as the one shown in Figure 18-6. Through the dialog boxes, you can customize how the artistic effect is applied — the thickness of the brush or pencil strokes, the frequency of them, how detailed the effect is, and the intensity of the effect. You can select an area before using the filter to restrict the amount of the photo that's affected, or you can apply the filter to the whole image.

Figure 18-6: Feel free to experiment with any filter that displays a dialog box.

Going a little crazy with special-effects filters

The Distort and Stylize filters are the least conservative effects. These unusual effects change the appearance of some (or all) of your image by stretching, pulling, or pinching or by mimicking textures and overlays, such as rippled water, glass, or the appearance of the image being ripped apart by a strong wind.

You might be wondering how on earth you'd use these filters to restore or retouch a photo. Well, you wouldn't. But you might use them to create an interesting piece of digital art, utilizing one or more of your photos, or to achieve a symbolic look that's suggested, but not artistically realized, in a photograph you've restored traditionally. For example, if you have a photo of someone's boat, it might be interesting to apply the Ocean Ripple filter to the water in the image and the Wind filter to the boat's sails. That's a bit literal, but you get the idea.

As you work with these filters, their dialog boxes help you control the way the filters work their special-effects magic. You can change the size of the tiles or cracks in an image, choose which texture to apply, and adjust the degree of pinching or twirling to use.

For a brief description of the more creative filters, check out the following list:

✦ **Texture filters:** These filters apply artificial textures to your image. Figure 18-7 shows Stained Glass (top), Craquelure (middle), and Grain (bottom) applied to different sections of a single image, purely for demonstrative purposes.

Figure 18-7:
Textures pack a lot of visual punch.

Use the Texturizer filter (found in the Texture category) to apply textures, such as Canvas, Sandstone, and Burlap to your photo. These textures make a photo look like it's printed on textured paper or some sort of fabric.

✦ **Distorting filters:** These filters manipulate the apparent shape of your image content, as shown in Figure 18-8, where the Ocean Ripple (left), Pinch (middle), and Twirl (right) filters have been applied to three sections of the photo. By creating an apparent shape to the surface of the image, the content looks as though it's being viewed through some sort

of distorting lens, or as though the photo exists within a substance and not simply on paper or a computer screen. The dialog boxes for the Distort filters allow you to control the degree of distortion achieved.

Figure 18-8:
I told you to stay away from those distortion filters!

+ **Stylize filters:** This category is sort of a hodgepodge of filters that don't really fit anywhere else. With names like Emboss, Glowing Edges, Solarize, and Wind, you'd be hard pressed to find a more descriptive yet nondescript name for them. When the Emboss, Glowing Edges, or Wind filters are applied, the results are extreme and may go beyond your intentions for dealing with digital photos. On the other hand, these examples may inspire you to create something unique.

Don't hesitate to mix and match filters. Apply one, then another, and then another after that. Stacking their effects can give you unexpected and often quite beautiful results. Don't be afraid to experiment with different combinations!

Getting Your Hands on Third-Party Filters

Finding third-party filters for Photoshop Elements is easy; just do a Google search for `"filters for Photoshop Elements"`. Be sure to use the quotation marks to restrict your search to sites that contain that exact phrase. Otherwise, you'll find sites pertaining to filters (for coffee, oil, and air) and sites pertaining to Photoshop but not to filters. Of course the first few will pertain to both, but you'll have to wade through some losers, which is good to avoid.

In addition to searching the Web, you may find interesting filters and other stuff by poking around these sites:

◆ **Alien Skin Software** (www.alienskin.com) is the maker of Eye Candy 4000, Xenofex, and Splat! plug-ins.

◆ **Auto FX Software's DreamSuite** (www.autofx.com) has two Series products. Series One provides special effects for graphics, text, and photos, and these effects are all easy to use. Series Two has features that enable you to turn your photos into puzzles (a great gift idea for family photos, or as a promotional item for clients), plus several other special effects.

◆ **Andromeda Software** (www.andromeda.com) offers several filter sets, including light-scattering filters, lens filters, screen and mezzotint filters, outlining and woodcut filters, and special focus filters. Andromeda also makes Velociraptor, a filter that puts trails on image contents, which gives the objects the appearance of movement that's like a Photoshop fireworks display. As you can tell, the variety of filters is quite wide, from conservative yet cool effects to real psychedelic experiences.

Using the Effects Tab Palette

Photoshop Elements has a list of effects that you can apply to some or all of your image. You can view the effects as a series of thumbnails (on the left Figure 18-9) or in a list (on the right Figure 18-9). You can apply the effects to a selection within your image or to the entire active layer.

Figure 18-9:
Welcome to Effects Central.

To switch between List and Thumbnails views of the Effects palette, click the More button at the bottom of the list and make a choice from the menu that appears.

If you view the effects as a list, you see additional effects that apply only to text (the word *Type* appears next to them). These effects allow you to create type that looks like wood, chrome, glass, pipe, or just about anything you can imagine. Figure 18-10 shows the List view of the Effects palette, and a Type effect selected.

Click the buttons in the lower-right corner of the Effects palette (whether docked or floating as an independent palette) to switch between List and Thumbnails view.

The Effects palette is normally docked at the top-right side of the Photoshop Elements window; if you click the tab, you can display the palette with its top still docked. If you want to move the palette, simply drag it away from the docking well by grabbing the tab with your mouse. You can then move the free-floating palette anywhere on the workspace. If you want to minimize the palette in place, click the Minimize (-) button to shrink it to just a title bar. When you want to use it again, click the Maximize (X) button.

Applying an Effect

After you know how to manipulate the Effects palette, you can easily apply these cool effects to your photo and text by following these steps:

1. **Select the portion of your image to which you want the effect to apply.**

 If it's text, make sure the Type layer in question is active and double-click the Type icon on the layer to select all the text on that layer.

2. **Display the Effects palette.**

3. **Apply the effect to your image or text:**

 ✓ **Image:** If you want to apply an effect to your image (not to text), drag the desired thumbnail onto your image. After a delay — how long a delay depends on your available system resources — the effect is applied to the image.

 If you have part of your image selected, drag the thumbnail into that selected area.

You can also click the Apply button to apply a selected effect to your entire image or a selection inside it.

✓ **Text:** If you want to apply a Type Effect, remember that you have to be in List view to see those effects. When you have the effect in view, drag it from the list onto your Type layer, or click the Apply button while your type is selected.

Click the drop-down list in the upper-left corner of the Effects palette to choose from different effect groups — Textures, Frames, Text Effects, and Image Effects — to be displayed alone. The default setting for this drop-down list is All, which shows all the available effects. Choosing one of the groups in the drop-down list distills the displayed set down to just that group.

Chapter 19: Storing and Organizing Your Digital Photos

In This Chapter

✔ Understanding your organizational options

✔ Choosing the right tools to organize and store your photos

✔ Keeping your treasured photos safe

*W*e all have at least one box or drawer that's full of photos that we've never had the time to put in an album — vacation photos, pictures of the family at holiday dinners for the last ten years, and even collections of vintage photos, all waiting for someone to take them out of their envelopes and put them in a book so that people can actually look at them. What about your digital photos? They may not be languishing in a drawer, but if they're in different folders scattered all over your hard drive, they may as well be in a shoebox under the bed.

The most important things you can do with your digital images is to organize them and then to store them in a way that keeps them safe from accidental erasure; unwanted changes; or loss due to fire, flood, or a computer meltdown. You can easily achieve the proper organization and reliable storage of your digital images, and plenty of tools are at your disposal to make it all happen. The key, however, is to *do* it — so don't put it off any longer!

Organizing Your Photos

When it comes to taking control of the organization of your photos, you have a few different approaches to choose from. Your personality, your computer, and your access to the Web all dictate your choice. Here are some approaches to consider:

✦ Setting up a file structure on your computer

✦ Working with software that makes it easy to organize and store your images and view them through a special interface

✦ Organizing and storing your images in an online gallery

What do I mean about your personality influencing your choice of organizational tools? If you're a very organized person who enjoys tidying up closets and dresser drawers, always knows where the remotes are, and always puts things away after using them, then using the file management tools already on your computer might appeal to you.

If, on the other hand, you don't tend to be tidy and often forget where you left your glasses or your keys, then you might prefer using software that organizes things for you or posting your images to an online gallery. The tidy person might like these latter approaches as well.

Using your computer's file-management tools

You already have some great tools for organizing your images, and the tools have been on your computer all along. If you're running Windows, you have My Computer and Windows Explorer right there at your fingertips. If you're using a Mac, you can use the Finder's file-management tools that you've already been using to create folders on your desktop or hard drive.

Using these tools requires devising some sort of filing system — one or more folders that will help you categorize your images. You might start with one called Photos and create subfolders such as Family Photos, Vacation Pictures, and Scanned Vintage Photos. You can create folders on your computer for whatever groupings fit the pool of images you have. After you create the folders, all you have to do is move your images into the appropriate folders and remember the folder names when you store new images in the future.

Using Windows Explorer to store and organize your photos

Working with folders under Windows XP is pretty basic, but deserves a review in the context of organizing your digital image files. To create folders to store your images by using Windows Explorer, follow these simple steps:

1. **Right-click the Start button and choose Explore from the context menu.**

2. **When Windows Explorer opens, click the C: drive icon in the folder list (see Figure 19-1).**

 If a plus sign is next to the icon, click that plus sign to display the folders currently on the drive. If a minus sign is next to the icon, that means you can already see all the folders.

 The Windows Explorer window is divided into two panes: the Folder pane on the left and then Content pane on the right. When you click a drive or folder in the Folder pane, that drive or folder's content is displayed in the Content pane. This two-sided display makes it possible to drag items from one folder to another simply by displaying the source (where the content is now) and target (where you want the content to be) folders in the separate panes.

3. **If you want to use the My Pictures folder or another folder as the basis for your image organization, double-click it. If you want to start a new folder for your photos, choose File⇨New⇨Folder from the menu bar.**

 If you go the new folder route, a new folder appears in the Content pane, with its temporary name highlighted.

4. **If you go the new folder route, give your new folder a name and press Enter to confirm it.**

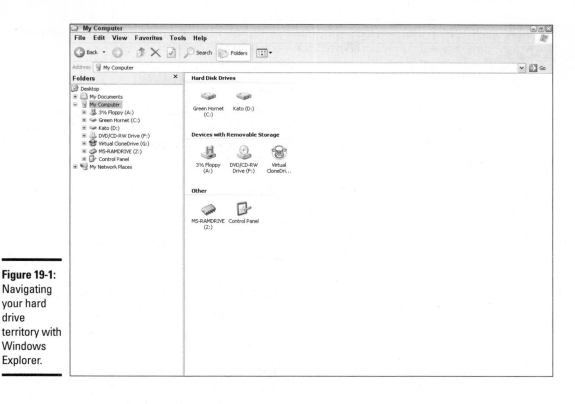

Figure 19-1:
Navigating
your hard
drive
territory with
Windows
Explorer.

With a folder created to house some or all of your photos, you can begin to place them in a single location. You can also make subfolders in that main folder to categorize your photos. For example, if you have a Photos folder, you can create a Vacation Photos subfolder and a Baby Pictures subfolder to keep those two, distinct photo subjects separate.

To create subfolders of the main folder, simply click the main folder to select it (on the left side of the screen, in the Folders pane) and then repeat Steps 3 and 4 from the preceding steps list. You use the File⇨New⇨Folder command to create a new folder, but because you're in an existing folder when you do it, the new folder appears inside the active folder.

The process is like taking one of those green hanging Pendaflex folders and putting one or more manila folders in it. The green folder represents the main Photos folder, and each of the manila folders is the same as the subfolders you create to categorize your photos. You can create as many subfolders as you want, and even create subfolders within subfolders. The folder hierarchy can become as complex as you want or need it to be, but be careful not to make managing files so cumbersome that the process becomes confusing when you need to place an image in the right folder.

If you don't need to categorize your photos by subject, consider creating folders that separate your photos by date. You can have a separate folder for individual years, months, or weeks, depending on how prolific a photographer you are.

Within Windows Explorer, choose View⇨Thumbnails to display a rather snazzy thumbnail view of all pictures in the current folder.

Organizing your photo images on a Mac

Whether you're using Mac OS 9 or the latest version of Mac OS X, you can easily create folders to store your photos and other digital images. You can choose to store them on your hard drive or make them quickly accessible from your ever-visible desktop.

To create a new folder in OS 9 and previous OS versions, follow these steps:

1. **Choose File⇨New Folder from the menu bar.**

 A folder titled Untitled Folder appears on the desktop. You can also press ⌘+N or Ctrl+click the desktop and choose New Folder from the context menu that appears.

2. **Give your folder a short, yet relevant name that will make it easy to find the folder in the future.**

3. **You can leave the folder on the desktop or open your hard disk and drag the folder there.**

4. **If you want folders within the folder you just created, open the folder and then repeat Steps 1 through 3 to create the subfolders.**

If you're using OS X, the procedure is nearly identical, except for the keyboard shortcut. Instead of ⌘+N, you press Shift+⌘+N to create a new folder.

You can duplicate an existing folder with the File⇨Duplicate command. Alternatively, drag the existing folder to a new location while holding down the Option button; this approach makes a copy of the original folder and leaves the original folder where it was.

From any Mac OS X Finder window, choose View⇨As Icons to display previews of pictures in the current folder.

Using photo album software

Setting up a series of folders to store and categorize your images is easy enough. To view them after they're stored, however, you either have to open them with the software you used to edit/retouch them or the generic software (such as Preview in Mac OS X) that came with your computer. If you find that inconvenient (and you probably will, especially if you like to look at and work with your images frequently or to view them side by side), you'll probably be glad to know that several great photo-album applications are on the market. These applications enable you to view one, two, or several of your images at the same time, all in one easily navigated workspace. Figure 19-2 shows a group of photos viewed through Paint Shop Photo Album from Jasc Software (www.jasc.com), which I use under Windows. At $50, this multimedia organizer, which also takes care of video and sound files, is a steal.

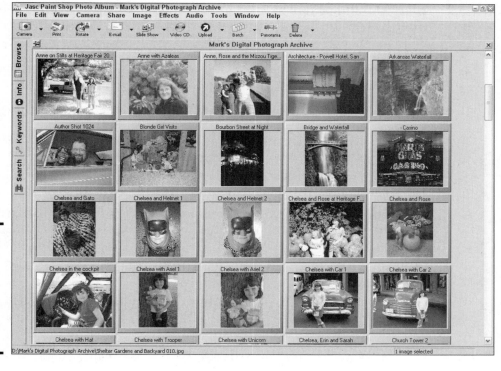

Figure 19-2:
Keep track of all your multimedia files easily with Paint Shop Photo Album.

Other photo album products to consider include

✦ **iPhoto:** This is another favorite organizer of mine, this time for Mac OS X. It's bundled free with every new Macintosh, or you can pick it up as part of the iLife suite. iPhoto includes a number of simple retouching and manipulation features.

✦ **Adobe Photoshop Album:** As you might expect, this relatively new entry from image powerhouse Adobe (www.adobe.com) has a number of image-editing features built-in. Album runs under Windows and sets you back only about $40.

✦ **LEAD Photo Album:** This Windows album program from LEAD Technologies (www.leadtools.com) supports over 100 image formats and enables you to create a slide show or wallpaper for your Windows desktop in a snap. It retails for about $100.

Want more? Do a search at your favorite search site for "Photo Album Software" (use the quotation marks to make sure the search engine uses the full phrase). You can also check Web sites, such as www.buy.com and www.amazon.com, where you can do similar searches for the photo album software that each site has to offer.

Your criteria for selecting photo album software is a personal thing. You may prefer ease of use and not care if you don't get a lot of fancy functionality. If you want lots of bells and whistles, you may not mind if the product is a little more complicated to use. Some photo album software serves as both

an organizational tool and a vehicle for creative display of your photos, and some just do the latter job. If you already have a system for organizing your images, you may not need software that does double duty.

Before you spend that hard-earned cash, make sure you shop around. Here's a list of features offered by the best album applications:

✦ Ability to categorize and classify each photo using built-in or custom-designed categories

✦ Provision for adding your own captions and other annotations

✦ Search capabilities so that you can locate all the images classified as vacation pictures, using keywords such as *beach* or *2004*

✦ Sorting abilities so that you can permanently or temporarily arrange your photos by filename or other criteria (these features go hand-in-hand with search capabilities)

✦ Features for uploading from your local album to your own Web space or sharing services

✦ Viewing capabilities that include looking at single photos and arranging them into slide shows

✦ Simple image-editing features, such as cropping, resizing, and rotating, so that you can make small changes to your pictures without firing up your image editor

Using online galleries

You probably already e-mail photos to friends, sending the images as message attachments that the recipients must open and view. Then your recipients can save any images they want to keep on their hard drives. A better way to share your images, assuming you don't mind having your images posted on the Internet, may be to use online galleries to display your photos.

The online approach to image distribution has some great advantages and some drawbacks. First, the advantages are that you can

✦ **Avoid the hassle of having to e-mail photos to lots of individuals.** Because you're placing all your photos on one Web site, all you have to do is let people know to check the site for your images. This makes it possible to share images that are larger than some e-mail services can handle (2MB for many services).

✦ **Share more images with more people.** Anyone with an Internet connection can view the images without owning any special software — other than a browser, which people need to surf the Web anyway.

✦ **Enjoy yet another relatively protected repository for your images.** If you lose the original files, you can download them from the online gallery.

Two possible disadvantages (and only you can decide if they are real disadvantages) are that

✦ **Your photos are on the Web, and anyone can view them.** This can expose you and your family to people with whom you would not normally share your vacation, holiday, and otherwise personal photos. You have to be careful about posting photos that show your house number, last name, or any other identifying information.

✦ **Most online galleries charge a fee for providing space on their site for your photos.** The fees are usually reasonable, but compared to e-mailing photos, which is free (you're already paying to have e-mail anyway), the cost may be more than you're willing to pay.

I recommend avoiding image hosting services that require you to log in simply to view images. Your friends and family members may decide *not* to view your photo album rather than provide an e-mail address (and other information).

To find an online gallery to post your photos, you can do a search online for `"Online Galleries"`. You'll see quite a few sites that are devoted to actual artists (and this may be of interest if you are an artist) and some that are for the general public to use. If you add `"+free"` to the search criteria, you'll ferret out those sites that offer the space for free or that will let you test their services for free or for a limited time. Here are some sites to consider:

✦ Web-a-photo (`www.web-a-photo.com`)

✦ PBase (`www.pbase.com`)

✦ Club Photo (`www.clubphoto.com`)

Obviously, the cost for an average person's online images is quite reasonable, and two out of the three sites in the preceding list are free. So you have no reason, therefore, not to try posting your images in an online gallery. If you're fearful of the exposure that posting your images on the Internet creates, then post only those images that are completely anonymous.

I'll be honest with you (as always) — there's always the chance that visitors to your site will redistribute your images elsewhere on the Internet. That's the chance you take by posting your photographs for the public to see.

Archiving and Backing Up Photos

Not all your photos will require instant, easy access. Vacation photos from the past, certainly if you visited a not-too-exciting place, may be a waste of valuable hard-drive real estate. But what if you don't want to delete these infrequently viewed images? You don't have to make rash decisions — you can simply archive the images you don't need to access quickly or frequently. If a photo is valuable to you on some level in the long run but you don't imagine wanting to look at or print it in the foreseeable future, just save it to disc — a CD or DVD is the best choice because Zip disks and floppy disks have a considerably shorter storage life. You have several archiving options, many of which may be on your computer right now. If they're not, you can easily acquire them.

Backing up your best shots

First, because you've already organized your photos (assuming you've read the beginning of this chapter), you should already have your photos categorized and know which ones are so dear to you that, if anything happened to them, your family would have to take your shoelaces lest you "do anything foolish." You need to back up these cherished shots, store them in some way to protect them from anything that can happen to your computer or your photo albums (printed or electronic).

Your backup options are simple:

✦ **Store the photos on disk.** I generally shy away from floppy disks because they offer very little storage space and are notoriously unreliable. Zip disks have a higher capacity and are more reliable, but they're considerably more expensive than CD or DVD media.

✦ **Write them to a disc by using a CD or DVD burner.** This method enables you to store up to 700MB on a single CD or several gigabytes on a DVD. If your computer already has a burner in it or attached to it, all you need is a package of writable CDs, which you can use with your burner.

✦ **Store them online.** The Web sharing sites listed earlier also can provide you with a sort of backup for your images. It's best to use these sites as a secondary backup (sort of as a backup to your backup) because you have no way to guarantee how long these services will be around!

Using CD-R and CD-R/W

Until just a few years ago, most computers came with a CD-ROM drive, and all you could do was read or install software from the content of a CD-ROM (ROM stands for Read Only Memory). Then CD burners hit the market, and now an increasing number of new computers come with one as standard equipment. If your computer has only CD-ROM capability, you can easily add a CD burner for $50 (or less).

With the ability to write to a CD, you now can save up to 700MB of data on a very reliable medium. Unlike floppy and Zip disks that can be ruined by exposure to magnets, heat, cold, sunlight, water, and rough handling, CDs are quite stable if handled correctly. Other than breaking or scratching them, you can't really hurt them.

Now, before you run out and buy a CD burner and CDs to burn, consider these writable-CD facts:

✦ Writable CDs come in two types: CD-R and CD-RW. CD-Rs can be written to (the R stands for Recordable), but only once. CD-RWs can be written to and erased, and written to again.

✦ You can use a CD-R or a CD-RW like a floppy or Zip disk by using a mode called Packet Writing (also called UDF). In that mode, you can copy files or groups thereof to the CD.

✦ CDs are virtually indestructible (unless you crack, break, or severely scratch them). Even so, you shouldn't expose CD-Rs and CD-RWs to direct sunlight or extreme heat.

For a comprehensive guide to recording your photographs on CD and DVD discs, head to Book IV. The chapters there lead you through organizing and recording your photo discs (as well as burning audio and video discs) and include information on packet writing and backing up data to disc. You'll be a digital burning wizard in no time!

Looking ahead to DVD storage

As commonplace as DVD (digital versatile disc) players have become in many households and on many computers, are they a reasonable tool for saving data? You bet! DVD recorders have dropped to under $100, and the blank discs are dropping in price by the minute. DVDs hold more data than a CD-R or CD-RW can — almost 5GB (gigabytes) or more.

Like CD burners, DVD burners also come in more than one type:

✦ DVD-Video discs (the prerecorded kind) come with stuff prewritten to them. You can view what's on them, but you can't erase and then rewrite to them.

✦ DVD+R and DVD-R discs can be written to only once.

✦ DVD+RW and DVD-RW discs can be written to, erased, and written to again.

If your computer already has a DVD-ROM (read-only) drive in it, that doesn't mean you can write to DVD discs. It simply means you can play them. To write to a DVD disc, you need

✦ A DVD+RW or DVD-RW drive that both plays and records DVDs

✦ DVD-R, DVD+R, DVD-RW or DVD+RW discs

Off-site storage for maximum safety

If your photos are so precious that you'd just die if anything happened to them, or if they're important for legal, financial, or other compelling reasons, don't risk losing them to a fire or burglary. You can store your archives off-site in one of three ways:

✦ Use a bank safe deposit box.

✦ Use a safe located in a secure storage facility.

✦ Arrange to keep one of two archive copies with a friend or family member.

If you save your precious images to CD or DVD, you can make two sets and store one set off-site, selecting one of the aforementioned places based on the level of security you need. The bank could burn down, but the safe deposit boxes are usually in or near the vault and are protected from very high temperatures, even in the event of a fire. If you keep a safe in a paid off-site storage space, the place is likely to be fireproof or well-protected by sprinklers and video cameras, so it's probably more secure than your home. If neither of these is an option, find a friend or relative you trust and give the extra set to that person.

Chapter 20: Printing Your Final Result

In This Chapter

✓ Figuring out if and when you need to print your photos

✓ Choosing the right printer for the job

✓ Understanding the printing process

✓ Hiring a professional printing company or service bureau

Digitally captured and retouched photos live on your computer. That's where they came to life, whether you captured them with a digital camera or scanned a printed original. It's also where you may have doctored them for any number of purposes — to make them smaller to e-mail them to friends and family, to make them safe for use on a Web page, or to make them picture-perfect for printing.

However, unless you deal only in Web images or on-screen presentations, you probably need lots of prints of your photos. In this chapter, you discover when and how to print your photos, which printers do what kind of job, and how to create the best-quality print of your digital images. You can find more information about choosing printers in Chapter 5 of Book I.

Why Do You Need Prints?

The reasons that you may need to print your photos are as numerous as the photos themselves. Look for your own reasons among those in the following list:

✦ You need to create a suitable-for-framing version of a photo that was too small or too damaged to be framed before you edited it. You can transform that wallet-sized photo into a framed picture that's suitable for the top of your grand piano. Or, perhaps a picture has wrinkles or tears that you can fix with your image editor before making a pristine, new print. See Book I, Chapter 16 for tips on restoring damaged photos.

✦ You want to create a backup print of a very precious photo in case something happens to the original. Better yet, display the duplicate and keep the precious original in a safer place, such as a safety deposit box. Put a CD or DVD that contains the digital version of the original in the box, too, so you don't have to duplicate your editing efforts.

✦ You're building a portfolio of your digital artwork, and you need a printed copy to show to prospective employers or clients. Make as many prints as you want economically, and distribute them far and wide.

✦ You need a *proof,* or printed evaluation image, that you submit to someone who can't view the image online for his or her approval. You can fiddle with the proof print to make sure that it's an accurate representation. This way, the person who is reviewing it can have the best possible copy to approve.

✦ You require an evaluation proof for comparing the digital image with the hard-copy original and just viewing the file electronically doesn't provide the necessary information about print quality. In this case, the proof of the pudding is in the viewing.

✦ Your photo is for printed marketing materials, such as ads, brochures, or fliers, and you need to create camera-ready art that a professional printer can use to create the finished materials. Although many professional printers today can work with digital files, some cannot. You'll need a print for the print shop's use.

✦ When I prepare publicity pictures for my local newspaper, I always provide the original photo on a CD. But I also include a print so that the editor can decide whether the photo is worth using without having to pop the CD in a drive and take the trouble of viewing it.

Although this chapter's title is "Printing Your Final Result," you may also want to print versions of your image as you go along in the editing process. Because computer monitors aren't capable of displaying colors exactly as they will print, you may want to print at least one "in-progress" version of your image so that you can check for color, clarity, and other qualities before you commit the final version to that sheet of expensive photo paper. You can purchase lower-priced photo paper for your test prints (because printing on plain old ink-jet paper may be misleading) and then use the good stuff for your final printout.

Why does the same photo look different if you print it on plain ink-jet paper than it does on photographic paper? The porous nature of regular ink-jet paper absorbs more of the ink, and this affects the reflective quality of the colors. Images look darker, contrast is lost, and overall quality is diminished if you print on porous paper. If you print on glossy or matte photographic paper, where a coating on the paper prevents absorption, your photo's color and content stand on their own, unaffected by the paper. No details, color, or contrast is lost.

Evaluating Your Printing Options

After you know that you need to print your photo, it's time to decide how to print it. If you have only one printer and no money for or access to another printer, the decision is really made — you use your one and only printer. If you have the cash for the perfect printer for your particular photo, that's great. If you don't have the cash but have access to a variety of printers, that's great, too. With the assumption that you have some choices available to you, consider the printing possibilities that are listed in Table 20-1. You can find more information on choosing printers in Book I, Chapter 5.

Table 20-1 **Printer Options**

Type of Printer	Price Range	Comments
Ink-jet	$75–$350	Great for color prints; good for text quality, too
Laser	$600– $3,000	Fast, economical for text, not the best choice for images
Dye-sublimation	$600– $1,000	Best color-print quality but can't handle text

Ink-jet printers

The name *ink-jet* gives you an idea of how the ink-jet printer works —
assuming that the word *jet* makes you think of the water jets in a whirlpool
bath or spa. The way that these printers work is rather simple. Piezoelectric
crystals make the ink cartridges vibrate. (The crystals are sandwiched
between two electrodes, which make the crystals dance.) Different levels of
voltage cause the crystals to vibrate differently; this adjusts the colors and
the amount of color that is sprayed through a nozzle onto the paper.

Color ink-jet printers can create near-photo-quality images, assuming that
you use good-quality photo paper for the output. Price isn't necessarily an
indication of print quality, and you should print a test page before making a
purchase, or take the recommendation of someone who owns the same
model.

Laser printers

Laser printers work much like photocopiers. A laser beam is aimed at a
photoelectric belt or drum, building up an electrical charge. In the case of a
color laser printer, this happens four times, once for each of the four colors
that are used to make up your image. The four colors are cyan, magenta,
yellow, and black. The electric charge makes the colored toner stick to the
belt, and then the belt transfers the toner to the drum. The paper rolls along
the drum as it moves through the printer, which transfers the toner from
the drum to the paper. Then, either pressure or heat (or both) is used to
make the toner stick to the paper.

Color laser printers are more expensive than ink-jets and black-and-white
laser printers. If you're creating camera-ready art for very important, detailed
publications, you probably want a color laser (assuming that the images are
in color) rather than an ink-jet, but the image quality from a color laser is not
as good as what you would get with a dye-sublimation printer.

Dye-sublimation printers

Here, the name of the printer doesn't tell you much about the way the printer
works. Despite their cryptic name, dye-sublimation printers work in a rela-
tively straightforward way. A strip of plastic film, called a *transfer ribbon,* is
coated with cyan, magenta, and yellow dye. When a print job is sent to the
printer, a thermal printhead heats up the page-sized (8½-x-11-inch) panel of
plastic transfer ribbon. Variations in temperature control what colors and
how much color are applied to the paper. Because the paper has a special
coating on it, the dye sticks.

Dye-sublimation printers provide an excellent image, especially for color photos. The subtle results are great for professional designers, artists, and photographers. The expense may be prohibitive for small businesses and home users, but the lower-priced models may be within reach. Unfortunately, dye-sublimation printers do not print text well — they're suited only for photographs.

Touring the Print Process

Regardless of the photo-editing and retouching software that you're using to process your photographs, some aspects of the image-printing process are the same. With most image editors, the print process consists of the following options:

✦ You get to choose which printer to output to. If you have a black-and-white laser and a color ink-jet, for example, you can choose to output to the color ink-jet.

✦ You can choose how many copies to print.

✦ You can choose to print only part of the image, by choosing the Selection option. This assumes that you made a selection before issuing the print command.

✦ You can adjust your printer's properties to print at different levels of quality, based on the version of the printout.

✦ You can choose to print crop marks, which can help you or a professional printer cut along the edges of the printout. If you want to frame a 5-x-7-inch photo, for example, and you're printing it on 8½-x-11-inch paper (letter size), the crop marks can help you cut the paper to fit inside the frame and within any mat that you're using.

Preventing surprises with Print Preview

Before you commit your image to paper, you may want to see a smaller view of the image in the context of a sheet of the currently set paper size, just to make sure that everything is okay. This prevents nasty surprises, such as printing your favorite portrait in horizontal format, cutting your subject in half. In virtually all software programs, you can choose File➪Print Preview to see how the printout will look. Figure 20-1 shows the Print Preview window in Photoshop Elements. If you're happy with what you see, go ahead and issue the Print command (choose File➪Print or press Ctrl+P).

Figure 20-1:
The Photoshop Elements Print Preview dialog box.

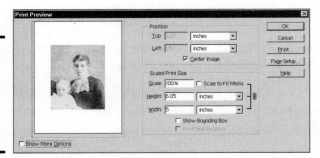

Higher-end photo-editing packages (such as Photoshop) let you choose to print color separations, which means printing each of the image's colors on a separate sheet. This can be helpful to a professional printing firm that may be using your printout to create the films that generate your prints.

Understanding your output options

In the Print Preview dialog box, you can print the image by clicking the Print button. You can also change the scale (size) and location of the image on the paper. With some image editors, selecting a Show More Options check box opens an extension of the original dialog box (see Figure 20-2). Options here may include applying a caption to your image or turning on crop marks. You may even be able to apply a background color and a border, which can be helpful if you're printing an image for framing and don't have a mat for the frame.

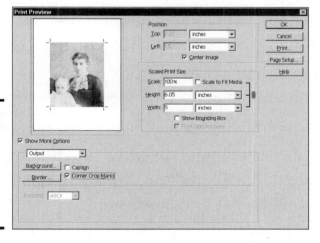

Figure 20-2: Expanding the Print Preview dialog box displays more options.

The Page Setup dialog box, which you open by clicking the Page Setup button in the Print Preview dialog box, is shown in Figure 20-3. The Page Setup dialog box allows you to change the printer that you're sending the job to and to view your printer's properties. This dialog box is another place where you can choose the Background, Border, and Corner Crop Marks options. In many software packages, the Page Setup dialog box also allows you to change the paper size and orientation.

Figure 20-3: Choose your paper, and choose your orientation.

Printing your photos

When you're ready to print your work, choose File➪Print and use the Print dialog box to select your printing options — which printer to use, how many copies to print, and so on. Figure 20-4 shows Photoshop Elements' Print dialog box.

Figure 20-4:
The Photoshop Elements Print dialog box gives you complete control over your printer.

If the software that you're using offers a drastically different set of options through its Print dialog box, you can press F1 to open the software's help files. If that doesn't work (though it usually does), use the Help menu to look for articles that pertain to printing. The software may have also come with a *Read Me file* — a file that came with the software if you downloaded it from the Web — or a printed manual that you can refer to.

Of course, before you click the Print or OK button to begin the print job, make sure that the right paper is in the printer and know how to load the paper in your printer — good side down, the proper end in first, and so on. The printer should come with instructions. You find more thorough instructions in a printed manual, but paper-loading hints, for example, are represented by icons that are on the paper tray. Most photographic paper has a "good" side, which has the image-enhancing coating on it, and most paper has a repeated brand name on the back, making it easier to tell which side to print on. If you're not sure, though, do a test print first. In the worst case, you'll print on the wrong side and have to do it again — and waste a single sheet of paper. If you're planning to print several copies of the image, it's better to waste a single sheet than to print all ten copies on the wrong side of the paper!

Using Professional Printing Services

Also known as a *service bureau,* a professional printing firm offers services to graphic artists, photographers, fine artists, businesses (for business cards, brochures, and so on), and the general public. Chains (such as Kinko's, AlphaGraphics, and Kwik Kopy stores) offer such services, and some office-supply stores can print your graphic files for a fee. You can also find small, privately owned printing services, which may charge more than the chains

do. But there, you get very personalized service, and you may find the staff more willing to help you if you don't know exactly what they need to complete your order.

I used service bureaus for many years, back in the days when laser printers could output text at no more than 300 dpi. Service bureaus were an economical way to produce black-and-white camera-ready pages (those that can be photographed by the printer to make printing plates) without having to purchase a costly high-resolution printer or image setter (a high-resolution printer that's especially suited for images). Today, most laser printers have 600-dpi or better resolution, so the need for service bureaus for text output is reduced. These bureaus are still helpful for making full-color prints from your digital photos if you don't own a color printer that provides sufficient quality.

Choosing a service bureau

Not sure who to call when you're ready to choose a service bureau/printing service? You can always check the yellow pages online or in print, or you can ask friends and business associates for referrals. The best people to ask are graphic artists or people who work for an ad agency. They are likely to use service bureaus extensively, and their recommendations would be valuable.

Before you hire a service bureau to print your photos, you want to ask the folks there the following questions:

✦ **What do you charge, and how do you determine your prices?** Do you have minimum fees?

✦ **When can you finish the job?** Note that most service bureaus will want to fit your job into their normal queue of projects. They may have an extra charge for "rush" jobs. Find out what constitutes a rush job. Is that overnight service, or is anything less than a week considered a rush job?

✦ **What file formats do you support?** With this information, you know the format in which you should save your photo after editing it. At one time, service bureaus could handle only Macintosh files and common Macintosh formats such as TIFF or PICT. Today, most service bureaus support all platforms and all image-file formats. It doesn't hurt to check, though.

✦ **Can I view a sample of the printout before paying for the final copies?** It can be helpful to view a proof or evaluation copy.

✦ **Is the kind of output that I'm looking for something that you have done before and done frequently?**

With answers to these questions in hand, you can choose the right service bureau for your needs. If the company that you're working with isn't open and cooperative, run — don't walk — to another company. I've worked with both kinds of service bureaus: the kind where the staff assumes that you should know everything and don't want to be bothered explaining things, and the kind where folks are more than willing to help and answer any of your questions. Obviously, the latter type of company is the best.

Tell them what you want — what you really, really want

After choosing a service bureau to work with, discuss your exact printing needs. When you tell the person who is helping you how you plan to use the printout, he or she should do the following:

✦ Suggest the type of paper for the printout

✦ Tell you what file format you need to use (a `.psd` file created in Photoshop, a `.tif` file, and so on) and whether you need to provide printed, camera-ready art

If you need to provide camera-ready art, ask whether you need to provide *color separations* (each color in your image, printed on a separate sheet of paper) and determine what kind of paper the bureau prefers that you print to. If you only have an ink-jet printer, the serviceperson may balk at your using it to create camera-ready art. In general, though, any good service bureau prefers to get the image as an electronic file. This way, the staff can work with the image as needed to give you the printout that you require.

Knowing when you need a service bureau

In the end, the choice of whether you work with a service bureau comes down to money. Time is money, and money buys quality if you shop carefully for printing services and/or your own printer. If you need a perfect, absolutely beautiful printout of your photo and can't afford a high-end printer (or don't know anyone who has one that you can use), spend the money to have a service bureau create the printout for you. If you need a high-quality printout and have a quality dye-sublimation or color laser printer at your disposal, you may be able to do the printing on your own.

If I sound as though I'm disregarding the role of ink-jet printers in the printing process, I'm not. I've printed many photos with an ink-jet printer and given them as gifts, used them as camera-ready art for brochures and business cards, and so on. Some of my original artwork has also been printed on an ink-jet, and the items look just fine in a portfolio. The printer that you use depends on the quality of the printout that you need. Determine whether the printer that you have is capable of providing this quality. You may love the output that your ink-jet generates, and if so, that's great. You've just saved some money, and you have a quick and easy way of creating your prints!

Chapter 21: Sharing Pictures on the Web

In This Chapter

↪ Sharing your digital photo masterpieces with friends and family

↪ Showing off your business online

↪ Using commercial sites to share your pictures

↪ Creating your own Web page for displaying pictures

Of course you can e-mail your photos to personal and business contacts, but most people are pretty tired of getting images that are attached to e-mail messages. They have to download the images to open and view them, and if they're on a dialup connection to the Internet, that can be a pain. And after the download is (finally) complete, what do they do with the pictures? If they don't need the image themselves, or if the subject of the photo isn't near and dear to them, they either throw it out (into the Trash or Recycle Bin) or they squirrel the images away in a folder that they'll never open again. I have a folder on my Windows desktop that's called Other People's Images. This is where I drag all the pictures that I would feel bad tossing out, but have no use for.

So if e-mail isn't the best way to share pictures with people who need or want to see them, what is? You have several options, including posting the pictures on your own Web site or using one of many image-sharing services. In this chapter, you discover what Web-sharing tools are available, how to pick the one that's right for you, and how to get busy sharing photos on the Web.

Appreciating the Advantages of Web Sharing

By using the Web to share images, you eliminate the other person's need to save or throw out the images that you've sent. He or she can view the images, say "Aw, isn't that cute!" or "Wow! Cool car!" and that's it. She doesn't need to download, save, throw out, or do anything with the image, other than just look at it. If people want to save or print the image after they view it, that's up to them, but it's not required or even firmly suggested. Figure 21-1 shows a page of images that was posted to a Web site. All that people have to do to see the pictures is type the Web address (in this case, www. laurieulrich.com/webpix) into their browsers, and voilà! The photos are available for viewing.

By using the Web to share pictures, you're saving your image recipients' time, hard drive space, and aggravation by creating a single repository for all the images that you want to share. You're also making it much easier for yourself to keep an up-to-date selection of images available to all who want to see them, so the Web option is a win-win proposition.

Figure 21-1:
Cats on
the Web,
straight
from your
digital
camera.

Before you share a batch of photos with the world (remember, the Internet is international!), check the photos for anything that you would regret sharing with the rest of the population. You probably want to avoid sharing identifying features, such as addresses and people's last names, that enable strangers to make undesired contact with you. Another thing to check for is embarrassing content. Going over the images with a very discriminating eye before you share them pays off in the long run.

Sharing your personal photos

The benefits of using the Web to share personal photos are obvious. You can share vacation photos, school pictures, and shots of your new house, pool, car, and bathroom tile. Through your online pictures, you can share all the stuff that you would tell people about in a holiday newsletter. Think of the savings in postage alone! Instead of enclosing that extra sheet (or sheets) of paper, just write the Web address inside your holiday card where your photos can be found, and your work is done. If most of your friends and family have e-mail, you can alert them that way, and save your wrist the strain of writing a Web address 50 times. Figure 21-2 shows an e-mail with a Web address in it, set up as a link. Recipients need only click the link in the e-mail, and they're taken directly to your photos.

Many e-mail programs create such a hot link for you. For example, if you type anything that begins with `http://` into recent versions of Outlook, Outlook Express, or America Online's mail system, the e-mail software automatically converts the address into a hot link, colors it, and supplies an underline that lets the recipient know that it is a link. With some e-mail software, you may have to make sure that the Rich Text (HTML) option is turned on. If your software is set to create messages only in Plain Text, the hot links may not be created automatically.

Figure 21-2:
Adding a
Web link
within your
e-mail
messages
is easy.

The recipient must also have the HTML option active for your link to be hot when the message is received. If not, the recipient can still jump to your Web page by highlighting the link, copying it (usually by pressing Ctrl+C, or ⌘+C on a Mac), and then pasting the link into a browser's address bar (by pressing Ctrl+V, or ⌘+V on a Mac). Although many folks who send and receive mail already know how to copy and paste links, you may want to include instructions on how to do this in your e-mail message.

Of course, some sharing is very targeted. You want only your friends from college to see one batch and your family to see another, and you don't necessarily want the two camps to see each other's photos. How can you control this? By placing different sets of photos on different Web sites and then telling only certain people about certain images (or, more specifically, by giving them only a certain Web site address). Other than someone deliberately searching for your photos online, people will go and look at only those photos that you're directing them to, and by controlling whom you tell, you control who sees your images. Of course, if you want everyone and anyone to see all your photos, you can store them all in the same place and use your name to identify them, making it possible for anyone to find them by searching the Web.

So where are these Web sites where your pictures can be found? They're everywhere — from the You've Got Pictures feature at America Online to sites that are hosted by the big names in cameras, such as Kodak. These sites are easy to use and easy to access, and they make sharing your photos with whomever you want very simple. I talk about different sites and the pros and cons of each a little later in this chapter in the "Using commercial sharing sites and services" section.

Sharing images with business associates

So you've opened a new warehouse or have a new product to offer. Don't spend the extra cash printing thousands of brochures or product information sheets, and certainly don't skimp and print black-and-white fliers because printing in color is so expensive. Color is cheap online, and the cost (if any) of sharing your images online is just a tiny fraction of the cost of printing.

If you don't have access to your company's Web site, you can usually get some free Web space from the people that you're already paying to provide your e-mail and Internet connection — your ISP (Internet service provider). Whether your ISP is an online community, such as AOL or MSN, or another firm, such as Earthlink or AT&T, you can take advantage of the free Web space that's allocated to each customer. Although you probably won't be given a lot of space, you may have enough to share a bunch of photos because photos that are saved for the Web (in GIF or JPG format) have a much smaller file size than photos shared in other formats. Even if your ISP gives you only 10MB of space, you can get a lot of photos in that space.

To find out whether your ISP offers free Web space, call its support phone number or visit its Web site. AOL makes it easy. By choosing Create a Home Page from AOL's People menu, you can create a personal or business Web site.

Just as AOL offers a lot of help in setting up your home page, most ISPs offer either online or phone support to coach you through the process. The folks at most ISPs assume that if you're using their free space rather than registering a domain of your own, you're probably not a full-fledged Web designer. Using Earthlink as an example, browsing to `www.earthlink.net/home/benefits/webspace` takes you to a page where you can click the Click-n-Build link and quickly put together a 6MB Web site. In fact, as its first suggestion, Earthlink recommends using its Free Webspace page to create a photo album.

Choosing a Web-Based Photo Sharing System

There are really too many free Web-page hosting sites to list, and deciding which ones will remain active during the life of this book is too difficult. You can find an up-to-date guide to free or nearly free hosting services at `www.clickherefree.com`. Of course, I'm hoping *that* service doesn't become defunct soon, too! Your best bet is to use your ISP or other big operations like AOL, MSN, and Kodak, which are likely to be with us over the long haul. Of course, longevity may not be important to you. After all, when one service pulls up stakes and packs up its tent, you can always switch to another, newer free service. As a bonus, you don't have to worry about erasing all your outdated photos from the old service. The service does it for you when it closes up the shop.

You have a lot of choices for displaying your images. Some of these are as follows:

✦ You can use an online sharing system to display your images. Most of these systems offer the space for free.

✦ You can build your own Web site using the free space that your ISP offers, or you can register your own domain and set up your own space on a host's Web server. In this case, a host offers space on its computer for you to store your pages, usually for a monthly or annual fee.

✦ You can set up your own *Web server* (a computer that "serves up" Web pages to people on the Internet), but I wouldn't recommend this option solely to store your images.

With all of these options, choosing a sharing system is easy. The best option for you just depends on what you want, how much you're willing to pay, and how much time you want to devote to setting up your images online. From simple and set up in no time to slightly complex and completely customized, the choices run the entire spectrum.

Using commercial sharing sites and services

Commercial normally means "for a fee," right? Well, not necessarily. Many of your sharing options are free, or they use something that you're already paying for. In the case of an online community, such as America Online, if you're a member, you're already paying for that membership. This enables you to send and receive e-mail, chat, surf the Web, and so on. For AOL's monthly fee, you get access to the Internet and to AOL's community features. One of those features is You've Got Pictures, which enables you to view your images online — and allows others to view them, too. You also get free Web space with your membership, which you can use for storing and displaying your photos. Doing business with an organization that sees you as a member is easy. The organization wants to provide services that you'll come to depend on, and that's all a part of keeping you as a customer. Therefore, you'll find both the You've Got Pictures and the Hometown features easy to use and simple to maintain, and you can get technical support when you need it. AOL doesn't want you to go away mad (or go away at all!).

Other commercial sharing services — Web sites known as *online galleries* — allow you to post your images for free, in exchange for making you look at ads around the periphery of the Web page that displays your images. The thinking is that by exposing you (and those you send to the site to see your photos) to the ads, the gallery's advertising partners gain exposure to a considerable customer base. Other sharing services provide free space simply because they want to be nice or to perpetuate an interest in photography. Some services sell software, which they offer you throughout their site, enticing you to buy their image-editing and/or photo album application. You don't have to buy, but the companies figure that many people will do so.

Quite a few different services are available. Your best bet for finding them is to type **"Online Galleries"** (include the quotation marks) or similar key words into the Google search engine (`www.google.com`) to find services like Club Photo's Photodrop. Most services offer similar features, and as an example in the next section, I describe the biggest and bestest, America Online's You've Got Pictures/Picture Center.

Using America Online's You've Got Pictures and Picture Center

If you're a member of AOL or find its monthly fee to be low enough to join just so that you can take advantage of its picture-display features, you'll find that the AOL system is very easy to use. Before sharing pictures online using the You've Got Pictures feature, make sure that your digital camera is attached to your computer or that you have scanned photos that you're ready to upload from your hard drive.

AOL's photo-sharing site is called the Picture Center on the opening screen, and a large "Sponsored by Kodak" logo appears on the You've Got Pictures welcome page. However, the capabilities remain much the same as with earlier AOL versions. From the site where your pictures are stored (which you can share with others, letting them know that they can see the pictures online), you can save the images to your computer for editing and printing. You can also order things, such as mugs and t-shirts with your images on them, or you can order enlargements and high-quality reprints.

The following sections provide a list of things that you can do with AOL's You've Got Pictures/Picture Center.

Create an Online Album

Click the Online Album button and a dialog box pops up, showing you exactly how to upload your photos to an album that you can display on the Web. An Add Pictures Now button lets you browse your hard drive for photos and then move them to an album layout page. You can select specific pictures for display and rotate them.

Click the Add to My Album button, and a wizard leads you through the steps to upload the photos to AOL. You can add or edit a title or create captions, and you can choose an album style that suits your personality. AOL currently offers three different layouts and hundreds of backgrounds — ranging from patterns and textures to special occasions, colors, and animals.

AOL even includes an e-mail facility that you can use to notify people of your new album. The boilerplate e-mail includes instructions for accessing the album. You can send the mail to any or all the people in your AOL address book.

Idea Center

This set of pages offers tips on creating a photo gallery, sharing ideas with other users, getting information on digital cameras, and using special features such as seasonal photography ideas.

Print Store

The Print Store has facilities for making prints from photos in your gallery at reasonable prices, creating super-sized prints, producing photo greeting cards, and ordering customized photo picture gifts, including ceramic picture mugs, mouse pads, jigsaw puzzles, sweatshirts, and t-shirts.

Why would you need to order prints if you can just print the online images? Web-safe image formats (normally .jpg for photos) are often posted at a less-than-optimum quality to save loading time when someone visits the page where the images are displayed. Therefore, if you print the online version of the image, you're likely to get a grainy or less detailed version of the image. If you have a high-resolution version of the image on your own computer, you can print from that, or you can order the prints (for a fee) from Kodak, through the same AOL site where you posted your Picture Center images for sharing.

AOL Photo Galleries

This section of the Picture Center offers a variety of photos to view. You can see galleries that were submitted by other AOL users as well as view special exhibitions. In recent months, the AOL Photo Galleries have included displays by Associated Press Pulitzer Prize winners, a Fall Folio of autumn leaves, nature photographs, and home renovation pictures taken from the *This Old House* PBS television series.

Digital Camera Center

This section offers lots of tutorials that can help you find out more about your digital camera, including a Digital Question of the Week, a Digital Cameras 101 basic course, a review of the latest digital cameras, and a beginner's My First Digital Camera section. Of course, these sections may change by the time you visit the Digital Camera Center, but discovering the new goodies is half the fun!

My Pictures

This section is reserved for viewing and maintaining any albums that you have created in the Picture Center. The page includes three "departments," as follows:

✦ **Pictures on My Computer:** Photos on your hard drive that you haven't uploaded to AOL yet.

✦ **My Albums Saved on AOL:** Multiple albums that you've created from pictures that you've uploaded.

✦ **Albums I've Received:** Your friends can send you their albums, which you can keep on AOL and view whenever you want. You can also edit any of the albums using the AOL tools.

You can purchase a dock for your digital camera (a Kodak digital camera, of course) that links your camera directly to your computer and to Kodak's EasyShare software to facilitate posting your images online and sharing them with others. To get to the site and find out about what Kodak offers, visit www.kodak.com. From the resulting Web page, you can click the EasyShare listing in the Site Index and find out more about the system.

Using your own Web space

Regardless of whether your ISP provides the space for free or you enlisted a paid host to provide space for your own domain, you can use your Web space to store and display photos that you want to share with friends, family, customers, and business associates. Placing the images online requires you to take the following simple steps:

1. **Prepare your photos for use on the Web by opening them in a photo-editing package, such as Photoshop Elements, and saving them in a Web-safe format.**

327

The two formats that all Web browsers (notably Internet Explorer and Netscape Navigator) can deal with are `.gif` and `.jpg`. The `.jpg` format is best for photos because it supports the multitude of colors and shading within the images. Figure 21-3 shows the Save for Web dialog box in Photoshop Elements and a photo that is being prepared for Web use.

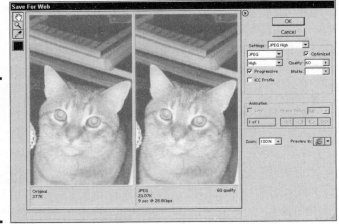

Figure 21-3: You can save an image especially for Web display in Photoshop Elements.

2. Set up the Web page where the images are to be displayed.

You can use a variety of graphical tools to design the page (for example, Microsoft FrontPage, Macromedia Dreamweaver, or Adobe GoLive), or you can create a page by writing HTML (HyperText Markup Language) code. Figure 21-4 shows a simple page that is being created using Dreamweaver. If you're using an ISP's free Web space, the ISP should give you step-by-step procedures for creating a Web page, and the software does most of the work for you.

Figure 21-4: Dreamweaver is an all-in-one solution for Web-page creation.

3. Upload the Web page and the images.

This is typically done with FTP (File Transfer Protocol) software. Or, if you're using AOL or your ISP, the service may provide an Upload page that loads both the Web page that you set up and the images that you want to display.

You can find free FTP software online from sites such as www.tucows.com and www.cnet.com. You can also do a search for free software by typing **"Free FTP Software"** at Google (www.google.com). When doing a search with a phrase like that, remember to use the quotation marks, which help refine the search to the exact phrase that you've typed. Venerable "oldies" like WSFTP LE, shown in Figure 21-5, are very popular. Folks who are new to the Internet may prefer a program like FTP Explorer, which has a Windows Explorer–like interface. You can upload files simply by dragging them from a Windows Explorer pane to the FTP Explorer window, as shown in Figure 21-6.

Figure 21-5:
Using an
FTP file
transfer
to upload
Web files.

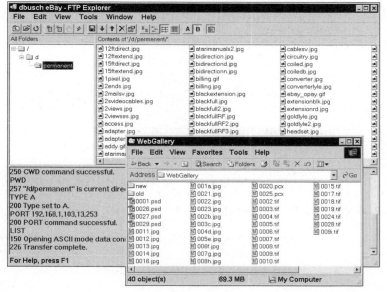

Figure 21-6:
It doesn't
get much
easier than
drag-and-
drop FTP file
transfers.

4. Visit the page online to see how it looks.

You should always check your page online to see whether it's okay before you send people to your site to see your images.

If you want to make changes, open the Web page file on your own computer, make the changes, and upload the file again.

If you check your page online and you see red *X*s (in Internet Explorer) or gray icons with a question mark (in Netscape Navigator) where the images should be, this means that the browser can't locate the image that's supposed to be there. Check your Web page settings to make sure that you have the right pictures in the right places, and check to see that you've uploaded all the images to your host's Web server. If this happens to you just once, you'll understand the importance of testing your Web pages after uploading them. Nothing is more embarrassing than sending someone to your site and having them report that the images are missing!

As time goes by, you can always expand and improve on your Web pages. You can try using the following tips:

✦ **Refreshing content:** Edit your Web pages, and add new pictures. Or, take down the old pictures and replace them with your latest shots. As you become more proficient in setting up images and designing Web pages, your site can grow with you.

✦ **Organizing pictures:** Set up multiple Web pages, and use them to categorize your images. For example, set up a Vacations page, a Baby Pictures page, or a Graduation Ceremony page. Any category or special topic can have its own page.

✦ **Adding links:** Create links on your Web pages that take visitors to other people's sites or to online galleries where you have other pictures stored. If you're a real photography bug, you may have some of your more artistic shots stored on a gallery site. Through a link on your own page, you can direct people to your works of art.

✦ **Letting others join in:** Set up a family Web site, and have each branch of your extended family post his or her own images to individual pages. This can help distant family members stay in touch (add e-mail links to the pages so that people can view the images and then immediately write an e-mail to talk about them), and it lets everyone in the family know about new arrivals and special events, like family reunions.

✦ **Advertising your business:** If you're in business, use the space to show pictures of your products, services, staff, and locations — anything that can enhance your customer's interest in you and your business. Like a family site with individual pages for different branches of the family or types of pictures, businesses can also categorize their images and set up individual pages to hold each group.

If you thought that your only goal for that box of old photos was to go through and put them in an album, you can now see that you can do so many more things with your images. The Internet enables you to share pictures with anyone, anywhere, and it doesn't cost much money or take up much of your time. Have fun!

Book II

Digital Movies

The 5th Wave By Rich Tennant

TROUBLE ON THE SET

All the software in the world won't make this a great film. Only you can, Rusty. Only you and the guts and determination to be the finest Frisbee-catching dog in this dirty little town. Now come on Rusty—it's magic time.

We're losing the light, Dad.

Book II: Digital Movies

Chapter 1: Introducing Digital Video

In This Chapter

- ✔ Defining digital video
- ✔ Editing video on your own computer
- ✔ Sharing digital video
- ✔ Discovering image terminology

In 1996, I read a technical paper on a new technology from Apple Computer called *FireWire*. This new technology promised the ability to transfer data at speeds of up to 400 megabits per second. "Yeah, right!" I quietly scoffed to myself, "Why on Earth would anyone need to transfer that much data that quickly?"

Thankfully I was wrong, and I soon learned about a new phenomenon called *digital video* that could take advantage of this new FireWire technology. Digital video files are big, too big in fact for computers of just a few years ago to handle. But FireWire allows high-quality video to be shared easily and efficiently between digital camcorders and computers.

Of course, more than just FireWire was needed for this digital video thing to catch on. Personal computers still had to become fast enough to handle digital video, and prices for digital camcorders fell to within reach of mere mortals only a couple of years ago. Digital video is here now, and anyone with a reasonably modern computer and a $500 digital camcorder can make movies like a pro. With the recent advent of DVD players and recordable DVD drives, sharing your high-quality movies with others has never been easier.

This chapter introduces you to digital video, showing you how easy it is to edit and share your movies with others. I end the chapter with a brief explanation of key videography terms that you'll find useful as you delve into digital video.

What Is Digital Video?

Human beings experience the world as an analog environment. When we take in the serene beauty of a rose garden, the mournful song of a cello, or the graceful motion of an eagle in flight, we are receiving a steady stream of infinitely variable data through our various senses. Of course, we don't think of all these things as "data" but rather as light, sound, smell, and touch.

Computers are pretty dumb compared to the human brain. They can't comprehend the analog data of the world; all computers understand are *yes* (1) and *no* (0). In spite of this limitation, we force our computers to show pictures, play music, and display moving video. Infinitely variable sounds,

colors, and shapes must be converted into the language of computers — 1s and 0s. This conversion process is called *digitizing*. Digital video — often abbreviated as *DV* — is video that has been digitized.

To fully understand the difference between analog data and digital data, suppose you want to draw the profile of a hill. An analog representation of the profile (shown in Figure 1-1) would follow the contour of the hill perfectly, because analog values are infinitely variable. However, a digital contour of that same hill would not be able to follow every single detail of the hill because, as shown in Figure 1-2, digital values are made up of specifically defined, individual bits of data.

Figure 1-1:
Analog data is infinitely variable.

Figure 1-2:
Digital data contains specific values.

Comparing analog and digital video

Digital recordings are theoretically inferior to analog recordings because analog recordings can contain more information. But the truth is that major advances in digital technology mean that this really doesn't matter. Yes, a digital recording must be made up of specific individual values, but modern recordings have so many discrete values packed so closely together that human eyes and ears can barely tell the difference. In fact, casual observation often reveals that digital recordings actually seem to be of a higher quality than analog recordings. Why?

A major problem with analog recordings is that they are highly susceptible to deterioration. Every time analog data is copied, some of the original, infinitely variable data is lost. This phenomenon, called *generational loss,* can be observed in that dark, grainy copy of a copy of a copy of a wedding video that was first shot more than 10 years ago. However, digital data doesn't have this problem. A 1 is always a 1, no matter how many times it is copied, and a 0 is always a 0. Likewise, analog recordings are more susceptible to deterioration after every playback, which explains why your 1964-vintage *Meet the Beatles* LP pops and hisses and has lost many of its highs and lows over the years. Digital recordings are based on instructions that tell the computer how to create the data. As long as it can read the instructions, it creates the data the same way every time.

Whether you're editing analog or digital material, always work from a copy of the master and keep the master safe. When adding analog material to your project, the fewer generations your recording is from the original, the better.

When you consider the implications of generational loss on video editing, you begin to see what a blessing digital video really is. You're constantly copying, editing, and recopying content as you edit your movie projects — and with digital video, you can edit to your heart's content, confident that the quality won't diminish with each new copy that you make.

Why DV is a big deal

Editing video on a Macintosh (or a Microsoft Windows computer, for that matter) has been possible for quite some time. As early as 1992, Apple was introducing Macintosh models with special ports that were designed to turn VHS-type analog video into digital computer files, along with special applications to edit, format, and display that video on a computer screen. Likewise, professionals have been editing video using powerful personal computers and very expensive add-ons and software for well over a decade.

But the advent of digital video has caused a huge fuss over desktop video. In fact, some folks are calling desktop video a *killer application,* or *killer app* — the type of application, such as desktop publishing or Web publishing, that makes people willing to buy a computer for the sole (or primary) purpose of performing that new, *killer* task.

Why all the hoopla? Editing digital video offers a number of advantages over editing analog video, mostly because of one simple difference: A DV camcorder creates a computer file as you record. How important can that one little technicality be? The following points give you an explanation:

✦ **Ease of transfer:** Because a DV camcorder stores its video as computer data, all you really have to do is copy that data from the camera to a file on your computer. In the past, analog editing required that the images go through a *digitizing process,* in which the computer had to look at the video as it was played back by the camcorder, analyzing each frame and turning it into a series of digital images that were stored in a single computer file. This was a time-consuming process that required reasonably expensive hardware (usually in the form of internal expansion cards) and a huge amount of computing power. With a DV camera connected

via a FireWire cable, you're really just copying the DV data from the camera to the computer, and it all happens pretty quickly.

✦ **Image quality:** The moment you record video images to VHS tape (and, to a lesser degree, Betamax tapes), those images lose some quality. VHS is simply not a medium that thrills the Picassos of the video world. With DV, on the other hand, the pictures that you get from a sub-$500 DV camera are almost as good as the video that's used for the evening news. And the more expensive the camera, the better the quality, to the point that a camera that costs only a few thousand dollars can rival the quality of a professional analog camera costing tens of thousands of dollars. In fact, feature films and television are being recorded on DV cameras right now, and few people can tell the difference between DV and pro-level analog cameras.

✦ **Copy quality:** When you copy a DV file from one device to another, *signal loss,* which results in lower quality, does not occur. With analog connections, portions of the signal can be lost when the video signal travels through the analog cabling. You know how a taped TV show generally looks worse than the original broadcast? Signal loss is partly to blame. With DV, the taped video is a computer file, so copying the video doesn't affect the quality level.

✦ **Cost:** Add everything up — the analog video hardware, a high-quality analog camera, and a powerful Mac or PC — and shooting and editing analog video at anything resembling high quality can be a very expensive proposition. With DV, on the other hand, only a few thousand dollars (including the camera, computer, and software) enables you to put together videos that are good enough for home, educational, or corporate videos — and probably good enough for the film festival circuit. (Certainly good enough if *The Blair Witch Project* — a favorite of mine — was any indication.)

✦ **Distribution (or all the cool kids like it):** A good number of professional documentary, independent, and even Hollywood filmmakers are turning to DV because it offers a revolution, not only in the way that video is made but also in how it is distributed. That advantage trickles down to those of us using iMovie, too. With digital video, we can put our movies on CDs, computer desktops, and the Internet more quickly and cheaply than with analog technologies. That makes it both easy and fun to get your personal video projects distributed as widely as your talent can take them.

So, DV makes analog look like the technology that relies on squirrels, eh? Desktop video's advantages are part of the reason why DV is seen as a killer app. And the killer app is what Apple envisioned when it started offering iMacs, Power Macs, iBooks, and PowerBook models, all sporting FireWire ports and a little program called iMovie. A little later, Microsoft joined in on the fun with Windows Movie Maker, and other Windows software companies like Pinnacle Systems have produced video editing programs like Studio.

Warming up to FireWire

Why do I keep harping about FireWire? Well, it's one of the hot new technologies that makes digital video so fun and easy to work with. FireWire — also sometimes called IEEE 1394 or i.LINK — was originally developed by

Apple Computer and is an interface format for computer peripherals. Various peripherals, including scanners, CD/DVD burners, external hard drives, and of course digital video cameras, use FireWire technology. Key features of FireWire are as follows:

✦ **Speed:** FireWire is really fast, way faster than USB or serial ports. First-generation FireWire ports are capable of transfer rates of up to 400 Mbps (megabits per second), while the latest second-generation FireWire ports (nicknamed FireWire 800 by those crazy individualists at Apple) can pump an astonishing 800 Mbps through a connection! Digital video contains a lot of data that must be transferred quickly, making FireWire an ideal format.

✦ **Mac and PC compatibility:** (What a concept.) Although FireWire was developed by Apple, it is widely implemented in the PC world as well. This has helped make FireWire an industry standard.

✦ **Plug and Play connectivity:** When you connect your digital camcorder to a FireWire port on your computer (whether Mac or PC), the camera is automatically detected. You don't have to spend hours installing software drivers or messing with obscure computer settings just to get everything working.

✦ **Device control:** Okay, this one isn't actually a feature *of* FireWire; it's just one of the things that makes using FireWire really neat. If your digital camcorder is connected to your computer's FireWire port, most video-editing programs can control the camcorder's playback features. This means that you don't have to juggle your fingers and try to press the Play button on the camcorder and the Record button in the software at exactly the same time. Just click the Capture button in a program like iMovie or Pinnacle Studio, and the software automatically starts and stops your camcorder as needed.

✦ **Hot-swap capability:** You can connect or disconnect FireWire components whenever you want. You don't need to shut down the computer, unplug power cables, or confer with your local public utility before connecting or disconnecting a FireWire component.

All new Macintosh computers come with FireWire ports. Some — but not all — Windows PCs have FireWire ports as well. If your PC does not have a FireWire port, you can usually add one via an expansion card. Windows 98 and higher include software support for FireWire hardware. (However, I strongly recommend that you stick with Windows XP if you're editing DV on a PC.) If you're buying a new PC and you plan to do a lot of video editing, consider a FireWire port as a must-have feature.

All digital camcorders offer FireWire ports as well, although the port isn't always called FireWire. Sometimes FireWire ports are instead called "i.LINK" or simply "DV" by camcorder manufacturers who don't want to use Apple's trademarked FireWire name. But rest assured, all digital camcorders have a FireWire-compatible port. FireWire truly makes video editing easy, and if you are buying a new camcorder, I strongly recommend that you buy a camcorder that includes a FireWire port. Chapter 2 of Book II provides more detail on choosing a great digital camcorder.

What Can You Do with Editing Software?

Okay, computer owners, gather 'round the campfire . . . let's talk DV. You already know that DV has advantages over VHS or other types of analog video. And today's low-end video editors — like iMovie or Studio — are simple to use. But why do those advantages add up to a killer app? One word: *editing amateur video* (well, okay, three words).

After all, for more than 20 years, you've been able to buy a VHS camcorder and take videos on vacation, on the job, or at school. Before that, 8mm cameras had been available for decades, offering families (from the dark ages of the 1950s and later) the opportunity to bore other family members and friends with endless spools of vacation film.

But, unless you were handy with a razor blade and had access to some high-end equipment, it was beyond the average Jane's resources to edit that raw footage into something that can keep Uncle Ralph's attention.

With a DV camcorder, you can easily get your footage into a FireWire-equipped Mac. With iMovie or Studio, you can manipulate that footage, edit it, and send it back out to the camera for easy playback. (Heck, you can even control the camera from within these programs.) It's easy, easy, easy.

Okay, using these video editors is easy. But are they powerful programs? Actually, yes. Even I'm surprised at the sophistication that's possible with these programs. (And I don't surprise easily. That time I cried in the haunted house was because I was *startled,* not scared.) You can accomplish the following video projects with a DV camcorder, a computer, and a video editor like iMovie or Pinnacle Studio:

✦ **Home video:** Shots of the kids, the dog, the car, the boat, the vacation house, the beach, the birds, the moon, the stars, the relaxing ebb and flow of the tide . . . (sorry, I got lost in the moment). Any of that stuff can be dumped into your computer, edited, transitioned, and titled to make it more entertaining to family and friends.

✦ **Event video:** Shoot the company softball game, a kid's play, or a church function. Then edit it and clean up the sound, and you have it archived for posterity.

✦ **Educational video:** Teachers and students alike can use a video camera and a video editor to document and edit all sorts of projects, from independent research projects to field trips to the zoo or aquarium. Likewise, kids can edit a video for a school-based news channel, teacher or principal announcements, and so on.

✦ **Training video:** Teachers, trainers, or human resources departments can shoot training videos, informational videos, or videos of company seminars that need to be edited and handed out to new hires or others on a need-to-know basis. Plus, today's video editors let you add still images, animations, and graphics that were created in other programs, so you can cut between slides and live action for training purposes.

✦ **Organizational or sales video:** Need to sell something, ask for money, or otherwise toot your own organizational horn? A DV camcorder and video editor are perfect for that sort of thing. Shoot the product enticingly, interview your CEO or director, and show the world what your organization is made of.

✦ **Fiction:** Write something! Make something up! Assemble actors or friends or family, and start yelling "Action!" and "Cut!"

Even without new footage from a DV camcorder, you can translate other video, photos, or animation into a readable format (external devices for translating VHS tapes, for instance, are available) and edit away using your video editor. For example, iMovie is a great way to create a standalone, narrated slide show or presentation, even if it doesn't have a lick of video footage.

Editing Video

Editing video projects with a program like Pinnacle Studio or Apple iMovie is pretty easy, but this wasn't always the case. Until recently, the only practical way for the average person to edit video was to connect two VCRs and use the Record and Pause buttons to cut unwanted parts. This was a tedious and inefficient process. The up-to-date (and vastly improved) way to edit video is to use a computer. This section introduces you to the video-editing techniques that you're most likely to use. Check out Chapters 8 through 12 of Book II for the details on video editing.

Video (and audio, for that matter) is considered a linear medium because it comes at you in a linear stream through time. A still picture, on the other hand, just sits there — you take it in all at once — and a Web site lets you jump randomly from page to page. Because neither of these is perceived as a stream, they're both examples of nonlinear media.

You tweak a linear medium (such as video) by using one of two basic methods — *linear* or *nonlinear* editing. If your approach to editing is linear, you must do all the editing work in chronological order, from the start of the movie to the finish. Here's an old-fashioned example: If you "edit" video by dubbing certain parts from a camcorder tape onto a VHS tape in your VCR, you have to do all your edits in one session, in chronological order. As you probably guessed, linear editing is terribly inefficient. If you dub a program and then decide to perform an additional edit, subsequent video usually has to be redubbed. (Oh, the pain, the tedium.)

What is the alternative? Thinking outside the line: *nonlinear editing!* You can do nonlinear edits in any order; you don't have to start at the beginning and slog on through to the end every time. The magical gizmo that makes nonlinear editing possible is a combination of the personal computer and programs that are designed for nonlinear editing (NLE). Using such a program (for example, Apple iMovie or Pinnacle Studio), you can navigate to any scene in the movie, insert scenes, move them around, cut them out of the timeline altogether, and slice, dice, tweak, and fine-tune to your heart's content.

Defining Key Image Terms

Most language and practices of video creation are rooted in film production. Terms that were first coined in the era of silver nitrate film and megaphones are still the fundamental lexicon of videography. This rich language continues to exist because video technology has, in many ways, simply improved rather than evolved. Today, when you talk about shutter speeds or wide-angle shots, you're communicating ideas that are based on the development of a time-honored craft. Your understanding of key words and concepts makes a world of difference in the quality of your videos. The following list of key terms and ideas can help you develop wonderful shots:

✦ **CCD:** In video, a camera acquires light and color on chips called *Charge-Coupled Devices,* or CCDs. These CCDs collect visual images and convert them into either an analog signal (waves with varying amplitudes) or, in the case of your digital camcorder, a digital signal (a series of 1s and 0s).

✦ **Focal point:** The convex (curved outward) shape of a lens bends an image and reduces it to a point, which is called the focal point.

✦ **Focal plane:** The point where the object being photographed is in focus and optimized in the lens. The image is an exact two-dimensional (2-D) likeness of the object that is being photographed.

✦ **Focal length:** The distance between the lens and the focal point.

✦ **Aperture:** The opening of a lens that controls the amount of light that's permitted to reach either the film or CCD in video cameras. It controls the amount of light that reaches the focal plane. The aperture is also sometimes called the *iris.*

Aperture is calculated as the focal length divided by the diameter of your lens. This measurement is also referred to as an *f-stop.* For example, a 100mm lens with a diameter of 50mm has a maximum aperture (or f-stop) of f/2 (100mm divided by 50mm).

If you have photography experience, you'll be happy to know that the same concepts in photography apply in video (and digital video).

You can also check out Book I, where you can find in-depth coverage of all aspects of digital photography, as well as the book *Photography For Dummies,* 2nd Edition, by Russell Hart (published by Wiley).

Chapter 2: Choosing a Camcorder

In This Chapter

✔ **Researching digital camcorders**

✔ **Understanding formats and standards**

✔ **Features that you want**

✔ **Features that you don't want**

*I*f you have just turned here from Chapter 1 of this minibook hoping to find out how to achieve world peace, I'm sorry, but I can't be of much help. My editors noted that world peace was not in the original outline, so that content had to be cut. Also, there was some question as to whether I successfully resolved that Mac-versus-PC thing.

Fortunately, I *can* tell you about digital video gear because it was approved in the outline. The most important piece of gear is, of course, a digital camcorder.

Finding Information about Digital Camcorders

Digital camcorders — also called *DV* (digital video) camcorders — are among *the* hot consumer electronics products today. This means that you can choose from many different makes and models, with cameras to fit virtually any budget. But cost isn't the only important factor as you try to figure out which camera is best for you. You need to read and understand the spec sheet for each camera and determine whether it will fit your needs. The next few sections help you understand the basic mechanics of how a camera works, as well as compare the different types of cameras available.

I don't make specific camera model recommendations — the market is constantly changing — but I can list some up-to-date resources to help you compare the latest and greatest digital camcorders. My favorites are

✦ **CNET.com** (www.cnet.com): This is a great online resource for information on various computer and electronics products. The editorial reviews are helpful, and you can read comments from actual owners of the products being reviewed. The Web site also provides links to various online retailers. If you order a camcorder online, consider more than just the price. Find out how much shipping will cost and pay close attention to the retailer's rating on CNET. Retailers earn high star ratings by being honest with customers and fulfilling orders when promised.

✦ **The local magazine rack:** Visit Barnes & Noble, Borders, Waldenbooks, or any other bookstore that has a good magazine selection. There you should find magazines and buyer's guides tailored to you, the digital video enthusiast. *Computer Videomaker* is one of my favorites, although many of its articles are aimed at professional and semi-pro videographers.

Mastering Video Fundamentals

Before you go in quest of a camcorder, I recommend reviewing the fundamentals of video and how camcorders work. In modern camcorders, an image is captured by a *Charged-Coupled Device* (CCD) — a sort of electronic eye. The image is converted into digital data, and then that data is recorded magnetically on tape.

The mechanics of video recording

It is the springtime of love as John and Marsha bound towards each other across the blossoming meadow. The lovers' adoring eyes meet as they race to each other, arms raised in anticipation of a passionate embrace. Suddenly, John is distracted by a ringing cell phone, and he stumbles, sliding face-first into the grass and flowers at Marsha's feet. A cloud of pollen flutters away on the gentle breeze, irritating Marsha's allergies, which erupt in a massive sneezing attack.

As this scene unfolds, light photons bounce off John, Marsha, the blossoming meadow, the flying dust from John's mishap, and everything else in the shot. Some of those photons pass through the lens of your camcorder. The lens focuses the photons on transistors in the CCD. The transistors are excited, and the CCD converts this excitement into data, which is then magnetically recorded on tape for later playback and editing. This process, illustrated in Figure 2-1, is repeated approximately 30 times per second.

Most mass-market DV camcorders have a single CCD, but higher-quality cameras have three CCDs. In such cameras, individual CCDs capture red, green, and blue light, respectively. Multi-CCD cameras are expensive (typically over $1,000), but the images produced are near-broadcast quality.

Early video cameras used video pickup tubes instead of CCDs. Tubes were inferior to CCDs in many ways, particularly in the way they handled extremes of light. Points of bright light (such as a light bulb) bled and streaked light across the picture, and low-light situations were simply too dark to shoot.

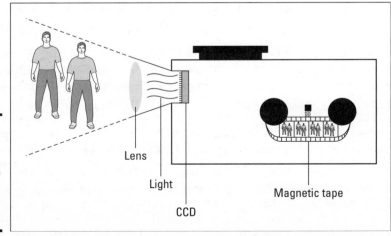

Figure 2-1: The CCD converts light into the video image recorded on tape.

Lens

Light

CCD

Magnetic tape

Broadcast formats

A lot of new terms have entered the videophile's lexicon in recent years: NTSC, PAL, and SECAM. These terms identify broadcast television standards, which are vitally important to you if you plan to edit video — because your cameras, TVs, tape decks, and DVD players probably conform to only one broadcast standard. Which standard is for you? That depends mainly on where you live:

- ✦ **NTSC (National Television Standards Committee):** Used primarily in North America, Japan, and the Philippines.

- ✦ **PAL (Phase Alternating Line):** Used primarily in Western Europe, Australia, Southeast Asia, and South America.

- ✦ **SECAM (Sequential Couleur Avec Memoire):** This category covers several similar standards used primarily in France, Russia, Eastern Europe, and Central Asia.

What you need to know about video standards

The most important thing to know about the three broadcast standards is that they are *not* compatible with each other. If you try to play an NTSC-format videotape in a PAL video deck (for example), the tape won't work, even if both decks use VHS tapes. This is because VHS is merely a physical *tape* format and not a *video* format.

On a more practical note, make sure you buy the right kind of equipment. Usually this isn't a problem. If you live in the United States or Canada, your local electronics stores will sell only NTSC equipment. But if you're shopping online and find a store in the United Kingdom that seems to offer a really great deal on a camcorder, beware: That UK store probably sells only PAL equipment. A PAL camcorder is virtually useless if all your TVs are NTSC.

Another consideration involves video-editing software. Many video-editing programs are compatible with both NTSC and PAL video, so make sure to use program settings that match whatever video format you're working with. Here's how to check settings in the programs featured in this book:

- ✦ **Apple iMovie:** iMovie automatically detects your standard when you capture video. If you want to export to a different format, choose File➪Export➪To QuickTime, and then choose Expert Settings in the Formats menu. Click Export, and then click Options in the Save Exported File As dialog box. Click Settings under Video, and choose a compressor that matches the standard you want to use (such as DV–NTSC or DV–PAL).

- ✦ **Pinnacle Studio:** Open Studio and choose Setup➪Capture Source. Make sure that the TV Standard menu is set to your local standard.

- ✦ **Windows Movie Maker:** From within the program, choose Tools➪Options. On the Advanced tab of the Options dialog box, choose NTSC or PAL under Video Properties.

About 99.975% of the time, you won't need to change your video standard. You should adjust video standard settings only if you know that you're working with video from one standard and need to export it to a VCR or camcorder that uses a different standard.

Some nice-to-know stuff about video standards

Video standards differ in two primary ways:

✦ **Video standards have different frame rates.** The *frame rate* of video is the number of individual images that appear per second, thus providing the illusion that subjects on-screen are moving. Frame rate is usually abbreviated as *fps* (frames per second).

✦ **The video standards use different resolutions.** Table 2-1 details the differences.

Table 2-1	Video Standards	
Standard	*Frame Rate*	*Resolution*
NTSC	29.97 fps	525 lines
PAL	25 fps	625 lines
SECAM	25 fps	625 lines

You're probably familiar with resolution measurements for computer monitors. Computer resolution is measured in pixels. If your monitor's resolution is set to 1024 x 768, the display image is 1024 pixels wide by 768 pixels high. TV resolution, on the other hand, is usually measured by the number of horizontal lines in the image. An NTSC video image, for example, has 525 lines of resolution. This means that the video image is drawn in 525 separate horizontal lines across the screen.

Interlacing versus progressive scan

A video picture is usually drawn as a series of horizontal lines. An electron gun at the back of the picture tube draws lines of the video picture back and forth, much like the printer head on your printer moves back and forth as it prints words on a page. All three broadcast video standards — NTSC, PAL, and SECAM — are *interlaced,* meaning the horizontal lines are drawn in two passes rather than one. Every other line is drawn on each consecutive pass, and each of these passes is called a *field.* So on a PAL display, which shows 25 fps, there are actually 50 fields per second.

Noninterlaced displays are becoming more common. Modern computer monitors, for example, are all *noninterlaced* — all the lines are drawn in a single pass. Some HDTV (high-definition television) formats are noninterlaced; others are interlaced.

Most camcorders record interlaced video, but some high-end camcorders also offer a progressive-scan mode. *Progressive scan* — a fancy way of saying noninterlaced — is a worthwhile feature if you can afford it, especially if you

shoot a lot of video of fast-moving subjects. With an interlaced camera, a problem I call *interlacing jaggies* can show up on video with a lot of movement. Figure 2-2, for example, shows video of a fast-moving subject that was shot using an interlaced camera. The stick seems to have some horizontal slices taken out of it, an unfortunate illusion created because the subject was moving so fast that the stick was in different places when each field of the video frame was captured. If the entire frame had been captured in one pass (as would have happened with a progressive-scan camcorder), the horizontal anomalies would not appear.

Figure 2-2:
Interlaced cameras can cause interlacing jaggies on fast moving subjects.

The many aspects of aspect ratios

Different moving picture displays have different shapes. The screens in movie theaters, for example, look like long rectangles; most TV screens and computer monitors are almost square. The shape of a video display is called the *aspect ratio*. The following two sections look at how aspect ratios affect your video work.

Image aspect ratios

The aspect ratio of a typical television screen is 4:3 (four to three) — for any given size, the display is four units wide and three units high. To put this in real numbers, measure the width and height of a TV or computer monitor that you have nearby. If the display is 32 cm wide, for example, you should notice that it's also about 24 cm high. If a picture completely fills this display, the picture has a 4:3 aspect ratio.

Different numbers are sometimes used to describe the same aspect ratio. Basically, some people who make the packaging for movies and videos get carried away with their calculators, so rather than call an aspect ratio 4:3, they divide each number by three and call it 1.33:1 instead. Likewise, sometimes the aspect ratio 16:9 is divided by nine to give the more cryptic-looking number 1.78:1. Mathematically, these are just different numbers that mean the same thing.

A lot of movies are distributed on tape and DVD today in *widescreen* format. The aspect ratio of a widescreen picture is often (but not always) 16:9. If you watch a widescreen movie on a 4:3 TV screen, you see black bars (also called letterboxes) at the top and bottom of the screen. This format is popular because it more closely matches the aspect ratio of the movie-theater screens for which films are usually shot. Figure 2-3 illustrates the difference between the 4:3 and 16:9 aspect ratios.

Figure 2-3:
The two most common image aspect ratios.

4:3 16:9 (widescreen)

A common misconception is that 16:9 is the aspect ratio of all big-screen movies. In fact, various aspect ratios for film have been used over the years. Many movies have an aspect ratio of over 2:1, meaning that the image is more than twice as wide as it is high! But for many films, 16:9 is considered close enough. More to the point, it's just right for you — because if your camcorder has a widescreen mode, its aspect ratio is probably 16:9.

Pixel aspect ratios

You may already be familiar with image aspect ratios, but did you know that pixels can have various aspect ratios too? If you have ever worked with a drawing or graphics program on a computer, you're probably familiar with pixels. A *pixel* is the smallest piece of a digital image. Thousands — or even millions — of uniquely colored pixels combine in a grid to form an image on a television or computer screen. On computer displays, pixels are square. But in standard video, pixels are rectangular. In NTSC video, pixels are taller than they are wide, and in PAL or SECAM, pixels are wider than they are tall.

Pixel aspect ratios become an issue when you start using still images created as computer graphics — for example, a JPEG photo you took with a digital camera and imported into your computer — in projects that also contain standard video. If you don't prepare the still graphic carefully, it could appear distorted when viewed on a TV.

Color

Remember back in the old days when many personal computers used regular televisions for monitors? In the early '80s, I had a Commodore 64 hooked up to a TV — it made sense at the time — but these days it's hard to believe, especially when you consider how dissimilar TVs and computer monitors have become. Differences include interlacing versus progressive scan, horizontal resolution lines, and unique pixel aspect ratios. On top of all that, TVs and computer monitors use different kinds of color.

Computer monitors utilize what is called the *RGB color space.* RGB stands for *red-green-blue,* meaning that all the colors you see on a computer monitor are combined by blending those three colors. TVs, on the other hand, use the *YUV color space.* YUV stands for *luminance-chrominance.* This tells us two things:

✦ Whoever's in charge of making up video acronyms can't spell.

✦ Brightness in video displays is treated as a separate component from color. *Luminance* is basically just a fancy word for *brightness,* and *chrominance* means *color* in non-techie speak.

I could go on for pages describing the technicalities of the YUV color space, but there are really only two important things you need to know about color:

✦ **Some RGB colors won't show up properly on a TV.** This is an issue mainly when you try to use JPEGs or other computer-generated graphics in a video project, or when you adjust the colors of a video image by using effects and color settings in your video-editing program. RGB colors that won't appear properly in the YUV color space are often said to be *illegal* or *out of gamut.* You won't get arrested for trying to use them, but they will stubbornly refuse to look right. Generally speaking, illegal colors are ones with RGB values below 20 or above 230. Graphics programs can usually tell you RGB values for the colors in your images. Some graphics programs (like Adobe Photoshop) even have special filters that help you filter out broadcast "illegal" colors from your images.

✦ **Video colors won't look exactly right when you view them on a computer monitor.** Because you'll probably do most of your video editing while looking at a computer monitor, you won't necessarily see the same colors that appear when the video is viewed on a TV. That's one reason professional video editors connect broadcast-style video monitors to their computer workstations. An external video monitor allows an editor to preview colors as they actually appear on a TV.

Picking a Camera Format

A variety of video recording formats exist to meet almost any budget. By far the most common digital format today is MiniDV, but a few others exist as well. Some digital alternatives are expensive, professionally-oriented formats; other formats are designed to keep costs down or allow the use of very small camcorders. (Various analog formats still exist, though they are quickly disappearing in favor of superior digital formats.) I describe the most common video formats in the following sections.

MiniDV

MiniDV has become the most common format for consumer digital videotape. Virtually all digital camcorders sold today use MiniDV; blank tapes are now easy to find and reasonably affordable. If you're still shopping for a camcorder and are wondering which format is best for all-around use, MiniDV is it.

MiniDV tapes are small — more compact than even audiocassette tapes. Small is good because smaller tape-drive mechanisms mean smaller, lighter camcorders. Tapes come in a variety of lengths, the most common length being 60 minutes.

All MiniDV devices use the IEEE-1394 FireWire interface to connect to computers, and the DV codec serves to compress and capture video. (A *codec* — short for *compressor/dec*ompressor — is a compression scheme that shrinks the size of a DV clip.) The DV codec is supported by virtually all FireWire hardware and video-editing software.

Digital8

Until recently, MiniDV tapes were expensive and available only at specialty electronics stores, so Sony developed the Digital8 format as an affordable alternative. Digital8 camcorders use Hi8 tapes instead of MiniDV tapes. A 120-minute Hi8 tape can hold 60 minutes of Digital8 video. Initially the cheaper, easily available Hi8 tapes gave Digital8 camcorders a significant cost advantage; however, MiniDV tapes have improved dramatically in price and availability, making the bulkier Digital8 camcorders and tapes less attractive.

Sony still offers a wide variety of affordably priced, high-quality Digital8 camcorders — Hitachi has offered Digital8s as well — and the format has modernized to stay competitive. Digital8 camcorders record digital video by using the same DV codec as MiniDV cameras, and Digital8 camcorders also include i.LINK (Sony's trade name for FireWire) ports. Digital8 cameras generally offer equivalent video quality to MiniDV cameras of similar price.

If you already have a lot of old Hi8 tapes and you're on a tight budget, a Digital8 camcorder may be worth considering. Digital8 camcorders have an analog mode, which means they can read the analog video recorded by your old Hi8 camcorder.

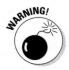

Keep in mind that Hi8/Digital8 compatibility goes only one way: Hi8 camcorders cannot read Digital8 video.

Other digital formats

Although MiniDV has become the predominant standard for consumer digital camcorders, many other formats exist. In addition to Digital8 (described in the previous section), the available alternative formats include these:

✦ **DVD-R:** A few digital camcorders now use recordable DVDs as the recording medium. The main benefit of this format is that you can place a recorded DVD into any computer with a DVD-ROM drive — no FireWire required — or directly into your DVD player. Alas, there are downsides: These units are still quite expensive, and built-in DVD-R drives draw a heavy load from camcorder batteries. If you go this route, plan to use a lot of wall current.

✦ **DVCAM:** Originally developed by Sony for video professionals, this format is based on MiniDV but offers a more robust tape design, higher image quality, and some high-end features designed to appeal mainly to

professional video producers and editors. DVCAM camcorders tend to cost about as much as a new economy car, and get much lower gas mileage.

✦ **DVCPro:** This is another expensive, MiniDV-based, professional-grade format like Sony's DVCAM. Panasonic is responsible for the DVCPro format.

✦ **Digital Betacam:** Here's yet another professional format that most of us probably can't afford. Digital Betacam (another Sony creation) is based on the dearly departed Betacam SP analog format, which for years was a beloved format among professional videographers.

✦ **MicroMV:** Someone at Sony really likes to create new recording formats. (Remember Betamax?) Sony offers a few consumer-priced camcorders that use the MicroMV format. As the name suggests, MicroMV tapes are really small, allowing MicroMV camcorders to be small and light as well. (Canon somehow manages to make some tiny MiniDV camcorders, but if you must have a teensy-weensy Sony, then MicroMV is your format.)

<div style="float:right">**Book II**
Chapter 2

Choosing a Camcorder</div>

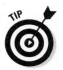

With any alternative recording format, the first two things you should consider are price and availability of recording media. If you're considering a camcorder that uses the WhizbangDV format, ask yourself how many stores sell WhizbangDV tapes. Will you still be able to find WhizbangDV tapes five years from now?

Analog formats

Analog video has been with us for decades, but it is fading quickly from the scene. Countless analog formats still exist. You've probably seen these formats around, and you might have even owned (or still own) a camcorder that uses one. Besides the generational-loss problems of analog video that I describe in Chapter 1 of Book II, analog formats usually provide fewer horizontal lines of resolution. The very best analog formats offer a maximum of 400 resolution lines — which is where the very cheapest digital formats *start* (lots of MiniDV camcorders offer 500 resolution lines or more). Table 2-2 provides a brief overview of common analog formats.

Table 2-2		Analog Video Formats
Format	**Resolution Lines**	**Description**
VHS	250	Your basic garden-variety videotape; VHS camcorders are bulky.
S-VHS	400	A higher-quality incarnation of VHS, but the tapes are still big.
VHS-C	250	A compact version of VHS.
8mm	260	Smaller tapes mean smaller camcorders.
Hi8	400	A higher-quality version of 8mm.
¾ inch Umatic	280	Bulky analog tapes once common in professional analog systems; a higher quality version offers 340 lines.
Betacam	300	Sony's professional analog format based on Betamax (remember those?).
Betacam-SP	340	A higher-quality version of Betacam.

Choosing a Camera with the Right Features

When you go shopping for a new digital camcorder, you'll be presented with a myriad of specifications and features. Your challenge is to sort through all the hoopla and figure out whether the camera will meet your specific needs. When reviewing the spec sheet for any new camcorder, pay special attention to these items:

✦ **CCDs:** A 3-CCD (also called *3-chip*) camcorder provides much better image quality but is also a lot more expensive. A 3-CCD camera is by no means mandatory, but it is nice to have.

✦ **Progressive scan:** This is another feature that is nice but not absolutely mandatory. (To get a line on whether it's indispensable to your project, you may want to review the section on interlaced video earlier in this chapter.)

✦ **Resolution:** Some spec sheets list horizontal lines of resolution (for example: 525 lines); others list the number of pixels (for example: 690,000 pixels). Either way, more is better when it comes to resolution.

✦ **Optical zoom:** Spec sheets usually list optical and digital zoom separately. *Digital zoom* numbers are usually high (200x, for example) and seem appealing. Ignore the big digital zoom number and focus (get it?) on the *optical zoom factor* (which describes how well the camera lens actually sees); the optical zoom factor should be in the 12x–25x range. Digital zoom just crops the picture captured by the CCD and then makes each remaining pixel bigger to fill the screen, resulting in greatly reduced image quality.

✦ **Tape format:** MiniDV is the most common format, but for your equipment, using other formats might make more sense.

✦ **Batteries:** How long does the included battery supposedly last, and how much do extra batteries cost? I recommend that you buy a camcorder that uses lithium ion batteries — they last longer and are easier to maintain than NiMH (nickel-metal-hydride) batteries.

✦ **Microphone connector:** For the sake of sound quality, the camcorder should have some provisions for connecting an external microphone. (You don't want your audience to think, "Gee, it'd be a great movie if it didn't have all that whirring and sneezing.") Most camcorders have a standard mini-jack connector for an external mic, and some high-end camcorders have a 3-pin XLR connector. XLR connectors — also sometimes called *balanced* audio connectors — are used by many high-quality microphones and PA (public address) systems.

✦ **Manual controls:** Virtually all modern camcorders offer automatic focus and exposure control, but sometimes manual control is preferable. Control rings around the lens are easier to use than tiny knobs or slider switches on the side of the camera — and you'll be familiar with them if you already know how to use 35mm film cameras.

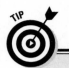

The importance of being filtered

Oddly, many camcorders come out of the box without any filter for the lens, even though all digital camcorders I've encountered are capable of accepting them. Filters can be used for quite a few different effects and touches, including changing the tone of shots, helping with glare, and giving the shot a slightly fuzzier, warmer, film-like look. (Suddenly I feel like I'm writing copy for a toy catalog.)

In the meantime, buy and use a UV (ultraviolet light) filter for your camcorder at all times! Install it and forget about it, at least until you go to change the filter. (In fact, you can usually stack other filters on top of the UV filter.) The filter does two things: It protects the optics from damaging UV light, and it offers a barrier from scratches and spills. Plus, if the filter gets dirty or dusty or smudged, you can clean it and eventually replace it with a new one. Replacing a damaged lens, on the other hand, can be so pricey that you may opt to replace the camera instead.

The spec sheet may try to draw your attention to various other camcorder features as well, but not all these features are as useful as the salesman might like you to believe. Features that seem exciting but are generally less important include

✦ **Night vision:** Some camcorders have an infrared mode that enables you to record video even in total darkness. Sony's NightShot is an example of this feature. If you want to shoot nature videos of nocturnal animals this may be appealing to you, but for day-to-day videography, it's less useful than you might think.

✦ **Still photos:** Many new digital camcorders can also take still photos. This is handy if you want to shoot both video and stills but don't want to lug along two cameras — but even relatively cheap digital still cameras take better photos than camcorders (even the most expensive ones).

✦ **USB port:** Some camcorders offer a USB connection in addition to FireWire. USB can be handy for transferring still photos into your computer, but I strongly recommend that you rely on FireWire for digital video capture. Many computer USB ports are not fast enough to handle full quality digital video.

✦ **Bluetooth:** This is a new wireless networking technology that allows various types of electronic components — including camcorders and computers — to connect to each other using radio waves instead of cables. Unfortunately the maximum data rate of current Bluetooth technology is still comparatively low (less than one megabit per second). In practical terms, that means Bluetooth won't be suitable for capturing digital video from your camcorder for the foreseeable future. A few camcorders incorporate Bluetooth technology anyway, and that may (or may not) come in handy if you still own the same camcorder a few years from now.

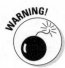

And then there are some features that are essentially useless. Don't pay extra for these:

✦ **In-camera special effects:** Most digital camcorders boast some built-in effects. But why? You can add special effects much more *effec*tively (so to speak) by using your editing software on your computer.

✦ **Digital zoom:** Digital zoom makes the image appear blocky and pixilated — again, why do it? I tend to ignore the big digital-zoom claims that camcorder manufacturers like to advertise. When you test the zoom feature on a camcorder, make sure you can *disable* digital zoom. Bottom line: You should be able to prevent the camera from automatically switching to digital zoom when you reach the optical zoom limit.

✦ **Built-in light:** If a camcorder's built-in light works as a flash for still photos, it at least serves a semi-useful purpose. But on-camera lights often have unfavorable lighting effects on your subjects; I recommend that you rely on other light sources instead when you're shooting video.

Chapter 3: Preparing Your Computer for Video

In This Chapter

- ✔ Deciding between a Mac and a PC
- ✔ Knowing tips for safe computer upgrades
- ✔ Choosing and configuring a Mac for digital video
- ✔ Choosing and configuring a PC for digital video
- ✔ Choosing analog video-capture hardware
- ✔ Improving the interface between you and your computer

A digital camcorder is just one part of the digital video equation. You also need a computer that is ready to capture, edit, and export digital video. Modern computers are pretty powerful, but you still have some important factors to consider if you want a computer that's well suited for digital video work. This chapter helps you choose a new computer, upgrade your current computer, and choose other gear that makes video editing fun and easy. But first, I start with something simple — trying to resolve the age-old debate of whether a Mac or Windows PC is better. (And if I succeed at that, I can work on a way to achieve world peace in the next chapter!)

Resolving the Mac-versus-PC Debate Once and for All

Yeah, right.

Wanna start a ruckus? Wear an "I ♥ Bill Gates" t-shirt to a *Macworld* convention. Go ahead, I dare you.

Legal disclaimer: Wiley Publishing, Inc., is not responsible for physical or emotional harm that may result from compliance with the preceding foolish suggestion.

Like the debate over whether cats or dogs make better pets, the question of whether to use a Mac or a PC has been disputed tirelessly between the true believers. (Coincidentally, the same used to be true in the ancient days of the Atari and Commodore 8-bit computers.) The Mac versus PC struggle has been a largely unproductive dispute: For the most part, Mac people are still Mac people, and PC people are still PC people.

But who is right? If you want the best computer for working with digital video, should you choose a PC or a Mac? Well, look at the following factors:

✦ **Ease of use:** Macintosh users often boast that their computers are exceedingly easy to use, and they are right. But if you're a long-time Windows user, you may not think so. Some things *are* easier to do on a Mac, but other things are easier to do in Windows. Neither system offers a clear advantage, so if you're a creature of habit, you'll probably be happiest if you stick with what you know.

✦ **Reliability:** The Windows Blue Screen of Death (you know, the dreaded screen that often appears when a Windows PC crashes) is world famous and the butt of countless jokes. But the dirty little secret of the Macintosh world is that until recently, most Macs crashed nearly as often as Windows PCs. Apple's new Macintosh operating system, Mac OS X, is built on a UNIX foundation, so it brings a new level of stability and refinement to the Macintosh world — but the latest version of Windows (Windows XP) is almost as dependable. Reliability is important to you because video pushes your computer's performance to its limits. Get a Mac with Mac OS X or a PC with Windows XP, and you should be just fine.

✦ **Digital video support:** I can't be wishy-washy any longer. If you want a great computer ready to edit digital video right out of the box, a new Macintosh is the safer bet. All new Macs come with built-in FireWire ports, making it easy to hook up your digital camcorder. Macs also come with iMovie, a pretty good entry-level video-editing program, and QuickTime, a great "Swiss army knife" that plays and converts all sorts of digital media formats. Windows comes with Windows Movie Maker, but it is not as capable as iMovie. Also, most Windows PCs still don't come with built-in FireWire. This means that you either have to special-order it or install a FireWire card yourself.

So there you have it: Macs and PCs are both pretty good (with a slight edge to the Mac when it comes to hardware). Sure, Macs all come with FireWire, but if you shop around, you should be able to find a Windows PC with FireWire for about the same price as a new Mac. Both platforms can make excellent video-editing machines, so if you're already dedicated to one or the other, you should be fine with what you currently use.

Just don't start any brawls, okay? You never know when a computer nerd wielding an iPod might take offense.

Upgrading Your Computer

Picture this: Our hero carefully unscrews an access panel on the blinking device, revealing a rat's nest of wires and circuits. A drop of sweat runs down his face as the precious seconds tick away, and he knows that fate hangs by a slender thread. The hero's brow creases as he tries to remember the procedure: "Do I cut the blue wire or the red wire?"

If the thought of opening your computer and performing upgrades fills you with a similar level of anxiety, you're not alone. The insides of modern computers can seem pretty mysterious, and you may be understandably nervous about tearing apart your expensive PC or Mac to perform hardware upgrades. Indeed, all the chips, circuit boards, and other electronic flotsam inside the

computer case are sensitive and easily damaged. You can even hurt yourself if you're not careful, so if you don't have any experience with hardware upgrades, you are probably better off consulting a professional before making any changes or repairs to your PC.

If you're looking for a guiding light in the middle of the PC hardware wilderness, take heart — I can highly recommend the best-selling *Building a PC For Dummies,* 4th Edition, written by Mark L. Chambers (published by Wiley). This great book helps you build a state-of-the-art Windows PC from the ground up, and it can lead you through the installation of a FireWire card, DVD recorder, or new hard drive upgrade. (Best of all, no experience is required . . . after all, the first figure in the book is a picture of a Phillips screwdriver!)

But if you have done hardware upgrades before, digital video may well inspire you to make more upgrades now or in the near future. If you decide to upgrade your computer, follow these basic rules:

✦ **Review your warranty.** Hardware upgrades can invalidate your computer's warranty, if it still has one.

✦ **RTM.** This is geek-speak for "Read the manual." The owner's manual that came with your computer almost certainly contains important information about what can be upgraded and what can't. The manual may even have detailed, illustrated instructions for performing common upgrades.

✦ **Back up your data.** Back up your important files on recordable CDs, Zip disks, or other storage device that's available to you. You don't want to lose work, pictures, or other data that will be difficult or impossible to replace.

✦ **Gather license numbers and ISP (Internet service provider) information.** If you have important things like software licenses stored in saved e-mails, print them so that you have hard copies. Also, make sure that you have all the access information for your ISP (account name, password, dialup numbers, server addresses, and so on) handy in case you need to reinstall your Internet connection software.

✦ **Gather all your software CDs.** Locate all your original installation discs for your various programs, including your operating system (Mac OS or Windows) so that you can reinstall the programs later if necessary.

✦ **Turn off the power.** The computer's power should be turned off to avoid damage to components — and yourself.

✦ **Avoid static electricity buildup.** Even if you didn't just walk across a shag carpet and pet your cat, your body still probably has some static electricity built up inside. A tiny shock can instantly destroy the tiny circuits in expensive computer components. Before touching any components, touch your finger to a bare metal spot on your computer's case to ground yourself. I also recommend wearing a grounding strap, which can be purchased at most electronics stores for $2–$3. Now *that's* what I call cheap insurance!

✦ **Handle with care.** Avoid touching chips and circuitry on the various computer components. Try to handle parts by touching only the edges or other less-delicate parts.

355

✦ **Protect those old parts.** If you are taking out an old component (such as a 64MB memory module) and replacing it with something better (like a 256MB memory module), the old part may still be worth something to somebody. If nothing else, if your newly purchased part is defective, at least you can put the old part back in to get your computer running again. And if the new part works fine, you may be able to salvage a few bucks by auctioning the old part on the Internet!

Again, when in doubt, consult with a computer hardware professional. In fact, you may find that the retailer that sold you the upgraded parts also offers low-cost or even free installation service.

Using a Macintosh

Apple has put considerable effort into promoting the great multimedia capabilities of modern Macintosh computers. Indeed, Apple has been at the forefront of many important developments in digital video, and the video capabilities of current Macs are impressive. In fact, any new Macintosh will work quite well with digital video. The following sections show you what to consider when choosing a new Mac, how to decide whether your current Mac can handle digital video, and what video-editing software is available for your Mac.

Buying a new Mac

To work with digital video, your computer needs a powerful processor, lots of memory, a big hard drive, and a FireWire port. Any new Macintosh meets these requirements. That said, not all new Macs are created equal. Generally speaking, the more money you spend, the better the Mac will be, so you shouldn't be surprised that some of the more affordable eMacs, iMacs, and iBooks are merely adequate. If you're serious about video, I recommend that your new Mac meet the following minimum requirements:

✦ **512MB RAM:** Video-editing software needs a lot of RAM (random access memory) to work with, so the more the better. You may be able to get away with 256MB for a while, but you will find that video editing work is slow and tedious. Fortunately, the RAM in most Macs can be easily upgraded. In fact, both desktop and laptop Macs incorporate a handy little access panel that enables you to upgrade RAM in mere seconds.

✦ **An 800-MHz G3 processor:** A lot of video pros will tell you that you need a lot more, but you can get away with *only* an 800-MHz G3 Mac. As you edit video, you'll find that you spend a lot of time sitting there, waiting for the computer to work. The faster the processor (and the more RAM), the less time you will spend waiting. (Of course, a Mac powered by a G4 or G5 processor can make your wait even shorter.)

✦ **A 60GB hard drive:** I'm going to get e-mails from the video pros; I just know it! Video files take up lots of drive space. At one time, 60GB was considered insanely massive for a hard drive, but when you are working with digital video, you'll eat up that space in a hurry. Less than 5 minutes of video eats up an entire gigabyte on your hard drive, which also has to

hold software files, system files, and all kinds of other information. Lots of people will tell you that you need at least 100GB of drive space, and they're right: 100GB or more would be really nice. But you should be able to get away with a 60GB hard drive if your budget is tight. If you can afford a bigger drive, it's worth the expense.

✦ **Mac OS X:** Any new Mac includes the latest version of Apple's operating system software. But if you are buying an older Mac, I strongly recommend that you buy one that already has Mac OS version 10.2 (Jaguar) or higher. If the computer that you want to buy doesn't have Mac OS X, factor the cost of an operating system upgrade (about $130) into the purchase price.

If you're considering a portable iBook or PowerBook computer, pay special attention to the specifications before you buy. Portable computers usually offer considerably less RAM and hard-drive space than similarly priced eMacs, iMacs, and PowerMacs.

Upgrading ye olde Mac

If you already have a Mac that is 2 or 3 years old, you should still be able to use it with digital video if it meets the basic requirements that I describe in the previous section. If it doesn't meet those requirements, you may be able to upgrade it. As a general rule, however, if your Mac doesn't already have a G3 or higher processor, upgrading is probably going to be more expensive or challenging than simply buying a new Mac. And in the end, a very old upgraded Mac probably will not perform that well anyway.

One of the biggest obstacles that you'll face involves FireWire. If your Mac does not already have a FireWire port, you may have difficulty adding one. PowerMacs can usually be upgraded with a FireWire card, but what if you have a PowerBook G3? In that case, look for a FireWire card that uses the PowerBook's CardBus interface.

Before you think you can get away without FireWire, keep in mind that if your Mac is too old for FireWire, its USB 1.1 ports won't be fast enough to capture full-quality digital video.

Some parts of your Mac may be more easily upgradeable, as I describe in the following sections. For more details on upgrade information and installation instructions, check out the very comprehensive *Mac OS X Panther All-in-One Desk Reference For Dummies,* by Mark L. Chambers, or *The iMac For Dummies,* by David Pogue (both published by Wiley). Macworld (www.macworld.com) also provides online articles and tutorials to help you upgrade your Mac. And of course, follow all the safe computer upgrade guidelines that I provide earlier in this chapter.

Improving your Mac's memory

Digital video editing uses a lot of computer memory, so you should see significant performance improvements if you upgrade your RAM. Memory is usually pretty easy to upgrade in most desktop Macs. In fact, most iMacs incorporate a handy access panel that enables you to add memory in mere

seconds. Depending on the age and speed of your Mac, memory comes on little cards called *DIMMs* (dual in-line memory modules) or modules called *SDRAM* (synchronous dynamic random access memory) *modules.* Both types of memory easily snap into place in special memory slots on the computer's motherboard. Figure 3-1 illustrates what a DIMM looks like. Read the documentation from Apple that came with your Mac for specific instructions on installing more memory.

Figure 3-1:
DIMMs look
something
like this.

Make sure that you obtain memory that is specifically designed for your Mac — specify the model as well as its processor type and speed (for example: an 800-MHz G4). Memory modules come in various sizes, so even if all the memory slots in your Mac appear full, you may be able to upgrade by replacing your current DIMMs or SDRAM modules with bigger ones.

Portable Macs can also receive memory upgrades, but the task is more technically challenging. It usually requires that you remove the keyboard and some other parts of your iBook or PowerBook. I recommend that you leave such upgrades to a professional unless you really know what you are doing.

Upgrading Mac hard drives

The hard drive in virtually any Mac can be replaced with a bigger unit. Most modern Macs have EIDE — or Enhanced Integrated Drive Electronics — hard drives, a standardized hard-drive format that's ubiquitous in the PC world. (The latest round of PowerMac G5 models use a new super-speedy interface called Serial ATA, but I doubt that you'll be looking to upgrade one of those whopping 160GB monsters anytime soon.)

Standardization keeps the initial cost of new Macs affordable, and it tends to make replacement parts cheaper and easier to find. But resist the urge to run off and buy (for example) that gargantuan 200GB EIDE drive that's advertised in a Sunday flier to replace the 4GB drive in your 4-year-old lime-green iMac. Hold your horses until you consider the following potential problems:

✦ **The new hard drive may be too big.** Older Macs may not support some of the massive newer hard drives that are available today.

✦ **The new hard drive may be too hot.** Literally. One of the greatest challenges facing computer hardware engineers today involves heat management. Modern processors and hard drives give off a lot of heat, and if too much heat is allowed to build inside the computer case, the life of your Mac will be greatly shortened. Many older iMacs were not designed to manage the heat that's generated by the newest, fastest hard drives.

You should only buy a hard drive that is recommended for your specific Macintosh model. This means that you should buy a new hard drive from a knowledgeable Macintosh retailer. As with memory, make sure that you specify your Mac's model and processor when purchasing a hard drive.

Adding an external hard drive to your Mac

By far, the easiest way to add storage space to your Mac is to use an external hard drive. External drives that connect to a FireWire or USB port are widely available, and although they tend to be more expensive than internal drives, their ease of installation and use makes them worthwhile.

Unfortunately, external drives are usually less than ideal for working with digital video. A FireWire 400 or USB 2.0 (a newer, faster USB standard) external drive is slower than an internal drive — and drive speed is crucial when you are capturing or exporting video. External hard drives are fine if you need a big place to store music or other files, but I don't recommend using an external drive as your main drive for video work.

Choosing Mac video software

Apple offers a pretty good selection of video-editing software for the Macintosh. It's a good thing it does, too, because not many other software vendors offer Mac-compatible editing programs. If you're a Mac user, your choices are pretty much limited to the following software:

✦ **Apple iMovie:** It comes free with all new Macintosh computers, and the latest version of iMovie is included in Apple's inexpensive iLife suite. iMovie is featured throughout Book II.

✦ **Apple Final Cut Pro HD:** If you *can* afford pro-level prices and you want one of the most cutting edge video-editing programs available, consider Final Cut Pro HD (about $1000). Final Cut Pro, shown in Figure 3-2, is used by many professional video editors.

✦ **Apple Final Cut Express 2:** This program offers many of the features of Final Cut Pro HD for a fraction of the price (about $300). Final Cut Express 2 is a good choice if you want pro-style editing features but can't afford pro-level prices.

✦ **Avid Xpress DV:** Avid has been making professional video-editing workstations and gear for years, so it's no surprise that the company also offers one of the most advanced video-editing programs as well. And it better be good too because it retails for $700 (for Windows or the Mac).

As you can see, if you're a professional video editor, you can choose among several programs for your Mac. If you're not a pro, however, your choices are a little more limited. Fortunately, iMovie is a reasonably capable program. You can even expand the capabilities of iMovie with plug-ins from Apple (and some third parties). Visit www.apple.com/imovie/, and check out the iMovie Downloads section for more information.

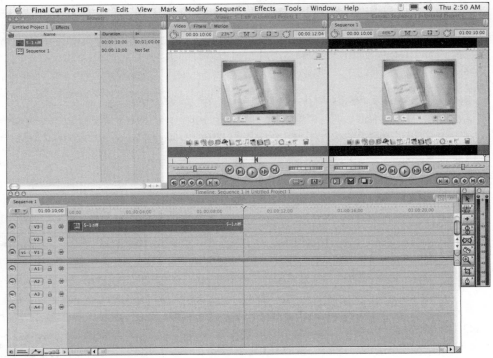

Figure 3-2:
Many video professionals do their work using Final Cut Pro HD on a Macintosh.

Using a Windows PC

Macintosh computers have long been favored by professional graphic and video artists, but you can do some pretty advanced video editing on a Windows PC as well. In fact, the greater variety of editing software that's available for Windows means that you can now do just about anything on a PC that you can do on a Mac. The next few sections show you what to consider when choosing and preparing a Windows PC for digital video.

Buying a new PC

Countless PC vendors now offer computers that run Windows for just about any budget. For about the same amount of money as you would have spent just to buy a printer 10 years ago, you can now buy a new PC — including the monitor. And if you shop around, you may even find someone to throw in the printer for free.

You may find, however, that a bargain-basement computer is not quite good enough for digital video. The hard drive may be too small, the processor may not be fast enough, the computer may not have enough memory, or some other features may not be ideal. Look for the following features when you're shopping for a new PC:

✦ **Windows XP:** Some bargain-basement PCs may come with Windows Me (Millennium Edition). Windows Me had some fundamental problems with stability and memory management that (in my opinion) make it unsuitable for digital video work. Windows XP, on the other hand, is

very efficient and stable. Upgrading a Windows Me machine to XP is often challenging, so I recommend that you buy a PC that already has XP installed.

✦ **512MB RAM:** Video editing requires a lot of random access memory (RAM) — the more the better.

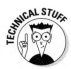

As if you didn't already have enough acronyms to remember, some PCs have a type of memory called DDR (double data rate) RAM. DDR RAM works twice as efficiently as regular RAM, so a computer with 256MB DDR RAM can work about as well as a computer with 512MB of other types of RAM.

✦ **64MB video RAM:** The video image on your monitor is generated by a component in your computer called the *video card* or *display adapter*. The video card has its own memory — I recommend at least 64MB of video memory. Some video cards share system RAM (the computer's spec sheet may say something like "integrated" or "shared" in reference to video RAM). This tends to slow the performance of your computer, so I recommend that you avoid shared video RAM.

✦ **A 1-GHz processor:** I recommend a processor speed of at least 1 GHz (that is, 1000 MHz). This shouldn't be a problem because most new PCs feature at least a 1-GHz processor. It doesn't matter if the processor is an Intel Pentium 4, an AMD Athlon XP, or even an AMD Duron or Intel Celeron unit. The faster the better — naturally.

✦ **FireWire:** Unlike Macs, the majority of new PCs still don't come with FireWire (also called IEEE 1394) ports. You can upgrade most PCs with a FireWire card, but buying a computer that already has FireWire is a lot easier.

✦ **A 60GB hard drive:** When it comes to hard drives, bigger is better. If you plan to do a lot of video-editing work, 60GB is an absolute minimum. Sure, it *sounds* like a lot, but you'll use it up in a hurry as you work with digital video.

Another option, of course, is to build your own computer. For some, the act of building a PC from scratch remains a vaunted geek tradition (you know who you are). If you choose to build your own system, make sure that your system meets — and preferably *exceeds* — the guidelines given here. I built a computer last year that was tailored specifically for video editing — and it only cost me about $400 plus some spare parts that I scrounged from my own stocks. But know what you're doing before you start down this path; it's definitely not the path of least resistance.

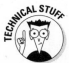

Again, you can turn to the written word for help in building a cutting-edge PC from scratch: Pick up a copy of *Building a PC For Dummies,* 4th Edition, written by Mark L. Chambers (published by Wiley). 'Nuff said.

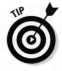

If you're a Linux devotee, good for you! However, if you plan to do much with digital video, you're going to have to bite the proverbial bullet and use either a Mac or the dreaded Windoze. Currently the mainstream offers no video-editing programs that are designed for Linux. Although some tools allow you to run some Windows or Mac programs, system performance often deteriorates, meaning that you probably can't capture and edit video efficiently.

Upgrading your PC for digital video

If you already have a PC, you can probably do some things to make it better suited for video work. These tweaks may not be simple, however. The diversity of the PC market means that your computer can probably be upgraded, but performing hardware upgrades requires experience and expertise (whether it's your own or somebody else's).

When considering an upgrade, your first step is to check your PC's documentation for information about what upgrades can be performed. The manufacturer may offer upgrade kits that are specifically designed for your computer. The following sections address some specific upgrades that you may be considering. Of course, be sure to follow the computer-upgrade guidelines that I provide earlier in this chapter. I also recommend buying a book that specifically covers PC upgrades, such as *Upgrading and Fixing PCs For Dummies,* by Andy Rathbone (published by Wiley).

Choosing a new hard drive

Not so long ago, I bought a 1.6GB hard drive for *just* $200. At the time, I couldn't imagine using up all that space, and the price seemed like an almost unbelievably good deal. But drive sizes have grown and prices have dropped — fast enough to make a lot of heads spin. Today that $200 can buy you a 160GB hard drive — a hundred times more space — and that's if you don't shop around for a better deal.

Big, cheap hard drives are a popular PC upgrade these days. They have become so ubiquitous that even one of my local grocery stores sells hard drives. Digital video consumes hard drive space almost as fast as my sons gobble chips and salsa at the local Tex-Mex restaurant, so you may be considering a hard drive upgrade of your own. If so, consider the following items before you nab that hard drive along with the broccoli at your local supermarket:

✦ **An EIDE interface:** Your hard drive connects to the rest of the computer through a special disk interface. Most modern PCs use the EIDE interface — and such drives are both fast and widely available. Check your computer's documentation to make sure that it uses this type of interface. Most new high-performance PCs use a Serial ATA connection for hard drives. A few computers use the SCSI (Small Computer System Interface) format, which is also fast, but SCSI drives are expensive and increasingly hard to find. If the PC is older and just uses a regular IDE interface, it probably isn't fast enough to work with digital video. It may also not support the large size of modern hard drives.

✦ **Drive speed:** EIDE drives are commonly available in speeds of 5,400 rpm and 7,200 rpm, while virtually all Serial ATA drives turn at 7,200 rpm or faster. This speed is always clearly marked on the drive's packaging. For digital video work, a 7,200-rpm drive is virtually mandatory.

✦ **Windows installation:** If you're replacing your old hard drive with a newer, bigger drive, you must (you guessed it) reinstall Windows. Do you have a Windows installation CD? You should have received an installation disc with your PC. If not, figure on spending at least $199 for a new Windows CD. (You'll need to buy the full version, not a cheaper upgrade version.)

✦ **Support for big hard drives:** Maybe your computer can't support the biggest hard drives that are on the market today (admittedly a remote possibility). Check the BIOS section of your PC's documentation to see whether your computer has any drive-size limitations.

If you decide to upgrade to a bigger hard drive, you can either replace your current hard drive or (in some cases) simply add a second hard drive to your computer. If you look inside your computer case, you should see a gray ribbon cable that runs from the motherboard to the hard drive. In some systems, that cable has two connectors — one connecting to the hard drive and the other to the CD-ROM drive. This arrangement is called *daisy-chaining*, and you can sometimes get away with daisy-chaining two hard drives. If you can, that's cool — you just keep your applications where they are and add a second great big hard drive to use exclusively as a scratch pad for all your video work. Again, consult your PC's documentation (and a book like *Building a PC For Dummies* or *Upgrading and Fixing PCs For Dummies*) to see whether daisy-chaining is an option.

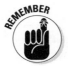

Finally, as I mention in the section "Adding an external hard drive to your Mac," earlier in this chapter, external hard drives (even FireWire 400 drives) usually aren't fast enough for video work. I recommend that you stick with internal drives for the bulk of your video work.

**Book II
Chapter 3**

Preparing Your Computer for Video

Upgrading to Windows XP

Earlier I recommended that you should run Windows XP if you plan to work with digital video. Windows XP is vastly more stable than previous versions of Windows (especially Windows 95, 98, and Me) — and it does a much better job of managing system memory, which is crucial when you work with video.

If you don't already have Windows XP, you need to upgrade. If you already have a version of Windows on your computer, you can purchase an upgrade to Windows XP Home Edition. If you don't already have Windows, the full version of the Windows XP Home Edition will cost about twice as much as the upgrade, and the full version of Windows XP Pro costs even more. Windows XP Professional is nice, but so is XP Home. If you don't need the extra networking tools that are built into Windows XP Pro, XP Home is just fine for video work.

You may have heard horror stories from friends who tried to upgrade their old computers to Windows XP. To be honest, I have a horror story of my own (but I'll spare you the gruesome details). For now, I can offer the following advice:

✦ **Avoid installing Windows XP on any computer that is more than 2 or 3 years old.** XP is a snob about modernity, and it may not support some of your older components and hardware. A quick way to check the hardware in your computer is to use Microsoft's online Upgrade Advisor. Visit the following Web site for instructions on how to download and use the Upgrade Advisor:

```
www.microsoft.com/windowsxp/pro/howtobuy/upgrading/
    advisor.asp
```

The Advisor inspects your system and advises you whether your computer can accept Windows XP.

✦ **Perform a "clean" installation.** Although the installation CD provides an option to upgrade your current version of Windows, this approach will most likely cause you troubles in the near future. So back up all your important data *before you begin installing,* and let the installer program reformat and repartition your hard drive using the NTFS (NT File System) when you are presented with these options. (NTFS hard drives are both faster and more reliable in case of a lockup or power failure.) The rest of the installation process is pretty simple. (Oh, yeah, you have to restore all the data from your backup onto that reformatted hard drive. You could be at it for a while.)

✦ **Check for online updates immediately after installation.** Microsoft is constantly developing updates and fixes for Windows XP, and you can quickly download and install those updates by choosing Start⇨All Programs⇨Windows Update. You must connect to the Internet to do so, so make sure that you have all the necessary information handy to reinstall your Internet service's software.

Installing a FireWire card

If you have a PC and want to work with digital video, you probably need to install a FireWire (IEEE 1394) card. A FireWire card is crucial to capturing video from a digital camcorder to your computer.

To install a FireWire card, you need to have an empty PCI slot inside your computer. PCI slots usually look like the open slot that's shown in Figure 3-3.

If you have an empty PCI slot, you should be able to install a FireWire card. Numerous cards are available for less than $100. Many FireWire cards also come packaged with video-editing software, so consider the value of that software when you make your buying decision.

PCI slot

Figure 3-3: Make sure that you have an empty PCI slot to accommodate a new FireWire card.

When you purchase a FireWire card, read the box to make sure that your computer meets the system requirements. Follow the installation instructions that come with the card to install and configure your FireWire card for use. After the card is installed, Windows automatically detects your digital camcorder when you connect it to a FireWire port and turn on the camcorder's power. You can then use Windows Movie Maker or other video-editing software to capture video from the camcorder.

Choosing Windows video software

Perhaps the nicest thing about using a Windows PC is that no matter what you want to do, lots of software is available to help you. Countless video-editing programs are available, but video-editing software for Windows breaks down into the following three major categories:

✦ **Basic:** At the low end of the price-and-feature scale are free programs (such as Windows Movie Maker) or programs that come free with cheaper FireWire cards (such as Ulead VideoStudio or Roxio VideoWave). These programs are usually capable, but limited in advanced features. I recommend moving up to the next level as soon as your budget allows.

✦ **Intermediate:** A growing number of video-editing programs now offer more-advanced editing features at a price that is not out of the average consumer's reach. Pinnacle Studio 9 — featured throughout this book — is a good example. Studio retails for $99 and offers more-advanced editing than most basic programs — plus you can expand the capabilities even more with the Hollywood FX Plus plug-in ($49).

✦ **Advanced:** If you're willing to spend $400 or more, you can get some of the same programs that the video pros use. Advanced video-editing programs include Adobe Premiere Pro, Avid Xpress DV, Pinnacle Edition, and Sonic Foundry Vegas.

Optimizing Windows for video work

Even if you have a brand-new computer with a wickedly fast processor and lots of RAM, you may experience problems when you work with digital video. Perhaps the most common problem is frames being dropped during capture or export. A *dropped frame* occurs when your computer can't keep up with the capture or export process and loses one or more video frames. Pinnacle Studio and most other video-editing programs report dropped frames if they occur. If you encounter dropped frames (or you just want to help your computer run more efficiently for video work), try the tips in the following sections to improve performance.

I recommend running Windows XP for digital video work, and the following sections assume that you are using XP (either the Pro or Home version). If you're using an earlier version of Windows (such as Me), you can still follow along, although some steps may be slightly different.

Updating video drivers

Windows operates the various components in your computer by using software tools called *drivers*. Outdated drivers can cause your computer to run slowly — or even crash. This is especially true of video display drivers in

Windows XP. The *display adapter* (another name for the video card) is the component that generates the video image for your computer's monitor. Hardware vendors frequently provide updates, so check the manufacturers' Web sites regularly for downloadable updates. If you aren't sure who made your display adapter, follow these steps to verify the manufacturer and model:

1. **Choose Start⇨Control Panel.**

2. **In the Windows Control Panel, click the Performance and Maintenance icon if you see that option, and then double-click the System icon.**

 If you do not see a Performance and Maintenance icon, simply double-click the System icon.

 The System Properties dialog box appears.

3. **Click the Hardware tab to bring it to the front, and then click the Device Manager button.**

 The Windows Device Manager opens.

4. **Click the plus sign next to Display Adapter.**

 More information about the display adapter appears in the list, including the manufacturer and model of your display adapter.

5. **Click the Close button (X) when you are done to close the Device Manager.**

As shown in Figure 3-4, my display adapter is made by NVIDIA. To check for updated drivers, I can do a Web search for the manufacturer's name and then visit the manufacturer's Web site to see whether updates are available. The Web site should contain installation instructions for the driver updates. Make sure that any driver updates that you download are designed specifically for Windows XP (or specifically for the version of Windows that you're using).

Click to see more information.

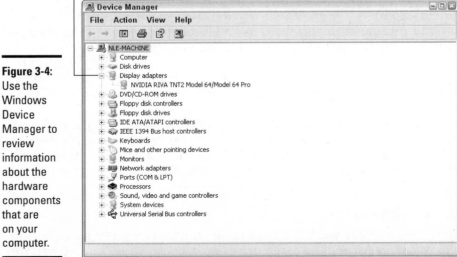

Figure 3-4: Use the Windows Device Manager to review information about the hardware components that are on your computer.

Adjusting power settings and screen savers

Your computer is probably set to power down after a period of inactivity. Normally this is a good thing because it conserves energy, but it can cause problems during video capture and some other video-editing actions. To temporarily disable power-saving options, follow these steps:

1. **Choose Start➪Control Panel.**

2. **In the Windows Control Panel, click the Performance and Maintenance icon if you see that option, and then double-click the Power Options icon.**

If you do not see a Performance and Maintenance icon, simply double-click the Power Options icon.

The Power Options Properties dialog box appears.

3. **On the Power Schemes tab, set all four pull-down menus (near the bottom of the dialog box) to Never, as shown in Figure 3-5.**

Alternatively, you can just choose the Always On scheme from the Power Schemes pull-down menu.

4. **Click the Save As button, name the power scheme** *Video* **in the Save Scheme dialog box that appears, and then click OK.**

5. **Click OK again to apply the changes and close the Power Options Properties dialog box.**

To conserve power in the future, you can turn on the power-saving features by simply choosing a different power scheme in the Power Options Properties dialog box.

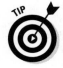

I also recommend that you disable screen savers when you are getting ready to work with video. To do so, right-click an empty area of the Windows desktop and choose Properties from the menu that appears. In the Display Properties dialog box, click the Screen Saver tab and choose (None) in the Screen saver menu. Click OK to close the Display Properties dialog box.

Figure 3-5:
Turn off
power-
saving
features for
video work.

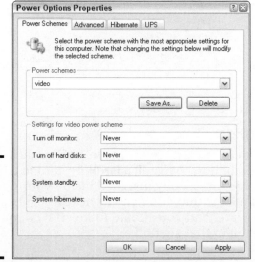

Choosing Analog Capture Hardware

The best way to capture video from a digital camcorder is to use a FireWire port. But if you want to capture analog video — whether from a VCR, Hi8 camcorder, or other analog source — you need some specialized hardware. You can install a video-capture card in your computer or (possibly) use an external *analog/video converter* that connects the analog device to your computer's FireWire or USB port.

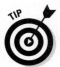

Read the packaging carefully before you buy video-capture hardware, and make sure that it is designed to capture analog hardware. Some FireWire cards are marketed simply as video-capture cards, even though they can only capture *digital* video.

When choosing an analog video-capture device, check the packaging to make sure that your computer meets the system requirements. The device should also be capable of capturing the following:

✦ NTSC (in North America, Japan, and the Philippines) or PAL (in Australia, South America, Southeast Asia, and most of Europe) video, whichever matches your local video standard

✦ 30 frames per second (fps) for NTSC video or 25 fps for PAL video

✦ 720×534 video frames for NTSC or 768×576 video frames for PAL

✦ Stereo audio

Although you don't have to get a device that can capture and export S-Video as well as composite video, try to get one if possible. S-Video provides better image quality than composite video. Composite video uses the standard RCA-style jacks, which are color-coded yellow for video and red/white for audio. Figure 3-6 shows an S-Video connector. S-VHS VCRs have S-Video connectors, as do some higher-quality analog camcorders.

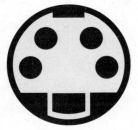

Figure 3-6:
Try to get a device with an S-Video connector like this.

Selecting capture cards

In the section "Installing a FireWire card" (clever title, eh?) earlier in this chapter, I provide an overview of how to install a FireWire card in a Windows PC. Analog video-capture cards are usually installed inside your computer in much the same way. This means that you need to have some expertise in upgrading computer hardware, and you should follow the computer-upgrade guidelines that I detail in that section.

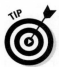

Okay, it may seem obvious, but I'll say it anyway: Make sure that your computer has an available expansion slot of the correct type in which you can install the card.

Many capture cards have neat little accessories called *breakout boxes*. The space that's available on the back of an expansion card is pretty small and may not provide enough room for all the needed audio and video ports. Instead, the ports reside in a breakout box — which can sit conveniently on your desk. The breakout box connects to the capture card using a special (included) cable. Figure 3-7 shows the card and breakout box that you get with Pinnacle Studio AV/DV Deluxe. This product allows both digital and analog video capture because it not only has *two* FireWire ports on the card, but it also has S-Video and composite video ports on a breakout box.

Selecting external video converters

If you don't feel like ripping into the innards of your computer, you may want to consider an external analog video converter, such as the Dazzle Hollywood DV Bridge. These devices usually connect to your computer's FireWire or USB (Universal Serial Bus) port. You connect your VCR or analog camcorder to the converter and connect the converter to your computer, and the analog video is converted into digital video as it is captured into your computer.

If you buy a USB converter, make sure that both the device and your computer use USB 2.0 (a newer, faster version of USB). The original version of USB could transfer data only at a rate of 12 Mbps, which is not quite enough for full-quality video capture. USB 2.0, however, can transfer 480 Mbps, which is even faster than the original FireWire 400 specification. (Apple has now introduced the second generation of FireWire, called FireWire 800, which literally doubles the data transfer rate to 800 Mbps! Unfortunately, FireWire 800 ports are limited to the most expensive Mac models, and they're not yet standard equipment on DV camcorders and other DV hardware.)

Book II
Chapter 3

Preparing Your Computer for Video

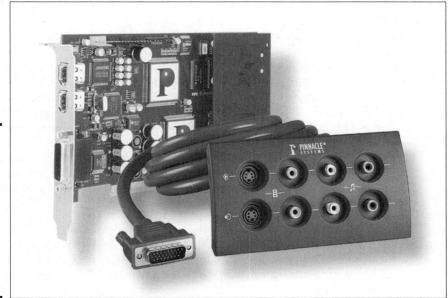

Figure 3-7: Some capture cards put all their audio and video connectors on a breakout box.

© Pinnacle Systems, Inc.

What is a video-editing appliance, and do I need one?

Several companies market versions of an expensive gadget called an *editing appliance* — basically a computer that's designed to do nothing but edit video. It has a hard drive, capture ports, and built-in editing software. Editing appliances are usually quite powerful — and so is the price. The Casablanca Prestige from Macro System (www.casablanca.tv) carries a hefty price of over $3,000 (monitor not included).

Unless you are a professional video editor working in a broadcast environment (in which case you probably aren't reading this book), you don't need an editing appliance. A regular computer (PC or Mac) provides you with a lot more value for your money because not only can you do some pretty advanced video editing on your computer, but you can also send e-mails, type memos for work, and shop at eBay. And when your computer is obsolete in a few years, a local school or youth organization will be happy to take it as a donation. An obsolete editing appliance, on the other hand, won't even make a good boat anchor 5 years from now.

Improving the Human–Machine Interface

A lot of science goes into the ergonomics of computers. Modern keyboards, monitors, and mice are well designed, and they make using your computer both pleasant and healthful — but they're designed for *general* computer use. Working with video is a lot easier if you have some specialized gear to improve the interface between you and your computer. The following sections suggest two special items that you may want to use to make video work easier.

Working with video monitors

Computer monitors and TV screens may look similar, but the two have profound technological differences. The most important difference involves color. Computer monitors can display more colors than TV screens. Also, computer screens are noninterlaced; TVs are usually interlaced. (Interlaced displays draw every other line of the picture on separate passes, whereas a noninterlaced, or progressive scan, display draws the whole picture at once.) The important point is that the video that you preview on your computer monitor may look a lot different when it's viewed on a TV.

To address this problem, many video editors connect a video monitor (that is, a TV) to their computers so that they can preview how the video looks on a real TV. Fortunately, you don't need expensive, specialized hardware to connect a video monitor to your computer. All you need is an old color TV and one of the following devices that connect to your computer:

+ **An analog-capture device:** If you have an analog-capture card or video converter, you may be able to connect a monitor to the video output connectors. Check the capture device's documentation for instructions on connecting a video monitor.

+ **A digital camcorder:** Connect a TV to the analog outputs on your digital camcorder, and connect the camcorder to your FireWire port. You can even use the camcorder itself as a monitor — but keep in mind that the LCD on your camcorder is probably noninterlaced, so you won't be seeing a "real" TV picture. (Is "real TV" an oxymoron? Who knows? Just make sure that your movie looks right on an interlaced screen.)

Some video-editing programs allow you to play video directly to an external monitor. In Pinnacle Studio, you must first export the movie as if you were going to export it to tape. After you have exported a file, simply connect your monitor and click the Play button in Studio's preview window.

If you have titles or other graphics in your movie that incorporate very thin lines, interlacing could cause the graphics or letters to flicker when they're viewed on a TV. Pay special attention to anything with very thin lines when you preview your movie on a video monitor.

Using a multimedia controller

A lot of video editing involves finding exactly the right spot to make a cut or insert a clip. The ability to easily move back and forth through video precisely, frame-by-frame, is crucial, but it's also not terribly easy when you are using the keyboard and mouse. For years, professional video-editing workstations have used knobs and dials to give editors more intuitive, precise control — and now you can get that same level of control on your computer. A *multimedia controller,* such as the SpaceShuttle A/V from Contour Design (www.contouravs.com), connects to your computer's USB port and makes manipulating video a lot easier. The SpaceShuttle A/V is shown in Figure 3-8.

<div style="text-align:right">

**Book II
Chapter 3**

Preparing Your Computer for Video

</div>

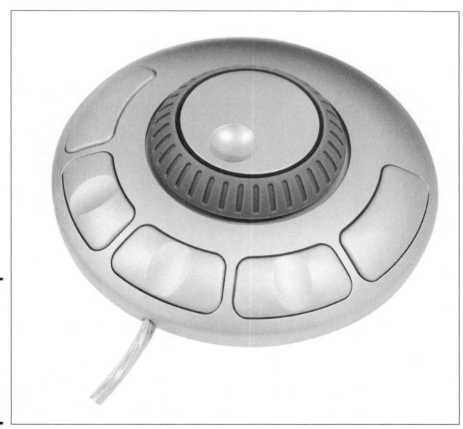

Figure 3-8:
Multimedia controllers like the Space-Shuttle A/V make video editing a lot easier.

Photo courtesy of Contour A/V Solutions, Inc.

I have used the ShuttlePRO (another controller from Contour Design) extensively with Adobe Premiere Pro, Apple iMovie, Final Cut Pro HD, and Pinnacle Studio, and it truly makes common editing tasks a breeze. I don't have to spend time trying to remember which keyboard key starts playback or moves to the next frame. Instead, I just use the simple, intuitive controls on the multimedia controller to swiftly and effortlessly control my editing program.

Chapter 4: Getting the Right Accessories

In This Chapter

- ✓ Adding the critical essentials
- ✓ Choosing audio equipment
- ✓ Picking out lights
- ✓ Selecting a tripod
- ✓ Checking your video equipment

Don't spread this around, but I once heard a good friend of mine — who is also a professional photographer — admit, "It's not just the camera; it's all the stuff that hangs off of it as well." (Old rock stars probably say the same things about their guitars.) Welcome to the world of . . . (dramatic pause) . . . *accessories*.

Now, of course your camcorder is the most important piece of equipment in your video toolkit, but it's not the only one . . . at least, it had better not be the only one if you want a steady panning shot, if your subject isn't well lit, or if you have to capture someone's dialog in the middle of an exceptionally noisy environment. It's in situations like these that you find out why the best video artists carry around enough stuff to warrant a station wagon or an SUV — like the Boy Scouts, they are just prepared.

In this chapter, I prepare you with details on the basic accessories that every camera operator needs, and I even throw in a checklist at the end that can help you stay organized during your first video shoot!

Accessorizing Your Camcorder

Few pieces of digital video gear are as underappreciated as camcorder accessories. Beyond the obvious things like a camcorder bag and spare tapes, you should have the following extras when you shoot video:

- ✦ **Extra batteries:** Your new camcorder should come with at least one battery, and I recommend buying at least one extra. For more about batteries, read the next section, "Managing Your Camcorder's Battery."

- ✦ **Lens cleaner:** Your camcorder's lens will inevitably need to be cleaned. Purchase a cleaning kit that's specifically recommended by your camcorder's manufacturer. This is important because the lens on your camcorder may have a special coating that can be damaged by the wrong kind of cleaner. Avoid touching the camcorder lens with *anything* (as much as humanly possible). I like to use canned air (available at computer supply stores) to blow dust or sand off the lens.

✦ **Lens hood:** Some high-end camcorders have hoods that extend out in front of the lens. A hood shades the lens surface to prevent light flares or other problems that occur when the sun or some other bright light source reflects directly on the lens. If your camcorder didn't come with a hood and your manufacturer doesn't offer one as an accessory, you can make a hood using black photographic paper tape (available at photographic supply stores). Make sure to check the camcorder's viewfinder, however, to ensure that your homemade hood doesn't show up in the video image!

✦ **Lens filters:** Filters fit onto the front of your lens and serve a variety of purposes. Some filters correct or modify the light that comes into the lens. *Polarizing filters* reduce reflections on glass or water that appear in a video shot. A *neutral-density filter* improves color in bright sunlight. A *clear* or *UV (ultraviolet) filter* is often used simply to protect the camera's lens from getting dirty or scratched. Filters usually screw into a threaded fitting that's just in front of the lens, and you can purchase filters from consumer electronics or photographic supply stores. If your camcorder doesn't accept a standard filter size (such as 37mm or 58mm), you probably have to order filters that are specially designed for your camcorder by its manufacturer.

Some high-end cameras have built-in neutral-density filters that you can turn on and off or adjust. This is a handy feature, but I still recommend that you always install at least a UV filter in front of your camcorder's lens to protect it from damage. A $15 UV filter is a lot easier and cheaper to replace than the glass lens in your camcorder. Tiffen (www.tiffen.com) sells a variety of camcorder filters; its Web site includes some excellent photographs that illustrate the effects of various lens filters on your video image.

Managing Your Camcorder's Battery

Rechargeable camcorder batteries can cost $40 or more, so knowing how to prolong the life of your battery and the perils of not caring for your battery properly saves you money as well as heartache from missed shots. First, you need the right battery for your camcorder. This is no big deal when you purchase your camcorder because a battery and charger are normally included in the purchase. The more you use your camcorder, though, the more you'll notice that your battery doesn't seem to stay charged as long as you would like or that it takes too long to recharge.

Now you have entered into the never-never land of camcorder rechargeable battery dilemmas. You ask yourself (because you don't know who else to ask) the following questions:

✦ **Is it okay to partially charge a battery before taking it off the charger and putting it back in the camcorder?**

Yes — providing you own a newer camcorder, such as a digital camcorder. Newer camcorder manufacturers typically provide lithium ion batteries. These batteries can be partially recharged before reuse. Other batteries — especially nickel-cadmium (NiCad) batteries — can be damaged by only partially charging them.

✦ **Is it okay to recharge a battery when some charge remains?**

If it's a lithium ion battery, yes. If it's a NiCad battery, no.

✦ **How do you know when to purchase a new camcorder battery?**

Battery manufacturers generally consider a rechargeable battery to have reached its useful life when it can provide only about half of its original consumption. For instance, if your battery could originally provide an hour's worth of power, you should replace it when it can provide only a half-hour's worth.

 You can save yourself a lot of trouble by purchasing an extra battery or two when you buy your camcorder. That way, you always have a backup in case the primary battery runs out of power. When purchasing batteries for your camcorder, consider the following:

✦ **Camcorder batteries have different specifications on how long they last. How much recording time relates to how much battery power?**

Most professional camcorder operators tell you that the camcorder battery should be rated to operate for a period of time that's twice that of the tape. Don't assume that the battery that's provided with your camcorder is the best battery for your circumstances. A manufacturer usually provides you with a battery that's good for about an hour of camera usage. Because digital camcorder and Digital8 tape is usually 60 minutes long, you may think you have the correct battery, but chances are you don't. Most people run their camcorders in the nonrecord mode as much as they do in the record mode because you can't look through the viewfinder of a camcorder unless it's turned on. So, if you're using a 1-hour tape, you would be wise to use a 2-hour battery. Besides, a 2-hour battery is good for 2 hours only when it's new. Within a year or so, your 2-hour battery will have become a 1-hour battery due to normal aging factors. This inevitable aging is accelerated if you don't take proper care of your battery.

✦ **When buying a new battery, what type should I consider?**

Always buy batteries that are made for your charger. And, obviously, always buy batteries that are rated for your camcorder. By rated, I mean that your camcorder has a certain power supply; for example, the Canon GL1 is rated as 7.2 volts DC.

Caring for your camcorder battery doesn't mean that you must have an emotional attachment. But you do need to discipline yourself to certain practices, or you'll waste money and lose valuable shooting opportunities because you'll be tending to sick batteries. Follow these basic guidelines, and your batteries should serve you well:

 ✦ **Never expose your batteries to elevated temperatures.** The numero uno enemy of batteries is heat. Anton/Bauer claims that heat can accelerate your battery's aging process by as much as *80 percent!* Heat can also cause a lithium ion battery to lose its ability to hold a charge.

✦ **For long-term storage between uses (as in weeks), keep your batteries in the refrigerator.** But before you nestle the batteries between the

Book II
Chapter 4

Getting the Right
Accessories

lettuce and rutabagas, put them (the batteries, that is) in a plastic bag to avoid the rare possibility of the battery seeping and causing food contamination.

✦ **Don't put a cold battery on a battery charger!** If you take a battery out of cold storage or out of a cold environment (such as your car in winter), always allow your battery to reach room temperature before charging. Batteries have been known to explode if placed on a charger while cold. Charging creates heat.

✦ **Don't allow your batteries to jostle around while you're carrying them.** Jostling directly affects your battery's life and performance. Also, never use a battery that has been physically damaged. The coating on the battery is supposed to keep the battery acid from seeping out. If the battery is damaged, these chemicals (which can be unstable and dangerous) can leak and cause damage to anything they touch.

Sounding Out Audio Equipment

All digital camcorders have built-in microphones, and most of them record audio adequately. You will probably notice, however, that the quality of the audio that's recorded with your camcorder's mic never exceeds "adequate." (And take it from me, brothers and sisters, the built-in audio that's provided by some camcorders really stretches the definition of the word.)

Most professional videographers emphasize the importance of good audio. They note that while audiences can tolerate some flaws in the video presentation, poor audio quality immediately turns off your viewers. To record better audio, you have the following options (which I further discuss throughout this section):

✦ **Use a high-quality accessory microphone.** Accessory microphones are usually available from the manufacturer. These accessory units make use of connections, accessory shoes, and other features of your camcorder. A good place to look for high-quality microphones is at a musician's supply store. Just make sure that the connectors and frequency range are compatible with your camcorder or other recording device (check the camcorder's documentation). Finally, the Internet is always a good resource as well. One good resource is www.shure.com, the Web site of Shure Incorporated. Shure sells microphones and other audio products, and its Web site is an excellent resource for general information about choosing and using microphones.

✦ **Record audio using a separate recorder.** Separate sound recorders give you more flexibility, especially if you just want to record audio (but not video) in a certain location.

Choosing a microphone

One of the crazy inconsistencies of video creation is that a lens is useful only if it remains connected to its camera body, but a microphone is often more useful when it is *not* connected to a camera body. Sitting on top of a camcorder, a microphone is susceptible to machine noises and inadvertent sounds that are made by the camera operator and crew. Also, especially

indoors, a camera-mounted microphone tends to be subject to reflective sounds. So you probably don't want to rely on your camcorder's built-in mic.

Omnidirectional, unidirectional, and shotgun microphones

Keep the following classifications of microphones in mind for your videography needs:

✦ **Omnidirectional — a microphone for all directions:** Omnidirectional microphones pick up sound from all directions. These microphones are typically used when you are confident that all the sound sources within an immediate proximity to the microphone are desirable. Your camcorder's factory-supplied microphone is probably omnidirectional. Omnidirectional microphones can cost as little as $29 or can cost hundreds of dollars.

✦ **Unidirectional — a one-person-at-a-time microphone:** Just the opposite of the omnidirectional type, a unidirectional microphone collects sound only from the area that's directly in front of it. Unidirectional microphones are especially helpful where you have more than one person wearing a microphone and you need to independently control the volume of each person. They are also useful in situations where you need to isolate one sound from a bunch of unwanted sounds. Unidirectional microphones also can cost as little as $29 or can cost hundreds of dollars.

✦ **Shotgun — a long-range microphone:** The term *shotgun microphone* may imply that it is a roaming and haphazard microphone. A shotgun microphone is just the opposite. You use it for pinpoint isolation of sound. Typically, you use shotgun microphones when you cannot place a microphone directly in front of a person on-camera. A crew member stands off-camera and directs the shotgun microphone at the person who is speaking. The shotgun microphone picks up sound only from where it is aimed. Basic shotgun microphones start at around $39 but can cost $1,000 or more.

In Figure 4-1, note that the room causes a multiplication of audio sources, that is, the camcorder's audio recorder is faithfully recording what it is receiving from the microphone. However, the omnidirectional camcorder microphone shown in Figure 4-1 is receiving the sum of all the sounds in the immediate environment — not just the speaker's voice. One way to put your microphone on a "sound diet" is by modifying or controlling the sound environment around the microphone.

Lavalier and handheld microphones

When you're recording weddings, training, or any other kind of video where the quality of the audio reproduction is important, I suggest that you invest in a decent lavalier microphone. A *lavalier microphone* is a small microphone that can be clipped to a necktie or blouse (see Figure 4-2). Hiding a lavalier microphone is easier than hiding a handheld microphone, but the handheld variety is more versatile. Although lavaliers are usually omnidirectional, you can buy unidirectional ones, which are typically used for recording musical instruments.

**Book II
Chapter 4**

**Getting the Right
Accessories**

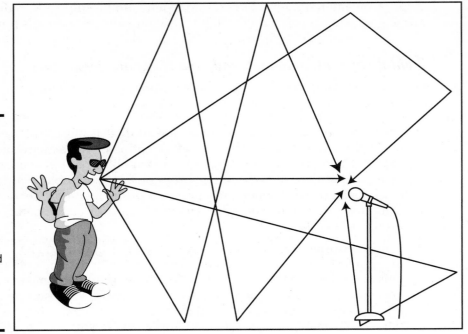

Figure 4-1:
A micro-phone doesn't know what sound to identify as the correct one, so it collects and assigns equal priority to all sounds.

Figure 4-2:
Two types of micro-phones.

You may also want a handheld microphone. Handheld microphones aren't always handheld (they're often on microphone stands), but that's not really important. Like lavaliers, most handheld microphones are omnidirectional.

Wired and wireless microphones

Based on your budget and your recording needs, you can use a wireless microphone, transmitter, and receiver or a hard-wired microphone, which is a microphone that's connected to a long cable. Hard-wired systems are . . .

well, you know, *hard-wired.* You have a microphone, and the microphone is connected to the recorder by a long audio cable — in some instances, a very long cable. A decent wireless microphone system typically costs $400–$500. You can find wireless microphone systems that cost less than this, but you'll have difficulty finding a system with a receiver small enough to fit on a digital camcorder for less than $400.

When you're buying a camcorder, double-check that it has a connector for an external microphone. And while you're at it, make sure that a headphone jack is included, too. Most digital camcorders have external headphone and microphone jacks, but these are good things to confirm nonetheless. The headphone jack is good for listening to sound levels. I further describe this helpful tip in the next section.

Hard-wired systems are inexpensive and dependable. Just plug one end of the cord into the microphone and the other into the recording device. Like wireless systems, wired systems also have limitations. Following are some limitations:

✦ Dragging the cord around on the floor causes it to accumulate dirt, which could result in equipment damage or signal distortion.

✦ Hiding the wiring when recording can be problematic.

✦ You may pick up a low hum if you inadvertently run audio wiring in a parallel path with electrical wiring.

Wireless systems combat some of the wired system's problems but have limitations of their own, as follows:

✦ They have a never-ending demand for fresh batteries.

✦ The transmitter is hard to hide on clothing.

✦ Radio interference is occasionally possible.

Whenever I have a choice, I use a wired system rather than a wireless one. Experience has proven, though, that Murphy's Law requires having both options (and spare batteries) handy.

Selecting an audio recorder

Many professionals use DAT (digital audio tape) recorders to record audio, but DAT recorders typically cost hundreds or (more likely) thousands of dollars. Digital voice recorders are also available, but the amount of audio that they can record is often limited by the storage that is built in to the unit. For a good balance of quality and affordability, some of the newer mini-disc recorders are good choices.

If you record audio with a separate recorder, one problem that you'll have later is precisely synchronizing the audio recording with the video image that you recorded. Professional video and filmmakers solve this problem using slates. A *slate* (also called a *take board*) is that black-and-white board thingie with all the chalk writing on it that someone snaps closed just before the director yells, "Action!"

The slate isn't just a kitschy Hollywood gimmick. When the slate is snapped closed in front of the camera, it makes a loud snapping noise that's picked up by all audio recorders on the set. That sound and the video image of the slate can be used later to precisely synchronize the separate audio and video recordings. If you plan to record audio with a separate audio recorder, I recommend that you construct and use a simple slate of your own. You can make it using two boards and a hinge purchased at any hardware store. (Just watch your fingers, okay?)

Shedding Some Light on the Scene

Most digital camcorders provide automatic aperture control (often called *exposure control*). The *aperture* is the part of the camera that controls how much light is let in through the lens. It expands and contracts depending on light conditions, much like the iris in the human eye. But all the automatic controls in the world can't make up for a poorly lit scene. Basically, you need the following key bits of gear to better light your scene:

✦ **Lights:** Right about now, you're probably thinking, "No kidding." You can buy professional lights if you want, but you don't need to spend hundreds of dollars to get good lights. Fluorescent shop lights are affordable and provide good-quality light, as are halogen work lights, which are available at many hardware stores.

✦ **Backdrop material:** For some shots, you may want to have a backdrop behind your subject. You can make a backdrop frame out of pipe or cheap 1×3 pine boards (also known as *furring strips*) from your local lumber yard and then tie, clamp, or staple the backdrop material to the frame. A backdrop of blue vinyl tablecloth material can even be used to create a "blue screen" special effect.

✦ **Clamps:** While you're at the hardware store buying lights and backdrop stuff, pick up some cheap spring clamps. Clamps can be used for holding backdrops together, holding lights in position, or playfully clipping unsuspecting crew members as they walk past.

✦ **Extension cords:** You need to plug in all your fancy lights somehow.

✦ **Duct tape:** If you can't do it with duct tape, it probably can't be done! I like to use duct tape to secure extension cords to the ground so that they aren't a trip hazard.

✦ **Translucent plastic sheets and cheesecloth:** Get these at your local art supply store to help diffuse and soften intense lights.

✦ **Reflective surfaces:** Use poster board, aluminum foil, or even plastic garbage bags to bounce light onto your subjects. Crumple foil to provide a more diffuse reflection, and tape the foil or plastic bags to boards so that they're easier to handle.

Lights get hot, so use care when handling them after they've been in use for a while. Also, if you use plastic, cheesecloth, or other materials to diffuse light, position those materials so they aren't too close to hot lights.

Stabilizing Your Video Image

Although modern camcorders are small and easy to carry around, you'll probably find that most of your shots benefit from a tripod or other method of stabilization. Even the cheap $20 tripod that you got for free with your camcorder purchase is better than nothing for stationary shots. If you're looking for a higher-quality tripod, the following features can make it worth the extra cash:

✦ **Strong legs and bracing:** Dual-stanchion legs and strong bracing greatly improve the stability of the camera.

✦ **Lightweight:** The best tripod in the world doesn't do you any good if it's so heavy that you never take it with you. Better tripods use high-tech materials like aircraft aluminum, titanium, and carbon fiber to provide lightness without sacrificing strength.

✦ **Bubble levels:** Some tripods have bubble levels (like those carpenters use) to help ensure that the camera is level. Few things are more disorienting in a video shot than an image that is slightly skewed from level.

✦ **Counterweights:** Adjustable counterweights help you keep the tripod head and camera balanced even if you're using a heavy telephoto lens or other camcorder accessory.

✦ **Fluid heads:** This is probably the most important feature of a high-quality tripod. A fluid head enables you to pan the camera smoothly, eliminating the jerky panning motion that's associated with cheaper tripods.

Book II
Chapter 4

Getting the Right Accessories

Video-Shoot Checklist For Dummies

A well-organized video shoot almost always results in better-quality video. But because you have so many things to remember, it's easy to forget a few things. Before I leave you to your creative banquet, I provide you with a couple of checklists to help you remember what you need to bring when you're preparing for a video shoot.

Basic checklist

The following basic checklist includes important items that you need on virtually any shoot, no matter how informal:

Camcorder	Lens cleaner
Lens filters	Spare *blank* tapes
Tripod	Your camcorder's owner's manual
Duct tape	Extra *charged* batteries
Scene list	Camcorder accessories (remote control, telephoto lens, and so on)

Advanced checklist

If you're planning a slightly more formal video shoot, you should bring the items on the basic checklist as well as the following more advanced items:

Lights	Extension cords
Reflectors	Microphone
Stool	Fans (to simulate wind)
Backdrop	Makeup and hair-care items
Clamps	AC adapter and/or battery charger for camcorder
Slate	Audio recorder (don't forget batteries and blank audio tapes or mini-discs)
Script	Clothes/wardrobe for the cast

 CHECK IT OUT

Transforming Your Living Room into a Studio

If you can temporarily prevent outdoor lighting from entering your living room (or any other large room in your house), you have the makings for a studio. You need to have the following essentials:

Studio light: Studio lights, such as the Omni Lights that I am proud to own, are a valuable investment. However, regular incandescent lights do very well, too. The important issue is that your lights need to be portable and powerful. Just remember the following basics:

 ✔ Lights get very hot. After they've been on a while, use gloves to handle them. Of course, keep the lights away from flammable objects.

 ✔ You're likely to need some commercial-quality extension cords so that you can move the lights wherever you want and distribute the power load to more than one circuit in the house. Home-quality extension cords can overheat and pose a serious electrical shock and fire hazard.

Backdrop: A nondescript backdrop is essential for studio shots. Here's what I suggest (and, in fact, am using as I write this book — in my living room): Buy some muslin at a fabric store. Paint it a dull, neutral color such as blue-gray. Make a backdrop frame (one that you can easily assemble and break down for carrying in your car). My frame is 8 feet wide by 7 feet high. I simply purchased ¾-inch galvanized pipe at the local hardware store to make the frame.

To construct a backdrop frame, go to your favorite hardware store and buy the following items:

 ✔ Four sections of threaded galvanized pipe, each 4 feet long by ¾ inch in diameter.

 ✔ Two sections of threaded galvanized pipe, each 3 feet long by ¾ inch in diameter.

 ✔ Three ¾-inch couples (for putting the 7-feet lengths and the 8-feet lengths together).

 ✔ Two 90-degree elbows (for connecting the sides with the top).

 ✔ Two T-shaped connectors (for connecting to the bottom of the 7-feet sides).

 ✔ Four 1-foot by ¾-inch threaded galvanized nipples (for making the backdrop feet).

 ✔ Four ¾-inch female caps (for making the ends of the feet).

 ✔ Spring clamps (six will probably do) for clamping your backdrop to the frame. These clamps are invaluable in video creation for a multitude of ingenious purposes.

Foamcore: At your local craft or office supply store, buy some 2 feet × 4 feet white foamcore board (¼-inch or ⅜-inch thick). This board is great for bouncing light as a soft light. You can also cut out shapes and slots and place them in front of a light to create fascinating background patterns. Finally, you can use the foamcore in front of a light to flag, a procedure in which you block light to keep it from hitting or spilling into areas of the shot where the light isn't wanted.

Chapter 5: Shooting Great Digital Video

In This Chapter

✓ Planning a video project

✓ Shooting better video

✓ Discovering composition

✓ Lighting it up

✓ Knowing when and how to zoom

✓ Recording better audio

*O*ne of the great things about digital video is how easy it is to edit. But all the editing in the world doesn't do you any good if you don't have decent source material from which to work. Shooting video is definitely an art form, but that doesn't mean that you need to be naturally gifted or have years of media schooling to produce great movies. All you really need is some patience, a few helpful tips, and maybe a little creativity. Oh yeah, and tapes — lots of blank videotapes. Not even the pros shoot perfect video every single time!

This chapter helps you shoot and record better audio and video. I show you how to plan a video project, and how to shoot video and record audio effectively.

Planning a Video Production

Camcorders are so simple to use these days that they encourage seat-of-the-pants videography, which isn't always the best idea. Just grabbing your camcorder and hastily shooting may be fine if you're shooting the UFO that happens to be flying overhead, but for most other situations, some careful planning can improve your movie.

The first thing you're probably going to do in any video project is to shoot some video. Even if you are shooting a simple school play or family gathering, you can and should plan many aspects of the shoot, as follows:

✦ **Make a checklist of shots that you need for your project.** While you're at it, make an equipment checklist, too.

✦ **Survey the shooting location.** Make sure that passersby can't trip over your cables or bump the camera. (It makes you unpopular, and can ruin your footage to boot.)

✦ **Talk to property owners or other responsible parties.** Identify potential disruptions, and make sure that you have permission to shoot. For example, your kids' school probably doesn't mind if you shoot video of Suzie's band concert, but commercial concerts or sporting events usually have rules against recording performances.

✦ **Plan the time of the shoot.** This is especially important if you are shooting outside. What part of the sky will sunlight be coming from? Do you want to take advantage of the special light that's available at sunrise or sunset?

✦ **Bring more blank tapes and charged batteries than you think you'll need.** You never can tell what may go wrong, and preparing for the worst is always a good idea. When it comes to blank tapes and spare (charged) batteries, too many is always better than not quite enough.

If you want to shoot high-quality video, you'll be glad to know that staging an elaborate video production with dozens of staff members, acres of expensive equipment, and lots of caterers is not necessary. But you can do some simple things to improve any shooting situation — whether you are casually recording a family gathering or producing your own low-budget sci-fi movie. The following sections help you shoot better video, regardless of the situation.

Composing a Shot

Like a photograph, a great video image must be thoughtfully composed. Start by evaluating the type of shot that you plan to take. Does the shot include people, landscapes, or some other subject? Consider what kind of tone or feel you want to achieve. Figure 5-1 illustrates how different compositions of the same shot can affect its overall tone. In the first shot, the camera looks down on the subject. Children are shot like this much too often. This approach makes them look smaller and inferior. The second shot is level with the subject and portrays him more favorably. The third shot looks up at the subject and makes him seem important and dominant — almost larger than life.

Figure 5-1: Composition can greatly affect how your subject is perceived.

 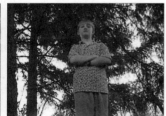

Being off-center

One of the most basic rules of video composition is to put your subject matter just slightly off-center in the viewfinder. Center, after all, is where your news anchor, president, or terrorist goes when he or she has something

important to say directly to the camera. When your subject isn't speaking directly to the camera, it makes more sense to the audience if he or she (or it) is about one-third of the way from the edge of the screen.

Which third? If the subject is a person, the rule is to have that person looking *into* the center of the screen, not toward the edge of the screen. In other words, if the subject is looking to the right, he or she should be on the left side of the frame; if the subject is looking left, he or she should be on the right side of the frame. That way, it seems that they are always looking toward the center instead of off-camera. Note that if you *need* your subject to be looking off-camera, it makes sense for them to look toward the edge instead of toward the center.

If your subject isn't a close-up of a person, you should still remember that the audience thinks of itself as being in the center, so action should take place *across* the center. This means that action should go from the left of the frame to the right of the frame, or vice versa, to involve the audience. This doesn't mean that the subject can't be walking toward or away from you; it simply means that you should place the camera so that the person walks across the center of the frame, if possible. (For instance, the person starts far away on the left side of the frame and, as he or she approaches, moves across the center of the frame toward the right side.)

Of course, rules are made to be broken. Occasionally, you see a shot in which all the action occurs only on one side of the frame. This is usually an artistic choice (it occurs a lot in music videos), where the videographer doesn't use the entire frame for the shot. If you see this while channel surfing, note that it's a stylized approach that may be jarring in nonfiction or corporate video but can be fun to use for other types of productions.

Avoiding amputations

When you're shooting a person, avoid cutting off the top of the head and don't frame a person so that he or she is cut off at the neck, waist, knees, or ankles. All of these shots look disconcerting, as if the person doesn't have a body, legs, calves, or feet, respectively. Instead, shoot just below the neck (so that we see a little shirt collar), waist (so that we see the top of her jeans), and so on, so we know that the person continues from the end of the frame.

Also, in an extreme close-up, cutting off the top of someone's head is acceptable but cutting off the chin is not. Seeing someone's mouth open and close without seeing the chin move is odd and looks like an uncomfortable B-movie horror shot in which a disembodied lump of flesh is talking on its own.

Watching your background

Shooting with the sun or another light source directly behind the subject can cause problems, as can any oddly shaped, colorful, or busy background. Also, make sure that you aren't accidentally composing the shot against a distracting background object, such as shooting so that it appears that a tree is coming out of your subject's head.

One frequent recommendation is that you shoot with the sun over your shoulder and behind you, with it shining on your subject. This is good advice, unless your subject is squinting into the sun or otherwise made uncomfortable. In that case, a little shade for the subject may be in order, or you can try a slightly different angle with the sun off to one side of both you and the subject. Just try to avoid heavy shadows on the subject's face.

Also note that for most computer-based video playback (CD-ROM, desktop, and Web-based video), the more complex the background, the worse the final video clip will look and the less it will compress. When a QuickTime movie is compressed into a final movie file, duplicate material in the background on each frame is discarded to make the file more compact. If you have a lot of movement in the background (such as waving tourists or cars in traffic), all that movement must be rendered in the final QuickTime file. The result is a movie that's hard to watch and takes up a lot of room on your hard drive or CD-ROM. The solution is to put your subjects against a simpler background that doesn't move on its own.

Considering your angles

When composing shots, another important consideration is the angle that you use between the camera lens and your subject. The following are a few considerations:

✦ **Shooting up from low angles:** If you shoot your subject from below, it makes the subject appear bigger and more imposing. In *Citizen Kane,* director Orson Welles had sections of his sound stage floor removed so that he could get dramatic camera shots from far below the Kane character, making him appear larger than life. (Orson Welles later took a different, more culinary approach to making himself look larger than life.)

✦ **Shooting down from high angles:** Stand on a chair or a ladder or use a camera crane, and shoot down at your subject or actor and you make him or her appear small and meek. (If you also end up showing his bald spot, you better check his contract to make sure that's allowed.) High angles are good to suggest adults looking at kids; low angles are good for suggesting kids looking at adults.

✦ **Shooting at crazy angles:** Tilting, or *dutching,* the camera at an angle to the ground (the *MTV* or *Monday Night Football* interview effect) can give a suggestion of hipness, coolness, or mystery to a shot — if used *very* sparingly. Crazy angles can also be used to suggest sloping ground or the "ship is sinking" effect, or to show the crazed psycho chasing down the innocent victim in a slasher film. Again, use crazy angles as a confection, not the main course.

Two other rules govern angles. Professionals call the first one the *180-degree rule,* which suggests that you shouldn't change the "right and left" of a scene between cuts. You should try to avoid crossing the line of action: If you start on one side of the action, stay on that side of the action. Otherwise, the audience becomes confused — it's like constantly switching sidelines while watching your kid's soccer game. (The only time this works is in a *Rocky*-esque 360-degree shot, where the camera rolls all the way around the action to establish tension.)

The other rule is the *30-degree rule,* which means that you should change the angle of the camera (relative to your subject) at least 30 degrees if you're cutting between two angles without a transition. Of course, you don't need to use your protractor and vast knowledge of trigonometry to figure out what equals 30 degrees; the idea is simply to make sure that you're changing the angle of the camera between two shots that are to be edited together. If you cut between two clips that don't have a dramatic enough difference in angles, it just looks like you bumped the camera or made a mistake in editing.

Evaluating Lighting

For the purposes of shooting video, light can be subdivided into two categories: good light and bad light. Good light allows you to see your subject, and it flatters your subject by exposing details that you want to show. Good light doesn't completely eliminate shadows, but the shadows don't dominate large portions of the subject either. Bad light, on the other hand, washes out color and creates *lens flares* (the reflections and bright spots that show up when the sun shines across the lens) and other undesired effects. Consider Figure 5-2. The right side of the subject's face is a featureless white glow because it's washed out by intense sunlight. Meanwhile, the left side of the face is obscured in shadow — not good.

Figure 5-2: This is what happens when you don't pay attention to light.

Your camera probably has settings to accommodate many special lighting situations. Always read the camcorder's documentation to see what features may be available to you — and practice using those features to see which ones work well and which ones don't.

Setting white balance

White-balancing is the process of telling the camera what color to use as a reference for pure white. Set white balance anytime you change the

lighting in which the camera is operating; the process gives the camera a color reference for the current lighting.

Camcorders can do an adequate job of white-balancing automatically, but automatic white-balancing is best in situations where the lighting will change — when you're moving from inside to outside, for instance. If you have the camera fixed in one spot for filming (such as for an interview in the subject's office), you should set up your lights for the shot and then manually white-balance the camera.

To white-balance manually, hold up a white card or piece of paper and then zoom the camera in so that the white object fills the frame. Then set the manual white-balance control on the camera. Zoom back out, and your camera is balanced to a pure white under the current lighting conditions, meaning that you'll get good color for filming.

Choosing lights

How do you light your shots effectively? Remain ever aware of both the good light and the bad. If you don't have control over lighting in a location, try to compose the shot to best take advantage of the lighting that is available.

Professional photographers and videographers typically use several different lights of varying type and intensity. Multiple light sources provide more control over shadows and image detail, and different kinds of lights have different effects. You can use the following types of lights:

✦ **Incandescent:** These are your good old-fashioned light bulbs like the ones that Thomas Edison invented. Most of the light bulbs around your house are probably incandescent. Incandescent lights are usually cheap, but the light temperature is lower than with other types of lighting (meaning that they are not as bright), and they usually provide wavering, inconsistent performance.

✦ **Halogen:** Okay, *technically,* halogen lights are also incandescent, but they usually burn at a much higher temperature (and provide a more consistent light over their lifetime) than do regular bulbs. Many professional video-lighting systems are tungsten-halogen lights. These lights have a tungsten filament that passes through a sealed tube of halogen gas. Good, cheap halogen work lights also work well for video lighting — and they are generally available at tool and hardware stores. Halogen work lights also sometimes come with useful stands, although you can make your own stands using threaded plastic pipe and clamps from your friendly neighborhood hardware store.

✦ **Fluorescent:** Fluorescents also tend to give off a high-temperature light, although the temperature can vary greatly depending on the condition and age of the bulb. Fluorescent light is usually both very white and soft, making it ideal for video lighting. (A good example: I use fluorescent lights to make sure that a blue screen is brightly and evenly lit.) Fluorescent fixtures and bulbs can be purchased for less than $20 and can be easily suspended above your subject.

Understanding color temperature

Color temperature is a standardized measurement of how colors appear, based on the characteristics of the light in which you see the colors. Your camcorder has to be told how to interpret color based on the color temperature of the light source(s) where you are recording. When you record in the sunlight, your camcorder's interpretation of an object's color is entirely different from its interpretation of that same object indoors.

A typical scenario is when you record video as you follow someone from outdoors to indoors. As you go indoors, your camcorder goes through all kinds of gyrations trying to adjust the iris. But you may notice that for a few moments, everything in the room appears to have a bluish cast and then appears normal again. This transition happens because the camera is trying to adjust to the new color temperature. The following table charts approximate color temperatures of various light sources. *Remember:* Fluorescent light color temperature varies according to the age of the lamp, coating, filtering, and other factors.

Light Source	Typical Color Temperatures (Degrees Kelvin)
Candle	1,900
60-watt household lamp	2,800
Professional lamp	3,200
Fluorescent light	3,700 (approximate)
Sunrise and sunset	2,000–3,500
Cloudless midday sun	5,600
Hazy day	8,000

If you use fluorescent bulbs, let them warm up for a few minutes before shooting your video. This should prevent flicker. If the bulbs still flicker after they've warmed for a bit, try using new or different bulbs. Also, pay attention to how fluorescent lights affect your audio recordings. Fluorescent bulbs tend to produce a hum in audio recordings, so some practice and testing may be necessary. If fluorescent humming in your audio recording is a problem, record audio separately or use a different kind of light.

Bouncing light

Shining a light directly on a subject is not necessarily the best way to illuminate it. You can often get a more diffuse, flattering effect by bouncing light off a reflective surface, as shown in Figure 5-3.

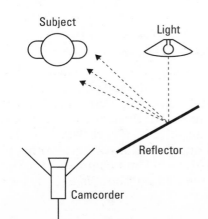

Figure 5-3:
Bounce
light off a
reflector
for a more
diffuse light.

You can make reflectors out of the following materials, depending on what light effect you're looking for:

✦ **Poster board:** White poster board is a good, cheap material that you can find just about anywhere. Thicker poster board is easier to work with because it's rigid (that is, it doesn't flop all over the place and make noise while a helper holds it). With some spray paint, coat one side of a poster board gold and the other silver. Experiment using each side to gain just the right light quality.

✦ **Aluminum foil:** Crumple a large sheet of foil, and then spread it out again and tape it to a backing board. Crumpling the foil provides a more diffuse reflection than you can get from flat foil, but its reflection is still highly effective.

✦ **Black plastic garbage bag:** Yep, black plastic bags are pretty good reflectors even though they have a dark color. As with foil, you can tape or staple the bag to a backing board to make it easier to work with.

Reflectors can also be used to "fill" the lighting of your subject. Consider Figure 5-4: A light is directed at the subject to light up his face. This light is often called the *key light*. A reflector is positioned so that some of the light that goes past the subject is bounced back onto the other side to fill in facial or other details.

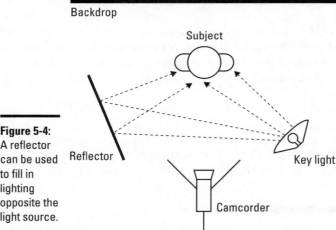

Figure 5-4: A reflector can be used to fill in lighting opposite the light source.

Hitting with hard light

Hard light is a term that is used in film and video for a direct light source that creates sharply defined (high-contrast) shadows. Hard light is dominant; it causes the eye to focus on highlights rather than shadows. As a rule, the smaller the diameter of the light source, the sharper the contrast between the light and the shadow. Figure 5-5 illustrates a single hard-light source that is imposed on a figure. If you're shooting indoors, you can adjust a hard light to be focused and trimmed so that it illuminates exactly what you want. Direct sunlight outdoors is usually hard light.

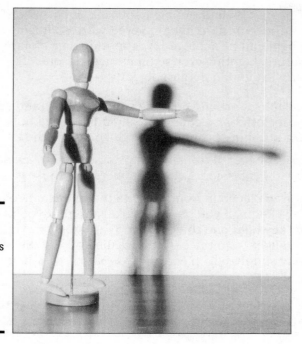

Figure 5-5:
Hard light
accentuates
dimension
and depth
with high-
lights and
shadows.

Suggesting with soft light

Sometimes you may find that a light you're using to illuminate a subject is
too intense. This is especially common with key lights. To counter this situ-
ation, you use *soft light,* which is more subjective than hard light. Soft light
washes an area with light and creates wispy (low-contrast) shadows, as
shown in Figure 5-6.

Figure 5-6:
The larger
the diameter
of a light
source, the
sharper the
contrast of
light and
shadow
created by
the soft
light.

Indoors, soft light is created by indirect light sources, such as hard light bouncing off a white surface or hard light covered with a diffusing cloth or filter. Outdoors, soft light can be achieved by shooting on a cloudy day or in the shadow of a structure. Lighting crews sometimes use one of the following materials between the light and your subject:

✦ **Cheesecloth:** Available at art and cooking supply stores (and some grocery stores), cheesecloth has a coarse mesh and is useful both for diffusing light and for straining beans or cottage cheese in the kitchen.

✦ **Translucent plastic:** Sheets of translucent plastic are also available at arts-and-craft stores. Professional videographers call these *gels*.

Colored gels are often placed in front of lights that illuminate a backdrop for special lighting effects. If you do this, make sure that you place a barrier between your key light and the backdrop (as shown in Figure 5-7) so that the colored light from the gel isn't washed out by the white key light. A barrier may simply be a piece of cardboard that is held up by a stand or helper.

If you diffuse your light, you may have to move your lights closer to the subject. Experiment to get the best results.

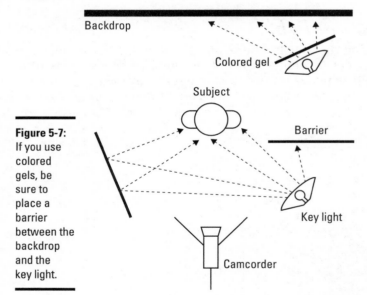

Figure 5-7:
If you use colored gels, be sure to place a barrier between the backdrop and the key light.

Lights (especially halogens) tend to get very hot. To avoid fire hazards, use extreme care when placing gels or cheesecloth in front of lights. *Never* attach diffusers directly to lights. Position your diffusers some distance away from the lights so that they don't melt or catch on fire, and check the condition of your lights and diffusers regularly. Read and heed all safety warnings on your lights before using them.

Controlling shadows

Shadows are the places where light is physically blocked by an object. How's that for an objective definition? Shadows can be good (see Figure 5-8), and

they can be very bad. The worst shadows are those that are caused by someone's nose, which can sometimes make that nose the focal point of the video. The simplest way to ensure that shadows make your subject look good is to believe what you see in your viewfinder. Your camera "sees" shadows differently than your eyes do because your camera sees in two dimensions instead of three dimensions.

Figure 5-8: Shadows add depth and texture to a scene and establish the direction of the light source.

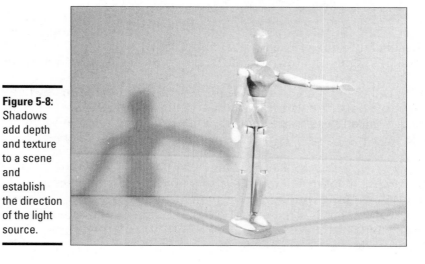

Key light (making Aunt Harriet a glamorous star)

The primary light of a shot is the *key light*. It sets the stage for the shot, establishes the texture and depth of a primary figure, and determines the direction of the shadows. The key light typically comes from a single direction, as shown in Figure 5-9, and is often a hard light. (See the section "Hitting with hard light," earlier in this chapter.) The key light can create problems by overlighting objects and casting ugly shadows.

Direction of light

Figure 5-9: The key light establishes a direction of light in the scene.

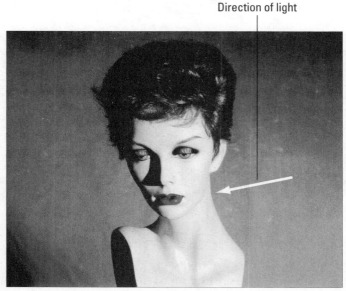

Key light is especially important when filming someone's face because subtle nuances of light can flatter or distort a facial feature. Correctly filming someone's face takes practice. The great challenge of recording the human face comes from the infinite variety of facial shapes and shades; you can't film everyone in the same manner. Of course, the intent of the shot can also dictate the manner in which you want the face to look. For example, lighting a face for a mysterious, eerie scene is entirely different from lighting the face for a casual interview.

The images in Figure 5-10 show how key lighting affects the way people look. (A) is an unusual angle, creating a mysterious look; (B) is a natural angle; (C) is also natural but highly shadowed; and (D) is overly bright on the forehead.

In Figure 5-10, I adjusted the vertical and horizontal location of the key light in each image to emphasize various features. Using a single facial structure, you can change the angle and the intensity of the key light to create a variety of effects, which creates a dynamic effect.

Set the key light by placing your light source 30 to 45 degrees to the right or left of your camera. A good general rule is to follow the natural light source, so if you're inside and the window is on the right, aim your light in the same direction as the light that is streaming through the window. I prefer to have the light on the left side, but experiment with both sides to determine which side you prefer.

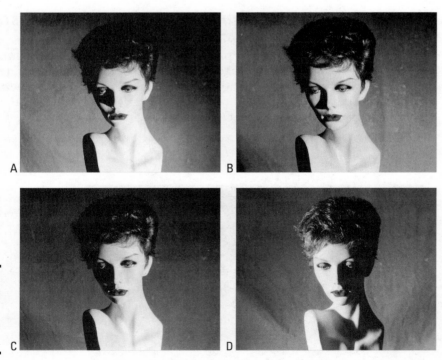

Figure 5-10: The angle of key lighting changes the effect.

Fill light (making Aunt Bertha a young starlet)

As important as a key light is, it usually creates a scene that's too stark and unattractive without the compromising wash of *fill light*. For the most part,

fill light casts no shadows and decreases some of the harshness of the key light's shadows (see Figure 5-11). Just as a key light can harshly overlight a subject, too much fill light can destroy the details of an image. For example, using too much fill light causes facial contours to disappear and surfaces to lose their texture. Place your fill light at a 45-degree angle to your camera on the opposite side from your key light (which is also at a 45-degree angle to the camera).

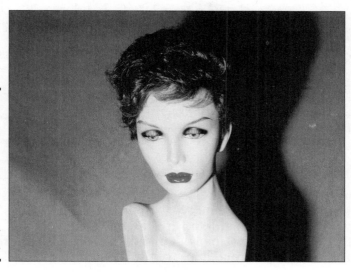

Figure 5-11:
A fill light brightens an overall shot by reducing the darkness of shadows that are produced by the key light.

Fill light comes from different sources, such as light coming through a window or light from a lamp in a corner. If you're trying to control fill light, you can close the drapes, turn off the room lights, and point a bright light at a piece of white poster board so that the light bounces onto your subject in an unfocused (fill) manner.

Backlight (giving Aunt Bertha much-needed depth)

Video creates a two-dimensional illusion of three-dimensional reality. When recording video, one of the basic challenges is to avoid giving the impression of pasting the subject against the background. The perception of separation of the subject from the background is a much more visually comfortable illusion. You can accomplish this separation by using *backlight*.

Backlight creates a kind of aura around the subject. The highlight lifts the subject from the background (see Figure 5-12). Backlight is accomplished by pointing a light from the back toward (but not directly at) the camera, illuminating the subject from behind.

To make backlight, aim an incandescent light (such as a utility light from a hardware store) from above and slightly behind the subject onto the subject's head and shoulders.

Figure 5-12:
Backlight is aimed at the subject so that it does not spill onto the background.

Using lens filters

Your camcorder can probably accept some filters that screw on in front of the lens. Filters can be used to improve various lighting situations. For example, if you are shooting outdoors in a brightly sunlit location, you may find that colors look kind of washed out in the light. A *neutral-density filter* can compensate for the light and improve the way that colors look.

Other lens filters can provide special lighting effects. For example, a *star filter* causes star patterns to shoot out from light points that appear in the image. This can give the scene a magical look. For more details on how lens filters can change and improve the way your video images look, check out the Tiffen Web site at www.tiffen.com.

Controlling Focus and Exposure

Virtually all modern camcorders include automatic-exposure and -focus controls. Automation is really handy most of the time, but it's not perfect. If you always rely on auto focus, you will inevitably see the lens "hunting" for the right setting during some shots. This can happen a lot if you shoot moving subjects. Likewise, if you are shooting over a crowd or past other objects, the camera may focus on the closer objects instead of the desired subject. If your camera has a manual-focus mode, you can avoid focus hunting by turning off auto focus.

Manual focus is pretty difficult to control if you're using a small dial or slider switch on the side of a camcorder. Try to get a camera with a focus ring around the lens; this makes manual focus much easier to control.

I also urge you to know how to use the manual-exposure control (also called the *iris*). Exposure determines how much light is allowed to pass through the lens. The lens dilates and contracts much like the iris in a human eye. Manual exposure control allows you to fine-tune exposure if the automatic control or camcorder presets aren't providing the desired light levels. Some

higher-end digital camcorders have a helpful feature called a *zebra pattern*. As you adjust the exposure, a striped pattern appears in the overexposed portions of the image. Overexposed areas appear as washed-out, colorless white blobs in your video image. A zebra pattern makes controlling exposure a lot easier: I have found that overexposing a video shot when you are manually adjusting exposure is very easy. For an example of an overexposed image, refer to Figure 5-7.

Although every camera is different, most camcorders have an infinite setting (∞) on the manual-focus control. In most cases, anything that is more than about ten feet away will be in focus when the lens is set to infinite. Ten feet isn't a long distance, so you may be able to resolve many focus problems by simply using the infinite setting.

Like a still camera, *shutter speed* for a camcorder is measured in fractions, suggesting what percentage of a second each frame is exposed. A video camera's shutter speed can affect the perception of motion for your audience.

Standard shutter speed is $\frac{1}{60}$, which means that each frame is exposed for $\frac{1}{60}$ of a second. Under normal, good light conditions, this is the right setting. If you'll be shooting fast motion, you may want to increase the shutter speed slightly (to $\frac{1}{250}$ or so) to keep the action from blurring. In lower-light situations or when you want to blur fast motion (for a streaking effect that's great for filming a lighted highway at night), select a slower shutter speed if your camera supports it.

Setting Up Your Camcorder

Perhaps the most important tip I can give you before you shoot your video is this: Know your camera. Even today's least-expensive digital camcorders are packed with features that were wildly advanced (and expensive) just a few years ago. Most digital camcorders include image stabilization, in-camera effects, and the ability to record 16-bit stereo audio. But these advanced features won't do you much good if they aren't turned on or configured properly. Spend a few hours reviewing the manual that came with your camcorder, and practice using every feature and setting. In particular, check the following items:

✦ **Audio:** Many new camcorders are set by default to record only 12-bit audio, also sometimes called the 32-kHz setting. Fire up your camcorder right now and make sure that it is set to 16-bit (48-kHz) audio instead, and never change it back. Sixteen-bit audio is higher quality, and it won't cause any problems later on when you want to capture video to your computer (or do pretty much anything else with it). For more on working with audio and understanding the bit and kilohertz settings, see Chapter 7 of Book II. I also describe audio recording in the section "Recording Sound," later in this chapter.

✦ **Focus and exposure:** In the previous section, I mention those times when you want to control focus and exposure manually. If you use manual-focus or -exposure control, switch these settings back to automatic before you turn off the camcorder. That way, the camcorder is ready for quick use later, when Bigfoot momentarily stumbles into your camp.

✦ **Special effects and exposure modes:** As with manual focus and exposure, if you use any of the built-in effects in your camera, be sure to disable them before turning off the camcorder so that it will be ready to go the next time you use it. The same thing goes for special exposure modes.

✦ **Stow the lens cap securely:** It seems obvious, I know, but if you have a clip or something that allows you to securely stow the camcorder's lens cap, use it. If you let the cap hang loose on its string, it will probably bang into the microphone and other parts periodically, making a lot of noise that you don't want to record.

✦ **Use a new tape:** Even though digital video doesn't suffer from the same generational loss problems as analog video (where each play of the tape degrades the recording quality), various problems can still occur if you reuse digital tapes. Potential problems include timecode breaks (described in the section "Avoiding timecode breaks," later in this chapter) and physical problems with the tape itself.

Keep the camcorder manual in your gear bag when you hit the road. It may provide you with an invaluable reference when you're shooting on location. Also, review the manual from time to time: Your camcorder no doubt has some useful or cool features that you forgot about. If you've lost your manual, check the manufacturer's Web site. You may be able to download a replacement manual.

Shooting Video

When your camcorder is configured and set up the way you want it, it's time to start shooting some video. Yay! One of the most important things that you should work on as you shoot video is to keep the image as stable as possible. Your camcorder probably has an image-stabilization feature built in, but image stabilization can do only so much. I recommend using a tripod for all static shots and a monopod or sling for moving shots.

Pay special attention to the camera's perspective. As I mention earlier (and demonstrate in Figure 5-1), the angle of the camera greatly affects the look and feel of the video that you shoot. I often find that lowering the level of the camera greatly improves the image. Some high-end camcorders have handles on top that make shooting from a lower level easier. Virtually all digital camcorders have LCD panels that can be swiveled up so that you can easily see what you're recording, even if you're holding the camera down low.

If you're shooting a person in a studio-like situation, complete with a backdrop and fancy lighting, provide a stool for your subject to sit on. A stool can help your subject remain both still and relaxed during a long shoot, and (unlike a chair) a stool also helps the subject maintain a more erect posture.

Panning effectively

Moving the camera across a scene is called *panning*. You often see home videos that are shot while the person who is holding the camcorder pans

the camera back and forth and up and down, either to follow a moving subject or to show a lot of things that don't fit in a single shot. This technique (if you can call it that) is called *firehosing* — and is usually not a good idea. Practice the following rules when panning:

✦ **Pan only once per shot.**

✦ **Start panning slowly, gradually speed up, and then slow down again before stopping.**

✦ **Slow down!** Panning too quickly — say, over a landscape — is a common mistake.

✦ **If you have a cheap tripod, you may find it difficult to pan smoothly.** Try lubricating the tripod's swivel head with WD-40 or a silicon spray lubricant. If that doesn't work, limit tripod use to stationary shots. Ideally, you should use a higher-quality tripod with a fluid head for smooth panning.

✦ **If you're shooting a moving subject, try moving the camera with the subject, rather than panning across a scene.** Doing so reduces out-of-focus issues with the camera lens and helps keep the subject in-frame.

Knowing when to tilt

Tilting the camera (moving it up and down relative to your subject) is another movement that you'll do less than you may think. After you have the camera placed correctly for a medium shot, for instance, moving the camera up and down is rarely useful. One instance where it can be used to good effect is to show extreme size — for instance, to tilt up from a low angle to show how huge a professional wrestler, a politician, or a city building is. Another common use of tilting is to add a sense of confusion or danger or to even indicate that something's not quite right with one of your characters. (My favorite classic TV program of all time is Batman, where tilting was practically a way of life when the camera was on arch-villains like the Joker, the Penguin, or Catwoman!)

If you decide to tilt, use a smooth motion and keep the subject nicely framed. When you reach the end of the tilt, hold the shot for a few seconds before performing any zoom or other movements.

Avoiding timecode breaks

Each frame of video is identified using a number called a *timecode.* When you edit video on your computer, the timecode identifies the exact places where you make edits. On your camcorder, a timecode indicator tells you how much video has been recorded on the tape. This indicator usually shows up in the camcorder's viewfinder or the LCD panel. A typical timecode looks something like this:

```
00:07:18:07
```

This number stands for 0 hours, 7 minutes, 18 seconds, and 8 frames (since the timecode began at 00). If you have a 60-minute tape, the timecode on that tape probably starts at 00:00:00:00 and ends at 00:59:59:29. In some cases,

however, the timecode on a tape can become inconsistent. For example, suppose you record 1 minute of video, rewind the tape 20 seconds, and then start recording again. Depending on your camcorder, the timecode may count up to 00:00:40:00 and then start over at 00 again. An inconsistency like this is called a *timecode break.* A timecode break is more likely to occur if you fast-forward a tape past a blank, unrecorded section and then start recording again.

When you capture video from a digital camcorder into your computer, the capture software reads the timecode from the tape in your camcorder. If the software encounters a timecode break, it will probably stop the capture and be unable to capture any video past the break.

The best way to avoid timecode breaks is to make sure that you don't *shuttle* the tape (fast-forward or rewind it) between recording segments. An alternative approach is to pre-timecode your tapes before shooting (as described in the sidebar "Blacking and coding your tapes"). If you have to rewind the tape (when, for example, someone wants to see a playback of what you just recorded), make sure that you cue the tape back to the end of the recorded video *before* you start recording again. Many camcorders have an *end-search feature* that automatically shuttles the tape to the end of the current timecode. Check your camcorder's documentation to see whether it has such a feature.

Mastering your tripod

If you have friends or neighbors who own video cameras, you've probably seen some pretty bad amateur home video. The bottom line is that the cameras can only get *so* sophisticated. Eventually, it's up to the carbon-based camera activation unit (you) to make some decisions and get things right.

Blacking and coding your tapes

Video pros also have a formatting process for new videotapes called *blacking and coding.* As the name suggests, blacking and coding is the process of recording black video and timecode onto new tapes. This helps ensure consistent timecode throughout the entire tape, thus avoiding potential timecode breaks. You don't need special equipment to black and code new camcorder tapes. All you need is a lens cap. Place the lens cap on the camcorder and start recording from the start of the tape all the way to the end. You should do this in a quiet, darkened room in case the lens cap leaks a little light. As the black video is recorded onto the tape, consistent timecode is also recorded on the entire tape from start to finish. If consistent timecode is recorded on the entire tape, timecode breaks are not likely to occur when you use the tape later to record real video.

Blacking and coding tapes is not mandatory with modern mini-DV camcorders: As long as you follow the basic recording guidelines that I mention earlier, you should be able to avoid timecode breaks. But if you find that timecode breaks are a problem with your camera, you should black and code all new tapes before you use them. I especially recommend blacking and coding your tapes if you have a Sony Digital8 camcorder. Because Digital8 camcorders use Hi8 tapes, the camcorder may switch to analog Hi8 mode during playback or capture if you accidentally play or fast-forward past the end of recorded digital timecode.

TIP

Here's one way to do it: Watch a little TV. But instead of getting engrossed in the dramatic story line (Did he do it? Was he framed?) or giggling along with the laugh track, take some time to watch the camera work. (This is especially effective when you're watching the evening news or some other show where a lot of one-camera, handheld shots are used.) You can see some of the basic, professional video tricks play out right before your eyes.

The number one rule? Move the camera only when you have to and only when it makes sense for the shot. And when you decide to move the camera, do it cleanly, deliberately, and with authority. (In this respect, it's sort of like karate, but you can wear jeans.)

Want to instantly make your video doubly-watchable? (Is that a word?) Buy a tripod, and put your camera on it. Use the tripod as much as you can.

Most of what seems *amateur* about amateur video is a shaking camera. Although some DV camcorders offer a special image-stabilization feature, this feature won't cover up the fact that you're holding the camera in your hand. In most cases, a digital stabilization feature can help in only limited ways, such as by smoothing out shots in which you use a high level of zoom. But only a good tripod can keep you from moving the camera too abruptly, tilting it slightly, or jostling it accidentally.

The tripod doesn't have to be pricey; an inexpensive one ($35 or less) should do fine. Most tripods are easy to adjust, standing to 5 feet or more but collapsing, even with the camera still attached, to 2 feet or less. Most tripods can also often help you pan the camera smoothly, and some enable you to tilt the camera up and down smoothly as well.

If you're in a situation where you can't use a tripod, you still have a few options. First, you can use some sort of camera-stabilization device to help you keep the camera steady. Stabilization systems range from shoulder-mounted *steady-cam* setups to small, weighted balances that you can use for easy, handheld shots where you need to move the camera. These systems cost a few hundred dollars and may not be right for home video, but they're perfect for video that you're shooting for an organization or business.

Second, you can place the camera on something that will make it as steady as possible, such as a fence post or a car hood. If you can't get the right angle on the shot with the camera on such a platform, you can try putting your elbows on the platform to hold the camera as steady as possible.

If you're forced to hold the camera, try to hold it in two hands, preferably with one hand under the base of the camera. (You may also find this convenient for zooming or manual focusing.) Keep your elbows close to your body, and plan your shots so that you can rest between them. You'll get tired of holding the camera like this, and your shots will start to get jittery and uneven.

Start recording early

If you're filming with actors or directing your subjects, calling, "Action!" tells them to begin performing. However, you should start recording a few

seconds *before* the action starts. This is called getting an *in handle,* which gives you a little extra footage on the tape to play with when you're editing later. Then, everyone in the scene should count to three (silently) after hearing "Action!" before doing anything because it makes it easier to edit out the "Action!" statement. (You can also point to your actors or count down with your fingers to silently tell your actors when to start acting. On the set of a TV show, the control-room director usually starts the tape, and then a floor director would say "5, 4, 3, 2, 1" and point to signal "Action!")

Stop recording late

Now for the flip side for the previous section: You should also wait a few seconds *after* the action in a scene has taken place to yell, "Cut!" More importantly (especially if it's not the right time or place to yell, such as during a wedding), you should wait a few seconds before pressing the Pause button on your camcorder. This gives you an *out handle,* which makes it easier, once again, to edit in iMovie. If you press Pause immediately after the action stops, you may find that you didn't quite get enough footage for a clean transition when you're editing.

The Fine Art of Zooming

Zooming is the process of changing the focal length of a lens. If you've ever had a fixed-length camera lens (one that didn't zoom), you know that to change the perceived distance to a particular object, you have to move the camera. With a zoom lens, you can change the focal length without changing the location of the camera.

Another calling card of amateur video is zealous use of the zoom buttons. Something happens to people when they get behind a camcorder with a zoom feature. They zoom in; they zoom out. Zoom in on the baby, zoom out from the baby. Zoom in on grandma, zoom out from grandma. Zoom in on the plush interior of your new car . . .

Spend a little time doing some research (that is, watching TV), and you'll see that a professional rarely zooms in and out during a single shot. (It happens sometimes in news footage and during newscasts but not much in interviews, informational shows, and fictional shows.) This doesn't mean that the zoom feature is useless. It just means that changing the focal length *between* shots instead of *during* shots is generally more effective.

Zoom technique and the three shots

Rather than zooming and moving the camera to follow the action, professional videographers often use a series of shots that are taken from different angles and that use different focal lengths. To get better-looking pictures for your own video, you should consider using this tactic. The common shots are as follows:

✦ **An establishing shot:** An establishing shot gives your audience a sense of location. Using a wide-angle focal length (zoom set to 0 or, on some cameras, W for wide), you shoot an entire scene without necessarily

showing your main action or by showing it as only a small part of the scene. In establishing shots, showing some zoom, especially to suggest the direction of the action, is common. For instance, if you're showing New York's Times Square in wide angle and you want to make it clear that you're going in to the heart of Times Square, you may smoothly zoom in a bit to convey that action.

✦ **A medium shot:** A medium shot keeps your subject in full frame, giving the audience the sense of what action is taking place and who or what is the main subject. A lot of your footage is likely to be shown in medium shots. Rarely will you want any zooming to go on during a medium shot because it simply distracts from the action.

✦ **A close-up shot:** A close-up shot shows something particular that continues to tell the story, such as a small object or a person's reaction during dialog. The number of close-ups that you use can vary depending on the meaning that you're trying to convey. You can sometimes zoom while in close-up mode but usually only to emphasize an action. For example, you may zoom in slightly on a sweating interview subject as he makes the fatal admission or zoom away from your on-air narrator as the story is ending. Otherwise, keep the focal length locked and just shoot the action with a steady hand (or better yet, a tripod).

The point, then, is to avoid zooming too much *during* each individual shot. Instead, shoot your establishing shot and hold steady for a while. Then change the focal length (zoom in) to a medium shot, and hold that one. Now, zoom in to a close-up shot and hold it. Zoom back to a medium shot, and hold that.

In most cases, you should also move the camera to change angles on your subject so that your establishing, medium, and close-up shots all have a slightly different look at your subject. For instance, you could start with a wide, establishing shot from behind your family walking into Times Square. Then get a medium shot from the side of them as they walk past stores. Finally, end with a straight-on close-up shot from in front of your daughter as she spots something interesting at a sidewalk vendor's table.

How would you get all these shots? Ideally, you would get one shot, pause the camera, move it, change the focal length, get the next shot, pause the camera, move it, and so on. In practice, this can be tough to do if you're shooting vacation footage. In that case, you should simply make sure that you're holding each shot — establishing, medium, and close-up — long enough before you begin zooming and finding a new angle. Then, you can edit out all the zooms and movements while having enough steady footage of each shot to build your edited video nicely.

Performing the zoom

Get to know your camera's zoom controls intimately. How you use them can make the difference between effective zooms and those that aren't as effective, especially if you want your zoom to end up in the final, edited video. (If you're zooming just to get to a different focal length, don't worry about how smoothly you press the buttons, as long as you have enough steady footage for each different shot between zooms.)

Zoom smoothly. Avoid zooming too quickly (unless you're making a music video or following a flying saucer through the sky), and try not to jostle or tilt the camera while zooming. Watching stories on a news program such as *20/20* or the evening national news can give you a good idea of how quickly you should zoom the camera in different circumstances. Most likely, smooth zooming simply means getting used to the controls of your camera. Remember that the more you zoom, the more a small movement of the camera will look like an earthquake to the viewer. If you have some serious zoom action going on, put your camcorder on a tripod.

It's important to plan your zoom shots before you record them. Sometimes, as you're zooming, you realize that you don't have the subject framed correctly. When you move the camera to correct this oversight, the jagged movement doesn't look great in the final product. Here's a simple trick: If you can, zoom in to the subject (or some landmark) *first,* before you record, and then zoom back out. Now you know that you can press the Record button and zoom in with the shot well composed.

Many cameras include a wireless remote controller that may, at first glance, seem completely useless. But it can be helpful for smooth zooming, especially if you're working with the camera on a tripod. Using the remote, you can zoom the camera without touching it, ensuring that the zoom movement is as smooth as possible. This means that you can even zoom in and out if you're filming yourself!

Sound recording tips

In video creation, overcoming the challenges in the audio environment is one of your biggest jobs. Your goal is to make the audio on the tape sound like what your ears are hearing in real life. This is seldom an easy task.

A cardinal rule is not to *overdrive* your audio recording capability. Overdriving occurs when you place a microphone too close to someone's mouth or too close to musical equipment. If you overdrive your recording, you will most likely distort the audio portion.

Here are some tips for increasing your success with sound recording. You can definitely achieve a high quality on a regular basis by observing the following simple rules:

✔ Obtain a set of earphones, plug them into the audio-monitoring port on your camcorder, and wear them during setup and recording. Once you're sure that the sound is okay, you can take off the earphones.

✔ Try turning off the *automatic gain control* (AGC) on your camcorder. I typically use the AGC in

only two circumstances: when I don't have the time to worry about how the audio turns out and when the audio situation is out of control, such as at a loud basketball game. Otherwise, I leave the AGC turned off and keep my fingers poised on the volume control.

✔ Sound-check your on-camera person (people). Whenever you can, get your people to talk naturally on-camera in the location that they will speak, adjust your sound level, record, and play back. With a little practice, you can perform this procedure in less than a minute. I promise that you will enjoy your time shooting video a lot more if you're confident that the audio is recording properly.

✔ *Riding the gain* is the practice of keeping an eye on the volume meter and a finger on the volume (gain) control. With a little practice, you can train yourself to anticipate moments when a presenter is about to speak loudly or softly. These subtle adjustments can prevent the presenter's voice from distorting or disappearing.

One more bit of advice: Avoid zooming the camera out to frame your subject, especially if you're in a close-up. Such a corrective zoom is like holding up a sign saying, "Whoops, I made a mistake here!" After you've zoomed in close, a smooth tilt or pan of the camera to get the person properly in frame almost always looks better than "searching" with a zoom movement.

Finally, if your camera has a digital zoom feature, I recommend that you turn it off. Digital zoom uses computer algorithms to go beyond the lens's physical capabilities for zoom. The numbers can be impressive — 320x optical zoom, for instance, as opposed to 10x or 16x — but the results aren't impressive. Most digital zooms look like spy camera footage at best. Unless you're trying to make the footage look like a shaking picture that's taken from the scope of an assassin's rifle, avoid using digital zoom. If you turn it off by default, you can't accidentally spill over into digital mode when you're pressing the zoom button.

Recording Sound

Recording great-quality audio is no simple matter. Professional recording studios spend thousands (sometimes even millions) of dollars to set up acoustically superior sound rooms. I'm guessing that you don't have that kind of budgetary firepower handy, but if you're recording your own sound, you can get pro-sounding results if you follow these basic tips:

✦ **Use an external microphone whenever possible.** The microphones that are built in to modern camcorders have improved greatly in recent years, but they still present problems. They often record undesired ambient sound near the camcorder (such as audience members at a play) or even mechanical sound from the camcorder's tape drive. If possible, connect an external microphone to the camcorder's mic input.

✦ **Eliminate unwanted noise sources.** If you *must* use the camcorder's built-in mic, be aware of your movements and other things that can cause loud, distracting noises on tape. Problem items can include a loose lens cap banging around, your finger rubbing against the mic, wind blowing across the mic, and the *swish-swish* of those nylon workout pants that you wore this morning. I discuss ambient noise in greater detail in the following section.

✦ **Obtain and use a high-quality microphone.** If you're recording narration or other audio in your "studio" (also known as your office), use the best microphone that you can afford. A good mic isn't cheap, but it can make a huge difference in recording quality. The cheap little microphone that came with your computer probably provides very poor results.

✦ **Position the microphone for best quality.** If possible, suspend the mic above the subject. This way, the microphone is less likely to pick up noises that are made by the subject's clothes or the bumping of the microphone stand.

✦ **Watch for trip hazards!** In your haste to record great sound, don't forget that your microphone cables can become an on-scene hazard. Not only is this a safety hazard to anyone walking by, but if someone snags a cable, your equipment could be damaged as well. If necessary, bring along some duct tape to temporarily cover cables that run across the floor.

Earlier I mention that you should plan which video scenes you want to record. Planning the *audio* scenes that you want to record is also important. For example, suppose I want to make a video about a visit to the beach. In such a project, I would like to have a consistent recording of waves crashing on the shore to use in the background. But if I record short, 5-to-10-second video clips, I'll never get a single, consistent *audio* clip. So, in addition to my various video clips, I plan to record a single, unbroken clip of the ocean.

Managing ambient noise

Ambient noise is the general noise that we don't usually think much about because it surrounds us constantly. Ambient noise can come from chirping birds, an airplane flying overhead, chattering bystanders, passing cars, a blowing furnace, the little fans that spin inside your computer, and even the tiny motor that turns the tape reels in your camcorder or tape recorder. Although it's easy to tune out these noises when you're immersed in them, they will turn up loud and ugly in your audio recordings later on.

If you're recording outdoors or in a public gathering place, you probably can't do much to eliminate the sources of ambient noise. But wherever you are recording, you can take the following basic steps to manage ambient noise:

✦ **Use a microphone.** I know, this is about the millionth time I've said it, but a microphone that's placed close to your subject can go a long way toward ensuring that the sound you *want* to record is not totally overwhelmed by ambient noise.

✦ **Wear headphones.** Camcorders and tape recorders almost always have headphone jacks. If you plug headphones into the headphone jack, you can listen to the audio that is being recorded — and possibly detect potential problems.

✦ **Shield the camcorder's mic from the wind.** A gentle breeze may seem almost silent to your ear, but the camcorder's microphone may pick it up as a loud roar that overwhelms all other sound. If nothing else, you can position your hand to block wind from blowing directly across the screen on the front of your camcorder's mic.

✦ **Try to minimize sound reflection.** Audio waves reflect off any hard surface, which can cause echoing in a recording. Hanging blankets on walls and other hard surfaces can significantly reduce reflection.

✦ **Turn off fans, heaters, and air conditioners.** Air that's rushing through vents creates a surprising amount of unwanted ambient noise. If possible, temporarily turn off your furnace, air conditioner, or fans while you record your audio.

✦ **Turn off cell phones and pagers.** You know how annoying it is when someone's cell phone rings while you're trying to *watch* a movie; just imagine how bothersome it is when you're *making* a movie! Make sure that you and everyone else on the set turns those things off. Even the sound of a vibrating pager may be picked up by your microphones.

✦ **Shut down your computer.** Obviously this is impossible if you are recording using a microphone that is connected to your computer, but computers tend to make a lot of noise, so shut them down if you can.

✦ **Warn everyone else to be quiet.** If other people are in the building or general area, ask them to be quiet while you're recording audio. Noises from the next room may be muffled, but they still contribute to ambient noise. Likewise, you may want to wait until your neighbor is done mowing his lawn before recording your audio.

✦ **Record and preview some audio.** Record a bit of audio, and then play it back. This can help you identify ambient noise or other audio problems.

Creating your own sound effects

As you watch a TV show or movie, it is easy to forget that many of the subtle sounds that you hear are actually sound effects that were added during editing, rather than "real" sounds that were recorded with the video image. This is often because the microphone was focused on the voice of a speaking subject as opposed to other actions in the scene. Subtle sounds like footsteps, a knock on the door, or splashing water are often recorded separately and added to the movie later. These sound effects are often called *Foley sounds* by movie pros, and someone who makes Foley sounds is called a *Foley artist*. Foley sound effects are named after audio pioneer Jack Foley, who invented the technique in the 1950s.

Recording your own sound effects is pretty easy. Many sounds can actually sound better in a video project if they're simulated, as opposed to recording the real thing. Consider the following examples:

✦ **Breaking bone:** Snap carrots or celery in half. Fruit and vegetables can be used to produce many disgusting sounds, and they don't complain about being broken in half nearly as much as human actors.

✦ **Buzzing insect:** Wrap wax paper tightly around a comb, place your lips so that they are just barely touching the paper, and hum so that the wax paper makes a buzzing sound.

✦ **Fire:** Crumple cellophane or wax paper to simulate the sound of a crackling fire.

✦ **Footsteps:** Hold two shoes and tap the heels together followed by the toes. Experiment with different shoe types for different sounds. This may take some practice to get the timing of each footstep just right.

✦ **Gravel or snow:** Walk on cat litter to simulate the sound of walking through snow or gravel.

✦ **Horse hooves:** This is one of *the* classic sound effects. The clop-clop-clopping of horse hooves is often made by clapping two halves of a coconut shell together.

✦ **Kiss:** Pucker up and give your forearm a nice big smooch to make the sound of a kiss.

✦ **Punch:** Punch a raw piece of steak or a raw chicken.

✦ **Thunder:** Shake a large piece of sheet metal to simulate a thunderstorm.

✦ **Town bell:** To replicate the sound of a large bell ringing, hold the handle of a metal stew pot lid and tap the edge with a spoon or other metal object. Experiment with various strikers and lids to get just the right effect.

Some sound effects may be included with your editing software or are available for download. Pinnacle Studio, for example, comes with a diverse library of sound effects, which you can access by clicking the Show Sound Effects tab or by choosing Album➪Sound Effects. If the sound effects aren't currently listed, navigate to the folder `C:\Program Files\Pinnacle\Studio 8\ Sound Effects` and then open one of the 13 sound-effect category folders, such as `\Animals` or `\Squeaks`.

Apple iMovie also includes some built-in sound effects. Open iMovie, and click the Audio button. To view a list of sound effects, make sure that you have iMovie Sound Effects listed in the menu at the top of the audio browser (as shown in Figure 5-13). You may also be able to download additional sound effects periodically from the following Web site:

`www.apple.com/imovie/audio_effects.html`

If you use Windows Movie Maker, you may be able to download free sound effects from Microsoft. Visit the following Web site, and look for links to downloadable sound effects:

`www.microsoft.com/windowsxp/moviemaker/`

If you are using another video-editing program, check the documentation or visit the publisher's Web site to see whether free sound effects are available.

Choose iMovie sound effects here

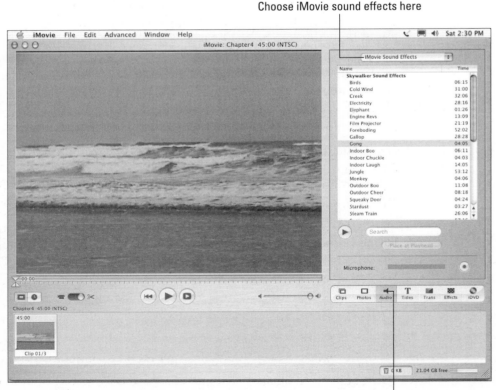

Figure 5-13: Many video programs include sound effects that you can use in your movies.

Click to view audio effects

Chapter 6: Importing Video Clips

In This Chapter

✔ **Getting ready to capture digital video**

✔ **Capturing digital video**

✔ **Troubleshooting video-capture problems**

✔ **Capturing analog video**

*S*oftware vendors all over the computer world have been rushing to offer programs that allow you to create and edit exciting movies on your computer. Video-editing programs have even become basic components of modern PC operating systems. Just as Microsoft Windows and the Apple Macintosh OS X come with Internet browsers, e-mail programs, and even text editors, current versions of Windows and the Mac OS include free tools to help you make movies. Windows XP includes a program called Windows Movie Maker, and Mac OS X comes with iMovie.

But all the video-editing software in the world doesn't do you much good if you don't have some actual video to edit. Thanks to FireWire (a new technology that allows computers and camcorders to easily share video) and a few other technologies, transferring video from the tape in your camcorder to the hard drive in your computer is easy. This chapter shows you how. I also show you how to work with video that was shot with an analog camcorder or transferred from a VHS videotape to your computer.

Preparing for Digital Video Capture

The process of transferring video to your computer is often called *capturing*. Capturing digital video is pretty easy, but you should take some specific steps to ensure that everything goes smoothly. In this section, I detail those steps for you. In the next section, I discuss capturing digital video with Studio and iMovie.

Your computer needs the right components to capture video — which means (among other things) that you need to have a FireWire or other capture card installed. For step-by-step instruction on adding a card to your PC, visit Chapter 2 of Book III.

Why is the process of transferring video to the hard drive called *capturing* instead of just *copying*? Even though the video is stored as digital data on your camcorder tape, that data must be converted to a computer file to be stored on your hard drive. *Capturing* is the process of turning video data into a computer file.

Turning off unnecessary programs

If you are like most people, you probably have several different programs running on your computer right now. Video capture requires a lot of available memory and processor power, and every running program on your computer uses some of those resources. E-mail, Web browser, and MP3 jukebox? Close 'em. Cute desktop schemes and screen savers? Disable those, too. I even recommend that you temporarily disable your antivirus software during video capture.

If you're using Windows, take a look at the system tray. (That's the area in the lower-right corner of your screen, next to the clock.) Every little icon that you see down there is a running program. Right-click each icon, and close or disable as many of them as possible. Eventually (well, okay, ideally) your system tray and taskbar look something like what's shown in Figure 6-1. You don't have to get rid of every item, but try to close or disable as many as possible. After all, it's a temporary arrangement. You should also disable your Internet connection during video capture. You can reactivate system tray items later — including your antivirus software — by simply restarting your computer.

If you're using a Macintosh, look at the Mac OS X Dock to make sure that your programs are closed. (An active program has a little arrow under it, as shown in Figure 6-2.) To exit a program, click its icon in the Dock and press ⌘+Q. The only icon that you can't close is the Finder, of course.

Figure 6-1:
The Windows Taskbar ideally looks like this when you're ready to capture video.

System tray

Figure 6-2:
Use the Mac OS X Dock to make sure that all open programs are closed.

The Finder icon

An active program

Defragmenting your hard drive

When your computer's operating system puts files on your hard drive, those files may wind up spread all over the place. This means that even if

you have 60GB of free space, that 60GB may be broken up into little chunks here and there. This can cause trouble during video capture, especially with Windows machines — and *most* especially with version of Windows before Windows XP (such as Windows Me). Even if you have a Mac, defragmenting is still a good regular computer maintenance practice, and if you experience dropped frames during video capture, defragmentation can only help.

I recommend that you defragment your hard drive monthly, or right before video capture if the drive hasn't been defragmented recently. Defragmentation organizes the files on your hard drive so that the empty space is in larger, more usable chunks. Some computer experts will probably tell you that defragmentation isn't as important with modern operating systems like OS X and Windows XP, but that advice does not apply when you're working with video. Video is one of the few remaining tasks that still requires a defragmented hard drive.

To defragment a hard drive in Windows, choose Start⇨All Programs⇨ Accessories⇨System Tools⇨Disk Defragmenter. Choose the hard drive that you want to defragment, and click the Defragment button (in Windows XP) or the OK button (in Windows Me and earlier versions).

The Macintosh OS doesn't come with a built-in defragmenter, but you can use an aftermarket defragmentation utility such as Norton Disk Doctor.

Making room for video files

Video files need a lot of space. Digital video typically uses 3.6MB of space per second, which (if you do the math) means that you need 1GB of space to hold about 5 minutes of video. You also need working space on the hard drive — so figure out approximately how much video you want to capture and multiply that number by 4. For example, to capture about 15 minutes of video, you'll need at least 3GB of drive space to store it. Multiply that by 4 (as a general rule) to figure out that you should have at least 12GB of free space on your hard drive to get the job done.

When I say that you need at least 12GB of space for 15 minutes of video, I do mean *at least*. Even though hard drive space may appear empty, your operating system — as well as your video-editing program — has to use that empty space periodically while working in the background. When it comes to hard-drive space, more really is better when you're working with video.

The first thing that you need to do is to figure out how much free space is available on your hard drive. In Windows, open My Computer (Choose Start⇨My Computer). Right-click the icon that represents your hard drive, and choose Properties from the menu that appears. The Properties dialog box appears, which is similar to the one shown in Figure 6-3. It tells you (among other things) how much free space is available. Click the OK button to close the dialog box.

On a Macintosh, click the icon for your hard drive once; then press ⌘+I. An Info dialog box (similar to Figure 6-4) appears, showing you how much free space is available. Click the Close button or press ⌘+Q to close the Info dialog box.

Figure 6-3:
This hard drive has plenty of free space to capture some video.

Figure 6-4:
This hard drive has 20.74GB of free space available.

What if you need more space? Your options may be limited, but consider the following items:

✦ **Take out the garbage.** Empty the Recycle Bin (in Windows) or Trash (on a Mac).

✦ **Delete unneeded Internet files.** The cache for your Web browser could be taking up a lot of hard-drive space. The Windows Disk Cleanup utility (pictured in Figure 6-3) can help you get rid of these and other unnecessary files. On a Mac, you can empty the cache or control how much drive space is devoted to cache by using the Preferences window for your Web browser.

✦ **Add a hard drive to your computer.** Adding a second hard drive to your computer can be a little complicated, but it's certainly one good way to gain more storage space.

Connecting a digital camcorder to your computer

Before you can edit video on your computer, you need to get the video *into* the computer somehow. Sorry, a shoehorn doesn't work — you usually connect a cable between your camcorder and the FireWire or USB port on your computer. Of the two, FireWire (also called IEEE 1394) is usually preferable.

FireWire ports have two basic styles: 6-pin and 4-pin. Note that I'm talking about the original FireWire port here, now affectionately called FireWire 400. The second-generation FireWire standard, called FireWire 800, is twice as fast but uses a different type of connector. It's currently available only on the latest and most expensive Mac computers. The FireWire 400 port on your computer probably uses a 6-pin connector, and the port on your camcorder probably uses a 4-pin connector. This means that you may need to buy a 6-pin–to–4-pin FireWire cable, if you don't already have one. Figure 6-5 illustrates the differences between FireWire 400 connectors.

Book II
Chapter 6

Importing Video Clips

Figure 6-5:
The two styles of FireWire connectors are 6-pin and 4-pin.

6-pin

4-pin

The FireWire connector on your camcorder may not be labeled "FireWire." It may be called IEEE 1394 (the "official" term for FireWire), DV, or i.Link. In any case, if the camcorder is digital and it has a port that looks like one of the connectors that are shown in Figure 6-5, it's FireWire compatible.

FireWire is a *hot-swappable* port technology. This means that you don't have to power off your computer when you want to connect a camcorder or other FireWire device to a FireWire port. Just plug in the device and turn it on, and away you go. (Meanwhile, you may want to practice saying buzzwords like *hot-swappable* with a straight face.)

Connect the FireWire cable between the camcorder and your computer, and then power on your camcorder. Your camcorder probably has two power modes. One is a *camera* mode, which is the mode that you use when you shoot video. The second mode is a *player* or *VTR* mode. This second mode is the one that you should turn on when you prepare to capture video from the camcorder's tape into your computer.

When you turn on the camcorder, your Windows PC will probably chime and then display the Digital Video Device window, which asks you what you want to do. This window is one of those handy yet slightly annoying features that tries to make everything more automatic in Windows. Click the Cancel button to close that window for now.

One really cool feature of FireWire is a technology called *device control*. In effect, this technology allows software on your computer to control devices that are connected to your FireWire ports — including digital camcorders. This means that when you want to play, rewind, or pause video playback on the camcorder, you can usually do it by using the Play, Rewind, Pause, and other control buttons in your Pinnacle Studio or Apple iMovie application.

Some camcorders can use USB (Universal Serial Bus) ports instead of FireWire ports. The nice thing about USB ports is that — unlike FireWire ports — virtually all PCs that were made in the last 5 years have them. The not-so-nice thing is that USB 1.1 ports are too slow to handle full-quality video. (USB 2.0 ports are fine because the speed of a USB 2.0 transfer is actually faster than standard FireWire.) Pinnacle Studio and Apple iMovie can capture from USB cameras using the same procedures that I describe in the next section, but you may find that the video quality is reduced when capturing using a USB 1.1 connection. Therefore, I recommend that you use FireWire or USB 2.0 whenever possible.

Capturing Digital Video

Modern video-editing software makes capturing really easy. In the following sections, I show you how to capture video using Pinnacle Studio (on a Windows PC) and iMovie (on a Mac). Fortunately, the capture process in most programs is pretty similar, so you should be able to follow along regardless of what software you are using.

Even if your FireWire card came with a separate capture utility, I recommend that you capture video in the program that you plan to use for editing whenever possible. That way, you don't have to go through the trouble of figuring out how to get the video from that capture utility into your desired editing program.

Capturing video in Pinnacle Studio

Pinnacle Studio for Windows offers an amazing level of moviemaking power for its price. The software is available by itself for a suggested retail price of $99, or you can buy it bundled with digital (FireWire) or analog video-capture cards for about $30 more. Other bundling deals include the Studio software, capture hardware, and the Hollywood FX plug-in (which adds advanced video-editing tools to the basic Studio package).

To begin the capture process in Studio, click the Capture tab or choose View➪Capture. The Capture mode appears, as shown in Figure 6-6.

Setting capture options

Pinnacle Studio has some cool options for capturing video. Unlike most affordable video-editing software, Studio supports online and offline editing. Studio facilitates offline editing using the Preview-quality capture mode. When capturing video with Studio, you can choose one of the following basic quality settings:

✦ **DV full-quality capture:** Choose this option if you plan to export your movie to videotape — and you have a generous amount of hard-drive space to use.

✦ **MPEG full-quality capture:** Choose this option if you plan to output your video to a VCD, S-VCD, DVD, or the Internet. MPEG capture can be further customized by using some suboptions that I describe in the next section.

✦ **Preview-quality capture:** Choose this option to capture a lot of video to your hard drive when storage space is a concern. With this option, Studio captures video at a lower quality, which results in a smaller file size. Later, when you're done editing, Studio recaptures — at full DV quality — only the portions that you want for your final movie; all your edits are automatically applied to the full-quality video.

If you're not quite satisfied with the quality of the preview that you get, you can customize Preview-quality capture with suboptions that I describe in the section "Previewing your capture settings," later in this chapter.

In addition to the three basic quality settings, Studio provides you with a variety of other capture options. You can find these options in the lower-right portion of the screen (as shown in Figure 6-6). One of the things that you can customize is the storage location for your captured video, which is often called the *scratch disk.* Click the folder icon to review the scratch disk folder, and change it if you want. For example, you may have a second hard drive that you want to use for video storage. The default location for your scratch disk is as follows:

```
C:\My Documents\Pinnacle Studio\Captured Video
```

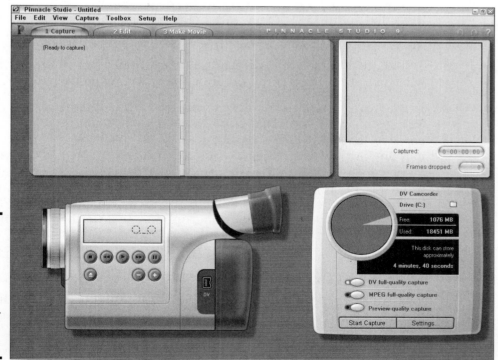

Figure 6-6:
The Studio Capture mode provides a friendly interface for capturing video.

This folder is created automatically when you install Studio on your computer.

You can also specify a variety of other capture settings. Click the Settings button in the lower-right corner of the screen to open the Pinnacle Studio Setup Options dialog box. Click the Capture Source tab to bring it to the front, as shown in Figure 6-7.

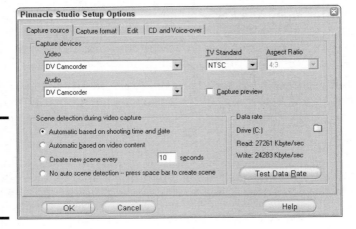

Figure 6-7:
Choose basic capture options here.

This dialog box contains a lot of options and settings, but only two of them are important for right now. First, I strongly recommend that you deselect the Capture Preview check box, which is on the Capture Source tab. When this check box is selected, Studio shows a preview of the video on-screen as you capture it. This preview uses valuable memory and processor power that is better devoted to the actual video-capture process. You can still view the video on the LCD or viewfinder of your camcorder, so the on-screen preview is redundant.

Second, review the scene-detection settings. Studio can automatically detect when one scene ends and another begins and automatically turn each scene into a separate video clip. This comes in handy during editing, but if you don't like the feature, you can select the No Auto Scene Detection — Press Space Bar to Create Scene radio button. Otherwise, I recommend that you keep the default setting, as shown in Figure 6-7.

After you have changed these settings, click the Capture Format tab to bring it to the front. If you are using the DV capture preset, you can't customize any of the settings on this tab. But if you are using the MPEG or Preview preset, you can adjust some options, as described in the next two sections.

Checking MPEG capture settings

If you're using the MPEG preset (your current preset is shown in the drop-down list in the upper-left corner of the Capture Format tab), you can choose a standard group of settings or customize your settings (as shown in Figure 6-8). You can adjust the following MPEG capture settings:

✦ **Sub-Preset:** Choose a sub-preset from the menu that's shown in Figure 6-8. Sub-presets include High quality (DVD), Medium quality (SVCD), Low quality (Video CD), and Custom. If you choose Custom, you can modify the remaining settings. If you choose the High, Medium, or Low quality sub-presets, the remaining options are grayed out.

✦ **MPEG Type:** Choose MPEG1 to make sure that your final movie is compatible with the widest variety of computers, or choose MPEG2 for slightly better quality.

✦ **Resolution:** This is the screen size, in width and height in pixels, of the image that you will capture. The size for full-quality DV is 720×480. A smaller size means a smaller image, but it also means that the file sizes for your video will be much smaller.

✦ **Pre-Filter:** If you're capturing at a smaller resolution, select this check box to improve the appearance of the image slightly (at the cost of sharpness).

✦ **Fast Encode:** This option speeds up the capture process, but it can reduce quality.

✦ **Data Rate:** You can fine-tune quality and file size by adjusting the data rate. To adjust the data rate, move the slider back and forth. Lower data rates mean smaller files but also lower quality. In most cases, you should keep the default data rate setting.

✦ **Include Audio:** If you want to capture only the video image from your tape, and not the audio, deselect this check box.

✦ **MPEG Capture:** This list box helps you tailor capture to the speed of your computer. The safest option is to simply select the Use Default Encoding Mode entry from the list box. If your computer is very fast (with a 2-GHz or faster processor), you can make capture more efficient by selecting the Encode in Real Time entry from the list box. If your computer is slower (with a 1-GHz or slower processor), select the Encode After Capturing entry from the list box if you encounter dropped frames or other problems during capture.

When you're done setting capture-format options, click the OK button to close the Pinnacle Studio Setup Options dialog box.

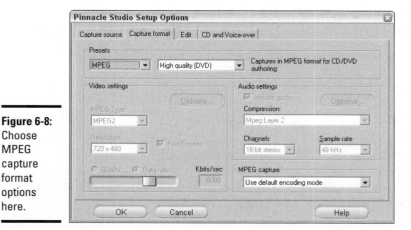

Figure 6-8: Choose MPEG capture format options here.

Previewing your capture settings

Pinnacle Studio's Preview capture mode is an excellent tool because it lets you store more source material on your hard drive for editing purposes without using up so much drive space. Like MPEG capture, if you choose the Preview preset in the main capture window (see Figure 6-6) and then click the Settings button, you have a group of sub-presets to choose from on the Capture Format tab (see Figure 6-8). It's usually best to just use one of the sub-presets, but if you choose Custom quality, you can also adjust the following settings:

✦ **List All Codecs:** Choose this option to list all the codecs that are installed on your system. (*Codecs* are compressor/decompressor schemes for audio and video.) I don't recommend using this option because some of the codecs that are installed on your computer may not be compatible with the Pinnacle Studio software.

✦ **Compression:** Here you can choose a specific codec. For most preview captures, the Intel Indeo Video R3.2 or PCLEPIM1 32-bit Compressor codec is fine.

✦ **Width and Height:** Here you can choose a custom size for the video. Remember, the smaller the size, the less hard-drive space you need. If you're using a PIM1 codec, I recommend a frame size of 352×240 or smaller. For Indeo codecs, use 360×240 or smaller.

✦ **Frame rate:** The default frame rate for NTSC video is 29.97, but your files will be much smaller if you choose 14.985. If you're working with PAL video, you can choose a frame rate of 25 or 12.5. A lower frame rate means that the video image won't be quite as smooth, but because it's only preview quality, this usually isn't a big deal.

✦ **Quality or Data Rate:** Select either the Quality or Data Rate radio button, and then use this slider to adjust the quality or data rate for the capture. It doesn't matter whether you choose Quality or Data Rate; the end result is the same. Remember, lower quality (or data rate) means smaller file sizes.

✦ **Include Audio:** Deselect this check box if you want to capture video only.

✦ **Channels:** Choose between 16-bit stereo (for better-audio quality) or 16-bit mono (for smaller files).

✦ **Sample Rate:** You can probably say it with me by now: Higher sample rates provide better quality; lower sample rates produce smaller files.

When you're done setting capture-format options, click the OK button to close the Pinnacle Studio Setup Options dialog box.

Capturing video

When you finally have your capture settings just the way you want them, you're ready to capture. To do so, simply follow these steps:

1. **Connect your camcorder to your FireWire port, as described in the "Preparing for Digital Video Capture" section.**

2. **In Pinnacle Studio, click the Capture tab near the top of the window or choose View⇨Capture.**

3. **Configure your capture options (as described in the section "Checking MPEG capture settings," earlier in this chapter).**

4. **Use the camera controls (as shown in Figure 6-6) to shuttle the camcorder tape to the spot where you want to start capturing video.**

Shuttle is another fancy term that video pros like to use when they talk about moving a videotape. When you rewind or fast-forward a tape, you are shuttling it. See: You're already a video pro and you didn't even know it!

5. **Click the Start Capture button.**

The Capture Video dialog box appears, as shown in Figure 6-9.

Figure 6-9:
Enter a name and capture limit here.

6. **Enter a name for the capture; this name will be used as the filename for the captured video later. You can also enter a time limit for the capture.**

By default, the time that is shown reflects the amount of free space on your hard drive. Figure 6-9 shows that my hard drive has enough room to store 607 minutes and 21 seconds of video using my current quality settings. It's usually safe to just leave this number alone unless you want Pinnacle to automatically stop capturing after a certain amount of time. For example, if I know that I want to capture only the first 5 minutes, I can enter 5 in the minutes field and 0 in the seconds field. Then I can go and get a cup of coffee or do something else without having to hurry back to manually stop capturing at some point. Pinnacle automatically stops capturing after 5 minutes have elapsed.

7. **Click the Start Capture button.**

Studio automatically starts playing your camcorder and capturing video.

8. **When you want to stop capturing, click the Stop Capture button or press Esc.**

As Studio captures your video, keep an eye on the Preview window, even if you have disabled on-screen preview in the capture settings. The Frames Dropped field should remain at 0. Dropped frames are a serious quality problem, but they can often be resolved. If you drop some frames, see the section "Frames drop out during capture," later in this chapter.

Capturing video in Apple iMovie

Apple's iMovie doesn't offer quite as many capture options as Pinnacle Studio, but the capture process is simple and effective nonetheless. In fact, you can set just two capture options. To adjust capture preferences, choose iMovie⇨Preferences. The Preferences dialog box appears, as shown in Figure 6-10. The two options that relate to video capture are as follows:

✦ **New Clips Go To:** This default setting sends incoming clips to the Clips Pane. This is the best place to send new clips, unless you want to quickly convert your imported video into a movie without any editing. What's the fun in that?

✦ **Automatically Start New Clip at Scene Break:** iMovie automatically recognizes when one scene ends and a new one begins. This useful feature often makes editing easier, so I recommend that you leave this check box selected.

Figure 6-10: Import options also apply to captured video.

The iMovie interface is simple and easy to use. To capture video, follow these steps:

1. **Connect your camcorder to the FireWire port (as described in the section "Connecting a digital camcorder to your computer," earlier in this chapter).**

2. **Switch the camera to VTR mode.**

3. **In iMovie, click the Camera button to switch iMovie to the Camera mode.**

The Preview pane displays the message `Camera Connected`, as shown in Figure 6-11.

4. **Use the camera controls to identify a portion of video that you want to capture.**

When you are ready, rewind the tape about 10 seconds before the point at which you want to start capturing.

5. **Click the Play button in the camera controls.**

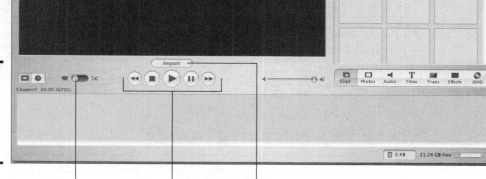

Figure 6-11: Capturing video in iMovie is pretty simple.

Camera button Camera controls Import button

6. **Click the Import button to start importing.**

7. **Click the Import button again to stop importing.**

It's just that simple. Your captured clips automatically appear in the Clips Pane, where you can then use them in your movie projects.

Troubleshooting Capture Problems

Video capture usually works pretty easily and efficiently with modern hardware, but some problems can still occur. Here's a quick tour of some common digital-capture problems — and their potential solutions.

You can't control your camera through your capture software

When you click the Play or Rewind button on the camera controls in your video-capture software, your digital camcorder *should* respond. If not, check the following items:

✦ **Check all the obvious things first:** Are the cables connected properly? Is your camcorder turned on to VTR mode? Does the camera have a dead battery?

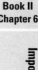

✦ **Did the camera automatically power down due to inactivity?** If so, check the camera's documentation to see whether you can temporarily disable the power-saver mode. Also, consider plugging the camera in to a charger or AC power adapter so that you aren't just running on battery juice.

✦ **Is your FireWire card installed correctly?** Open the System icon in the Performance and Maintenance section of the Windows Control Panel. Click the Hardware tab, and then click the Device Manager button. If you see a yellow exclamation mark under IEEE 1394 Bus host controllers, you have a hardware problem.

✦ **Is your camcorder supported?** Most modern digital camcorders are supported by Apple iMovie, Pinnacle Studio, Windows Movie Maker, and other programs. But if the software just doesn't seem to recognize the camera, check the software vendor's Web site (www.apple.com, www.pinnaclesys.com, or www.microsoft.com, respectively) for camera compatibility information. If your camera is so new that it wasn't originally supported by your editing software, check the publisher's Web site to see whether software updates are available to accommodate newer camcorder models.

Frames drop out during capture

Video usually captures about 30 frames per second, but if the capture process doesn't go smoothly, some of those frames could get missed or *dropped,* as video pros call it. *Dropped frames* show up as jerky video and cause all kinds of other editing problems, and they usually point an accusing finger at your hardware, for one of the following reasons:

✦ **Your computer isn't fast enough.** Does your computer meet the software's system requirements? How fast is the processor? Does it have enough RAM?

✦ **Your computer isn't operating efficiently.** Make sure that all unnecessary programs are closed, as I describe in the section "Turning off unnecessary programs," earlier in this chapter. You may also be able to tweak your computer's settings for better video-capture performance. Check out the OS Tweaks in the Tech Support section of www.videoguys.com for tips and tricks to help your computer make the best use of its resources.

✦ **You left programs running.** Make sure that your e-mail program, Internet browser, music jukebox, and other programs are closed. You should also disable your Internet connection during video capture, even if you have a broadband (cable modem or DSL) connection. When your connection is active, you probably have a few utilities running in the background that are looking for software updates to your operating system and other programs. A well-meaning message that updates are available for download can appear right in the middle of video capture, causing dropped frames.

✦ **Your hard drive can't handle the data rate.** Does your hard drive meet your software's performance requirements? If so, maybe some hard-drive maintenance is in order. Remember, the more stuff that is packed onto your hard drive, the slower it will be. This is one reason that I recommend (pretty often, in fact) that you *multiply the amount of space you think you'll need by 4.*

To keep your hard drive working efficiently and quickly, defragment your hard drive periodically (at least once a month). In Windows, choose Start➪All Programs➪Accessories➪System Tools➪Disk Defragmenter. On a Mac, you need to obtain a third-party disk-maintenance tool such as Norton Disk Doctor.

If you're using Pinnacle Studio, you can use that software to test your hard drive's data rate. In Studio, choose Setup➪Capture Source. In the Setup Options dialog box that appears, click the Test Data Rate button. Studio tests your data rate and lists the read, write, and Max safe speeds. The Max safe speed is a speed that Studio determines is necessary for glitch-free video capture. For DV-format video, the Max safe speed should be at least 4000 kilobytes per second.

Capture stops unexpectedly

If the capture process stops before you want it to, your culprit could be a mechanical glitch. Check the following items:

✦ **Did you forget to rewind the camcorder tape?** This is a classic "oops" that happens to nearly everyone sooner or later.

✦ **Is your hard drive full?** This is bad juju, by the way. Try to avoid filling your hard drive at all costs.

✦ **Is there a timecode break on the tape?** Inconsistent timecode on a digital videotape can create all sorts of havoc when software tries to capture video.

✦ **Did Fluffy or Junior step on the Esc key?** It happens. My cat has fouled more than one capture process. (Hey, biomechanical still counts as "mechanical," right?)

Capturing Analog Video? Yuck!

After all this talk about how great digital video is, you may be wondering why I devote an entire section to analog video. Most people assume that digital video is the new hotness and that analog video is just old and stinky.

Analog video *is* old and stinky, but you may still have some really good old video footage on analog tapes. Your daughter in middle school isn't going to be taking those first baby steps again, so if you have those steps on analog, you probably need to have a way to convert it to digital. If you have or used to have a VHS, VHS-C, S-VHS, 8mm, or Hi-8 camcorder, you can still capture video that was shot with those cameras into your computer. You can then edit it, put it online, or even burn it on a DVD. All you need is the right hardware. This section shows you how to use ye olde analog video with your brand new (or even not-so-new) computer.

Preparing for analog video capture

Earlier in this chapter, I show you how to capture digital video into your computer. If you have the right hardware — a digital camcorder and a

FireWire port — digital video is really easy to work with. Analog video can also be easy to capture *if you have the right hardware.* The next few sections help you prepare to capture analog video into your computer.

Unlike digital video, analog video is not compatible with computers. This is because all the data that computers work with is digital. Before you can use analog video in your computer, it must be converted to digital format, or be *digitized.* Analog video-capture hardware digitizes the video as it is captured.

Getting your computer ready to capture analog video is a lot like getting ready to capture digital video. Before you can capture analog video, you have to do the following things:

✦ **Set up your capture hardware.** I show you what hardware you need and how to set it up in the following section.

✦ **Turn off unnecessary programs.** Whether you're working with analog or digital video, your computer works more efficiently if you close all programs that are not needed for the capture process (as I demonstrate in the cleverly named section "Turning off unnecessary programs," earlier in this chapter).

✦ **Make sure that you have enough free space on your hard drive.** Five minutes of digital video uses about 1GB of hard-drive space. Unfortunately, no single, simple formula exists for figuring out how much space your analog video will require.

Digital video that was recorded with a MiniDV, MicroMV, or Digital8 camcorder uses the DV codec, which uses a steady 200 megabytes per minute of video. A *codec* (that's short for compressor/decompressor) is the software scheme that's used to compress video so that it fits reasonably on your computer. Some analog-capture devices let you choose from a list of different codecs to use during video capture; many codecs have settings that you can adjust. The codec that you use (and the settings that you select) can greatly affect both the quality of your capture video and the amount of space that it consumes on your hard drive. I show you how to adjust capture settings in the section "Adjusting analog video-capture settings in Studio," (another clever name!) later in this chapter.

Fortunately, most analog video-capture programs make it pretty easy to determine whether you have enough hard drive space. The Pinnacle Studio capture window, for example, shows you exactly how much free space is available on your hard drive, and it gives you an estimate of how much video you can capture using the current settings.

You need to leave some free space on your hard drive to ensure that your video-editing software and operating system can still work efficiently.

Setting up capture hardware

Before you can capture analog video, you need to have some way to connect your VCR or analog camcorder to your computer. To do so, you have two basic options. You can either use an analog-capture card or an external video converter. I describe each option in the next two sections.

Using a capture card

The best quality in analog video capture is available if you use a special video-capture card. Analog-capture cards are available at many computer and electronics retailers. A capture card connects to the motherboard inside your computer — so installation requires some expertise in working with computer hardware. Also, make sure that your computer has room to add an expansion card.

If you buy a capture card, make sure that it can capture analog video. Many FireWire cards are marketed as digital-video capture cards, but if you don't read the packaging carefully, you may be confused about the card's capabilities. If a FireWire card doesn't *specifically* say that it can *also* capture analog video, assume that it can't. Your analog capture card is likely to use an external breakout box, with analog connectors for capturing analog video. Most analog-capture cards have breakout boxes because enough room isn't usually available on the back of a narrow expansion card for all the necessary analog connectors.

**Book II
Chapter 6**

Importing Video Clips

If you decide to buy and install an analog-capture card in your computer, you should use the software that came with the card when you're ready to capture. A capture card normally comes with software that is optimized for that card.

After you have a capture card installed in your computer, all you need to do is connect your VCR or analog camcorder to the appropriate ports. Those ports are usually located on an external breakout box. You will probably have to choose from among the following kinds of connectors:

✦ **Composite:** Composite connectors — the most common type — are often used to connect video components in a home entertainment system. Composite connectors may also be called *RCA jacks* and use only one connector for the video signal. A composite video connector is usually color-coded yellow. Red and white composite connectors are for audio. Make sure that you connect all three.

✦ **S-Video:** S-Video connectors are found on many higher-quality analog camcorders as well as S-VHS VCRs. S-Video provides a higher-quality picture, so use it if it's available as an option. The S-Video connector only carries video, so you still need to use the red and white audio connectors for sound.

✦ **Component:** Component video connectors often look like composite connectors, but the video image is separated over three connectors that are color-coded red, green, and blue. The red cable is sometimes also labeled R-Y and carries the red portion of the video image, minus brightness information. The green cable (sometimes labeled Y) carries brightness information. Video geeks like to say *luminance* instead of brightness, but it means the same thing. The blue wire (sometimes labeled B-Y) carried the blue portion of the image, minus brightness. Component video provides a higher-quality video image, but it's usually found only on the most expensive, professional-grade video-capture cards. Like S-Video, component connectors don't carry audio, so you still need to hook up the red and white audio cables.

When you're done hooking everything up, you'll probably have quite a rat's nest of cables. Your capture software can't control your VCR or camcorder through the analog cables, so you'll have to manually press the Play button on the device before you can start capturing in the software.

Using a video converter

Video converters are kind of neat because they don't require you to break out the tools and open your computer case. As their name implies, video converters *convert* analog video to digital before it even gets inside your computer. The converter has connectors for your analog VCR or camcorder, and it connects to your computer via the FireWire port. Converters are available at many electronics retailers for about $200. Common video converters include the following:

✦ **Canopus ADVC-50:** www.canopuscorp.com

✦ **Data Video DAC-100:** www.datavideo-tek.com

✦ **Dazzle Hollywood DV Bridge:** www.dazzle.com

All three of these video converters are compatible with both Macintosh and Windows computers. Video converters pipe in video through a FireWire port — so as far as your computer is concerned, you're capturing digital video. Capturing analog video with a video converter is just like capturing digital video. The only difference is that you have to manually press the Play button on your analog camcorder or VCR before you start to capture.

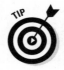

If you have a digital camcorder, you may be able to use it as a video converter for analog video. Digital camcorders have analog connectors so that you can connect them to a regular VCR. Connect a VCR to the camcorder, set up the camcorder and your computer for digital capture, and push the Play button on the VCR. If the video picture from the VCR appears on the capture-preview screen on your computer, you can use this setup to capture analog video. This should work without having to first record the video onto tape in your digital camcorder. This means that using your camcorder as a converter doesn't cause increased wear on the camcorder. Alas, some camcorders don't allow analog input while a FireWire cable is plugged in. You have to experiment with your own camera to find out whether this method works.

Capturing those analog clips

After you have your capture hardware set up and connected properly, you're ready to start capturing video. If you're using an external video converter that's connected to your computer's FireWire port, follow the instructions for digital capture in the section "Capturing Digital Video," earlier in this chapter. The only difference is that you have to manually press the Play button on the analog VCR or camcorder before you can start capturing.

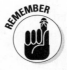

Apple iMovie can't capture video from an analog capture card. To capture analog video in iMovie, you must use a video converter that's connected to your Mac's FireWire port. Capturing video in this manner is just like capturing digital video, as I demonstrate in the section "Capturing video in Apple iMovie," earlier in this chapter.

The exact procedure for capturing analog video varies; it depends on the software that you're using. Because I feature Pinnacle Studio throughout this chapter, I show that program here for the sake of consistency. Begin by opening Studio, and then choose View➪Capture. Studio's capture window appears, as shown in Figure 6-6. The next section shows you how to adjust Studio's settings to get ready for analog capture.

Adjusting analog video-capture settings in Studio

To make sure that Studio is ready to capture analog video instead of digital video, click the Settings button at the bottom of the capture window. The Pinnacle Studio Setup Options dialog box appears. Click the Capture Source tab to bring it to the front. On that tab, review the following settings (refer to Figure 6-7):

✦ **Video:** Choose your analog capture source in this menu. The choices in the menu can vary, depending on the hardware that you have installed.

✦ **Audio:** This menu should match the Video menu.

✦ **Capture preview:** You should deselect this check box — selecting it may cause dropped frames (that is, some video frames are missed during the capture) on some computers.

✦ **Scene detection during video capture:** This setting determines when a new scene is created. For most purposes, I recommend selecting the Automatic Based on Video Content check box for analog capture.

✦ **Data rate:** This section tells you how fast your hard drive can read or write. Click the Test Data Rate button to get a current speed estimate. Ideally, both numbers should be higher than 10,000 kilobytes per second for analog capture. If your system can't reach that speed, see the discussion on optimizing your hard drive in the section "Defragmenting your hard drive," earlier in this chapter.

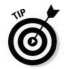

If you have trouble with dropped frames when you capture analog video, try disabling automatic scene detection by selecting the No Automatic Scene Detection radio button. Scene detection uses some computer resources, and it can cause some dropped frames if your computer isn't fast enough.

When you're done reviewing settings on the Capture Source tab, click the OK button to close the Setup Options dialog box. You are almost ready to begin capturing analog video. Like many analog video-capture programs, Studio lets you fine-tune the audio and video that will be captured. Click the buttons on either side of the capture controller to open the Video Input and Audio Capture control panels. These control panels allow you to adjust color, brightness, and audio levels of the incoming video.

On the Video Input control panel, first choose whether you're going to capture video from the Composite or S-Video connectors using the radio buttons under Video Input. The Audio Capture control panel allows you to turn audio capture on or off.

Now press the Play button on your VCR or camcorder to begin playing the video that you plan to capture, but don't start capturing it yet. As you play the analog video, watch the picture in the preview screen in the upper-right

corner of the Studio program window. If you don't like the picture quality, you can use the brightness, contrast, sharpness, hue, and color saturation sliders on the Video Input control panel to adjust the picture. Experiment a bit with the settings to achieve the best result.

As you play your analog tape, you'll probably notice that although you can see the video picture in the preview window, you can't hear the sound through your computer's speakers. That's okay. Keep an eye on the audio meters on the Audio Capture control panel. They should move up and down as the movie plays. Ideally, most audio should be in the high green or low yellow portion of the audio meters. Adjust the audio-level slider between the meters if the levels seem too high or too low. If the audio seems biased too much to the left or right, adjust the balance slider at the bottom of the control panel.

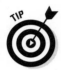

If you're lucky, the tape that you're going to capture from has color bars and a tone at the beginning or end. In that case, use the bars and tone to calibrate your video picture and sound. The tone is really handy because it's a standard 1-kHz tone that's designed specifically for calibrating audio levels. Adjust the audio-level slider so that both meters read just at the bottom of the yellow zone.

When you're done playing with the settings in the Video and Audio control panels, stop the tape in your VCR or camcorder and rewind it to where you want to begin capturing.

Capturing your analog video

Once all your settings are, uh, *set*, you're ready to start capturing — finally! I recommend that you rewind the tape in your VCR or camcorder to at least 15 seconds *before* the point at which you want to begin capturing. Then follow these steps to capture an analog video source:

1. **Click the Start Capture button at the bottom of the Studio capture window.**

2. **Enter a descriptive name for the capture.**

3. **To automatically stop capturing after a certain period of time, enter the maximum number of minutes and seconds for the capture.**

4. **Press the Play button on the VCR or camcorder.**

5. **Click the Start Capture button in the Capture Video dialog box.**

 The capture process begins, and you'll notice that the green Start Capture button changes to a red Stop Capture button. As Studio captures your video, keep an eye on the Frames Dropped field under the preview window. If any frames are dropped, try to determine the cause and then recapture the video. Common causes of dropped frames include programs that are running in the background, power-saver modes, or a hard drive that hasn't been recently defragmented.

6. **Click the Stop Capture button when you're done capturing.**

 Studio reviews the video that has been captured and improves scene detection if possible. When the process is done, the captured clips appear in Studio's clip album.

Chapter 7: Importing Audio

In This Chapter

✔ Audio fundamentals

✔ Recording audio

✔ Working with CD audio

✔ Using MP3 files

✔ Selecting the right microphone

We often think of movies as a purely visual medium. As a result, overlooking audio is easy. But most video and film professionals will tell you that audio is almost as important as — if not more important than — the visual picture. Those same pros will probably tell you that audiences can forgive or ignore a few visual flaws, but poor-quality audio immediately enhances the cheese factor of a movie.

Movie sound is a pretty big subject, which is why I devote not one but *two* chapters in this minibook to audio. This chapter helps you understand the fundamentals of audio, and it helps you obtain and record better quality audio. After you have some audio source material to work with, check out Chapter 17 for more on working with audio during the shoot.

Understanding Audio

Consider how audio affects the feel of a video program. Honking car horns on a busy street; crashing surf and calling seagulls at a beach; a howling wolf on the moors — these sounds help us identify a place as quickly as our eyes can, if not quicker. If a picture is worth a thousand words, sometimes a sound in your movie is worth a thousand pictures.

What is audio? Well, if I check my notes from high school science class, I get the impression that audio is produced by sound waves moving through the air. Human beings hear those sound waves when they make our eardrums vibrate. The speed at which a sound makes the eardrum vibrate is the *frequency*. Frequency is measured in kilohertz (kHz), and one kHz equals 1,000 vibrations per second. (You could say it really *hertz* when your eardrums vibrate. I'm sorry, I should have avoided that one.) A lower-frequency sound is perceived as a lower pitch or tone, and a higher-frequency sound is perceived as a high pitch or tone. The volume or intensity of audio is measured in *decibels* (dB).

Understanding sampling rates

For over a century, humans have been using analog devices (ranging from wax cylinders to magnetic tapes) to record sound waves. As with video, digital

audio recordings are all the rage today. Because a digital recording can only contain specific values, it can only approximate a continuous wave of sound. A digital recording device must *sample* a sound many times per second; the more samples per second, the more closely the recording approximates the live sound (although a digital approximation of a "wave" actually looks more like the stairs on an Aztec pyramid). The number of samples per second is called the *sampling rate.* As you might expect, a higher sampling rate provides better recording quality. CD audio typically has a sampling rate of 44.1 kHz — that's 44,100 samples per second — and most digital camcorders can record at a sampling rate of 48 kHz. You will work with the sampling rate when you adjust the settings on your camcorder, import audio into your computer, and export movie projects when they're done.

Delving into bit depth

Another term you'll hear bandied about in audio editing is *bit depth.* The quality of a digital audio recording is affected by the number of samples per second, as well as by how much information each sample contains. The amount of information that can be recorded per sample is the bit depth. More bits per sample mean more information — and generally richer sound.

Many digital recorders and camcorders offer a choice between 12-bit and 16-bit audio; choose the 16-bit setting whenever possible. For some reason, many digital camcorders come from the factory set to record 12-bit audio. Using the lower setting doesn't give you any advantage, so always check your camcorder's documentation and adjust the audio-recording bit depth up to 16-bit if it isn't there already.

Recording Audio

At some point, you'll probably want to record some narration or other sound to go along with your movie project. Recording great-quality audio is no simple matter. You can get nearly pro-sounding results by following the basic tips I provide in Book II, Chapter 4. The easiest way to record audio is with a microphone connected to your computer, although some computers can make a lot of noise with their whirring hard disks, spinning fans, and buzzing monitors. The following sections show you how to record audio using a microphone connected to the microphone jack on your computer.

Recording audio with your Macintosh

You can record audio directly in iMovie. In fact, if you have an iMac, PowerBook, or newer iBook, your computer already has a built-in microphone. It will work for very basic narration, but keep in mind that the built-in mic does not record studio-quality sound. If you have a better mic, connect it to the computer's external microphone jack. The following sections show you how to set up your microphone and record audio.

Setting up an external microphone

Some microphones can connect to the USB port on your Mac. A USB microphone is easier to use because your Mac automatically recognizes it and selects the USB mic as your primary recording source. If your external microphone connects to the regular analog microphone jack — and your Mac already has a built-in mic — you may find that iMovie doesn't recognize your external microphone. To correct this problem, you must adjust the Sound settings within Mac OS X:

1. **Open the System Preferences window by choosing Apple⊅System Preferences.**

2. **Click the Sound icon to open the Sound Preferences dialog box.**

3. **Click the Input tab to bring it to the front.**

4. **Click the External Microphone/Line In entry in the device list box.**

5. **Press ⌘+Q to close the Sound Preferences dialog box and System Preferences.**

Your external microphone should now be configured for use in iMovie.

Recording in iMovie

After you decide which microphone to use and configure it as described in the previous section, you're ready to record audio using iMovie. As with most tasks in iMovie, recording is pretty easy:

1. **Open the project for which you want to record narration or other sounds, and switch to the timeline view if you're not there already.**

 If you don't have a project yet and just want to record some audio, that's okay too.

2. **If you're working with a current movie project, move the play head to the spot where you want to begin recording.**

3. **Click the Audio button above the timeline to open the audio pane (shown in Figure 7-1).**

4. **Say a few words to test the audio levels.**

 As your microphone picks up sound, the audio meter in iMovie should indicate the recording level. If the meter doesn't move at all, your microphone probably isn't working. You'll notice that as sound levels rise, the meter changes from green to yellow and finally red. For best results, try to keep the sound levels close to the yellow part of the meter.

 If the audio levels are too low, the recording may have a lot of unwanted noise relative to the recorded voice or sound. If levels are too high, the audio recording could pop and sound distorted. Unfortunately, iMovie doesn't offer an audio level adjustment for audio you record, so you'll have to fine-tune levels the old fashioned way, by changing the distance between the microphone and your subject.

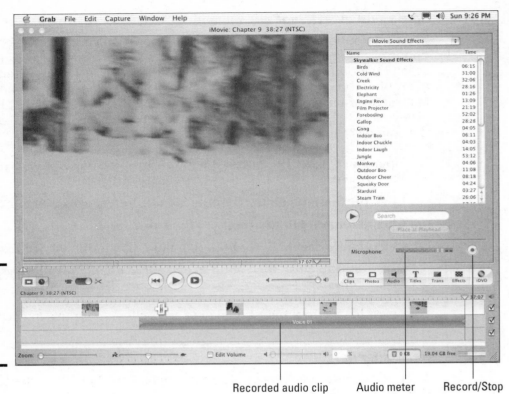

Figure 7-1:
You can record audio directly in iMovie.

Recorded audio clip Audio meter Record/Stop

5. Click Record and begin your narration.

The movie project plays as you recite your narration.

6. When you're done, click Stop.

An audio clip of your narration appears on the timeline.

Recording voice-over tracks in Pinnacle Studio

Recording audio in Windows is pretty easy. Most video-editing programs — including Pinnacle Studio and Windows Movie Maker — give you the capability to record audio directly in the software. Before you can record audio, however, your computer must have a sound card and a microphone. (If your computer has speakers, it has a sound card.) The sound card should have a connector for a microphone as well. Check the documentation for your computer if you can't find the microphone connector.

After your hardware is set up correctly, you're ready to record audio in Pinnacle Studio or most any other movie-making program. To record audio in Studio, follow these steps:

1. Open the movie project for which you want to record audio, and switch to the timeline view if you aren't there already.

If you don't have a project yet and just want to record some audio, that's okay too.

2. **If you're working with a current movie project, move the play head to the spot where you want to begin recording.**

3. **Choose Toolbox➪Record Voice-over.**

 The voice-over recording studio appears, as shown in Figure 7-2.

4. **Say a few words to test the audio levels.**

 As your microphone picks up sound, the audio meter in Studio should indicate the recording level. If the meter doesn't move at all, your microphone probably isn't working. You'll notice that as sound levels rise, the meter changes from green to yellow and finally red. For best results, try to keep the sound levels in or near the yellow part of the meter. You can fine-tune the levels by adjusting the recording volume slider.

5. **Click Record.**

 A visible three-second countdown appears in the recording-studio window, giving you a couple of seconds to get ready.

6. **When recording begins and your movie project starts to play, recite your narration.**

7. **When you're done, click Stop.**

 An audio clip of your narration appears on the timeline.

Recording volume

Record/Stop Audio meter

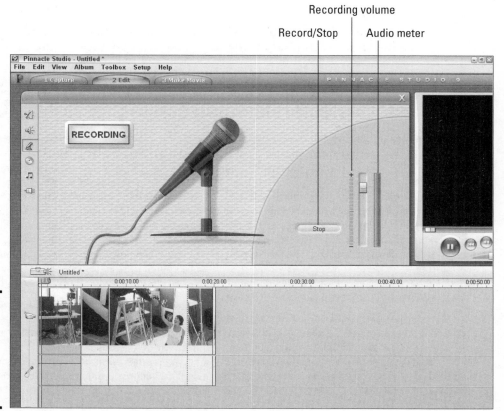

Figure 7-2:
Studio
includes its
own, er,
studio for
recording
audio.

Working with CD Audio

If you're even remotely interested in technology — and because you're reading this book, I'll go out on a limb and guess that you are — you probably started upgrading your music collection to compact discs (CDs) many years ago. At some point, you'll probably want to use some of the music on those CDs for your movie soundtracks. Most editing programs make it pretty easy to use CD audio in your movie projects. The next few sections show you how to use CD audio in Pinnacle Studio and iMovie.

Importing CD audio in iMovie

If you're using Apple iMovie, you can take audio directly from your iTunes library or import audio from an audio CD. Here's the basic drill:

1. **Put an audio CD in your CD-ROM drive, and then click the Audio button above the timeline on the right side of the iMovie screen.**

 The audio pane appears, as shown in Figure 7-3.

2. **If iMovie Sound Effects are currently shown, open the pull-down menu at the top of the audio pane and choose Audio CD.**

 A list of audio tracks appears, as shown in Figure 7-3.

3. **Select a track and click the Play button in the audio pane to preview the song.**

4. **Click the Place at Playhead button in the Audio panel to place the song on the timeline, beginning at the current position of the play head.**

Comprehending copyrights

As I show throughout this chapter, you can easily import music into your computer for use in your movies. The tricky part is obtaining the rights to use that music legally. Realistically, if you're making a video of your daughter's birthday party, and you plan to share that video with only a grandparent or two, Kool and the Gang probably don't care if you use the song "Celebration" as a musical soundtrack. But if you start distributing that movie all over the Internet — or (even worse) start selling it — you could have a problem that involves the band, the record company, and lots and lots of lawyers.

The key to using music legally is licensing. You can license the right to use just about any music you want, but it can get expensive. Licensing "Celebration" for your movie project (for example) could cost hundreds of dollars or more. Fortunately, more affordable alternatives exist. Numerous companies offer CDs and online libraries of stock audio and music, which you can license for as little as $30 or $40. You can find these resources by searching the Web for *royalty free music* or by visiting a site such as www.royaltyfree.com or www.royalty freemusic.com. You usually must pay a fee to download or purchase the music initially, but after you have purchased it, you can use the music however you'd like. If you use audio from such a resource, make sure you read the licensing agreement carefully. Even though the music is called "royalty free," you still may be restricted on how many copies you can distribute, how much money you can charge, or what formats you can offer.

Another — more affordable — alternative may be to use the stock audio that comes with some moviemaking software. Pinnacle Studio, for example, comes with a tool called SmartSound that automatically generates music in a variety of styles and moods. Although you should always carefully review the software license agreements to be sure, normally the audio that comes with moviemaking software can be used in your movie projects free of royalties.

Choose audio CD

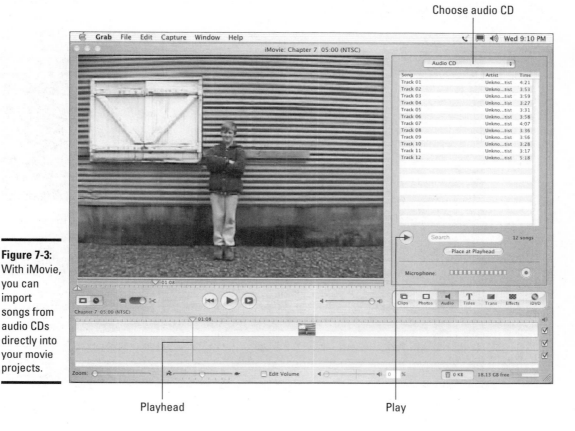

Figure 7-3:
With iMovie, you can import songs from audio CDs directly into your movie projects.

Playhead

Play

Importing CD audio in Studio

Pinnacle Studio provides an audio toolbox to help you work with CD audio and other formats. To open the audio toolbox in Studio, place an audio CD in your CD-ROM drive and choose Toolbox⊅Add CD Music. You may be asked to enter a title for the CD. The exact title doesn't matter, as long as it's something you will be able to identify and remember later. The audio toolbox then appears (see Figure 7-4), which enables you to perform a variety of actions:

✦ Choose audio tracks from the CD by using the Track drop-down list.

✦ Use playback controls in the audio toolbox to preview audio tracks.

✦ Add only a portion of the audio clip to your movie by adjusting the in point and out point markers.

✦ Add a track to the movie as a clip in the background music track at the bottom of the timeline by clicking the Add to Movie button. The clip is at the current position of the play head.

After you add a CD audio track to your movie project, play the project to preview your addition. The first time you preview the movie with the CD audio track added, Studio captures the required audio from the CD. If the disc isn't in the CD-ROM drive the first time you try to play the project, Studio asks you to insert the disc before the process can continue.

Choose a track

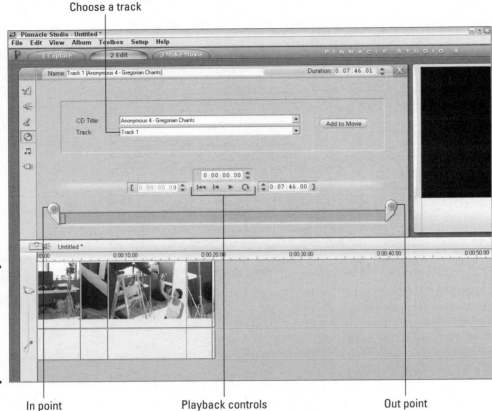

Figure 7-4:
Use Studio's
audio
toolbox to
add CD
audio to
your movie.

In point Playback controls Out point

Working with MP3 Audio

MP3 is one of the most common formats for sharing audio recordings today.
MP3 is short for *MPEG Layer 3,* and MPEG is short for *Motion Picture Experts
Group,* so really you can think of MP3 as an abbreviation of an abbreviation.
I'm sure that in a few years an MP3 file will simply be called an *M* or *P* (or
maybe even a *3*) file — but whatever their collective nickname, MP3 audio
files are likely to remain popular. The MP3 file format makes for very small
files — you can easily store a lot of music on a hard drive or CD — and
those files are easy to transfer over the Internet.

Who am I kidding? You probably already know all about MP3 files. You might
even have some MP3 files already stored on your computer. If so, using those
MP3 files for background music in your movie projects is really easy:

✦ **In iMovie:** Pull MP3 files directly from your iTunes library into iMovie,
 using the procedure described earlier in this chapter for importing CD
 audio. Simply choose iTunes from the pull-down menu at the top of the
 audio pane.

✦ **In Studio:** Choose Album⇨Sound Effects to show the sound-effects
 album. Click the folder icon and browse to the folder on your hard drive
 that contains the MP3 files you want to use (as shown in Figure 7-5).
 When a list of MP3 files appears in the album, simply drag and drop the
 desired files on the background music track of your timeline.

Browse to folder containing MP3s

Sound effects album

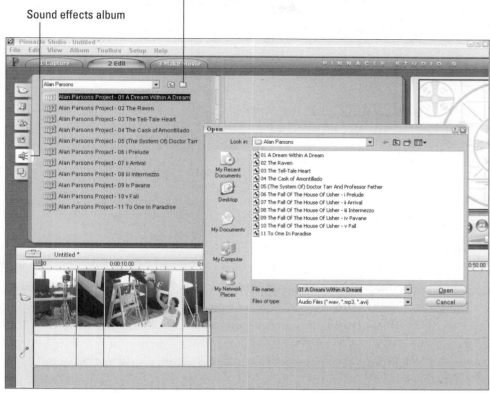

Figure 7-5:
Access MP3 audio files through Studio's sound-effects album.

Storing audio on your hard disk is handy because the audio will be easier to plop into your movie projects. MP3 is a great format to use because the audio sounds about as good as CD audio, but it takes up a lot less storage space. If you're not sure how to copy music from audio CDs onto your hard disk in MP3 format — the process of converting audio to the MP3 format is often called *encoding* or *ripping* — check out the next two sections.

Ripping MP3 files on a Mac

The process of turning an audio file into an MP3 file is sometimes called *ripping* or *encoding*. Apple has thoughtfully provided the capability to create MP3 files with its free audio-library-and-player program, iTunes (now available on both Mac OS X and Windows). To download the latest version of iTunes, visit `www.apple.com/itunes/` and follow the instructions there. After iTunes is installed on your computer, copying audio onto your hard drive in MP3 format is quite simple:

1. **Insert an audio CD into your CD-ROM drive.**

2. **If iTunes doesn't launch automatically, open the program using the Dock or your Applications folder.**

3. **With the iTunes program window active (as shown in Figure 7-6), choose iTunes⇨Preferences.**

The iTunes Preferences dialog box opens.

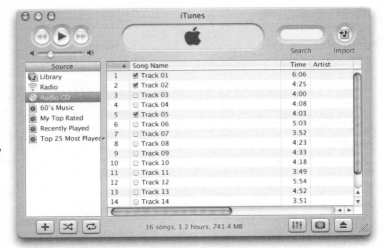

Figure 7-6:
iTunes can rip CD audio onto your hard disk in MP3 format.

4. **Click the Importing button at the top of the Preferences dialog box.**

5. **Make sure that MP3 Encoder is selected in the Import Using menu and then click OK.**

 The iTunes Preferences dialog box closes, and you return to the main iTunes window.

6. **Place check marks next to the songs you want to import.**

 You can use the playback controls in the upper-left corner of the iTunes window to preview tracks. In Figure 7-6, for example, I have chosen three tracks to import.

7. **Click Import in the upper-right corner of the iTunes window.**

 The songs are imported; the process may take several minutes. When it's done, the imported songs are available through your iTunes library for use in iMovie projects.

Ripping MP3 files in Windows

The process of turning audio files into MP3 files is sometimes called *encoding* or *ripping*. Microsoft provides a free audio-player program called Windows Media Player — WMP for short. It comes with Windows, and you can download the latest version from www.windowsmedia.com. WMP allows you to copy music from audio CDs to your hard drive in a high-quality (yet compact) format. Unfortunately, as delivered, WMP does not rip files in MP3 format. Instead, it uses the Windows Media Audio (WMA) format.

Windows Media files are about as small as MP3 files, but it's a proprietary format: Most video-editing programs can't import WMA files directly. If you want to import music from CDs into a Studio movie project, it's better to copy the music directly from within Studio, as described earlier in this chapter.

If you really want to be able to copy music onto your hard drive in MP3 format, you can use iTunes for Windows — or, you can pick up a commercially available MP3 encoding program. Such programs are available at most electronics stores, and you can also download software from Web sites such as www.tucows.com.

For example, if iTunes isn't handy, I use a tool called Musicmatch Jukebox from Musicmatch (www.musicmatch.com), shown in Figure 7-7. The Basic version of Jukebox is still free — what a bargain! — and allows you to encode MP3 files.

Figure 7-7: Preparing to rip using Musicmatch Jukebox.

CHECK IT OUT

Connecting a Tape Player to Your Computer

If you've recorded audio onto an audio tape, you can connect the tape player directly to your computer and record from it just as if you were recording from a microphone. Just follow these steps:

1. **Buy a patch cable (available at almost any electronics store) with two male mini-jacks (standard small audio connectors used by most current headphones, microphones, and computer speakers).**

2. **Connect one end of the patch cable to the headphone jack on the tape player and connect the other end to your computer's microphone jack.**

The key, of course, is to have the right kind of cable. You can even buy cables that allow you to connect an old record player to your computer and record audio from your LPs.

3. **Record audio from the tape using the same steps described in the sections in this chapter on microphone recording.**

You have to coordinate your fingers so that you press Play on the tape player and click Record in the recording software at about the same time. If the recording levels are too high or too low, adjust the volume control on the tape player.

Chapter 8: Choosing Your Video-Editing Software

In This Chapter

✔ Comparing features betwixt editors

✔ Using iMovie

✔ Working with Pinnacle Studio

✔ Putting Premiere Pro to work

✔ Enlisting Final Cut Pro HD

All too often, things in this world are chosen simply by their price — and hey, I can understand that completely. After all, I have a die-cast model of a $150,000 Aston Martin Vanquish V12 sitting on my desk instead of the real thing in my garage. I opted for a slightly less expensive Jeep instead.

Just a few short years ago, video-editing software was another good example of price-tag envy — you either shelled out $5,000 (or more) for a professional-level package, or you sat helplessly on the edge of your computer chair and wished you had the money. After all, DV camcorders were expensive too, and you had to be a Mensa member to handle the countless controls and settings in a video editor. So, why even bother?

Then, friends, we were liberated by an application with a funny-sounding name — iMovie — and suddenly *nothing* was the same. iMovie was cheap, it was easy to use, and it produced a quality movie that you weren't ashamed to show to others. (Thanks, Steve — and all the rest of the good folks at Cupertino — we all owe you one.) Sudden demand from normal human beings forced down the price of DV camcorders . . . and the rest, as they say, is history.

In this chapter, I introduce you to four modern video editors (starting with iMovie) and list the pros and cons of each. The first two qualify as truly inexpensive, ranging in price from free — say that with me, *free* — to around $100. The last two will set you back a little more (up to $1,000), but they're filled with enough powerful state-of-the-art features to satisfy most video-editing professionals, and they run on today's PCs and Macs.

Sure, you can still spend $5,000 on a dedicated video-editing system . . . but not me, pardner.

Making the Smart Choice

Although I don't have the room in this short chapter to fully describe every detail in each of these editors, I think most computer owners who want to start editing video will make a final decision on what application to use (or buy) based on four criteria:

✦ **Price:** There I go again, but price is indeed the primary limiting factor. (I bet you don't drive an Aston Martin either.)

✦ **Ease-of-use:** How do I make it go? Even the higher-priced editors in this chapter have received at least one facelift to make sure they're more user-friendly.

✦ **Platform:** All of these editors are limited to either PC or Mac.

✦ **Power-user features:** What can you do with an editor after you've mastered the basics? Naturally, the high-end entries will be chock-full of toys for advanced users, but I think you'll be surprised at just how capable a $100 video-editing program can be.

Therefore, in this chapter, I address each of these issues for each application and provide one author's opinion as well.

I encourage you to read further reviews on the Web and within your favorite computer and video print magazines before you make your choice. Each of these programs is well supported on its home turf with descriptions, screenshots, and the occasional tutorial, so take advantage of this information and read before you buy.

It Began with iMovie

Apple's iMovie still turns heads, even though it now has competition from other low-end editors. Take a gander at Figure 8-1, and you'll see why — you can understand what's going on.

Figure 8-1: The face that changed everything: iMovie at work.

Here's the rundown:

✦ **Price:** If you're considering a new Macintosh or you've just bought one, I encourage you to dance the Superiority Jig for a moment or two — iMovie is bundled free with new Macs as part of the iLife suite. (If you didn't get iMovie with your Mac or you want the latest version, you can pick up a copy of iLife '04 for around $50 at www.apple.com. That's practically free, and you get copies of iTunes, iDVD, GarageBand, and iPhoto as well.)

✦ **Ease-of-use:** iMovie is drag-and-drop heaven. I think it's safe to say that, of all the editors I describe in this chapter, iMovie is the easiest to use. Everything happens in one window, and iMovie is integrated with iTunes and iPhoto, allowing you to easily choose material from your music library and digital photograph collection to include with your video. You can capture directly from your DV camcorder, too.

✦ **Platform:** It's designed for Mac only, so PC owners will have to look elsewhere — perhaps the latest version of Windows Movie Maker, which is bundled for free with Windows XP (for more information, visit www.microsoft.com/windowsxp/moviemaker).

✦ **Power-user features:** iMovie includes the now-infamous Ken Burns Effect, which lets you pan and zoom to add motion to still photos. If you export your finished film to QuickTime (Apple's multimedia player and conversion utility), you can convert it into dozens of different file formats so that you can offer clips on your Web site or import them into a Windows video application. Within iMovie, iDVD is just a button away for adding chapter markers and burning your new creation to disc. The latest version of iMovie 4 allows you to edit multiple clips at once, and you can set alignment guides to ensure that your audio tracks and video clips are synchronized. Plug-ins are available from a wide range of third-party vendors, so you can expand your system with new titles, effects, and transitions.

Folks using iMovie 4 can take advantage of professional-quality audio effects provided by Skywalker Sound, as shown in Figure 8-2. Perhaps this same sound has shown up in one of those little-known films by George Lucas. I can't think of any right now, but he's done some good work.

On the downside, iMovie doesn't come with a bushel basket full of transitions and effects, and it's not the speediest performer when rendering effects or converting video. However, iMovie is easy enough for your kids to use, and I highly recommend it to any Mac owner who's never dabbled in digital video. (If you're willing to spend $300, you can graduate to Final Cut Express 2, the baby brother of Final Cut Pro HD. It addresses the performance shortcomings of iMovie, but the learning curve is much steeper.)

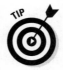

For a more in-depth look at iMovie, iDVD, and QuickTime, pick up a copy of *Mac OS X Panther All-in-One Desk Reference For Dummies*, written by Mark L. Chambers (published by Wiley). The book includes chapters devoted to each of these applications.

Figure 8-2:
Listen to the sounds of the chirping birds — oops, let me add them first.

Studio Fits Like a Glove

Figure 8-3 illustrates Pinnacle Studio 9, from Pinnacle Systems (www.pinnaclesys.com). This video-editing software is a step above iMovie in features, while maintaining a more intuitive menu system and control layout than "the big boys."

Here's the rundown:

✦ **Price:** Studio 9 runs a clean $100 from the Pinnacle Systems Web store. (Because most PCs still don't come with a FireWire port, Pinnacle Systems also sells a number of different kits that bundle Studio 9 and a FireWire PCI adapter card, allowing you to install FireWire on your PC.)

✦ **Ease-of-use:** Although the Studio window is a bit more complex than iMovie, the essential Timeline display and clip library remain recognizable, and I like the streamlined, tabbed Capture/Edit/Make Movie interface — it's a 1-2-3 approach to editing.

✦ **Platform:** It runs under Windows 98SE/Me/2000 and Windows XP only.

✦ **Power-user features:** Studio offers widescreen video support, as well as voiceover narration. You can create movies with surround sound, and Studio includes a noise-reduction audio tool. (If you've got a shaky camera hand, the Image Stabilization enhancement feature comes in quite handy, too.) Both audio and video plug-ins are supported (see Figure 8-4). Studio offers a great range of output, too: You can send your completed film back to your DV camcorder, create an AVI/MPEG/Windows

Media file on your hard drive, and even build a RealVideo stream for your Web server. You also have much more control over the quality of your finished film in Studio than in iMovie.

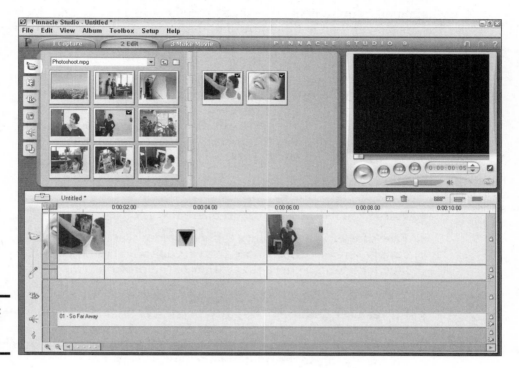

Figure 8-3:
Editing in
Studio 9.

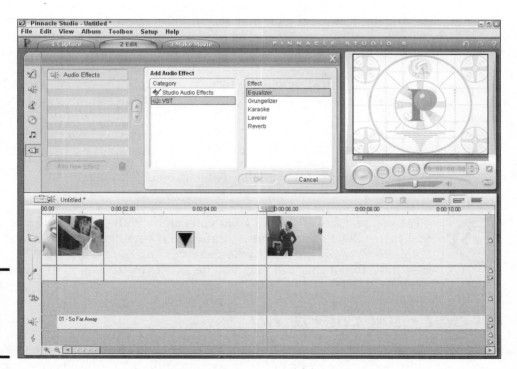

Figure 8-4:
Using
VST audio
plug-ins
in Studio.

All is not perfect, however: Studio has suffered from more than its share of software bugs in past versions, and Studio 9 is no exception. (Make sure you update your copy *immediately* with the latest patch as soon as you install it, and I recommend running Studio 9 only on a PC that exceeds the minimum requirements specified by Pinnacle Systems.) Like iMovie, rendering is slower than it should be, and the Timeline display and controls are somewhat quirky.

Prosumers Prefer Premiere Pro

Adobe Premiere Pro has been around for many years now, but the rather steep price tag and its hardware requirements have made it less appealing to entry-level digital filmmakers.

Here's a rundown of the big four criteria:

✦ **Price:** You'll drop $700 on Premiere Pro 1.5.

✦ **Ease-of-use:** The program's tabbed windows and plethora of toolbars simply scream "Photoshop" to everyone who sees them, so expect a far steeper learning curve than either of the previous two editors.

✦ **Platform:** It runs under Windows XP only.

✦ **Power-user features:** The latest version of Premiere Pro includes — insert drum roll here — HD (high-definition) video support, as well as project management tools and automatic video color adjustment. Not only can you use the built-in filters and effects, but you can also use standard Premiere plug-ins and even your Adobe After Effects plug-ins. Oh, did I mention that your effects are rendered in real time? (That means no waiting!) This is a professional-grade video editor, and the tools you get reflect that.

Other than the price and learning curve, most entry-level video-editing junkies will pale at the hardware required to run Premiere Pro. I recommend nothing less than the most powerful Pentium 4 you can afford, with a bare minimum of 512MB of memory and at least 120GB of EIDE hard drive territory (or serial ATA hard drive space, if you can afford it). Invest the time and money in Premiere Pro only if you're a serious amateur, or if you're working on professional-quality video projects. 'Nuff said.

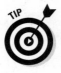

Care to find out more about Premiere before you buy? Chapter 11 of Book II gives you just a tiny taste of what you can do with this powerful editor. If that taste whets your appetite for more, I recommend a copy of *Adobe Premiere Pro For Dummies* by Keith Underdahl (published by Wiley). It's a wise investment that will help you decide if you need all that power.

All Hail Final Cut Pro HD

Ask professional Hollywood and TV video editors about their choice of software, and you've got a better-than-even shot of hearing all about Apple's Final Cut Pro, shown in Figure 8-5. Final Cut Pro HD is generally considered

the best video-editing package that doesn't require dedicated hardware. But, like Premiere Pro, you pay the price in dollars and hardware, so only the serious need apply.

Here's the summation:

✦ **Price:** Apple charges a cool $1,000.

✦ **Ease-of-use:** This application sports a face only a professional video editor could love, with multiple windows, mixers, and color gadgets hidden everywhere (which, of course, you can fully customize and configure). Like Premiere Pro, you're going to need time to absorb it.

✦ **Platform:** Another Mac-only application.

✦ **Power-user features:** Where to begin? The *HD* at the end of the name means high-definition video support, as well as real-time rendering to speed things up. You get Soundtrack, a separate application that can create royalty-free soundtracks for your movies, and Cinema Tools to help you track the progress of your film project. You'll get the best broadcast-quality video compression support in this price range, and Apple is especially fond of LiveFonts, the animated font system for titles.

What I wrote earlier about Premiere Pro goes double for Final Cut Pro HD: I wouldn't even consider using this software on anything less than a Power Mac G5 with 1GB worth of memory, and expect to spend days poking around the menu system and dialogs before you even get an idea where most of the settings are hidden. Final Cut Pro HD is used to create many of today's Hollywood classics — and it is not (repeat, *not*) for the faint of heart or the casual filmmaker.

Figure 8-5:
A look at the vista provided by Final Cut Pro HD.

Chapter 9: Basic Video Editing

In This Chapter

✓ Starting an editing project

✓ Working with video clips

✓ Assembling a movie project

✓ Fine-tuning the project

*B*y themselves, digital video cameras aren't *that* big of a deal. Sure, digital camcorders offer higher quality, but the video quality of analog Hi8 camcorders really wasn't too bad. Digital video doesn't suffer from generational loss (where some video quality is lost each time the video is copied or even played) like analog video does, but again, this isn't something that should motivate millions of people to instantly trash their old analog camcorders.

But video editing . . . now, *that's* cool. Until recently, high-quality video productions with special effects, on-screen titles, and fancy transitions between scenes were magical productions made by pros using equipment that cost hundreds of thousands (if not millions) of dollars. But thanks to the dual revolutions of digital camcorders and powerful personal computers, all you need for pro-quality video production is a computer, a digital camcorder, a little cable to connect them, and some software. Within just a few mouse clicks, you'll be making movie magic!

Starting a New Project

Your first step in working on any movie project is to actually create the new project. This step is pretty easy. In fact, when you launch your video-editing program, it usually starts with a new, empty project. But if you need to create a new project or you just want to be sure that you're starting from a clean slate, choose File⇨New Project. Regardless of whether you're using Apple iMovie, Pinnacle Studio, or almost any other video-editing program, a new, empty project window should appear.

After you have a new project started, your first step is generally to capture (from a video source like a camcorder) or import some video (from existing files on your hard drive) so that you have something to edit. If you have some video to import, see Chapter 6 of Book II for information on how to do that. Captured video appears as clips in the clips pane (in iMovie) or the Album (in Studio), where it is ready to use in your movies.

If you plan to use clips from your PC's hard drive, you can import them into Pinnacle Studio by following these steps:

1. **Click the Edit view mode tab or choose View➪Edit to ensure that you're in Edit mode.**

If this is the first time that you've used Studio, you'll probably see the sample clips from Pinnacle's Photoshoot sample movie.

2. **Click the Select Video Files button in the clip browser, as shown in Figure 9-1.**

The generic Open File window, which is common to virtually all Windows programs, appears.

3. **Browse to the folder that contains your clips.**

4. **Choose the desired file, and click the Open button.**

The file is imported — life is good!

If you're using a Mac, import clips into iMovie by following these steps:

1. **Open iMovie, and choose File➪Import.**

The generic Open File dialog box, which is common to virtually all Mac OS X programs, appears.

2. **Browse to the folder that contains the desired clips.**

3. **Click and drag over the scene clips to select them, and then click the Open button.**

The clips are imported and appear in the Clip browser.

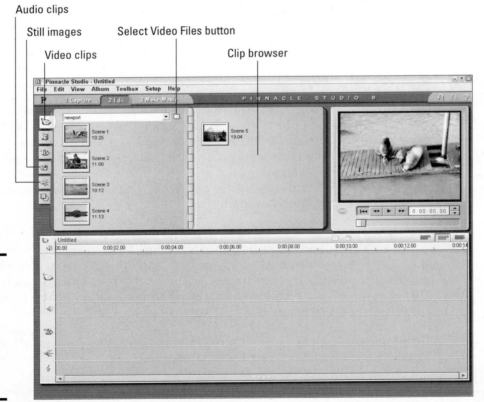

Figure 9-1: Imported video clips appear in the clip browser of your video-editing program.

If you're using Apple iMovie, you need version 3 or higher to import QuickTime-format video files.

After you have imported the clips, I recommend that you save and name the project by choosing File⇨Save Project. Saving early is important because it preserves your work and is also required before you can perform certain editing tasks later on.

Working with Clips

As you make movies, you'll quickly find that *clip* is the basic denomination of the media that you work with. You'll spend a lot of time with video clips, audio clips, and even *still* clips (you know, those things that used to be called "pictures" or "photos").

A still clip usually consists of a single picture, an audio clip usually consists of a single song or sound effect, and a video clip usually consists of a single scene. A *scene* most often starts when you press the Record button on your camcorder and ends when you press the Record button again, even if only for a second. When you import video from your camcorder, most video-editing programs automatically detect these scenes and create individual clips for you. As you edit and create your movies, you'll find this feature incredibly useful.

Organizing clips

Virtually all video-editing software stores clips in a grid-like area called a *clip browser* or *album.* Apple iMovie and Pinnacle Studio further subdivide clips by content. Each program has separate browser panels for video clips, audio clips, and still images. In Studio, you can access these panels by using tabs along the left side of the clip browser or *album,* as it is called in Pinnacle's documentation. In iMovie (see Figure 9-2), you can access the panels by using buttons at the bottom of the clip browser or *pane,* as Apple's documentation calls it.

The clip browser doesn't just store your clips, it also tells you some important information about them. One of the most important bits of info is the length of the clip. If you've already imported clips, you notice a set of numerals (like 19.04) next to each scene. This tells you that the clip is 19 seconds and 4 frames long. If you don't see names or lengths listed next to clips in the Studio clip browser, choose Album⇨Details View. This should change the browser view so that it looks more like that shown in Figure 9-3.

A video image is actually made up of a series of still images that flash by so quickly that they create the illusion of motion. These still images are called *frames.* Video usually has about 30 frames per second.

The clip also has a name, of course, and you can change the name if you want. If, for example, you think that "Starship" would be a more descriptive name than "Scene 5," click the clip once, wait a second, and then click the clip's name once again. You can then type a new name. When you're done typing a new name, just press Enter or click in an empty part of the screen.

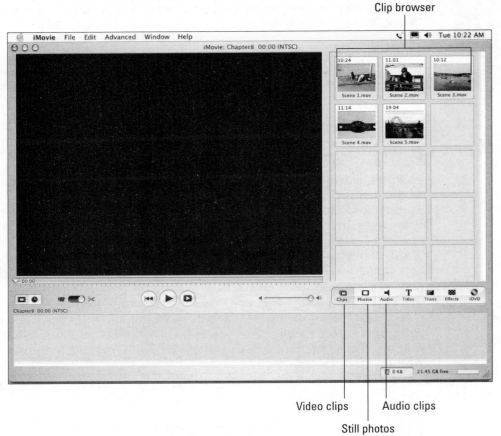

Clip browser

Video clips

Still photos

Audio clips

Figure 9-2:
The browser helps keep your various clips organized.

Menu

Click to view additional pages.

Figure 9-3:
In some cases, not all your clips fit on just one page.

If you have a *lot* of clips in the browser, they may not all fit on one screen. In iMovie, simply scroll down (using the scroll bar on the right) to see more clips. In Pinnacle Studio, you can select different groups of clips from the menu at the top of the browser. If there are too many clips in a group to fit on a single page all at once, you can click the arrows (as shown in Figure 9-3) to view additional pages.

TIP

In iMovie's clip browser, you can manually rearrange clips by dragging them to new empty blocks in the grid. You can move the clips wherever you want. This handy feature allows you to sort clips on your own terms, rather than just having them listed alphabetically or in some arbitrary order.

Previewing clips

As you gaze at the clips in your clip browser, notice that a thumbnail image is shown for each clip. This thumbnail usually shows the first frame of the clip. Although the thumbnail may suggest the clip's basic content, you don't really know exactly what the clip contains until you preview the whole thing. Previewing a clip is easy: Just click your chosen clip in the browser, and then click the Play button in the playback controls of your software's preview window.

As the clip plays, notice that the play head under the preview window moves. You can move to any portion of a clip by clicking and dragging the play head with the mouse. Figure 9-4 shows Studio's preview window and playback controls.

As you preview clips and identify portions that you want to use in your movies, you'll find that precise, frame-by-frame control of the play head is crucial. The best way to get that precision is to use keyboard buttons instead of the mouse. Table 9-1 lists important keyboard controls for three popular video-editing programs. If you're using different editing software, check the manufacturer's documentation for keyboard controls.

Table 9-1	Keyboard Controls for Video Playback		
Command	*Apple iMovie*	*Microsoft Windows Movie Maker*	*Pinnacle Studio*
Play/Stop	Spacebar	Spacebar	Spacebar or K
Fast forward	⌘+]	Ctrl+Alt+→	L
Rewind	⌘+[Ctrl+Q	J
One frame forward	→	Alt+→	X
One frame back	←	Alt+←	Y

Figure 9-4:
Use playback controls and the play head to preview clips.

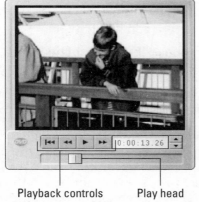

Playback controls Play head

Some controls are fairly standardized across many video-editing applications. In fact, the spacebar also controls the Play/Stop/Pause function in professional-grade video editors like Adobe Premiere Pro and Apple Final Cut Pro HD.

If you don't like using the keyboard to move to just the right frame, you may want to invest in a multimedia controller, such as the SpaceShuttle A/V from Contour A/V Solutions (www.contouravs.com). This device connects to your computer's USB port and features a knob and dial that you can use to precisely control video playback. Using the SpaceShuttle A/V is so much easier than using the mouse or keyboard, you'll wonder how you ever got by without one!

Trimming out the unwanted parts

Professional Hollywood moviemakers typically shoot hundreds of hours of footage just to get enough acceptable material for a 2-hour feature film. Because the pros shoot a lot of "waste" footage, don't feel so bad if every single frame of video that you shot isn't totally perfect either. As you preview your clips, you're sure to find bits that you want to cut from the final movie.

Consider a scene where the subject scratches his lip for a few moments at the beginning of the clip, which would be fine, except that it kind of looks like he is picking his nose. You can't have *that* in the final movie. Besides, the clip may be about 11 seconds long, and you really only need about 5 seconds or so.

The solution is to trim the clip to just the portion that you want. The easiest way to trim a clip is to split it into smaller parts before you place it in your movie project. Follow these steps to do so:

1. **Open the clip that you want to trim by clicking it in the browser, and move the play head to the exact spot where you want to split the clip.**

 Use the playback controls in the preview window to move the play head. Table 9-1 lists some keyboard shortcuts to help you move the play head more precisely.

2. **In Pinnacle Studio, right-click the clip in the browser and choose Split Scene from the menu that appears. In Apple iMovie, choose Edit⇨ Split Video Clip at Playhead.**

 You now have two clips, where before you had only one.

3. **To split the second clip again, choose the second clip by clicking it in the browser and move the play head about 5 seconds forward in the clip.**

4. **Repeat Step 2 to split the clip again.**

You now have three clips that were created from the one original clip (as shown in Figure 9-5). Splitting clips like I've shown here isn't the only way to trim unwanted portions of video. You can also trim clips once they're placed on the timeline of your movie project (a process described in the section "Trimming clips in the timeline," later in this chapter). But splitting the clips

before you add them to a project is often a much easier way to work because the unwanted parts are split into separate clips that you can use (or not use) as you want. In the next section, I show you how to add clips to the timeline or storyboard of your editing program and start turning your clips into a movie.

Three new clips

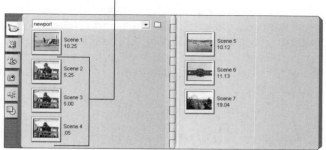

Figure 9-5:
Splitting clips is one way to trim unwanted bits of video.

Understanding timecode

A video image is actually a series of still frames that flash by rapidly on-screen. Every frame is uniquely identified with a number called a *timecode*. All stored locations and durations of all the edits that you perform on a movie project use timecodes for reference points, so a basic understanding of timecode is important. You'll see and use timecodes almost every time you work in a video-editing program like Pinnacle Studio or Apple iMovie. Timecode is often expressed like this:

hours:minutes:seconds:frames

The 14th frame of the third second of the 28th minute of the first hour of video is identified as follows:

01:28:03:13

You already know what hours, minutes, and seconds are. *Frames* aren't units of time measurement, but rather the individual still images that make up your video. The frame portion of the timecode starts with zero (00) and counts up to a number that's determined by the frame rate of the video — hence, 01:28:03:*13* for the 14th frame. In PAL video, frames are counted from 00 to 24, because the frame rate of PAL is 25 frames per second (fps). In NTSC, frames are counted from 00 to 29.

"Wait!" you exclaim. "Zero to 29 adds up to 30, not 29.97."

You're an observant one, aren't you? The frame rate of NTSC video is 29.97 fps. NTSC timecode skips the frame codes 00 and 01 in the first second of every minute, except for every tenth minute. Work it out (you may use a calculator), and you see that this system of reverse leap-frames adds up to 29.97 fps. This is called a *drop-frame* timecode. In some video-editing systems, drop-frame timecode is expressed with semicolons (;) between the numbers instead of colons (:). Therefore, in drop-frame timecode, the 14th frame of the third second of the 28th minute of the first hour of video is identified as follows:

01;28;03;13

Why does NTSC video use drop-frame timecode? Back when everything was broadcast in black and white, NTSC video was an even 30 fps. For the conversion to color, more bandwidth was needed in the signal to broadcast color information. By dropping a couple of frames every minute, enough room was left in the signal to broadcast color information, while at the same time keeping the video signals compatible with older black-and-white TVs.

Although the punctuation (for example, colons or semicolons) for separating the numerals of timecode into hours, minutes, seconds, and frames is fairly standardized, some video-editing programs still go their own way. Pinnacle Studio, for example, uses a decimal point between seconds and frames. But regardless of whether the numbers are separated by colons, decimals, or magic crystals, the basic concept of timecode is the same.

Don't worry! Trimming a clip doesn't delete the unused portions from your hard drive. When you trim a clip, you're actually setting what the video pros call *in points* and *out points*. The software uses virtual markers to remember which portions of the video that you chose to use during a particular edit. If you want to use the remaining video later, it's still on your hard drive, ready for use.

You can also usually unsplit your clips that you have split. In Pinnacle Studio, hold down Ctrl and click each of the clips that you split earlier. When each clip is selected, right-click the clips and choose Combine Scenes from the menu that appears. Unfortunately, Apple iMovie doesn't have a simple tool for recombining clips that you have split. If you just split a clip, you can undo that action by choosing Edit⇨Undo or by pressing ⌘+Z (this only undoes the split).

Turning Your Clips into a Movie

You're probably wondering when the fun begins. This is it! It's finally time to start assembling your various video clips into a movie. Most video-editing programs provide the same two basic tools to help you assemble a movie. These tools are as follows:

✦ **Storyboard:** This is where you throw clips together in a basic sequence from start to finish — think of it as a rough draft of your movie.

✦ **Timeline:** After your clips are assembled in the storyboard, you can switch over to the timeline to fine-tune the movie and make more advanced edits. The timeline is where you apply the final polish.

The storyboard and timeline are basically just two different ways of showing the same thing. In most editing programs — including iMovie, Studio, and Windows Movie Maker — you can toggle back and forth between the storyboard and the timeline whenever you want. Some people prefer to use one or the other exclusively; for now, starting with the storyboard keeps the example simple.

Visualizing your project with storyboards

If you've ever watched a "making of" documentary for a movie, you've probably seen filmmakers working with a storyboard. It looks like a giant comic strip, where each panel illustrates a new scene in the movie. The storyboard in your video-editing program works the same way. You can toss scenes in the storyboard, move them around, remove scenes, and generally put your clips in the basic order in which you want them to appear in the movie. The storyboard is a great place in which to visualize the overall concept and flow of your movie.

To add clips to the storyboard, simply drag them from the clip browser to the storyboard at the bottom of the screen. As shown in Figure 9-6, I have added five clips to the iMovie storyboard.

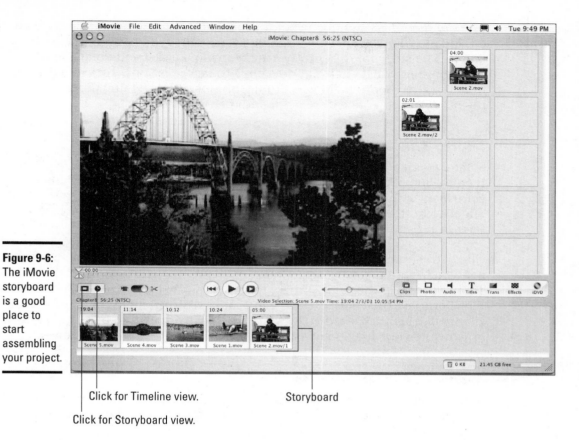

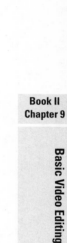

Figure 9-6:
The iMovie storyboard is a good place to start assembling your project.

Click for Timeline view.

Storyboard

Click for Storyboard view.

The storyboard should show a series of thumbnails, as shown in Figure 9-6. If your screen doesn't quite look like this, you may need to switch to the Storyboard view. Figure 9-6 shows the buttons that are used for toggling between the Storyboard view and the Timeline view in iMovie; the equivalent buttons for Studio are shown in Figure 9-7.

Click for Text view.

Click for Timeline view.

Click for Storyboard view.

Storyboard

Figure 9-7:
Studio's storyboard looks a lot like the storyboard in iMovie, but with three rows instead of one.

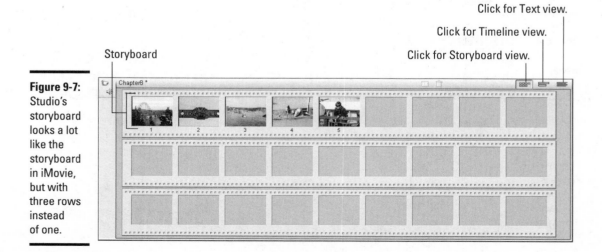

457

The *storyboard* is possibly one of the most aptly named items in any video-editing program because the thumbnails actually tell the basic story of your movie. The storyboard is pretty easy to manipulate. If you don't like the order of things, just click and drag clips to new locations. To remove a clip from the storyboard in iMovie, Studio, or most other editing programs, click the offending clip once to select it and then press Delete.

Using the timeline

Some experienced editors prefer to skip the storyboard and go straight to the timeline because the timeline provides more information and precise control over your movie project. To switch to the timeline, click the Timeline button. (Refer to Figure 9-6 for the location of the button in iMovie; refer to Figure 9-7 to find the button in Studio.)

One of the first things that you'll probably notice about the timeline is that not all clips are the same size. Consider Figure 9-8, which shows the Timeline view of the same project that is shown in Figure 9-7. In the Timeline view, the width of each clip represents the length (in time) of that clip, unlike in Storyboard view, where each clip appears to be the same size. In Timeline view, longer clips are wider and shorter clips are narrower.

Adding clips to the timeline

Adding a clip to the timeline is a lot like placing clips on the storyboard. Just use the drag-and-drop feature to move clips from the clip browser to the timeline. In Figure 9-9, I am inserting a clip between two existing clips on the timeline. Clips that fall after the insert are automatically shifted over to make room for the inserted clip.

Figure 9-8: The timeline provides a bit more information about your movie project.

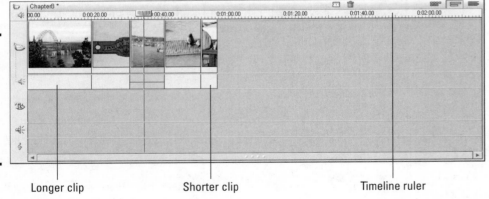

Longer clip Shorter clip Timeline ruler

Figure 9-9: Use the drag-and-drop feature to place your clips in the timeline.

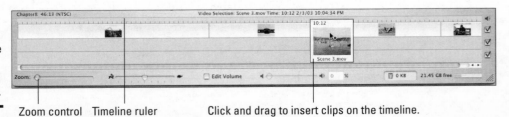

Zoom control Timeline ruler Click and drag to insert clips on the timeline.

Zooming in and out on the timeline

Depending on the size of your movie project, you may find that clips on the timeline are often either too wide or too narrow to work with effectively. To rectify this situation, adjust the zoom level of the timeline. You can either zoom in and see more detail or zoom out and see more of the movie. To adjust the zoom, follow these guidelines:

✦ **Apple iMovie:** Adjust the Zoom slider control in the lower-left corner of the timeline (refer to Figure 9-9).

✦ **Microsoft Windows Movie Maker:** Click the Zoom In or Zoom Out magnifying glass button above the timeline, or press Page Down to zoom in and Page Up to zoom out.

✦ **Pinnacle Studio:** Press the plus key (+) to zoom in, or press the hyphen (minus sign) key (–) to zoom out. Alternatively, hover your mouse pointer over the timeline ruler until the pointer becomes a clock, and then click and drag left or right on the ruler to adjust the zoom.

**Book II
Chapter 9**

Basic Video Editing

Tracking timeline tracks

The timeline displays several different tracks. Each track represents a different element of the movie — video resides on the video track and audio resides on the audio track. You may have additional tracks available as well, such as title tracks (see Book II, Chapter 10 for more on adding titles to your movie) or music tracks (see Book II, Chapter 12 for details about adding music to your movie). Figure 9-10 shows the tracks that are used in the Pinnacle Studio timeline.

Some advanced video-editing programs (such as Adobe Premiere and Final Cut Pro) allow you to have many separate video and audio tracks in a single project. This advanced capability is useful for layering many different elements and performing some advanced editing techniques.

Titles track

Audio track

Video track

Figure 9-10:
Different timeline tracks contain different kinds of content.

Background music track

Sound effects/narration track

When you record and capture video, you usually capture audio along with it. When you place one of these video clips in the timeline (refer to Figure 9-10), the accompanying audio appears just underneath it in the audio track. Seeing the audio and video tracks separately is important for a variety of editing purposes. (Chapter 12 of Book II describes working with audio in greater detail.)

Locking timeline tracks in Pinnacle Studio

Pinnacle Studio offers a handy *locking* feature on timeline tracks. Locking the track doesn't prevent burglars from stealing it late at night, but it does allow you to temporarily protect a track from changes as you manipulate other tracks. For example, if you want to delete the audio track that came with some video but you don't want to delete the video itself, follow these steps:

1. **Click the track header on the left side of the timeline.**

A lock icon appears on the track header, and a striped gray background is applied to that track. In Figure 9-11, I have locked the main video track.

Selected audio clip

Lock icon

Track header

Figure 9-11: Locking some of your tracks can protect them from changes while you edit other tracks.

2. **Perform edits on other tracks.**

For example, to delete the audio track for one of your video clips, click the audio clip once to select it (as shown in Figure 9-11) and then press Delete. The audio portion of the clip disappears, but the video clip remains unaffected.

3. **Click the track header again to unlock the track.**

You can undo changes (such as deleting an audio clip) in Pinnacle Studio by pressing Ctrl+Z. If you followed the previous steps, press Ctrl+Z once to relock the track and press Ctrl+Z again to undelete the audio clip.

What did iMovie do with my audio?

Apple iMovie 3 offers some useful improvements over previous versions of the software — and a few changes that are less welcome. One thing that I find a little aggravating is that the timeline does not automatically show the audio clips that accompany video clips. Refer to Figure 9-9 to see what I mean. Each clip in the timeline includes both audio and video, but the timeline shows only a single track.

To view combined audio and video clips separately in iMovie, you must extract the audio from each video clip individually. To do so, follow these steps:

1. **Click once on a clip on the timeline to select it.**

2. **Choose Advanced⇨Extract Audio, or press ⌘+J.**

The audio now appears as a separate clip on the timeline, as shown in Figure 9-12.

3. **Repeat Steps 1 and 2 for each clip on the timeline.**

It may be a good idea to wait until later (like when you're done editing the video portion of the movie) to extract audio from your video clips. If you still need to trim the video clip (as I describe in the section "Trimming clips on the timeline," later in this chapter), you have to trim the audio clip separately if it has been extracted.

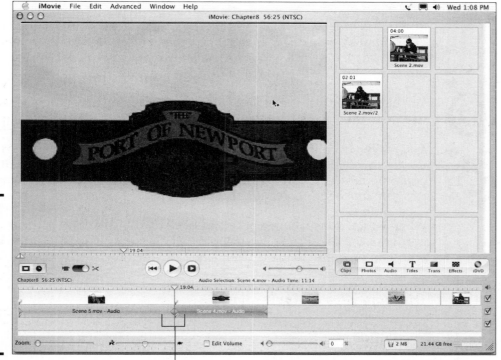

Figure 9-12:
To work with audio and video separately in iMovie 3, extract audio clips from the video clips.

Extracted audio clips

Fine-Tuning Your Movie on the Timeline

After you've plopped a few clips onto your timeline or storyboard, you're ready to fine-tune your project. This fine-tuning is what turns your series of clips into a real movie. Most of the edits that I describe in this section require you to work on the timeline, although if you want to simply move clips around without making edits or changes, you'll probably find that easier to do in the storyboard. This is especially true if you're using iMovie. To move a clip, simply click and drag it to a new location, as shown in Figure 9-13.

Trimming clips on the timeline

Dropping clips onto the storyboard or timeline is a great way to assemble the movie, but a lot of those clips probably contain some material that you don't want to use. Suppose that a clip is about 19 seconds long, which is much longer than you really want. As you play through the clip, you notice that about 15 seconds into the clip, the camera moves. You don't want to include that in the movie, so you decide to trim the clip to just the first 5 seconds.

Trimming clips in Pinnacle Studio

The easiest way to trim clips in the Studio timeline is to use the Clip Properties window. To open this window, double-click a clip in the timeline. The Clip Properties window appears above the timeline, as shown in Figure 9-14. The left pane of this window shows the in point frame, which is the first frame of the clip. The right pane shows the out point frame, or the end of the clip. To adjust the in and out points, click and drag the in and out point razor tools back and forth. As shown in Figure 9-14, I have dragged the out point razor so that only the first 5 seconds of the clip will play.

You can also adjust the in and out points by typing new numbers in the timecode indicators under each pane.

The playback controls in the Clip Properties window include a Play Clip Continuously button. Click this button to preview the clip so that it loops continuously. This can help you better visualize the effects of any changes that you make to the in and out points.

When you're done trimming the clip, click the Close button in the upper-right corner of the Clip Properties window. The window closes, and the length of your clip on the timeline is changed accordingly.

Trimming clips in Apple iMovie

Apple iMovie's approach to trimming is typical Apple — simple and effective. iMovie uses the preview window for clip-trimming operations. If you look closely at the lower-left corner of the preview window, you can see two tiny triangles, as shown in Figure 9-15. These are in point and out point markers; you can use them to trim clips in the timeline.

Figure 9-13:
Click and
drag clips
on the
storyboard
to move
them to new
locations in
the movie.

To move a clip, simply drag and drop in Storyboard view.

Play Clip Continuously button

In point

Clip Properties window

In point razor Out point razor Out point

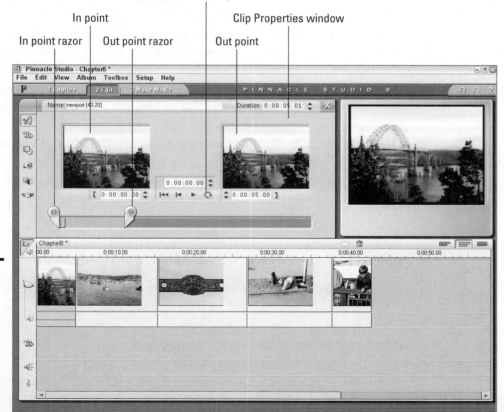

Figure 9-14:
Fine-tune
the in and
out points
for clips on
the timeline
by using
the Clip
Properties
window.

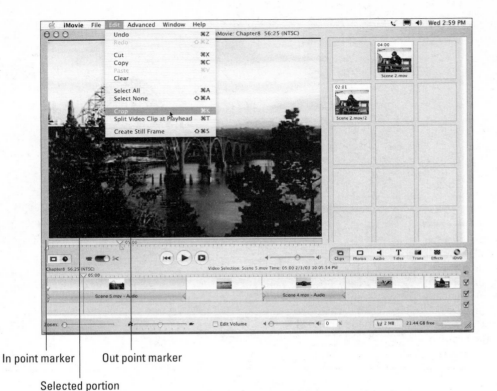

Figure 9-15:
Use the
iMovie
preview
window to
trim clips in
the timeline.

In point marker Out point marker

Selected portion

To trim a clip in iMovie, follow these steps:

1. **Click a clip on the timeline to select it.**

When you click the clip, it should load into the preview window. If it does not, make sure that the desired clip is selected on the timeline. The clip should turn blue when it is selected.

2. **Click and drag the out point marker in the lower-left corner of the preview window to a new location along the playback ruler (see Figure 9-15).**

3. **Click and drag the in point marker to a new position, if you want.**

The selected portion of the clip — that is, the portion between the in and out points — turns yellow in the preview window playback ruler.

4. **Choose Edit⇨Crop.**

The clip is trimmed (*cropped*) to just the portion that you selected with the in and out points. Subsequent clips on the timeline automatically shift to fill in the empty space on the timeline.

If you trim a video clip from which you have extracted the audio, only the video clip is trimmed; you have to trim the audio separately.

Removing clips from the timeline

Changing your mind about some clips that you placed in the timeline is virtually inevitable, and fortunately, removing clips is easy. Just click the offending clip to select it, and press Delete. Poof! The clip disappears.

If you're using iMovie, you should know, however, that when you delete a clip by pressing Delete, the clip goes to the iMovie Trash bin. After the trash is emptied (by double-clicking the Trash icon at the bottom of the iMovie program window), the deleted clip is no longer stored on your hard drive. This means that if you decide you want it back later, you have to recapture it. Therefore, to simply remove a clip from the timeline, I recommend that you first switch to the storyboard, and then drag the unwanted clip back up to the clip browser so that you can use it again later.

Undoing what you've done

Oops! If you didn't really *mean* to delete that clip, don't despair. Just like word processors (and many other computer programs), video-editing programs let you undo your actions. Simply press Ctrl+Z (in Windows) or ⌘+Z (on the Mac) to undo your last action. Both Pinnacle Studio and Apple iMovie allow you to undo several actions, which is helpful if you've done a couple of other actions since making the "mistake" that you want to undo. To redo an action that you just undid, press Ctrl+Y (in Windows) or ⌘+Shift+Z (on the Mac).

Another quick way to restore a clip in iMovie to its original state — regardless of how long ago you changed it — is to select the clip on the timeline and then choose Advanced⇨Restore Clip. The clip reverts to its original state.

Adjusting playback speed

One of the coolest yet most unappreciated capabilities of video-editing programs is the ability to change the speed of video clips. Changing the speed of a clip can serve the following purposes:

✦ Add drama to a scene by slowing the speed to create a "slow-mo" effect.

✦ Make a scene appear fast-paced and action-oriented (or humorous, depending on the subject matter) by speeding up the video.

✦ Help a given video clip better fit into a specific time frame by speeding it up or slowing it down slightly. For example, you may be trying to time a video clip to match beats in a musical soundtrack. Sometimes this can be achieved by slightly adjusting the playback speed of the video clips.

Of course, you want to carefully preview any speed changes that you make to a video clip. Depending on the software, you could encounter some jittery video images or other problems when you play around with speed adjustments.

Pay special attention to audio clips when you adjust playback speed. Even though a small speed adjustment may be barely perceptible in a video clip, even the tiniest speed changes have radical affects on the way that audio sounds. Usually, when I adjust video speed, I discard the audio portion of that clip. Pinnacle Studio is unusual in that when you change the speed of a video clip, the audio portion of that clip is automatically discarded.

Adjusting playback speed in Apple iMovie

Changing playback speed in iMovie couldn't be easier. If you look closely, you can see a slider adjustment for playback speed right on the timeline. To adjust the speed, follow these steps:

1. **Switch to the timeline (if you aren't there already) by clicking the Timeline View button (refer to Figure 9-6).**

2. **Click the clip that you want to adjust to select it.**

 The clip should turn blue when it is selected.

3. **Adjust the speed slider at the bottom of the timeline, as shown in Figure 9-16.**

 To speed up the clip, move the slider toward the hare. Move the slider toward the tortoise to (surprise) slow down the clip.

4. **Play the clip to preview your changes.**

5. **Giggle at the way the audio sounds after you make your changes.**

If you don't want to include the audio portion of the clip after you've made speed changes, choose Advanced⇨Extract Audio to extract the audio and then delete the audio clip after it is extracted.

Another neat thing that you can do to video clips in iMovie is to reverse the playback direction. To do so, select the clip and choose Advanced⇨Reverse Clip Direction. The clip now plays backward in your movie. To change it back to the normal direction, just choose Advanced⇨Reverse Clip Direction again.

Giggle at the preview here.

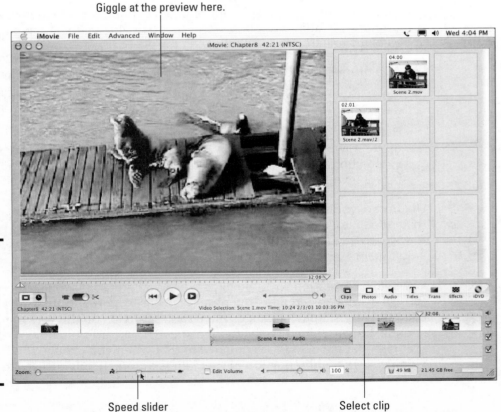

Figure 9-16: Use the speed slider at the bottom of the timeline to adjust playback speed.

Speed slider Select clip

Adjusting playback speed in Pinnacle Studio

Pinnacle Studio gives you pretty fine control over playback speed. You can also adjust the Strobe to create a stop-motion effect that you may find useful. The only way to really know is to experiment, which you can do by following these steps:

1. **Switch to the timeline (if you're not there already) by clicking the Timeline View button (refer to Figure 9-7).**

2. **Double-click a clip on the timeline to open the Clip Properties window.**

3. **Click the Vary Playback Speed tool on the left side of the Clip Properties window (as shown in Figure 9-17).**

The Vary Playback Speed controls appear, as shown in Figure 9-17.

4. **Move the Speed slider left to slow down the clip, or move it to the right to speed up the clip.**

An adjustment factor appears above the slider. Normal speed is shown as 1.0 X. Double speed would be 2.0 X, and so on. If you slow the playback speed, a fraction appears instead. For example, half speed is indicated as ⅚₀ X.

5. **Move the Strobe slider to add some strobe effect.**

6. **Click the Play button in the preview window to view your changes.**

Book II
Chapter 9

Basic Video Editing

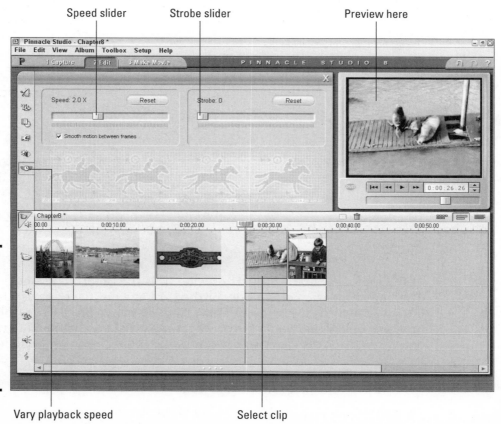

Speed slider Strobe slider Preview here

Figure 9-17: Use the speed slider at the bottom of the timeline to adjust playback speed.

Vary playback speed Select clip

7. **If you don't like your changes and want to revert to the original speed or strobe setting, click one of the Reset buttons.**

8. **Click the Close button in the upper-right corner of the Clip Properties window when you're done making changes.**

The Clip Properties window closes. If you sped up the playback of the clip, the clip now appears narrower on the timeline. If you slowed the playback speed, the clip is wider on the timeline.

Fixing Color and Light Issues

Even if you follow all the best advice for shooting great video, you will probably wind up with some video that has ugly coloration or poor lighting. Fortunately, modern editing programs give you some tools to correct some image-quality issues.

Adjusting image qualities in Pinnacle Studio

Pinnacle Studio provides a pretty good selection of image controls. You can use these controls to improve brightness and contrast, adjust colors, or add a stylized appearance to a video image. To access the color controls, double-click a clip that you want to improve or modify. When the Clip Properties window appears, click the Adjust Color or Add Visual Effects tab on the left side of the window. The Color Properties window appears, as shown in Figure 9-18.

Adjust color or add visual effects

Color Type menu

Figure 9-18: Although this book is printed without color, trust me: I have converted this clip to black and white.

At the top of the Color Properties window is the Color Type menu. Here you can choose a basic color mode for the clip. The normal mode is All Colors, but you can also choose Black and White (shown in Figure 9-18), Single Hue, or Sepia. Below that menu are eight controls that you manipulate using sliders. These controls, listed in the order that they appear, are as follows:

✦ **Hue:** Adjusts the color bias for the clip. Use this if skin tones or other colors in the image don't look right.

✦ **Saturation:** Adjusts the intensity of the color in the image.

✦ **Brightness:** Makes the image brighter or darker.

✦ **Contrast:** Adjusts the contrast between the light and dark parts of the image. If the image appears too dark, use Brightness and Contrast together to improve the way it looks.

✦ **Blur:** Adds a blurry effect to the image.

✦ **Emboss:** Simulates a carving or embossed effect. It looks cool but is of limited use.

✦ **Mosaic:** Makes the image look like a bunch of large colored blocks. This is another control that you probably won't use much.

✦ **Posterize:** Reduces the number of different colors in an image. Play with it; you may like it.

Most of your clips are probably fine just the way they are, but it's good to know that these controls are available if you need them. And if, after making a bunch of changes, you decide that you liked the clip better the way it was, just click the Default button to return the clip to its original settings.

Book II
Chapter 9

Basic Video Editing

Modifying light and color in Apple iMovie

Although Apple iMovie doesn't have specific image controls (as does, say, Studio), you can still modify color and light characteristics by using some of the iMovie effects. Start by selecting a clip that you want to adjust, and then click the Effects button in the upper-right portion of the timeline. In the Effects window that appears (see Figure 9-19), you can use any of several effects to improve the appearance of the clip.

Preview of changes

Figure 9-19: I used iMovie's Brightness & Contrast effect to improve this backlit clip.

Click to view effects.

Most effects have controls that you can adjust by moving sliders. You can also control how the effect starts and finishes. Effects that can modify color and lighting include the following:

✦ **Adjust Colors:** Allows you to adjust hue, saturation (color), and lightness.

✦ **Aged Film:** If the clip looks really bad, you can avoid blame by applying this effect to make the clip look like it's from a really old film. ("See, it's not my fault that the colors are all wrong — this was shot on 8mm film 40 years ago!") Your secret is safe with me. The Aged Film effect gives you the following tools:

 • **Exposure slider:** Lets you make the aged effect appear lighter or darker.

 • **Jitter slider:** Controls how much the video image "jitters" up and down. Jitter makes the clip look like film that is not passing smoothly through a projector.

 • **Scratches filter:** Lets you adjust how many film "scratches" appear on the video image.

✦ **Black & White:** Converts the clip to a black-and-white image.

✦ **Brightness & Contrast:** Adjusts brightness and contrast in the image. (In Figure 9-19, I have increased the brightness and contrast to improve the appearance of a backlit video clip.) Separate sliders let you control brightness and contrast independently.

✦ **Sepia Tone:** Gives the clip an old-fashioned sepia look.

✦ **Sharpen:** Sharpens an otherwise blurry image. A slider control lets you fine-tune the level of sharpness that is applied.

✦ **Soft Focus:** Gives the image a softer appearance, simulating the effect of a soft-light filter on the camera. The following slider controls let you customize the Soft Focus effect:

 • **Softness slider:** Controls the level of softness. Move the Softness control toward the Lots end of the slider for a dream-sequence look.

 • **Amount slider:** Controls the overall level of the Soft Focus effect.

 • **Glow slider:** Increases or decreases the soft glow of the effect. Setting the Glow slider toward High tends to wash out the entire video clip.

To see a full-screen preview of an effect, click the Preview button. If you are happy with the effect, click the Apply button to apply the effect to the clip. When you click the Apply button, you may see a red progress bar appear on the clip. This shows the progress of the *rendering,* the process that applies the effect to the clip. The rendering process creates a temporary file on your hard drive that iMovie uses to show how the clip looks after the effect has been applied.

Chapter 10: Adding Transitions and Titles

Anyone with two VCRs wired together can dub from tape to tape, copying only the desirable scenes, and call it *editing*. But the results will be pretty sloppy, especially compared to the high-quality movies that you can make with your computer. Modern video-editing programs like Apple iMovie and Pinnacle Studio give you powerful tools to help you add special elements to your projects. For example, you can add a transition that allows one clip to gracefully fade into the next, and you can add your own on-screen credits and notations using titles.

This chapter shows you how to use transitions and titles in your movie projects. These are two of the most popular tools that are offered by video-editing programs. Unlike some other (more obscure) effects and tools, transitions and titles are things that you'll probably actually use in every single movie.

Using Fades and Transitions between Clips

One of the trickiest aspects of movie editing (for me, anyway) is making clean transitions between clips. Often the best transition is a simple, straight cut from one clip to the next. Other times, you want to fade gently from one scene to the next. Or, you may want a more fancy transition — say, one that makes it look like the outgoing scene is being rolled apart like drapes to reveal the incoming scene behind it. Most transitions can be generally divided into a few basic categories, as follows:

✦ **Straight cut:** This is actually no transition at all. One clips ends and the next begins. Poof! — just like that.

✦ **Fade:** The outgoing clip fades out as the incoming clip fades in. Fades are also sometimes called *dissolves*.

✦ **Wipe:** The incoming clip wipes over the outgoing clip using one of many possible patterns. Alternatively, the outgoing clip may wipe away to reveal the incoming clip.

✦ **Push:** The outgoing clip is pushed off the screen by the incoming clip.

✦ **3-D:** Some advanced editing programs provide transitions that seem to work three-dimensionally. For example, the outgoing clip may wrap itself up into a 3-D ball, which then spins and rolls off the screen. Pinnacle's Hollywood FX plug-ins for Studio provide many interesting 3-D transitions.

Whatever style of transition you want to use, modern video-editing programs like Apple iMovie and Pinnacle Studio make the process easy. But before you can use transitions, you need a project that already has several clips on its timeline. If you don't yet feel comfortable with editing clips on the timeline, check out Chapter 9 of Book II. The following sections show you how to select and use transitions in your movie projects.

Choosing the best transition

When Windows Movie Maker first came out in 2000, choosing what type of transition to use between clips was easy because you had only two choices. You could use either a straight-cut transition (which is actually no transition at all) or a cross-fade/dissolve transition. If you wanted to use anything fancier, you were out of luck.

Thankfully, most modern video-editing programs — including Windows Movie Maker 2 — provide you with a pretty generous assortment of transitions. Transitions are usually organized in their own window or palette. Transition windows usually vary slightly from program to program, but the basics are the same.

How do you decide which transition is the best? The fancy transitions may look really cool, but I recommend restraint when choosing them. Remember that the focus of your movie project is the actual video content, not showing off your editing skills or the capabilities of your editing software. More often than not, the best transition is a simple dissolve. If you do use a fancier transition, I recommend using the same or a similar transition throughout your project. This makes the transitions seem to fit more seamlessly into the movie.

Reviewing iMovie's transitions

Apple iMovie offers a selection of 13 transitions from which to choose. That may not sound like a big number, but I think you'll find that iMovie's 13 transitions cover the styles that you're most likely to use. To view the transitions that are available in iMovie, click the Trans button above the timeline. A list of transitions appears, as shown in Figure 10-1.

As you look at the list of transitions, most of the names probably look pretty foreign to you. Names like "Circle Closing," "Radial," and "Warp Out" are descriptive, but really the only way to know how each transition looks is to preview it. To do so, click the name of a transition in the list. A small preview of the transition briefly appears in the transition preview window.

Transition preview window

Click to view transitions

Book II
Chapter 10

Adding Transitions
and Titles

Figure 10-1:
iMovie 3
provides
a good
selection of
transitions
that you can
use in your
projects.

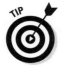 Whoops! You missed it. Click the transition's name again. Wow, it sure flashes by quickly, doesn't it? If you would like to see a larger preview, click the Preview button. A full-size preview appears in iMovie's main viewer screen.

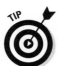 If your transition preview window shows nothing but a black screen when you click a transition, move the mouse pointer down and click a clip in the timeline or on the storyboard to select it. The selected clip should now appear when you preview a transition.

Previewing transitions in Pinnacle Studio

Pinnacle Studio comes with 142 (yes, 142) transitions. In fact, so many transitions are provided with Studio that they don't all fit on one page. To see a list of Studio's transitions, click the Show Transitions tab on the left side of the album, as shown in Figure 10-2. Several pages of transitions are available, and you can view additional pages by clicking the arrows in the upper-right corner of the album.

To preview a transition, simply click it in the album window. A preview of the transition appears in the viewer window to the right of the album. A blue screen labeled "A" represents the outgoing clip, whereas the incoming clip is represented by the orange "B" clip. In Figure 10-2, I am previewing a wipe that uses a heart pattern.

Click to show transitions. Click to see more pages.

Figure 10-2:
Pinnacle
Studio
comes with
several
pages of
transitions.

Adding a transition to the timeline

Adding a transition to a project is pretty easy and works the same way in almost every available video-editing program. For now, add a simple dissolve (also called a *fade*) transition to a project. If your editing program currently shows the storyboard for your project, switch to the timeline (see Book II, Chapter 9 for more on the timeline and basic editing). Next, click and drag the Dissolve transition (in Pinnacle Studio) or the Cross Dissolve transition (in iMovie) from the list of transitions and drop it between two clips on the timeline. The transition now appears in the timeline between the clips.

The appearance of the transition can vary slightly, depending on the editing program that you are using. As shown in Figure 10-3, Pinnacle Studio displays the transition as a clip on the timeline. Apple iMovie, on the other hand, uses a special transition icon that overlaps the adjacent clips, as shown in Figure 10-4.

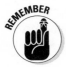

When you first apply a transition in iMovie, the program must *render* the transition before it can be viewed. Basically, rendering is a process that allows the computer to play back the transition at full speed and quality.

To preview the transition, simply play the timeline by clicking the Play button under the preview window or by pressing the spacebar. If you don't like the style of the transition, you can delete it by clicking the transition to select it and then pressing Delete. If you think the transition just needs some fine-tuning, check out the next section.

Dissolve Transition

Figure 10-3:
Transitions
look like
clips in the
Pinnacle
Studio
timeline.

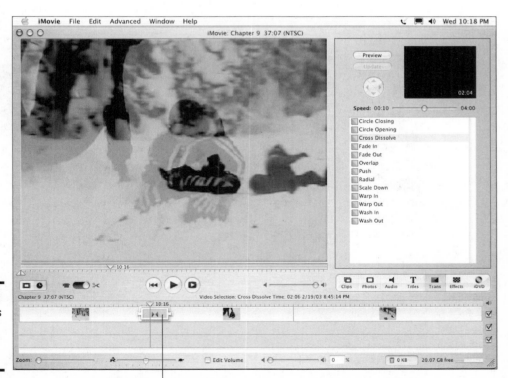

Figure 10-4:
iMovie uses
a special
transition
icon.

iMovie uses a special transition icon.

Adjusting transitions

Video transitions usually have some features or attributes that can be adjusted. Most important, perhaps, is the length of the transition. The default length for most transitions is about 2 seconds.

Sometimes a 2-second transition is too long — or not long enough. Sometimes, for example, a 2-second dissolve really *is* too long because it obscures a spectacular crash at the end of Scene 1. The next two sections show you how to adjust the length of transitions and make other changes, where possible.

Modifying iMovie transitions

The iMovie transition window doesn't just provide a place to store transitions; it also allows you to control them. To adjust the length of a transition, follow these steps:

1. **Click the transition on the timeline to select it.**

2. **Adjust the Speed slider in the Transitions window.**

 The length of the transition is shown in the preview window, as shown in Figure 10-5.

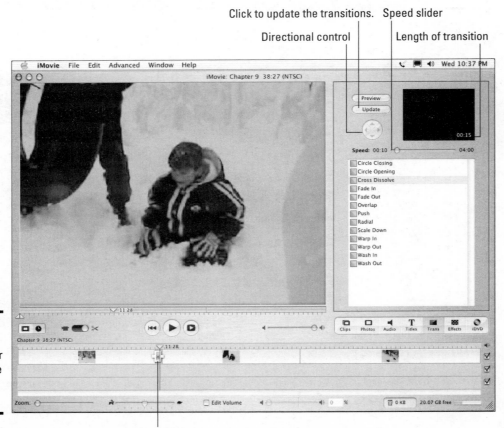

Click to update the transitions. Speed slider

Directional control Length of transition

Figure 10-5: Use the Speed slider to adjust the length of the clip.

Short transition

3. **Click the Update button in the Transitions window to update the length of the transition on the timeline.**

4. **Click the Play button under the preview window to preview your results.**

Some iMovie transitions, such as Push, allow you to control the direction of travel for the transition. When you click the Push transition to select it in the transition window, the directional control (shown in Figure 10-5) becomes active. Then you simply click the arrows in the directional control to change the direction in which the Push transition moves.

Adjusting transitions in Studio

Adjusting transitions in Pinnacle Studio works a lot like adjusting regular video clips. To modify a transition, here's the drill:

1. **Double-click the transition on the timeline.**

 The Clip Properties window appears above the timeline.

2. **Adjust the duration of the transition in the upper-right corner of the window by clicking the up or down arrows next to the Duration field at the top of the Clip Properties window.**

3. **Change the duration to the required number of frames (if necessary), as shown in Figure 10-6.**

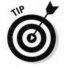

You can also reverse the direction of some transitions (for example, the Horizontal Snake Wipes on page 2 of the Standard Transitions) by selecting the Reverse check box. (If this box is grayed out, the current transition cannot be reversed.)

**Book II
Chapter 10**

Adding Transitions
and Titles

Reverse check box Duration

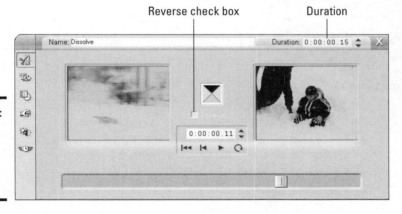

Figure 10-6: Modify transitions in the Clip Properties window.

Giving Credit with Titles

In their rush to get to the pictures, folks who are new to video editing often overlook the importance of titles. *Titles* — the words that appear on-screen during a movie — are critically important in many different kinds of projects. Titles tell your audience the name of your movie, who made it, who starred

in it, who paid for it, and who baked cookies for the cast. Titles can also clue the audience in to vital details — where the story takes place, what time it is, even what year it is — with minimum fuss. And of course, titles can reveal what the characters are saying if they're speaking a different language.

Virtually all video-editing programs include tools to help you create titles. The following sections show you how to create and use effective titles in your movie projects.

Creating titles for your movies

It's easy to think of titles as just words on the screen. But think of the effects, both forceful and subtle, that well-designed titles can have. Consider the *Star Wars* movies, which all begin with a black screen and the phrase "A long time ago, in a galaxy far, far away . . ." The simple title screen quickly and effectively sets the tone and tells the audience that the story is beginning. And then, of course, you get those scrolling words that float three-dimensionally off into space, immediately after that first title screen. A story floating through space is far more interesting than white text scrolling from the bottom to top of the screen, don't you think?

Titles can generally be put into two basic categories: full-screen and overlays. Full-screen titles, like the one shown in Figure 10-7, are most often used at the beginning and end of a movie, where the title appears over a background image or a solid color (such as a plain black screen). The full-screen title functions as its own element in the movie, as does any video clip. An overlay title makes words appear right over a video image, as shown in Figure 10-8.

Figure 10-7: A full-screen title stands alone and is often used at the beginning or end of a movie.

Figure 10-8: An overlay title appears right on a video image.

Making effective titles

When using titles in your movies, you should follow some basic guidelines to make them more effective. After all, funny or informative titles don't do much good if your audience can't read them. Follow these general rules when creating titles for your movies:

✦ **Less is more.** Try to keep your titles as brief and simple as possible.

✦ **White on black looks best.** When you read words on paper, black letters on white paper are easier to read. This rule does not carry over to video, however. In video images, light characters over a dark background are usually easier to read. An exception would be if you already have a relatively light background. In Figure 10-8, the darker-colored title works well over the snow-covered background. But what if I want to put that same title near the top of the screen instead? The dark-colored title doesn't work as well at the top of the screen because trees in the background can make it harder to read. As an alternative, I can create a small, dark background shape behind lighter-colored text, as shown in Figure 10-9. (I show you how to control title colors and styles in the next couple of sections.)

Figure 10-9: Small, dark blobs or shapes behind titles can make them easier to read.

> Instant Replay
> 0:00:31.26

Video displays such as TVs and computer monitors generate images using light. (You can think of a TV screen as a big light bulb.) Because TV displays emit light, full-screen titles almost never have black text on a white screen. Most people find staring at a mostly white TV screen about as unpleasant as staring at a lit light bulb: If you watch viewers look at a white TV screen, you may even see them squint. Squinting is bad, so stick to the convention of light words over a dark background whenever possible.

✦ **Avoid very thin lines.** In Chapter 2 of Book II, I describe the difference between interlaced and noninterlaced video displays. In an interlaced display (such as a TV), every other horizontal resolution line of the video image is drawn in a separate pass or field. If the video image includes very thin lines — especially lines that are only 1 pixel thick — interlacing could cause the lines to flicker noticeably, giving your viewers a migraine headache in short order. To avoid this, choose fonts that have thicker lines. For smaller characters, avoid serif fonts such as Times New Roman. *Serifs* (the extra strokes at the ends of characters in some fonts, such as the font that you're reading right now) often have very thin lines that flicker on an interlaced video display.

✦ **Think big.** Remember that the resolution on your computer screen is a lot finer than what you get on a typical TV screen. Also, TV viewers typically watch video from longer distances than do computer users — say, across the room while plopped on the sofa, compared to sitting just a few inches away in an office chair. This means that the words that look pleasant and readable on your computer monitor may be tiny and unintelligible if your movie is output to tape for TV viewing. Never be afraid to increase the size of your titles.

✦ **Think safety.** Most TVs suffer from a malady called *overscan,* which is what happens when some of the video image is cut off at the edges of the screen. You can think of TVs as being kind of like most computer printers. Most TVs can't display the far edges of the video image, just as most printers can't print all the way to the very edges of the paper. When you're working on a word processing document, your page has margins to account for the shortcomings of printers as well as to make the page more readable. The same applies to video images, which have *title-safe margins.* To ensure that your titles show up on-screen and are not cut off at the edges, make sure that your titles remain within this margin (also sometimes called the *title-safe boundary*).

Apple iMovie doesn't show these margins on-screen; instead, it automatically keeps your titles inside the margins. If you know that your movie will be viewed only on computer screens, select the QT Margins check box in the Titles window. This places the margins closer to the edge of the screen.

Pinnacle Studio's Title Editor works like most video-editing programs: The margins are displayed on-screen, and you have to remember to keep your titles inside them. The margins appear in the Title Editor window as red dotted lines, as shown in Figure 10-10.

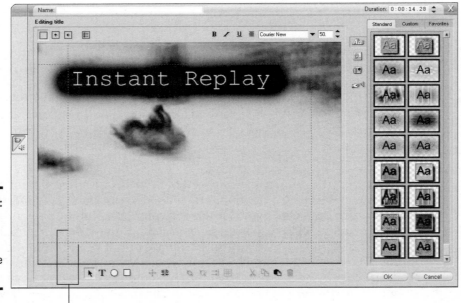

Figure 10-10: Don't let your titles fall outside the title-safe margins.

Title safe margins

✦ **Play, play, play.** I cannot stress enough the importance of previewing your titles, especially overlays. Play your timeline after adding titles to see how they look. Make sure that the title is readable, positioned well on-screen, and visible long enough to be read. If possible, preview the titles on an external video monitor.

 You can use transitions between full-screen titles and other video clips. Dissolves (described in the section "Using Fades and Transitions between Clips," earlier in this chapter) often look nice when used to transition from a full-screen title to the video.

Using Studio's Title Editor

Pinnacle Studio comes with a remarkably advanced title designer, considering the price. Studio's Title Editor is based on Pinnacle's Title Deko, a high-quality title designer that's used by many professional video editors. Studio also provides a selection of predesigned titles that are ready to drop right into any video project. To access these titles, click the Show Titles tab on the left side of the album. A selection of titles appears, as shown in Figure 10-11. Click the arrow in the upper-right corner of the album to view additional pages.

To see a preview of the title, click it once in the album. The title appears in the viewer window. To add a title to your project, simply drag the title thumbnail from the album down to the timeline, just as if it were a video clip. In Figure 10-11, I have dropped a "Snow Boarding" title at the beginning of my timeline's video track. If the title is dropped on the video track, the title will be a full-screen title, which by default has a plain black background.

If you use a predesigned title, you'll probably want to change some of the text. For example, even though I like the style of the "Snow Boarding" title, I don't want the words *Snow Boarding* to appear because that's not what is happening in the video. To edit the title, double-click it after you have added it to the timeline. The Studio Title Editor opens. You can also open the Title Editor and create a new title by double-clicking any blank space in the Title track (see Figure 10-11) of the timeline. The next section shows you how to edit a title.

Editing titles

The Title Designer window is one of the most complex windows in the Studio software. If you are working with a predesigned title, double-click it in the timeline to change the text. The title opens in the title editor. To change the text, click once on the title and start typing. Highlight unwanted words, and press Delete to delete them.

Book II
Chapter 10

Adding Transitions
and Titles

Title track

Video track

Show titles

Click to view more pages.

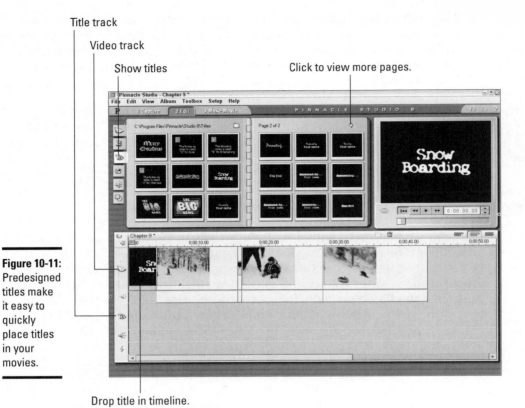

Figure 10-11:
Predesigned
titles make
it easy to
quickly
place titles
in your
movies.

Drop title in timeline.

You can change the font style or size for the title if you don't like it. Select the text that you want to change, and then choose a new font in the font menu at the top of the Title Editor. In Figure 10-12, I've changed the font to Trendy because I didn't like the Pretext font that was used in the "Snow Boarding" title. Figure 10-12 also shows the basic controls of the Title Designer. Some of the most important controls are as follows:

✦ **Roll:** Click this to make the title roll vertically up the screen. This is especially useful if you have a long list of credits that you want to roll at the end of the movie. If you choose the Roll option, the Title Editor allows you to scroll down the editing area to add more rows of titles. You can make a roll title as long as you want. Each time you add a new line of text to the bottom of a rolling title, the title screen gets a little longer.

✦ **Crawl:** Click this to make the title crawl across the screen from right to left. Crawl useful text, such as "Order now! Quantities are limited!" across the bottom of the screen. Like rolling titles, you can make a crawling title wider by simply adding more text to the right side of the title.

✦ **Text styling:** Select some text in your title, and then click one of these buttons to style the text. Just like in a word processor or almost any other computer program, click B to make the text bold, click I to make it italic, and click U to underline the text.

✦ **Text justification:** Click this button to open a submenu of text justification and alignment options. You can choose to align text left, right, or centered. If you click the Shrink to Fit button, the text automatically shrinks

to fit in the text box in case you make the box smaller. If you click the Scale to Fit button, the text shrinks or grows to fill the entire text box if you make the box smaller or bigger. If you want long lines of text to automatically wrap to the next line, click the Word Wrap On button. Otherwise, click the Word Wrap Off button. Click the Close (X) button in the upper-right corner of the Text justification menu to close the menu.

✦ **Add Text Field:** Click this button and then click and drag a text box in the editing area to create a new line of text from scratch.

✦ **Text styles:** Use these predefined styles to quickly format text. To apply a style to some existing text, select the text in the editing area and then click a style in the list.

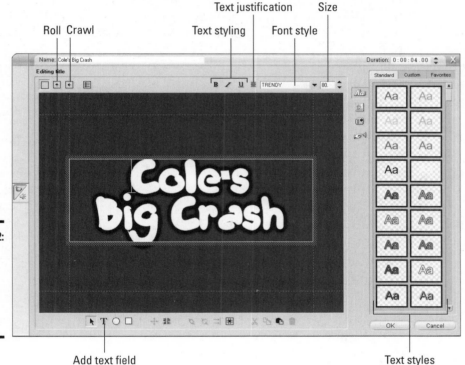

Roll Crawl Text styling Text justification Font style Size

Figure 10-12:
Use the
Studio Title
Editor to
create and
edit your
titles.

Add text field Text styles

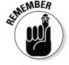

When you edit titles in Studio, make sure that the words stay inside the title-safe boundaries, which are the red dotted lines around the edges of the Title Editor window. Text that falls outside those boundaries may be cut off when the movie is viewed on a TV screen.

To change the color of your text, click the Custom tab on the right side of the Title Editor screen. As shown in Figure 10-13, this tab offers a variety of controls for text. The controls are divided into three sections: Face, Edge, and Shadow. Each section has a radio button for the following options: Color, Gradient, or Transparent. If you want the element to be a solid color, select the Color radio button, click the color box next to it to open a color picker and choose a specific color. If you want the element to be a gradient (a color that gradually changes from one color at one side of the letter to a different

color at the other side), select the Gradient radio button and then click the gradient box next to it to specify the colors that are to be used in the gradient. If you want the element to be transparent, select the Transparent radio button.

The three sections of the Custom tab control separate elements of the title text, as follows:

✦ **Face:** This section controls the basic face of the text. You can choose a solid color, make the color a gradient, or make the text face transparent. Only choose the Transparent radio button if the text has a thick, visible edge. You can also blur the appearance of the face by using the slider control at the bottom of the Face section.

✦ **Edge:** Here you can change the color and also size the edges of characters. Like the text face, edges can be a solid color, a gradient, or transparent. Choose the Transparent option if you simply don't want the text to have an edge.

Figure 10-13: Change the color and appearance of text with these controls.

Adjust the upper slider in the Edge section to change the size of the edge. Move the slider to the right to make the edge thicker, or move it to the left to make the edge thinner. Remember, very thin lines can flicker when the movie is viewed on a TV screen, so try to make the edge at least 3 pixels thick. An indicator to the right of the size slider tells you the current thickness in pixels. To blur the appearance of the text's edge, adjust the lower slider in the Edge section.

✦ **Shadow:** Add a shadow for your text, give that shadow a color, and control the direction of the shadow by using the Round direction control. Shadows can help make text easier to read over some backgrounds. Like other text elements, shadows can be a solid color, a gradient, or transparent. The upper slider in the Shadow section changes the apparent distance between the text and the shadow, and the lower slider blurs the shadow slightly. Generally speaking, the farther a shadow is beneath the text, the more you should blur the shadow. The radial control underneath the sliders lets you adjust the direction of the shadow. Select a radio button around the A to change the direction of the shadow.

Book II
Chapter 10

Adding Transitions
and Titles

When you're done editing your title, click OK in the lower-right corner of the Title Editor to close it and return to the Studio timeline.

As you play with the Title Editor a bit, you'll probably find that creating titles from scratch takes a while. That's why I normally use one of the ready-made text styles (on the Standard tab of the Title Editor) as a starting point.

Changing backgrounds

If you've read this chapter from the beginning, you've already heard me preach about how white words over a black background are easier to read than any other style of title. But face it: Plain black backgrounds are a little, er, boring. To spice up the appearance of your full-screen titles a bit, use the Title Editor to add a background. Follow these steps to do so:

1. **Double-click a full-screen title in your timeline to open it.**

2. **Click the Backgrounds button to show the background controls.**

3. **To change the color of a solid background, select the Background Color radio button and then click the color box to choose a new color.**

You can also choose the Gradient or Transparent radio buttons.

4. **To use a background image instead of a solid color or gradient, select the Background Picture radio button and then click a picture in the list.**

In Figure 10-14, I have chosen a winter-themed background for my full-screen title. If you have a picture that you would like to place in the background, click the Pictures button and then click the Folder icon in the pictures list to browse to the picture file on your hard drive. You can then click and drag the picture onto the title and position it anywhere you want.

Background Color radio button Color box

Background Picture radio button Gradient button

Background

Pictures

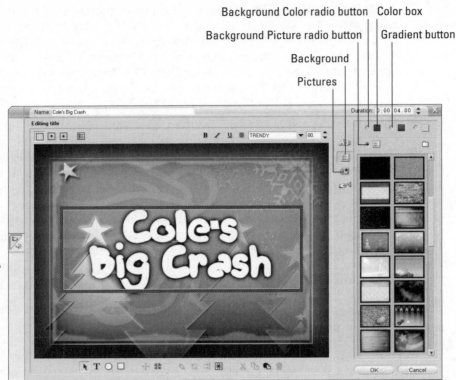

Figure 10-14:
Studio
comes with
some nice
background
images for
your titles.

Creating Titles in iMovie

Apple prides itself — and rightfully so — on providing computers and software that are easy to use. Adding titles to your iMovie project could hardly be easier. To create a title, follow these steps:

1. **If you're creating an overlay title, click the video clip in the timeline that is to appear behind the title.**

 This operation ensures that the proper clip appears in the preview window as you edit and preview your title. If you're currently working in Storyboard mode, I recommend that you switch over to the timeline by clicking the Timeline button, which appears under the lower-left corner of the iMovie preview window. If you're creating a full-screen title (one that is over a black background instead of superimposed over a clip), don't worry about selecting a clip in the timeline: Just go straight to Step 2.

2. **Click the Titles button above the timeline.**

 The iMovie Title Designer appears.

3. **Type the words for the title in the text boxes near the bottom of the Title Designer (as shown in Figure 10-15).**

4. **Choose a style for your title from the Titles list (not to be confused with the brand of golf ball).**

Font face menu

Preview window

Type text here. Titles list Color box

Figure 10-15:
iMovie's
Title
Designer is
easy to use.

Drop title in timeline. Size slider

Click to display titles.

Most of the listed titles are for moving titles. When you click one, a preview of the motion appears in the preview window at the top of the Title Designer. If you want a static title that doesn't move, choose Centered, Stripe Subtitle, or Subtitle.

5. **If the movie is to be output to videotape or DVD for viewing on conventional TVs, make sure that the QT Margins check box is deselected.**

 The QT Margins option allows titles in movies that are destined for the Web to use a little more screen space, but this isn't recommended for movies that are to be shown on TVs. The problem is overscan, which I describe in the section "Making effective titles," earlier in this chapter.

6. **To create a standalone title with a black background, select the Over Black check box.**

7. **Click the Color box to choose a new color for the title.**

8. **Use the Font menu to choose a new font face, and adjust the size of the title using the Size slider.**

9. **When you're ready to add the title to the project, drag the title from the Titles list and drop it into the timeline, just before the clip over which you want the title to appear.**

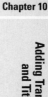

The title appears in the timeline. If you created an overlay title, it is automatically superimposed on the video clip before which you placed the title. If you chose the Over Black option in Step 6, the title is a stand-alone clip in the timeline, with a black background.

If you decide to edit a title that you created earlier, select the title in the timeline, make your changes, and then click the Update button at the top of the Title Designer window.

CHECK IT OUT

Changing the Length of Titles

After you've added some titles to your movie project and previewed them a couple of times, you'll probably find that you need to change how long some of them appear. Does the title flash by so quickly that you don't have time to read it? Does the title seem to linger a few seconds too long? Changing the length of titles is pretty easy, but you must be viewing the timeline in your editing program, not on the storyboard. As I describe in Book II, Chapter 9, the timeline is where you perform "fine-tuning" edits, such as changing the length of a title.

Use one of the following methods to change the length of a title.

In almost any video-editing program:

1. **Hold the mouse pointer over an edge of the title in the timeline.**

2. **Click and drag the edge back and forth to make the title longer or shorter.**

This method is quick and easy but not very precise.

In Pinnacle Studio:

1. **Double-click the title to open the Title Editor.**

2. **Type a new number in the Duration field or use the arrows next to the Duration field to increase or decrease the duration.**

In iMovie:

Simply move the Speed slider to the left or right in the Title Designer window.

 In addition to altering the duration of your title, you can change which clip your overlay titles appear over. Just drag the titles left or right in the timeline to change when they appear.

Chapter 11: Using Special Effects in iMovie and Adobe Premiere Pro

In This Chapter

✔ **Creating composite scenes in Premiere Pro**

✔ **Animating clips and objects in Premiere Pro**

✔ **Putting effects to work in Premiere Pro**

✔ **Filtering and fixing color or brightness in iMovie**

✔ **Using effects creatively in iMovie**

*H*ave you ever watched a movie where it appeared that the hero was hanging by fingertips from a ledge of a tall skyscraper, or a giant lizard creature appeared to be chasing live humans through a jungle? Of course, moviemakers don't really risk the lives of big-name stars, and they don't breed giant lizard creatures to train them as harmless-yet-scary-looking movie extras. Scenes like these are created by using a little bit of movie magic called *compositing*.

Guess what? You don't have to be a Hollywood movie mogul with a multi-million-dollar budget to use compositing. With some simple videographic tricks and Adobe Premiere Pro, you can create composite scenes with the best of 'em. In this chapter, I show you how.

This chapter also shows you how to use Premiere Pro's animation features (which can move video scenes, titles, and other graphics across the screen), and I demonstrate how to take advantage of iMovie's built-in special effects.

Compositing Video

Over the years, we have come to expect sophisticated illusions in our entertainment — starships flying into a space battle, lovers standing on the bow of a long-gone ocean liner, or a weatherman standing in front of a moving weather-satellite graphic — and if you ever wanted to create some of your own, now you can: Adobe Premiere Pro is fully capable of creating such effects.

One of the great spells you can cast in the magic of moviemaking involves *compositing*. When you composite clips, you combine portions of two or more clips to make a video image that would otherwise be difficult or impossible to capture. Consider the scene I described in the introduction to this chapter, where an actor appears to be hanging by his fingertips from the 50th floor of a skyscraper as cars move like ants on the streets far below. Did the producers risk the actor's life and force him to hang from a tall

building? Not likely — think of the insurance costs! They probably shot him hanging from a prop in a studio and then superimposed that image over a shot taken from an actual skyscraper.

Fundamental to the process of compositing is the careful layering of images. Using Premiere Pro, you can superimpose up to 99 separate video tracks upon one another. Each track contains part of the final image; by making parts of each track either opaque or transparent, you can create a convincing illusion of three-dimensional space.

Adjusting the opacity of a clip

Video clips in Premiere Pro can vary between transparent and opaque. One of the most basic superimposition effects is to make a clip less opaque — that is, more transparent. The more transparent clip becomes a ghostlike image superimposed over the more opaque image behind it. You can change the opacity of an entire clip, or change it gradually throughout a clip. To adjust the opacity of a clip, follow these steps:

1. **Add a clip to the Video 1 track in a sequence.**

Clips in the Video 1 track should not be made transparent, so you might think of Video 1 as the background layer. When you layer additional clips over it and make them transparent, the background clip on Video 1 should show through.

2. **Add a clip to a superimpose track in the sequence.**

Video 2 and any higher-numbered tracks are all considered *superimpose tracks* because they're the ones you superimpose over a primary or background image. You can think of the video tracks on the timeline as layers on top of each other. If you superimposed 50 tracks on top of each other, Track 50 would be the very top layer and opaque areas of that track would cover all other tracks.

After you have added a clip to a superimpose track, the superimposed clip should appear directly above the background clip in Video 1, as shown in Figure 11-1.

3. **Click the arrow to expand the track view, as shown in Figure 11-1.**

Expand track.

Show Keyframes. Add/Remove Keyframe. Click and drag to adjust.

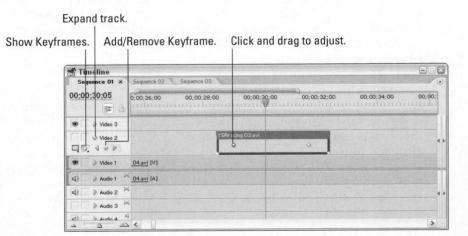

Figure 11-1: Use the opacity rubberband to adjust opacity throughout a clip.

4. **Click the Show Keyframes button in the track header for the superimpose track and then choose Show Opacity Handles from the menu that appears.**

 A yellow opacity rubberband appears on clips in the superimpose track.

5. **Click the clip for which you want to adjust opacity (doing so selects it).**

6. **Place the CTI (short for Current Time Indicator) cursor somewhere in the selected clip — this makes the selected clip the target of the next action.**

7. **Press Page Up on your keyboard to move the CTI to the beginning of the clip.**

8. **Click the Add/Remove Keyframe button on the track header to set a key frame.**

9. **Move the CTI to a new place in the clip and click the Add/Remove Keyframe button again to create another key frame.**

10. **Press Page Down on your keyboard to move the CTI to the end of the selected clip, and click the Add/Remove Keyframe button again to set another key frame.**

11. **Click and drag on the key frames you created to adjust the yellow opacity rubberband.**

 As you drag the rubberband down, the clip becomes more transparent. As you drag it up, the clip becomes more opaque.

If you find that the key frames are kind of hard to click and drag with the mouse, carefully hover the mouse pointer over a key frame. When the mouse pointer has a yellow dot next to it, you can click and drag the key frame.

Using keys

In the preceding section, you adjust the opacity of a clip to make the entire image transparent or semitransparent. But what if you want only parts of the image to become transparent while other parts of the image remain fully opaque?

You've probably heard of a video technique called *bluescreening,* often used in special-effects shots in movies, or during the evening news when a meteorologist must appear in front of a moving weather map. In actuality, the announcer is standing in front of a blue screen — usually wearing a color that clashes with the blue. Why the clash? Because you're not supposed to *see* the blue.

Here's how the blue screen becomes a weather map: Video-editing software uses a *key* — a setting that recognizes the special shade of blue and defines it as transparent. Because the wall behind the announcer is the only thing painted that shade of blue, it "disappears." In effect, the image of the meteorologist has been placed on a virtual glass slide and superimposed electronically over the image of the weather map. Pretty slick, eh?

Of course, if the meteorologist happens to wear a tie or blouse that *matches* the transparent color, you can see chunks of the weather map right through the person. (Oops . . .) Editors can make only *so* much movie magic; some careful videography is needed to make blue-screen-style effects work.

A blue screen key is one of many keys that work by recognizing a specific color in an image. Some keys use an alpha channel instead of a color to define transparent areas of an image. If you've worked with still graphics in a program such as Adobe Photoshop, you're probably familiar with alpha channels. An *alpha channel* is basically a layer in the image that defines transparency within the image. Generally speaking, the only time you'll use an alpha key is when you're dealing with a still graphic that was imported from a program like Photoshop or Adobe Illustrator.

The following sections show you how to use different kinds of keys to define transparent areas in your video image.

Understanding the key types

Although the example just given — a key that recognizes a blue screen behind a meteorologist — is extremely common, it isn't the only kind of key available to you in Premiere. In fact, Premiere Pro provides 14 different kinds of keys for you to use. To view a list of the keys, click the Effects tab in the Project window (or choose Window➪Effects) and then expand the Keying folder under Video Effects. Premiere Pro's keys are

+ **Alpha Adjust:** This key works a lot like the opacity controls (described earlier in this chapter); it's for still graphics that have an alpha channel. Use this key to adjust opacity of the whole graphic, ignore the alpha channel, invert the alpha channel, or use the alpha channel as a mask.

+ **Blue Screen:** Use this key when you've shot video with the subject in front of a blue screen. The blue screen must be well lit and brilliant for this key to be effective. Any shadows that the subject casts on the screen reduce the effectiveness of this key.

+ **Chroma:** This key enables you to *key out* (make disappear) a specific color or range of similar colors. With some fine-tuning, you can use this key with almost any clip. In Figure 11-2, I have applied a Chroma key to the clip on the left to create the superimposition effect shown on the right. (I show how to do this in the next section.)

+ **Difference Matte:** This matte enables you to key out the areas of two images that match each other.

+ **Garbage Matte:** Use the Garbage Matte key to remove undesired objects that won't key out properly. When you apply a garbage matte to a super-imposed clip, you can click and drag handles around the edge of the screen to (in effect) crop out portions of the image.

+ **Green Screen:** This key works just like the Blue Screen key except it uses (surprise) green instead of blue.

+ **Image Matte:** This key uses a second still image to create transparency. When you use this key, you choose an image (such as a flower or a heart) to provide the basic shape for the key.

Figure 11-2:
You can
create
super-
impose
effects like
this one
with the
Chroma key.

✦ **Luma:** Luma is short for *luminance,* which is just a fancy word for color. This key eliminates darker colors from an image.

✦ **Multiply:** With this key, transparency is based on bright areas on the video track underneath the superimpose track.

✦ **Non-Red:** This key works like the Blue Screen and Green Screen mattes, but it keys out both blue and green screens. If you encounter rough edges (called *stair-stepping*) around unkeyed objects with the Blue Screen or Green Screen keys, try using the Non-Red key instead.

✦ **RGB Difference:** This key is similar to the Chroma key, but with fewer options. This key works best when the background and subject contrast strongly.

✦ **Remove Matte:** This matte keys out the alpha channel and either the black or white background layers.

✦ **Screen:** With this key, the transparency is based on dark areas on the video track underneath the superimpose track.

✦ **Track Matte:** Use this matte with a black-and-white image that moves across the screen. Transparency moves with the image.

Applying a key

Applying a key to a clip is pretty easy. A key allows portions of one image to be transparent when it is superimposed over another image. Remember, you can apply a key only to a clip in a superimpose track — that is, Video 2 or higher. To apply a key, follow these steps:

1. **Click a clip in a superimpose track to select it, and make sure that the CTI on the timeline is somewhere over the clip.**

2. **Open the Effects tab in the Project window, or choose Window➪ Effects.**

3. **Expand the Video Effects folder and then expand the Keying folder.**

4. **Drag and drop a key from the Effects tab to the selected clip in the superimpose track.**

5. **Click the Effect Controls tab in the left pane of the Monitor window, or choose Window⇨Effect Controls.**

 The effect controls for the selected clip should appear. The key you have applied should be listed under Video Effects.

6. **Click the right-pointing arrow next to the key to expand its controls, as shown in Figure 11-3.**

 If the key uses color information — for example, the Chroma key I'm applying in Figure 11-3 — you may need to choose a base color for transparency. Click and hold the eyedropper in the Effect Controls, move the mouse pointer over the video image on the right side of the Monitor, and release the mouse button over the color you want to key out.

7. **Adjust any other settings that may be available.**

 Each key is different, so experiment with the settings to achieve the desired result.

Click to expand key controls.

Some keys have an eyedropper for choosing colors.

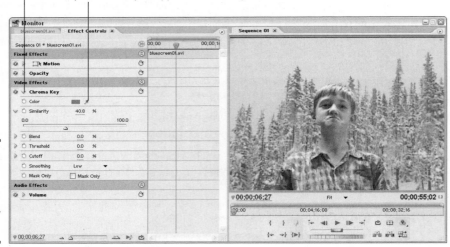

Figure 11-3: Use the Effect Controls tab to adjust key settings.

Creating a matte

Some of the keys available in Premiere Pro use matte images to define transparent areas. You can create your own mattes by using a graphics program such as Adobe Photoshop, and you can create some mattes within Premiere itself. You can create mattes for a variety of purposes:

✦ **A solid, brightly colored matte can help you key transparency on another clip.** To create a matte of a solid color, choose File➪New➪ Color Matte. Choose a color for the matte from the Color Picker. If you see a warning that the picture is out of the color gamut for your video format ("Whaddaya *mean* I can't use fluorescent puce there?"), choose another color. Then place this matte on a track that is under the clip to which you're trying to apply a key. The brightly colored matte shows through to help you identify transparent areas and adjust as necessary. When you've made all the necessary adjustments, just delete the color matte.

✦ **To mask out specific areas of an image, create a "garbage" matte and crop out the undesired object.** To do this, first create a color matte (this will be your "garbage" matte) or import a background image. Next, select the image that has an object you want to crop out and add it to a super- impose track above the color matte or background image. If the image has an alpha channel, that channel automatically becomes transparent. Otherwise, you can apply the Chroma key to the clip and select the color in the image that you want to make transparent. Using a still graphic as a garbage matte rather than the Garbage Matte key provided by Premiere Pro allows you to create a matte with much more complex shapes. Consider the matte in Figure 11-4, which creates the shape of a snowflake. You would never be able to create a shape like this using the Premiere Pro Garbage Matte key.

Figure 11-4:
Create a
matte in a
graphics
program if
you want
to use
complex
shapes.

When preparing a still graphic for importation into a video project, remem- ber the importance of sizing your image to fit properly in the video image.

Animating Clips

I know what you're thinking when you read this heading — "Why do I need to animate a video clip in which the subjects are already moving?" You may not need to animate the actual *subjects* in the video, but you can move the video image across the screen. For example, a small picture-in-picture image

can sail across the screen to give a hint of action that will happen later in the movie. You can move a clip across the screen along a fixed path or a zigzag pattern, you can rotate clips, and you can distort them. To begin animating a clip, follow these steps:

1. **On the timeline, click the clip that you want to animate to select it, and make sure that the CTI is somewhere over the clip.**

 Usually any clip that you animate should be in a superimpose track — that is, one that occupies any track above Video 1.

2. **Click the Effect Controls tab on the left side of the Monitor, or choose Window⇨Effect Controls.**

3. **Under Fixed Effects, click the right-pointing arrow next to Motion to expand the Motion controls.**

Adjusting Motion controls

You can adjust the Motion controls in a variety of ways. Perhaps the easiest way to adjust a clip is to click the box next to Motion. You can then click and drag corners of the video image to shrink it to a smaller size, as I've done in Figure 11-5. To move the clip, click and drag the circle in the middle of the clip. If you want more precise control, use the following controls under Motion:

✦ **Position:** The position of the clip is expressed in pixels along an X (horizontal) and Y (vertical) axis. Zero for the X axis is the left edge of the screen, and zero for the Y axis is the top of the screen. The default position for any clip is right in the middle. For example, in NTSC-format DV video, the default position is 360 by 240. You can change the position of the clip by typing new numbers next to Position, or you can click and drag left or right on either Position number.

✦ **Scale:** The default scale for any clip is 100, which means its size is 100 percent of the screen size. Reduce the scale to shrink the clip image.

✦ **Scale Width:** If you remove the check mark next to Uniform Scale, you can adjust height and width independently. With Uniform Scale unchecked, the Scale control adjusts height, and the Scale Width control adjusts width.

✦ **Rotation:** Use this control to rotate the clip. Expand the Rotation control and click and drag left or right on the clock-style rotation control to spin the image on its axis.

✦ **Anchor Point:** All the other controls assume work off the clip's anchor point, which is usually in the center. If you want to rotate the clip around a corner instead of the center, for example, just move the anchor point.

If you don't like the changes you've made to the Motion controls, just click the Reset button next to Motion in the Effect Controls tab. This resets the clip back to the default settings.

Click to change size.

Reset

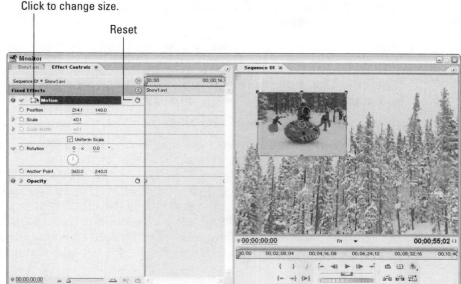

Figure 11-5:
Use the
Motion
controls
to resize or
animate a
video image.

Using Special Effects
in iMovie and Adobe
Premiere Pro

Animating a clip

As you play with the Motion controls, you should see how easy it is to
change the on-screen position, size, and orientation of a clip. But what if
you want the clip to move across the screen after you've shrunk it? To do
this, you must use key frames. To control motion with key frames, follow
these steps:

1. **Click the clip you want to animate on the timeline to select it.**

2. **Move the CTI to the beginning of the selected clip.**

The easiest way to do this is to first position the CTI somewhere over
the clip and then press Page Up on your keyboard.

3. **In the Motion controls for the selected clip, click the Toggle
Animation button next to the control you want to animate.**

In Figure 11-6, I'm animating the Position control.

Toggle Animation Add/Remove Keyframe

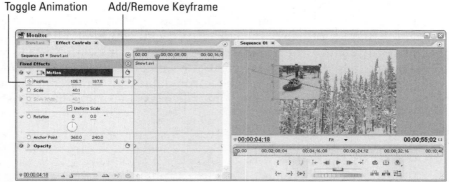

Figure 11-6:
This clip
moves
across the
screen as
it plays.

4. **Adjust the Scale, Position, and any other Motion controls you want to change.**

 These settings represent what the clip looks like and where it's positioned at the *start* of the animation.

5. **Click the Timeline window to make it active, and press Page Down to move the CTI to the end of the clip.**

6. **Adjust the Scale, Position, and any other Motion controls for the clip.**

 These settings represent what the clip looks like and where it's positioned at the *end* of the animation.

When you make the adjustments just described, Premiere Pro automatically creates key frames at the beginning and end of the clip. Premiere then automatically calculates how the clip should move and change to steadily go from one key frame to the next. In Figure 11-6, I've started the clip off-screen to the left and ended it off-screen to the right. As the clip plays, it appears to move across the screen.

You can add additional key frames anywhere along the path of the clip to make more dynamic changes. Just move the CTI to a position somewhere in the middle of the clip and click the Add/Remove Keyframe button in the Motion controls, and then adjust settings as needed.

Using Effects in Premiere Pro

Personal computers capable of editing video have been widely available for several years now, and in the last couple of years, they've become downright cheap. This — combined with continuing price drops on DV camcorders — has led to an explosion in the number of video-editing programs available. From mild to wild, entry-level to professional, there is a video editor for every need and budget.

Not all video-editing programs are created equal, however. Many editors offer special effects that you can apply to your video clips, but few offer the quality and variety available with Adobe Premiere Pro. You can add even more effects from third-party vendors.

Effects can help you clean up your video or add special touches that amaze and astound your audience. What's really cool about effects is that you can add them to (or remove them from) any clip you want. Effects do not permanently change your clips, so if you aren't happy with a result, you can simply delete the offending effect. Although this book isn't the place to cover each of Premiere Pro's effects in detail, this chapter shows you the basics of using effects — including the brass-tacks specifics of using several common effects.

Built-in effects

Adobe Premiere Pro comes with over 50 effects built right in. Some of these effects may not seem immediately useful, but you may be surprised in a future project when what seems like the most obscure effect comes in handy. You can get a look at Premiere's effects by choosing Window⇨Effects, or

just click the Effects tab in the Project window. Expand the Video Effects folder to reveal the following 14 categories:

✦ **Adjust:** These seven effects let you tweak levels of color and light. They can be useful for fixing color- and light-related problems in your video clips.

✦ **Blur & Sharpen:** These 11 effects run the gamut from blur to sharpen. The blur effects allow you to soften the outlines of things to simulate disorientation, or suggest speed by unfocusing parts of the video image. The sharpen effects perform a variety of sharpening enhancements to an image. Use these effects to sharpen images that appear too soft.

✦ **Channel:** This category includes two effects. The Invert effect inverts colors in a clip. The Blend effect enables you to blend the colors of superimposed clips.

✦ **Distort:** This folder contains 13 effects that bend, twist, or exaggerate the shape and view of your video.

✦ **Image Control:** These ten effects change the way color is viewed in your clips. They can remove a color (or range of colors) from a clip, convert a color image to black and white, or adjust the overall tint of the image (useful if, for example, you want to transform an ordinary outdoor scene into an alien landscape).

✦ **Keying:** These effects allow you to control transparency in clips and perform compositing effects such as bluescreening.

✦ **Noise:** The Median effect — the only effect in the Noise category — can be used to reduce noise in the video image. If more extreme settings are applied, the image begins to look like a painting.

✦ **Perspective:** These four effects add a three-dimensional feel to your clips — for example, when you bevel the edges of the video image or create shadows.

✦ **Pixelate:** These three effects modify the pixels that make up your video image to create some unusual visual coloration and appearances. (Textures, anyone?)

✦ **Render:** The three Render effects allow you to simulate various properties of real light. One of the effects simulates lens flares — momentary bright circles that often occur in video footage when the sun reflects or glares on the lens. Although you probably work hard to avoid *real* lens flares when you shoot video, well-placed *simulated* lens flares can have a dramatic effect, especially if you're depicting a sunrise or sunset. The Lightning effect is especially cool because you can create realistic lightning on-screen.

✦ **Stylize:** These 12 effects create a variety of image modifications. With the Stylize effects, you can simulate video noise (on-screen "snow"), create clip mosaics, add texturized or windswept appearances to the image, and more.

✦ **Time:** The Echo effect creates visual echoes (or double-image) of a picture. The Posterize Time effect modifies the apparent frame rate of a clip. Use this effect to make it look like you dropped frames during capture or output even if you really didn't.

✦ **Transform:** These nine effects transform the view of your clip in a variety of ways. You can rotate the image in three dimensions, you can simulate a panning effect, or you can simulate a vertical-hold problem on a TV (you can have a lot of fun with this one; just imagine your friends banging on their TVs trying to figure out why the vertical hold is messed up).

✦ **Video:** These three effects help correct video problems or prepare video for output to tape. You can apply the Broadcast Colors effect to clips when you want to filter out colors that aren't broadcast-legal, or use the Field Interpolate effect to replace missing fields knocked off the screen by interlacing. If you have a clip with many thin lines, the lines may flicker when viewed on a regular TV. Use the Reduce Interlace Flicker effect to soften the image and reduce the flickering problem.

Applying effects

To apply an effect to a clip, you simply drag the effect from the Effects tab to a clip on the timeline. (Choose Window⇨Effects to open this tab, or click the Effects tab in the Project window.) You can adjust attributes of an effect by using the Effect Controls tab. To reveal this tab, click the clip on the timeline to select it and then choose Window⇨Effect Controls, or click the Effect Controls in the left pane of the Monitor window. The Effect Controls tab appears, as shown in Figure 11-7. Key features of the Effect Controls tab include these:

✦ Each effect applied to a clip has a separate listing under Video Effects. Click the arrow to expand the view of options for each effect.

✦ To disable an effect, click to remove the tiny circle next to the effect's title in the Effect Controls.

✦ Each effect has its own unique controls. Click the right-pointing arrow next to an effect control to view more specific controls.

✦ To enable keyframing so that the effect can be changed over time, click the Toggle Animation button, shown in Figure 11-7. I show you how to use key frames in the next section.

✦ The Effect Controls tab includes a key frame viewer, which, as you can see in Figure 11-7, looks like a miniature timeline, complete with its own CTI (current time indicator).

✦ To add a key frame for a control at the current location of the CTI, click the Add/Remove Keyframe button. Use the arrows on either side of any Add/Remove Keyframe button to move the CTI to the next (or previous) key frame.

✦ Some effects have Color Pickers. In Figure 11-7, I must use the Color Picker to choose a fill color for the background after the camera view has been modified. Some Color Pickers have eyedroppers next to them. Eyedroppers are used to choose a color from the video image in the Monitor. To use an eyedropper, click and hold on it, move the mouse pointer over the desired color in the video image, and then release the mouse button.

✦ To quickly reset all settings back to their defaults, click the Reset button. (I use this button a lot, especially when I'm working with key frames.)

Reset

Effect Controls tab CTI Key frames viewer

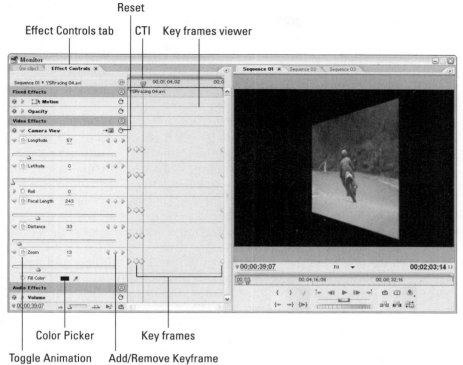

Figure 11-7:
Control your
effects with
the Effect
Controls tab.

Color Picker Key frames

Toggle Animation Add/Remove Keyframe

Using key frames

Effects can have a variety of, er, *effects* on clips in Premiere Pro. Video clips can be blurred, recolored, distorted, and more. You can apply an effect as is to an entire clip, or you can set up the effect so it changes over time. To do the latter, Premiere needs a way to determine exactly how and when to make such changes. For this purpose, the program uses reference points called *key frames*. If you want an effect to change over time, you use key frames to specify when those changes occur. Premiere Pro automatically extrapolates how the effect should progress from one key frame to the next.

The types of key frames I'm talking about in this section are effect key frames. Video codecs (the compression/decompression schemes used to make video files smaller) use another kind of key frame called a *compression* key frame. Although the names sound familiar, these are entirely different things.

After you have applied an effect to a clip, you can adjust that effect by using key frames. To set key frames, follow these steps:

1. **On the timeline, locate the clip that has the effect you want to modify.**

2. **Select the clip and then open the Effect Controls for the clip (Window⇨ Effect Controls) if they're not already shown.**

3. **Click the Enable Animation button next to each control that you want to be affected by key frames.**

The Enable Animation button enables the use of key frames for the effect. If the Enable Animation button is disabled, the effect will be applied evenly across the entire clip.

4. **Move the CTI in the key frames viewer (see Figure 11-7) to the exact frame where you want to set a key frame.**

 You can move the CTI by using the playback controls in the Monitor, or you can use the J, K, and L keys on your keyboard. Use the left- and right-arrow keys to move a single frame at a time.

5. **In the Effect Controls tab, click the Add/Remove Keyframe button next to an effect control.**

 You need to add a key frame for each control that you want to change. In Figure 11-7, I have applied the Camera View effect to a clip. However, I want the camera view to change only after the clip has played for a few seconds. Thus, at the first two key frames, I set all the controls to their defaults. At the third key frame, I adjusted the Longitude, Focal Length, Distance, and Zoom controls to the desired settings. At the last key frame, which is at the very end of the clip, I set the exact same settings as at the third key frame. The effect of these changes is that the clip plays normally from the beginning until it reaches the second key frame. At that point, the camera angle starts to morph until it gets to the settings I specified at the third key frame. At that point, the camera angle remains morphed until the end of the clip.

6. **Set additional key frames as desired.**

 Don't forget to use those Previous and Next Keyframe buttons. They provide an easy way to move from key frame to key frame. If you want to remove a key frame, simply move to the key frame and click the Add/Delete Keyframe button to remove the check mark. When you remove that check mark, you'll notice that the key frame disappears from the clip.

If you apply multiple effects to a clip, each effect gets its own key frames. Thus, if you set a key frame for one effect, don't assume that it applies to the other effects on that clip as well. To view the key frames for an effect, click that effect in the Effect Controls tab to select it.

Removing effects

You'll probably change your mind about some of the effects you apply to your clips. Don't feel bad; this is perfectly natural. In fact, you'll spend a lot of time in video editing on good ol' trial and error. You'll try an effect, you won't like it, so then you'll try something else.

To get rid of an effect, click the clip on the timeline to select it and then choose Window➪Effect Controls to reveal the Effect Controls tab. You have two options for removing effects from a clip:

✦ **You can temporarily disable an effect by clicking the little circle next to the effect's listing in the Effect Controls tab.** This can be handy because any settings that you changed for the effect are preserved. With the circle removed, the clip is disabled and is not applied to the clip when the sequence is rendered or output.

✦ **You can delete an effect by clicking its title in the Effect Controls tab and pressing Delete on your keyboard.** Don't worry! This doesn't delete the effect from Premiere Pro, it just removes the effect from the current clip.

Using Other Video Effects

Lots of effects are available with Premiere Pro, and I couldn't possibly describe them all here. Rather than provide a brief overview of many effects, the following sections show you a detailed approach to using a few common effects. You can adapt the techniques described here when using other effects.

Distorting video

Adobe Premiere Pro comes with a plethora of effects that you can use to distort your video. You can find some of the best ones in the Distort and Transform folders. Distortion effects range from mild to wild. You may find that the best way to give your video a custom appearance is to apply multiple effects. Consider the clip in Figure 11-8. I have applied the Pinch effect, found in the Distort folder under Video Effects. The Pinch effect simulates a pinching or pulling of a spot in the video image.

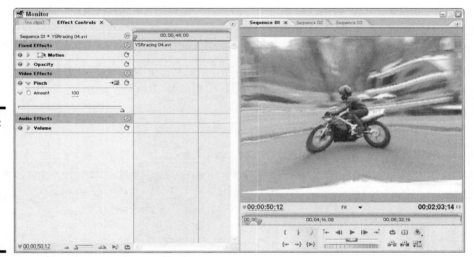

Figure 11-8: The Pinch effect has distorted this video clip in a most peculiar way.

To apply the Pinch effect, drag it from the Effects tab and drop it on a clip on the timeline. The Pinch settings dialog box then appears, as shown in Figure 11-9. The bottom of this dialog box shows a representation of the pinch that you're about to apply. You can use the grid to move the pinch point, and move the Amount slider to control the degree to which you pinch the image. (I want an extreme pinch appearance, so I've set the slider as high as it will go.)

You can open the Pinch Settings dialog box at any time by clicking the Setup next to the Pinch effect in the Effect Controls tab. Use the plus (+) and minus (–) signs in the Pinch Settings dialog box to zoom in or out on the preview window.

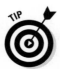

A minor application of the Pinch effect can give the illusion that the footage was shot using a very wide-angle lens, also called a fisheye lens.

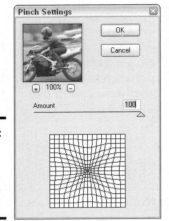

Figure 11-9: Use this dialog box to control the Pinch effect.

Now, to really make things tricky, several seconds into the clip, I want to zoom in on the image and reduce the pinch effect. To do this, I first apply the Camera View effect (located in the Transform folder) to the clip. The Camera View effect contains, among other things, a zoom effect. Next, I add two key frames to the clip. Between those key frames, the zoom level goes from the default level (10) to a slightly more zoomed-in level (7). I also change the key frames at the beginning and end of the clip to match these settings. Finally, I also create key frames for the Pinch effect so it diminishes as the camera view zooms in. Figure 11-10 shows the key frames that I created.

Pinch key frames

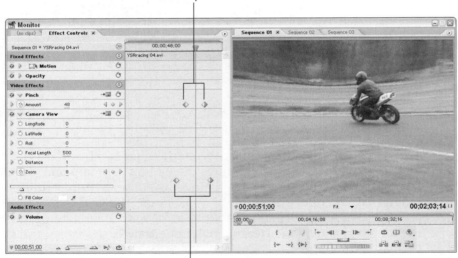

Figure 11-10: Apply multiple effects to a clip and control them separately by using key frames.

Camera View key frames

Disorienting your audience (on purpose)

Suppose a subject in a movie is sick or disoriented. What is the best way to communicate this to the audience? You could have someone in the movie say, "Hey, you don't look well. Are you sick?" and then the unwell person can stumble and fall down. That may be effective, but an even better way to convey a feeling of illness or confusion is to let your audience see through the subject's blurry and distorted eyes.

You can begin by shooting some footage as if it were from the subject's viewpoint. Handhold the camera and let it move slightly as you walk. You probably don't need to exaggerate the movement, but the camera shouldn't be tripod-stable either. As you shoot, pan across the scene — but not too quickly — as if the subject were looking around the room. Occasionally you may want to dip the camera slightly left or right so the video image appears to tilt. A tilting video image has a strong disorienting effect on the viewer.

Now that you have some footage to work with, you can perform the real magic in Premiere Pro. One effect that can provide a feeling of illness or disorientation is Camera Blur (found in the Blur folder). Use key frames to adjust camera blur throughout a clip, as if the subject's vision were moving in and out of focus. Another good one is Ghosting (also in the Blur folder). Ghosting produces ghost images of moving objects. Similar to ghosting is the Echo effect, found in the Time folder, which is used in Figure 11-11. Echo gives you a bit more control over the number and timing of echoed images.

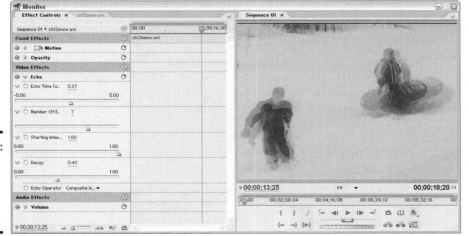

Figure 11-11: The Echo effect can be used to disorient the viewer.

Working in the Golden Age of Cinema

Motion pictures have been around for well over a century now. You may want to use some old (or at least old-*looking*) footage in your movie projects, but thankfully, creating footage that looks old doesn't require a trip to some dank film vault deep beneath a Hollywood movie studio. Here are some ways you can simulate an old-fashioned look with your own video:

✦ **Pay attention to your subjects and the scene.** Cowboys of the Old West didn't carry cell phones at their hips, for example, nor was the sky filled with white condensation trails left by jet airplanes. Remove objects from the scene that don't fit the period you're trying to simulate, and shoot carefully so the background doesn't depict modernity.

✦ **Remove color from the clip.** Perhaps the easiest way to convert a color image to grayscale is to use the Black & White filter in the Image Control folder, although I prefer to use the Color Balance (HLS) effect. Adjust the saturation level to –100, which (in effect) makes the clip grayscale. One advantage of using the Color Balance (HLS) effect is that you can use key frames to change the effect in the middle of a clip.

Grayscale is just a fancy way of saying *black and white*. Grayscale is a more technically accurate term because black-and-white video images are actually made using various shades of gray.

✦ **"Weather" the video image.** Film tends to deteriorate over time, so if you're trying to simulate old footage, you should simulate some of that deterioration. Use the Noise effect under Stylize to add some graininess to the video image.

✦ **Reduce audio quality and if possible use a mono setting.** Audio recordings made 75 years ago did not use 16-bit stereo sound. To reduce quality, reduce the sampling rate of the audio when you export your movie. Alternatively, you may want to go for the "silent movie" effect and not record any audio at all. Just use an appropriate musical soundtrack and title screens for dialogue.

✦ **Speed up the clip.** Older film often plays back at a faster speed, so speed up the clip by selecting it, choosing Clip⇨Speed/Duration, and increasing the Speed percentage in the Clip Speed/Duration dialog box that appears.

Flipping video

Do you ever wish you could produce a mirror image of a video clip, or maybe rotate it and change its orientation on the screen? Such modifications are easy to make with Premiere Pro. Effects that you can use to flip video can be found in the Transform folder of Video Effects. These effects include two classics:

✦ **Horizontal Flip:** This effect flips the video left to right, as shown in Figure 11-12.

✦ **Vertical Flip:** This effect flips the video top to bottom.

When flipping video, watch out for letters and numbers that appear in the frame. Backward letters stick out like sore thumbs (or rude gestures) when your audience views the movie.

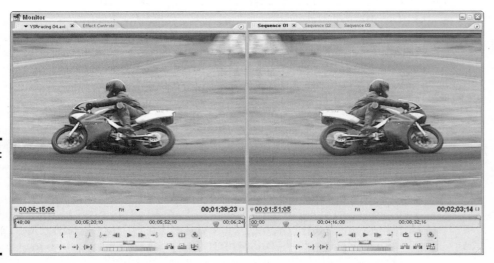

Figure 11-12: The Horizontal Flip effect was applied to the clip on the left.

Adding Web links to movies

The term *multimedia* is used pretty loosely these days, although few types of media are as *multi* as the movies you can create with Premiere Pro. Not only can your movies contain audio, video, and still graphics, but they can also include links to the World Wide Web. Of course, for the links to work, your audience must be watching the movie on a computer that can connect to the Internet. Also, the movie needs to be output in a format that supports Web links, such as QuickTime. Web links can be handy if you want a specific Web page to open during or after playback. To create a Web link, follow these steps:

1. **Move the CTI to the point in a sequence at which you want the link to be activated.**

2. **Choose Marker⇨Set Sequence Marker⇨Unnumbered.**

A marker appears on the Timeline ruler. Actually, you can make it a numbered marker if you want.

3. **Double-click the marker.**

The Marker dialog box appears, as shown in Figure 11-13.

Book II
Chapter 11

Using Special Effects in iMovie and Adobe Premiere Pro

Figure 11-13:
Timeline markers can link to World Wide Web addresses.

Marker @ 00;01;51;05

Comments: Visit Dummies.com today!

Duration: 00;00;00;01

Marker Options

Chapter:

Web Links

URL: http://www.dummies.com/|

Frame Target:

Marker Options will only work with compatible output types.

OK
Cancel
Prev
Next
Delete

4. **In the URL field, type the complete URL (Uniform Resource Locator) for the link target.**

The URL is the Web address for the site that you want to open. To be safe, it should include the `http://` part of the address. Consider the URL that you enter here carefully. Does it point to a page that will still be online several months (or even a year) from now? Consider how long users might be viewing copies of your movie.

5. **Click OK to close the dialog box.**

Test your Web link in the final output format! If it works, the desired Web page should open in a Web browser. Some formats (such as QuickTime) support Web links; others don't.

 Be really, really careful when you type the address for your Web URL. Exact spelling and syntax is crucial, or else your Web link is broken — and that creates a bad impression with your audience. Furthermore, because most Web servers run a UNIX-based operating system, everything after the `.com` part of the Web address is probably case-sensitive. Watch that capitalization!

Using Effects in iMovie

Obi-Wan lifts his hand, presses a button, and a beam of light shoots out of the handle of his lightsaber and he's ready to do battle. Captain Kirk tells Scotty to "Energize," and his body turns to sparkles and slowly fades away as he's transported across space. Marty McFly climbs into the Delorean and sits next to the Doc, as the car lifts up from its wheels and zooms off into the future. The wonderful world of special effects makes the movies that much more magical.

With iMovie, alas, you can do none of these things. No lightsabers, no transporters, no all-aluminum sports-car time machines. (Am I the only one who wishes they still made the Delorean?) iMovie's special effects are a bit more basic, but you can do some interesting things to the images, including changing the speed, running clips backward, adjusting the color, switching to black and white, and introducing effects to make entire scenes look a bit more artsy or more filmlike.

In this section, you look at all the special effects built into iMovie. You can use some of these effects to change the colors, brightness, and contrast of scenes. Others can be used to create interesting looks and effects, such as black and white or sepia tone. Then you see how you can use the effects to create transitions and even a few science-fiction-type effects for your film. Finally, you take a quick look at iMovie's simple controls for slow- and fast-motion video.

Built-in effects

Most of the effects built into iMovie are there to give you some control over how each frame of your clips looks in terms of its color, brightness, contrast, and other settings. For instance, the Adjust Colors effect is powerful stuff, making it possible to turn a color video into black and white or to change the colors and brightness of a clip to emphasize something within the context of your story.

Other effects are just simplifications of the Adjust Colors and Brightness/ Contrast effects. The Black and White effect, for example, makes it possible to turn a clip into black and white for, perhaps, a Hitchcockian result. The Sepia Tone effect is another one-button effect that changes colors so that your images look more like old photographs or early film.

So, you can change the look of a particular clip. Sounds cool. But (in my best infomercial voice) wait . . . there's more! One trick of these effects is that you don't have to apply the effect to the entire clip in the same way. So, for instance, a clip can start at one color level and then progress to another color level. This color shift is an effect all to itself — the audience watches the shift take place.

The Effects panel

You accomplish all of your effects wizardry in the Effects panel, so I take a look at what makes it different. To open the panel, click the Effects button at the bottom of the Shelf pane. Now you see the Effects panel interface, most likely with the Adjust Colors effect selected (see Figure 11-14).

The Effects panel is certainly familiar if you've worked with the transitions or title panel, but it also offers some subtle differences. Select an effect in the list of effects, and the controls at the bottom of the panel change. Some effects, such as Adjust Colors, offer various sliders for changing the effect. Others, such as Black and White, don't have sliders. Every time you select a different effect or change one of the settings, a preview appears in the Effects preview area in the top-right corner — as long as a clip is selected on the timeline.

Above the list of effects are two more sliders; these determine the timing of the effect. (Note that these sliders represent the amount of time from the *beginning* of the clip for Effect In and the amount of time from the *end* of the clip for Effect Out.) If you want to affect the entire clip with the selected effect, the Effect In time should be set to 00:00 (all the way left), and the Effect Out time should also be set to 00:00 (all the way right). When you apply the effect to the clip, the entire clip is affected. (For instance, the entire clip is sepia tone if that's the effect you selected.)

If you select different Effect In and Effect Out times, something else happens — the effects happen more gradually. That is, if you set the Effect In time for a few seconds after the clip has started and set the Effect Out time for later in the clip, the effect takes place over time, as the audience watches. In this case, if you had chosen Sepia Tone, the clip would become increasingly more *sepia tone-ish* (that can't be a word) as it plays. (We get back to this a bit more in the section "Creating Special Looks.")

Figure 11-14:
The Effects panel includes controls for setting effects options, previewing the effect, and applying it to the selected clip.

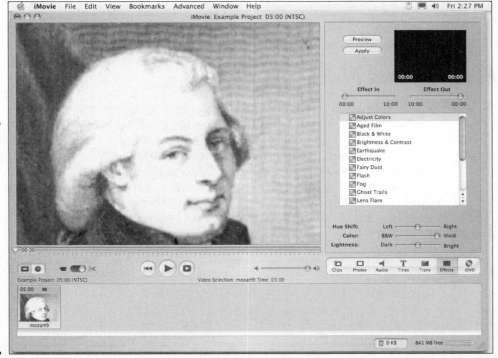

After you set the sliders, you're left with either two or three buttons in the top-left corner of the Effects panel (depending on the effect and your previous action). This, frankly, is more thinking than we've been forced to do with iMovie's other panels so far. (And when I have to think more, I feel let down.) The buttons are Preview, Update, and Apply. Here's what the buttons do:

✦ **Preview:** As with transitions and titles, the Preview button on the Effects panel displays a frame-by-frame preview of the effect in the Monitor.

✦ **Update:** Apply any changes you've made to an existing effect (which usually means that everything gets rendered all over again).

✦ **Apply:** The button you click to begin the rendering process. (Go figure.)

So you see how to set effects: Just select a clip in the Clip Viewer or timeline, make some selections in the Effects panel, and then click the Apply button. iMovie places a tiny checkerboard square icon in the clip's thumbnail to let you know that an effect has been applied.

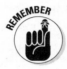

Interestingly, emptying the Trash in iMovie (File↪Empty Trash) does not affect your ability to restore an effects clip to its original state, even though it does affect any other sort of Undo command within iMovie. So, don't worry about being able to reverse your special effects even after emptying the Trash.

You may notice that when effects are applied to clips, the clips aren't split into more than one clip, even if the effect doesn't span the entire length of the clip.

Like transitions and titles, effects have to render in iMovie after you've selected a clip and an effect and clicked the Apply button. A small line appears under the thumbnail, filling with red as the rendering progresses. As with other rendering, you have to wait for the process to finish before you can view the clip in the monitor, full screen, or through your camcorder.

Filtering and Fixing the Picture

Although lightsabers are no doubt cool, the fact remains that most of iMovie's effects simply help you change the hue, brightness, and contrast of the image. That's not to say that you can't get a lot out of such changes. You can, in fact, use color shifts and hue changes to create some interesting transitions, as you see in the "Using active effects" section, later in the chapter. But that still doesn't make for *Star Wars,* eh? (Although you can still pull off the cheapest *Star Wars* effect out there: Breathe loudly into the microphone like Darth Vader. Put that behind your Halloween videos.)

The effects used to alter the look of the picture include Adjust Colors and Brightness/Contrast. I take a look at each individually.

Adjusting colors

Select a clip in the Timeline, pop up the Effects panel, and select Adjust Colors. Three sliders appear below the Effects scrolling list. The sliders are Hue Shift, Color, and Lightness, as shown in Figure 11-15.

The sliders are self-explanatory to a certain extent, but I'm not earning my keep if I don't go behind the labels and tell you what's going on here. (Sounds like a VH-1 series, doesn't it? "Behind the Labels.") Cut to a bulleted list:

✦ **Hue Shift:** Hue shift, at its simplest, changes the colors within your image. The word *hue* itself suggests a gradation of color, so that moving the slider shifts all the colors in the image toward one side or the other of a certain spectrum. In iMovie, this shift is from Red/Yellow on the left side to Blue/Green on the right side.

Although you don't want to make shifts too dramatic (unless you're going for a particularly wacky, surreal color scheme), a little shifting can make up for bad light, an incorrect white balance, or refraction that affected the colors you were shooting. You may find that if a clip is a little too green or blue in its natural state, sliding the hue a bit to the left helps stabilize the colors. If something is too yellow, red, or orange, shifting the hue to the right can help.

✦ **Color:** The Color slider simply enables you to scale each pixel in your images from their full color value toward an associated gray value. Sliding the bar all the way to Vivid lightens things up slightly, almost giving them a Ted Turner colorized effect. It's okay, given a certain music video quality. Sliding toward B&W (black and white), even slightly, can create a more interesting effect. You can get the suggestion of black-and-white images, but there really is color value there, which can be useful for an audience. Woody Allen comes to mind: Any video that you'd like to make look a little more like older film, a 1930s period piece, or something similar could take a slight color shift toward black and white. (You could go all the way to black and white, but a digital black-and-white effect tends to look flat.)

✦ **Lightness:** Again, lightness creates a pixel shift, but note that it's not a brightness control, which is different from lightness (even though they rhyme). In this case, if you slide the slider toward Dark, all the pixels shift toward black, which means the darker pixels (the blues, browns, and grays) get there first, with the lighter pixels right behind. Slide toward Bright, and all pixels start shifting toward white, with lighter colors getting there first. At a full Bright setting, the entire image is white. (In Figure 11-15, you can tell my Lightness setting is moving to a full Bright.)

To apply any of these effects to the entire clip in a uniform way (no shifting while the clip plays back), select 00:00 as the Effect In time and 00:00 as the Effect Out time. Then click Apply. The clip is altered according to your desires.

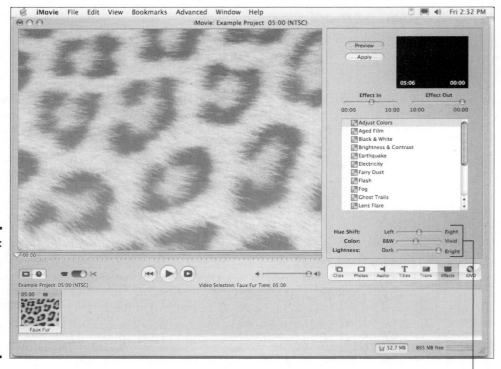

Figure 11-15:
The Adjust Colors effect has three sliders for controlling the effect.

Use these sliders to adjust colors.

Adjusting brightness and contrast

To specifically adjust the brightness and contrast of your images, select a clip and then select Brightness & Contrast from the Effects list. Two sliders appear in the preference area of the Effects panel: Brightness and Contrast. Here's what they do:

✦ **Brightness:** Slide from Dark to Bright, and the image lightens up quite a bit, with the lightest pixels becoming lighter very quickly as the darker pixels become lighter much more slowly. If you slide all the way to Bright, you get a fully white image. Slide all the way to dark, and you get a fully black image.

✦ **Contrast:** Contrast moves individual pixels, as much as it can, more toward their closer dark or light value: Dark colors get darker and light colors get lighter. This is useful for a clip that seems washed out, with too many color values too close. In fact, contrast is often a more useful tool than brightness, especially if you were filming in sunlight or good artificial light but need a slightly more vivid clip.

Again, it's not a great idea to compensate for bad lighting or bad footage with these effects. Only very small value changes will work; larger changes simply make it clear that you've been messing with the brightness or contrast. If there's any trick to setting brightness and contrast, it's to use the values together to create a slightly more robust image. For instance, if you need to brighten the overall image somewhat, nudge the Brightness slider to the right a bit. Now, nudge up the contrast along with it, close to the same amount. You should see that the image brightens but also maintains

a certain amount of depth, thanks to the contrast. Figures 11-16 and 11-17 show the difference a little contrast can make.

Figure 11-16: Here, I've bumped up the brightness without changing the contrast.

Figure 11-17: Now, both brightness and contrast have been pushed up a bit, giving the image more depth.

Creating special looks

The Adjust Colors and Brightness & Contrast effects are the intellectuals of the bunch, with all their sliders, options, controls, and . . . well . . . big ideas. The others among the Effects crowd are the specialists. They do one thing and do it well, and then they go home to their families and watch a little TV. On the weekends, maybe they attend a meeting or play some pool down at the union hall.

Black & White, Sepia Tone, and Water Ripple don't even have options; you just point and shoot, so to speak. With Sharpen and Soft Focus, you have one slider for selecting more or less. Which you choose is more or less up to you.

Here's a look at my favorite special effects:

✦ **Black & White:** You can achieve the same look by using Adjust Colors and going in yourself to switch to black and white, but this simple effect is a bit easier. Note that you need images with a lot of contrast (bright lights casting dark shadows) if you're going to use black and white with digital video. My suggestion is that unless the clip looks *great* in the preview using the straight Black & White filter, consider cheating a little with the Adjust Colors sliders, especially the Color slider, to give your clip a black-and-white feel. (See the "Adjusting colors" section, earlier in the chapter.)

✦ **Sepia Tone:** This is intended to make the clip look like an old silent film, a daguerreotype from the Old West, or the like. It looks good in certain situations, especially when the video shows young children wearing big cowboy hats and stomping around like Bad Bart.

✦ **Sharpen:** If you've ever used Photoshop or a similar program, this effect will be familiar. Each pixel is *quantized* a bit (a fancy word for "perform a little math on it to make it more uniform") to make the overall appearance seem like you've sharpened the focus of the image. It doesn't work very well because it's a digital effect. The bottom line is that it looks like you applied a sharpen filter to the image, not that you've corrected the focus problem. But it's an interesting effect to use for a night-vision sequence or when you *want* the clip to look more digitized. ("Captain, I've got them on the scope right now!")

One place Sharpen might help is if you'll be exporting to QuickTime video, especially video that's less than full screen. A slight sharpen effect — coupled with compressing the video and changing the size from 640 x 480 (full TV display) down to 320 x 240 or smaller — could result in a slightly better image than you started with. You're still better off if the image starts in focus. You're also much more likely to get that call from Ron Howard you've been waiting for.

✦ **Soft Focus:** This is the opposite of Sharpen, putting a slight blur on all the pixels to make them seem a little softer and less focused. Again, it's a digital effect and something that's better achieved with a special lens for your camera. That said, this effect is a bit more useful in my opinion. You can use soft focus to give your clips a filmlike quality — a *very* little softening can make some of the harshness of video and the scenes a little more pleasing to the eye. This is especially useful for close-up shots of people in which you'd like to smooth their skin tones and give them a warm, friendly feel. If you want to show your subject sweating, stay away from soft focus.

Want to see soft focus in action? Watch pretty much any old movie with a female star. It was very common with Hepburn movies (both Hepburns, but a little more so with Audrey). It's often pronounced in shots that intercut between the male lead and the female one — the woman is usually shot with a very soft lens, almost to the point (in some cases) where it looks blurry. If you have someone on tape that you want the camera to love and cuddle, consider a little soft focus if you aren't already using a soft lens filter on your camera.

Using active effects

Here's another secret to great filmmaking: Most of these effects can look great when they're *active* or *transitional,* meaning the audience sees them applied gradually. Sharpen is only *so* useful when applied to an entire clip (although it certainly can be useful at times), but it can be an interesting transitional effect when it happens over time. Using the right combinations of settings, you can use Sharpen to take a clip from being in full focus to gradually being sort of digitally enhanced by the end of the clip — an effective and interesting transition to the next scene or perhaps to a Sci-Fi effect. The same thing can be true of gradually changing from color to the Black & White effect or gradually changing from color to the Sepia Tone effect. All these changes can be effective special effects and transitions.

TIP

When in doubt, split the clip

This far into your travels through the wonderful world of iMovie's special effects, you may have lit on an interesting question: What do I do if I can't do what I want to do? As long as you're still talking about iMovie's video effects (and not some issue with your career ambitions), I probably have the solution.

The most likely solution is to split the clip. The one thing you can't really do with an iMovie special effect is make it *immediately* appear or disappear within a single clip. For instance, you can't cause a clip to play for a few seconds, immediately turn black and white, play for a few seconds, and immediately turn back to color. Instead, iMovie transitions those effects slowly.

If you split the clip, though, you can apply the effect immediately to the new second half of the clip.

For this example, split the clip twice, into three parts. On clip one, put no effect. On clip two, put a black-and-white effect with no Effect In and Effect Out times. For clip three, leave it color. When you play back the video, the clips go from color, immediately to black and white, and then to color again. (Think of the flash transitions between black and white and color in Quentin Tarantino's *Kill Bill Volume 1*. Sassy.)

In any instance where you can't figure out how to make something happen — even outside the realm of iMovie effects (transitions, titles, sound, graphics) — think about whether it would work if you split the clip. Often enough, that's the answer. (Now if only splitting my bank accounts would somehow help.)

Plus, the change can go in either direction. You can start from sepia tone and work back to regular colors or vice versa. Or you can have a clip go from regular to effect and back again. The key is changing the Effect In and Effect Out sliders.

Changing Effect In

How you set the Effect In time determines when the effect is first applied to the clip and how gradually. The rule is: If you want the effect to be active at a particular second, select that time as your Effect In time. If you want the effect to take place gradually over the entire clip, select an Effect In time somewhere close to the end of the clip. (You can even select a time that's beyond the end of the clip, if you don't want the full effect to occur during the length of the clip.)

Suppose you have a six-second clip and want it to go to sepia tone about halfway through the clip and then stay there. Select the Sepia Tone effect and move the Effect In slider to about 03:00, which is three seconds. Now the preview shows you that the Sepia Tone effect ramps up gradually from 00:00 to 03:00 and then continues through to the end of the clip.

Note that these effects never begin abruptly if they're planned for the middle of a clip — they always take effect gradually. It's simply a question of *how* gradually. With the same sepia tone example, if you set the Effect In time to the end of the clip, about 06:00, the entire clip is spent slowly changing from regular colors to sepia tone.

With this whole-clip transition possible, you have some intriguing potential. For instance, you can select an exaggerated effect — a major color shift, full-white brightness, full-black darkness, high soft focus, or high sharpen effects. Now, set the Effect In slider to the end of the clip's running time, and that effect ramps up slowly. By the time you get to the end of the clip, it's fully black, white, fuzzy, sharpened, or taken over by wacky colors. In effect, you've created a nice transition.

So what can you do with an Effect In transitional effect? Here are some of my favorites:

✦ **Blow out!** The blow out, or white out, effect makes a nice transition or a good, basic sci-fi effect. You achieve the effect by selecting Brightness & Contrast and sliding both sliders all the way to the right. Now, set an Effect In time that's pretty late in the clip and watch the magic unfold in the preview area. As the clip moves on, it is filled with brightness and contrast until the last frames, which are completely bright white. It's good for a *Twilight Zone* type plot twist: With scary music, a frightened-looking actor, and enough tension in the story, this effect looks like a nuclear flash, a time warp, or another type of major event. (It also looks good over a still clip image for that "all time has stopped at the end of the world" look.)

✦ **The Medeci effect.** Another favorite is a gradual move from focused to blurry using the soft focus controls. Select a clip, select Soft Focus, and then slide the slider all the way to High. Now, set the Effect In time for late in the clip. As the clip plays on, it becomes increasingly blurry. What's this good for? How about the point of view of a character in your story who has just been poisoned by the bad guy and is going under? Now you can do your own version of the effect made famous by pretty much every James Bond movie.

✦ **Old West family portrait.** You know that effect in which a full-color, full-action image slowly dissolves into a still image that looks like an old photograph? You could do that with a gradual move to sepia tone (with the next clip a still clip that's also in sepia tone colors). Select Sepia Tone as the effect and slide Effect In almost all the way to the end of the clip. After the clip is rendered, tack on a still clip of that last frame (Edit⇨Create Still Clip) that's also in sepia tone. Now, you have a few seconds for a dramatic swell of music to end the voiceover ("And that's the story of the trip of '62") or to begin rolling credits.

✦ **Dream sequence.** Okay, maybe there is a use for the Water Ripple effect. Select it and choose an Effect In time. (In the selected clip, your actors should be making that *Wayne's World* dream sequence noise or scratching their chins while . . . wondering . . . what . . . if. . . .) By the end of the clip, the image is rippling and you can move on to the next clip, which shows the dream sequence playing out.

Changing Effect Out

Changing the Effect Out time does pretty much the opposite of what I've just been discussing. The clip starts will a full-blown effect and then gradually changes to its regular colors, brightness, and texture. Start the clip with a sepia tone and change back to regular colors or start at full bright white

and return to a regular brightness. You do this by setting Effect In to 00:00 (the effect starts with the beginning of the clip) and Effect Out to some amount of time, in seconds, before the clip ends.

One major difference between the Effect In and Effect Out sliders is that the latter counts from the *end* of the clip. If, for example, you have a ten-second clip and want the effect to end after four seconds, you must set the Effect Out slider to 06:00 — that four seconds is six seconds from the end of the ten-second clip.

You saw how Effect In can work for transitions, but how can Effect Out work? In a sense, Effect In settings let you transition *out* of a clip, whereas Effect Out can let you transition *into* a clip. Here are a few ideas:

✦ **What time is it?** Set Soft Focus to High and then set an Effect Out point just a second or two into your clip. The clip comes gradually into focus, giving you a sense that you've transitioned into the scene — sort of like you just woke up (or that you're watching from the point of view of a character just waking up).

✦ **Yes, it's World War I, but we're shooting in color.** You see this effect used often to transition the beginning of an historical movie into a modern color presentation, such as a black-and-white WWI dogfight followed by a transition from black-and-white to color for the characters. Select the Black and White effect and then set an Effect Out time. The image moves from black and white to full color in front of your eyes. (Clearly, this one could be used also with the Sepia Tone effect for similar reasons, especially if you're transitioning from piano music and an Old-West-style opening credit sequence into a story you're telling in color.)

✦ **Admiral, we have them on the satellite feed.** Select the Sharpen effect and set an Effect Out time. The image begins very sharp and then transitions to a regularly focused shot, suggesting that the satellite operator/hacker/spy has just successfully tweaked the digital image into full-focused video.

Changing the In and Out

You can change the In, you can change the Out, and if you like, you can do both. If you set an Effect In point and an Effect Out point, you can cause an effect to happen within the clip and then return it to normal before the clip ends.

Book II
Chapter 11

Using Special Effects in iMovie and Adobe Premiere Pro

Chapter 12: Adding Audio to the Mix

In This Chapter

✓ Understanding audio tracks

✓ Adjusting volume levels with rubberbands

✓ Adding sound effects to your movie

✓ Working with SmartSound

As you rush to trim video clips, create transitions, and add some cool special effects to your movies, overlooking the audio portion of the project is an easy thing to do. But the audio portion of a movie is nearly as important — or *as* important, depending on whom you ask — as the video portion.

In Chapter 7 of Book II, I show you how to record better audio and import it into your computer. This chapter shows you how to make good use of that audio in your movie projects. Most movie-editing programs also come with built-in sound effects and other audio tools, so I show you how to use those as well. Finally, I help you choose effective musical soundtracks for your movies.

Using Audio in a Project

Most movie-editing programs follow similar patterns. They all use story-boards and timelines for assembling the project, and most programs have similar windows for organizing and previewing clips. Many programs also have a lot in common when it comes to editing audio. For example, even the most affordable editing programs usually have separate audio tracks in the timeline for background music, narration (or sound effects), and the audio that accompanies the video clips that are on the timeline. (Audio tracks are described in greater detail in the next section.)

Many movie-editing programs can also show audio waveforms. A *waveform* is a line that graphically represents the rising and falling level of sound in an audio clip. Figure 12-1 shows the waveform for some narration that I recorded in Pinnacle Studio. Waveforms are useful because they allow you to edit your audio visually, often with pinpoint accuracy. By looking at the waveform, you can tell when loud sounds or extended periods of quiet occur.

Figure 12-1:
Waveforms allow you to see what you're doing as you work with audio.

More sound Less sound

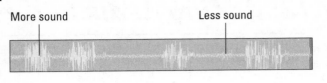

Although many movie-editing programs use audio waveforms, Apple iMovie isn't one of them. Fortunately, plenty of other programs can display audio waveforms — including Apple Final Cut (both the Express and Pro HD versions), Adobe Premiere Pro, Pinnacle Studio, and Windows Movie Maker.

Understanding audio tracks

A movie program can play several sources of audio at once. For example, while you hear the audio that was recorded with a video clip, you may also hear a musical soundtrack and some narration that was recorded later. When you're working on a movie project in your editing software, each of these unique bits of audio would go on its own separate audio track in the timeline.

Most editing programs provide audio tracks for main audio (the audio that was recorded with a video clip), music, and narration. More advanced editing programs offer you many more audio tracks that you can use any way you see fit. Adobe Premiere, for example, can provide up to 99 separate audio tracks on the timeline. Although it's difficult to imagine anyone actually *needing* that many audio tracks, having too many is better than not having enough.

Pinnacle Studio provides three separate audio tracks, as shown in Figure 12-2. To lock a track in Studio, click the track header on the left side of the timeline.

Main audio

Figure 12-2:
Pinnacle Studio's timeline provides three separate audio tracks.

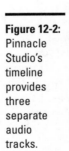

Sound effects or narration Background music

Apple iMovie handles audio tracks a little differently, but you still have essentially three audio tracks to work with. The main audio track is actually hidden inside the video track. Two other audio tracks handle sound effects

and background music. You can extract audio from video clips (simply select the clip on the timeline and choose Advanced⇨Extract Audio), but doing so causes the main audio to take up one of the other two audio tracks. Figure 12-3 shows iMovie's audio tracks. You can enable or disable audio tracks by using the check boxes on the right side of the timeline. This is helpful during editing when you want to hear just one or two audio tracks at a time.

Figure 12-3:
Apple
iMovie
provides
three audio
tracks.

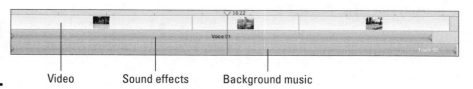

Video Sound effects Background music

Adding audio to the timeline

Adding audio to the timeline is pretty easy. Record and import your audio as described in Book II, Chapter 7, and then simply drag and drop it to an audio track. You can move clips by dragging them to the left or right in their respective tracks, and you can trim them by dragging on the edges. In fact, you'll find that editing audio tracks is a lot like editing video tracks — you can use the same basic editing techniques that I describe in Chapter 9 of Book II.

You may want to edit main audio independently of the video clip with which it is associated. In iMovie, first extract main audio from the video clip by selecting the clip and choosing Advanced⇨Extract Audio. In Studio, click the track header on the left side of the timeline to lock either the main video or main audio track. When the main video track is locked, you can edit the main audio track without affecting clips in the video track.

One nice feature of iMovie is that it allows you to link audio clips to video clips. For example, suppose that you've recorded some narration to go along with a video clip. If you decide to move that video clip to a different part of the timeline, you have to move the narration clip as well. If the two clips are linked, moving one also moves the other. To link an audio clip to a video clip in iMovie, follow these steps:

1. **Position the audio and video clips that you want to link on the timeline.**

2. **Move the play head to the beginning of the audio clip.**

3. **Click once on the audio clip to select it.**

4. **Choose Advanced⇨Lock Audio Clip at Playhead.**

A yellow pin appears on both the audio and video clips, as shown in Figure 12-4. If you move the video clip to a different place on the timeline, the linked audio clip moves with it. To unlink the clips, select the audio clip and choose Advanced⇨Unlock Audio Clip.

521

Figure 12-4:
Yellow pins indicate that the audio and video clips are linked.

Pins

Adjusting volume

Perhaps the most common thing anyone does to audio tracks is adjust the volume. As you preview your project, you may notice that the background music seems a little too loud or that the narration isn't loud enough. You may also have sounds in the main audio track that you want to eliminate, without affecting the rest of the audio clip. Virtually all video-editing programs allow you to adjust volume in two different ways:

✦ You can adjust the overall volume of an entire clip or track.

✦ You can adjust volume dynamically within a clip, making some parts of the same clip louder and some parts quieter.

To begin adjusting volume in iMovie, select the Edit Volume check box at the bottom of the timeline. In Studio, click the clip that you want to modify and then choose Toolbox➪Change Volume so that Studio's audio toolbox appears above the timeline.

Each program displays audio rubberbands across audio clips. *Rubberbands* (see Figure 12-5) aren't just for holding together rolled up newspapers or your ponytail. In video programs, they show you the volume for an audio clip, and they allow you to make dynamic adjustments to the volume throughout the clip.

Figure 12-5:
Rubberbands make it easy to adjust volume in your audio clips.

Audio rubberbands Edit volume Volume slider

Adjusting overall volume

Modifying the overall volume for an audio clip or a whole track is pretty simple, but the procedure varies a bit depending on which program you are using.

In Apple iMovie, follow these steps to adjust the overall volume:

1. **Click a clip to select it. (To select and adjust multiple clips simultaneously, hold down ⌘ as you click each clip.)**

Be careful not to click the purple rubberband line. If you accidentally click the rubberband and a dot appears on the line, press ⌘+Z to undo the change.

2. **With the desired clip(s) selected, adjust the Volume slider to the left to reduce volume or to the right to increase volume.**

As you adjust the slider (shown in Figure 12-5), you see the rubberband lines move up or down.

Pinnacle Studio provides a variety of volume controls in the audio toolbox, as shown in Figure 12-6. To open this toolbox, click an audio clip on the timeline and choose Toolbox⟹Change Volume. The toolbox contains a separate set of controls for each of the three audio tracks, as follows:

✦ **Left:** Main audio track

✦ **Middle:** Sound effects/narration track

✦ **Right:** Background music track

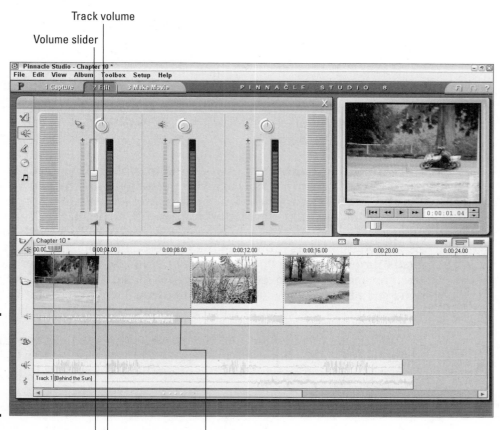

Figure 12-6:
Use Studio's audio toolbox to adjust volume.

Track volume

Volume slider

Fade in Fade out Audio rubberband

To adjust the overall volume for an entire track, turn the knob at the top of the track's volume controls. As you turn the knob, you see the blue audio rubberband line for the entire track move up or down on the timeline. To adjust the volume for a specific clip, place the play head at the very beginning of that clip on the timeline and move the volume slider for that track up or down. Then place the play head at the end of the clip, and adjust the volume slider back to the middle to restore the volume of subsequent clips on the timeline.

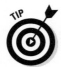

You can also mute whole tracks on the timeline. In iMovie, simply remove the check mark from the right side of the timeline next to the track that you want to mute. In Studio, click the icon at the top of the volume controls (see Figure 12-7) in the audio toolbox to mute a given track.

Adjusting volume dynamically

Believe it or not, I very seldom adjust the overall volume of an entire clip or track. I usually prefer to adjust volume dynamically throughout the clip. Adjusting volume dynamically allows me to fine-tune audio to better match other things that are going on in the project. I adjust volume dynamically at times like these:

+ **When narration is about to begin:** I may reduce the volume of background music a bit so that the spoken words are more easily heard.

+ **When the sound changes between video clips:** Such a change often sounds abrupt or harsh. I can reduce that harshness by fading audio in at the beginning of the clip and fading it out at the end. Studio has handy Fade In and Fade Out buttons (see Figure 12-6), which automatically make fade adjustments to the audio rubberbands for a clip.

+ **When I can eliminate unwanted sounds from a clip:** I can eliminate off-camera sounds by dynamically adjusting volume, as I've done in Figure 12-7.

Dynamic volume adjustment is where audio rubberbands really come in handy. Click once on a rubberband for one of your audio clips. When you click the rubberband, you'll notice that a little dot appears. You can click and drag that dot up or down to adjust the volume of the clip. Not only can you place as many dots as you can squeeze onto a rubberband, you can also move those dots around on the rubberband to make constant adjustments throughout the clip. Like real rubberbands, audio rubberbands are stretchy and can be moved quite a bit, but unlike real rubberbands, they don't snap back when you stop moving them. Play around a bit with the rubberbands to see just how much fun volume adjustments can be!

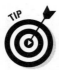

Those little dots on audio rubberbands act like pins to hold the bands in place. To get rid of a dot, click and drag it off the top or bottom of the clip. Twang! The dot disappears, and the rubberband snaps back into place.

Muted track

Figure 12-7:
Use
rubberbands
to adjust
volume
dynamically
throughout
an audio
clip.

Click and drag rubberband dots to adjust volume.

Working with sound effects

Sound effects can really separate a good movie from a great movie. In Chapter 7 of Book II, I suggest that if a picture is worth a thousand words, sometimes a sound is worth a thousand pictures. Consider how the following sound effects can affect the mood of a scene:

✦ A quiet room somehow seems even quieter if you can hear the subtle ticking of a clock.

✦ Applause, cheering, or laughter suggests how the viewer should feel about an event in the movie.

✦ Chirping birds suggest peace and serenity.

✦ Footsteps make movement seem more real, even when the feet are not shown in the video image.

Those are just a few examples, but you get the idea. You can create and record your own sound effects, and in Book II, Chapter 17, I offer some tips for doing exactly that. Fortunately, most video-editing programs now come with ready-to-use libraries of common sound effects to enhance your movie projects. The next two sections show you how to find and use the sound effects in iMovie and Studio.

Using sound effects in Apple iMovie

To view a list of sound effects in iMovie, click the Audio button above the timeline and choose iMovie Sound Effects from the menu at the top of the audio pane. A list of sound effects appears (as shown in Figure 12-8), including standard sound effects as well as special Skywalker Sound Effects that were new with iMovie 3. Skywalker Sound, as you may know, is the brainchild of George Lucas of *Star Wars* fame, and the sound effects that are included with iMovie are very high-quality effects. (I'm told Mr. Lucas is no slouch at filmmaking.)

Figure 12-8:
Apple iMovie includes a collection of high-quality Skywalker Sound Effects.

To preview a sound effect, choose it from the list and click the Play button in the audio pane. To use a sound effect in your project, simply click and drag it to an audio track on the timeline. You can trim and adjust the volume of sound effects just as you would any other audio clip.

Using sound effects in Pinnacle Studio

Pinnacle Studio comes with a diverse collection of sound effects. To view a list of them, click the Show Sound Effects tab on the left side of the album or choose Album➪Sound Effects. When you view the Sound Effects tab of the album, you may not actually see a list of effects, particularly if you've used this tab to import MP3 audio or other sounds that are not directly connected with Pinnacle Studio. If sound effects aren't shown, click the folder icon at the top of the album and browse to the following folder on your hard drive:

```
C:\Program Files\Pinnacle\Studio 8\Sound Effects
```

In that folder is a selection of 13 subfolders, each of which contains a category of sound effects. For example, to find chirping birds, double-click the Animals folder and then click the Open button. A list of animal sound effects appears in the album (as shown in Figure 12-9). To preview a sound effect, simply click it in the album. To use it in your movie project, click and drag it to the sound effects/narration track on the timeline.

Figure 12-9: Pinnacle also comes with a large collection of sound effects.

Adding a Soundtrack to Your Project

Background music for movies is nothing new. Even before the day of "talkies," silent movies were traditionally accompanied by musicians who played in the theater as the movie was shown. I'm sure that you're eager to use music in some of your movie projects as well. The next two sections show you how to add soundtrack music to your movies.

Adding music from a CD

In Book II, Chapter 7, I show you how to import music from audio CDs or MP3 files. After you have inserted an audio file into your editing program, you can add the file to the music track on your timeline. The procedure varies, depending on which editing program you are using, as follows:

+ In Apple iMovie, use iTunes (again, as described in Book II, Chapter 7) to import music from audio CDs into your iTunes library. Then click the Audio button in iMovie, choose iTunes from the menu at the top of the audio pane, and click and drag a song from your iTunes library to an audio track on the iMovie timeline.

+ In Pinnacle Studio, place a music CD in your CD-ROM drive and choose Toolbox⇨Add CD Music. The Add CD Music toolbox appears. Choose the audio track that you want to use in the Track menu, and then click the Add to Movie button. Close the Add CD Music toolbox, and then click the Play button under the preview window to play your timeline. The first time that you play the timeline, Studio imports the music from the CD. After the music is imported, you can remove the CD from your CD-ROM drive.

Generating background music with SmartSound

Pinnacle Studio comes with a tool called SmartSound, which can automatically *generate* royalty-free music in a variety of styles to match your project. To generate some music from SmartSound, open a project in Studio and

choose Toolbox⇨Generate Background Music. The audio toolbox appears, as shown in Figure 12-10. (If you did not install the SmartSound files on your hard drive during installation, you must insert the Studio program disc in your CD-ROM drive.)

Figure 12-10:
SmartSound
enables you
to create
varying
styles of
background
music for
your movie.

SmartSound offers music in a variety of styles. Each style includes several songs; most have a few different styles available. Click the Preview button to preview a style, song, and version. When generating background music, figure out approximately how long you want the musical piece to play. For example, when three 10-second clips are placed on the timeline, their total length is a little more than 30 seconds. Adjust the duration of the music by typing a new time in the Duration box (in the upper-right corner of the audio toolbox). When you click the Add to Movie button, SmartSound automatically generates a piece of music in the chosen style, song, and version, and it plays for approximately the duration that you chose. You can also name the selection if you want, using the Name field at the top of the toolbox.

One advantage of SmartSound's automatically generated music is that you can use it without paying royalties every time someone views your movie. Even so, remember that SmartSound does have *some* licensing restrictions. They're worth reviewing before you use the music in a movie that you plan to show to the public. For SmartSound license details, click the SmartSound button in the Studio audio toolbox.

Chapter 13: Exporting Digital Video to Tape

In This Chapter

⤳ **Preparing your movie for TV playback**

⤳ **Setting up your hardware for export**

⤳ **Exporting your movie**

1 don't think I'm going out on a limb by suggesting that almost everyone you know owns a TV and a VCR. These ubiquitous bits of home entertainment gear are all that anyone needs to view your latest movie production — because exporting your movie to videotape is pretty simple. Well, it's *usually* simple, especially *if* you have the right hardware. But even if all you have is a digital camcorder, sending your movie to videotape isn't very difficult.

This chapter shows you how to get your movie ready for videotape and helps you prepare the movie project and your export hardware. Then I show you how to export the movie to tape.

Prepping Your Movie for TV Playback

Throughout this book, I harp on the fact that televisions and computer monitors are very different. This means that the video that looks just peachy in the preview window of your editing software may not look all that great when it's viewed on a regular TV. Computer monitors and TVs differ in the following important ways:

+ **Color:** Computer monitors and television screens generate colors differently. This means that colors that look fine on your computer may not look so hot when viewed on a TV.

+ **Pixel shape:** Video images are made up of a grid of tiny little blocks called *pixels*. Pixels on computer monitors are square, but the pixels in TV images are slightly rectangular. Basically this means that some images that look okay on your computer may appear slightly stretched or squeezed on a TV. This usually isn't a problem for video that's captured from your camcorder, but still images and graphics that are generated on your computer could be a problem.

+ **Interlacing:** TV video images are usually interlaced, whereas computer monitors draw images by using progressive scanning. The main problem that you encounter when you export a project to tape is that the very thin lines that show up on the screen may flicker or appear to crawl. Pay special attention to titles, where thin lines are likely to appear in some letters. See Book II, Chapter 2 for an in-depth discussion of interlacing and progressive scanning.

In view (so to speak) of these issues, I strongly recommend that you try to preview your movie on an external monitor before burning it to a DVD or exporting it to tape.

If you use the LCD on your camcorder to preview your movie, keep in mind that the LCD panel probably isn't interlaced. However, the camcorder's viewfinder probably *is* interlaced. This means that flickering thin lines (for example) may show up in the viewfinder but not on the LCD panel. Preview the movie using *both* the LCD and the viewfinder before you export it.

Setting Up Your Hardware

Getting your hardware ready for exporting a movie to tape isn't that difficult. The easiest thing to do is connect your digital camcorder to your FireWire port and turn on your camcorder to VTR or Player mode. Oh yeah — be sure to insert a blank tape into the camcorder. After your movie is recorded onto the tape in your camcorder, you can connect the camcorder to a regular VCR and dub your movie onto a regular VHS tape.

I strongly urge you to use a fresh tape that has black video recorded on its entire length. This prevents errors in communication between your digital camcorder and your computer. See the sidebar "Blacking and coding your tapes" in Book II, Chapter 5 for instructions on how to prepare a digital videotape for use.

If your master plan is to eventually record your movie on a VHS tape, you may want to skip the middleman — that would be your digital camcorder — and record straight from your computer to a regular VCR. To do so, you have the following three basic options:

✦ **Use an analog video-capture card.** Analog capture cards (such as the Pinnacle AV/DV board) can usually export to an analog source as well as import from one. When you export video using an analog card, I strongly recommend that you use the software that came with that card. Most analog capture cards come with special utilities to help you import and export video. The Pinnacle AV/DV board uses Pinnacle Studio to capture and export video. To get Studio ready for analog export, follow these steps:

1. **Connect the analog outputs for the card to the video inputs on your VCR.**

2. **Make sure that the software that came with the capture card is set to export to the correct ports.**

 The Pinnacle AV/DV, for example, uses the Pinnacle Studio software. In Studio, choose Setup➪Make Tape. The Pinnacle Studio Setup Options dialog box appears, as shown in Figure 13-1. On the Make Tape tab, choose Studio AV/DV analog in the Video drop-down list.

3. **Make sure that the right analog output ports are selected.**

 The Pinnacle AV/DV board has both composite and S-Video outputs, so choose the one to which you have connected your VCR.

Composite and S-Video connectors are described in Chapter 6 of Book II.

✦ **Use a video converter.** Book II, Chapter 6 also describes how to capture analog video using a converter that connects to your computer's FireWire port. The converters that I list in Chapter 6 also have analog outputs to which you can connect a VCR.

✦ **Use your digital camcorder as a converter.** I know, I said I was going to show you how to *avoid* using your camcorder as the middleman when you export to VHS tape. But if you don't have an analog-capture card or a video converter, you may be able to connect your digital camcorder to your FireWire port and then connect a VCR to the camcorder's analog outputs. If nothing else, this arrangement reduces wear and tear on your camcorder's expensive tape-drive mechanism. Some digital camcorders don't allow you to make this connection because some models can't send video out the analog ports at the same time they are taking video in through the FireWire cable. Experiment with your own camcorder and VCR, and see whether this arrangement will work for you.

Figure 13-1: Choose analog outputs using Studio's Make Tape setup options.

If you are exporting to a VCR, make sure that a new, blank tape is inserted and ready to use and make sure that the VCR is set to the right channel. (Many VCRs have to be set to a special "AV" channel to accept video from composite video cables.) As a last step before you begin your export, preview your movie on a TV that's connected to the VCR to make sure that the VCR is picking up the signal.

Exporting the Movie

After your hardware is set up properly and you're sure that your movie will look good on a regular TV, you're ready to export the movie. Regardless of what software you are using, keep in mind that — like video capture — video export uses a lot of memory and computer resources. To make sure that your system is ready for export, follow these tips:

✦ **Turn off unnecessary programs.** If you're like I am, you probably feel like you can't live without your e-mail program, Internet messaging program, Web browser, and music jukebox all running at once. Maybe *you* can't live without these things, but your video-editing software can get along just fine without them. In fact, the export process works much better if these programs are closed, and you're less likely to have dropped frames or other quality problems during export.

✦ **Disable power-management settings.** If you're exporting a movie that's 30 minutes long and your hard drive is set to go into power-saving mode after 15 minutes, you could have a problem during export because the computer may mistakenly decide that exporting a movie is the same thing as inactivity. Power management is usually a good thing, but if your hard drive or other system components go into sleep mode during export, the video export will fail. Pay special attention to this if you're working on a laptop, which probably has pretty aggressive power-management settings. Check the following settings:

 • On a Mac running Mac OS X Panther, click the Energy Saver icon in System Preferences to adjust power settings. Crank up both the sliders in the Energy Saver window to Never, and deselect the Put the Hard Disk(s) to Sleep When Possible check box before you export your movie.

 • In Windows, open the Control Panel, double-click the Performance and Maintenance icon, and then double-click the Power Options icon. Set all the pull-down menus to Never before exporting your movie.

✦ **Disable screen savers.** Screen savers aren't quite as likely to ruin a movie export as power-management settings, but it's better to be safe than sorry. Follow these guides to disable screen savers:

 • On a Mac running Mac OS X Panther, open the Desktop & Screen Saver icon in System Preferences and drag the Start screen saver slider to Never in the Screen Saver dialog box.

 • In Windows, right-click a blank area of the Windows desktop and choose Properties from the menu that appears. Click the Screen Saver tab of the Display Properties dialog box, and choose the screen saver None. (That's my favorite one, personally.)

Whenever you export a movie to tape, you should place some black video at the beginning and end of the movie. Black video at the beginning of the tape gives your audience some time to sit down and relax between the time they push the Play button and the time the movie starts. Black video at the end of the movie also gives your viewers some time to press Stop before that loud, bright static comes on and puts out someone's eye.

Some editing programs — like Apple iMovie — have tools that allow you to automatically insert black video during the export process. I show you how to insert black video using iMovie in the next section. But if you're using some other software that doesn't have this feature — like Pinnacle Studio or Windows Movie Maker — you need to add a clip of black video

to the beginning and end of the project's timeline. You can usually do this by creating a blank full-screen title. I show you how to do this in the section "Adding black video to your timeline," later in this chapter.

Exporting to tape in Apple iMovie

Like most Apple software , iMovie is entirely functional and to the point. And at no time is this more evident than when you want to export your movie to tape. iMovie cannot export directly to an analog capture card, but it can export video at full quality to your digital camcorder. To export your finished movie to tape, follow these steps:

1. **Connect your digital camcorder to the FireWire port on your computer, and turn the camera on to VTR or Player mode.**

 Make sure that you have a new, blank videotape cued up and ready in the camcorder.

2. **In iMovie, choose File⇨Export.**

 The iMovie Export dialog box appears, as shown in Figure 13-2.

Figure 13-2: Set your export options here.

> iMovie: Export
>
> Export: [To Camera ▼]
>
> Wait [5][▲▼] seconds for camera to get ready.
>
> Add [30][▲▼] seconds of black before movie.
>
> Add [30][▲▼] seconds of black to end of movie.
>
> Please make sure your camera is in VTR mode and has a writable tape in it.
>
> (Cancel) (Export)

3. **Choose To Camera from the Export drop-down list.**

4. **Adjust the Wait field if necessary.**

 The Wait field controls how long iMovie waits for the camera to get ready before it begins to export. I recommend leaving the Wait field set at 5 seconds unless you're exporting to a video converter (such as the Dazzle Hollywood DV Bridge) that's connected to your FireWire port. In that case, you may want to increase the wait to about 10 seconds to ensure that you have enough time to press the Record button on your VCR.

 Whatever you do, *don't* reduce the Wait field to less than 5 seconds. Virtually all camcorders need some time to bring their tape-drive mechanisms up to the proper speed, and the Wait field gives the camcorder time to get ready.

5. **Adjust the two Add fields to determine the amount of black video that will be recorded at the beginning and end of the tape.**

 I recommend putting at least 30 seconds of black video at the beginning and end of the movie.

6. **Click the Export button.**

 iMovie automatically exports your movie to the tape in your camcorder. If you're exporting directly to a digital camcorder, iMovie automatically controls the camera for you; you don't have to press the Record button on the camcorder. But if you are exporting through a video converter, you must press the Record button on your analog VCR.

Exporting to tape in Pinnacle Studio

Exporting movies to tape from Pinnacle Studio is a slightly more complex process than what is found in, say, Apple iMovie or Windows Movie Maker. But one of the main reasons for this complexity is that Studio gives you more export options than iMovie — and it exports better-quality video than Movie Maker by far. The next two sections show you how to export your movie to tape from Pinnacle Studio.

Adding black video to your timeline

In the section "Exporting the Movie," earlier in this chapter, I describe the importance of placing black video at the beginning and end of a movie that will be recorded onto tape. If you plan to export your Pinnacle Studio movie project to tape in a digital camcorder, you need to add some black video clips to the beginning and end of the timeline. To add a black video clip to the beginning of your project, follow these steps:

1. **In the Edit mode, click the Titles tab on the left side of the album.**

 A selection of titles appears in the album.

2. **If any tracks on the timeline are currently locked, click the track headers on the left side of the timeline to unlock them.**

 When a track is locked, a tiny lock icon appears on the track header and a zebra-stripe pattern appears across the track. Unlocking all tracks is an important step because you're going to insert a title clip at the beginning of the timeline. If all tracks are unlocked, they all shift over automatically when you insert the title. This keeps all your narration, music, and title overlays properly synchronized with your video.

3. **Click and drag any title to the beginning of the video track on your timeline.**

4. **Double-click the title to open the title editor, as shown in Figure 13-3.**

5. **Select the text in the title, and press Delete to delete all the title text.**

6. **Adjust the duration of the title by using the Duration field in the upper-right corner of the title editor.**

 I recommend a duration of 30 seconds.

Adjust duration.

Figure 13-3: Use the title editor to create a clip of black video.

Delete this text.

7. **Close the title editor.**

 The blank title appears at the beginning of the timeline.

8. **Click the blank title once to select it, and then choose Edit⇨Copy.**

9. **Move the play head to the end of the timeline.**

10. **Choose Edit⇨Paste.**

 A copy of the blank title now appears at the end of the movie as well.

I also like to add a Dissolve transition between the initial black video clip and the first clip of the movie. This technique makes the beginning of the movie a little easier on the eyes as it fades in. In Figure 13-4, I have done this by dragging a Dissolve transition to the timeline from the Transitions tab of the Studio album. See Chapter 10 of Book II for more on using transitions.

Exporting the movie

Pinnacle Studio provides the Make Movie mode as your central location for exporting a finished movie project, whether you're exporting to tape, DVD, the Internet, or a carrier pigeon. (Just kidding — Export to Carrier Pigeon won't be available until the *next* version of Studio, if not later.) To open the Make Movie mode, choose View⇨Make Movie.

Transition tab Dissolve

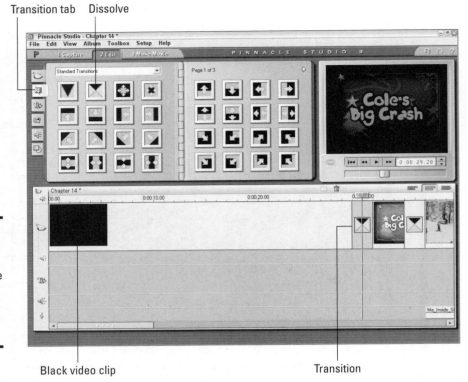

Figure 13-4:
I like to add
a transition
between the
black video
and the first
clip of the
movie.

Black video clip Transition

If any of the clips in your movie were captured at Preview quality (see Book II, Chapter 6 for details on Preview quality capture), you are prompted to insert the tapes that contain the original source clips at full quality. Make sure that you have those tapes handy, and follow the on-screen instructions to recapture the footage.

You're ready to start exporting your movie to tape. Follow these steps to do so:

1. **In the Make Movie mode, click the Tape button at the left side of the Make Movie window.**

Basic video settings appear in the Make Movie window, as well as the estimated file size for the exported file. Studio needs to export the movie as a file before it can be recorded onto tape, and that file is probably going to be big. As shown in Figure 13-5, I have a movie that is only about 50 seconds long, and yet it will create a file that is over 157MB in size. This is why I always recommend that you buy the biggest hard drive that you can afford.

2. Click the Settings button.

The Make Tape tab of the Pinnacle Studio Setup Options dialog box appears. As I describe in the section "Setting Up Your Hardware," earlier in this chapter, make sure that the correct output source is selected in the Video menu. In Figure 13-6, I am preparing to export to a DV camcorder that's connected to my FireWire (IEEE 1394) port.

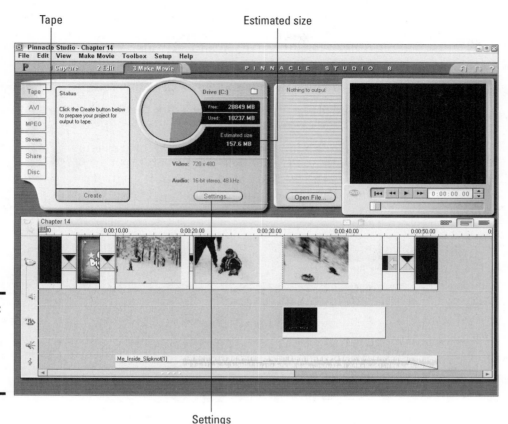

Figure 13-5:
Studio is
ready to
export my
movie to
tape.

Figure 13-6:
Review your
Make Tape
options
here.

3. **If you're exporting to a DV camcorder, select the Automatically Start and Stop Recording check box.**

With this option enabled, Studio automatically controls your camcorder for you, meaning that you won't have to press the Record button on the camcorder. If you're exporting to a video converter such as the Dazzle Hollywood DV Bridge, deselect this check box.

If you enable automatic control of your DV camera, you should set the Record Delay Time to 5 seconds, as shown in Figure 13-6. This gives the camcorder's tape mechanism enough time to spool up to the proper speed for recording.

4. Click OK to close the Pinnacle Studio Setup Options dialog box.

5. Back in the Make Movie window, click the Create button at the bottom of the export control.

Studio creates a file for your movie. The process may take several minutes, especially if your movie is long and has a lot of effects and transitions. When the file is created, the export control tells you that your project is ready for output, as shown in Figure 13-7.

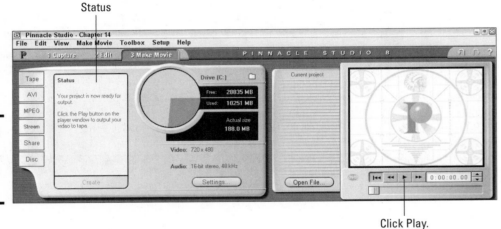

Figure 13-7:
The project
is ready for
output to
tape.

Click Play.

6. Click the Play button under the preview window.

If you chose to give Studio automatic control of your DV camcorder (in Step 3), Studio automatically starts the recording feature on your camcorder, stopping when the movie has been exported.

If you're exporting through an analog output (such as a Pinnacle AV/DV card), you must press the Record button on your analog VCR a few seconds before you click the Play button in the Studio preview window. One nice thing about Studio is that while it's waiting for you to click the Play button, the software sends out a black video signal through the analog outputs. This means that you can press the Record button on your analog VCR and let it record that black video for 30 seconds or so before you play your movie in the export process. Presto! — you eliminate the need to add black video clips to the beginning and end of the timeline. When the movie has been exported, Studio reverts to outputting black video through the analog outputs. You should record 20 to 30 seconds of this black video on the VHS tape before you press the Stop button.

Chapter 14: Putting Your Movies on the Internet

In This Chapter

✔ **Choosing a video format**

✔ **Exporting your movie**

✔ **Optimizing your movie's export settings for the Internet**

✔ **Finding an online home for your movies**

✔ **Putting your movies on the Web**

Since the first home movie cameras became popular about 50 years ago, friends, family, and neighbors have taken part in a vaunted tradition: falling asleep in front of someone else's home movies. Until recently, this tradition required that you, the moviemaker, lure your unsuspecting audience to your house, baiting them with the promise of good food and drink. But now thanks to the Internet, you can bore, er, I mean, *entertain* many more people with your movies without ever having to prepare a single hors d'oeuvre tray.

Software companies have tried to make it easier to place your movies online. Nearly all video-editing programs — including Apple iMovie, Pinnacle Studio, and Windows Movie Maker — provide tools to help make your movies ready for sharing online. (For the lowdown on editing your movies, see Chapters 8 through 12 of Book II.)

When you want to share movies on the Internet, the most important consideration is file size. Movie files are usually really big, and a majority of Internet users still have slow dialup modem connections. This means that big movie files take a long time to download, and the long download time may discourage your audience members from viewing the movies.

This chapter helps you prepare your movies for online use. I show you how to use the most efficient file formats so that your video files aren't too big, and I also show you how to find an online home for your movies once they're ready to share.

Choosing a Video Format

Many different video formats are available for the movies that you edit on your computer. Each format uses a different codec. (A *codec,* short for *compressor/decompressor,* is a software tool that is used to make multimedia files smaller.) Common video file formats include MPEG and AVI, but these

two formats are usually not suitable for movies that you plan to share online because they have big file sizes. Three other popular formats, however, are perfectly suited to the online world. These formats are as follows:

✦ **QuickTime (.QT):** Many Windows users and virtually all Macintosh users have the QuickTime Player program from Apple. QuickTime is the only export format that's available with iMovie. Pinnacle Studio cannot export QuickTime movies, but some more advanced Windows programs like Adobe Premiere can.

✦ **RealMedia (.RM):** This is the format that is used by the popular RealPlayer, which is available for Windows and Macintosh systems, among others. Pinnacle Studio can export RealMedia-format video.

✦ **Windows Media Video (.WMV):** This format requires Windows Media Player. Almost all Windows users and some Macintosh users already have it. Both Pinnacle Studio and Windows Movie Maker can export Windows Media Video.

Each of these three video formats has strengths and weaknesses. Ultimately, the format that you choose depends mainly on the editing software that you're using. For example, if you're using iMovie on a Mac, QuickTime is probably your only option. In the section "Comparing player programs," later in this chapter, I introduce you to the various software programs that are used to play these Web-friendly video formats.

Streaming your video

Doing stuff on the Internet usually means downloading files. For example, when you visit a Web page, files that contain all the text and pictures on that Web page are first downloaded to your computer and then your Web-browser program opens them. Likewise, if someone e-mails you a picture or a document with yucky work stuff, your e-mail program must download the file before you can open it.

Downloading files takes time, especially if they are big video files. You sit there and you wait. And wait. And wait. Finally the movie file is finished downloading and starts to play, but by then you've left the room for a cup of coffee again. But software designers are crafty folk, and they've devised methods of getting around the problem of waiting a long time for downloads. They have come up with the following basic solutions:

✦ **Streaming media:** Rather than downloading a file to your hard drive, streaming files can be played as the data streams through your modem. It works kind of like a radio, where "data" streams through in the form of radio waves, and that data is immediately played through the radio's speakers as it is received.

With streaming audio or video, no file is saved on your hard drive. To truly stream your movies to other people, your movie files need to be on a special *streaming server* on the Web. There is a remote possibility that your Internet service provider offers a streaming media server, but most service providers do not.

✦ **Progressive download:** Newer video-player programs can "fake" streaming pretty effectively. Rather than receiving a movie signal that's broadcast over the Internet like a radio wave, viewers simply click a link to open the movie as if they were downloading the file. In fact, they *are* downloading the file. But as soon as enough of the file has been received, the player program can start to play it. The program doesn't need to wait for the whole file to download before it starts to play. Current versions of QuickTime, RealPlayer, and Windows Media Player all support progressive download.

The really cool thing about progressive download is that you don't need any special kind of server to host the files. Just upload the video file to any server that has enough room to fit it in.

I'm being kind of picky about terminology here. Many people now refer to progressive download video files as "streaming video," and because the two formats basically function the same way, why not? The good news is that you don't need to do anything special to stream (or *progressively download,* or whatever you want to call it) your movies to your audience. Just output your movie in QuickTime, RealVideo, or Windows Media Video format, and let the player programs do the rest.

Comparing player programs

When you share your movie over the Internet, you're actually sharing a file. Make sure that your intended audience can open that file. Different movie-file formats require different programs for playback. The following sections introduce you to the three most common programs that are used for playing movies from the Internet.

QuickTime

Apple QuickTime (see Figure 14-1) is perhaps the most ubiquitous media player in the personal computer world today, which makes it a good overall choice for your audience. QuickTime is available for Macintosh and Windows systems and is included with Mac OS 9 and higher. QuickTime can play MPEG and QuickTime media. The QuickTime Player also supports progressive download, where files begin playing as soon as enough has been downloaded to allow continuous playback. The free QuickTime Player is available for download at the following Web site:

`www.apple.com/quicktime/download/`

Apple also offers an upgraded version of QuickTime called QuickTime Pro. QuickTime Pro costs about $30 (the regular QuickTime Player is free). Key features of QuickTime Pro are as follows:

✦ Full-screen playback

✦ Additional media-management features

✦ Simple audio and video creation and export tools

✦ Advanced import/export options

Figure 14-1:
Apple
QuickTime
is one of
the most
common
and best
media
players
available.

If you already have iMovie (and therefore the regular QuickTime), you don't need the extra features of QuickTime Pro. Your audience doesn't need QuickTime Pro either (unless, of course, they want to watch movies in full-screen mode). In most cases, the standard QuickTime Player should suffice. Apple iMovie exports QuickTime-format files. If you're a Windows user, QuickTime Pro allows you to convert MPEG files to QuickTime format. Some advanced Windows editing programs (such as Adobe Premiere) can also export files in QuickTime format.

RealPlayer

Another very popular media player is RealPlayer from RealNetworks. RealPlayer is available for Macintosh, Windows, and even UNIX-based systems. The free RealPlayer software is most often used for RealMedia streaming media over the Internet, although it can also play MPEG-format media. Pinnacle Studio allows you to export movies in the RealMedia format using the Streaming option in the Make Movie window. I show you how to export a RealMedia movie in the section "Exporting Movies for the Online World," later in this chapter. To download the RealPlayer in its various incarnations, visit www.real.com/.

Although RealNetworks offers a free version of the RealPlayer (as shown in Figure 14-2), you have to search its Web site carefully for the Free RealOne Player link before you can download it. RealNetworks offers other programs as well, and although they're not free, they offer additional features. RealNetworks has specialized in the delivery of streaming content, and it offers a variety of delivery options. You can use RealNetworks software to run your own RealMedia streaming server, or you can outsource such "broadcast" duties to RealNetworks.

A complaint that's often heard about RealPlayer is that the software tends to be intrusive and resource-hungry once installed. Some people also complain that the program collects information about your media-usage habits and sends that information to RealNetworks. Although RealPlayer is extremely

popular, consider that some folks simply refuse to install RealNetworks software on their computers. RealMedia is an excellent format, but I recommend that you offer your audience a choice of formats if you plan to use it; include (for example) QuickTime or Windows Media Video.

Figure 14-2: RealPlayer, a popular media player, is often used for streaming media on the Internet.

Windows Media Player

Microsoft Windows Media Player (version 7 or newer) can play many common media formats. I like to abbreviate the program's name as *WMP* because, well, it's easier to type than Windows Media Player. WMP comes preinstalled on computers that run Windows Me or Windows XP. Although the name says "Windows," versions of WMP are also available for Macintosh computers that run OS 8 or higher. Figure 14-3 shows Windows Media Player running in Mac OS X. WMP is even available for Pocket PCs and countless other devices! WMP is available for free download at the following Web site:

www.microsoft.com/windows/windowsmedia/download/

Figure 14-3: Windows Media Player is required for viewing Windows Media– format movies.

543

Windows Media Player can play video in MPEG and AVI formats. Although Pinnacle Studio can output both of these formats, they're not terribly useful for online applications because they create big files and have an appetite for resources. Windows Media Player can also play the Windows Media Video (WMV) format, and Studio can output that as well (by using the Streaming option in the Make Movie window — I show you how in the section "Exporting Internet movies from Studio," later in this chapter). I like the WMV format because it provides decent quality (for Web movies) with remarkably small file sizes.

What are the compelling reasons for choosing WMP (the Macintosh version is shown in Figure 14-3) over other players? Choose Windows Media Player as your format for one or more of the following reasons:

✦ **Most or all of your audience members use Windows.** Most Windows users already have WMP installed on their systems, so they won't have to download or install new software before viewing your Windows Media–format movie.

✦ **You want the look, but not the expense and complexity, of streaming media.** If you don't want to deal with the hassle of setting up and maintaining a streaming-media server, Windows Media format files can provide a workable compromise. WMP does a decent simulation of streaming media with *progressive downloadable video:* When downloading files, WMP begins playing the movie as soon as enough of it is downloaded to ensure uninterrupted playback.

✦ **You're distributing your movie online, and an extremely small file size is more important than quality.** The Windows Media format can offer some very small file sizes, which is good if your audience will be downloading your movie over slow dialup Internet connections. I recently placed a 3:23-long movie online in Windows Media format, and the file size was only 5.5MB. Of course, the movie was not broadcast quality, but because most of my friends and family still have slow dialup connections to the Internet, they appreciated the relatively small download size.

Exporting Movies for the Online World

When you output a movie from Pinnacle Studio in MPEG or AVI format, you run into a familiar trade-off: Although those two formats can offer high quality, they're usually too big to use on the Internet, regardless of whether you plan to place your movie on a Web page or e-mail it to some friends. For online use, the QuickTime, RealMedia, and Windows Media Video formats are much better. The following sections show you how to export Web-friendly movies from Apple iMovie and Pinnacle Studio.

Making QuickTime movies with iMovie

If you're using Apple iMovie and you want to make movies in QuickTime format, you're in luck. QuickTime is the only movie file format that iMovie can produce. QuickTime movies can be played using the QuickTime Player program, which is available for free for Windows and Macintosh systems. To output in a different format, such as RealMedia, you must use more advanced software, such as Final Cut Express.

E-mailing your movies

The World Wide Web seems to get all the attention these days, but I think that e-mail, more than anything else, revolutionized the way that we communicated during the last decade. Most of your friends, relatives, and business associates probably have e-mail addresses, and you probably exchange e-mail messages with those folks on a regular basis.

E-mail is already a great way to quickly share stories and pictures with others, and now that you're making your own movies, it seems only natural to start e-mailing your movie projects to friends as well. Before you do, keep in mind that movie files tend to be really big. Most e-mail accounts have file-size limitations for e-mail attachments, sometimes as low as 2MB. Other e-mail accounts don't allow file attachments. And of course, many people still have slow dialup connections to the Internet, which means that it will take them a long time to download a movie that you send them.

To e-mail a movie to someone, first ask the person whether it's okay to do so. Send an initial e-mail that says something like, "Hi there! I just finished a really awesome movie and I want to send it to you. The movie is in QuickTime format, and the file size is 1.3MB. Can I e-mail it to you?" Most people will probably say yes, and they'll appreciate that you took the time to ask them first.

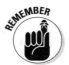

Pinnacle Studio can export movies in RealMedia or Windows Media Video format, but not in QuickTime format. To create QuickTime movies in Windows, you need QuickTime Pro or a more advanced editing program such as Adobe Premiere.

Exporting a QuickTime movie from iMovie is pretty simple. The QuickTime format offers a variety of quality and output settings that you can adjust, and iMovie provides several easy-to-use presets. You can also customize export settings. Follow these steps to export a QuickTime movie:

1. **When you're done editing your movie in iMovie, choose File➪Export.**

The iMovie: Export dialog box appears, as shown in Figure 14-4.

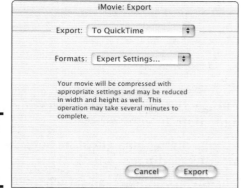

Figure 14-4:
Choosing export settings.

2. **Choose To QuickTime from the Export menu.**

3. **Choose the best preset for the way that you plan to distribute your movie from the Formats menu.**

iMovie provides three preset formats for export: Email, Web, and Web Streaming. Table 14-1 (at the end of these steps) lists the specifications for each preset as well as the CD-ROM and Full Quality DV presets. Unless

your movie is very short, the CD-ROM and Full Quality DV presets generally produce files that are too big for online use. To fine-tune your settings, choose Formats⇨Expert Settings.

4. Click the Export button.

A Save Exported File As dialog box appears.

5. If you chose a preset format, give your movie a filename, choose a folder in which to save it, and click the Save button to save your movie to a file and finish the export process.

If you chose a preset format in Step 3, you're done! For more information about getting your movie online, see the "Putting Your Movie on the Web" section, later in this chapter.

If you chose Formats⇨Expert Settings, you still have a few more steps to complete in the export process. Your Save Exported File As dialog box looks like that shown in Figure 14-5, and you have some additional settings to adjust. At the bottom of the dialog box, you can either choose Presets from the Use menu or click the Options button. If you click Options, the Movie Settings dialog box appears.

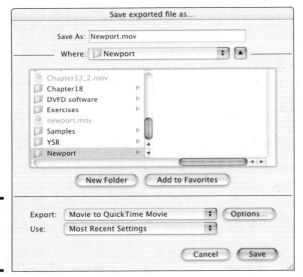

Figure 14-5: Name and save your movie file.

6. (Optional) In the Movie Settings dialog box, select the Video and Sound check boxes to include both in your movie.

7. (Optional) In the Movie Settings dialog box, click the Settings button under Video and adjust the video settings.

The Compression Settings dialog box appears, as shown in Figure 14-6. Start by choosing a codec from the menu at the top of the dialog box. The Sorenson or H.263 codecs are pretty good for most movies, and the Motion JPEG A codec works well for movies that will be played on older computers. MPEG-4 — which I've chosen in Figure 14-6 — provides a superior balance of quality and compression, but viewers must have QuickTime 6 (or later) to play it.

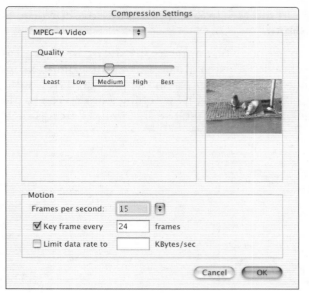

Figure 14-6:
Adjust video compression settings here.

Adjust the Quality slider, and preview your video image. The Best quality setting provides better picture quality, but it increases the file size.

In the Frames Per Second drop-down list, choose a frame rate (in Figure 14-6, I've chosen 15 frames per second), or just choose Best from the menu to let iMovie automatically determine a good frame rate. More frames per second increase the file size.

I recommend that you do not change the Key Frame Every *x* setting. (The default value is 24 — that is, a key frame occurs once every 24 frames — and a smaller number means *more* key frames.) Key frames help QuickTime compress and decompress the movie. More key frames provide better quality, but they also increase the file size.

Click OK when you're done adjusting the compression settings. You're returned to the Movie Settings dialog box.

8. (Optional) In the Movie Settings dialog box, click the Filter button.

The Choose Video Filter dialog box appears. Here you can apply filters to your video image that can blur, sharpen, recolor, brighten, and perform a variety of other changes to the picture. Most filters also have adjustments that you can make by using slider controls. A preview of your video image appears in the Choose Video Filter dialog box so that you can see the affects of the various filters. I don't usually find these filters very useful because I normally apply filters or effects to my video during the editing process. After making your selections, click OK to close the Choose Video Filter dialog box.

9. (Optional) In the Movie Settings dialog box, click the Size button to adjust those settings.

In the Export Size Settings dialog box that appears, choose Use Current Size or choose Use Custom Size, and enter a custom width and height in pixels. As shown in Table 14-1, a common frame size for Web movies is 240 pixels wide by 180 pixels high. Click OK to close the Export Size Settings dialog box.

10. **(Optional) Back in the Movie Settings dialog box, click the Settings button under Sound.**

The Sound Settings dialog box appears, as shown in Figure 14-7. For online movies, choose QDesign Music 2 from the Compressor drop-down list. Reduce the sampling rate in the Rate field (for online use, I recommend 22.05 kHz or lower). Switching from Stereo to Mono also reduces the file size. Click OK to close the Sound Settings dialog box.

Figure 14-7: Make sound settings here.

11. **(Optional) In the Movie Settings dialog box, select the Prepare for Internet Streaming check box to take advantage of streaming or progressive download for this movie, and select the Fast Start option in the Streaming menu.**

12. **Click OK to close the Movie Settings dialog box, and then click Save in the Save Exported File As dialog box.**

The movie is exported with the settings that you provided.

13. **Preview your movie in QuickTime, and check the file size of the movie.**

If the movie file is too big, re-export it with lower quality settings (such as a smaller frame size, lower frame rate, or lower sample rate for the audio). If the movie is smaller than you expected, you may want to re-export it with slightly higher quality settings. When you're done, you can share your QuickTime movie file online by attaching it to an e-mail or by placing it on a Web site. (In the section "Putting Your Movie on the Web," later in this chapter, I show you how to find and establish an online screening room for your movie.)

Table 14-1	iMovie QuickTime Export Presets		
Preset	*Frame Size (pixels)*	*Frame Rate (frames per second)*	*Audio (channels, sample rate)*
E-mail	160×120	9.99	Mono, 22.05 kHz
Web	240×180	11.99	Stereo, 22.05 kHz
Web streaming	240×180	11.99	Stereo, 22.05 kHz
CD-ROM	320×240	14.99	Stereo, 44.1 kHz
Full quality DV (NTSC)	720×480	29.97	Stereo, 32 kHz

Exporting Internet movies from Studio

Pinnacle Studio provides you with a number of different export options. Two Web-friendly formats available in Studio are RealVideo and Windows Media. To begin exporting your finished movie by using either of these formats, follow these steps:

1. **Launch Pinnacle Studio, and choose View⇨Make Movie.**

2. **In the Make Movie window that appears, click the Stream button on the left.**

As shown in Figure 14-8, the export controls now include radio buttons for Windows Media or RealVideo.

3. **Choose a format, and then click the Settings button.**

The Pinnacle Studio Setup Options dialog box appears. In the next two sections, I describe the settings that are available on the Make RealVideo and Make Windows Media tabs. Make your adjustments to these settings, and then complete Steps 4 and 5.

4. **Adjust the settings to your liking, and then, back in the export controls, click the Create Web File button.**

5. **Choose a location for your movie, and name it in the Save As dialog box that appears.**

Your movie is ready for viewing. See the section "Putting Your Movie on the Web," later in this chapter, for more details.

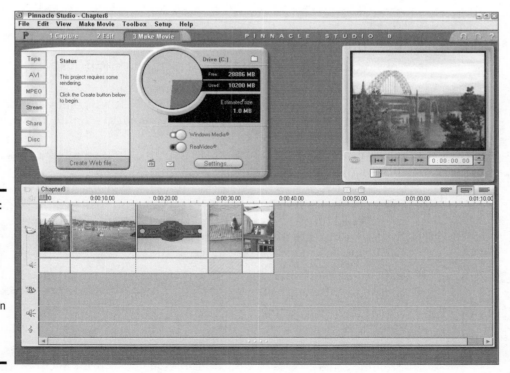

Figure 14-8:
Click the Stream button, and then select Windows Media or RealVideo in the Make Movie window.

Using the RealVideo format

RealVideo is a popular format for online videos, and making RealVideo movies in Pinnacle Studio is pretty easy. In the Make Movie window, click the Stream button and then select the RealVideo radio button. Next, click the Settings button. The Make RealVideo tab of the Pinnacle Studio Setup Options dialog box appears, as shown in Figure 14-9.

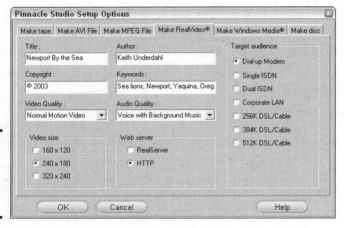

Figure 14-9: Adjusting settings for RealVideo export.

Review the following settings, adjusting them as needed:

✦ **Title:** Enter a title for your movie. This title will appear in the program window when people view your movie, so it should be written in plain English.

✦ **Author:** That's you! Enter your name here.

✦ **Copyright:** Enter the year. You can enter the month and day, but that's not necessary.

✦ **Keywords:** Enter some keywords that relate to your movie. This can help people who are searching for your movie using the keywords that you list.

✦ **Video Quality:** Choose a video quality option here. Most of the time, the safest choice in this menu is Normal Motion Video. The Smoothest Motion Video option works well with video that doesn't have a lot of action, whereas the Sharpest Image Video option is best for video that *does* have a lot of action. The Slide Show option shows a series of still images, which obviously isn't ideal for most video. If you choose the No Video option, no video is included in the file.

✦ **Audio Quality:** Choose an option from this menu that matches the majority of the audio in your project. Choices include No Audio, Voice Only, Voice with Background Music, Music, and Stereo Music.

✦ **Video Size:** Select a frame size for your video image here.

✦ **Web Server:** If you know that your movie will be placed on a RealServer streaming media server, choose the RealServer option. Otherwise, choose HTTP.

✦ **Target Audience:** If your movie will be placed on a RealServer, you can choose multiple options here. The server automatically detects the connection speed of each person who accesses your movie, and a movie of the appropriate quality level is sent. Movie quality settings are automatically tailored to the target audience that you choose.

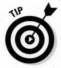

If you're placing your movie on a regular Web server (HTTP), you may want to output two different versions of the same movie for people with different connection speeds. Output a lower-quality movie with the Dial-up Modem setting, and then output a higher-quality version of the same movie with one of the DSL/Cable settings. Give each file a unique name, and provide separate descriptive links to each one on your Web page.

Using the Windows Media format

Although Microsoft was late to the online multimedia game, Windows Media Video is quickly becoming one of the most popular video formats on the Web. Pinnacle Studio can export directly to Windows Media format. To do so, choose View⇔Make Movie, click the Stream button on the left side of the Make Movie window, and then select the Windows Media radio button. You can review and adjust those settings by clicking the (surprise!) Settings button in the Make Movie window. The Make Windows Media tab of the Pinnacle Studio Setup Options dialog box appears, as shown in Figure 14-10.

Figure 14-10: Adjusting settings for a Windows Media file export.

When you adjust settings for a Windows Media export, check the following items:

✦ **Title:** Enter a plain-English title for your movie here. This title will appear at the bottom of the Windows Media Player window when your movie is played.

✦ **Author:** They can't give out awards if they don't know who made the movie! Enter your name here to give yourself proper credit.

✦ **Copyright:** Enter a year (and month and day if you like) here.

✦ **Description:** Type a brief description of your movie. This description will scroll across the bottom of the Windows Media Player window as the movie plays.

✦ **Rating:** Give your movie a rating if you want.

✦ **Markers:** If you include markers in your Windows Media movie, viewers can jump from clip to clip by pressing the Next and Previous buttons in their Windows Media Player programs. I have added a marker for every clip (refer to Figure 14-10). If you select the Markers for Named Clips Only option, only clips that you manually named while you were editing your project will have markers.

✦ **Playback Quality:** Choose the Low, Medium, or High presets in the menu on the left. If you choose Custom, a second menu appears to the right, displaying a wider selection of presets. A summary of movie settings for each preset is shown under the Playback Quality menus.

Putting Your Movie on the Web

After your movies are exported in a Web-friendly format, it's time to make those movies available *on* the Web. This means that you have to upload your movies to a *Web server* (basically a big hard drive that is connected to the Internet, set up so that anyone with a Web browser can access files kept on it). The next two sections help you find a Web server on which to store your movie files, and I show you how to make a simple Web page that can serve as your online theater.

Finding an online home for your movies

If you want other people to be able to download and watch your movies, you must place the movie files on a Web server. Your Internet service provider (ISP) may provide some free Web-server space with your Internet account. This free space is usually limited to 5 to 15MB, but the exact amount can vary. You can use your Web-server space to publish pictures, movies, and Web pages that anyone on the Internet can see. Check with your ISP to find out whether you have some available Web server space, and if you do, get instructions for uploading your files to its Web server.

If your ISP doesn't provide Web-server space or if you can't get enough space to hold all your movie files, don't worry. Plenty of other resources are available. Several companies specialize in selling server space that you can use to store your movies. Three services are as follows:

✦ **.Mac** (www.mac.com): This service from Apple includes e-mail tools, an address book, antivirus service, and most importantly, 100MB of storage space on its Web server. Uploading movie files to .Mac is just as easy as copying files to different drives on your computer. The .Mac service costs approximately $100 per year and provides many more features than I can list here.

✦ **HugeHost.com** (www.hugehost.com): As the name implies, HugeHost.com lets you put huge files online. The service is quite affordable, as well. For example, 1000MB (yes, that's 1GB) is just $5 per month, or $55 per year. See the HugeHost Web site for other pricing plans.

✦ **Neptune Mediashare (**www.neptune.com**):** This service is partnered with Microsoft so that you can easily access the Neptune Web site directly from within Windows Movie Maker. When you export a movie for the Web from Movie Maker, you are given the opportunity to log on to your Neptune Mediashare account and upload files instantly. The Mediashare Pro service provides 100MB of storage space for $39 per year.

Regardless of what you use as a Web server for your movie files, make sure that you get specific instructions for uploading. You also need to know what the Web address is for the files that you upload. You can then send that address to other people so that they can find and download your movie.

Creating a (very) simple Web page

Yes, you read that heading correctly: I'm going to show you how to create a simple little Web page. No, I'm not going to tell you *everything* you need to know about designing and managing a Web site (so you can start breathing again), but making a simple Web page is pretty, um, simple. To make a Web page, open a text-editing program, as follows:

✦ **Macintosh:** Open the Applications folder, and then double-click the TextEdit icon.

✦ **Windows:** Choose Start⇨All Programs⇨Accessories⇨Notepad.

After you have your text-editing program open, type the following text, exactly as shown here:

```
<html>
<head>
<title>My Online Theater</title>
</head>
<body>
<center>
<h1>My Online Theater</h1>
<p>
<a href="Newport.wmv">Newport By the Sea</a> 1.03 MB,
   Windows Media Video</p>
</center>
</body>
</html>
```

Notice that the line that starts with refers to the name of a movie that I created. The text between the quotation marks (Newport.wmv in my example) is the filename of the movie file. Change that text to match the filename of your own movie. Filenames on Web sites are usually case sensitive, so make sure that you use uppercase and lowercase letters exactly as they're used by the movie file. Also change the descriptive text (Newport By the Sea in my example) part to match your own movie. I've also listed the file size and format, just so people who visit the page will know what to expect. You can change that information on your own file as well. When you're done typing all these lines, save the file and give it the following filename:

```
index.html
```

Upload this file to the same directory on your Web server that contains your movie file. (You should get upload instructions from your ISP or Web-server provider.) Make sure that both this `index.html` file and your movie file are in the same directory on the Web server. If the address to your movie file is as follows:

`www.webserver.com/myaccount/Newport.wmv`

simply provide your audience with this address instead:

`www.webserver.com/myaccount/`

When people visit that page, they'll see something similar to Figure 14-11. If you have several movies on your Web server, you can list them all on a single page. Just copy the line that starts with `<p>`, and then enter the file-name and other information for each movie in each respective line.

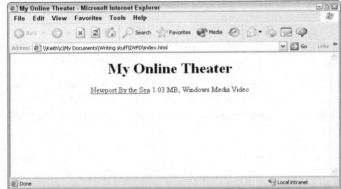

Figure 14-11:
A simple Web page makes your movies easy to access.

Web-page creation and management involve a lot more than what I have described here. Web design is a big subject, and if you're interested in creating more-complex Web pages, I recommend that you obtain a book that covers the subject more thoroughly, such as *HTML 4 For Dummies*, 4th Edition, by Ed Tittel and Natanya Pitts, or *Creating Web Pages For Dummies*, by Bud Smith and Arthur Bebak (both published by Wiley).

Chapter 15: Video Preproduction: Planning, Storyboarding, and Scripting

In This Chapter

✔ Engaging your viewer with well-crafted shots

✔ Using storyboarding and scripting to plan your video

I'm going to make a big assumption: You intend to use your digital video camcorder for more than just shooting video. Perhaps you want to impress an individual or group of people with an idea that you would like to translate into film. Maybe you want to motivate people to do, support, or buy something by showing them a touching or powerful film. Or, you may want to teach someone a step-by-step process through a training video. Then again, you may want to document an event, such as a wedding or a football game.

With few exceptions, you can't expect to record video that, *unedited,* will meet your goals and expectations. Unedited video is usually boring beyond belief. You've probably sat through some of it (a friend's family vacation, for example) at one time or another, so I won't bother to prove my point. The best way to get good video is to know how to use your camcorder as a persuasion tool and to plan (or *script*) the intended outcome.

Preparing to Shoot Digital Video

You need to become familiar with the vocabulary that's associated with filmmaking to understand how things are done and how to communicate your ideas effectively. I always want to be helpful, so, in this section, I describe and illustrate some of the terms that are associated with the different kinds of video shots.

Using the right angle for the right situation

The following words are associated with different types of video shots:

✦ **Extra long shot (ELS):** Shows a person within the fullness of the surrounding area. For example, you tell the viewer what is going on with the person in the video by showing her *and* the big picture around her. Use this shot to effectively establish the environment for opening and closing shots.

✦ **Long shot (LS):** The character in this shot occupies one-half to three-quarters of the screen height. This shot clarifies the relationship between the character and the overall place by showing what's in the subject's immediate proximity. This shot usually shows people from their feet to their head.

✦ **Medium long shot (MLS):** Shows the subject's body plus a little above and below the body. This shot is often used when the subject is moving.

✦ **Knee shot:** Shows a three-quarter shot from the head to the knee. Use this shot to re-establish the relationship of the character to a location or to another character. That is, after using a close-up shot, you need to show the subject's surroundings again.

✦ **Medium shot (MS):** Shows the top of the head to just below the waist. Use this shot to develop a comfort zone for the viewer: a comfortable, conversational distance between the viewer and character. Overuse this technique, however, and you risk boring the viewer. A basic rule of creating video is to provide timely visual stimulation through changing views. Too much of a comfortable shot can cause the viewer to lose attention.

✦ **Medium close-up (MCU):** Often called a *bust shot,* it cuts from the top of the head to just above the diaphragm. Use the MCU as an attention-getting shot because it violates the comfort zone, thus making the viewers slightly uncomfortable and thereby getting their attention. The shot also implies that the character is significant or has something important to say. For this reason, the MCU, mixed with an occasional knee shot, is the favorite of the evening news.

✦ **Close-up (CU):** Shows the upper forehead to the upper chest. Use this shot for emphasis, but use it sparingly to hit the important phrase in a statement or to establish strong feeling. It is also used frequently in interviews.

✦ **Big close-up (BCU):** A full-head shot. Use this shot to elicit a laugh or cynicism, but be careful because the shot can appear bizarre.

✦ **Very close-up (VCU):** This face shot shows the middle of the forehead to above the chin. This shot exposes the character's emotions. Reserve it for dramatic moments.

✦ **Extreme close-up (ECU):** Use this shot for a very tight face shot or isolated details, such as a person's eyes widening in fear. This shot is at the edge of the lens's capability to focus. Use the ECU for objects more often than characters.

Figure 15-1 is made up of ten stills that are named according to the type of shot shown. These names indicate the proximity of the lens to the subject (the person, item, or event being recorded).

Selecting the length of shot

Even though you can use your camcorder to establish environment, bring a character closer to the viewer, or show movement, you need to use good judgment in selecting the correct mixture of shots. The following are two of the main reasons for changing the perspective of a shot:

✦ **Storytelling:** The viewer needs to know relationships as well as details. A wide-angle shot establishes the place and the proximity of other characters. A close-up provides necessary visual details, such as a raised eyebrow, a shaking hand, or a flashing smile. Changes of perspective are often as important to a story as spoken words.

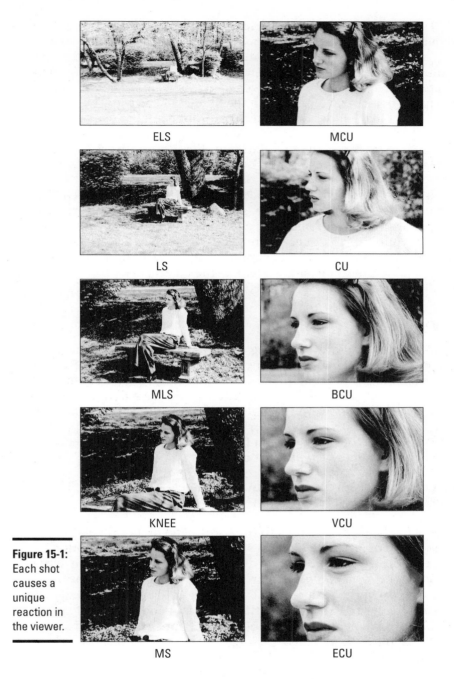

Figure 15-1: Each shot causes a unique reaction in the viewer.

ELS

MCU

LS

CU

MLS

BCU

KNEE

VCU

MS

ECU

✦ **Editing:** Changes of perspective are essential to good editing. Transitions are much easier to edit when the character's perspective changes. A good filmmaker provides the editor (even when the two are the same person) with both wide-angle shots and close-ups of the same sequence; this enables the editor to decide when to use the wide shot or the close-up. For example, in an infomercial, the spokesperson talks about the importance of a product's new features. If you have a wide-angle shot of the narrator talking about the feature and close-ups showing the feature's details, you can edit the segment from the wide shot to the close-up as necessary, to allow the viewer to visually comprehend the significance of the feature.

Be sure to use the right shot at the right moment; otherwise, you may misinform your viewers or make them uncomfortable. At the opening of a scene, the viewer wants to know where the action is taking place. A close-up would not communicate the setting to the viewer. In a scene with an intimate conversation between characters, the viewer wants to be up close, with alternating close-ups of one character and then the other. Using a wide-angle shot makes the viewer feel left out or like an eavesdropper. But in conversations that aren't intimate, say, between two businesspeople, the viewer likes alternating medium close-ups of the two. Extreme close-ups in this situation make the viewer uncomfortable.

Off-camera action is something that occurs outside the viewing area that is brought to the attention of the viewer. You want to use dramatic action off-camera (such as a foot snapping a twig when the subject is sitting alone by a campfire) if your intent is to create tension. Off-camera action needs to be used carefully. Off-camera action is counterproductive if the viewer needs the action to understand the story (such as the emergence of the twig snapper from the edge of the woods).

Using focus as a technique

You may have noticed that while using your camcorder, you use the focus mechanism on your lens more than any other camcorder feature. Focusing is about the most basic function that is performed by your camcorder (either automatically or manually). With just a little knowledge and practice, you can turn focusing into a powerful technique for getting the most out of every shot. The first thing that you should practice is controlling the depth of focus (the amount of focused space in front and behind your subject). You adjust the f-stop to achieve depth of focus.

Aperture equals focal length divided by the diameter of your lens. The setting of the aperture is referred to as the *f-stop*.

The depth of focus directly relates to the f-stop. The higher the f-stop, the greater the depth of focus. At higher f-stops, therefore, the perception of being in focus exists for a substantial distance on either side of the actual plane of focus (the *focal plane*). By perception of focus, I mean that only a very thin plane is ever actually in focus. The larger the depth of focus, the more the objects in front and behind the focal plane look like they are in focus. Higher f-stops mean that more of the shot appears to be in focus, but the shot also requires more light.

The opposite is true for depth of focus at lower f-stops. The lower the f-stop, the lower (or shallower) the depth of focus. This means that at lower f-stops, the perception of a shot being in focus is nearly nonexistent on either side of the focal plane. A typical situation in which you use a lower f-stop (for a shallower depth of focus) is when you want to blur out a background for some reason. Using lower f-stops requires less light for the shot.

Take a look at Figure 15-2, which shows two stills. The still on the left was shot at f/11. The still on the right was shot at f/2.8. In the left still, objects in the background are in focus. In the right still, the background is blurred and rendered irrelevant.

Figure 15-2:
An image with large depth of focus (left) versus an image with short depth of focus (right).

Setting camera height

You can also use the *vertical angle* of a shot to influence a viewer's perception of a character. Take a look at the three stills in Figure 15-3. The first still illustrates the use of a *neutral camera height,* in which the camera's lens is set at chest to eye height. Such shots are objective, that is, they don't influence a viewer's perception of the subject.

In the second shot, the camera height is set above the character's eye height. This angle, which looks down at the character, generally suggests inferiority, weakness, or submission of the character to the viewer or to other characters in the video.

In the third shot, the camera height is set waist-high to the character, which is a subjective shot. This shot suggests strength and dominance of the character over the viewer or over other characters in the video. In *Citizen Kane,* the main character was often shot this way. Orson Welles intentionally did this to establish superiority. The setting of camera height as I've described here applies to a stationary camera.

Moving the camera

You can create energy in an otherwise static shot simply by moving your camera. As with the various perspective shots, videographers bestow specific names on each of these camera movements.

Panning and tilting

Panning and tilting are performed with a camcorder that's resting on the head of a tripod. I further discuss each of these concepts in Chapter 5 of Book II.

Panning is moving the camera from left to right. The two basic kinds of panning are *following pan* and *surveying pan.* In the following pan, the camera operator pans (moves the camera left or right) to follow a character, for example, from one spot to another. The surveying pan is used to locate a character or an object, for example, a character searching for and finding another character on a crowded street.

Figure 15-3:
Camera
height
places the
viewer in a
subjective
relationship
with the
character
in a shot.

Tilting is moving it up and down on the tripod's head. Tilting is often done simply as a matter of course, such as tilting down to follow an action. However, you can also tilt to achieve a particular effect, such as tilting up or down to denote height or depth. The classic tilt is when someone shoots video at the base of a tall building and moves the camera by tilting up to establish that the building is tall.

Craning, dollying, and trucking

In addition to moving the camera from side to side or up and down, you can create even greater dynamic energy by moving the camera over, into, out of, or across the scene. Although moving the camera over a scene, called *craning,* may be too elaborate for your purposes, at least you now know the term if and when you hear it. The other two movements — dollying and trucking — are quite easy and effective.

Dollying refers to moving the camera forward or backward in a scene (see Figure 15-4). Although, at first glance, dollying may seem similar to zooming, the two are used differently. You dolly by moving the camera forward (toward the subject) or backward (away from the subject), whereas you zoom in and out by adjusting the lens. Dollying changes the relationship of the character to his surroundings. When you dolly in, you isolate the character from everything on the left or right. When you dolly out, you introduce the character to her surroundings. Zooming doesn't give the effect of deleting or adding surroundings. Zooming just includes more or fewer details in the picture.

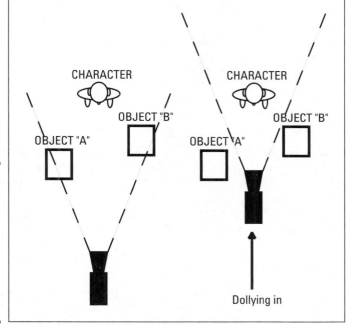

Figure 15-4: When a camera dollies, the relationship between the surroundings and the character changes.

Dollying causes the relationship between the character and the overall scene to change. Generally, you must adjust the focus and tilt the camera while you dolly because you are changing the focal depth by moving the camera toward or away from the subject. Foreground objects disappear or appear as the camera moves in or out. Zooming, on the other hand, does not change the spatial relationship between the character and the scene.

Trucking refers to moving the camera to the left or right in relationship to a scene, as shown in Figure 15-5. When you truck your camcorder, you change the character's background. This movement makes a dull scene interesting.

Trucking is used a lot in commercials where the character stands still, telling you the importance of a product. The camera trucks (moves right or left), keeping the character in the center — the background moves while the character remains stationary. Trucking keeps the viewer visually engaged.

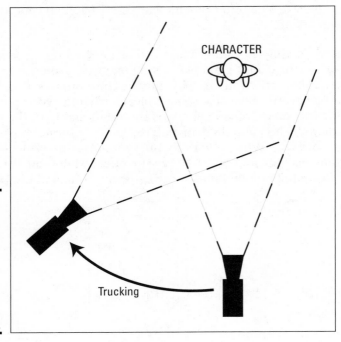

CHARACTER

Trucking

Figure 15-5:
Trucking provides a dynamic effect: As the camera moves, the background changes.

Although trucking can make a scene interesting, it can also cause major changes to the lighting of a character. Sometimes these changes are detrimental, especially when filming indoors. Lighting is usually set based on camera position. To properly light a trucking move, you need to set lights for both ends of the trucking movement. If you don't have enough lights, you may want to reconsider your trucking move.

Composing the picture

One of the fundamental requirements in shooting stimulating video is composing your picture, which is preparing the environment where the shooting takes place. For example, assume that you're shooting on location at someone's office. You can either make the picture look humdrum (like the workday world) or make it look special. You make the normal special by composing a picture.

Consider the following points when preparing the environment:

✦ **Shoot for light.** Lighting has the most obvious impact on the quality of your shot, specifically the location and intensity of the light in relationship to your character. Whether natural or artificial, the light should give primary significance to your character's face and secondary significance to the scene. If you can't get the sun to cooperate, close the blinds and use artificial light. Don't forget to white-balance your camcorder!

✦ **Position the character.** Set the character, sitting or standing, in a digni-
fied manner and location. For example, if the character is sitting, secure
a posture for the character that is neither stiff nor sloppy. Avoid embar-
rassing the character by paying attention to how his or her lap is posi-
tioned. Also, *always* check the background. Don't place the character in
front of something that inadvertently looks comical. For example, don't
let the character sit so that horizontal bookshelves seem to be sprout-
ing out of his or her ears. (This may seem silly, but it's a real problem.)
Believe me, many problems of this kind are avoidable; you simply have
to be attentive to your shooting environment and use good judgment to
prevent them.

✦ **Dress the shot.** This takes only a moment, but in the rush of the moment,
you may forget or ignore details of the shot. Not only does this step
help ensure a good shot, but it's also an act of kindness to your charac-
ter. For example, if a desk is in the shot, clean the desk and make it look
"professional" (unless, of course, a messy desk is important to the scene).
Avoid ultra-white or shiny objects in the foreground. Ask the character
whether he or she wants family photos in the shot. Also, if possible, dress
up the background with a vase of flowers or a book arrangement —
anything to avoid a flat background. If you brought along a light kit, throw
a colored slash of light across the background (but only after you white-
balance). If the person is wearing glasses, be sure to check that the
glasses don't cause a reflection of the light. Be aware, however, that a
lot of people don't like to take off their glasses for a video shot.

I further discuss composition in Book II, Chapter 5.

Framing the shot

Framing the shot is simply a matter of placing the subject properly in the
picture. You don't have much to remember to frame a shot correctly. Keep
these three things in mind when framing: safety margins, offset versus sym-
metrical, and proper headroom.

Safety margins

Safety margins are two imaginary rectangles on the outer edges of your pic-
ture, as shown in Figure 15-6. Some camcorders actually show these rectan-
gles in their viewfinders. The *outer rectangle* warns you that any images or
characters outside the rectangle's boundaries may not appear on some
monitors. Obviously, vital parts of a scene, including titles and credits, must
be kept inside the outer rectangle. The inner rectangle is the safe area.
Within this rectangle, you can safely add images or characters at any time
during the editing process.

Be sure to keep safety margins in mind while shooting. You don't want to
use a shot that's too tight, thereby creating the risk of an editor later put-
ting images or characters on someone's chin or neck rather than across his
or her chest. Although you may not have safety margins in your camcorder's
viewfinder, you can teach yourself to remember where they are.

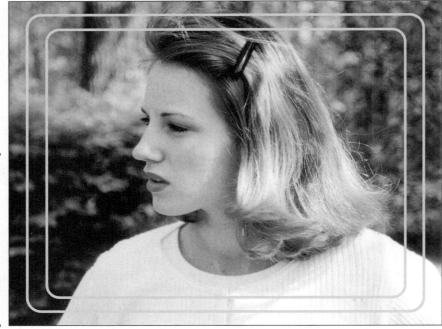

Figure 15-6:
Safety margins around the shot help you ensure that nothing important is cut off at the edge of the screen.

Offset versus symmetrical

One of the simplest things that you can do to add appeal to a shot is to *offset the frame* — that is, center the character on the third of the frame that is opposite the direction that he or she is facing, as shown in Figure 15-7. For example, if the character's shoulders are turned toward the viewer's right, frame the character on the viewer's left. If the character's shoulders are turned toward the viewer's left, frame the character on the viewer's right. If the character's shoulders are square with the camera, use symmetry by centering the character in the screen.

But just how far offset should the subject be? Imagine for a moment that the video you see in your viewfinder is divided into thirds vertically and horizontally. Envision a grid that's similar to a tic-tac-toe board, where the screen area is divided into nine blocks. This is called the *Rule of Nines,* and you can fill the blocks of this imaginary grid to determine where your subjects should be offset.

Proper headroom

Establishing proper headroom is one of the simplest techniques to understand, and after you know the basic idea, you'll set proper headroom without thinking about it. Simply remember that a person should not look as though he or she has slipped toward the bottom of the screen (too much headroom). Also, a person shouldn't appear crowded into the frame as though his or her head might scrape the top of the screen (too little headroom).

After you start practicing these techniques, you'll probably like the look that you achieve. They are especially helpful if you plan to layer text later on to allow room. Figure 15-7 illustrates the use of offset framing with a graphic added later in the editing process.

Figure 15-7: Offset framing of your subject makes it easy to add a graphic during editing.

Preproducing Your Digital Video

Preproduction refers to the planning and implementation of the many details that can help you produce a successful video. You may find it odd that I bring up the matter of *preproducing* your video *after* telling you how to shoot it. But trust me, this order is logical. Why? Because of the language. For you to pre-produce your video, first you need to understand some of the technical vocabulary of creating video. If you haven't read the section "Preparing to Shoot Digital Video," earlier in this chapter, put a pencil in the margin right here, read through that material, and then come back to this section.

Preproducing a video is literally sitting down and writing out the details of how scenes will look and what people will say in those scenes. The three main elements of preproduction are as follows:

✦ **Storyboarding:** The process of brainstorming an idea into existence.

✦ **Scripting:** Deciding in advance what characters will say and what the camcorder will do in each scene — such as a wide-angle shot followed by a close-up.

✦ **Planning the shoot:** Putting all the necessary plans on paper so that when the time for shooting arrives, everything and everyone are prepared.

Storyboarding

Storyboarding is the process of planning each scene of your movie on paper (or poster board, chalkboard, or just about anything else you can write on). Most modern films are planned this way. An artist or producer sketches a picture of each scene, and then those scenes are laid out in order on a board or on paper. The crew consults the storyboard to see how each scene relates to the overall story.

565

If you're making a home movie of your family vacation or even a wedding, creating a storyboard may seem like overkill. Still, you may find it useful to sit down with pen and paper before filming and plan what you want to shoot. You don't even have to sketch drawings; just create a basic outline of the planned shoot.

In the preproduction stage, one of the most exciting parts of storyboarding is visualizing the finished product. In your mind's eye, you follow your character's action from scene to scene. You can almost hear the music playing and see the special graphics and animation that you will include during the editing process. Within all this excitement, though, you need to ask this question, "Does this storyboard realistically provide the editor (who just may be you) with enough video opportunities to get the job done?" What if a review of your footage during editing reveals that the shot you took didn't turn out very well? Going back and reconstructing the scene for another shot is difficult, if not impossible.

If anything, err toward excess. You may add 15 minutes or an hour to the shooting schedule by taking another shot from a different angle, but by doing so, you may save yourself a lot of time and headache in the postproduction stage.

So how do you do it? Create your storyboard as quickly and simply as possible. The storyboard is just a set of visual notes that you work from while you are filming your video.

Whatever you use to draw or sketch your storyboards, the storyboards should be drawn dark enough to be photocopied because you usually need more than one set. To create a storyboard, follow these steps:

1. **On individual sheets, draw the key events and the scene where the events will take place.**

 Don't worry about your artistic abilities (or lack thereof) as long as the drawing illustrates the most important elements of the scene.

2. **On each sheet, include some basic ideas of what is happening and what is being said.**

 Write notes and labels if necessary.

3. **Play with the order of the key events by moving them around and adding and deleting the sheets as needed, until you are satisfied with the order of the key events in the story line.**

4. **Name the scenes or segments of scenes for each of the key events.**

 Use the scene names to develop lists of the elements that need to be prepared prior to video shooting, such as costumes or props.

Scripting

Scripting is a textual plan of all that will be said and performed in a scene. A shooting script usually includes camera instructions, locations in the scene for sound effects, and general instructions to the editor for editing. For people like myself, scripting is as much fun as the actual filming. For

other people, just using a word processor is nearly impossible — let alone writing creatively. I don't claim that writing a script is easy, but I quake to think what may happen in some videos without one.

To understand how a script can help you, you first need to distinguish between the following two approaches to scriptwriting:

✦ **Subjective:** Subjective scripting is storytelling. (See Figure 15-8 for an example of a subjective script.) The subjective script depends largely on video to establish the environment. (Note the video instructions in the left column in Figure 15-8.) Subjective scripting has characters, a plot, and some kind of dramatic development. In a video where you're primarily communicating a feeling (such as a music video), you present a combination of movements and sounds to elicit an emotional response in your viewer.

VISUAL	AUDIO
(Scene opens. Camera LS. Martha is seated on the left side of her bed. Bed is frame right. She is in her bathrobe. Her long hair is for the first time untied and lying across her shoulders, slightly unkempt. She is staring camera left at nothing.)	
	(The night table telephone rings.)
(Martha reacts with a start.)	
(Camera MCU. Martha stares down left at the phone.)	
(Camera BCU on phone.)	*(Second ring.)* *(Third ring.)*
(Camera VCU on Martha. The look of worry belies her temptation not to pick up the phone.)	*(Fourth ring interrupted by Martha grabbing the phone from the receiver. Martha speaks softly, barely above a whisper.)*
(Camera MS on Martha and phone. She suddenly reaches out and snatches it up mid-ring.)	*MARTHA: HELLO.* *(Pause. Soft unintelligible voice on phone.)*
(Martha looks down left again.)	*MARTHA: YES, YES IT IS . . . THIS IS SHE.*
(Camera VCU on photograph by the phone. The photo is obviously an old one of a much younger Martha and a much slimmer George.)	*(More soft unintelligible voice on phone.)* *(Music softly fades in - the Scene One wedding reception ballad. This time it has an echoish cast. Behind the music, the sound of laughter.)*
(Tracking left, Camera frame right CU on Martha, still looking down at picture. Tears are forming.)	*MARTHA: DID YOU . . . DID YOU . . . FIND HIM?*

Figure 15-8: In this example, the story-teller leads the audience through the experience.

✦ **Objective:** Objective scripting is goal-oriented information or instructions (see Figure 15-9). You want to influence or train your viewer to do or believe what you're presenting. Objective scripts are need-oriented: They exist to resolve a problem or to influence the viewer to agree with you or to buy something.

Subjective scripts are much more complicated than objective scripts. Conversely, objective scripts are subject to a tough test — namely, the success or failure of achieving the objective.

Planning the shoot

After you develop your storyboard and script (if your story is complicated or involves a lot of speaking), you're ready to plan the shoot. You need to assign camera instructions, such as shots and close-ups for the various key events. Of course, you may modify your plans when the time comes to do the actual shooting. But to prevent chaos during shooting, you're wise to have a shooting plan. And be sure that you plan more than enough shots for each key event.

One of the most important steps in preproduction is planning your shooting order. *Shooting order* refers to a chronological list of the segments to be shot. By the way, you don't necessarily want to shoot your video in the order of the plot. Doing so can be a waste of time and resources.

Figure 15-9: The writer of the objective script must equip the viewer with enough information to make a decision or to perform a function.

VISUAL	AUDIO
(Camera LS on ACME 200HP riding lawn mower. Mower is frame center, visibly rumbling in neutral. Behind the mower is wide swath of mown lawn, smoke still rising from the turf.)	*(Trainer's voice off camera.)* TRAINER: CAUTION MUST BE USED WHEN APPROACHING THE ACME 200HP LAWN MOWER WHEN IT IS IDLING IN NEUTRAL.
(Surveying pan right to trainer. She is wearing the required flame retardent jump suit and approved safety helmet as described in previous scene.)	TRAINER: IF YOU FOLLOW THESE SIMPLE INSTRUCTIONS, YOU WILL HAVE NO PROBLEM MOUNTING THE UNIT AND PLACING IT BACK IN GEAR.
(Following pan of trainer to mower. Camera MLS. She stops camera right of mowing unit.)	TRAINER: AS I MENTIONED EARLIER, STEEL-TOED SHOES ARE REQUIRED WHEN RIDING THE ACME 200HP RIDING MOWER. THIS IS PARTICULARLY IMPORTANT WHEN APPROACHING THE MOWING UNIT, EVEN IN THE NEUTRAL, UNENGAGED MODE.
(Postproduction. Add dotted line to indicate edge of safety area.)	

Chapter 16: Digital Video Production Tips

In This Chapter

✓ Producing quality digital video on location

✓ Making your shooting decisions with editing in mind

✓ Creating a two-camera look with one camera

✓ Working with people

One of my favorite moments in creating a video is the deep feeling of satisfaction I get at the end of a good day of shooting. Using a day productively and safely to tuck away video clips for later editing are my basic goals — and some days you accomplish these things, while other days don't quite measure up.

What makes some video projects go well and others poorly? What can you do to ensure success? What problems lurk out there just waiting to grab you when you least suspect them? Answers to these questions aren't always easy or foolproof, and nothing about creating quality video is inherently easy. But you can have a satisfying experience. A large part of the enjoyment you derive from successful video cinematography comes from preventing, facing, and overcoming obstacles.

The breakthrough technology of digital video provides you with the opportunity to produce professional-quality video. The emphasis here is on the word *opportunity*. You can make beautiful video. Digital video provides you this opportunity, but you still have to do the work. This chapter is filled with advice for creating a successful video. Some of my suggestions are always true in every kind of project. Others are the good-to-know variety for those times when you face special challenges.

Planning for Success and Preparing for Survival On Location

I tend to be overly optimistic. Life's more fun that way — you know, thinking that I'm just one light lunch away from losing those extra pounds. Optimists like me have to work hard at being realists. The same is true in creating a video. Optimism is great. Preparing for the unforeseen is even better. By knowing and doing certain things, you and others will enjoy the results of your efforts.

You don't have to go far to be on location. It may simply be an office on another floor of the building you're already in. Or it may be out in the parking lot. And, of course, it can be on someone else's property. So what is the

difficulty of shooting on location? When you're on location, you're on someone else's turf, subject to someone else's schedule, and using someone else's resources to get your job done. These variables can often prevent you from getting your job done to your satisfaction.

Dangers of on-location filming

On-location shooting is tough — especially on your equipment. Lenses can be ruined from exposure to the sun and camcorders damaged when they are dropped while working in rough terrain. Accidents like these often happen to responsible people making careless mistakes.

Protecting equipment

Of course, sometimes you can't avoid shooting video in places where equipment can be damaged or lost. But you can increase the survival rate of your equipment by insisting that you and others develop some simple habits.

The number one culprit of on-location shooting is grime, so make sure that you do the following:

✦ Protect your equipment to and from a shoot by keeping the equipment in cases.

✦ Keep plastic covering available for protection against windblown debris.

✦ Carry a lens cleaning cloth for your lens and canned air (available at electronics stores) for blowing dust off your equipment.

✦ Always wipe your equipment at the conclusion of a shoot. If you have used electrical wiring, take special care to remove grime before storing the wiring with your other equipment.

The number two culprit is theft. I've been victimized a number of times, so I know how it feels. A friend of mine had a very expensive camcorder stolen from the lobby of a hotel. The camcorder was at his side on the floor — and then it was gone! Expensive toys attract attention. Don't ever leave your equipment unguarded — even in seemingly safe locations.

Knowing your legal and safety limitations

Shooting on location is supposed to be fun and interesting. To keep it enjoyable, I suggest refraining from doing things that may put you in jeopardy. Here are a couple of basic rules about using a camcorder on someone else's turf:

✔ **Don't take your camcorder anywhere you have to hide it to get it in.** For example, don't take your camcorder where signs are posted forbidding the use of cameras and recording devices, such as inside art museums or at concerts. You risk the possibility of your equipment being confiscated or worse.

✔ **Don't record people on your camcorder without their permission.** People can get very upset about this — even to the point of wanting to punch you in the nose. As a basic courtesy, I always ask for permission before I record.

Be aware that your gear is not the only target — purses and bags are targets, too.

The third culprit is breakage. Breakage happens two ways. The most obvious way is by dropping equipment. But, more often, breakage happens when untrained people use equipment. Very few pieces of equipment can withstand forceful abuse. The most common damage occurs when people try to force a piece of equipment to do something that it's not meant to do.

Be sure to follow these two basic rules:

✦ If you don't know how to use the equipment, ask.

✦ If the equipment doesn't want to do what you're attempting to do, stop. You're probably doing something wrong.

Effects of weather

Weather and temperature can drastically affect video equipment. Simple things can cause big problems. For example, taking a camcorder from a warm environment to a cold one can cause condensation within the equipment — rendering the camcorder unusable for an hour or two. Leaving equipment in the cold can be a problem, too. For example, if you have a fluid-damped tripod, the fluid can become thick in cold temperatures, which can make the tripod unusable until it's warmed.

Here are some suggestions for dealing with weather:

✦ Don't take electronic equipment from hot to cold environments (or vice versa) without allowing time for the temperature of the equipment to adjust.

✦ Don't leave equipment in your car (including the trunk) overnight in cold climates.

✦ Avoid exposing your equipment to extreme heat.

✦ Avoid using your equipment in extremely high humidity.

Power

Electrical demands on location are always more complicated than shooting in a studio. The problem is not so much your camcorder, which actually draws a low amount of current, but lighting and other items that use a lot of power. To avoid power catastrophes, keep the following points in mind:

✦ **AC outlets:** When using electricity on location, always, always, always ask for permission before plugging in. I have witnessed two occasions when people's computers went down while I was plugged into their electrical outlets. In both instances, they immediately blamed me for the outage and lost files! Imagine that. Come to think of it, remind computer users in the building to save their work before you plug in, just in case.

✦ **Circuit breakers:** If you plan to use lighting on location, always be prepared to restore a tripped circuit breaker. Find out where the electrical panel is located and, if possible, identify the circuit you'll use. Again, ask

whether you may use the circuit and explain that you might possibly cause an outage. And if you're using your own lighting, avoid doing anything that could cause burns to people or equipment.

✦ **Batteries:** Using batteries on location can be a shocking experience. Not literally, but almost. The typical problem with batteries is that they run out of power. Many batteries take longer to charge than they do to expend. Bottom line — have two hours of charged batteries for every hour you plan to shoot. And if you expect a lot of shooting time, recharge the batteries on location if possible.

If you plan to take your camcorder out of the country, find out in advance what kind of converter you'll need for running your equipment and for recharging your batteries.

Shipping and travel

Shipping video equipment can cause you anguish because you must trust your equipment to people who have no idea what they're handling. Unless your camcorder case is designed for shipping, be sure to take extra precautions when shipping your camcorder. An inexpensive way to ship your camcorder is to wrap it in oodles of bubble packing and put it in oversized boxes. Even so, insure your shipment for its total value. If you're taking your camcorder on a plane, you may want to put the case in cargo but carry the camcorder on the plane.

If you plan to take your camcorder across international borders, beware! You may not be allowed to take it from one country to another without prior arrangement. I was once prohibited from taking a camcorder into Canada! Before leaving the country, contact your local customs service office a few weeks in advance to find out what you might have to do to take your camera across international borders.

Types of on-location shoots

You typically engage in four kinds of on-location shooting (all these terms are coined by yours truly, but methinks they'll do fine for the purposes of this little discussion):

✦ Spontaneous

✦ Event style

✦ Formal events

✦ Made-for-video creation

Spontaneous

Spontaneous shooting is the simplest and chanciest form of on-location shooting. As the name implies, you turn on your camcorder, point, and shoot. In spontaneous shooting, you have little or no way of predicting how your camera's settings and capabilities will match up with the challenges of the circumstances or the environment. Most people with camcorders are experts at spontaneous shooting because that's all they ever do.

Of course, you can do a few basic things to make your spontaneous shoots more effective. If possible, take a few seconds before pressing the record button to look through the viewfinder and check the lighting and background. If you're shooting a dolphin show at the local aquarium, you may not have any control over the lighting and background, but in other situations, you might be able to reposition your subject for better lighting, or pick up that clutter sitting in the background.

Event style

Event style shooting is different from spontaneous shooting in subtle but significant ways. Like spontaneous shooting, event style allows you little or no control of the environment. But in event style shooting, you can manipulate some of the circumstances.

Book II
Chapter 16

Digital Video
Production Tips

Say that you're asked to videotape a high school football game. Being the "official" videographer gives you license to go places and do things others might not have the freedom to do or explore. Although you have no control over time and events, you do have control over the circumstances.

For example, because you are the videographer, you ask to attend the afternoon pep rally to get some introductory shots for the video. At the rally, you decide to sit across the gym from the students, where you can use your zoom to capture groups of students as they do the berserk things teenagers do at pep rallies.

You could also arrive early to the game and explain to one of the coaches that you're shooting a video for the parents' club. Ask whether you can move about the sidelines during the game. Again, you're controlling the circumstances, as follows:

✦ You make conscious decisions about the location of the camera.

✦ You position yourself early to wait for shot opportunities.

✦ You ensure that your settings are correct.

✦ You wear headphones to hear the events as they unfold because after the game starts, the crowd noise makes it difficult to know whether you're recording the sounds of the game or not.

In an event style shoot, you have numerous, seemingly unrelated ways to control what is being recorded on tape. You can't tell people what they should wear, and you aren't able to control the elements of the environment, such as the weather or time of day. But you do have some control over the subject matter (such as going to the pep rally) and the circumstances (such as selecting where you stand at the rally and the game). Your chances for getting good footage are better with event style shootings than with spontaneous shootings.

Formal events

When shooting formal events, such as weddings and lectures, you have some control over the environment as well as the circumstances. The distinguishing factor of a formal event is that you're expected to provide a relatively

high-quality finished product. You may be doing this for free — for example, for relatives or your church. Or you may be shooting the formal event as an employee or a freelance videographer. Whether you're working for free or for hire, it doesn't matter. You have a customer, and the customer is expecting the video. Though the expectations are higher in formal events, so are the opportunities to deliver a quality video.

In formal events, your customer usually allows you to prepare for the event. Quite often, the customer even allows you to alter event planning in some little ways to accommodate your shooting needs. Prior to a formal event, you usually do the following:

✦ Negotiate with the customer about the location and operation of your video and sound equipment.

✦ Resolve your electrical needs (especially if you're planning to provide lights).

✦ Plan a list of shots with the customer.

Formal events are often more controllable than spontaneous and event style videos. Though the action is unstoppable and occurs for reasons totally unrelated to your project's needs, you still have some leverage in planning the environment and the circumstances.

A simple example of environmental control occurs at a lecture. For example, the lecturer (your *customer*) stands in front of a live audience and makes a PowerPoint presentation by using a projector and a screen. Normally, the lecturer will want to lower the room lights to enhance the image on the screen. You will need to do some advance negotiation with the lecturer and figure out a lighting compromise that's best for the screen and the camcorder.

Made-for-video creation

The fourth type of on-location shooting is a made-for-video creation. In this scenario, you're shooting events that wouldn't be occurring if you weren't holding a camcorder and recording it all. For instance, if you want to shoot a science fiction epic or a dramatic masterpiece starring kids from around the neighborhood, you're producing a made-for-video creation. When shooting a video like this, you have the greatest opportunity for producing quality video because you have ultimate control of

✦ Costumes worn by the cast

✦ Set design and background

✦ Camera positioning

✦ Lighting

Of course, there is no such thing as *unlimited* control. The weather may turn bad, your cast may become unhappy, and budgetary constraints can get in the way of your creative vision.

Using Time to Your Advantage

Time is the single most precious resource in creating a video and the hardest to control. So time management is important in order to strike a balance between the amount of time you need and want and the amount of time you actually have.

When all the dust has cleared, the failure or success of your project's time management efforts hinges on whether you created appropriate and sufficient materials for editing. During editing, your video is cropped, embellished, and assembled into a coherent and useful message. But if you left something out or created confusing unrelated video clips, your video will suffer, and you'll add many unpleasant hours to the editing process.

Following are some hints for making your editor (even if that editor will eventually be you) a grateful fan and not causing him or her an appreciable loss or graying of hair.

Logging your shots

I'm sure at one time or another you've seen a re-enactment of a film or video shoot in which someone holds up a strange looking board with a little board on top of it that says something such as "Scene 14, shot 7, take one. Action." Then the person slams down the little board, making a large clacking sound. What was that person doing? Sending a message to the editor using a take board.

Take a look at Figure 16-1, which illustrates what's often referred to as a *take board.* Though it may look different from one video to the next, the take board usually includes the name of the video, the date, the scene number, and the take number. The term *scene* refers to a series of shots that, when edited, complete a dramatic action or a portion of a message, such as the famous shower scene in Alfred Hitchcock's movie *Psycho.*

Figure 16-1: The take board provides all the information the editor needs to identify a given segment of a scene.

A *shot* is a specific segment of a scene. A *take* is a taping of one of the shots in that segment. Frequently, even in simple videos, a shot is taped many times because a word is misstated by the speaker, the camera is out of focus, a noise occurs on the set, and so on. The tape board is clacked to create a sound that's easy for the editor to hear later while he or she shuttles the video back and forth. While editing, the editor hears the clack and realizes the take has begun. She stops the tape, backs it up, or goes forward until she can read the message on the take board. The take board is only one-fourth of the conventional record-keeping process.

The other three parts are

✦ **The script:** The actual plan of the video, including descriptions of action, camera instructions, instructions to the actors, and any dialogue in the scene.

✦ **The time code:** A particular kind of identifying information recorded by the camcorder onto the videotape. The time code makes frame-accurate editing possible. It is the frame-by-frame permanent identification of the video information on the tape. You can usually see the current time code in the camcorder's viewfinder.

✦ **The log:** Someone logs information about each take, as shown in Figure 16-2. If you have comments about a specific take or scene, this is where you record them. For example, if you have taken several different shots of your child posing in front of trees in the neighborhood park, keeping a log of where you shot the film helps you later when you find that the light wasn't right at that time of day, but the location was perfect. The log provides the perfect way to remember.

DATE: 5/19/99

LOCATION:

TAPE	SCENE	SHOT	TAKE	COMMENT
001	02	4	1	Bad focus
"	"	"	2	Stumbled words
"	"	"	3	Good !!
"	02	5	1	Good !!
002	02	5	2	Confidence Shot (use #1)
"	"	6	1	Sound of airplane
"	"	"	2	Good !!

Figure 16-2: The log always contains details about the segment.

Figure 16-2 shows the number of the scene and take, and information about the take. By keeping an accurate log during shooting, you ensure that all the planned shots have been taped and that you've written all the information the editor will need to find the good footage. One of the important functions of logging details is to ensure continuity.

Continuity

One time-consuming problem editors face is reconciling missing or visually unrelated sequences. Figure 16-3 illustrates a common mistake. Say that in one of your scenes, the presenter points to an object, requiring a close-up. After pointing, the presenter goes on with the narration. According to the script, you need to shoot a close-up of that object. You do the wide shot showing the presenter and the object, and then reposition the camera to set up for the close-up. While shooting the close-up of the object, you have the presenter's hand come into the picture and out again. Later on, the editor puts the wide shot of the pointing hand and the close-up of the pointing hand together — only to discover that the hand in the wide shot is the left hand and the hand in the close-up is the right hand.

Aaargh! This little situation is called a *break in continuity*. Basically you have the following two options to fix it:

✦ Assemble the movie without correcting the break in continuity and hope that your audience doesn't notice.

✦ Go back and reshoot the scene.

Neither of these options is very desirable, and reshooting the scene will waste a lot of time. It could even result in further continuity breaks if something about the original shooting location has changed since your first shoot.

The very *best* solution is to maintain continuity in the first place. Pay attention to even the minor details of your shot and don't be afraid to shoot extra takes if those details aren't exactly right.

Creating editing options

One of the simplest ways to cover yourself in the event of unnoticed goofs (and you will have many) is to give your editor lots of alternatives.

Here are a couple of tips that will help you avoid video goofs:

✦ **When a person is looking directly into the camera:** What do you do if you discover while editing that you need to take something out of the speech? A straight cut of video footage will look apparent and bad. You can anticipate this problem and give yourself more editing options by shooting the speech twice from different angles or zoom perspectives. Then, if some of the speech must be cut, the editor can switch between takes at the editing point. To the viewer, this will look like a simple changing of camera angles, similar to what you often see during the evening news on TV.

Figure 16-3:
The middle image (the close-up shot) isn't continuous with the preceding shot because the person has switched pointing hands.

✦ **When a person is looking directly at someone off camera:** Imagine that you're shooting an ordinary interview in which the interviewer is sitting off camera and directly next to it. The person on camera isn't looking into the lens, but is looking directly at the interviewer. This may be disorienting to the audience unless you also record some *reaction shots* of the interviewer. After the interview, shoot the interviewer asking questions, nodding, shaking his or her head, or otherwise reacting to things the interviewee said during the interview. The editor can splice these reaction shots periodically with the video of the interviewee so that it looks like there were two cameras in the room during the interview, and the video simply switches back and forth between the cameras as questions are asked and answered.

Record a long track of some *ambient sound.* Ambient sound is silence in the environment where you're shooting. Silence is very different from one location to the next. For example, ambient sound at a computer workstation is filled with the sound of the computer's fan motor. Outdoor ambient sound may include as background the sound of cars on a nearby street. An editor needs a continuous track of ambient sound to play in the background of the interview to cover up the inconsistent, broken ambient sound that will occur as the editor splices interview and reaction shots. Don't forget to note ambient sound in your log.

Working with People On and Off Camera

Creating a video on location can involve as few as one crew member (that would be you) or as many as a dozen or so. But no matter the number, if you have a crew at all, two of the most important principles of successful on-location shooting are knowing that the director is the boss and that the director allows the crew members to do their jobs. In order for a crew to work efficiently, everyone should be clear about his or her role.

The following section provides descriptions of crew roles. These roles are not necessarily held by one person. And one person can have more than one role. The director needs to make sure that people understand their roles.

Take a few minutes to indoctrinate whomever you enlist for your video crew on the finer points of moviemaking, and provide some do's and don'ts to follow while they're on the set. Helpers should be trained on any equipment they're going to use, and they should know where they can (and cannot) stand to avoid showing up in the picture. Anyone who is holding a microphone must be told that little hand movements may cause loud thumps and other noise; anyone who is holding a light reflector should be reminded to sit still, lest strange shadows pan wildly back and forth on the scene, and be sure to remind *all* helpers that silence is golden. A camera lens may be limited to a specific field of vision, but a microphone isn't.

Roles that people play

First, an important clarification: A video shoot is not a democracy. Clear-cut roles are as essential in video as they are on a football team or in an army platoon. Second, pecking orders don't exist in creating a video. There isn't a concept of greatest and least. Everyone simply has a job to do. Following is a formal description of roles. In real life, the interaction is probably much looser than I describe here.

Producer

The *producer* (probably you) is the person responsible for the overall completion of the project. Frequently, the producer gets involved before anyone else on the crew. The producer negotiates with the customer, sets the budget, signs the contracts (if this a commercial project), and stays involved with the project long after the crew dissolves. The producer also works with the editor, arranges for distribution, oversees general administration, and sees

the project to its conclusion. Additionally, if a representative of the customer is at the shoot, the producer is responsible for interacting with the customer and communicating concerns to the director.

On location, the producer does all that is necessary to keep the director focused on the video.

Director

The *director* is the leader and must understand everyone's role and guide the overall movement of the video. But even more important, the director is the person with the vision. The director knows what the project is supposed to be like and what it is intended to accomplish. The director's first and foremost job is to hold the vision together throughout the video. A good crew keeps the director focused on leading, not problem solving.

Customer/technical consultant

In some videos, especially training videos, the customer will provide a *technical consultant,* also known as a subject matter expert (SME). The SME is often ultimately responsible for the technical accuracy of what is said and done in front of the camera. The director and the producer frequently depend on the instructions of the SME, but the SME instructs the crew only at the request of the director and only in the specific instances where such action is needed. Otherwise, the video can become a chaotic mess. Also, the SME cannot appear on camera. If he or she does, you need another SME — because after a person appears on camera, you can't depend on his or her objectivity.

Subject matter experts are often present even in your spontaneous home videos. For example, if you're shooting a video of your infant granddaughter taking her first steps, her parents may be off camera giving you instructions on when to start recording. Or if you're filming your child's soccer game, the coach may be able to tell you what part of the field your child will be playing in most.

Videographer (camera operator)

In the world of television news, such people are called photographers. A good videographer is a humble but confident person. The videographer must follow the director's orders but must also be able to tell the director if there's a better way to do the job. Usually, directors and videographers develop close professional relationships and learn to read each other's subtle or implied meanings and moods. One important rule that's seldom, if ever, broken is that no one other than the director ever directs the videographer.

Sometimes the videographer, depending strictly on the preference of the director, is a kind of assistant director, giving instructions to the other crew members. A director may choose this route when he or she has to give full attention to the person in front of the camera.

Sound technician

Sound technicians have a bit of an odd role: They listen to the audio with earphones without actually watching the action that is being filmed. I've never been able to figure out whether they're sleeping or concentrating on the sound. Sound technicians keep their fingers poised on a field mixer, anticipating fluctuations of volume in order to maximize the recorder's dynamic range. The sound technician must call for a retake whenever an alien sound or a speaking glitch is heard through the earphones. The sound tech usually works with the videographer.

Gaffer

The *gaffer* is the crew member responsible for anything having to do with light and electricity. Typically, the gaffer works directly with the videographer in framing the shot and setting light levels.

Grip

On a small crew, a *grip* is primarily an assistant to the gaffer. The grip is responsible for setting up lighting for a shot. Normally, the grip also helps move the camera and tripod and any other gear.

Production assistant

The *production assistant,* affectionately referred to as the PA, is the do-everything-else person on the crew. Usually, PAs are the ones who keep the shooting log up-to-date and typically handle the take board. PAs also assist in moving equipment as needed. On your own crew, the PA might simply be one of your kids who keeps you supplied with Diet Coke. (Hey, this is important stuff!) One important note about PAs: They are usually eager to help — sometimes to a fault. Be sure that they know how to use the equipment before allowing them to handle it.

Professionals and amateurs

Two kinds of people appear on camera in videos: professionals and amateurs. Professionals have usually logged many hours in front of a camera. They are (usually) fun to direct because they (usually) know exactly how to do whatever you ask them. But, unfortunately, there's a cost for such skill. If you have something important to shoot and the video is message heavy, try to find the money to hire professionals. Because they are so good at what they do, you can cut your shooting time in half.

In videography, amateurs are not trained to speak or perform in front of a camera. Some amateurs are astonishingly effective — most aren't. The director's biggest job with amateurs is to set them at ease during filming. If an amateur is not nervous, he or she will usually look good in front of the camera. The viewers of video aren't turned off by people who lack beauty. They're turned off by people who act incompetently in front of the camera.

Choosing effective clothing

Whether you're making a video of a story filled with fictional characters or you're shooting your family's summer vacation, you should carefully consider what the people on camera are wearing. The following are a few basic tips for choosing effective clothing:

✦ Avoid dark clothing, particularly in dark rooms or locations. The audience will get a better view of subjects who wear light-colored clothing.

✦ Avoid patterned dresses that may blend into backgrounds.

✦ Avoid low necklines in close-ups because they make it look like the person isn't wearing anything at all.

✦ Avoid white and red clothing. White interferes with your *aperture* settings (the light that reaches the focal plane in your camcorder). Red duplicates poorly on film and in video and tends to bleed into adjacent, non-red portions of the video.

✦ Avoid tight stripes and herringbone patterns because camera and video player technologies can't handle these designs. The result on-screen is called *moiré* — an unpleasant wavy or shimmering effect on the fabric.

Book III

Digital Music

Book III: Digital Music

Chapter 1: Digital Music Hath Charms

In This Chapter

- Getting in touch with your inner music fan
- Exploring the seven wonders of the online music world
- Getting acquainted with the basics and background of music online
- Joining the pack of MP3 users
- Understanding the legalities (and illegalities) of MP3
- Finding the best MP3 files
- Playing MP3 files
- Creating MP3 files from your CDs, records, DVD players, TV, or movie soundtracks
- Making your own songs into MP3 files
- Turning MP3 songs into normal, audio CD songs

To understand the world of music online, you may want to think of it in terms of the growth of the World Wide Web. Before the Web, the Internet was just a bunch of scattered text and images that only academics, hardcore techies, and dogged research scientists really knew how to navigate. Then along came a snazzy little program called a *Web browser,* which provided a user-friendly, magazine-style way to travel across the Internet. Instead of looking at messy lines of disorganized text, *Web surfers* could zoom through a multimedia landscape of images, pictures, and, yes, sounds. The Net was no longer just a place to do research; it could entertain you. It was ready for music.

Ah, but the Web wasn't the only musical transformation to arrive with the Internet. Today's digital music aficionado needs a storage solution that can squeeze large digital audio files into one-tenth of their normal size. Enter MP3, one of the most familiar and popular data file formats ever introduced to the world's computer owners. You can record your MP3 files on an audio CD or jauntily transport them to your personal MP3 player — heck, you can even store them like other files on your computer's hard drive.

How can you join in on this musical revolution? Never fear, in this chapter, I show you the advantages of online music and MP3 digital audio, and how you can enjoy both with your computer.

The Art of Being a Music Fan

The best way to begin exploring music online is to think about how you operate offline. Whether you're aware of it or not, you probably have a pretty ritualized way of enjoying music. Almost everyone does. The better you understand your likes, dislikes, needs, and wants as a music fan offline, the better prepared you are to tackle the online world of music.

Take me, for example. I'm a typical music fan for a guy in his early 30s. Like most guys, I had a fairly intense obsession with my chosen rock gods, Styx and DEVO. Yes, I'm a little embarrassed to admit it, but back then my bedroom was plastered with, at highest count, 13 posters, and I had DEVO t-shirts, flowerpot hats, Styx birthday cakes, and even my own stylish black Velcro DEVO wallet.

Now, if I were a teenager in the year 2004, being an obsessive music fan would be much easier. Instead of schlepping out to the magazine store to rifle through racks of rock magazines, I could just search for *DEVO* on any Internet search engine, such as Yahoo! (www.yahoo.com) or Google (www.google.com). Instead of biking from record store to record store, I could surf shopping sites like Amazon.com (www.amazon.com) or Tower Records (www.towerrecords.com) for available Styx recordings.

Instead of rummaging through flea markets and music stores for the complete *Grand Illusions* songbook, I could just call up a site like the On-Line Guitar Archive (www.olga.net) and find all kinds of files to show me how to play just like Styx guitarist extraordinaire, Tommy Shaw. Well, almost like him anyway.

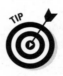

You can also find tablature for other instruments as well, such as drums, keyboards, and bass guitar. Just type in the kind of tablature you're looking for in your favorite search engine to see a list of tablature sites. By the way, in case you don't already know, *tablature* is simply a transcription of a certain instrument's part in a song. For example, a guitar tablature of a song tells you which chords to play and when to play them. Think sheet music.

If you can tap into the passion that got you interested in music in the first place, you can have all the more success and fulfillment when you venture out onto the Net.

The Seven Wonders of the Online Music World

For the sake of your day-to-day explorations, you're most likely to deal in one of these seven areas:

+ Audio
+ Video
+ Merchandise

✦ Radio

✦ Concerts

✦ News and information

✦ Community

Sounds kind of like the stuff you play around with offline, right? It is, and more.

Audio

Music isn't much without audio. It's like the sky without air, the sea without water, the . . . um, help me out here, will you? Despite all the trimmings that go along with music — shirts, posters, magazines, and so on — the most important thing is the sound.

To exist online, music audio — or any audio for that matter — must be in a form that you can access and listen to on your computer. And that form would be . . . digital, baby!

If you really want to know, *digital music* is nothing much more than *binary code,* which essentially means strings of 1s and 0s. When strung together in their own unique ways, the numbers can be decoded into, say, the love theme from *Titanic* or "Number of the Beast" by Iron Maiden — though, fortunately, never an accidental mix of the two.

For almost as long as people have been using computers, they've been coming up with different software programs that let you record and listen to music through these machines. You may have heard of *MIDI* or *WAV* files, which were among the first formats for digital audio.

These days, music online takes one of two audio formats:

✦ Streaming audio

✦ Nonstreaming audio

Streaming audio

Streaming audio does exactly that — it streams fluidly, and almost instantly, onto your computer. Click a button, and the music flows — that is, as soon as it can make its way over the often-congested Net wires and into your machine.

But you pay a price for the instant access. Streaming audio is not stored on your hard drive; instead, music plays from the *hosting site* — the Web site that stores the music file — and stops when the music's done. Basically, streaming audio is like a radio broadcast. You tune in and listen, and then the music fades away.

To listen to streaming audio — or any online audio, for that matter — you need to use special programs. Currently, the most popular program for streaming audio is RealPlayer from RealNetworks (`www.real.com`), which is available for both the PC and Macintosh. Microsoft Windows and the Mac OS also come with their own audio players that can handle streaming audio. On the PC side, you can use the Windows Media Player or Apple iTunes (shown in Figure 3-1); Mac owners can use either iTunes or the Apple QuickTime Player.

Nonstreaming audio

Nonstreaming audio does not play instantly on your computer, as streaming audio does. Instead, you must download the music file to your hard drive and play the file later. The bad news is that you have to wait to hear the music. And how long you wait depends on the speed of your Internet connection and the size of the music file. The good news is that after you download the music file, it's yours to play again and again.

The most popular format for nonstreaming audio today is *MP3*, a convenient acronym for a format with the unseemly name, *MPEG Audio Layer 3*. To enjoy MP3, you simply download your chosen MP3 file and play it by using an *MP3 player*. If you already have RealPlayer, the Windows Media Player, or iTunes (as mentioned previously for playing streaming audio), then you're set. You can also find dozens of other MP3 players on the Internet. I dive into more detail on MP3 later in this chapter.

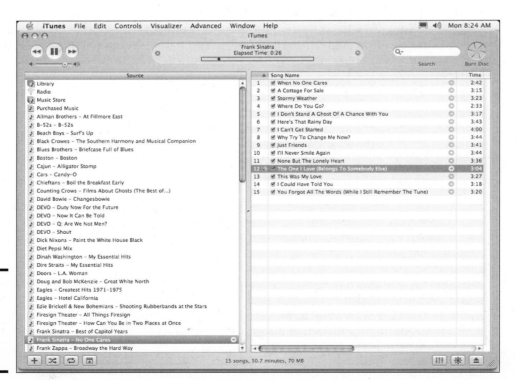

Figure 3-1: iTunes does the streaming trick for your Mac.

Video

Long before the Internet killed the radio star, music video was already digging the grave. Ever since MTV came on to the culture scene back in the early '80s, it's hard to imagine a new pop song without an accompanying video. You can find plenty of music videos online, ranging from digital versions of the same fare you catch on MTV or VH1 to *indie* (or independent) footage these networks would never air.

The Internet is truly the most democratic medium around these days, which means that anyone with the time and the will can participate. This situation means that bands, even small garage groups, can use their camcorders to shoot a video and put it online.

Most online music video comes in the streaming variety, which means you need a special player, such as RealPlayer, Windows Media Player, or QuickTime Player. Also, with streaming video, just like with streaming audio, you can't save the video file to your hard drive for later viewing. To view the video again, you have to restream it to your computer.

Merchandise

As any music fan knows, there's nothing like some good stuff to go along with the tunes. Here's just a smattering of the music-related stuff you can get on the Internet:

T-shirts	Banners	Books/magazines
Wallets	Instruments	Figurines
Posters	Songbooks	Computer games

You name it — the stuff is out there.

And, of course, you can find plenty of people who want to sell you the stuff — and not just at eBay. Web-based stores are filled with all kinds of music-related merchandise. Instead of having to wait for the next local concert to buy that latest Shania Twain jersey, you can just boot up a country music Web store.

Even better for some are the many sites offering concert tickets. Major ticket companies, such as Ticketmaster (www.ticketmaster.com) and Tickets.com (www.tickets.com), offer the option of purchasing concert tickets over the Net. Buying tickets online is a fast way to get good seats while avoiding those annoying busy signals and long lines.

Radio

Music wouldn't be much without radio. Radio is how we tune in to hear the latest artists, pass the time while we jog, and stay sane during endless morning commutes.

Though not nearly as portable as its offline counterpart, *Net radio* has a lot to offer. Unlike offline radio, Net radio isn't limited by any broadcasting range. With literally thousands of radio stations broadcasting their shows over the Internet, you can tune in to a pop music show from Korea while sitting on the California coast. Plus, all kinds of radio shows are made exclusively for broadcast over the Internet. These programs, such as those developed by Pseudo. com (`www.pseudo.com`) in New York, often offer more experimental or cutting-edge content than you find on your local FM station.

Sometimes, these programs throw in a live video feed so that radio seems a lot more like television. You may find interviews with your favorite bands or even impromptu studio performances.

Net radio usually comes in streaming format because it emulates the offline listening experience. So to tune in, you can use the same software you use for any other streaming audio (see "Streaming audio" earlier in this chapter).

Concerts

The crowds. The sweat. The butane lighters waving precipitously in the air. Nothing quite captures the group hug that is a live concert, not even the Internet. But it comes close. These days, artists from the Rolling Stones to Justin Timberlake have *netcasted* their concerts to the online audience.

Because the events are live, the audio and, occasionally, the video are generally streamed over the Net, which means that you tune in with your preferred streaming audio player, kick back, and enjoy the show.

Bear in mind: Netcasts are sometimes hard to receive because of overly busy servers and net congestion. Go figure.

To add that all-powerful human element, some sites offer live chat simultaneously with the netcast so that you can commune with other like-minded fans. Waving a lighter at your desktop, however, can be dangerous.

News and information

Every music fan has to stay informed. The Net, of course, is perfectly catered to keeping you pumped with news and information. If you want to know something about your favorite band or style of music, you can find something out there to keep you clued in. Just explore the following sources:

✦ **Newsgroups** are sprawling, usually unedited message boards where surfers write (or *post* in Netspeak) their views and rants about their favorite bands. The `alt.music.rush` newsgroup is for old diehards like me.

✦ **Mailing lists** — sometimes called *LISTSERVs* — are e-mail discussion and information services that you must subscribe to. You can join, for example, a George Thorogood mailing list to get all the latest updates and info on his whereabouts and recordings.

✦ **Music news sites** are the music equivalents of CNN. Sites like MTV (`www.mtv.com`) feature daily updates of news and information.

And don't forget to check out the bevy of personal homepages devoted to bands for the latest gossip and information. Like all homespun products, though, the reliability of the info may be a little suspect.

Community

It's one thing to be, say, a John Denver fan, but it's a whole different experience to be among a group of people who share your passion. The community for music online is sprawling and seemingly endless. And it's no surprise. After all, music fans, particularly fans of the Grateful Dead, were among the first pioneers on the Net.

Today, fans mingle in newsgroups, mailing lists, or live *chats*. They run their own Web sites, events, and even offline gatherings. Some sites such as iMusic (www.imusic.com) are run by companies that empower fans with the tools to create their own special interest groups.

The Background of Music Online

Like intrepid explorers, people looking for music and music-related stuff online have to be armed with the right knowledge. Throughout your journeys, you're sure to run across some references to original manifestations of music online. Most are still around in some form or another. So if you're going to venture out on the wires, you'd better be prepared to know what's around the corner.

Here's a little primer on the background of music online. If you know about these basics of Net surfing, feel free to skip ahead.

BBS blues

Long before college students were burning up their Net connections looking for the latest MP3s, they were hanging out in *Bulletin Board Services (BBSes)*.

Launched extensively in the late 1980s and early 1990s, BBSes are text-based, online community centers where people with special interests gather to leave messages for each other, trade software, or chat in real-time. These sites, which still exist today, were the foundation for music community online — places where fans and musicians could stay in touch and share information even if they lived across the country from each other.

Unsurprisingly, music fans were some of the first to stake their flags in these new electronic frontiers. Acid rock legends The Grateful Dead inspired one of the most dedicated legions of music fans. As one of the oldest BBSes still in business, The WELL (www.thewell.com) remains a buzzing hive for Deadheads.

Tommy, can you FTP me?

For a while, the Internet wasn't as easy as *point 'n' click*. It was more like *fetch 'n' get*. Finding information took a lot more work and effort than it does today.

Dedicated online music surfers still trade files the old way by using the *File Transfer Protocol* (FTP). Simply put, FTP means that you can put a file on to or get a file off of someone else's computer. But rather than use a disk to transfer a file, your computer dials up the other person's computer and transfers the file over your Internet connection. Because the owner of the other computer probably doesn't want every Joe or Jill Schmoe rummaging through his or her stuff, he or she probably gives you a secret password that lets you in.

Today, FTPing is most commonly used with MP3s. Cute FTP (www.cuteftp.com) is among the more popular FTP programs. To get MP3 songs, the owners may require you to access the files from their computer *servers* — the hardware that stores files for Internet access. If they say, "Hey, dude or dudette, you gotta FTP my server," you'll know what they mean.

E-zines

Way back when, someone got the bright idea that people may be compelled not only to search for information online but also to actually take the time to read it. Electronic magazines, or *e-zines,* quickly began filling the demand.

Zines have a long and important history in popular music. Offline, so-called *fan zines* date back to the birth of rock 'n' roll, when intrepid kiddies literally cut and pasted together their own fan papers and distributed them at concerts. With the advent of photocopying technologies, fan zines became more accessible. Any fans could type out their own fan zines, devoted to a favorite band, and copy them for others to buy, hopefully.

Electronic zines are made very much in the same spirit. You can find three basic types of e-zines on the Web:

✦ **Fan e-zines** are created by and for other fans.

✦ **Professional e-zines** look to entertain, inform, *and* make a buck. The quality may be better, but you have to endure the advertising.

✦ **Cross-media e-zines** appear in both print and electronic formats. Many of these, such as Rolling Stone (www.rollingstone.com), combine articles and information that appear in the regular newsstand version with new features made specifically for the Web site.

Netcasts

Netcasts. Cybercasts. Webcasts. All these terms mean basically the same thing — live or previously recorded events that are broadcast over the Internet. Concerts are obviously perfect for netcasts, as are interviews and special events like the MTV Video Music Awards.

Joining the Pack of MP3 Users

Technically speaking, zillions of people use MP3 technology today. MP3 tunes are blasted from home stereos, cars, portable players, some cellular phones, necklaces, and wristwatches. Here's how people are using MP3 today. You're probably familiar with some of these uses; others may give you some ideas.

Music lovers

The majority of MP3 users love music. Although some MP3 files contain speeches or narrated books, most contain music. Why? Because converting music to MP3 makes the following tasks easier:

✦ **Collecting and trading songs:** Many MP3 enthusiasts head for the Internet's musical buffet trays, like LimeWire. Those programs enable visitors to copy MP3 songs from each others' hard drives, although the legality of the process falls in and out of question. In its heyday, Napster offered more than a million songs from today's most popular albums, all up for grabs; today, Napster's wares are strictly legal. (See Chapter 7 of Book III for the lowdown on Napster.)

✦ **Creating personal radio stations:** MP3 "radio stations" allow people to listen to or create their own radio stations. Anybody with an Internet account can broadcast his or her MP3 collection to listeners anywhere in the world.

Musicmatch Jukebox (see Figure 3-2) lets you personalize an Internet radio station so it's based on your musical tastes. Type in the name of your favorite artist, and Jukebox creates a station for playing that artist's music, as well as music from similar musicians you may enjoy. Type *Beatles,* for example, and Jukebox begins playing Beatles songs, as well as songs from similar artists that you would enjoy.

✦ **Finding rare songs:** Can't find an old, out-of-print song that's in the public domain? Chances are, someone has converted it to MP3 and uploaded it to the Internet for free downloading. The Internet's under-popularized newsgroups contain a wealth of older MP3 tunes, sorted by decade and genre.

✦ **Making greatest hits CDs:** The latest batch of inexpensive CD-RW drives read from *and* write to CDs. Software like Roxio's Easy Media Creator and Musicmatch Jukebox convert MP3 files and copy them to a CD that can play on your home or car stereo.

✦ **Organizing songs:** Computers organize huge numbers of songs much better than those tall, black CD racks. No more fiddling with plastic CD cases or home stereo knobs when you want to hear an old favorite. You can double-click that MP3 file's name and hear the song play for immediate satisfaction. Plus, a CD usually holds about ten songs, whereas hard drives hold thousands.

✦ **Listening to music on-the-go:** Get out of the way, Sony Discman. Most portable MP3 players don't have any moving parts. That means skateboarders won't hear any sound skips or bumps, even when rail-sliding down the stairs at City Hall. I highly recommend the Apple iPod and iPod mini, which can hold a whopping 10,000 or 1,000 songs, respectively. That, my friends, is the definition of *sassy!*

✦ **Finding new bands:** Today's record company agents don't seek musical talent as much as they look for music that *sells,* which leads to waves of newly signed bands with the same sound. Using MP3, undiscovered bands post their songs inexpensively on the Internet, giving the public the first chance to hear new talent.

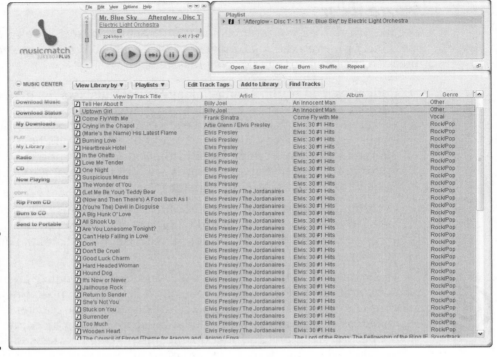

Figure 3-2:
Musicmatch
Jukebox is
my favorite
MP3
player for
Windows.

Musicians

For every band riding the Billboard charts, hundreds of thousands of undiscovered bands still play their Stratocasters in the garage. Most bands can barely afford beer. Without gobs of money, bands can't distribute their CDs through the music store chains or pay the marketing and advertising costs to expose people to their music. (And who do you have to know to get your tune on a TV show like *The O.C.?*)

MP3 lowers the costs of a chance at success. Any musician with a PC and some microphones can record a song. The computer then creates an MP3 version and uploads the tune to dozens of Internet sites showcasing new talent. Many bands — both signed and unsigned — now bypass the record labels and retail chains and use MP3 technology to let millions of people hear their songs, with these potential results:

✦ If listeners like what they hear on a band's MP3, they may buy the band's homemade CD through the mail.

✦ The listeners are happy because they're hearing fresh, new talent that they've discovered themselves. The band's happy because it can compete on merit, not cash.

✦ In fact, everybody's happy except the recording industry and music stores.

Those darn companies

A few savvy record companies have finally realized that they can embrace MP3 technology rather than battle it. Some labels release a few of their artists' tunes in MP3 format and then offer to sell the entire CD through mail order. The record industry keeps resisting the digital era, however, fearing that it'll lose money. (Maybe record industry executives should talk to the companies who stuff free product samples into our newspapers, magazines, and mailboxes.)

On the other hand, companies like Apple, Wal-Mart, and the newly reborn Napster are making money hand over fist selling both individual tracks and entire albums online. I think that Apple's iTunes Music Store is the best of these offerings by far, and I buy at least half of my music these days through this service.

As more record companies view MP3 as a cost-effective marketing tool, you'll hear even more mainstream MP3 songs released legally on the Internet.

Disc jockeys

Your average disc jockey hates toting around turntables, CD players, and boxes of records. Today's ultra-fashionable DJ carries a laptop to work. It's easier to mix MP3 songs on a laptop and pump the results out to the dance floor.

Using MP3, DJs create and store an evening's worth of music on the computer. As the songs play back, the DJ blends them into each other, subtly speeding them up or slowing them down so they play at the same beat. DJs can add special effects and incorporate digital tricks unavailable on the turntable. Software replaces expensive equipment with an on-screen multi-channel mixer board, complete with fading, backspin, scratching, and balance adjustment:

Book III
Chapter 1

Digital Music
Hath Charms

✦ Some programs are available in several versions. The *Home* version of a program will likely work fine for creating simple mixes, while the *Professional* version is sure to offer every audio bell and whistle. (Sorry, I couldn't help it.)

✦ Some MP3 DJ programs mechanically overlap songs by a set number of seconds, leaving an evening of boring mixes. OtsDJ (www.otsjuke.com) analyzes the beginnings and ends of songs and varies its mixes accordingly.

✦ Visiosonic (www.visiosonic.com) produces MP3 DJ software with point-and-click control knobs, sliders, and other gizmos that keep DJs and broadcasters happy. Upgrade to more elaborate versions that record your most inspired on-the-fly mixes for later use.

New MP3 disc jockey programs pop up all the time. To find the most current, search for *disc jockey* and *MP3* using Google.

Print media

MP3 files aren't just filled with tunes. Check out Audible (www.audible.com) for the latest spoken word files. Authors often narrate their own works, or you can even pick up an MP3 file narrating *The New York Times,* updated daily.

The Audible site also carries MP3-format *audiobooks* with lectures, readings, and business/technology news.

Comedy lovers

Comedians quickly jumped on the MP3 stage. They're converting sets into MP3 format, distributing them on the Net for free, and hoping that chuckling listeners may laugh their way to the music store and buy their latest CD.

The Internet has carried authorized stand-up comedy MP3s from George Carlin, Red Foxx, and Maryellen Hooper.

Students

Aside from listening to tunes while running to class (or sitting in class), students use MP3 technology in another important way: Some portable MP3 players also serve as digital tape recorders, letting you record notes or even classroom lectures (if you have the professor's permission, of course).

Taking a literature class? The Audible Web site carries poems by Emily Dickinson and study guides to works like *The Great Gatsby.* Audible lets you download hundreds of lectures and courses from Harvard and Stanford. Some are free; others require payment.

Studying Martin Luther King Jr. or Winston Churchill? Download their free speeches to hear what they *really* sounded like. You can also find foreign language tutorials to get a flavor of what you're trying to speak.

Understanding the Legalities (And Illegalities) of MP3

The technology behind MP3 is perfectly legal. So are baseball bats, automobiles, and laser pointers. All of these things can be used illegally, however.

Standard disclaimer: Digital music issues are still being tossed around in the courts. But let's start with what's generally assumed to be legal:

+ Downloading MP3 songs from the Internet if the artist has authorized those songs for distribution is legal.

+ Nobody will press charges if you make MP3 copies of your CDs, albums, and soundtracks for your own personal use.

Now, for the illegal parts. Giving away or selling any of the MP3 copies you've made from your CDs, albums, or video sound tracks is illegal. Some Web sites say downloading a bootleg MP3 is okay "if you only keep it 24 hours." That's not true. It's still illegal. Just keep in mind the following points:

- In short, MP3 technology *is* legal, and you're encouraged to download, copy, and trade authorized MP3s. *Authorized* means that the MP3 files have been approved for distribution by the artist who created them. (As the bumper sticker reads on the back of my Jeep, "MP3 Is Not a Crime.")

- Feel free to make your own MP3 copies from your own CD collection. You can even copy those MP3 songs onto another CD with your computer's CD-RW or DVD drive — as long as you don't give away or sell either the original CD or the copy you've made. If you give away the copy, you must destroy the original, or vice versa.

- To be perfectly clear, any time you make unauthorized copies and give them away, sell them, or post them on a Web site, you're breaking the law.

- Trading unauthorized MP3 songs means the record company doesn't make any money. Many consumers won't cry over that. But illegal MP3s also take money from the artists who created the works — no matter how little the record company might be paying them.

Finding the Best MP3 Files

Millions of MP3 files are scattered around the Internet. The key is to know where to look:

- **Use Google!** Search engines automatically scour the Internet to locate MP3 sites and songs.

- **Visit Internet newsgroups.** These groups are a separate world from the Web, yet they provide some of the easiest places to find MP3 files and information.

- **Use FTP** *(File Transfer Protocol)* **— one of the fastest and most complicated ways to find MP3 files.** You need special software, but when the switches are set correctly, it's a rocket.

Many Web sites now review authorized MP3s uploaded by bands. By reading the reviews, you can narrow your downloads to the bands you think you'll enjoy the most.

Playing and Creating MP3 Songs

You can listen to MP3 files on your computer, provided it has a sound card and speakers. For the best sound, however, connect the computer's sound card to your home stereo, or invest in the best in computer speaker systems.

Away from home? Portable MP3 players are the latest toys for taking your music with you. Some PDAs already play MP3s. Most Windows CE palmtops and many Palm units play MP3 files as well (although you may need a clip-on audio device).

Creating MP3 files from your own CDs

Creating an MP3 file is a two-step process: ripping and encoding.

+ *Ripping* means placing your musical CD — the latest by John Mayer, for example — into your computer's CD or DVD-ROM drive and telling the software to copy a song or songs into huge files onto your hard drive.

+ *Encoder* software then compresses those huge files (known as WAV files on the PC and AIF files on the MAC) into the much smaller MP3 format, letting you delete the original recording.

Most all-in-one MP3 players, such as Musicmatch Jukebox or Apple's iTunes, rip and encode in one step. Just insert the CD, and, after a few minutes, your MP3 files appear on the hard drive.

MP3 files aren't always created from CDs, although that's the easiest method. You can turn any recording into an MP3 file by connecting a few wires from the back of your home stereo's amplifier to your computer's sound card.

Copying MP3 files onto CDs

If your computer has a CD-RW drive or DVD recorder, you can free up your hard drive by storing your MP3 files onto CDs.

Because songs on a CD that you buy in a record store are stored in a special file format that's much larger than MP3, those CDs usually hold less than a dozen songs. By compressing those songs with MP3 and storing the resulting MP3 files onto a blank CD, you can usually fit hundreds of MP3 files onto a single CD (usually called an *MP3 disc*). Just insert your newly created MP3 disc into your computer, load up your MP3 player, and start listening to the tunes. Remember, though, MP3 is a different format than the one used for standard, record store CDs. These MP3 CDs will play on most of the latest audio CD players, DVD players, boom boxes, and standard home stereos — check the manual that came with your audio and video equipment to find out whether it supports MP3 discs.

The songs on a CD purchased at a record store are known simply as *audio CDs.* These songs are stored in a format different from MP3. They play in both your computer and your home stereo's CD player, but their bloated file format means only ten or so songs fit onto the CD. A CD with MP3 files plays on your computer, but it may not play on your home stereo's CD player, but on the plus side, MP3's compressed file format lets you store hundreds of songs on the CD.

Chapter 2: Using Your Computer as a Music Platform

In This Chapter

✔ **Listening to CDs on your computer**

✔ **Maximizing your computer for playing music**

✔ **Upgrading your computer's CPU**

✔ **Installing a sound card**

✔ **Installing a hard drive**

✔ **Hooking up your stereo**

✔ **Adding cool extras**

✔ **Installing a CD or DVD burner**

Computers weren't made for music. They were made, more or less, for word processing, calculations, spreadsheets, and a bunch of other stuff that you'd look really silly dancing to.

For anyone who wants to explore the world of music online, this challenge of turning a computer into a music machine is considerable. Though most new computers can play back music, they're not meant to be stereos.

So whether you listen to Bette Midler or Nine Inch Nails, you want to get the full oomph of the music experience through an awesome-sounding machine — not some lame background music squeezing through your computer's speakers. So roll up your sleeves, whip out that credit card, and prepare to turn your computer into a lean, mean music machine. In this chapter, you find out how to transform your hardware into rockware.

Listening to CDs on Your Computer

If you're like me, you enjoy playing music in the background while you work. (In case you're wondering, I'm listening to George Thorogood's classic album *Bad to the Bone* right now). Virtually all computers in use today can play music CDs!

What you need

To play music CDs on your computer, make sure you have the following stuff:

✦ A computer. (Go figure.)

✦ A CD-ROM drive.

✦ External computer speakers that plug into your machine.

✦ If you have a Windows PC, a sound card, which is a piece of computer hardware that lets your computer play sounds. It probably came with your machine.

If you have a Macintosh, you don't have to worry about a sound card. All Macs come equipped with built-in sound. Isn't that nice?

✦ A CD player application, which comes with either Windows or the Mac OS. Other programs can also play CDs on your computer.

Don't worry if you don't know what all this stuff is. You will know by the end of this chapter.

Play it, Sam

To fire up your favorite CD, follow these steps:

1. **Get a music CD.**

 Pick a CD, any CD. . . .

2. **Press the Open/Close button of the CD-ROM drive, place the disc in the tray, and then press the Open/Close button again.**

3. **If your CD player application doesn't automatically start up, launch the program.**

 In Windows XP, choose Start⇨All Programs⇨Accessories⇨ Entertainment⇨Windows Media Player.

 In Mac OS X, click the iTunes icon in the Dock.

 If you're using another program for playing MP3 songs and audio CDs, go right ahead and launch it.

4. **Click the Play button.**

 The buttons on the controller are similar to those you find on any car or home stereo. You can also stop, pause, move from track to track, move forward or backward in a track, and adjust the volume.

How's that sound? Music to your ears, I hope.

Creating a Dream Music Machine

Think of a computer as a stereo. Audiophiles seldom go out and buy just one complete stereo. Instead, they carefully select each component separately — for example, a receiver, a tape deck, a CD player, speakers, an equalizer, an amplifier, and so on. If they listen to more albums than CDs, they invest more in a killer turntable.

If these audiophiles are into *DVDs* — short for *digital versatile discs,* which can hold both audio and video — they may get a DVD player as well. Virtually all PCs and Macs can play DVDs if they come with a DVD-ROM drive.

You can modify and customize your computer in a similar fashion. You can start out with the basics — a monitor, a hard drive, a keyboard, and so on — and then add different *peripherals,* or additional hardware devices, as you see fit.

You can also customize your computer internally. You can add memory, different sound capabilities — whatever you desire. The following subsections show you how you can put together your dream machine.

Choosing a computer

Because any new desktop computer or laptop can play music, you don't need to worry too much about what you get. In general, like I always tell my friends, get the best one you can afford. However, keep in mind that with all the technological innovations happening, the computer you buy now may be out of date in just a few months. But that shouldn't stop you from constructing a killer computer system to satisfy your online music cravings.

Here are some things to consider if you're starting completely from scratch:

✦ **Macintosh or PC?** If that's the question, the answer is probably among the most personal in the high-tech world. Mac and PC users are equally dedicated to their machine of choice. My sister-in-law bought a candy-colored Mac because it matched her sofa. My friend bought a PC because he likes playing all the latest computer games. For music purposes, you can find more goodies available for PC than Mac, but the Mac is home to the exceptional iTunes player and iTunes Music Store. I'll be honest: The average online music fan can be happy with either one. Therefore, don't buy a computer *just* for music. Think about the other things you want to use it for, too.

Music-loving programmers have been busy. In addition to the standard Windows and Mac OS–based MP3 players, programmers have written players for DOS, Macintosh, Amiga, Atari, OS/2, BeOS, FreeBSD, Solaris, Linux, SunOS, IRIX, HP-UX, AIX, and other UNIX platforms.

✦ **Computing power.** A computer's performance is dictated by its *processor* — the device inside your computer that does all that complicated thinking — and the amount of RAM installed in the computer. Processors are measured by the speed at which they make calculations; such measurements come in units called *megahertz.* If you're using a PC, I suggest getting at least a Pentium III processor. For a Macintosh, don't get anything less than a G3. For each platform, anything less than 500 MHz won't do you much good. On the RAM side, your computer should have at least 128MB (megabytes) of memory to fully enjoy today's audio player applications.

✦ **Monitor.** The bigger, the better. Though you're tweaking your computer for music, you're going to be viewing a lot of Web pages along the way. The more screen space you have to see what you're surfing, the more pleasurable the ride will be.

✦ **Keyboard.** An *ergonomic* keyboard can save your wrist from the dreaded wrist-crunch condition called *carpal tunnel syndrome.* (If you don't think carpal tunnel can happen to you, don't be so sure; for a while, I had to sleep with wrist splints.) Unlike normal keyboards, an ergonomic keyboard is split and angled in such a way to line up more comfortably with the natural position of your hands.

✦ **Mouse.** You can get by just fine with the mouse that comes with your computer, but you may want to invest in a mouse (or trackball) that has several buttons that you can program to do different things. Not bad for late nights of MP3 trolling.

Book III
Chapter 2

Using Your Computer
as a Music Platform

What about upgrading my PC's processor?

Upgrading a computer's central processing unit, or *CPU,* seems easy enough. You remove the case, pull out the old chip, push in a compatible replacement, and screw the case back on. The problem is dealing with the disappointment when you first turn on the computer. Unfortunately, doubling your computer's processing speed rarely makes it run twice as fast.

Your computer's speed depends on many things, including its amount of memory, motherboard speed (known as *bus* speed), and hard drive speed (particularly the amount of free space left on it). Even a slow graphics card can hold back your computer's performance.

Don't be surprised if that new CPU speeds up your computer by only 25 percent. And if that new CPU doesn't increase the speed by at least 200 MHz or so, the results probably won't even be noticeable enough to warrant the upgrade.

Several companies make upgrades for your CPU; they keep releasing upgrades faster than I can type them into a book. Table 2-1 shows some of the most popular upgrade makers and their Web sites.

Table 2-1	CPU Upgrade Makers	
This Company . . .	*. . . Found Here . . .*	*. . . Does This*
Evergreen	www.evertech.com	Evergreen's products upgrade everything from a 486 to a Pentium 4.
Kingston	www.kingston.com	The world's largest independent memory manufacturer, Kingston also carries an impressive array of inexpensive CPU upgrades.
AMD	www.amd.com	Behind Intel, AMD is the second most popular PC CPU on the market (and the basis for many an upgrade).
PowerLeap	www.powerleap.com	PowerLeap helps simplify the upgrade process by mounting its replacement chips on a tiny circuit board. Flip the tiny switches on the board to make it compatible with the CPU that you're replacing.

If your computer is more than four years old — or if the chipmaker recommends it — make sure that your computer is running the most current BIOS available before adding the new CPU. The Web site of your computer's manufacturer usually carries a program to update a computer's BIOS. The upgrade chip manufacturer can usually help you here. In fact, many PC owners opt to replace both the motherboard and the CPU at once, which greatly improves performance; however, you may have to buy new memory modules because the older, slower RAM chips aren't compatible with your new motherboard.

When upgrading your computer's CPU, keep in mind the following:

✦ **Tools:** One hand, a screwdriver, and the replacement CPU manual

✦ **Cost:** Anywhere from $75 to $600, depending on the power

✦ **Time:** Anywhere from an afternoon to a weekend, depending on your technical experience within the bowels of your PC

Static electricity can zap a CPU. Tap your computer's case to ground yourself before touching the CPU. If you live in a particularly dry, static-prone area, wear rubber gloves (the kind that doctors and dentists wear these days) or a *grounding wrist strap* (to fasten between your wrist and the computer's case).

Here are the general steps to upgrade your computer's CPU to a faster model (of course, if the manual for your new upgrade chip describes the installation process differently, follow those instructions instead!):

1. **Check the manual or the upgrade manufacturer's Web site to make sure your upgrade chip is compatible with your computer.**

Installing an incompatible CPU into your computer can destroy it. Check the manufacturer's guarantees and compatibility list *very* carefully before ordering and installing the chip.

While you're looking around in the manual and on the Web site, check to see whether you need a BIOS upgrade as well.

2. **Unplug your computer and remove the cover.**

If you live in a dry area with static, wear a grounding wrist strap or rubber gloves. No static problem? Then just touch the case to ground yourself before starting.

3. **Find your computer's central processing unit (CPU) on the motherboard.**

Your computer's processor is usually the largest black square thing on the motherboard — the largest socket. The processor is usually covered with a heat sink and fan unit as well.

4. **Remove the original processor.**

After you unplug the fan and remove the heat sink, take a second to examine the processor. Some chips come with a little lever. Pull the lever, and the old processor pops out, ready for replacement. Other chips need to be pried out with a little metal tool. (The cheap tools usually come inside the new CPU's box.)

A socket with a little lever is called a Zero Insertion Force (ZIF) socket. A lever-less socket is a Low Insertion Force (LIF) socket.

5. **Examine the holes in the socket and the pins in the CPU.**

Make sure that you're putting the right CPU into the socket. The pins and holes should line up exactly. (Look for a notch in the corner of the CPU and socket and match them up.) Check the replacement CPU's instructions; chips requiring a socket with a lever won't work if there's no lever.

6. **Line up the chip's pins over the socket's holes; then gently push the processor into the socket.**

 Don't bend any pins. Please. And don't push too hard; sometimes a motherboard can crack, making you head back to the computer store and frown while buying a new one.

7. **If your new processor came with a cooling fan, install it per the installation instructions.**

 The more powerful your processor, the more it heats up. (Just ask the guy at the airport with a laptop on his lap.) Some upgrade chips need a tiny fan to keep them cool. In fact, some chips come with a fan mounted right on their backs.

8. **Close the socket handle, if necessary, screw the cover back on your computer, plug it in, and see whether it runs more quickly.**

 Hopefully, you'll notice a difference in computer speed, especially when converting CDs to MP3s.

Picking a sound card

Attention Mac users: You can skip this subsection. Your Mac comes with built-in sound capability that can knock your socks off.

For PC users, the *sound card* is the core of your computer's audio power. The sound card processes audio information and then sends it out through your speakers. Whether you know it or not, you almost certainly have a 16-bit sound card already inside your computer. The only reasons you may need to install a new sound card are as follows:

✦ You want a better card with more features.

✦ You need to replace the card.

✦ You're adding a sound card to an older PC.

✦ You're building your own PC.

A basic sound card, like the popular series of Sound Blaster cards from Creative Labs (www.creativelabs.com), can do you fine.

Some companies offer *3-D audio* sound cards; these sound cards are made especially for computer games. With them, you get all the magical sounds of flying bullets and whooshing phasers — obviously not the stuff of your favorite bands. But if you should choose a 3-D sound card, it can handle your music as well. You can also pick up a card that's capable of Dolby Surround sound, but you'll need the corresponding surround sound speaker system to take full advantage of your music. (More on this in the next section.)

Installing a card

Whether you're installing a new whiz-bang sound card or a FireWire port card, the steps are the same. And they're surprisingly easy. This section shows how to install a new card, whatever species it may be.

Many multimedia computers come with four to six speakers, ready to play back surround sound. Although four speakers may sound cool for a while, surround sound was really designed for DVD players that play back movies recorded with surround sound technology. Although it's great for computer games, the technology doesn't really make the current generation of MP3 songs sound any better.

To install a new card, keep in mind the following:

+ **Tools:** One hand and a screwdriver

+ **Cost:** Anywhere from $50 to $300 and more

+ **Time:** An afternoon should be plenty of time

Cards are particularly susceptible to static electricity. Tap your computer's case to ground yourself before touching the card. Also, be careful not to bend the card while installing it. Doing so can damage its circuitry.

Cards are pretty easy to install. They're self-contained little units. For example, they suck electricity right out of that little slot that they plug into. You don't need to plug special power cables into them. (A wire from some CD players connects to some sound cards, however, to route the sound directly to the card.)

Cards come in several different lengths and standards. Be sure that you buy the right type of card for your computer. Usually the choice runs between PCI and ISA cards. (PCI slots are always shorter than ISA slots and usually white; ISA slots are always longer than PCI slots and usually black. Check your computer's manual to be sure.)

Cards are delicate. Handle them only by their edges. Even the oil from your fingers can damage their circuitry.

Some cards are longer and fatter than others. You may need to rearrange some of your existing cards to accommodate new cards of different lengths and thicknesses.

To install a card, follow these steps:

1. **Turn off your computer, unplug it, and remove the cover.**

2. **Find the slot that's the right size for your card.**

See the row of slots along the inside of your computer? Some are already filled with cards. And see the row of slots along the back of your computer, where cables plug into the backs of the cards? Your new card plugs into a slot adjacent to the other cards. A sound card's plugs and ports are then accessible from outside the PC.

Examine the slots closely; then examine the slots along the bottom of your card. Slots vary in size; you need one that will fit your card *exactly*.

Don't confuse your computer's expansion slots — the ones where the cards plug in — with its much-smaller memory slots, where the RAM chips slide in.

TIP

If you have a lot of room, keep your cards spaced as far apart as possible. Doing so keeps them a little cooler.

3. **Remove the slot's cover.**

Unused slots usually have a little cover to keep dust from flying in through the back of your computer. With a small screwdriver, remove the screw that holds the cover in place. Don't lose the screw! You need it to secure the card in place.

Dropped the screw in there "somewhere"? Turn the computer on its side and shake it gently until the screw falls out. You can't leave it inside there, or it may short-circuit something important.

Removed the dropped screw? Keep it handy, as well as the little cover bracket. You'll want to replace the cover if you ever remove the card.

4. **Push the card into its slot.**

To spare yourself some possible aggravation, first check your card's manual to see whether you need to flip any of the card's switches or move any of its *jumpers* — little prongs with a movable bar. Then you won't have to take the card back out if it's not working right.

Holding the card by its edges, position it over the slot, as shown in Figure 2-1. The shiny silver edge with the ports and plugs in it should face toward the *back* of your computer.

Figure 2-1:
The card's two tabs should fit perfectly into one of your computer's slots.

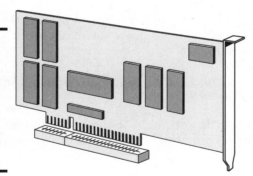

Slots come in several sizes. Modern computers come with PCI (Peripheral Component Interface) slots for the Pentium's Plug and Play technology, and an occasional ISA (Industry Standard Architecture) slot to stay compatible with older cards. PCI slots are shorter; ISA slots are longer. Your card can only fit into one of the slots, so compare the tabs on the card's bottom with the holes in the slots.

TECHNICAL STUFF

There's also a special slot, called an AGP slot, which only holds video cards. Because all sound cards these days are PCI cards, you can safely ignore your AGP slot.

MARK'S MAXIM

Push the card slowly into the slot. You may need to rock it back and forth gently. When it pops in, you can feel it come to rest. Don't force it!

Don't leave any cards resting against any other cards. Doing so can cause electrical problems, and neither the card nor the computer will work.

5. Secure the card in the slot with the screw.

Yep, each of those expensive cards is held in place by a single screw. Make sure that you *use* a screw; don't just leave the card sitting there. Cards should be grounded to the computer's case. Without a secure connection, they may not work.

6. Plug the computer back in and turn it on. The Windows fancy Plug and Play feature recognizes and installs the card.

Windows XP should recognize your new sound card and set it up to work correctly.

7. If everything works, carefully put the cover back on — you're done!

If the card still doesn't work, you probably have to run the card's installation software. Still doesn't work? Then try the following:

✦ Check the manual to make sure that the card's switches and jumpers are set correctly.

✦ You may have to run the card's software and restart your computer before it will work. That's because the software puts a driver in one of your computer's special areas. Your computer reads that file only when it's first turned on or when it's restarted.

✦ Make sure that the card is seated securely in its slot and screwed in reasonably tight.

✦ Make sure that the card is in the right slot and that each of its copper-colored tabs fits firmly into a slot.

✦ It can take some fiddling to get a card working right. The key is not to get frustrated.

✦ Nine times out of ten, the problem lies with the software. The card is sitting in the slot correctly, but the software is conflicting with some other software or not talking with the card. Check the manual that accompanied the card for possible software troubleshooting information, or visit the manufacturer's Web site to read online documentation like FAQ files or a knowledge database.

✦ If the card still doesn't work, root around in its box for the manual. Most manuals list a technical support phone number or Web site that offers help.

Selecting speakers

Until recently, computer speakers were pretty much an afterthought. After all, who really needed to listen to those system startup tones in stereo? But with the increased popularity of computer games, DVDs, and online music, a good set of speakers is becoming essential.

You may be surprised at how good computer speakers can sound these days. Part of the reason is that some major stereo speaker manufacturers, such as Boston Acoustics and Altec Lansing, are now knee-deep in the business as well.

The major speaker manufacturers understand that the future of the music listening experience will rely more and more on digital distribution, and consumers are going to demand better ways to enjoy the sounds.

Here are some features you can look for when selecting your computer speakers:

✦ **Price:** You can get a decent pair of speakers for about $100. Like anything else, you can spend more, depending on your passion. High-end speakers can cost as much as $500.

✦ **Subwoofer:** A *subwoofer* is an additional component to a computer speaker system that specifically handles the sound system's bass. Subwoofers usually sit on the floor, while the two stereo speakers are angled toward the listener from higher up. Using a subwoofer isn't necessary, but doing so gives you a richer, fuller bass sound — something especially nice when you use some tiny computer speakers for everything else.

✦ **Dolby Surround:** *Dolby Surround* is a feature you use when listening to DVD concert movies that were shot with this special sound technology, or to DVD audio discs. For more on Dolby Surround, check out Dolby's Web site at www.dolby.com.

✦ **Rear speakers:** These speakers are for the true audiophiles; you place them behind you for that theater surround sound experience. You use these speakers for listening mainly to DVD movie audio.

Adding memory

Online, it's nice to be an elephant. In a nutshell, the more *random access memory,* or *RAM,* your computer has, the more programs your computer can run at a time. After you sink yourself in the playfield of music online, you may find yourself giving new meaning to the idea of *multitasking* — that is, doing a lot of things at once.

If you have 128MB of RAM and use Windows 98 or Mac OS 9, you should be fine. But if you're running Windows XP or Mac OS X (or you plan on watching DVDs and getting into MIDI or any kind of music production), you really need 256 or 512MB. And if you can afford even more, by all means, splurge.

Need help adding RAM to your PC? I can highly recommend the comprehensive *Building a PC For Dummies,* 4th Edition, by Mark L. Chambers (and published by Wiley, if you hadn't guessed already). The book is a great guide to help you make sense out of all the memory craziness . . . plus, you get step-by-step instructions on how to install hardware like memory modules and sound cards.

Exploring bandwidth

Unlike the regular roads, speeding on the information superhighway is not only acceptable, but also the only way to ride.

Your on-ramp to the superhighway is your *Internet service provider* (ISP) — the company that provides you online access — which is available for a variable monthly subscription.

Bandwidth, which measures how much data can flow through the telephone lines to and from your modem, is the golden ring. The more bandwidth, the faster the connection, and the quicker you can download your favorite MP3s. Here's a look at the different options for playing with the bandwidth:

✦ **Dialup** access means that your computer sends and receives data over the Internet through a modem. The speed of data through a modem is measured in *bits per second (bps).* When I downloaded my first song online, I was using a 2400 bps modem, which took about an hour to get one song. These days, most computers come with modems that can handle 56,000 bits per second (sometimes abbreviated 56Kbps).

 Not bad, but not lightning-fast by any means. We're still in an era when we actually have time to kill during long downloads. And if you're using dialup, you'd better get used to heading off for a snack while your MP3s download.

✦ **Integrated Services Digital Network (ISDN)** was the first technology that provided faster bandwidth than a basic dialup modem, but it has been practically rendered extinct by DSL and cable modem services. Unlike DSL and cable connections, an ISDN connection isn't "always on" either. You actually have to dial your ISP, just like an older dialup modem. How primitive! I recommend that you give ISDN a wide berth and let it finish fading away into archaic Internet history.

✦ **Digital Subscriber Lines (DSL)** are now offered by the majority of Internet providers and phone companies. DSL not only gives you high-speed access (30 times faster than a 56K modem), but also gives you fast access for sending data upstream yourself — especially important for bands who want to post a lot of MP3s.

✦ **Cable modems** are being enjoyed by a growing group of home surfers. Cable companies offer this service. If your neighborhood is wired for this, you can get it; if not, you have to wait. Right now, cable modems deliver data at about 500 times faster than a 56K modem.

✦ **T1** connections, common in the workplace and some newfangled apartment buildings, offer high speed, *broadband* connections at around 1.5 megabits per second (Mbps). That's cruising nice and fast. No wonder so many bosses are banning access to MP3 sites from the workplace.

Storing stuff

In a scene from the film *Diner,* the 1950s coming-of-age film, one guy chastises his girlfriend for messing up his meticulously organized record collection. How dated, indeed. With music online, storing songs, sites, graphics, or whatever else suits your fancy is a nice, clean digital affair.

Your hard drive will probably suffice for most of your storage needs. My motto, as always, is to get the biggest one you can afford. You can easily fill up the space — especially if you get addicted to games. An 80 to 120 gigabyte (GB) drive is pretty spacious, but — like RAM — you'll never have too much hard drive space.

Floppy disks are a problem. One MP3 song, for example, can weigh in at about 4.5MB. A floppy can hold only about 1.4MB. That's a squeeze.

**Book III
Chapter 2**

**Using Your Computer
as a Music Platform**

Though you may try to *compress* a song, floppies don't really make a lot of sense for these kinds of things.

If you really start getting on a roll, you probably want to take your tunes on the road. For more general, transportable storage needs, a portable storage device like a USB flash drive is a nice way to travel. These solid-state wonders have no moving parts to wear out, and can store anywhere from 128MB to a whopping 1GB in a form factor that's about the size of a keychain. Plus, a USB 2.0 model can transfer an entire album's worth of songs in under 15 seconds!

Another medium for storing your MP3 and other computer sound files is the tried-and-true recordable CD or DVD. You can get yourself a CD or DVD recorder and, with the right software, burn audio CDs that you can play in most conventional CD players. You're limited to putting up to 80 minutes of audio on each disc. If you store the MP3 files as data files, you can get tons of songs (up to 700MB worth) on a single CD. However, if you go that route, you can't play the discs in older CD players (though more and more new CD and DVD players have the ability to play MP3 files).

Installing a larger hard drive

It happened ever so slowly. But suddenly, your 20GB hard drive has only 500MB of free space. And you still need to convert your new *Trance Factory* CD.

It's no secret why your hard drive suddenly shrunk. MP3 files are huge. Sure, they're compressed files, but that doesn't mean they'll fit on a floppy. The Beatles' "I Am the Walrus" eats up 4MB (and that's only at the standard sampling rate).

If you're turning your computer into a music player, it's time for a second hard drive. Huge, fast hard drives now cost less than ever. Best yet, today's large drives come with much-appreciated installation software to start the drive spinning.

The problem comes when figuring out which type of drive to buy. Over the years, manufacturers have created drives according to more than a dozen different standards. Today, three standards prevail: Serial ATA, SCSI, and EIDE. Being less expensive, EIDE currently rules the market. Unless you already have a Serial ATA or SCSI drive, buy EIDE.

Another expansion solution that's become quite popular these days is the external FireWire or USB 2.0 drives. Although they're naturally more expensive than a "bare" internal drive, portable drives are as simple to install as plugging the cable from the drive to the corresponding port on your computer! Also, you can haul your MP3 files around with you from place to place with a portable drive — just make sure that the computers you plan to visit have the same ports onboard. (There's nothing more embarrassing than showing up to jam with your friend and finding out that he doesn't have a USB 2.0 port on his PC.)

EIDE stands for Enhanced Integrated Device (or Drive) Electronics. Yawn. SCSI stands for Small Computer System Interface.

Also keep in mind the following tips:

✦ When buying a second drive, do yourself a favor and pick up a copy of PowerQuest's PartitionMagic software at the same time. The software makes it easy to install your new hard drive as your C drive, change your existing hard drive to your D drive, and then copy all the information from D to C. (That sounds boring, but it's very handy.)

✦ It takes more hard drive space to create an MP3 than to merely listen to it. Converting an entire CD at once can require 500MB of space or more. Find the largest hard drive you can afford. Then buy one a little bit bigger.

✦ Before installing a second hard drive, do these chores: Back up your first hard drive and dig around for your original Windows CD. (You may need the CD's serial code for installation; it's often on a sticker on the CD case, as well as with your manual.)

Installing or replacing an EIDE hard drive

Don't like fiddling around inside computers? Most computer shops will install your new drive for around $50 in labor costs. (Or, as I mention in the previous section, you can pick up an external drive instead.)

If you're bravely tackling this beast yourself, keep the following in mind:

✦ **Tools you need:** One hand, a screwdriver, and a Windows install disc.

✦ **Cost:** Roughly $50 to $200.

✦ **Time:** No more than an afternoon.

✦ **Stuff to watch out for:** If you're replacing your current hard drive, make sure that you have your Windows install CD on hand. You'll need some of the programs on that disc.

When installing a new drive, make it your C (or *master*) drive. The master drive is the one that the computer looks at first and boots from. The new drive will probably be faster, making Windows run faster, as well. Your old drive then becomes your secondary drive, or *slave*. You need to move a little jumper on the second drive to make that drive work as the slave (see Figure 2-2).

Some hard drives automatically set themselves up for one hard drive if they're set up as the master. You may have to check the drive's manual on this one. (Your manufacturer may also have been nice enough to print the master/slave jumper positions on the top of the drive.)

You may need rails to mount your hard drive inside your computer. Some drives come with mounting rails; others don't. If you're replacing an old drive, you can often unscrew its old rails and swipe them. Otherwise, you may need to head back to the store to buy some. (They're usually pretty cheap.)

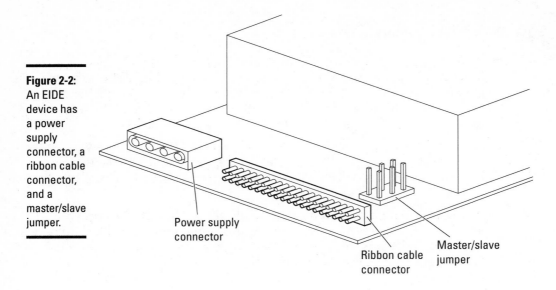

Figure 2-2:
An EIDE device has a power supply connector, a ribbon cable connector, and a master/slave jumper.

Power supply connector

Ribbon cable connector

Master/slave jumper

The following steps show you how to install a second hard drive or replace your existing drive:

1. **Make sure that your current hard drive is error-free; then back up its data.**

Start by running the Windows ScanDisk program to ensure that your hard drive is error-free. Under Windows XP, double-click My Computer, right-click the drive you want to replace, and choose Properties. Click the Tools tab, and click the Check Now button. Doing so finds and repairs errors.

Next, back up your hard drive before removing it. You don't want to lose any of your data.

2. **Turn off and unplug your computer and remove the case.**

Before removing your computer's case, turn it off and unplug it. Then remove the computer's case by removing the screws holding it on.

3. **If you're replacing your hard drive, remove the cables from the old drive; if you're adding a second hard drive, don't remove the cables.**

If you're adding a second drive, check out the flat ribbon cable connected to the first drive. Do you see a second, unused plug on it? If not, head back to the store for a new ribbon cable. It needs to have *two* connectors. (Most already do, luckily.) You second-drive installers can now jump ahead to Step 6.

Hard drives have several cables plugged into them, including the following:

- **Ribbon cable:** The ribbon cable leads from the hard drive to its controller card or the motherboard. The cable pulls straight off the drive pretty easily.

• **Power cable:** The smaller cable is made of four wires that head for the power supply. Power cables come in two sizes, as shown in Figure 2-3. Like the ribbon cable, the power cable pulls straight off the drive's socket; it usually takes a *lot* more pulling, though. Don't pull on the wires themselves; pull on the cable's plastic connector. Sometimes a gentle back-and-forth jiggle can loosen it.

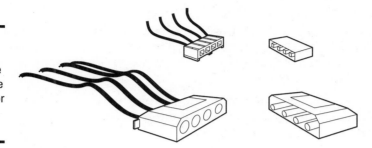

Figure 2-3: EIDE devices use one of these two sizes for the power cable.

4. Remove the mounting screws holding the drive in place.

Hard drives are held in place by screws in their sides. The screws on one side may be hidden from view by a particularly long card, or even another drive mounted on its side. That means you have to pull out the card or remove the obstructing drive just to get at the screws. Such a bother.

5. Slide the old drive out of the computer.

After you remove the old drive's cables and screws, you can slide the old drive out of the computer. Give it a gentle tug. Some drives slide out toward the computer's center; be sure not to gouge your motherboard while pulling out the drive.

6. Slide the new drive in where the old one came out.

Adding a second drive? Slide it into a vacant bay, which usually is next to the first drive. Check your computer's manual; you may be able to mount the drive on its side in a special spot inside your computer.

If you're replacing drives, your new drive should slide in place right where the old one came out. Doesn't fit? If the new drive is smaller than the old one, you need to add rails or mounting brackets to make it fit.

When handling drives, be careful not to damage their exposed circuitry by bumping it into other parts of your computer. Also, be sure to touch your computer's metal case to get rid of any static electricity before picking up your drive.

7. Attach two cables to the hard drive.

Try sliding the drive out a little bit to connect the two cables more easily. (Refer to the drive's manual to see where each cable connects to the drive.)

Ribbon cable: The plug on the ribbon cable should push onto little pins on the end of the drive, and it should fit only one way. The other end of the cable goes to a socket on the motherboard. (The edge of the cable with the red stripe connects to pin number one.)

If you're installing a second hard drive, the ribbon cable should have a spare connector on it. (If not, head back to the store.) It doesn't matter which connector goes onto which drive; the computer looks at the drives' master/slave jumpers to figure out which one is drive C.

Adding a second drive: If this is your second drive, look for its master/slave jumper. Make this second drive the master drive. The hard drive's label (or the manual) will tell you where to put the jumper. Make your old drive the slave drive.

EIDE drives usually come configured as master drives. If you're installing just a single EIDE drive in your computer, you usually don't need to mess with any of the jumpers.

Power supply: The power supply cable fits into the drive's socket only one way. Even so, check the ends to make sure that you're not forcing it in the wrong way. Refer to Figure 2-2 to make sure that you've found the right power cable socket.

Power supply cables come with both large and small connectors. The connectors are supposed to fit only one way, but the small ones often fit either way. The trick? Look for the number 1 somewhere near the drive's little socket. The power supply connector's red wire fastens onto the number 1 prong.

8. **Replace the screws.**

 Cables attached? Master/slave jumper set? Then fasten the drive in place with those little screws. Make sure that they are short screws to prevent damage to the inside of the hard drive.

9. **Replace the cover, plug in the computer, and turn it on.**

 Chances are, your hard drive won't work right off the bat. Hard drives must be prepared before they start to work, unfortunately. Take a deep breath before worrying about that task. Exhale. Now move on; it's time to break in that new hard drive.

Today's hard drives come with installation software that takes care of the rest automatically, so rejoice! If you have any questions about your specific drive, check the manual; if you installed a used drive and you didn't get a manual, visit the manufacturer's Web site. (Most drive manufacturers have the entire manual in PDF [Adobe Acrobat] format for each drive, ready and waiting for you to download.)

Hooking Up the Stereo

So if you're turning a computer into a music machine, why not just do the obvious: Hook it up to the stereo? If you want to make audiotapes of your MP3s (or even streaming audio concerts) for your car's tape deck, this is probably a good idea. Also, if your band wants to convert a demo tape

into MP3 format for posting on the Web, you can reverse the hookup — that is, run the sound out from your stereo into the microphone jack of your computer.

If you just want to listen to music you find on the Web, you may find it easier to just invest in some high-end computer speakers. A basic computer can do the essential functions of your stereo:

✦ Play compact discs.

✦ Play high-quality sound through high-end computer speakers.

The main reason most people seem to want to connect the two beasts is to crank their MP3s out of their stereo system. For a rundown on this procedure, head to Chapter 3 of Book III.

Stereo speakers are not magnetized in the same way as computer speakers. If you place your stereo speakers too close to your computer, they could damage your hard drive. Play it safe and keep at least a few feet of space between the two. Or, better yet, shell out some cash for a good set of computer speakers with a subwoofer.

Adding Groovy Extras

After you get started, you can easily get carried away with accessorizing your computer. Ultimately, a computer is a tool, and the more tools you have, the more stuff you can do. So if you want a breakdown of the possible extras (or *peripherals*) and how you can use them for music online, here's a nice birthday gift wish list.

Scanners

A *scanner* is much like a digital copy machine. It connects to your computer and creates digital images of any object that's scanned — photos, newspaper clippings, even the back of your hand. (If you're into that sort of thing.)

For music fans, a scanner is definitely a plus. If, say, you end up running your own fan e-zine for your favorite band, you may want to scan all kinds of accumulated art for your site (watch out for copyright violations, of course). But even if you want to upload some old-fashioned film photos of you and your buds outside the Marilyn Manson show, you can't beat a scanner. And with scanner prices falling as low as $50, investing in a scanner is a sure thing.

You can get three types of scanners:

✦ **Flatbed** scanners are just that — flat. These make the most sense. You can lay out clippings nice and easy and get smooth clean copies.

✦ **Sheetfed** scanners are ideal if you're trying to save desk space. For these scanners, you manually feed whatever you want to be digitized into the machine. This is not ideal, though, for scanning little scraps of concert set lists or whatever else you may want to archive.

✦ **Handheld** scanners put the power of digitization in the palm of your hand, and they may be perfect for scanning your old ticket stub collection. However, you have to make multiple swipes over anything larger and "stitch" the images together in an image editor, so most folks eschew handheld scanners unless they're on the road with a laptop.

Unfortunately, there's not enough room in this section to even begin to explore today's scanners — however, if you need all the details, you can always find 'em in *Scanners For Dummies,* 2nd Edition by Mark L. Chambers (published by your friends at Wiley). The entire book is dedicated to describing all aspects of scanning on a PC or Mac, as well as plenty of step-by-step instruction. Check it out!

Cameras

Digital cameras, which take digital pictures that you can post and trade on the Web, are becoming indispensable for the serious surfer. For musicians, a digital camera is the best way to snap shots of yourself — practicing, performing, posing — and spread them on the Net alongside your latest MP3s. For fans, digital cameras provide another cool way to let the world see you and all your obsessions.

We're primarily here to enjoy music, so I won't go into minute detail here. Suffice it to say that you may want to consider three kinds of digital cameras:

✦ **Web cams:** This nifty little eyeball plugs right into the back of your computer and beams an image of your pretty mug on-screen. If you have the gumption, you can hook up a live Web cam to your Internet home page and let people check you out 24/7 (24 hours a day, seven days a week). Plenty of bands are now doing this for a little DIY — Do-It-Yourself — promotion.

✦ **Digital cameras:** These devices take still images in digital form. Instead of using film, the pictures are stored on a memory card, miniature hard drive, or CD-ROM. You don't have anything to rewind, develop, or — oops! — accidentally expose to the light. Plus, you can zap the images right up on to a Web page — just the thing for showing pictures of you worshipping in your combination Courtney Love/Slim Whitman shrine. (Now *there's* an unusual visual image for you.)

✦ **Digital camcorders:** You can use a digital (or DV) camcorder to film your band performing or to make your own music video — then you can post the results on your Web site. Most of these camcorders come with optional accessories that make it pretty easy to plug the machine into the back of your computer and upload your goods. Virtually all DV camcorders can also pretend that they're digital still cameras, so you can take still images as well.

For the lowdown on digital cameras and digital photography, check out Book I. Book II, Chapter 2, has more information about digital camcorders.

CD and DVD burners

A *CD burner* is the common slang for a *CD-RW drive,* which enables you to record and rerecord data (including audio) onto your own CDs. With these devices, you can do the following:

- Store about 80 minutes of audio per disc
- Store 700MB of computer data per disc
- Play audio CDs and CD-ROMs

Of course, a DVD burner can store many more songs on a DVD-RW or DVD+RW disc, and any DVD recorder can also record audio CDs or MP3 discs. (A DVD burner also is pretty doggone handy for watching DVD movies.)

Installing a new CD or DVD burner

If your PC came with a read-only CD-ROM or DVD-ROM drive, you can't burn your own audio CDs; for that, you need a CD-RW, DVD-RW, or DVD+RW recorder. Again, these drives are available as internal units, or you can take the easy route and buy an external USB 2.0 or FireWire recorder.

Here's the rundown on what's required:

- **Tools:** One hand and a screwdriver
- **Cost:** Anywhere from $50 to $300
- **Time:** Yet another afternoon job

When you install an internal CD or DVD burner, it'll use either an EIDE or SCSI connection. Because EIDE is practically standard equipment, I cover the installation of an EIDE drive in this section.

The master/slave jumpers on your new recorder will be set to slave if the drive will share a cable with an existing hard drive. If the drive is the only device connected to your secondary EIDE cable, it should remain set to master. As with the hard drive settings that I describe earlier in the chapter, you must move the jumper on the recorder to make that drive work as the slave.

To install an internal EIDE CD or DVD recorder, follow these steps:

1. **Turn off your computer, unplug it, and remove its case.**

2. **Slide the CD drive into the front of your computer.**

You need a vacant drive bay, which is an opening where your disk drives normally live. The drive should slide in through the front.

3. **Connect the cables.**

a. **Connect the cable between the new drive and the motherboard — it should fit only one way.**

Remember, a CD or DVD drive can coexist with a hard drive (both are EIDE devices), so another connector on the same cable may already be connected to a hard drive.

b. **Rummage around the tentacles of wires leading from your power supply until you find a spare power connector and plug it into your new drive.**

 c. **Connect the thin audio cable from the drive to the tiny CD Input pins marked on your system's sound card.**

 Nothing marked *CD Input?* Try *Line Input* pins, or a different type of Input pins.

4. **Screw the drive in place.**

 Most drives screw in from the sides, just like a hard drive.

5. **Replace your computer's cover, plug the computer in, and turn it on.**

 When Windows boots up, it should recognize the new drive and automatically install it for you.

Headphones

Take my advice: Invest in a good pair of headphones.

Unfortunately, a lot of computer speakers don't come with headphone jacks; instead, you have to plug your headphones directly into your computer. Most computers nowadays come with a standard headphone jack. In fact, iMacs come with two headphone jacks so that both you and a friend can enjoy the music!

Also, a pair of headphones with its own separate volume control is nice, in case you want to adjust the volume while you're crashed out on the floor. Remote controls for computer audio are still fairly rare.

Enjoying digital music on portable MP3 players

You can find all kinds of devices now that let you listen to digital audio on the go: walking, driving, flying, you name it. For more information, see Chapter 11 of Book III.

Getting Away with the Minimum

Can you get away without all these goodies? Fortunately, you can. The minimum requirements are worth repeating:

 ✦ Computer

 ✦ External speakers

 ✦ Sound card

 ✦ Internet access

And if you're not sure about what else you need, you can always wait. Hang out a little bit online. Get a feel for what kind of online music fan you are. Then take it from there. As you do with a car, a house, or a stereo, you can always add some finishing touches and extra features later.

Chapter 3: Playing MP3 Files on Your Computer and Home Stereo

In This Chapter

✓ Using Winamp

✓ Customizing Winamp

✓ Using other MP3 players

✓ Changing the Windows default MP3 player

✓ Playing songs on your iPod

✓ Connecting your computer to your home stereo

By now, your computer is stuffed with MP3 songs. It's time to sit back, pop open a Pellegrino, and give your music a good listen. But what MP3 software works best to play them all? Choosing among home stereos at a music store is easy; you walk in a room, and the salesperson flips the buttons.

But who has time to try out all the MP3 software that's out there?

This chapter describes the major contenders, focuses on one of the most popular, and wraps things up with tips on wringing out the best possible sound: hooking your computer up to your home stereo.

Using the Winamp MP3 Player

Hundreds of MP3 players float around the Internet, but one player has broken rank as the clear leader among the hip crowd: Winamp. Shown in Figure 3-1, Winamp (www.winamp.com) stuffs an incredible amount of power into a relatively small package, earning millions of downloads in the past five years.

Winamp has plenty of chops, playing MP3, CDs, MIDI, WAV, AAC, and even WMA — the format that's used for Microsoft Windows Media Audio files. The basic version is free to use, while the Pro version (which includes the ability to rip MP3 files and burn audio CDs at the full speed of your drive) is a mere $15. What a bargain!

The program's built-in ten-band equalizer adjusts the sound; a minibrowser pops up Web pages when necessary. Winamp tunes in Internet broadcasts from MP3 radio stations around the world. More than 150 special software enhancements, called *plug-ins,* allow fiddling with the sound — for example, eliminating a singer's voice, storing the files in different formats, or adding 3-D sound effects.

Figure 3-1:
Winamp has powerful features that make it a favorite among music fans.

Goofier plug-ins create animated dancers, oozing lava lamps, and light shows to squirm across the screen. More than 20,000 utilities, called *skins,* decorate the look of Winamp, making it as fashionable as you prefer. Savvy users create their own skins and upload them for sharing.

This section shows you how to wring the best sound quality from Winamp. Mac users should check out iTunes, which offers many of the same configuration settings.

Installing and running Winamp

Compared to many programs, Winamp is a breeze to install. Make sure that you download the latest version at www.winamp.com. (The programmers issue new versions almost monthly.)

Winamp comes in several versions. Unless you're pressed for hard drive space, download the full version, which includes video support and the ability to rip and burn. Besides, the Winamp installer lets you choose what parts to install, so you can change your mind at the last minute.

Follow these instructions to install your copy of Winamp:

1. **Double-click the Winamp installation program's name, and read the standard legalese.**

2. **Click the I Agree button when you finish reading the License Agreement.**

3. **Choose the components of Winamp that you want to install, and click the Next button.**

You'll probably want the full version so that you get all the goodies. If not, click the Type of Install drop-down list box and choose Full, Standard, Lite, Minimal, or Custom, depending on your computer's space limitations. (If you choose Custom, you can pick and choose the functionality you want to add — naturally, the fewer features you install, the less space the program takes up on your hard drive.)

4. Choose where to install Winamp, and click the Next button.

Winamp asks you to install itself into your Program Files folder with your other programs. Unless this offends you, click the Next button.

5. Choose your icons and associations, and click the Next button.

Winamp now asks you how it should act. Typically, you should leave all the check boxes selected (as shown in Figure 3-2). You want Winamp to play your CDs and other sounds, and you want its icons to be easily accessible.

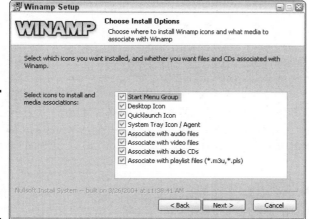

Figure 3-2:
Winamp gives you control over what it should (and shouldn't) play.

6. Choose the correct Internet connection settings, and click the Next button.

Be sure to choose whether your Internet connection is "always on" (through a network, cable modem, or DSL line) or through the phone lines. (If you don't have an Internet connection on this computer, you can also disable the program's Internet services.) A working Internet connection lets Winamp identify songs from inserted CDs.

7. Choose your language and program skin.

Although it sounds a tad creepy, a skin simply controls how the program looks when it's running!

8. Click the Install button.

Time to get another Diet Coke while you wait!

9. **Visit the Winamp Walkthrough if you're a new user.**

 Winamp calls up its Web page for a demo of its many features.

10. **Click the Run Winamp button.**

 Winamp appears on-screen, ready to play your CDs, MP3s, and just about anything else that relates to sound. If you're using the Classic skin, you get the same features, but the Winamp window looks different from what is shown in Figure 3-1. Don't panic — I tell you more about skins in the section "Customizing Winamp with add-ons," later in this chapter.

Keep the following points about Winamp in mind:

✦ Winamp resembles a wall where other people hang their signs. Winamp is the framework, and users write software to add features — plug-ins and skins — to Winamp.

✦ Not too proud to embrace this grassroots group support, Winamp's Web page offers a wealth of add-on programs, plug-ins, and skins. You can also find documentation, the most current version, and forums for online discussion.

✦ Like a wine club, the Winamp community often praises the virtues of past versions. Some versions run better on certain computers or sport different features. To sample past vintages, head for Winamp Heaven at www.winampheaven.com, where you can find about 100 versions for download, dating back to computing's Precambrian days of April 21, 1997.

✦ To start running Winamp, choose its icon from your Start menu, desktop, or Quick Launch toolbar (that row of little icons by your Start button).

Adjusting Winamp's main controls

Winamp consists of four separable windows, but it keeps most of them under wraps. In fact, Winamp works fine when shrunken to the pencil-thin waif that's shown in Figure 3-3. The main window, shown in Figure 3-4, serves as the control panel for the others; it works like the front panel of a CD player.

Figure 3-3:
Winamp's
minimalist
window.

Toggle Windowshade mode

Anyone with a CD player is already familiar with the controls for moving from song to song or for skipping parts of songs. Some of the other controls aren't as apparent. Some controls to remember are as follows (check out the dissected parts in Figure 3-4 for reference):

✦ To toggle Winamp between full size and miniscule, click the word WINAMP on the bar that's along the program's top. (Check it out — you'll end up using that feature a lot.)

✦ Slide the bottommost bar in the Winamp section back and forth to skip forward or backward within the song. The second-longest bar, right above it, changes volume. (It also turns from cool green to fiery orange as the volume increases.) The smallest bar adjusts the sound's positioning between the two speakers. It's lime green when the balance is right.

✦ In Figure 3-4, you can tell that Winamp is currently playing back music in stereo because the Stereo button is illuminated; some older songs or live recordings light up the adjacent Mono button.

✦ The song in Figure 3-4 was recorded at 256 Kbps and 44 kHz. That's much higher than the standard MP3 sampling rate of 128 Kbps (which sounds nearly as good as a CD), so this is a very high-quality MP3 song.

✦ Click the tiny EQ and PL buttons to bring up the Equalizer and Playlist windows, respectively. I cover them next.

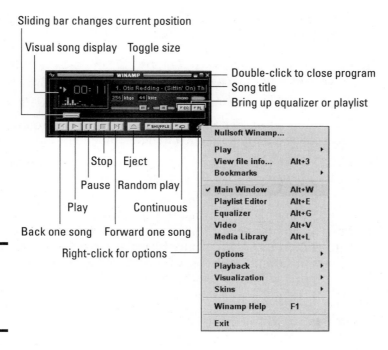

Figure 3-4: Winamp's basic control window.

Book III
Chapter 3

Playing MP3 Files on Your Computer and Home Stereo

Adjusting the equalizer

Winamp's equalizer adjusts the volume of various frequencies in a song, making it sound better according to your physical location, your mood, or the song's particular sound. Tweak the controls yourself, moving the bars up or down to increase or decrease the volume in certain ways. Slide up the bars on the left end to increase the bass, for example; move down the bars on the right to decrease the treble.

Click the Presets button to load custom-made sound settings, as shown in Figure 3-5. Choose the Jazz setting and close your eyes, and the band sounds as if it were playing in a smoky jazz club. Another setting puts that same band in a church or stadium.

Figure 3-5:
Click the EQ button and then the Presets button to see Winamp's equalizer settings for different environments and moods.

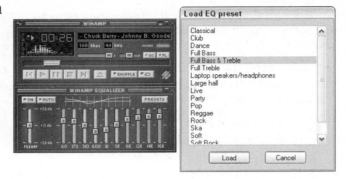

Here are a few pointers I recommend you keep in mind as you fiddle with the Winamp equalizer:

✦ If the Equalizer isn't working, turn it on by clicking the EQ button in the upper-left corner. (It lights up when turned on.)

✦ The ten-band equalizer controls frequency ranges from 60 Hz to 16 kHz.

✦ Don't be impatient when switching from different preset frequency settings. It takes a few seconds for the changes to be heard in the song.

✦ A Preamp bar on the left side increases or decreases the sound's volume before it reaches the equalizer. This not only affects the overall sound but also the overall volume.

✦ When playing through your computer's speakers, the sound may not change much — no matter how much you tweak the equalizer. When you hook up your computer to your stereo, as I discuss in the section "Connecting Your Computer to Your Home Stereo," later in this chapter, you can hear more subtleties in the sound.

Creating playlists

Want to hear the blues all night? Or a mixture of your Miles Davis and Frank Zappa MP3s? (Man, you do have eclectic taste!) Anyway, Winamp lets you create customized MP3 playlists for playback randomly, in alphabetical order, or in any order that you choose.

Creating a playlist is easy enough; click the PL button to bring up Winamp's Playlist window. Then drag and drop the files that you want to play into the Playlist window, as shown in Figure 3-6. As the songs drop into the window, their names and lengths appear.

Not into dragging and dropping? Each of the buttons along the bottom of the Winamp window help manage your playlist. Click the Add button, for example, to reveal the Add Dir button. Clicking the Add Dir button reveals a standard Windows file-browser box. Choose the directory where you store your MP3 files, and click the Open button to add them to the Playlist.

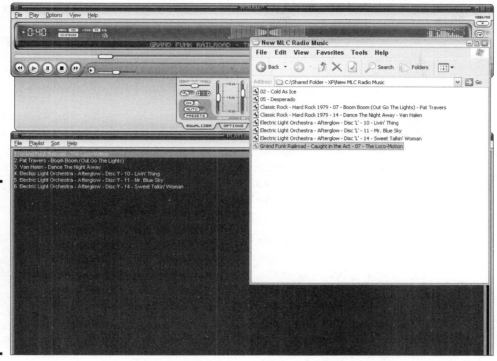

Figure 3-6:
Drag and
drop sound
files into
Winamp's
Playlist
window to
place them
in the
playback
queue.

As you create playlists in Winamp, remember these hints:

✦ After you load files into Winamp, click the Misc button to sort them alphabetically.

✦ To save a playlist, hold down your mouse button on the List Opts button in the playlist's lower-right corner. A menu pops up. Without releasing the mouse button, slide your cursor up to the pop-up menu's Save List option. Release the mouse button, and a window pops up in which you type the file's name.

✦ To load a playlist, repeat this process, but slide the mouse pointer up to the Load List option and then choose your playlist.

✦ As opposed to MP3 files, a Winamp playlist file merely contains text. Each line consists of a file's name, its path on the computer, and the artist's name and song that are listed on the ID tag. Winamp uses the playlist as a map when pulling files from different directories. Playlist files end with an M3U extension; MP3s end with an MP3 extension.

✦ The Misc button allows you to sort the list, create an HTML version of the list, and do other goodies. Feel free to experiment.

✦ To select all the songs that are loaded on Winamp's current playlist, double-click the Sel button. Press Delete or click the Rem button, and Winamp removes all those songs from the playlist. It doesn't erase any files, it just removes the songs from the current list.

✦ Click the Sel button once, and a menu appears. Choose Sel Zero from that menu, and Winamp *deselects* any songs that you've currently selected (but it leaves the songs on the playlist). Choose Inv Sel from

the Sel menu, and Winamp deselects any songs that you've currently selected and instead selects the songs that you hadn't selected. Yes, you have to play with these playlist buttons a few times before you figure them out completely. Just remember that they never delete any files; they just alter your playlist.

Using the minibrowser

Winamp's minibrowser is a tiny Internet browser — a little window for grunt-level Web chores. Hold down Alt and press T to bring up the Minibrowser window, as shown in Figure 3-7. From there, a single click leads you to the Winamp Web site to grab skins, plug-ins, and other goodies. Another click brings up an online store for MP3-inspired CD purchases.

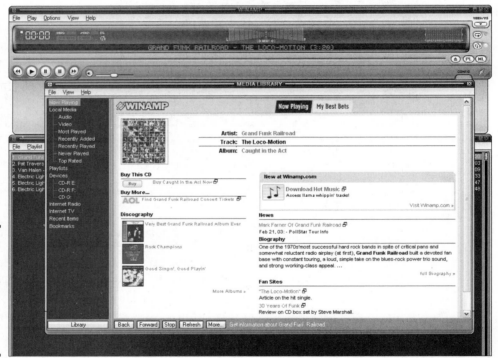

Figure 3-7: Winamp includes a minibrowser for those without a "real" browser.

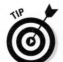

Be sure to check out SHOUTcast Radio, Nullsoft's collection of Internet radio stations. A list appears, showing the hour's most popular Internet radio stations. Click something interesting, and you join others who are listening through Winamp to hear an MP3 Internet radio station.

Customizing Winamp with add-ons

Although Winamp works great "out of the box," its users have made it even better by creating thousands of add-ons — from decorative *skins* to plug-ins for altering an MP3 sound. This section shows you how to find and install Winamp skins, plug-ins, and MP3 utilities.

Adding skins

Skins are just that — wraparounds for Winamp's face, giving it a new look. Thousands of skins are available, and if you have an Internet connection, Winamp automatically lets you check out the latest in skins. Found some eye-pleasers? Follow these steps to wrap them around your copy of Winamp:

1. Right-click the lightning bolt in the lower-right corner of the Winamp main window — the window with the play control buttons.

2. On the menu that appears, choose Skins and select Get More Skins!

Your Internet browser appears and opens the Winamp site to the Skins page.

3. Pick and choose from the available skins, and download the file(s) directly into Winamp's Skins folder.

Winamp automatically begins wearing the skin.

Skins are pretty cool things, folks, so I expect you'll be experimenting with them a lot; remember the following as you do so:

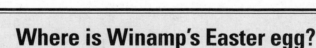

- ✦ To load a different skin, right-click the lightning bolt again and choose Skins; a window pops up to reveal all your installed skins. Click a skin's name, and Winamp quickly slips it on.

- ✦ Want Winamp's normal, default skin? Then choose Base Skin from the list of skins.

- ✦ Skins come in a wide variety of themes, including Anime, Cars, Futuristic, Games, Music, People, Retro, Sports, TV, and a bunch of others.

- ✦ When adding things to Winamp, start with skins. They're an easy way to introduce yourself to the program's fun. Just remember to choose Base Skin to return to normal if something looks too wild.

**Book III
Chapter 3**

**Playing MP3 Files on
Your Computer and
Home Stereo**

Where is Winamp's Easter egg?

Computer history buffs point back to the late '70s for the origins of "Easter eggs." Back then, savvy players of Atari's 2600 game console discovered a secret room with the programmer's initials hidden in the Adventure game cartridge.

Just as painters sign their paintings, programmers often place their own digital signature in their work. Dubbed an *Easter egg*, this signature requires you to enter a predetermined sequence of keystrokes in a precise order before it reveals itself.

After Winamp is installed and loaded, it plays back its "trademark" logo sound (the one about the llama). When you take the following steps, the logo appears across the top of Winamp, on its title bar:

1. **Open Winamp.**

2. **In this order, press N, U, and L.**

3. **Press Esc.**

4. **Press L.**

5. **Press Esc again.**

6. **Press S, O, F, and T.**

Winamp's logo appears on the title bar. Special keystrokes in older versions revealed the age of Winamp programmer Justin — calculated to the second — as well as a picture of him and his cat.

Using plug-ins

Skins merely change how Winamp looks. Plug-ins change what Winamp does and how it sounds. Check out Table 3-1 for a description of some of Winamp's built-in battalion of plug-ins. Figure 3-8 shows an example of a plug-in from WildTangent.

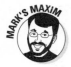

Table 3-1 only describes the plug-ins that currently come built in to the full version of Winamp. Winamp's Web site carries hundreds of additional plug-ins that were written and submitted by users to perform different and often more esoteric functions.

Table 3-1	Which Plug-in Does What?
Plug-in Type	*Function*
Input	Handles the player's guts: decoding MP3s, WMAs, Mjuice, Audiosoft, VOC (the old SoundBlaster format), CDs, MIDI, and MOD. Users add their own plug-ins for different formats and fun.
Output	Converts your songs into other file formats: WAV, WMA, Microsoft DirectSound (allowing you to hear music while a game is using your sound card, for instance), and files that are ready to be copied onto a home stereo–format CD.
DSP/Effect	Digital Sound Processors add reverb or chorus, strip the singer's voice, or tweak the audio in other ways.
General Purpose	Various. Anything that doesn't fit into other categories appears here: DJ tools, cross-fading mixers, 3-D sound controllers, equalizers, the song looper, alarm clocks, and other Winamp-influenced bursts of creativity.
Media Library	Organizes, sorts, or otherwise "pumps up" the default options within your Winamp Media Library.

Figure 3-8: WildTangent released a holiday visualization of a woman in a Santa costume dancing to the beat.

Remember the following things about plug-ins:

✦ For years, only well-heeled "hi-fi" enthusiasts could afford to collect the latest equipment, always testing their sound with the latest gadget. Winamp lets users play with more gadgets than they have time for. And for the most part, everything's free.

✦ To load an effect, right-click the lightning-bolt symbol in the lower-right corner of the Winamp window, choose Select Preferences from the Options menu, and click the desired category of plug-in. Choose a plug-in from within that category, and click the Start, Stop, or Configure button to stir things up.

✦ You can configure most plug-ins to your taste. Highlight your plug-in, and click the Configure button. The About button reveals the plug-in version number and author.

Other MP3 Players and Encoders

Of course, Winamp isn't the only program that encodes MP3s. Other top player/encoder applications are as follows:

✦ **iTunes** (www.apple.com): Don't get me started on how thoroughly Apple has energized the digital music scene — and iTunes has been a big part of it. This program does it all with aplomb . . . and it plays, rips, and records for absolutely free. It also provides Windows users access to the Apple iTunes Music Store. Read all about it in Chapter 8 of Book III.

✦ **Musicmatch Jukebox** (www.musicmatch.com): This application plays, organizes, and creates MP3s — for free. An extra $20 gets you the professional version, which rips CDs into MP3s and burns CDs much faster, automatically tags your new MP3 files with information from the Internet, and does other goodies. I delve into Jukebox in Chapter 7 of Book III.

✦ **RealPlayer Jukebox:** Although not as fully featured as Musicmatch, RealPlayer Jukebox (www.real.com) does the job, playing and ripping MP3s from your CDs and burning new audio discs.

The Other MP3 Players

Hundreds of programs play MP3 files. If you're not enamored with Winamp, head to www.cnet.com and visit the MP3 Players section. You can find plenty of players to sample for just about every variety of operating system.

Here's a brief look at two of the more popular MP3 players that you may run across. They don't create MP3s; they just play them back.

Windows Media Player

When Microsoft entered the MP3 player race, the corporate giant simply added MP3-playback capabilities to the sound arsenal of Windows Media Player. The result plays MP3s and a wide variety of other audio and video formats.

Microsoft also whipped up a new music-compression format to compete with MP3. Dubbed WMA, or *Windows Media Audio,* by Microsoft creative titans, the new version is half the size of MP3 files, reducing download time.

The WMA format is incompatible with MP3, however, and sometimes you can't freely copy it because it contains a rights-management system for copyright holders.

The version of Media Player that's bundled with Windows 98 sometimes can't play MP3s. If this is the case, you need to download a newer version of Media Player. (The free program is available at www.microsoft.com — head to the Downloads section.)

✦ Media Player is a convenient, albeit awkward, freebie, but it isn't nearly as configurable as Winamp or Musicmatch.

✦ Owners of portable MP3 players sometimes use the WMA format because the files are usually half the size of an MP3 file. That's because MP3 must generally be formatted at 128 Kbps for near-CD quality sound, whereas WMA sounds nearly the same when formatted at 64 Kbps. That makes the files half the size, so twice as many files can be stuffed into a portable MP3 player. However, keep in mind that not all players can handle the WMA format.

Sonique

Sonique (www.sonique.com) breathes cool. This free program changes shapes, supports skins and plug-ins, handles Internet radio, and plays MP3s. Figure 3-9 shows one configuration of the interface; other faceplates blink and swirl like Las Vegas neon. The program features attractive skins, an equalizer, and user playlists, and best of all, it sounds great.

Figure 3-9: Just one configuration of the Sonique interface.

Sonique plays them all, including MP3 files, Microsoft Windows Media files, music CDs, and other formats. Check it out for kicks, and see if you don't get hooked. Beware, though: Sonique has a rather bizarre user interface. Instead of Winamp's buttons and menus, Sonique uses an odd collection of knobs and widgets that take some time to figure out.

Changing Your Default MP3 Player

MP3 players have big egos. As soon as you install one, it assumes that you want it to automatically play all your sound files, including MP3s, CDs, and any other piece of sound that's on your hard drive.

And that's the problem. What if you don't like this newcomer and want to switch back to your old player? If you're lucky, it's as easy as clicking a button.

For example, to reassign MP3-playing rights to Winamp, follow these steps:

1. **Right-click the lightning bolt symbol in the lower-right corner of the Winamp window, select Options, and choose Preferences.**

2. **Choose File Types, and click the All button.**

 When you click the Select All button, Winamp highlights all the file types that it supports.

 To ensure that you don't lose Winamp as your default player in the future, select the Restore File Associations at Winamp Start-Up check box.

3. **Click the Close button, and Winamp grabs back its abilities.**

Most MP3 players come with a similar method for reassigning their MP3-playing rights. If you spot it, use it — it's much simpler than the Windows method that follows in the next section.

Assigning an MP3 Player to Your MP3 Files (The Hard Way)

If the wrong MP3 player leaps into action when you double-click a song — and you can't fix the file associations from within the correct program — follow these steps to change the MP3 player that is assigned to MP3 files under Windows XP:

1. **Right-click any MP3 file in Windows Explorer and choose Open With.**

 Windows displays the Open With dialog box.

2. **When the list of programs pops up, select Choose Program.**

3. **In the Recommended Programs list, choose the program that you want to play your songs by clicking the program's name.**

 If a specific player you've installed doesn't appear in the list, click the Browse button, navigate to the program on your system, click to select it, and then click the Open button.

4. **Select the Always Use the Selected Program to Open This Kind of File check box.**

5. **Click OK to save your changes.**

Now, whenever you click an MP3 file, your newly selected MP3 player should pop into action to play it.

If you experiment with several different MP3 players, each player tries to set itself up as the default player. Following this procedure lets you choose the player that should automatically jump up and begin playing MP3 files.

When you first listen to an MP3 file being played back from download.com or amazon.com, a dialog box will probably appear. Select the Open This File from Its Current Location check box. Then deselect the Always Ask Before Opening This Type of File check box.

Playing Songs on Your iPod with Your Mac

Naturally, Apple is overjoyed if you play your iPod music on your Mac through your Mac's speakers. (And on other Macs, too — see the Check It Out section, "Playing Songs on Your iPod with Another Mac.") Depending on your Mac model, you may already have excellent speakers, but you can also connect high-quality speakers to your Mac using the Mac's lineout connection (if you have one) or headphone connection (every Mac has one of those). When you play music in iTunes, it plays through those speakers.

Okay, you uber-technowizards in the audience may be on to me, but it's really no big deal. Here's the scoop: iTunes can play both MP3 and AAC files (the latter type is short for Advanced Audio Coding, Apple's latest digital audio format). Unless you choose File⇨Get Info while a song is highlighted in the iTunes list, I'll bet you can't tell whether you're listening to a song in MP3 or AAC format. Therefore, although this chapter is supposed to be about MP3 songs, the stuff in this section applies equally to AAC files. Now, don't we all feel better?

If you're short on hard drive space, use the iPod to hold all your music. For example, I use a laptop on the road as a portable stereo, but the iTunes music library is essentially empty to save the laptop's hard drive space for other things. I therefore have access to one or more iPods using my laptop version of iTunes, and I can leave my music library on my home computer. *Sassy!*

You can play the songs on the iPod using iTunes. When you set your iPod to manually update and connect the iPod to your Mac (any iPod, not just yours), the iPod name appears in the iTunes Source list. When you select an iPod name from the list, that iPod's songs appear in the iTunes window.

To play music on your iPod in iTunes, follow these steps:

1. **Connect the iPod to your Mac, holding down the ⌘ and Option keys to prevent automatic updating.**

2. **Set your iPod to update manually.**

 To set your iPod to update manually, see Chapter 12 of Book III.

3. **Select the iPod name in the iTunes Source list.**

 After selecting the iPod in the iTunes Source list, the list of songs on the iPod appears, as shown in Figure 3-10. You can scroll or browse through the iPod songs just as you would in any iTunes library.

The iPod in the Source list.

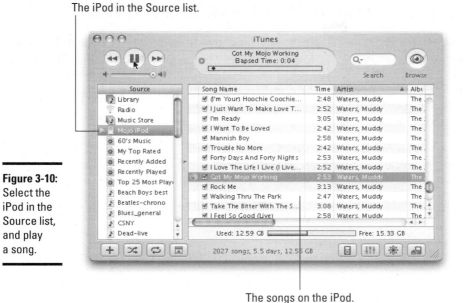

Figure 3-10:
Select the
iPod in the
Source list,
and play
a song.

The songs on the iPod.

4. (Optional) View the iPod playlists.

After selecting the iPod in the iTunes Source list, you can click the triangle next to its name to view the iPod's playlists, as shown in Figure 3-11.

5. Click a song in the iPod song list, and click the iTunes Play button.

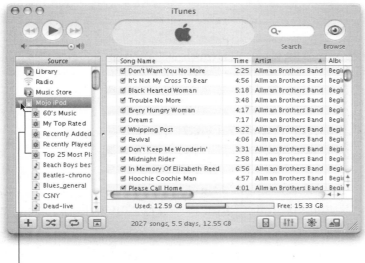

Figure 3-11:
View the
playlists on
the iPod (in
iTunes).

Playlists on the iPod.

 When you play an iPod song in iTunes, it's just like playing a song from the iTunes library or a track on a CD. The status display that's above the list of songs tells you the name of the artist and the song (if known) as well as the elapsed time.

Connecting Your Computer to Your Home Stereo

The speakers that are connected to many computers sound like squawking menus at drive-up fast-food joints. To improve the sound, ditch the tinny speakers and connect your computer to your home stereo. Just run the right-sized wires between the right places to turn your computer into a mighty combination MP3/audio CD player. These two points will speed you on your way:

✦ **Tools you need:** A Y-cable (a ⅛-inch stereo plug with two RCA phono plugs, usually red and green; see Figure 3-12) and an extension cable that's long enough to connect your computer and stereo.

✦ **Cost:** $5 to $10, if the sound card didn't already come with the correct cable.

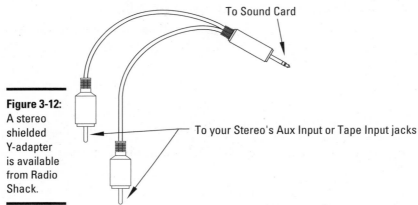

To Sound Card

To your Stereo's Aux Input or Tape Input jacks

Figure 3-12: A stereo shielded Y-adapter is available from Radio Shack.

Keep the volume turned down on the stereo and also on the sound card while connecting the cables — you don't want to pop anything.

To connect your computer to your home stereo, follow these steps:

1. **Turn down the volume on your stereo and sound card.**

Turn down the stereo's volume knob, which is usually pretty easy to find.

If you can't find your sound card's volume knob — which is either somewhere on the back of the card or through its software program — simply turn off your computer (after saving any open files, of course).

2. **Find the correct cable.**

You need a shielded Y-adapter cable (refer to Figure 3-12). This cable has a stereo ⅛-inch plug on one end and two RCA phono plugs on the other end. You can find the cable at Radio Shack. Other electronics stores and some computer stores carry the cord as well.

The package of a stereo Y-adapter cable refers to it as "a male stereo ⅛-inch plug to two male RCA plugs." That sounds confusing, but that's often what the package says.

The best sound card manufacturers throw the cord in for free; others make you head to Radio Shack. If your computer and stereo aren't very close together, pick up a 12-foot stereo cable. A 20-foot stereo cable provides even more room. If your computer and stereo are more than 20 feet away, ask the Radio Shack salesperson how to buy the right cable and plugs to make your own extension cable.

3. **Plug the ⅛-inch stereo plug into your sound card's speaker jack.**

 Hopefully your sound card has all its little jacks labeled so that you know which hole does what. If it doesn't, you have to open the card's manual. Then run the extension cord between your computer and your stereo system.

 If you have a carpet, push the cord into the crack between the carpet and the edge of the wall. Use the right tool for the job: A spoon handle works well. No carpet? One alternative is to buy a rug . . . but whatever you do, don't leave the cord laying across the floor. If somebody trips over it, he will pull out the plug — and the music will stop.

4. **Plug the cable's two RCA phono plugs into the stereo's Aux Input or Tape Input jacks.**

 Check the back of your stereo for some unused input jacks; you should see several pairs of stubby little metal heads. Use the Aux Input or the Tape Input jacks — whichever ones aren't being used.

 One jack of the pair is probably red or labeled "Right" — push the cord's red plug into that jack. The other jack is probably black, white, or green — this jack is for your other plug, no matter what color it is.

 Don't plug your sound card's output into your home stereo's Phono Input jack. Your stereo doesn't expect such a strong signal from that jack. (If you throw caution to the wind and plug the cord in there anyway, keep the card's volume *very* low.)

5. **Turn on the stereo, and switch it to Tape Input or Aux Input.**

 Turn the stereo's input select switch to the jack that you've used, either Tape Input or Aux Input.

6. **Play an MP3 file on the sound card, and adjust the volume.**

 Gradually turn up the volume on your stereo and sound card. If everything is hooked up right, the sound should start filling the room.

 If the sound doesn't start filling the room, make sure that the stereo is turned to Aux Input or Tape Input — or whatever input jack you plugged the sound card into. If the stereo isn't turned to the correct input switch, your sound card won't come through. (Oh, is the stereo plugged in and turned on?)

Unfortunately, your home stereo isn't always a friend. It reveals the shortcomings of a cheapie sound card, for instance, as well as an MP3 encoder that's not quite pulling its weight.

Book III
Chapter 3

Playing MP3 Files on
Your Computer and
Home Stereo

CHECK IT OUT

Playing Songs on Your iPod with Another Mac

To connect your iPod to a Mac other than your own and play your iPod songs, follow these steps:

1. **Follow the steps in the "Playing Songs on Your iPod with Your Mac" section.**

However, after connecting your iPod to the other Mac in Step 1, iTunes starts up and displays the following message:

> This iPod is linked to another iTunes music library. Do you want to change the link to this iTunes music library and replace all existing songs and playlists on this iPod with those from this library?

2. **Click the No button.**

By clicking the No button, you change that computer's iTunes setting to update

manually. You can then play songs on your iPod, add songs from that computer to your iPod, and even edit your iPod playlists and song list using that computer.

Unless you want to change the contents of your iPod to reflect this computer's music library, don't click the Yes button. If you click the Yes button, iTunes erases the contents of your iPod and then updates the iPod with the library on this computer. If you're using a public computer with no music in its iTunes library, you end up with an empty iPod . . . this is considered the quintessential definition of A Bad Thing. If you're using a friend's computer, your friend's library copies to your iPod, erasing what was in your iPod.

Chapter 4: Internet Radio on Your Computer

In This Chapter

- ✓ Discovering Internet radio stations
- ✓ Considering the legalities of Internet radio
- ✓ Getting the scoop on SHOUTcast radio stations
- ✓ Figuring out what equipment you need to get started
- ✓ Tuning in to SHOUTcast
- ✓ Webcasting through SHOUTcast

If you've perused Chapters 2 and 3 of Book III, you're well aware of how MP3 technology turns PCs into jukeboxes packed with music. Portable MP3 players let you listen to "Stairway to Heaven" during the next Perseids meteor shower.

But wait, there's more: MP3 technology lets anybody tune in to the thousands of MP3 radio stations now heard through the Internet.

This chapter shows you how to tune in to those stations and create your own personalized stations that play your favorite songs. Or, if you're hankering to be a DJ and willing to spend an hour or two configuring your computer's software, check out SHOUTcast, which gives you the chops to create your own radio station, capable of sharing your favorite music with listeners worldwide.

What's an Internet Radio Station?

Some people fill up their garages with stuff they just *know* they're going to use someday. They might not use it, but hey, it's there if they ever want it.

The same goes for MP3 files. Some people grab every MP3 they can find and stuff them onto their hard drives. These folks may not play the songs very often — if at all — but they've created one heck of a library. (If only MP3s didn't take up quite so much hard drive space. . . .)

To combat the MP3 storage problem, many MP3 fans are eyeing an increasingly popular alternative, and that's Internet radio. Because MP3 files are so small, they can be broadcast — *Webcast* — across the Internet. And because the Internet allows for two-way communication, it's easier than ever to find or even create a radio station that plays your favorite music.

If I Webcast, am I gonna get busted?

Like everything else associated with MP3s, the legalities of Webcasting are currently in a state of flux. Parts of the law are spelled out in vivid detail, especially the details of how to pay $20 for a "statutory license" that handles the royalty payments. To qualify for the statutory license, however, Webcasters must meet a healthy list of requirements. Here are just a few:

- In any three-hour period, you can't play more than three songs from a particular album or more than two consecutively, and you can't play four songs by a particular artist or boxed set, including no more than three songs consecutively.

- You can't say in advance what particular song you'll play or when you'll play it.

- If you're continuously playing a recorded program, the show must be longer than three hours long.

- You must identify the song, the album, and the artist when Webcasting. (SHOUTcast handles this, so you're safe.)

- You can't encourage listeners to copy your transmissions, nor allow them to make copies, if possible.

- You must pay royalties.

As of this writing, nobody's decided on a scheme for calculating royalty payments. The easiest way, however, is to operate under a statutory license by filing an Initial Notice with the U.S. Copyright Office before Webcasting.

For the most current information on Webcasting legalities, contact the RIAA at `www.riaa.com`, or read up on it on the SHOUTcast site at `www.shoutcast.com`. Finally, to read the law yourself, head to `lcweb.loc.gov/copyright/legislation/dmca.pdf` and read the text with Adobe Acrobat Reader — I warn you, however, that this is *not* light reading.

The more you think about it, the better those Webcasts sound, huh? Following are some of the benefits of Internet radio:

- ✦ Internet radio stations don't fill up your hard drive with MP3 songs. Instead of saving the songs, you simply listen to them, just like any other radio. Depending on how you set up your software, you can also view the current song's name and creator.

- ✦ Musicmatch, Rolling Stone, Napster, Winamp, and hundreds of other Internet sites now broadcast music directly from their Web sites. (If you don't like corporate stuff, head for SHOUTcast, which I describe in the next section. Many of those stations are run directly from the computers of music fans like yourself.)

- ✦ Luckily, most Webcasting radio stations don't have commercials (thank goodness).

- ✦ The Internet carries an incredible variety of music, much more than what you'd hear within your local radio's reception area. Instead, you can listen to Korean pop, Indian sitars, African rhythms, or '60s rock, or stations that match your music mood for the day.

- ✦ The Internet lets you create personalized radio stations. Musicmatch Jukebox, for instance, lets you choose your favorite artist, click a button, and hear a station playing music by that artist, as well as other musicians playing that type of music. If you allow it to do so, Jukebox will

even keep track of the MP3s you listen to and create a personalized radio station based on your musical tastes. (I cover Musicmatch Jukebox in Chapter 7 of Book III.)

The better your modem connection, the better your Webcast music sounds. Cable and DSL users have near-CD quality music. Stations don't sound nearly as good with a dialup modem, but the music may still sound as good or better than your FM radio.

What's a SHOUTcast Radio Station?

Nullsoft, the corporate arm of the folks who created Winamp, created the popular SHOUTcast radio to let Winamp users share their musical tastes with the world. (Good news, Mac owners: SHOUTcast is now available for Mac OS X as well as Linux!)

Tuning in to a SHOUTcast radio station is pretty easy. First, make sure that you've installed a copy of Winamp. (Grab a copy at www.winamp.com.) Next, log on to SHOUTcast at www.shoutcast.com, and you're ready to start listening.

The last time I signed on, SHOUTcast had 67,505 listeners tuned in to 6,397 different Internet radio stations. Click a station from the list, and Winamp begins playing the station's music. In the "Listening to SHOUTcast" section, later in this chapter, I describe the process in more detail, but in the following list, I give you the highlights:

✦ Radio stations aren't *broadcast* through the Internet. The term *broadcast* refers to airwave transmissions. No, Internet radio stations are being *Webcast.* (Some Internet radio DJs are picky about that.)

✦ A SHOUTcast radio station is essentially an Internet feed from a copy of Winamp running on somebody's computer. Basically, you're listening to what's playing on the Webcaster's copy of Winamp. When you tune in, you start listening in the middle of the stream — a song won't start at the beginning.

✦ By adding additional software and tweaking your settings, you can configure your own copy of Winamp to Webcast over SHOUTcast. Depending on the speed of your Internet connection, you're limited to anywhere from one listener to several hundred.

✦ It's *much* more complicated to Webcast your own station than it is to listen to an existing station. You can still do it, though, as you find out in an upcoming section.

✦ The faster your Internet connection, the better the stations will sound when listening. The same goes for Webcasting: Faster connections let more people listen.

✦ Yes, it's completely legal to listen to Internet radio, and it's free. If you're Webcasting your own station, however, head for the Recording Industry Association of America Web site (www.riaa.com) to see its recommended procedures.

What Equipment Do I Need for SHOUTcast?

Forget about the transmission towers, stacks of paperwork, huge legal fees, or even an expensive radio. To listen or broadcast on SHOUTcast, you need the following equipment:

✦ **A computer that's powerful enough to play MP3s through Winamp:** I talk about Winamp extensively in Chapter 3 of Book III.

✦ **A copy of Winamp:** If you're running Windows, any version above 2.5 will do. Download the latest version from www.winamp.com — the Basic version is free. (Computers running Mac and Linux will have different requirements — for more information, visit the SHOUTcast Web site and take advantage of the online instructions and documentation.)

✦ **An Internet connection:** You can listen with a 56K modem, although the sound improves considerably as your connection speed increases. And, theoretically, you *can* broadcast with a 56K modem, but you can reach only one listener. A 56K modem simply isn't fast enough. Bummer. To reach more listeners, you need DSL, a cable modem, or something even faster.

✦ **SHOUTcast software:** To set up your own station, download the required software on the SHOUTcast Web site at www.shoutcast.com.

Listening to SHOUTcast

After you install your copy of Winamp, follow these instructions to tune in to a station:

1. **Make sure that Winamp has registered the PLS file extension.**

After installation, Winamp is automatically configured to play MP3s and most other sound file types. But make sure that Windows knows to send the SHOUTcast Webcast to Winamp. Open Winamp and press Ctrl+P. Then, as shown in Figure 4-1, make sure that PLS is highlighted in the Associated Extensions list along with MP3 and other optional file types.

2. **Head to SHOUTcast at** www.shoutcast.com **with your Internet browser.**

You can start listening right from the main page.

Figure 4-1:
Make sure that pls is highlighted in the Winamp Associated Extensions list, as shown here.

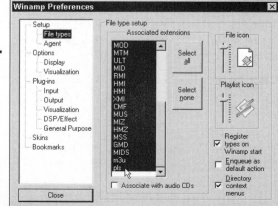

3. Choose a station matched for your connection speed.

First, examine the stations' descriptions until you find one that you like. When you first log on, SHOUTcast displays stations sorted by popularity.

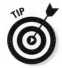

Don't like the popular stations? Choose your favorite genre from the Jump To drop-down list box. Or you can type a word describing your musical tastes in the Search For box and click Go. Either way, SHOUTcast dishes up currently broadcasting stations that meet your needs.

Next, look in the column on the far right to find the *bit rate* for the stations you're interested in. Be careful to choose a station that your modem can handle. If you have a modem with a 56K dialup connection, choose stations transmitting at less than 56; for example, all the stations shown in Figure 4-2 have bit rates of 48. If you start hearing skips or gaps in the sound, choose a station that's Webcasting at a lower bit rate.

4. Click the station's Tune In button.

Winamp begins playing the station (see Figure 4-3).

5. Configure your browser, if necessary.

Depending on how your browser is configured, this step might take place when you tune in to a station.

Internet Explorer: When you tune in to a SHOUTcast station, Internet Explorer sometimes sends a message, asking whether it should open this file from its current location or save this file to disk (see Figure 4-4). Select the first option — Open This File from Its Current Location. If possible, deselect the Always Ask Before Opening This Type of File check box. Without this option checked, Internet Explorer will always begin playing playlists when you click them.

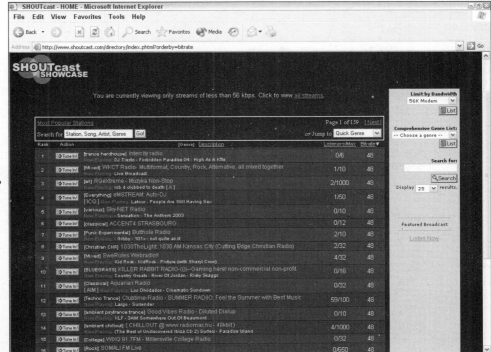

Figure 4-2: Choose a station that Webcasts at a bit rate that's lower than your modem speed, or the sound will skip.

Figure 4-3:
What you
see after
clicking the
Tune In
button.

Figure 4-4:
Choose the
Open This
File from Its
Current
Location
option.

Netscape Navigator: When you first click a SHOUTcast station, Netscape brings up the box shown in Figure 4-5, which has four buttons: More Info, Pick App, Save File, and Cancel. Click Pick App, and when the next box appears, type the location and name of Winamp. (If you chose the default Winamp location during installation, you should type `C:\program files\winamp\winamp.exe`.) Click OK, and you're through.

Figure 4-5:
Click the
Pick App
button.

Your computer loads Winamp and begins playing the station.

6. If that station turns out to be less than ideal, click a different one.

After a few moments, Winamp begins playing the new station's songs.

That's it — unless you want some more information, which appears in the following list:

✦ The next time you load Winamp, the program remembers which station it previously played. Click the Winamp Play button — the same button that starts playing MP3 files — and, if the station is still Webcasting, Winamp will begin playing the station.

✦ Can't find a cool station you heard a few days back? Load Winamp and press Ctrl+L to see the Open Location window. Click the downward-pointing arrow, and Winamp lists all the locations of the last few dozen stations you've listened to. Click each one until you find your favorite.

✦ When listening with a low-speed, dialup modem connection, any sort of Web surfing or page flipping often causes skips in the sound. The solution? Don't Web surf while listening, or get a cable or DSL connection.

✦ Using a proxy server on a network? You can still listen, if you tell Winamp about it. Load Winamp, press Ctrl+P, and click Setup. Under Internet Settings, click the Using LAN Internet Connection button. Then type your proxy into the HTTP Proxy text box.

✦ Modems rarely receive information at their labeled speed. A 56K modem usually can't keep up with a 56 Kbps SHOUTcast Webcast. That's because 56K modems usually receive at around 40K to 48K per second, depending on their brand and the quality of the Internet connection. Luckily, SHOUTcast carries stations that Webcast at a variety of rates to support many modems.

✦ To find out more information about a particular station, slide your mouse over the words in the site's Genre (Description) column and look for underlined words. The underlined words usually link to the station's Web site, which often displays the information you're looking for about the station.

✦ When you connect your computer to a home stereo and use a cable modem, some Webcasts sound just as good or better than an FM radio station.

Setting Up Your Own SHOUTcast Radio Station

When you've grown familiar with listening to Webcasts, and you're ready to set up your own station, these instructions will put your tunes on the Net. The good part is that it's free. The unfortunate part is that it's dreadfully complicated and generally accompanied by much gnashing of teeth.

First, don't try Webcasting unless you're running a reasonably fast (300 MHz) or faster PC running Windows XP, NT, or 2000. (Okay, you can use Windows 98 or Me, but remember that they're nowhere as stable as The Big Three.) You also need Winamp 2.65 or better, plus a whole lotta MP3s.

You need to have an Internet service provider, which you probably already have or you couldn't have downloaded these goodies. Make sure that you're using a decent ISP that keeps everything flowing smoothly.

I'll be honest with you — aren't I always? The SHOUTcast server has a *ton* of highly configurable features, settings, and other advanced hoo-hah, and I just don't have the room to give it a full description here. However, the procedure coming up should get you started with the default settings, and you can eventually graduate to the professional stuff after you become familiar with how things work. (Luckily, you'll find plenty of online documentation on the SHOUTcast Web site, ready for your perusal. More on this at the end of this chapter.)

Finally, many ISPs will shut you down if you're caught running a server from your computer — take care.

Follow these steps to get started with SHOUTcast:

1. **Log on to the SHOUTcast home page (**www.shoutcast.com**) with your Internet browser and click the Download button.**

 The Download SHOUTcast button is part of a string of options listed across the top of the page.

 When you click the Download button, the SHOUTcast download page appears. Three buttons appear on the page:

 • Be a Listener

 • Be a D.J.

 • Be a Server

2. **Click the Be a D.J. button.**

 A new page appears, containing all the necessary enhancements for Webcasting needed for Winamp. The rest of these steps walk you through each enhancement.

3. **Make sure that you're using the latest 2.x version of Winamp.**

 A shortcut link is thoughtfully provided at the top of the Everyone Wants to Be a D.J. page.

 Already have a copy of Winamp? I strongly recommend that you update to the latest 2.x version.

4. **Download and install the DSP Plug-In for Winamp.**

 When you click the link entitled Download the Latest Version of the SHOUTcast Broadcasting Tools for Winamp 2.x at the top of the page, the page jumps to the section about downloading the SHOUTcast DSP. Find the line mentioning the SHOUTcast DSP Plug-in for Winamp 2.x and click the Click Here link to begin the download. Your browser downloads the file to whatever directory you choose.

 Make sure Winamp isn't running; then install the downloaded DSP Plug-in program, following its instructions.

This particular plug-in sends the music currently played by Winamp to the SHOUTcast server, where it can be Webcast. It's considered the *source*.

5. **Open Winamp and press Ctrl+P to begin configuring the software.**

 This is the beginning of the hard part, although the folks at Winamp have made it easier over the years.

6. **Click the DSP/Effect area and choose SHOUTcast Source for Winamp.**

 A new dialog box pops up, as shown in Figure 4-6. (I told you this was complicated.)

7. **Click the Encoder tab.**

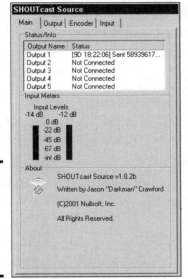

Figure 4-6: Where it all happens — the SHOUTcast Source dialog box.

Make sure that MPEG Layer-3 is chosen under Encoder type. (It's probably already selected.) Also, if you have an older PC or you're sharing a single cable or DSL Internet connection among multiple computers, I recommend that you choose a lower sound quality and mono Webcasting in the Encoder Settings drop-down list. It will likely take some experimentation before your system and your broadcast run smoothly, but 56 Kbps is a good place to start.

Alternately, you can use a speed of 24 Kbps Mono while you're testing and then gradually increase the rate (and switch to stereo if possible).

8. **Click the Output tab.**

 Type a password into the Password field — keep it between five and seven characters, and make sure that you remember the case. (You'll need it later.)

 The default values for the other settings should work for most folks, so click OK to close the window.

At this point, you've set up Winamp, and your source is ready. Now it's time to download and set up the SHOUTcast server software on your computer.

9. Log on to SHOUTcast's home page with your Internet browser and click the Download button.

The Download button is part of a string of options listed across the top of the page. Feeling a sense of déjà vu? Yep — you were here before in Step 1.

10. Click the Be a Server button.

Last time you were here, you clicked the Be a D.J. button. That led you to configure Winamp as the source for your tunes. Now, it's time to set up the SHOUTcast server software to send those tunes out onto the Internet.

Setting up the server requires three steps. Here goes.

11. Download the latest version of SHOUTcast Server.

Click the Proceed to License Agreement to Download SHOUTcast DNAS link. After accepting the legalities, download the version for your operating system. You'll probably choose Windows, but versions are available for Mac OS X, Linux, Solaris, and FreeBSD as well.

Save the file to a spot on your computer where you can remember to find it in the next step.

12. Unzip and run the downloaded SHOUTcast Server installer.

After the program installs itself into a SHOUTcast folder in your C drive's Programs folder, its ReadMe file pops up.

13. Read the ReadMe file.

Yes, it's complicated, but you must read it in order to figure out what's going on. The biggest problem is your Internet connection. If you want to broadcast to 100 listeners at a mere 24 Kbps, you need 2,400 Kbps, or 2.4 Mbps of bandwidth. An average cable modem has only around 750 Kbps — barely enough to dish up a half-dozen listeners.

Also, you want a *clear* connection: no proxies, firewalls, networks sharing modems, and other conveniences.

When you installed the program, it installed the SHOUTcast Distributed Network Audio Server (DNAS). The DNAS accepts the broadcast feed from your newly configured Winamp; it then broadcasts that sound over the Internet to your listeners. It also lists your broadcast on the SHOUTcast Web site.

14. Edit the SHOUTcast DNAS configuration file.

Click the Windows Start button, choose Programs, and click SHOUTcast DNAS. From there, choose Edit SHOUTcast DNAS configuration. An odd-looking file then appears on-screen, as shown in Figure 4-7.

Most of this file consists of comments and instructions. (Any line beginning with a semicolon or the [symbol is a comment or label

and shouldn't be changed.) Only the following lines need an ogle (at least, until you want to perform advanced tweaks):

- **MaxUser=:** Choose a conservative number of maximum users for your server. Multiply your modem's speed by 0.9 and divide that by your bit rate. For example, if you have a bit rate of 24, a 56K modem's dialup connection would reliably support a single listener.

 Best yet, start with a MaxUser of 1, just to get the thing up and running. Then you can increase your users as you fine-tune everything.

- **Password=:** This must be the same password that you entered in Step 8.

Again, you can begin Webcasting with everything else left at the defaults for now, so click the Close button in Notepad to save the file.

15. **Load the SHOUTcast Server.**

Click Start, choose All Programs, and click SHOUTcast DNAS. From there, choose SHOUTcast DNAS GUI. The server leaps to the screen, waiting for you to run Winamp (see Figure 4-8). It places its tiny icon next to the clock on the Windows system tray.

16. **Load Winamp and click the Connect button to start Webcasting.**

Watch the words next to the Connect window; they should say `Connecting to Host`. Finally, list the number of bytes of music you've Webcast. If everything has worked out the way it should, you're sharing your tunes with the world. If not, you'll probably see some sort of an error message.

Figure 4-7: Edit the SHOUTcast DNAS configuration file very carefully.

Figure 4-8:
The soon-to-be-very-familiar face of the SHOUTcast server.

And what do you do if you see an error message? Your first step is to read the ReadMe files that came with the Winamp plug-in and the SHOUTcast server program. There's some complicated stuff in there, and a single mistake can ruin everything. Still having problems after perusing the ReadMe files? Here are some other troubleshooting tips (although I hope you don't need 'em!):

✦ Head to the SHOUTcast Online Documentation at `www.shoutcast.com/support/docs`. You'll find excellent descriptions of how to fix problems.

✦ Remember that firewalls of all sorts can interfere with your Webcasting (including the built-in firewall in Windows XP). Therefore, you may have to allow connections to your machine at address 8000 so that others can access your music. Again, check the online SHOUTcast documentation and consult your firewall settings.

✦ Read the SHOUTcast Web site forums. If something is confusing to you, it will have already confused somebody else. Chances are, you'll find an answer there.

✦ Before posting on the SHOUTcast Web site forum, be sure to pour over the ReadMe files and the Online Documentation. Although forum members are willing to help people with problems, they're often irritated by people who haven't taken the time to grasp the basics of Internet Webcasting.

✦ SHOUTcast offers some promos that do play along with your playlists — things like, "Milking our bandwidth for all it's worth with SHOUTcast streaming audio!"

Chapter 5: Attending Internet Concerts

In This Chapter

✓ **Finding netcasts of concerts**

✓ **Listening to concerts**

✓ **Chatting with the stars backstage**

Nothing beats seeing your favorite artist in concert. And nothing's worse than not being able to see anything. Oftentimes, a concert tour inconveniently bypasses your hometown. Or maybe the show comes when you have other — unbreakable — plans.

That's where concert netcasts come in.

With a few clicks, you can tune into live and archived online broadcasts of musical events and concerts from around the world. All kinds of artists have been cybercast online, including the following hit-makers:

✦ Maroon 5

✦ Paul McCartney

✦ Alanis Morissette

✦ Jet

This chapter shows you how to get set up, where to find the shows, and what you can do along the way, including chatting with the band backstage.

Getting Ready

Tuning into concerts online is a lot less labor-intensive than going to a real show. No driving. No parking. No tickets to buy. No crowds.

The necessary hardware and software

To see and listen to online concerts, you need to have the following items (odds are, you already do):

✦ A computer (preferably a Pentium III or higher or a Macintosh G3 or higher)

✦ A modem (the faster, the better — ideally a 56-Kbps unit)

✦ External computer speakers (or a line out to your stereo)

✦ An Internet connection

✦ Streaming audio software, such as RealPlayer (shown in Figure 5-1), Windows Media Player, or QuickTime Player

On the downside . . .

Unfortunately, those who were performing and distributing live online music have encountered a number of setbacks in the recent past, including the following:

✔ Problems with copyrights and digital music protection groups

✔ Royalty payments (which have forced many Webcasters out of business)

✔ Competing streaming media formats

Due to these complications, online concerts are harder to find than they were just a couple of years ago. But take heart, good citizens: It may take a Google search or two, and some of the larger Webcasting sites may have dried up and blown away, but you can still find a wide variety of concert performances online. I give you a few tips for doing so in the section "Finding Concerts Online."

See Chapters 2 and 4 of Book III for more info on turning your computer into a lean, mean music machine.

After you're loaded up, all you have to do is find the sites, kick back, and enjoy.

A quick word about speed

Broadband — you hear about it all the time. The term means broad bandwidth or, in simpler terms, really fat streams of data or, in yet other words, fast Internet downloads.

Figure 5-1:
Hey, that's the latest version of Real-Player — good choice!

Most of us still live in the B.B. (that is, before broadband) era of the Internet evolution, using pitifully slow modems to access the Internet. A lucky minority (and you know who you are) live in the A.B. (after broadband) era; you operate in the world of T1 lines, DSL service, and cable modems. These folks can access the Internet at speeds many times that of a 56-Kbps modem.

Alas, you may run into some frustration when tuning into a live concert with your regular modem. Here's why: Streaming audio and video is not saved to your hard drive as it downloads, so you can't download it and play it later. You basically just connect and let the music play — much like a typical live radio program.

This means that you have to queue up while thousands — if not millions — of other listeners are tuning in. And the more listeners, the more crowded the data pipeline. The more data that's in the pipeline, the slower the download. The slower the download, the choppier the sound. Hence the frustration.

Concert netcasts can be really cool and fun. But ultimately, they are still somewhat of a novelty. If you want perfect sound, go to the show.

Finding Concerts Online

With so many events happening in so many places at so many times, you may find that you can't find everything.

But you can come close.

You can find online concerts in the following ways:

✦ **Surf specialty sites.** These sites regularly netcast live events.

✦ **Visit the home pages of concert halls and nightclubs.** Many clubs and halls netcast their own events.

✦ **Search streaming-audio guides.** These guides list countless live netcasts.

✦ **Join communities that hover around your favorite artist.** Check out Web pages or subscribe to mailing lists. The best way to keep up on a band, of course, is through the fans.

These days, not only can you listen to concerts online, but you can also watch them. More sites are beginning to carry live video netcasts of concerts. Unfortunately, if you're using a dialup connection, that data still has to squeeze through tiny phone lines — therefore, video quality may be pretty lousy. It may skip, hop, jump, cut, and putter out in the middle of your favorite song.

Specialty sites

The easiest way to find live concerts is to visit the sites that have made it their business to bring live events to the Web on a regular basis.

These sites are serious about letting you rock out at home. They send their own crews to every show, wire up the club, and then pump the music — in the form of 1s and 0s — to your PC.

Netcasting concerts is not a perfect science — even broadcasting live shows on TV is not without its potential mishaps. But netcasts, just like TV broadcasts, are the next best thing to being there.

The following sections give you some of the sites that specialize in bringing you online concerts.

RollingStone.com

In addition to providing their fill of news, reviews, and music culture reports, the Web site for *Rolling Stone* magazine (www.rollingstone.com) often streams live concert events. Naturally, you can also find interviews, all sorts of downloads, and video archives.

Virtue TV

Based in London, Virtue TV (www.virtuetv.com) has offered live Internet video broadcasts since 1998. In addition to interviews with film directors and media personalities, the site offers streaming video concerts — live and archived — from venues around England (and sometimes, even faraway places like Tokyo).

BBC Radio 3

For some of the best in classical, jazz, and world concerts online, visit the hallowed halls of the BBC — specifically, BBC Radio 3 — at www.bbc.co.uk/radio3. The weekly live broadcast schedule is available, and if you miss an event, you can listen to the archived RealAudio stream later.

Wired sites

Some concert halls are taking matters into their own hands. Instead of relying on another Web site to netcast an event, these venues do the work on their own.

Of course, tuning into a wired club means that you're not going to hear music from the place down the street. But you do get a prime seat for anything — and sometimes everything — that plays from the home page's home stage.

Check out the sites in the following sections.

Jazz From Lincoln Center

Jazz From Lincoln Center in New York City (www.jazzatlincolncenter.org/radio) has become a highlight concert series for jazz lovers around the world. Now, you can tune in online without having to make the trip to the big city.

The site carries Lincoln Center's award-winning productions, such as tributes to Louis Armstrong and Duke Ellington. You can also check out other productions that you may have missed in the sound archives.

Prairie Home Companion

If you're interested in live performances from all sorts of artists, the weekly online broadcast of Garrison Keillor's popular Prairie Home Companion (`prairiehome.publicradio.org`) always includes fine music mixed in with the humor. The diverse list of performers includes Randy Newman and bands like BeauSoleil. (Has Lake Wobegon really been around for 30 years?)

Guides for online concerts

If you want a larger view of the concerts that are taking place online, you can check out the following *TV Guide*–style sites to help you through the fray:

✦ The Windows Media Guide (`www.windowsmedia.com`) details live music events that are available in the Windows Media format. This site includes daily listings of major concert events and even in-studio radio station performances.

✦ Real.com Guide (`music.guide.real.com/concerts`) has a special subsection that's devoted to live concerts from sites across the Net. The types of performers are incredibly varied, ranging from chamber musicians to hip-hop artists.

Fan pages

Although fan pages may have plenty of information about a band, they're unlikely to netcast a concert themselves.

However, if you're wondering when a band is going to be performing online, checking in with other fans is a great place to start.

Going Backstage: Chatting with Bands Online

Book III
Chapter 5

Attending Internet
Concerts

Of course, the ultimate concert experience is going backstage to meet your favorite artist in person. The problem is that backstage passes aren't easy to come by.

Many sites that netcast concerts now offer the opportunity for fans to chat live with the bands, using chat programs that do not require a download. (Just follow the links with your browser to get things going.)

Often, these services convince a band to spend time at the keyboard before or after a show. After you log on, the artist takes your questions (which often go through a chat host first).

Some sites that offer chat are as follows:

✦ VH1 (`www.vh1.com`)

✦ MTV (`www.mtv.com`)

✦ Rolling Stone.com (`www.rollingstone.com`)

✦ Spin (`www.spin.com`)

Want to get your questions answered? If you're in an unmoderated chat room (that is, without a host), try addressing the artist by name before you ask your question (for example, "SHIN FAT: What's your favorite album?"). That's a great way to get someone's attention during the flood of questions.

If a moderator is screening the questions, state your question as succinctly and eloquently as possible. The more you stand out, the better your chances of getting a response.

Finding Shows That You Missed

The great thing about concerts on the Internet is that they never fade away. Long after the show hits the wires, you can surf around and listen to what you missed. Each of the following sites offers archives of shows for your listening pleasure:

✦ MTV (www.mtv.com)

✦ VH1 (www.vh1.com)

✦ Virtue TV (www.virtuetv.com)

Although you may have a favorite format and player for your streaming Internet urges, installing all of the Big Three players is always a good idea: RealPlayer, Windows Media Player, and QuickTime Player. That way, you're covered regardless of what format a concert takes.

Just because you can play back an archived show doesn't mean that it's yours to save. Because these netcasts are stored in streaming format, you can listen to them while you're connected, but not after the fact (that is, unless you have your computer connected to your stereo and you decide to tape the show).

Getting Concert Information

While you're kicking back and listening to your favorite artist perform live online, you may want to find out when that band is coming to town.

The following sites enable you to search for and get information about international tours:

✦ Pollstar (www.pollstar.com)

✦ JamBase (www.jambase.com)

✦ Mojam (www.mojam.com)

Of course, because you probably want to buy tickets for these events, you can also check the home pages of major ticket vendors, such as Ticketmaster (www.ticketmaster.com).

Chapter 6: Ripping CDs into MP3s

In This Chapter

✔ **Ripping songs from a CD**

✔ **Recording songs from albums**

✔ **Recording sound from TV or tape**

✔ **Recording sound from a microphone**

✔ **Editing recorded music or sound**

✔ **Quickly creating MP3s from CDs**

✔ **Organizing your growing MP3 collection**

✔ **Adding CD art to your MP3 collection**

✔ **Automatically filling out your MP3 tags**

✔ **Listening to Internet radio with Musicmatch Jukebox**

*T*he term *ripping* basically means copying sounds from a CD onto your hard drive. MP3 aficionados use the word *ripping* because they're tearing the digital sound from CDs and copying those numbers onto their hard drives. Besides, ripping sounds more cool than copying.

This chapter shows how to rip songs from your own CDs into your computer, where you convert them into MP3 files. It also shows you how to record albums, camcorder soundtracks, TV shows, videotapes, or any other noise-makers onto your hard drive. Once there, you can clean up the sounds so they're ready to be converted into MP3s.

If you're creating MP3s from something besides CDs or if you're looking for tips to make the cleanest rips possible, stick around.

Why Use Ripping Software?

Creating an MP3 used to require two steps. First, you had to rip the CD's contents onto the hard drive; then you encoded the contents into MP3 files. The tracks from the CD were stored as files in a WAV format on your hard drive, but WAV files are huge. We're talking uncompressed files of 40MB to 50MB or, in the case of a rocking Rolling Stones live jam, 200MB. Hence the need to put those digital audio files on a diet by converting the WAV files into MP3 files, a process called *encoding*. Here's the lowdown on creating MP3s:

✦ In the early days, people needed two pieces of software to create MP3s. The first software ripped the sounds from the CD; the second piece encoded the sounds into MP3 files. Today, all-in-one programs, such as Musicmatch and Winamp, perform both chores at the same time: You insert the CD and click a button, and the software automatically transforms the songs directly into MP3 files.

✦ Some MP3 purists dislike all-in-one software because they lose control over the sound quality. When the software automatically turns the CD's songs into MP3s, it bypasses the WAV file step, which leaves you no way to edit the WAV file to correct any flaws in the rips.

✦ Plus, not everybody rips CDs exclusively. Some people convert their aging album collection into MP3s for easier storage and to get rid of that stinky mildew smell. They need that extra step of cleaning up the sounds before encoding them into MP3s.

✦ Despite the rather nasty connotation, ripping doesn't hurt CDs.

✦ Popular sound-editing programs like Adobe Audition (`www.adobe.com`) and Roxio's Sound Editor (part of Easy Media Creator) can enhance, filter, mix, and clean up dirty WAV files. They remove pops from an album, for example, or fix CD rips that don't sound right.

How Do I Rip Songs from a CD?

Start the ripping application of your choice, insert the CD, choose the songs, and click the software's Copy or Record option. The software grabs the Compact Disc Audio (CDA) straight from the CD as a WAV file and then encodes it as an MP3 file and saves the sound on your hard drive. Note that ripping (technically known as *digital audio extraction*) doesn't work on the oldest of CD-ROM drives. If your drive can't perform digital audio extraction, it's time to buy a new one.

You don't even need a sound card; the CD's music (which is already stored on the CD using numbers to represent the sounds) becomes numbers on your hard drive.

As you wander into the wonderful world of ripping songs from a CD, keep these points in mind:

✦ Some ripping programs need *lots* of room to work. If your hard drive lacks at least 600MB of free space, rip the songs one at a time.

✦ Hard drive not big enough? Chapter 2 of Book III contains tips on installing a second drive.

✦ Bought a blazingly fast 52x speed drive? It'll never rip audio that quickly. That rating indicates how fast the drive *reads* a CD's information. Rippers need a CD to *send* data.

✦ Immediately after ripping a CD, listen to the MP3 files in Musicmatch Jukebox or Winamp. If the sound has skips, pops, unwanted noise, or other distortion, set the software to rip at a lower speed.

Recording from Sources besides CDs

If you want to create MP3s from something besides CDs — records, tapes, radios, TVs, camcorders, or similar sounds — the next few sections are the ones you want. Rippers really earn their due here.

Connecting sound cables to your computer

Whereas ripping refers to copying sound off a CD — and bypassing the sound card in the process — you need the sound card when creating MP3s from a turntable, TV set, VCR, camcorder, or microphone.

Sounds are stored as numbers on the CD, which the ripper merely copies onto your hard drive. When copying sound from other sources, you need the sound card to convert audible sound into numbers.

To grab audio from those sources, record the sound through your sound card. You can set up your computer to capture audio by connecting the output cables from your sound source into the Line In jack on your sound card.

This section shows you how to connect the appropriate cables for recording the sound onto your hard drive.

Tools you need: The appropriate cable (see Table 6-1) to connect from the sound source to the computer's sound card.

Cost: About $5 to $10, if the sound card doesn't already include the correct cable.

Stuff to watch out for: Sound cards rarely label their jacks well. Instead of using big letters, they use bizarre pictures or weird circles. If the jacks on the back of your sound card aren't marked, you'll have to dig around for the manual.

Follow these steps to connect a cable from your album, tape, VCR, camcorder, or TV set to your sound card's input jack for recording:

1. **Turn down the volume on your sound card and sound source.**

 You don't want to hear any speaker-shattering pops when pushing cables into jacks.

2. **Find the correct cables for your sound device and your sound card.**

 Different components use different cables; Table 6-1 shows what cable to use. Although most stereo stores carry these cables, Radio Shack is always a good last resort.

 An ⅛-inch jack is often called a "mini-jack" at electronics stores.

Book III
Chapter 6

Ripping CDs into MP3s

Table 6-1	Cables for Connecting a Device to a Sound Card
This Device . . .	*Needs This Cable*
Turntable, VCR, tape deck, or stereo TV	Y-cable with one pair of RCA jacks on one end and a ⅛-inch stereo plug on the other
Mono TV	Y-cable with a single RCA jack for the TV and a ⅛-inch stereo plug on the other
Camcorder	Y-cable with two RCA jacks for the camcorder and one ⅛-inch stereo plug for the sound card. Camcorders with ⅛-inch audio jacks (or headphone jacks) need an ⅛-inch stereo jack on each end of a cable.

(continued)

Table 6-1 *(continued)*

This Device . . .	Needs This Cable
Microphone with then ¼-inch plug	Plug the microphone's cord into a ¼-inch to ⅛-inch adapter and plug it into the sound card's MIC jack.
Microphone with ⅛-inch plug	Plug the microphone directly into the sound card's MIC jack.

3. Connect one end of the cable to your sound device.

Check the back of your VCR, camcorder, turntable, stereo, or TV for output jacks. You should see a pair of stubby little metal heads (RCA jacks) along one side. If it's not stereo, you'll see only one little stub. If you're lucky, they're labeled.

Take the Y-cable adapter, like the one shown in Figure 6-1, and plug the cable's two RCA jacks into those output jacks, making sure that the red jack goes into the red plug. (That's for the right speaker.)

If your camcorder has an ⅛-inch stereo jack (or headphone jack), plug your cable into it.

Figure 6-1:
The ⅛-inch plug goes into your sound card's Line In jack; the two RCA jacks connect to the VCR, camcorder, turntable, or other device.

To sound card

To the Output jacks

4. Connect the cable's ⅛-inch plug into your sound card's Line In jack.

Make extra sure the cable doesn't mistakenly push into the other nearby jacks.

5. Adjust the mixer levels.

Now, start playing your turntable, camcorder, or whatever else you're trying to record. This is where recording becomes an art: You carefully adjust the volume level through the Windows mixing board while watching the recording software's volume level to make sure the incoming sound is not too loud or soft.

To see the Windows built-in mixing board, double-click the speaker icon in the screen's bottom-right corner. When the mixing board appears, choose Options⇨Properties from the menu bar, as shown in Figure 6-2.

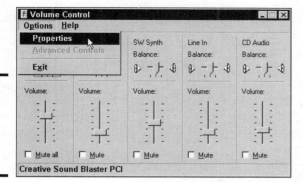

Figure 6-2:
Choose
Options⇨
Properties
from the
menu bar.

Because you want to record the incoming sounds, choose Recording from the Properties window. Click in any empty box to put a check mark inside it; doing so shows all the options of what you're able to record.

Click OK, and the Recording Control window appears. Because you're recording from the sound card's Line In jack, select the Line In Balance box (as shown in Figure 6-3) and slide the meter up or down until the recording level looks right in your recording software's meter.

Figure 6-3:
Adjusting
the
recording
level.

Now turn on the volume meter — sometimes called a VU meter — on your recording software, which is Cool Edit 2000, in this case. Slide the mixing window's Line In bar up or down until the sound level in its adjacent meter looks just right: The Windows meter should stay below the red levels, and the recording software's meter should come close to — but not reach or surpass — 0 on the control bar.

See how the mouse pointer slides the bar up or down in Figure 6-4? When you slide the bar to adjust the volume coming in through the Line In jack, the volume meter along the bottom of Cool Edit 2000 moves back and forth accordingly.

6. **Listen in through your sound card's speakers.**

The incoming sound should begin playing through your sound card's speakers.

Figure 6-4:
Adjusting
the volume.

Cool Edit 2000 sound level meter

If you don't hear anything, try these troubleshooting tips:

✦ Check the sound card's mixer software. Make sure that the Line In or Line box is checked and that the controller is slid up about halfway.

✦ Keep checking your cable connections as well. You're always aiming for the sound card's Line In jack. Don't use the Mic jack for anything but microphones, or the sound will be awful.

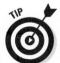

✦ Experiment a few times by recording at different levels. Sooner or later, you'll find one that sounds right. You might have to change the level for everything you record.

✦ To listen to your computer through your home stereo's speakers, flip back to Chapter 3 of Book III. That chapter shows you how to connect cables in the proper direction.

Recording songs from albums

Albums may be a joy for listening, but they're a pain to store. Plus, you always worry about when it's time to change the needle. Playing any rare singles? Don't they deteriorate each time they're played?

Converting albums to MP3 combats these problems and adds an advantage: Because the sounds originated from an album, the MP3 still holds some of that warm vinyl feel — none of that sterile CD feeling. Any of today's portable MP3 players will easily hold a full album — some, like Apple's iPod mini, can store 1,000 songs.

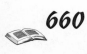

Most all-in-one MP3 ripping software records albums and converts them to MP3s on the fly, but that skips the WAV stage. Without this intermediate stage, you have no way to remove any recording flaws before the final encoding.

These steps show how to record songs from an album and save them as WAV files (where you can touch them up before turning them into MP3s):

1. **Clean the album.**

The cleaner the album, the cleaner the sound. Try these cleaning tips:

- Wash both sides of the album with a lint-free cloth. Most music stores sell record-cleaning brushes designed expressly for removing dust.

- To remove extra-stubborn goo from the grooves, try a mixture of 50/50 rubbing alcohol and distilled water. Lacking that, small amounts of baby shampoo can do the trick. Be sure to rinse well.

- Always wash the record with a circular motion; don't scrub "across grain" because it might scratch the grooves. When you finish cleaning, dry the album and touch it only by the edges.

- If it's an important album — a rare import, or an old 78 — check the phone directory for professional record-cleaning services found in many big cities. They can often remove any extra-persistent grunge from the vinyl.

2. **Clean the turntable's needle.**

Wipe it off with the little brush that comes with the turntable. Lost yours? Pick one up at the music or stereo store. They're cheap.

3. **Connect the turntable's output cables to your sound card.**

See the "Connecting sound cables to your computer" section, earlier in this chapter.

4. **Adjust your recording level.**

Your recording program will have a recording monitor display, which flashes according to the incoming volume levels.

Start playing your album and watch the monitor. If it flashes too close to the right end (or the red), turn down the volume going into the sound card, or use the sound card's mixer program to turn down the incoming sound. (I cover how in "Connecting sound cables to your computer," earlier in this chapter.)

If the level's too high, it will distort; if it's too low, you'll hear background noise. Take your time to find the right level before recording. Be patient.

5. **Start the recording software.**

Begin recording using Adobe Audition, Roxio Capture, or another recording-and-editing package.

6. **Play the album.**

Be sure to press the Record button on your recording software *before* playing the album. Don't worry about the initial plop when the needle

falls onto the record or the empty space before the first song. You can easily edit out those sounds later, as I describe in "Editing Recorded Music or Sounds," later in this chapter.

As you convert album songs into WAV files, keep the following points in mind:

✦ Hear a persistent humming sound in the background? Plug your turntable into the "unswitched AC adapter" on your receiver or amplifier. If you can't find the unswitched adapter, try plugging your computer and turntable into the same wall outlet. (Use an adapter, if needed.) The two devices then share a common ground.

✦ Remember to record at a level that's very close to the 0 on the recording level — but never too close. Otherwise, the recording won't sound loud compared to others, like MP3s created from CDs.

✦ Recording an old mono album? You might only hear the sound on one speaker. You can correct this with sound-editing software, however, as I explain later in the "Editing Recorded Music or Sounds" section.

✦ Record the entire album's first side and save that as a single WAV file. Then do the same with the flip side. You can easily separate the tracks into separate files later with sound-editing software.

✦ In the eyes of the law, converting albums to MP3 files isn't any different from copying CDs. You can keep the file for your own personal use, but don't give it away or sell it, or you might be violating copyrights.

Recording from tapes, camcorders, a microphone, or TVs

Recording from TVs, audio tapes, or videotapes works the same as recording from an album. Why would you want to? Well, perhaps you want an MP3 file of that hot new band playing on *The Late Show with David Letterman* in the wee hours.

Or maybe you videotaped a Hawaiian luau last summer, complete with fire-walkers and mystic drumbeats. (You would be surprised at the sound quality from today's DV camcorders.)

Here's how to copy those sounds to your hard drive (where you can clean them up and convert them to MP3 files):

1. **Connect the sound source's output cables to your sound card.**

 I describe how in the "Connecting sound cables to your computer" section, earlier in this chapter. Basically, you connect the Output cables of your sound source to your sound card's ⅛-inch Line In jack. Table 6-1 shows the required cables.

 Remember that *everything* plugs into the sound card's Line In jack except a microphone. Microphones must plug into the sound card's Mic jack.

2. **Adjust your recording levels and start recording.**

 Check out Steps 4 and 5 in the preceding section, "Recording songs from albums"; everything's the same. Make sure that you begin recording *before* your sound begins playing. You can always edit out any unwanted

garbage later, but if the ukulele starts playing *before* you push the recording software's Record button, you'll need to start over.

3. **Click the Stop button when you're finished.**

Grabbed the sound? Hit the Stop button on the recording software; then stop the sound source. It's now time to clean up the sound, as I describe in the next section.

Just because you can grab a TV performance off the air doesn't mean you own it. The same goes for a band playing at a local street fair. You can keep the soundtrack for your own personal use, but don't give it away or sell it, or you might be violating copyrights.

Editing Recorded Music or Sounds

After you record the music or sounds and save them as immense WAV files on your hard drive, you can convert them straight to MP3s using an encoder program. But while the file is still in WAV format, there's no excuse not to touch it up a little bit. Remove those clicks and pops from the album. Edit the TV recording so it starts the moment David Letterman says, "And now, here's. . . ."

The following sections describe some tips for editing WAV files down to the best possible recording.

Making mono recordings play on both speakers

When recording from a mono source — a single microphone or a TV with only one speaker — the computer fills only one side of its stereo signal with the sound. You can't get true stereo from a mono recording, but you can fake it.

Tell your sound-editing software to copy the recorded track onto the other, empty track. For instance, if the sound is recorded on only the right side, duplicate it to the left side, too.

The sound-editing software can match up the two tracks so that they're identically positioned. Save the resulting file, and your mono sound will now play over both speakers. It's still not stereo, but it's much better than only one speaker.

Ripping audio from the Internet

Saving audio or music sent in a "live stream" from the Internet is a copyright violation. That's why most sound programs won't let you save incoming RealAudio programs and other streams. (You can always bypass copy-protection schemes by sticking a microphone next to your PC's speakers, but that rarely sounds good.)

Versions of Winamp before Version 2.10 could save streamed MP3 files, but that function is disabled in the current versions. (Head for the Web site www. winampheaven.net to check out every version of Winamp ever released.) Older versions of Windows Media Player save streamed MP3 files in your Windows Temporary folder, if you take a peek.

Cutting out the bad parts

When you record something through a sound editor like Roxio's Sound Editor (part of Roxio's Easy Media Creator suite), the software shows pictures of the sound waves, like in Figure 6-5.

Sound-editing software works much like word processing software. You position the cursor in different places to choose sections for cutting and copying, or to move highlighted segments to different locations.

The first editing step is to find the beginning and end of your recorded sounds so you can trim off the unnecessary sounds. Use the software's Zoom or Magnify commands (those little magnifying glass icons on the toolbar) to magnify your view of the sound. That gives you a better picture of when sounds start and stop.

A tall wave means a loud sound; very small waves (or no waves) mean no sound.

Figure 6-6 shows a live recording saved in Sound Editor. You'll note how the sound wave comes to an abrupt stop — that's the end of the song, and you can delete anything past that point. Double-check by clicking at the ending point and the clicking the Play button. The software plays any sounds past that point, letting you make sure they're not needed.

Highlight all the sound waves past your chosen ending point and press the Delete key, and Sound Editor chops them out.

Figure 6-5:
Roxio's Sound Editor and other sound-editing packages show recorded sounds as a picture.

Figure 6-6:
Sound Editor shows where the sound file ends, letting you trim off any excess sounds.

Here are some more editing tips:

✦ Listen to your file from the beginning to see when it starts. Click at the actual starting point, highlight the material in front of it, and delete it, too. Your resulting file is now trimmed to its exact size.

✦ Having trouble finding the exact spot to trim? Use the magnify command to zoom in until you can spot individual sound waves. That makes it easy to choose the exact spot.

✦ Prefer a nice fade out on a recording? Choose where you want the fade out to begin, highlight the sound from that spot onward, and choose the software's fade option. The software will make the sound fade away, like the ending of many songs.

✦ When dealing with a noisy recording, check your sound-editing software's filter and noise reduction menus. Many of them can reduce the pops of a crackling album and cut out some hiss from tapes.

✦ The more money you spend on your sound-editing software, the more tricks it has for manipulating sound. Adobe Audition may be expensive, but it has features not found on less-expensive software. Look for a multiple Undo command so that you can go back to normal if an auditory experiment goes awry.

Introducing Musicmatch Jukebox

Some software performs a single task, stops, and lets another program take over. CD rippers, for example, copy music from your CD onto your hard drive. The encoders then go to work, converting the extracted WAV files into MP3s.

Musicmatch Jukebox (www.musicmatch.com), by contrast, plans the menu, cooks the meal, and delivers it to the table. When you insert the CD and click a button, a window appears, listing the song titles. Click the songs you want encoded, and the software automatically converts them into MP3s.

The program can even record files from albums, stopping to separate record tracks into separate songs. It converts MP3s into WAV files and then burns them onto a CD for you to play in your car or home stereo. It can even download MP3s into your portable MP3 player.

Looking for Internet radio stations? Musicmatch not only tunes them in, but also creates them based on your personal tastes. To sample the best that MP3 has to offer, you needn't go further than Musicmatch.

Musicmatch Jukebox works on any version of Windows from Windows 98 through Windows XP, but you need a Pentium III or Pentium 4 processor and at least 128MB of RAM. If your system doesn't meet these specifications, the software will probably give up during the installation process. Finally, some older CD-ROM drives can't handle ripping. If your drive has trouble, it may need an upgrade.

Two different versions of Musicmatch are available: The Basic version is free, and the Plus version sets you back $20. (Of course, the Plus version offers all sorts of enhanced features, like faster ripping and CD burning, the ability to print labels, and even a built-in slideshow mode that displays images with your music.)

Putting Musicmatch to Work

Musicmatch Jukebox handles just about every aspect of the MP3 world. In fact, it can do so much that completing a simple task may sometimes seem confusing. The next few sections show how to make Musicmatch automate those tasks that once took hours of work.

Making MP3 files from a CD

Musicmatch can convert an entire CD all at once, or just convert the songs you choose. Either way, follow these steps to rev up the Musicmatch MP3 creator and start creating MP3s:

1. **Start Musicmatch by double-clicking its icon on your desktop.**

Or start Musicmatch from your Start button, depending on where you told the program to lodge itself during the installation process. The program leaps into action, accompanied by its oft-bothersome Welcome Tips window.

Just like Winamp, Musicmatch consists of several detachable windows. The Recorder window, necessary only while creating MP3s, lists a CD's songs. The My Library window, in the middle, is where the MP3s stay organized by CD for easy access.

Don't see Musicmatch's Recorder window? Choose Options➪View➪ Show Recorder from the Musicmatch menu bar. You can also toggle the display of the Playlist window and the My Library window as well.

Finally, Musicmatch Jukebox's control window sits on top, ready to play any selected CDs or MP3s.

Windows always needs to know which player should play your MP3 files when you double-click them. If you have more than one MP3 player, the players often fight for that privilege. That's why Musicmatch sometimes says `Another application has associated file types playable by the Musicmatch Jukebox`. It then asks if Musicmatch should be your default player. I choose No, leaving Winamp as my default player — it loads more quickly. Besides, even when it's not the default player, Musicmatch still plays any MP3s that you load into the program.

2. Insert a music CD into your CD-ROM drive and click the Record button in the Playlist window.

When a CD is inserted into the drive, Musicmatch uses your Internet account to dial up CDDB (`www.cddb.com`), a vast database of CD titles and their accompanying songs. Figure 6-7 shows how Musicmatch correctly identified my beloved copy of Stevie Ray Vaughan's *Couldn't Stand the Weather* and automatically entered all the CD's song titles in the Recorder window.

No Internet connection? Jukebox can sometimes pull in the information from a disc's CD-TEXT data, but if that doesn't work either, it's time to start typing in the titles yourself.

Figure 6-7:
When you insert a new CD, Musicmatch consults an Internet database and automatically enters the album and track titles.

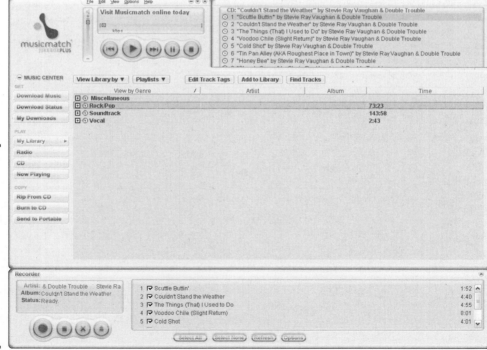

Although Gracenote's CDDB database holds an enormous amount of CDs, it occasionally misses a few releases from smaller labels. Instead, it lists the songs as Track 01, Track 02, and so on. To add them yourself, click each track name as shown on the right side of the Recorder window (see Figure 6-8) and type the correct name. Then click the window's left side to enter the Artist and Album names.

 3. **In the Recorder window, select the check boxes for the songs you want to convert or click Select All to select them all.**

Normally, the Recorder window pops up with all the titles checked. If you don't want to convert all the songs to MP3, click to remove check marks from the titles that you don't want.

Be sure to stop the CD from playing. Although Jukebox can convert a CD while it's playing, it's much slower and more prone to error.

 4. **Click the Recorder window's Record button (which looks like a big red circle) to begin converting songs to MP3 files.**

By default, the new files are stored in the My Music folder inside your My Documents folder.

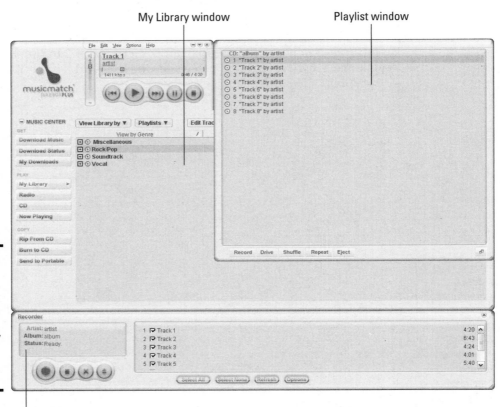

Figure 6-8: To enter titles manually, click Track 01, Track 02, and so on, and start typing.

When creating MP3s with the Musicmatch MP3 creator, remember these tips:

✦ As the program encodes your CD's songs, it lists the newly created MP3s in the My Library window (which I discuss in the next section) for easy access later. They're sorted by artist, album, and genre.

✦ If your new MP3 file sounds weird, you may be pushing your processor too hard. Musicmatch Jukebox rips and encodes in a single step, so it requires more processing power than plain encoders.

✦ Some people intentionally encode files at 96 Kbps or lower or use the Windows Media Audio (WMA) format instead of MP3. The files will be smaller, letting you squeeze more of them onto your portable MP3 player. Actually, you probably can't tell that much sound difference between the two when you're on a skateboard doing a one-footed, nose-boned tailgrab. (Make sure that your portable player can handle the WMA format before using it, though.)

Playing MP3 files

Musicmatch displays your MP3s in a list in the My Library window, just like books stacked on a shelf. But the files are a lot easier to organize than CDs or albums. Here's how to find a song or group of songs and play them:

1. **Click the My Library button (shown on the left side of Figure 6-9) to display the My Library window.**

Figure 6-9:
You can view your collection by different criteria.

2. Find the songs you want to play.

First, notice the column names View by Album, Artist, Genre, and Time along the top of the My Library window. Click one of those names to sort the MP3s in the list by that category. Clicking Artist, for instance, sorts the songs by the musicians who created them. Click View by Album, and the songs are sorted alphabetically by their CD's name.

There's more, though. Click the View Library By drop-down list box, as shown in Figure 6-9, and Musicmatch offers to display your music in other ways, sorting them by Moods, Preferences, Tempos, and Year. Or, choose All Tracks to see every song in the collection (see Figure 6-10).

3. Select the songs to play.

Select songs the same way you select files in Windows. Hold down Ctrl and click files to select them one by one. Alternatively, you can click one file, hold down Shift, and click another file to highlight all the files between the two you clicked. Or, you can lasso a bunch of files by holding down the mouse button and circling the files with the mouse pointer.

4. Place the songs into the Playlist window.

After you select your files and they're highlighted in the My Library window, right-click the selection and choose Add Track(s) to Playlist Window. (Or, just drag and drop the songs into the Playlist window.) The songs appear in the Playlist window, as shown in Figure 6-11, and automatically begin playing.

Figure 6-10: Choosing the All Tracks option displays every song in your collection.

Figure 6-11:
Songs added to the playlist begin playing automatically.

Here's how to get the most out of your playlists:

✦ **In a mood for jazz?** View your My Library list by Genre. Then drag the word Jazz to the playlist. All your songs categorized under Jazz appear in your playlist.

✦ **Using a network?** Feel free to drag and drop songs from networked computers into your Playlist window. They're often a little slow to load, but they'll play just fine. Make sure that you're not dragging from networked drives that have passwords, however, or Musicmatch might freeze up.

✦ **Not sure what a button does in Musicmatch?** Rest your mouse pointer over the confusing item, and a helpful message usually explains its function.

✦ **Want to play random selections from your entire music library?** Drag your entire library to the Playlist window; or right-click anywhere in the Playlist window, choose Select All, and then choose Add Track(s) to Playlist. The entire list appears in the Playlist window. Then click Shuffle at the bottom of the Playlist window. Jukebox plays your entire collection, shifting randomly from song to song like a radio station.

✦ **Want to easily add tracks to your playlist?** You don't need to use the My Library window to add tracks. Just click the Playlist window's Open button. From there, you can add all your tracks, certain albums, certain genres or artists, tunes from your CD player, or even tunes that aren't in your My Library area.

Adding tag information and CD art

Here's a little trick. Every MP3 file contains a special built-in storage space for the song's title, CD, recording date, genre, and other information. Musicmatch Jukebox automatically fills out most of that information, known as an *ID tag*, as soon as you encode the CD.

But here's how to grab the CD's cover art, as well. You don't need a scanner, and you don't even have to use your CD's original art. Just follow these steps, and Musicmatch automatically displays your CD's cover art whenever it plays a song from that CD:

1. **Drag any MP3 song to the Musicmatch Playlist window.**

The song begins to play.

2. **Open your Web browser and connect to Amazon.com.**

When Amazon comes up, look for its Search area in the upper-left corner. In the drop-down menu, choose Popular Music. Then in the second box, type the name of your CD and artist. Amazon should display the cover of your CD.

3. **Right-click the CD cover (either from within the Now Playing panel or within your Internet browser), choose Copy from the menu, and close your browser.**

Right-click your CD's cover from the Web page and choose Copy (as shown in Figure 6-12) to copy the CD's cover to the Windows Clipboard. Close your browser; you don't need it anymore.

Figure 6-12: Copying the cover art to the Windows Clipboard.

4. **From the Musicmatch menu bar, choose Edit⇨Paste/Tag Art from Clipboard.**

Wham! Your CD cover appears in Musicmatch, as shown in Figure 6-13.

Figure 6-13:
The CD cover now appears in Musicmatch whenever you play that song.

Creating MP3s from Albums or Other Sources

If you don't need to do any sound editing of your albums, camcorders, or other sound sources, Musicmatch creates MP3s from them just as easily as it does from CDs.

Connect a Y cable from your audio source and plug it into your sound card's Line In jack, as I describe earlier in this chapter. Then perform the following steps:

1. **Choose Options➪Recorder➪Source➪Line In from the Musicmatch menu bar.**

2. **Start playing your sound source to adjust the mixer settings.**

3. **Open your Windows Mixer.**

 Double-click the little speaker icon by your clock in the Windows system tray.

 Adjust the volume under the Line Balance settings. Make sure that the little box beneath the Line Balance area is checked.

Book III
Chapter 6

Ripping CDs into MP3s

That whole Napster thing

Napster took digital audio to a rather revolutionary next step: user-friendliness. Napster enabled its members to search for specific artists and songs on the hard drives of other Napster users and then download those songs from their hard drives. Unless you denied access to your computer, other Napster users could search your hard drive for songs and then download them from your computer.

Most of us already know the ending to the Napster story. The controversy that surrounded the original Napster program stemmed from the fact that many (if not most) users were unlawfully distributing music copyrighted by the artists and record labels. For example, heavy metal rockers Metallica and rap star Dr. Dre were the first groups to file suit against Napster because the program allowed users to distribute illegal copies of their songs. Theoretically, you could download MP3 versions of every Metallica song ever recorded without shelling out a single penny for a CD. You can understand why the group and its label were up in arms.

After the courts stepped in, Napster was shut down. Today, Napster has resurfaced with a new legal face, providing online music both as a stand-alone program (www.napster.com) and as a built-in music store within Roxio's Easy Media Creator. I briefly describe the new Napster in Chapter 7 of Book III.

 4. **Turn on your sound source — start playing the album, turn on the camcorder, or whatever else you're recording — and quickly click the Record button in Musicmatch's Recorder window.**

The program automatically transfers the incoming sound into MP3 format, skipping the WAV file in the process.

Creating CDs from MP3s

Musicmatch uses your computer's CD or DVD burner to create two types of CDs. Why two? It creates one type of CD for playing on your home or car stereo, and another type that's packed with hundreds of MP3 files for playing on your computer. It creates both types of CDs from any of the MP3 files in your collection. Feel free to mix and match your favorite MP3s to create your own greatest hits CDs.

Before you can create any type of CD, you need a CD-RW drive, DVD-RW or DVD+RW drive, and a pile of blank CDs. (A growing number of audio CD players now support CD-RW discs, which means you can erase the disc and burn a new set of songs — check your audio player's specs to see if it supports CD-RW media.)

To create either type of CD in Musicmatch, follow these steps:

 1. **Create a playlist of the songs you want to store on the CD.**

Follow the steps in the section "Playing MP3 files," earlier in this chapter. Basically, you want to fill your Playlist window with the songs you want to copy to a CD.

If you're creating a CD for your home stereo, start with about ten MP3s. You probably won't be able to fit many more songs, although you'll be given that chance later.

 2. **Click the Burn button beneath the playlist.**

The Create CD from Playlist window pops up, as shown in Figure 6-14.

 3. **Choose the type of CD you want to create from the window.**

To choose the type of CD you want, click one of the following buttons (shown in Figure 6-14):

 • **Audio:** Click this button to create a CD for playing in your home and car CD player. This is the default selection.

 • **MP3:** Click this button to create an MP3 disc, which stores a huge number of MP3s to play back on your computer, boombox, or on a portable MP3 player that can handle those CDs.

 • **Data:** Click this button if you want to simply burn the MP3 files as data files on a standard CD-ROM.

MP3 button

Audio button Data button

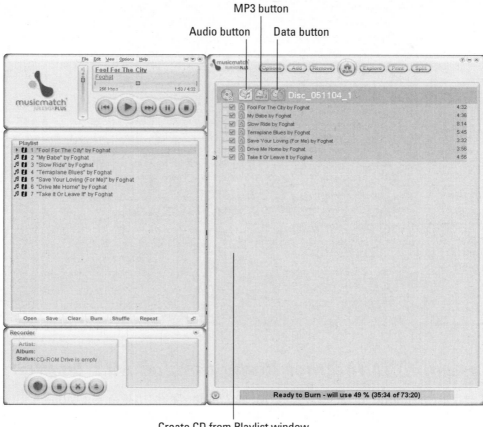

Figure 6-14:
Seven
MP3 songs
consume
about 49
percent
of this
audio CD.

Create CD from Playlist window

Clicking one of the three buttons shows how much space you have left on the CD. In Figure 6-14, for instance, the seven MP3s listed in the Create CD from Playlist window have consumed 49 percent of the audio CD, leaving room for several more songs.

When I click the MP3 button, however, those same seven songs consume only 11 percent of the CD, leaving much more room. (That shows you how much MP3 compresses songs.)

4. **Add or remove songs until the CD is filled.**

Keep dragging or removing songs from the Playlist window until you're satisfied with the amount of songs stuffed onto the CD.

5. **Place a blank CD or CD-RW disc into your CD or DVD recorder and click the Burn button.**

Musicmatch converts the MP3 songs into audio format, if necessary, and copies them to the CD.

If you purchase the upgrade version of Musicmatch, you can print CD covers and jewel box inserts to go with your newly created CDs. It can print any artwork you'd like on the cover, or it can tile the covers from the works you've placed on the CD (see Figure 6-15).

Figure 6-15:
Print CD
covers for
your newly
created
CDs.

Listening to Internet Radio through Musicmatch

Among its other duties, Musicmatch picks up Internet radio stations. It plays
the stations in three different ways, as I describe in the following sections.

Listening to Musicmatch Radio

Musicmatch contains a list of stations broadcasting in certain genres, from
Adult Alternative to Rap & Hip-Hop. The songs coming from these stations
are from top-name artists in their fields. To tune one in, follow these steps:

1. **Run Musicmatch Jukebox and click the Radio button.**

 The Radio window appears, as shown in Figure 6-16.

2. **Choose your connection speed from the Radio Quality drop-down list
 box in the upper-right corner of the Radio window.**

 If you have a dial-up modem, you should choose Low from the list box.
 If you're one of the lucky ones who has a faster modem (cable, DSL, T1,
 and their cousins), you receive better sound when you choose CD from
 the list.

3. **Choose the type of station you want to hear by clicking a genre link.**

 Click the type of music that moves you — remember, you can switch
 stations at any time. Alternative Rock, for instance, plays artists such as
 Green Day, Jet, and Maroon 5. (Coincidentally, so do I.)

 The music begins playing — at the beginning of a song, unlike many other
 stations. To hear a different type of music, click a different genre of music.

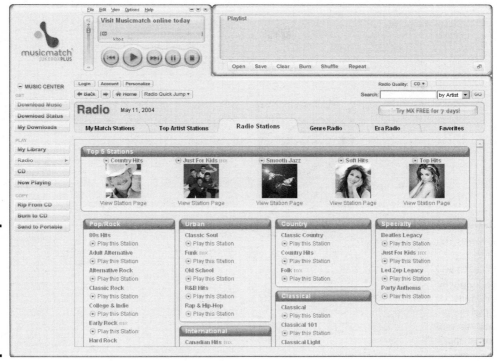

Figure 6-16: Click the Radio button to hear presorted radio stations.

Book III
Chapter 6

Ripping CDs into MP3s

Creating a personalized station

Musicmatch offers radio stations customized to your particular interest. First, you can simply choose your favorite type of music, and Musicmatch begins playing those types of songs. (Yawn.)

But wait, there's more! You can create a station based on your favorite artists. Click the Create/Edit Station button from the Radio window and then type your favorite artist into the Search field — The Doors, for example — and click Go. If that artist is included in the list, click the Add button to add the music to your station's list (see Figure 6-17). (Alternately, leave the Search field blank and go choosing bands willy-nilly, with the joy of a 5 year old.)

When you find the artist list of your dreams, type a name for your station, and click the Play This Station button to hear your new station. You'll hear a mixture of songs by your favorite artist, as well as other songs by musicians similar to that artist . . . on your own station! When a song comes up in the Musicmatch radio station, the album cover also appears.

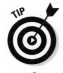

When you're playing a bunch of songs, either through Musicmatch Radio or your own playlist, click the Now Playing button. If you're connected to the Internet, Musicmatch brings up a page displaying information about the currently playing artist — as well as a way to buy more music by that artist.

When you base a station on a favorite artist, Musicmatch checks to see what other artists that fans of the selected artist like to listen to. Then it bases your radio station on your artist, as well as songs by those additional artists.

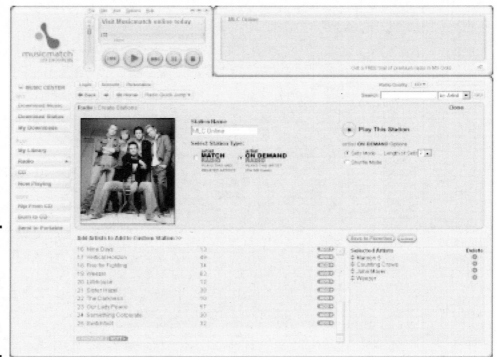

Figure 6-17:
Hey, welcome to MLC Online! Only the best in classic rock need apply.

CHECK IT OUT

How Do I Change an Entire CD's Tags Simultaneously?

Keeping a song's tag correct is important, but changing the tag can be awfully tedious. For instance, when you copy a CD's cover art from the Web, you want every song on the CD to have that cover art. And, if you decide to add the CD's recording year to the tag, do you really want to edit the tags for *all* the songs individually?

Luckily, Musicmatch does the work for you, changing the tags of many songs simultaneously. Here's what you need to do:

1. **In the My Library window, right-click the album you want to change — or highlight all the songs you want to change simultaneously — and choose Edit Track Tag(s) from the pop-up menu.**

 The Edit Track Tag(s) window appears, listing all the songs you selected.

2. **Click the Select All button to highlight all the songs.**

 Notice how all the fields are grayed out.

3. **Click the little white box next to the item you want to change for all the highlighted songs.**

 For example, click the little white box next to where the CD's cover art should appear.

4. **Update the field that you selected in Step 3 (by pasting in the cover art, for example) and click the OK button.**

 Musicmatch updates the tags of all the highlighted songs simultaneously. If you updated the art, for example, all the songs now have the CD cover in their tags.

Chapter 7: Choosing an Online Music Vendor

In This Chapter

↙ **Considering the pros and cons of online music**

↙ **Recognizing what counts in a music source**

↙ **Comparing what's out there**

O kay, I'll be blunt: You may not need this chapter. (How's that for an opening sentence?)

You see, there's really no single reason to settle on just one source of online music — after all, variety is the spice of life, right? If you have the time to visit six or seven Web sites and compare all those different vendors, you can probably find the ones that offer *Afternoon Delight* by the Starland Vocal Band — and then you can begin worrying about locating the best price. Should you spend 89 cents or 99 cents on this timeless '70s classic? And which of those sites provides you with downloads in MP3 format? If you're that much of a music fan and you don't mind the hassle of all that comparison shopping, then skip this chapter and move on.

Still with me? Good. You see, I personally don't like wading through the morass of multiple online music services available these days. I like convenience, and I like low prices. I like a large selection of songs, and I like 'em in a format I can actually use. (Otherwise, why not just buy the CD and save yourself the trouble?)

If you're with me, then this chapter is for you. I introduce you to what's out there and give you the facts that can help you decide on the one (or perhaps two) online music vendors that fit you best.

So How Do You Rate a Vendor?

I think we can safely agree that most music lovers are tolerant, caring individuals who provide shelter for animals and contribute to all sorts of charitable causes . . . and they also care about the following five criteria:

✦ **Price:** How much am I paying for a track, or for an entire album? Is there free music on hand? Do I have to pay a membership fee?

✦ **Format:** I prefer MP3, but other formats can offer better sound. For example, Apple's iTunes Music Store offers downloads in Apple's higher-quality AAC format — however, those files have a certain amount of copy protection built-in. Finally, I should mention Windows Media Audio (or WMA),

which delivers quality equal to (and often better than) MP3. While the WMA format is supported by a number of MP3 players, it's also saddled with an extreme level of digital "copy protection." (More on this later.)

✦ **Library size:** Although *Afternoon Delight* may not be on your hit list, everyone wants a large selection to choose from, and many vendors offer a surprisingly limited library.

✦ **Search features:** How simple and straightforward is it to search for the music you want to hear?

✦ **Convenience:** How easy is it to navigate a vendor's site? Can you hear a decent preview before you buy? Are your login ID and password saved for future visits?

Think broadband — no, on second thought, *demand* broadband — before devoting yourself to online music. With a cable modem or DSL connection, downloading a typical 4 to 6MB song takes less than a minute. That same song can take 10 to 15 minutes to download on a 56 Kbps dialup connection. You have been warned — severe boredom and loss of musical enthusiasm can result if you try downloading an entire album with your dialup modem.

I review four of today's most popular online vendors in the following sections, covering the points in my list. Don't worry; you won't be tested on this, but keep a highlighter handy to help you pick the right music source for you. Better yet, use one of the handy stickers from the front of this book to tag the page for you!

I fought the law and the law won: Sharing and piracy

Apple CEO Steve Jobs gave personal demonstrations of the iTunes Music Store and the iPod to Paul McCartney and Mick Jagger. According to Steven Levy at *Newsweek* (May 12, 2003), Jobs said, "They both totally get it." The former Beatle and the Stones frontman are no slouches — both conduct music-business affairs personally, and both have extensive back catalogs of music. They know all about the free music-swapping services on the Internet, but they agree with Jobs that most people are willing to pay for high-quality music rather than download free copies of questionable quality.

I agree with the idea, also promoted by Jobs, that treating technology as the culprit with regard to violations of copyright law is wrong. Conversely, the solution to piracy is not technology because determined pirates always circumvent it with newer technology, and only consumers are inconvenienced.

I'm certainly not a lawyer, but I think the law already covers the type of piracy that involves counterfeiting CDs. The fact that you aren't allowed to copy a commercial CD and sell the copy to someone else makes sense. You also can't sell the individual songs of a commercial CD.

Giving music away is, of course, the subject of much controversy, with services such as the original incarnation of Napster closed by court order while others flourish in countries that don't have copyright laws as strict as the United States. Nothing in the Apple realm of technology enables the sharing of music at this level, so I don't need to go into it, except to provide one observation: The songs I hear from free sharing services such as Kazaa have, for the most part, been low in quality — on a par with FM radio broadcasts. That's nice for listening to new songs to see if you like them, but it's not useful for acquiring as part of your real music collection. The iTunes Music Store is clearly superior in quality and convenience, and I prefer the original, authorized version of a song, not some knock-off that may have been copied from a radio broadcast.

Apple's iTunes Music Store

Although not the first vendor to appear on the scene, Apple's iTunes Music Store (shown in Figure 7-1) has made quite a splash among both PC and Macintosh owners. To access the store, you have to install and use iTunes — which is not a disadvantage in my book because I rate iTunes as one of the best digital audio players available. (Oh, did I mention that it's a free download for both Mac OS X *and* Windows XP/2000? Or that it can rip MP3 files from your audio CDs and burn your own compilation CDs? Anyway, I talk about iTunes in depth elsewhere in this minibook, so I'll stop there and get to the music.)

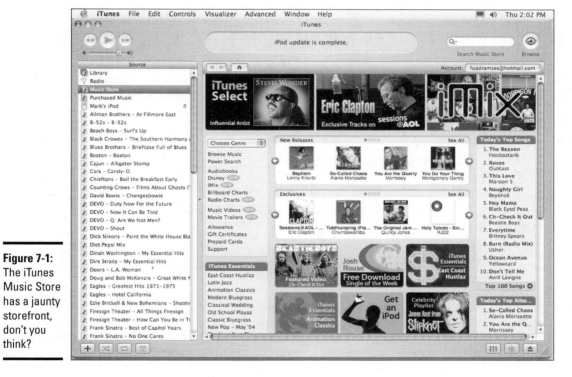

Figure 7-1:
The iTunes Music Store has a jaunty storefront, don't you think?

Here's how the iTunes Music Store scores on the list:

✦ **Price:** At the time of this writing, individual tracks were selling for $0.99, and an entire album set you back $9.99. No membership fee is required.

✦ **Format:** The songs you download to your music library from the iTunes Music Store are in AAC format, which is somewhat of a disadvantage for those who like to transport their music on something besides an iPod. Also, each track can be played only on a maximum of five individual Macs or PCs, so the copy protection is there. (On the positive side, you can burn as many audio CDs from your iTunes tracks as you like, no questions asked. Apple feels you should own the music you buy, and I agree wholeheartedly.)

✦ **Library size:** A big plus for this vendor because you have over 700,000 individual tracks to choose from — including audio books, prerelease singles, and exclusive-release singles.

✦ **Search features:** You can search for a specific album, artist, track name, or genre by using the application's Power Search (shown in Figure 7-2).

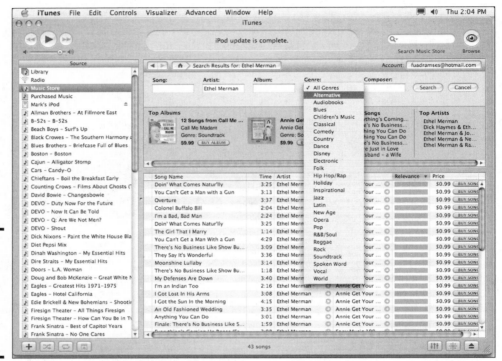

Figure 7-2:
Looking for that all-too-rare alternative hit from Ethel Merman.

Check out the new iMix feature, which allows you to share your playlist data with others (and rate their playlists in return). If you like a specific artist, see what other folks who favor the same artist are listening to. Everything's integrated into iTunes, so there's no switching from window to window. *Sassy.*

✦ **Convenience:** Another highlight for the iTunes Music Store: It's easy to browse because the Music Store window includes a nifty navigation system that will remind you of your Web browser (only faster). You can enjoy a full 30 seconds of any track before you buy, and the reviews and artist histories are quite good. After you create an Apple ID, iTunes remembers it for future visits, and your credit card is automatically billed as you purchase your music.

Don't forget to check out the Free Download track, which changes every week. The free song is often a prerelease or exclusive-release track, so you'll find some real jewels here!

For a dabbling of iTunes information, head to Chapters 8 and 10 of Book III. For an in-depth look at iTunes, don't miss *iPod & iTunes For Dummies,* written by Tony Bove and Cheryl Rhodes (published by Wiley). That book tells you all about what's under the hood.

Walmart.com

Yes, that's right, your friendly neighborhood mega-discount store also has an online music vending business. You may be thinking that the sheer mammoth presence of the Wal-Mart name will spell the eventual doom of other vendors, but the service has some problems that currently make it a tough sell.

Time for the details:

✦ **Price:** The bright spot for this vendor — individual tracks are only $0.88 each, and a full album is $9.44. No membership is necessary to buy music.

✦ **Format:** I am no big fan of Microsoft's WMA files, and unfortunately, Walmart.com is a proponent of this format, which means that you're limited to playing your downloaded music using Microsoft's Windows Media Player 9. Why? Walmart.com tracks include encrypted DRM signatures (that's short for Digital Rights Management), so you're forced to use Windows Media Player 9 to play these songs. Although Windows Media Player is available for Mac OS X and most flavors of UNIX and Linux, I personally rate the program as a distant second to iTunes in ease-of-use. Because of the DRM protection, you can burn a single song to CD no more than ten times, and you can play the songs only on up to three PCs. At least Walmart.com's WMA files are 128 bit, so the quality is actually better than a typical MP3 file.

✦ **Library size:** Less than 300,000 tracks at the time of this writing, but Walmart.com does offer exclusive tracks on a regular basis.

✦ **Search features:** Limited to album, artist, and song name.

✦ **Convenience:** Walmart.com provides a 30-second preview, but you won't find supplemental reviews or artist history on the site. After you sign in with your online customer ID, you can elect to pay with a credit card, online check, or — my personal favorite — a Wal-Mart shopping card.

Napster

It's certainly a name you recognize, right? Ah, but this is the new, improved, even-fresher-smelling *legal* Napster.com — no more illicit music swapping. The feline still wears earphones, but only time will tell if the service will succeed.

Like with the iTunes Music Store, you have to install a program to browse and buy music; the Napster program is free and doesn't take up a tremendous amount of space on your hard drive. Figure 7-3 illustrates Napster in action. If you like, you can use it as your default music player as well, and it can rip tracks from your existing audio CDs.

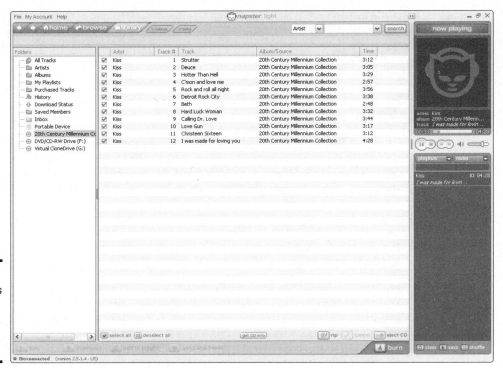

Figure 7-3:
It's a bird, it's a plane — nope, it's Napster gone legal.

Now for the tale of the tape:

✦ **Price:** Napster is now a subscription service, charging about $10 a month for all the music you want to hear — note that I said "hear" and not "own." The price includes access to commercial-free Napster radio stations as well. On the downside, you still have to *buy* tracks at $0.99 a pop if you want to burn them to CD or transfer them to your portable player. (Ouch.)

✦ **Format:** Here we go again: It's Windows WMA, so you're limited to listening to the tracks you download on a maximum of three computers. Computers running Macintosh and Linux have to run Windows Media Player 9 to play these songs. Oh, and the Napster player itself runs only under Windows. (Sigh.)

✦ **Library size:** An impressive 700,000 tracks are on tap, with exclusive tracks and live recordings included.

✦ **Search features:** Search fields include hunt for a specific album, artist, and song name, or you can search for another member's playlists.

✦ **Convenience:** You'll get 30-second previews of each song, with extensive music reviews and artist history. (Like the iTunes Music Store, Napster also recommends music based on what you've listened to and bought in the past.) You pay by credit card, and the Napster software takes care of logging in and maintaining your music collection.

You can give Napster gift certificates to friends and family, which gives them free downloads or a number of subscription months. Napster Cards are also available in many grocery stores and discount stores — they work the same way. Instant gratification is a good thing.

Napster is now integrated within Roxio's Easy Media Creator. In fact, a link to it appears within the Easy Media Creator Home window, as shown in Figure 7-4. If you decide on Napster as your primary music vendor, you can buy, organize, and burn from within one window!

Figure 7-4: It's our favorite cat again — this time within Roxio's Easy Media Creator.

eMusic.com

Book III
Chapter 7

Choosing an Online
Music Vendor

A relative newcomer on the online music vendor scene, eMusic (www.emusic.com) has an interesting storefront, a simple subscription pricing setup, and a bright future — and, according to the site's home page, it's all "100% Legal" with "No guilt here!" Hey, that's a slogan for the new digital millennium if I've ever heard one.

Here's the rundown:

✦ **Price:** After a two-week free trial period, you must subscribe to eMusic. Ten dollars per month gets you 40 song downloads, $15 brings in 65 downloads, and the Premium service delivers 90 song downloads in a month for $20. Album downloads simply count towards your monthly limit.

✦ **Format:** Now we're in happy territory! eMusic delivers songs in good old-fashioned MP3 format, with no DRM tagging along. In fact, the service uses VBR (variable bit rate) encoding, which delivers the smallest possible MP3 files with CD quality.

✦ **Library size:** eMusic recently passed the 400,000 mark in individual tracks — most are from independent labels, and alternative bands have the focus.

✦ **Search features:** You can hunt for a specific album, artist, song name, or record label.

✦ **Convenience:** Dialup visitors will appreciate the high- and low-fidelity 30-second previews. The reviews and artist history are terse at one or two sentences, but they're well-written. Payment is by credit card, and you create a login account when you join the site.

Chapter 8: Buying Music with iTunes

In This Chapter

✔ **Logging into the iTunes Music Store**

✔ **Previewing and buying songs**

✔ **Handling authorization**

✔ **Setting preferences**

*W*hen Apple announced its new music service, Apple chairman Steve Jobs remarked that other services put forward by the music industry tend to treat consumers like criminals. Steve had a point. Many of these services cost more and add a level of copy protection that prevents consumers from burning CDs or using the music that they bought on other computers or portable MP3 players.

Apple did the research on how to make a service that worked better and was easier to use, and it forged ahead with the iTunes Music Store. By all accounts, Apple has succeeded in offering the easiest, fastest, and most cost-effective service for buying music for your computer and your iPod. (And yes, Virginia, the iTunes Music Store is available to both Mac and PC owners.) In this chapter, I show you how to log on and take advantage of what the iTunes Music Store has to offer.

Setting Up an iTunes Music Store Account

As of this writing, the iTunes Music Store offers more than 200,000 songs, with most songs priced at $0.99 each and entire albums available at far less than what you would pay for the CD. You can play the songs on up to three different computers, burn your own CDs, and use them on players such as the iPod.

You can preview any song for up to 30 seconds, and if you already established your account, you can buy and download the song immediately. I don't know of a faster way to add a song to your music collection.

To open the iTunes Music Store, follow these steps:

1. **Run iTunes and click the Music Store option in the Source list.**

The Music Store's front page appears (see Figure 8-1), replacing the iTunes song list. You can check out artists and songs to your heart's content, although you can't buy songs until you open a Music Store account. You can use the Choose Genre pop-up menu to specify music genres, or you can click links for new releases, exclusive tracks, and so on — just like with any music service on the Web.

Figure 8-1:
The iTunes
Music
Store's front
page.

2. **Click the Sign In button on the right to create an account, or sign in to an existing account.**

 You need an account (with a credit card) to buy music. iTunes displays the account sign-in dialog box, as shown in Figure 8-2.

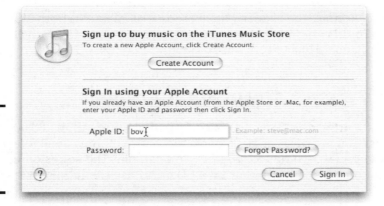

Figure 8-2:
Sign in to
the iTunes
Music
Store.

If you already set up an account in the Apple Store in the .Mac service, you're halfway there. Skip Step 3 through Step 6 and type in your Apple ID and password. Apple remembers the personal information that you previously entered, so you don't have to reenter it. If you forgot your password, click the Forgot Password button, and iTunes provides a dialog box that gives you a test question. If you answer the question correctly, your password is then e-mailed to you.

3. **To create an account, click the Create Account button.**

 iTunes displays a new page, replacing the iTunes front page, with an explanation of the steps to create an account and the Terms of Use.

4. Click the Agree button, and fill in your personal account information.

iTunes displays the next page of the setup procedure, which requires you to type in your e-mail address, password, test question and answer (in case you forget your password), and birth date, and select privacy options.

5. Click the Continue button.

The next page of the account setup procedure opens. On this page, you enter your credit card information.

The entire procedure is secure, so you don't have to worry. The Music Store keeps your personal information — including your credit card information — on file, and you don't have to type it again.

6. Click the Done button to finish the procedure.

Previewing a Song

You may want to listen to a song before buying it, or you can just browse the store listening to song previews. When you select an artist or a special offering, the browser window divides and gives you a list of songs that you can select to play, as shown in Figure 8-3. Click the Play button to play a preview.

The previews play on your computer off the Internet in a stream, so a few hiccups may occur in the playback. Each preview lasts about 30 seconds.

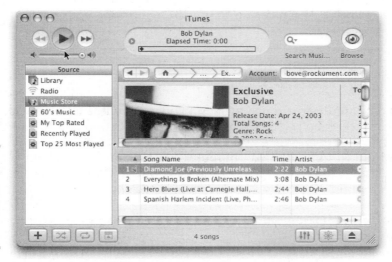

Figure 8-3:
Preview songs online in the iTunes Music Store.

You don't have to open an account just to preview songs!

Buying and Playing Songs

With an account set up, you can purchase songs and download them to your computer. Select a song and click the Buy button at the far right of the song (you may have to scroll your iTunes window horizontally). The store displays a warning to make sure that you want to buy the song; you can either go through with the purchase or cancel it. The song downloads automatically and shows up in your iTunes song list. Purchased songs also appear in a special Purchased Music playlist under the Music Store heading as well as in the iTunes Library song list.

If, for some reason, your computer crashes or your Internet connection is lost before the download finishes, iTunes remembers to continue the download when you return to iTunes. If the download doesn't continue, choose Advanced⇨Check for Purchased Music to continue the download.

You don't have to use the 1-Click technology. You can instead add songs to a shopping cart in the store, which delays purchasing and downloading until you're ready. If you decide to use the shopping-cart method, the Buy button for each song changes to an Add Song button. When you're ready to purchase everything in your cart, click the Buy Now button to finish the sale and download all the songs at once. To switch from 1-Click to a shopping cart, check out the section "Setting the Music Store Preferences," later in this chapter.

All sales are final. If your computer's hard drive crashes and you lose your information, you also lose your songs — you have to purchase and download them again. But you can mitigate this kind of disaster by backing up your hard drive. You can also "back up" by burning your purchased songs onto an audio CD.

Handling Authorization

The computer that you use to set up your account is automatically authorized by Apple to play the songs that you buy. Fortunately, the songs aren't locked to that computer — you can copy them to another computer and play them from within the other computer's iTunes program. When you first play them, iTunes asks for your Apple Music Store ID and password to authorize that computer. You can authorize up to three computers at a time.

To add a fourth computer, deauthorize a computer by choosing Advanced⇨ Deauthorize Account.

After you set up an account, you can sign in to the Music Store at any time to buy music, view or change the information in your account, and see your purchase history. To see your account information and purchase history, click the View Account link in the store after signing in with your ID and password. Every time you buy music, you get an e-mail from the iTunes Music Store with the purchase information. If you use the 1-Click option, the Music Store keeps track of your purchases over a 24-hour period so that you are charged one total rather than a bunch of single purchases.

Setting the Music Store Preferences

Your decision to download each song immediately or to add songs to a shopping cart for a later batch download is probably based on how your computer connects to the Internet. If you have a slow connection, you should use the shopping-cart method.

You can change your preferences with the iTunes Music Store by choosing iTunes⇨Preferences. In the Preferences window, click the Store button. In the Store Preferences window that appears (shown in Figure 8-4), you can enable the following options:

✦ **Change from 1-Click to Shopping Cart or vice versa.** 1-Click is the default.

✦ **Play songs after downloading.** You can choose whether songs automatically play after purchase.

✦ **Load a complete song preview before playing the preview.** The default is Streaming. This option provides better playing performance (fewer hiccups) with previews over slow Internet connections.

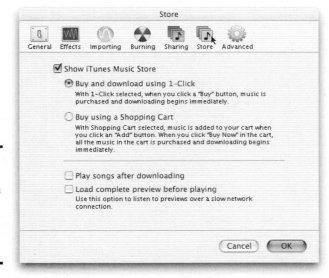

Figure 8-4:
Set your preferences for the iTunes Music Store.

If you use more than one computer with your account, you can set the preferences for each computer differently while still using the same account. For example, your store-authorized home computer may have a faster connection than your authorized PowerBook on the road, and you can set your iTunes preferences accordingly.

Chapter 9: Downloading and Editing Song Information

In This Chapter

✔ Retrieving information from the Internet

✔ Typing song information

✔ Editing the information for a selected song

✔ Speed editing multiple songs at once

✔ Adding liner notes, artwork, comments, and ratings

*O*rganization depends on information. You expect the computer to do a lot more than just store music with "Untitled Disc" and "Track 1" as the only identifiers. Adding all the song information seems like a lot of trouble, but your computer will come through for you. You can get most of this information automatically, without typing.

This chapter shows you how to add and edit song information using iTunes and Winamp.

Filling in the Blanks in iTunes

Why type song information if someone else has typed it? You can get information about most commercial CDs from the Internet. However, you need to check your Internet connection first.

Retrieving information automatically

During the iTunes setup process, you specify whether iTunes connects automatically or manually to the Internet. But you can also change the setup of your Internet connection to connect automatically at any time; just follow these steps:

1. **Choose iTunes➪Preferences.**

The Preferences window appears.

2. **Click the General button.**

The General Preferences window appears.

3. **Select the Connect to Internet When Needed option.**

iTunes triggers your modem automatically (like a Web browser), calls your service provider, and completes the connection process before retrieving the track information.

Part III

Organizing Your Music

You can stop an automatic modem connection as quickly as possible — a good idea if your service provider or phone service charges extra fees based on timed usage. When iTunes finishes importing, switch to your remote connection program without quitting iTunes, terminate the Internet connection, and then switch back to iTunes.

Retrieving information manually

You can connect to the Internet at any time and get the song information when you need it. After you connect, choose Advanced⇨Get CD Track Names from the iTunes menu bar.

Even if you automatically connect to the Internet, the song information database on the Internet (known as CDDB) may be momentarily unavailable, or you can have a delayed response. If at first you don't succeed, choose Advanced⇨Get CD Track Names again.

After connecting and retrieving track information using a modem, your Internet service may still be connected until the service hangs up on you. You may want to switch to a browser, without quitting iTunes, and surf the Web to make use of the connection — iTunes continues to import or play the music while you surf.

Typing the song information

You can type a song's information in either Browse view or the song list view. Click directly in the information field, such as Artist, and click again so that the mouse pointer turns into an editing cursor. You can then type text into the field.

Editing artist and band names

Just like when typing the song information into iTunes, you can edit a song's information in either Browse view or the song list view. Edit a song's track information by clicking directly in the field, and clicking again so that the mouse pointer turns into an editing cursor. You can then select the text and type over it, or use ⌘+C (copy), ⌘+X (cut), and ⌘+V (paste) to move tiny bits of text around within the field. (Music-lovers using the Windows version of iTunes should press Ctrl+C, Ctrl+X, and Ctrl+V instead.) As shown in Figure 9-1, I changed the Artist field to `Beck, Jeff`.

You can edit the Song Name, Artist, Album, Genre, and My Ratings fields right in the song list. Editing this information with File⇨Get Info is easier. Keep reading to find out.

Speed editing multiple songs

Editing in the song list is fine if you're editing the information for one song, but typically you need to change all the tracks of an audio CD. For example, if a CD of songs by Bob Dylan is listed with the artist as `Bob Dylan`, you may want to change all the songs at once to `Dylan, Bob`. Changing all the song information in one fell swoop, of course, is fast and clean, but like most powerful shortcuts, you need to be careful because it can be dangerous.

Long distance information: Using the CDDB database

The first time I popped an audio CD into the Mac was like magic. iTunes, after thinking for less than a minute, displayed the song names, album title, and artist name automatically. How did it know? This information isn't stored on a standard music CD — you have to either recognize the disc somehow or read the liner notes.

The magic is that the software knows how to reach out and find the information on the Internet — in the Gracenote CDDB service (CDDB stands for, you guessed it, *CD Database*). The site (www.gracenote.com) hosts CDDB on the Web and enables you to search for music CDs by artist, song title, and other methods (see the following figure). The iTunes software already knows how to use this database, so you don't have to!

iTunes finds the track information by first looking up a key identifying number on the audio CD — a number stored on every publicly released music CD, not for spying on listeners but simply to identify the CD and manufacturer. iTunes uses this number to find the information within the CDDB database. The CDDB database keeps track information for most of the music CDs you find on the market.

Although the database doesn't contain any information about personal or custom CDs, people can submit information to the database about CDs that the database doesn't know about. You can even do this from within iTunes: Type the information for each track while the audio CD is in your CD drive and then choose Advanced⇨Submit CD Track Names. The information you typed is sent to the CDDB site, where the good people who work tirelessly on the database check out your information before including it. In fact, if you spot a typo or something erroneous in the information you receive from CDDB, you can correct it and then use the Submit CD Track Names command to send the corrected version back to the CDDB site. The good folks at Gracenote appreciate the effort.

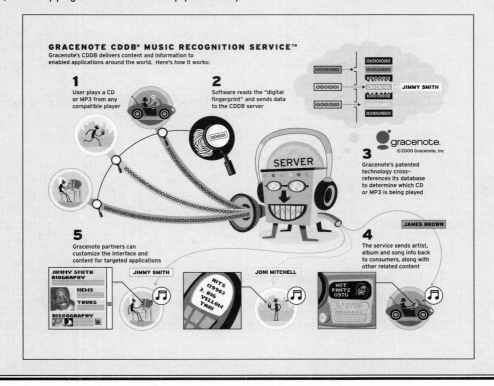

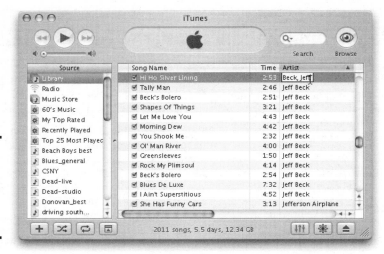

Figure 9-1:
Click inside
the Artist
field to
edit the
information.

You can change a group of songs in either Browse view or the song list view. Follow these steps to change a group of songs at once:

1. **Select a group of songs by clicking the first song and holding down the Shift key while you click the last song.**

The last song, and all the songs between the first and last, are highlighted at once. You can add to a selection by Shift-clicking other songs, and you can remove songs from the selection by holding down the ⌘ key when clicking (*command-click* in Mac jargon). Under Windows, hold down the Ctrl key while you click.

2. **Choose File⇨Get Info or press ⌘+I (sorry, PC users — there's no Windows shortcut here).**

A warning message displays: `Are you sure you want to edit information for multiple items?`

On a highway, speed can kill. Speed editing in iTunes can also be dangerous for your song information. If, for example, you change the song name, the entire selection then has that song name. You must be careful about what you edit when doing this. We recommend leaving the Do Not Ask Me Again check box unselected so that the warning appears whenever you try this.

3. **Click the Yes button to edit information for multiple items.**

The Multiple Song Information window appears, as shown in Figure 9-2.

4. **Edit the field you want to change (typically the Artist field) for the multiple songs.**

When you edit a field, a check mark appears automatically in the box next to the field. iTunes assumes you want that field to be changed throughout the song selection. Make sure that no other box is checked except the field you want, which is typically the Artist field (or perhaps the Genre field).

Figure 9-2:
Change the
artist name
for multiple
songs
at once.

[Screenshot of "Multiple Song Information" dialog box with fields: Artist (Beck, Jeff), Composer, Album, Comments, Genre (Rock), BPM, Part of a Compilation (No), Volume Adjustment (-100% / None / +100%), Year, Track Number, Disc Number, Artwork, My Rating, Equalizer Preset (None), Cancel and OK buttons]

5. **Click OK to make the change.**

iTunes changes the field for the entire selection of songs.

You can edit the song information *before* importing the audio tracks from a CD. The edited track information for the CD imports with the music. (What's interesting is that when you access the library without the audio CD, the edited version of the track information is still there — iTunes remembers CD information from the CDs you inserted before. Even if you don't import the CD tracks, iTunes remembers the edited song information until the next time you insert that audio CD.)

Adding liner notes and ratings

While the track information grabbed from the Internet is enough for identifying songs in your iTunes library, some facts, such as composer credits, are not included. Composer information is important for iPod users because the iPod allows you to scroll music by composer as well as by artist, album, and song. Adding composer credits is usually worth your while because you can then search and sort by composer and create playlists.

After your songs import into the music library, locate a single song and choose File⇨Get Info (or ⌘+I). You see the Song Information window, shown in Figure 9-3.

When you select one song, the Song Information window appears; when you select multiple songs, the Multiple Song Information window appears. Be careful when selecting multiple songs and using the Get Info command.

The Song Information window offers the following tabs to click for different panes:

✦ **Summary:** The Summary tab (shown in Figure 9-3) offers useful information about the music file's format and location on your hard disk, and its file size, as well as information about the digital compression method (bit rate, sample rate, and so on).

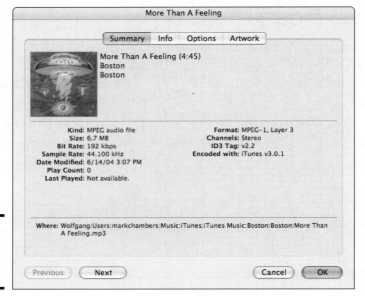

Figure 9-3:
The Song
Information
window.

✦ **Info:** The Info tab allows you to change the song name, artist, composer, album, genre, and year, and comments, as shown in Figure 9-4.

✦ **Options:** The Options tab enables you to adjust the volume, select an equalizer preset, assign ratings, and choose start and stop times for each song. You can assign up to five stars to a song (your own rating system, equivalent to the Top 40 charts).

✦ **Artwork:** The Artwork tab allows you to add or delete artwork for the song (the iTunes Music Store supplies artwork with most songs).

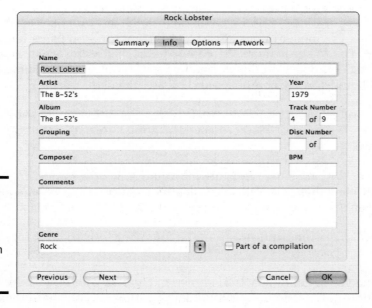

Figure 9-4:
View and
edit the
song
information
in the
Info tab.

Adding MP3 Tag Data in Winamp

After you've encoded your file in Winamp, there's one last step: Filling out the song's ID tag. MP3 files contain more than just music. There's room inside the file to store information about the song itself: its name, composer, artist, album, length, and other pertinent information.

To fill out an ID tag of a newly created MP3 file — or any MP3 file — load it into Winamp and double-click its name to display the dialog box shown in Figure 9-5.

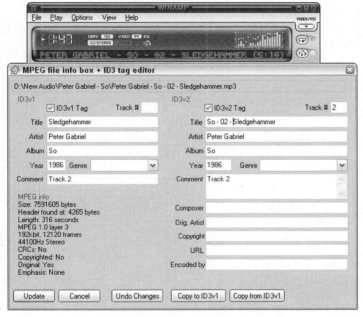

Figure 9-5: Double-click a file's name in Winamp to call up its ID tag for editing.

By the way, ID tags sometimes aren't called ID tags. They're often called *ID3* tags. And, like most other bits of computer unpleasantness, ID3 tags have moved through several versions, each confusing things a little bit more. So some programs, like Winamp, display the information stored in both tag formats. The first version of the ID3 tag, known as ID3v1, included space for the song's track number (its order on the CD), title, artist, album, recording year, genre, and a tiny comment.

MP3 users quickly tired of the restrictive format, so the tag engineers released the ID3v2 tag. That tag includes more space for each description, a lengthy comment area, and additional spaces for more detailed information.

Why should anybody care about ID tags when the file's name usually already contains the artist's name and song title? Because the larger your collection grows, the more difficult it becomes to keep track of your songs. With properly filled-out ID tags, players can find songs more easily and play them on demand.

The following list highlights tidbits about tags that you may find useful:

✦ Some programs like Musicmatch Jukebox automatically fill out every song's tag as they create the MP3, using the number on the CD and dialing the Internet's Gracenote CDDB database (as I describe earlier in this chapter).

✦ Many MP3 songs downloaded from the Internet lack *any* tag information. Luckily, some programs can read a file's name to find the artist and song information and then fill out the tag automatically.

You'll find many tagging programs — as well as tag information — at `www.id3.org`.

✦ Napster, which I briefly describe in Chapter 7 of Book III, can actually search through an MP3 file's ID tag information as well as its filename when looking for songs.

Chapter 10: Organizing Your iTunes Music Library

In This Chapter

✓ **Browsing your music library**

✓ **Changing viewing options**

✓ **Sorting the song list**

✓ **Searching for songs or artists**

✓ **Creating a playlist of multiple songs**

✓ **Creating a playlist of albums**

✓ **Creating a smart playlist**

✓ **Viewing and changing a smart playlist**

✓ **Playing a playlist on your iPod**

You rip a few CDs and buy some tunes from the iTunes Music Store, and watch as your music library fills up with songs. That song list is getting longer and longer, and as a result, your library is getting harder to navigate.

The iTunes library is awesome even by jukebox standards — it can hold up to 32,000 songs depending on your disk space. Finding Chuck Berry's "Maybelline" is a challenge using a rotating dial of 32,000 songs. The 40GB iPod holds about 10,000 songs — enough music to last four weeks if played 24 hours a day! Therefore, even if you keep your iTunes library down to the size of what you can fit on your iPod, you still have a formidable collection at your fingertips. If you're a music lover, you'll want to organize this collection to make finding songs easier.

In this chapter, I show you how to search, browse, and sort your music library in iTunes. You can find any song in seconds and display songs sorted by artist, album, genre of music, or other attributes. You can change the viewing options to make your library's display more useful. I also discuss playlists and how you can use them to organize your iTunes library.

Browsing by Artist and Album

You can switch to Browse view to find songs more easily. The Browse view is useful as long as you track information for the songs. You aren't overwhelmed by a long list of songs, because when you select an album, iTunes displays only the songs for that album.

To view albums in Browse view, click the Browse button in the upper-right corner. iTunes organizes your music library by artist and album, which makes finding just the right tunes easier, as shown in Figure 10-1. Click the Browse button again to return to the default view — the Browse button toggles between Browse view and the default song list view.

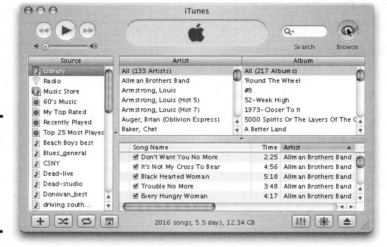

Figure 10-1: Click the Browse button to browse the iTunes library.

The Browse view sorts by artist, and within each artist, by album. It displays the songs in a list underneath a set of columns. This type of column arrangement is a tree structure, although it looks more like a fallen tree.

When you click an artist in the Artist column (as shown in Figure 10-2), the artist's album titles appear in the Album column on the right. At the top of the Album column, the All selection is highlighted, and the songs from every album by that artist appear in the Song Name column below the Artist and Album columns.

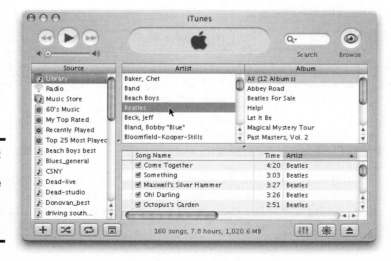

Figure 10-2: Select an artist to see the list of albums for that artist.

To see more than one album from an artist at a time, hold down the ⌘ key (under Windows, the Ctrl key) and click each album's name. iTunes displays the selected albums.

As you click different albums in the Album column, the Song Name column displays the songs from that album. The songs are listed in proper track order, just as the artist intended them.

This technique is great for selecting songs from albums, but what if you want to look at *all* the songs by *all* the artists in the library at once? You can see all the songs in the library in Browse view by selecting All at the top of the Artist column.

Understanding the Song Indicators

As you make choices in iTunes, it displays an action indicator next to each song to show you what iTunes is doing. Here's a list of indicators and what they mean:

✦ **Orange waveform:** iTunes is importing the song.

✦ **Green check mark:** iTunes has finished importing the song.

✦ **Exclamation point:** iTunes can't find the song. You may have moved or deleted the song accidentally. You can move the song back to iTunes by dragging it from the Finder (or Windows Explorer) to the iTunes window.

✦ **Broadcast icon:** The song is on the Internet and plays as a music stream.

✦ **Black check mark:** The song is marked for the next operation, such as importing from an audio CD or playing in sequence. Click to remove the check mark.

✦ **Speaker:** The song is currently playing.

✦ **Chasing arrows:** iTunes is copying the song from another location or downloading the song from the Internet.

Changing Viewing Options

iTunes gives you the ability to customize the song list. The list starts out with the Song Name, Time, Artist, Album, Genre, My Rating, Play Count, and Last Played categories — you may have to drag the horizontal scroll bar along the bottom of the song list to see all these columns. You can display more or less information, or different information, in your song list; you can also display columns in a different order from left to right, or with wider or narrower column widths.

You can make a column fatter or thinner by dragging the dividing line between the column and the next column. As you move your cursor over the divider, it changes to a double-ended arrow; you can click and drag the divider to change the column's width.

You can also change the order of columns from left to right by clicking a column heading and dragging the entire column to the left or right. In addition, you can Ctrl+click (press the Ctrl key and click) any of the column headings to display a shortcut menu offering the same options as the View Options dialog box, the Auto Size Column option, and the Auto Size All Columns option.

Maybe you don't like certain columns because they take up valuable screen space. Or perhaps you want to display some other information about the song. In the View Options dialog box (choose Edit⇨View Options), you can add or remove columns, such as Size (for file size), Date Added, Year (for the year the album was released), Bit Rate, Sample Rate, Track Number, and Comment, to name only a few (see Figure 10-3).

Figure 10-3:
The viewing options for the song list.

You can select the columns you want to appear in the song list. To pick a column, click the check box next to the column header so that a check mark appears. Any unchecked column headings are columns that don't appear. Note that the Song Name column always appears in the listing and can't be removed — that's why it doesn't appear in the View Options dialog box.

The viewing options you choose depend on your music playing habits. You may want to display the Time column to know at a glance the duration of any song. You may want the Year column to differentiate songs from different eras, or the Genre column to differentiate songs from different musical genres.

You can also browse by genre in the Browse view, rather than by artist. To add a Genre column to the Browse view, choose iTunes⇨Preferences (under Windows, choose Edit⇨Preferences). Click the General tab at the top of the dialog box that appears. In the General Preferences dialog box, select the Show Genre When Browsing option.

Sorting Songs by Viewing Options

Knowing how to set viewing options is a good idea because you can use them as criteria when sorting the listing of songs. Whether you're in Browse view

or viewing the song list in its entirety, the column headings double as sorting options.

For example, if you click the Time heading, the songs reorder by their duration in ascending order — starting with the shortest song. If you click the Time header again, the sort is reversed, starting with the longest song. This can be useful if you're looking for songs of a certain length, such as when you need a song to match the length of a slideshow or a movie clip.

You can tell which way the sort is sorting — ascending or descending order — by the little arrow indicator in the heading. When the arrow is pointing up, the sort is in ascending order; when it's down, the sort is in descending order.

You can sort the song list in alphabetical order. Click the Artist heading to sort all the songs in the list by the artist name, in alphabetical order (the arrow points up). Click it again to sort the list in reverse alphabetical order (the arrow points down).

Searching for Songs

As your music library grows, you may find it time-consuming to locate a particular song by the usual browsing and scrolling methods described earlier in this chapter. So, let iTunes find your songs for you!

Locate the Search field — the oval field in the top-right corner, to the left of the Browse button. Click in the Search field and type the first characters of your search term. Follow these tips for best searching:

✦ Search for a song title, artist, or album title.

✦ Typing very few characters results in a long list of possible songs, but the search narrows as you type more characters.

✦ The Search feature ignores case. When you type *miles,* for example, it finds "Eight Miles High" as well as "She Smiles Like a River."

✦ If you're in Browse view with an artist and a particular album selected, you can't search for another artist or song. Why not? Browsing with searching narrows your search further. The song you're looking for isn't on the selected album you're browsing.

If you want to search the entire library in Browse view, first click the All selection at the top of the Artist column to browse the entire library before typing a term in the Search field. Or, if you prefer, click the Browse button again to return to the default song list view, and type a term in the Search field with the library's song list.

The search operation works immediately, searching for matches in the Song Name, Artist, and Album columns of the listing.

To back out of a search so that the full list appears again, you can either click the circled X in the Search field (which appears only after you've started typing characters) or delete the characters in the Search field. You then see

the entire list of songs in the library's song list, just as before. All the songs are still there, and remain there unless you explicitly remove them. Searching only manipulates your view of them.

Organizing Your Music with Playlists

To organize your music for different operations, such as copying to your iPod or burning a CD, you make a *playlist* — a list of the songs you want.

You can use playlists to organize your music and do the DJ thing. Select love songs from different albums to play the next time you need a romantic mood. Compile a list of surf songs for a trip to the beach. I create playlists specifically for use with an iPod on road trips, and others that combine songs from different albums based on themes or similarities.

You can create as many playlists of songs, in any order, as you want. The files don't change, nor are they copied — the music files stay right where they are, only their names are stored in the playlists. You can even create a smart playlist that automatically adds songs to itself based on the criteria you set up.

Graphical user interfaces like Mac OS X and Windows were made for creating playlists: dragging items visually to arrange a sequence. Save yourself a lot of browsing time by creating playlists — which, by the way, can really improve the way you use music with an iPod. You can create playlists of individual songs or whole albums.

Creating playlists of songs

You can drag individual songs into a playlist and rearrange the songs quickly and easily.

To create a playlist comprised of songs, follow these steps:

1. **Click the + button or choose File⇨New Playlist.**

 The + button, in the bottom-left corner of the iTunes window under the Source list, creates a new playlist in the Source list named "untitled playlist."

2. **Type a name for the playlist.**

 The playlist appears in the Source list, as shown in Figure 10-4. After you type a new name, iTunes automatically sorts the playlist into alphabetical order in the Source list, underneath the preset smart playlists and other sources.

3. **Select the library in the Source list and drag songs from the library to the playlist.**

4. **Select the playlist in the Source list and drag songs to rearrange the list.**

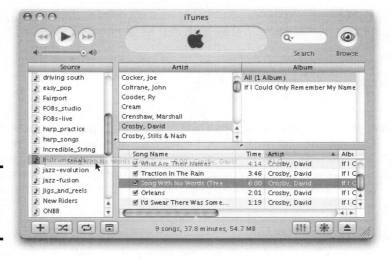

Figure 10-4:
Create a
playlist and
add songs.

The order of songs in the playlist is based on the order in which you dragged them to the list. To move a song up the list and scroll at the same time, drag it over the up arrow in the first column (the song number); to move a song down the list and scroll, drag it to the bottom of the list. You can move a group of songs at once by selecting them (on the PC, click and press Shift+click; on the Mac, press ⌘+click).

You can drag songs from other playlists to a playlist. Remember that only links are copied, not the actual files. Besides dragging songs, you can also rearrange a playlist by sorting the list — click the Song Name, Time, or Artist column headings, and so on. And when you double-click a playlist, it opens in its own window, displaying the song list.

To create a playlist quickly, select multiple songs at once (as I describe in the previous section) and then choose File⇨New Playlist from Selection. You can then type a name for the playlist.

Creating playlists of albums

You may want to play entire albums of songs without having to select each album as you play them. To create a playlist of entire albums in a particular order, follow these steps:

1. Create a new playlist.

Create a playlist by clicking the + sign under the Source list or by choosing File⇨New Playlist. Type a name for the new playlist.

2. Select the library in the Source list, and click the Browse button to find the artist.

The Album list appears in the right panel.

3. Drag the album name over the playlist name.

4. Select and drag each subsequent album over the playlist name.

Each time you drag an album, iTunes automatically lists the songs in the proper track sequence.

You can rename a playlist at any time by clicking its name and typing a new one, just like any filename in the Finder or in Windows Explorer.

Viewing a Smart Playlist

At the top of the Source list, indicated by a gear icon, you can find what Apple (and everyone else) calls a *smart* playlist. iTunes comes with a few sample smart playlists, such as the My Top Rated playlist, and you can create your own. Smart playlists add songs to themselves based on prearranged criteria. For example, as you rate your songs, My Top Rated changes to reflect your new ratings. You don't have to set anything up — My Top Rated is already defined for you.

The smart playlists are actually ignorant of your taste in music. You can create one that grabs all the songs from 1966, only to find that the list includes "Eleanor Rigby," "Strangers in the Night," "Over Under Sideways Down," and "River Deep, Mountain High" (in no particular order) — which you may not want to hear at the same time. You may want to fine-tune your criteria.

Creating a smart playlist

To create a new smart playlist, choose File⇨New Smart Playlist. The Smart Playlist dialog box appears (as shown in Figure 10-5), giving you the following choices for setting criteria:

✦ **Match the Following Condition(s):** You can select any of the categories used for song information from the first pop-up menu, and select an operator, such as the greater than (>) or less than (<) operators from the second pop-up menu — combine them to express a condition: `Year is greater than 1966` or something like that. You can also add multiple conditions by clicking the + button, and then decide whether to match all or any of these conditions.

✦ **Limit To:** You can make the smart playlist a specific duration, measured by the number of songs, time, or size in megabytes or gigabytes. You can have the playlist select songs by various methods such as random, most recently played, and so on.

Limiting a smart playlist to what can fit on a CD, or for the duration of a drive or jogging exercise with an iPod, is useful.

✦ **Match Only Checked Songs:** This option selects only songs that have a black check mark beside them, along with the rest of the criteria. Checking and unchecking songs is an easy way to fine-tune your selection for a smart playlist.

✦ **Live Updating:** This allows iTunes to automatically update the playlist continually, as you add or remove songs from the library.

After setting up the criteria, click OK to create the smart playlist. iTunes creates the playlist with a gear icon and the name "untitled playlist." You can click in the playlist and type a new name for it.

A smart playlist for recent additions

Setting up multiple criteria gives you the opportunity to create playlists that are way smarter than the ones supplied with iTunes. For example, I created a smart playlist with criteria shown in Figure 10-5 that does the following:

✔ Adds any song added to the library in the past week that *also* has a rating greater than three stars.

✔ Limits the playlist to 72 minutes of music to fit on an audio CD, and refines the selection to the most recently added if the entire selection becomes greater than 72 minutes.

✔ Matches only checked songs and performs live updating.

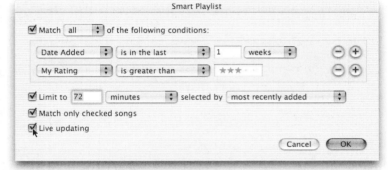

Figure 10-5: Set criteria for your own smart playlist.

Book III
Chapter 10

Organizing Your iTunes Music Library

Editing a smart playlist

To edit a smart playlist supplied by Apple, select the playlist and choose File⇨Edit Smart Playlist. The Smart Playlist dialog box appears, with the criteria for the smart playlist.

You may want to modify the smart playlist so songs with a higher rating are picked. To do so, simply add another star or two to the My Rating criteria.

You can also choose to limit the playlist to a certain number of songs, selected by various methods such as random, most recently played, and so on.

Selecting a Playlist on Your iPod

When you update your iPod, the playlists copy to the iPod. Playlists make playing a selection of songs or albums in a specific order easy. The playlist plays from the first song selected to the end.

Follow these steps to play a playlist on your iPod:

1. **Select the Playlists item from the iPod main menu.**

The Playlists item is at the top of the main menu and may already be highlighted; if not, scroll the main menu until Playlists is highlighted. Then press the Select button. The Playlists menu appears.

2. **Select a playlist.**

 The playlists are listed in alphabetical order. Scroll the Playlists menu until the playlist name is highlighted and then press the Select button. A list of songs in the playlist appears.

3. **Select a song from the list to start playing.**

 The songs in the playlist are in playlist order (the order defined for the playlist in iTunes). Scroll the list until the song name is highlighted and then press the Select button. The artist and song name appear. Highlight the first song to play and press the Select button to start playing.

Chapter 11: Choosing a Portable Music Player

In This Chapter

✔ Choosing an MP3 player

✔ Understanding storage devices

✔ Choosing portable players

✔ Choosing home players

✔ Listening to MP3 files in your car

✔ Considering your needs

*W*hen Diamond Multimedia released its Rio portable MP3 player in 1999 — the first portable MP3 player in the United States — the record companies quickly filed suit. This new-fangled device was illegal, they claimed, and violated copyright laws. To the relief of MP3 fans, the record companies lost the case.

Diamond faces new problems today: The Rio line has been hit with legions of competitors. A few years ago, only a few small imports released players. Today, big names like Apple, Sony, Panasonic, Toshiba, and a host of others have released portable MP3 players. The Microsoft Pocket PC and the Handspring Visor can play MP3 files, as well.

The home stereo market has opened up, too. Some of the latest CD/DVD players handle CDs stuffed with hundreds of MP3 songs.

Which MP3 player is best? Is it finally time to buy one? Or is the MP3 player yet another toy for people with too much money? This chapter helps you decide.

 No matter which portable player you purchase, splurge on a new set of headphones. Check out a stereo shop for some lightweight sports headphones. The cheap little ones shipped with most players almost always stink.

Deciding on a Storage System

Keep one key element in mind when choosing an MP3 player: How many tunes can it hold?

See, MP3 technology squishes songs to less than 10 percent of their normal size, but that's still a huge amount of space. Songs average about 4MB of space apiece. That means storage capacity is the key factor to consider when shopping for a portable MP3 player.

Unfortunately, nobody has come up with a standard storage medium for portable MP3 players. Most of today's portable players use one of six types: CompactFlash, SmartMedia, or MultiMediaCards; Sony Memory Sticks; CDs; and hard drives. If you graduate from one MP3 player to another, the new one might use different storage, rendering all your old storage cards useless.

In the next sections, I examine the pros and cons of each type of storage system, and then explain how to choose one that's right for you.

When looking at storage systems, remember that one minute of music consumes about 1MB of MP3 storage space. That means a 32MB card holds roughly a little more than half an hour of music.

CompactFlash

If you've seen a laptop, you've probably seen a PC card — those business-card-sized thingies that slide into the laptop's side to add more storage, a modem, or other fun accessories.

Cut a standard PC card in half down the middle, and it won't work anymore. But the two remnants will each be about the size of a CompactFlash card. Popular with many portable MP3 players, digital cameras, and other gadgetry, CompactFlash cards store information without requiring a battery. Best yet, CompactFlash cards have no moving parts, making them great for joggers and stunt drivers.

CompactFlash cards come in sizes from 4MB to the recently announced 2GB. The most popular sizes for MP3 players are from 128MB to 512MB. In fact, the best MP3 players toss in a CompactFlash card in the box. (Read the box's fine print closely.)

Here are some pros and cons about CompactFlash cards:

✦ CompactFlash cards are sturdy. Encased in plastic, they can survive a 10-foot drop. (Your MP3 player might not, but you can still salvage the CompactFlash card.) Under average use, the card will last more than 100 years without losing data.

✦ Although CompactFlash cards are a bit larger than SmartMedia or MultiMediaCards (which I discuss next), they hold more information, and they're often slightly less expensive.

✦ CompactFlash cards certainly aren't cheap, though. At the time of this writing, a 128MB card cost around $30, a 256MB card cost about $60, and a 1GB card cost $190. (Shortly after introduction, Simple Technology's 512MB card carried a price tag of $1,599. Technology marches on.)

✦ SanDisk began cranking out CompactFlash cards in late 1995, giving the technology a big head start compared to other types of tiny storage devices.

✦ To transfer information quickly between a CompactFlash card and your computer, check out some of the PC-card adapters. Slide the CompactFlash card into the end of the PC card, slide the PC card into a PC-card slot like the ones on a laptop, and you have immediate access to the CompactFlash data. A slightly less speedy alternative is to buy a card reader that plugs into one of your PC's ports.

✦ Head for the CompactFlash Association at www.compactflash.org for all the information you could ever want to know about CompactFlash cards. Even more information comes from the card's creators: SanDisk (www.sandisk.com), Kingston (www.kingston.com), or SimpleTech (www.simpletech.com).

IBM Microdrive

IBM invented the hard disk drive and sold the first one in 1956. Now it has pulled out a magnifying glass to shrink a hard drive. *Really* shrink it. The IBM Microdrive, shown in Figure 11-1, fits into a CompactFlash card — other manufacturers have also released their own Microdrive designs.

The Microdrive's whirling platter is the size of a large coin, and the whole thing weighs less than an AA battery. Yet it stores many hours of CD-quality audio.

It's no panacea for your MP3 storage needs, however (even if that word rolls merrily off your tongue at high-tension social gatherings):

✦ Whirling hard drives consume much more electricity than solid-state memory cards. Don't count on powering the thing very long — if at all — with a single AA battery, like those used by many of today's MP3 players. Microdrives are also more fragile and subject to possible skipping.

✦ Like any CompactFlash card, Microdrives aren't cheap. Count on spending about $200 for a 2GB card. That's cheaper than a CompactFlash card of about the same capacity, but it still might cost more than your player.

✦ Microdrives are Type II cards, meaning they're slightly thicker than some of the other, Type I cards. Better make sure that your player can use it before shelling out the bucks. (Most players can use them.)

✦ For more information about IBM Microdrive products, race to www.ibm.com.

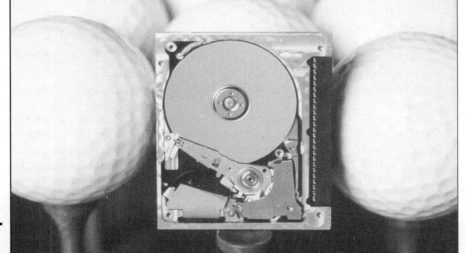

Figure 11-1:
The IBM
Microdrive.

Microdrive is a registered trademark of IBM.

**Book III
Chapter 11**

**Choosing a Portable
Music Player**

SmartMedia

The postage-stamp-sized cards are relatively easy to find because digital camera owners have snapped them up for years. Toshiba created the Solid State Floppy Disc Card (SSFDC) that's now, thankfully, referred to as a plain ol' SmartMedia card.

Smaller than a CompactFlash card and only as thick as thin cardboard, SmartMedia cards result in smaller MP3 players.

So what's the big problem with SmartMedia cards? Actually, there are two problems. First, they're still expensive, costing around $60 for a 128MB card. The other problem? SmartMedia cards can store far less than higher-capacity CompactFlash cards, so these cards might be on their way out. Bummer. I still have a bunch of them.

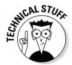

SmartMedia cards come in two voltages: 3.3 volts and 5 volts. Hardly any device uses the 5-volt card anymore. (Turn the card with its shiny side up; the voltage is stamped on that side. Also, the 3.3-volt card has a notch on its right side; the 5-volt card has a notch on the left side.)

MultiMediaCard

The designers of the CompactFlash card didn't rest on their laurels; they also came up with the MultiMediaCard, a postage-stamp-sized card created to compete with the SmartMedia card (see Figure 11-2). It's one of the tiniest storage devices available.

However, the MultiMediaCard has never taken off the way it was supposed to, and its lack of acceptance mirrors the SmartMedia cards. Although capacities run to 512MB, it costs significantly more than a CompactFlash card with the same storage size.

In short, CompactFlash has quite a head start on both SmartMedia cards and MultiMediaCards. But plenty of MultiMediaCard enthusiasts hang out at www.mmca.org.

CDs

CDs seem like a natural storage solution. MP3 files are huge, and CDs hold huge amounts of data. If you leave off the extended Grateful Dead jams, a single CD can often hold 200 or more MP3 songs.

For years, though, only *computers* could play MP3 CDs. Home stereos required their CDs to store music in standard audio CD format — technically called the Red Book format (see Chapter 7 of Book IV to read more about the Red Book format) — that allowed only 10 to 12 songs per disc.

But that's changing, albeit slowly. A large percentage of the personal (see Figure 11-3), home, and car audio CD players on the market now recognize MP3 discs.

Some people will scream in delight when receiving one of these as a birthday present. Others will say, "Welllll." That's because a CD player is still a CD player, even if it's finally able to play MP3 files. It's too big to drop into

a shirt pocket, and you can't erase the songs on the disc (unless your player supports CD-RW media). Plus, CD players are susceptible to motion, making them a second-tier option for the athletic crowd.

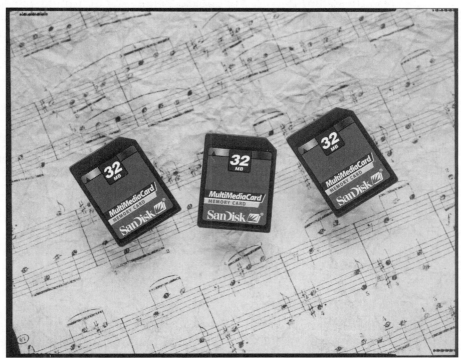

Figure 11-2:
MultiMedia
Cards.

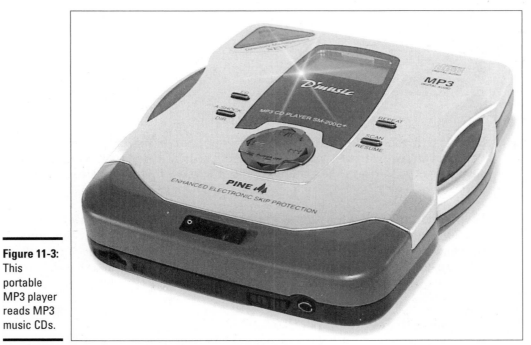

Figure 11-3:
This
portable
MP3 player
reads MP3
music CDs.

It also takes a relatively long time to burn a CD with your favorite songs. And all those moving parts can cause problems: hinges break, CDs scratch, and some players are persnickety about how the MP3s are stored on the disc.

But hey, these new players are cheap, coming out at around $50 apiece. CDs are about the cheapest storage medium around, costing less than a quarter for about 200 songs. Adding the two prices together makes this one of the cheapest solutions around — if you can put up with the awkwardness of a CD.

Hard drives

Everything about computers has grown smaller through the years, and hard drives are no exception. That's why serious MP3 aficionados once sat around waiting for a player with a tiny hard drive that's big enough to hold their entire collection. There's no need to wait any longer: The Apple iPod, the most successful portable MP3 unit on the market, offers models with 15, 30, and 40GB worth of storage.

Other hard-drive-based systems are appearing at cheaper prices than the iPod — for example, the Nitrus and Karma players from Rio (www. rioaudio.com) and the NOMAD MuVo2 from Creative Technology (www. creative.com) — so let the price wars begin.

Sony Memory Sticks

Companies have two ways to make money on portable MP3 players. They can sell the player, or they can make a player that uses a new breed of card and sell both the player and the card. Sony took the latter route with its Memory Stick, shown in Figure 11-4.

Sony is using its Memory Stick for a good portion of its product line, from cameras to recorders to MP3 players. It's a sturdy little beast, with a good design — it's hard to touch the metal contacts, so that keeps them clean and free of dust.

Unfortunately, very few — if any — other MP3 players can use Memory Sticks. If you buy them, they'll work only on Sony products. I bit the bullet and bought a 64MB Memory Stick for my Sony PC-5 camcorder. But I was sure upset that the camera couldn't use my collection of SmartMedia cards or my growing collection of CompactFlash cards.

So, which storage format is best?

If you're trying to save money in storage costs, it's obvious that MP3 CD players are the cheapest way to go. Because you're only paying a fraction of a penny per minute of song storage, you can buy a bunch of blank CDs, fill 'em up with your MP3 collection, and be done with it (or, even better, find a

model that accepts reusable CD-RW media, and just use the same disc over and over).

But you have more to consider than just storage costs:

- ✦ The cost-effective CD player might be the one for you, but only if you don't mind the awkward size.

- ✦ If you're clumsy and afraid of losing something expensive, go for the CD player. You won't be out a bundle when you leave a card-based MP3 player at the bar.

- ✦ If you need something smaller, the CompactFlash card, SmartMedia card, MultiMediaCard, or Memory Stick might be the thing. They're all relatively expensive, however — especially if you're prone to losing things. But they're also more convenient than some of the other systems when it comes to transferring songs back and forth.

- ✦ A Microdrive stores songs for half the price of the CompactFlash and similar cards, but it draws more power and is subject to rattles. Plus, if you lose one of those expensive little things, you'll be crying for weeks.

- ✦ Today's best bet — if you don't mind carrying around a slightly larger device — is a hard drive player. With up to 40GB of storage, it can hold your entire music collection, letting you take it with you wherever you go. Plug the gadget into your home or car stereo, and you won't have to think about buying a dedicated home MP3 player. (Can you tell how much I love my iPod?)

- ✦ If you have a digital camera or other device that already uses one of these formats, think about buying a portable MP3 player that uses the same format. When you can use the same card for both toys, you don't have to buy twice as many cards.

- ✦ Consider buying an older MP3 player. Check out the auctions on eBay (www.ebay.com) or Yahoo! (www.yahoo.com). Just as people trade in their old cars when buying new ones, many people sell their old MP3 players when buying the latest big thing. Last time I looked, I found more than 1,000 players on eBay, with some going for just $35.

Introducing the iPod

In his trademark style, Apple CEO Steve Jobs introduced the 30GB iPod with a remark about Apple's competitors: "We're into our third generation and the rest of them haven't caught up with the first."

As an iPod owner, you're on the cutting edge of music player technology. This section introduces the iPod and tells you what to expect when you open the box.

The iPod is, essentially, a hard drive and a digital music player in one device. Originally, iPods worked only with Macintosh computers, but the latest models support both Macs and Windows PCs running iTunes. The hard drive enables the device to hold far more music than MP3 players. The 40GB iPod model (available as of this writing) can hold around 10,000 songs; that's about 9,000 more songs than can fit on a typical MP3 player.

I've put enough music in an iPod to last three weeks if played continuously, around the clock — or about one new song a day for the next 20 years.

The design of the iPod is superb. At less than 6 ounces, it weighs less than two CDs. With an LCD screen, touch wheel, menu buttons, and backlighting for clear visibility in low-light conditions, the iPod is designed for easy one-handed operation. It offers up to 20 minutes of skip protection — keeping music playing smoothly, not missing a beat even with jarring physical activity — which is twice that of other hard-drive-based MP3 players on the market. And with a thickness of only 0.62 inches, the iPod fits comfortably in the palm of your hand and slips easily into your pocket.

The iPod is a music *player* — although an add-on device is available to turn it into a voice recorder. In my opinion, however, what makes the iPod great is the way it helps you manage your music. In league with iTunes, you can have your iPod do the following things:

✦ Update itself automatically to copy your entire iTunes music library

✦ Copy music directly

✦ Delete music

✦ Update by playlist

Because of the lightning-fast FireWire connection, you'll spend only about ten seconds copying a CD's worth of music from iTunes on your Mac to your iPod. The iPod supports the most popular digital audio formats, including MP3 (including MP3 Variable Bit Rate), AIFF, WAV, and the new AAC format, which features CD-quality audio in smaller file sizes than MP3. It also supports the Audible AA spoken word file format.

The iPod is also a *data player,* perhaps the first of its kind. As a hard disk, the iPod serves as a portable FireWire backup device for important data files, including your calendar and address book.

The iPod is a convenient way for viewing data on the road (while listening to music, of course). You can display text files, notes, and your calendar, and play one of several different games if you're stuck in a line at the air-port. It even offers a sleep timer and alarm clock that can wake you up with your favorite music.

Choosing a Portable Player

When shopping for MP3 players, the following terms pop up either on the box or the advertisements. You might already know what some of them mean; others might be completely foreign. Either way, here's a look at what they mean.

Don't just buy a player without researching it a little bit. First, head to groups.google.com and search for the name of the player you have your eye on. Chances are, that site will turn up discussions of many owners either praising or damning their purchase. The MP3 Hardware forums at MP3.com are another great place for finding information.

Skip protection

When you shake a CD player, the laser read head inside moves, making the sound skip. So, those clever engineers added *skip protection*. When your CD player starts reading the CD, it reads some of the song in advance, storing it in memory that isn't affected by movement.

Then, should the little laser doohickey get jostled, the player reads the music from the memory — the *buffer*. Skip protection technology keeps the song playing smoothly.

Sometimes skip protection is measured in seconds — the number of seconds of music that's read ahead. Other times, skip protection is measured by the amount of memory used to store the music. Either way, the larger the number, the smoother the song plays under rough conditions.

Radio tuner

Face it, the cheapest portable MP3 players can't store more than ten songs. If you're taking off in the morning and returning later in the afternoon or evening, those ten songs might become monotonous.

That's why the best MP3 players toss in a few extra dollars of circuitry to include a radio tuner. That lets you hear your favorite stations when your MP3 tunes become tiring. A radio tuner is definitely a feature to look for.

Microphone

Everybody stumbles on a key thought from time to time that could change their lives — if only they could remember it when they got home. So some MP3 players add a microphone for recording those thoughts that seem so important at the time.

Beware, however: MP3 players don't record sounds in MP3 format. They record them as a WAV file. An MP3 player also records sounds in a low-quality format that's fine for speech but lousy for everything else. Most limit the recordings to a few minutes, as well. Even if you do smuggle one into a concert, you'll get only a bad recording of the first part of one song.

Directory and subdirectory restrictions

Some people meticulously organize their MP3 collections. They create one folder called MP3 and then create folders inside that folder for each artist. Next, they create folders in each artist's folder, one for each album. This meticulous organization makes it easy to find songs on a huge hard drive.

However, some players don't recognize all this work. They want all the songs lumped together in a single folder. That makes it harder for you to pluck the right song from a big pile. This might just be a minor inconvenience, but beware of it, nonetheless. (If the manufacturer's Web site doesn't hold such nuggets of information, a little research online should pinpoint reviews of just about any player you're considering.)

ID tags

MP3 files contain more than music. The format includes space for people to add information about the music: the artist, song, album, type of music, recording year, and other interesting tidbits.

Even if a file is named incorrectly, an MP3 player can look at the tag (assuming that it's been filled out correctly) and find out what song is *really* inside the file.

The best players read ID tags and display the information on-screen, making it easy to see what's being played. The worst players ignore the ID tags and just display a number in place of the song's title.

Now the technical bit. As the MP3 format evolves, so does the ID tag format. In fact, it's gone through several incarnations, with the most popular being either ID3v1 or ID3v2. ID3v2 is growing in popularity because it holds more information about the song — even a picture of the CD cover, if desired. However, some players can handle only the earlier, ID3v1 tag. That frustrates people who have meticulously entered ID3v2 information into their 563 MP3 files.

Just tell me which MP3 player to buy!

I tried doing that in one of my earlier books, which contained pictures and reviews of all the MP3 players on the market at that time. A week after the book came out, dozens more new players appeared, followed by more players every week after that. There's just no way a book can keep up.

Instead, I'll tell you how to cut through the promotional and marketing stuff and find out what users think about today's crop of MP3 players. Here's how to find the best MP3 player for your pocket, your car, or your home stereo:

✔ Go to MP3.com (www.mp3.com) and click the Portable Players button in the Tech Guide section. The folks at MP3.com get all the new goodies before anybody else, so you'll find pictures, specs, and a review of each one.

✔ Head for the Internet's Usenet, a spot where computer geeks from around the world meet to discuss just about everything. To search through the Usenet messages easily, head to the Google Usenet Archive (groups.google.com). That service currently keeps track of all the Usenet messages posted since 1999. Type the name of the player you're considering and click the Search button. Wham! You see messages from anybody who's talked about that player in the past two years. Best yet, these messages are from *real* people — no company hype here.

✔ To find *everything* on the Internet about a particular MP3 player, head to the Google (www.google.com) search engine. You'll find chatter from owners and dealers and information from the player's Web site — just about anything related to the product. Another good search engine is Surfwax (www.surfwax.com). Surfwax searches bunches of search engines simultaneously and posts the results for your perusal. Some people like CNET.com (www.cnet.com) for reviews and information, too.

By using a combination of these techniques, you can find all the information you want about a particular player. Remember, however, that this is the Internet, so don't take any single message at its word. Posts that appear repeatedly from different people are more likely to be accurate than a post from one user.

Playback options

Does the player simply play all your songs in a row? Can you program them to play back in a certain order? Can it shuffle them randomly so that you don't get tired of the tunes as quickly? When it shuffles them randomly, does it always use the same random order? Don't laugh — it happens.

Power

Portable players come with batteries. But are the batteries replaceable or rechargeable? There is a tradeoff. Rechargeable batteries are cheaper in the long run, unless you're living in California during a power crisis. But if they run out during the afternoon, you can't run into a 7-Eleven and grab some new ones. You're stuck.

How long do the batteries last? And does an AC adapter come with the player, or do you have to buy it separately?

Accessories

Many MP3 players, eager to stand out among the competition, toss in some extra goodies: a power adapter that plugs into your car's cigarette lighter, for instance. How are the earphones? Does it have a carrying case? And, if you'll be jogging with it, does it come with a belt clip?

Playing MP3s through Your Home Stereo

You already know that you can play MP3 tunes on your computer, and you might even have a portable player to listen to tunes when you're away from the computer. But serious music fans want a third player: one that hooks up to their home stereo to fill the house with music.

You can make the tunes come out of the home stereo in several ways:

 ✦ **Your computer is an MP3 player — connect it to your stereo.** Chapter 3 of Book III shows you how to connect the right cables between your computer and home stereo. If you have a spare computer and enough space for it to fit next to your home stereo, go for it.

 ✦ **Connect your portable MP3 player to your home stereo.** Just follow the instructions in the Check It Out section, "Hooking Up an MP3 Player to a Home Stereo," at the end of this chapter.

 ✦ **Hook up an FM transmitter to the back of your MP3 player and a receiver to your home stereo's input jacks.** If they're not too far apart, you'll hear your music without a problem.

Listening to MP3 Files in Your Car

You can play MP3 files from your home stereo, from your computer, and from a portable player using headphones. But MP3 is still a relative new-comer in the world of car audio.

If your car's audio system doesn't recognize MP3 music discs, consider these less expensive workarounds:

✦ **Use a cassette player adapter.** If your car has a cassette player, check out a CD-to-Cassette Player adapter. It looks like a cassette tape with a stereo cable hanging from one end. Plug the cable into your portable MP3 player's headphone jack, insert the cassette, and start listening to your MP3s through your car stereo. It sounds amazingly good — well, at least compared to the road noise.

✦ **Use a wireless FM adapter.** Plug the cable from an FM transmitter into your portable MP3 player. Then tune your car's FM radio to the right frequency and listen to your MP3s. Unfortunately, sound quality varies because of local interference, and you're dependent on the batteries that power your wireless adapter.

✦ **Buy a car stereo with a CD Input jack.** Some car stereos lack a CD player. Instead, they have a CD Input jack. Plug a ⅛-inch stereo cable between this jack and your portable MP3 player to hear MP3s through your car's stereo system.

✦ **Burn MP3 songs onto a CD in audio format.** Does your car have a CD player? Then convert your MP3 songs back into standard *CD audio* format and copy them to a CD. You can't fit more than a dozen onto the CD, but at least you can hear them.

✦ **Connect a portable MP3 player to amplified speakers.** Take some amplified speakers — like the ones that come with your PC — and plug a portable MP3 player into them. Carry it all to your car and start listening. To change songs, just swap new cards in and out of the portable player.

Just like car stereos, dedicated MP3 players for cars can be ripped off. To avoid that, substitute your portable MP3 player. You can easily grab your portable MP3 player when you leave the car, keeping it safe.

 CHECK IT OUT

Hooking Up an MP3 Player to a Home Stereo

Hooking up an MP3 player to your home stereo is easy; just follow these steps:

1. Buy a shielded Y-adapter cable — Radio Shack part number 42-2481.

2. Turn down the volume on your stereo and MP3 player.

3. Plug the cable's ⅛-inch stereo plug into your player's headphone jack.

4. Plug the cable's two RCA phono plugs into the stereo's Aux Input or Tape Input jacks.

5. Turn on the stereo and switch it to Tape Input or Aux Input.

6. Play an MP3 file and adjust the volume.

For more complete instructions, refer to Chapter 3 in Book III and read the section on hooking up your computer's sound card to your home stereo. You use the same cable; the only difference is that you're using the MP3 player's headphone jack instead of the computer's Line Out jack.

Chapter 12: Syncing an iPod to Your Mac

In This Chapter

✔ Copying your entire iTunes music library

✔ Copying only certain playlists or only selected songs

✔ Setting up your iPod to update manually

✔ Copying music directly to your iPod

✔ Deleting music from your iPod

*i*Tunes is the software that puts music on your iPod. (It's more than just music — you can include audio books or anything that's stored as a song in iTunes.) iTunes can fill your iPod very quickly with the tunes in your library.

If you're too busy to copy specific songs to your iPod, and your entire iTunes music library fits on your iPod anyway, why not just copy everything? Copying your library is just as fast as copying individual songs, if not faster, and you don't have to do anything except connect the iPod to the Mac. This chapter shows you how to set up iTunes to automatically update your iPod.

This chapter also shows how you can update your iPod manually, choosing which songs to copy. iTunes is flexible in that you can use either option, or *both* options, to update your iPod. You can, for example, update automatically with all the songs in playlists, go into iTunes and copy other music that's not in playlists directly to your iPod, and then delete songs from your iPod if you need to make room. This chapter explains how to set your preferences for updating and change them when you need to.

Changing Your Update Preferences

If you at some point changed your iPod preferences to update manually, you can change them back to update automatically at any time (and vice versa). Change your iPod preferences by following these steps:

1. **Connect the iPod to your Mac through the Mac's FireWire connection.**

 Your iPod must be connected for you to change the update preferences.

2. **Select the iPod name in the iTunes Source list.**

3. **Click the iPod options button on the lower-right side of the iTunes window.**

 The iPod Preferences window appears, as shown in Figure 12-1.

4. **Select the update preferences that you want, and click the OK button.**

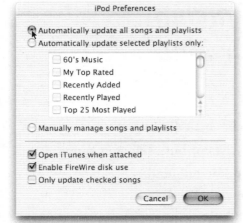

Figure 12-1:
Set your
preferences
with the
iPod
Preferences
window.

5. **Click the OK button to accept the warning message that appears.**

For example, if you select the Automatically Update All Songs and Playlists option button, iTunes displays a confirmation message (see Figure 12-2).

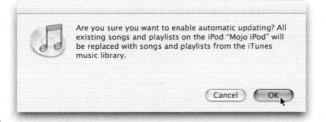

Figure 12-2:
Confirm that
you want to
update your
music
library
automat-
ically.

Updating Your iPod Automatically

Out of the box, the iPod updates itself automatically, *synchronizing* itself — the iPod matches your library exactly, song for song, playlist for playlist — with your music library. If you made changes in iTunes after the last time you synchronized, those changes are automatically made in the iPod when you synchronize again.

If you share an iPod and a large iTunes library with someone and you can't fit the entire library on your iPod, you can update automatically by playlist rather than the entire library. That way, when it is your turn to use the iPod, you can automatically erase all the music on the iPod that's associated with the other person's playlists and copy your playlists. The other person can do the same when you switch. You can update the iPod with different songs as often as you like.

Of course, because the music for your iPod is on your computer, if someone erases your music from the iPod, it's no big deal — you can update the iPod quickly with your music when it's your turn. Make backups of your music library regularly.

Before you connect your iPod to a Mac to automatically update, keep the following things in mind:

✦ iTunes remembers your updating preferences from the last time that you updated your iPod. If you already set your preferences to update automatically, iTunes remembers and starts to automatically update your iPod. If you already set your preferences to update manually, iTunes remembers and makes your iPod active in the iTunes Source list.

✦ You can prevent your iPod from automatically updating by holding down ⌘ and Option as you connect the iPod; keep these keys held down until the iPod name appears in the iTunes Source list. This works even if you choose to automatically update the iPod in the Setup Assistant.

✦ If you connect your iPod to another Mac, you may be in for a surprise. When you connect an iPod that was previously linked to another Mac, iTunes displays the following message:

```
This iPod is linked to another iTunes music library.
Do you want to change the link to this iTunes music
library and replace all existing songs and playlists
on this iPod with those from this library?
```

If you don't want to change your iPod to have this other music library, click the No button. Otherwise, iTunes erases your iPod and updates your iPod with the other Mac's library. By clicking the No button, you change that computer's iTunes preferences to manually update, thereby avoiding automatic updating.

✦ Songs that are stored remotely (such as songs that you share from other iTunes libraries on a network) are not synchronized because they are not physically on your computer.

Updating the entire library

Your iPod is set up by default to automatically update itself from your iTunes library. Just follow these simple steps to set the updating process in motion:

1. **Connect the iPod to your Mac through the Mac's FireWire connection.**

When you connect the iPod to the Mac, your iPod automatically synchronizes with your iTunes music library.

When the updating finishes, the iTunes status view tells you that the iPod update is complete (see Figure 12-3).

2. **Click the iPod Eject button, which appears in the lower-right corner of the iTunes window.**

You can also eject (or *unmount*) the iPod by dragging the iPod icon on the desktop to the Trash. After you drag it to the Trash, the iPod displays an OK to disconnect message. You can then disconnect the iPod from its dock or disconnect the dock from the computer.

While the updating is in progress, do not disconnect your iPod. (In fact, the iPod displays a Do not disconnect warning as soon as you plug it in.) The iPod is a hard drive, after all, and hard drives need to be shut down properly so that you do not to lose critical data.

The update is finished.

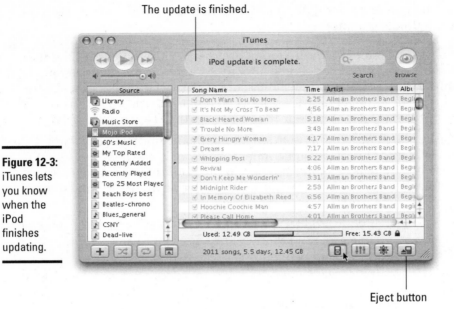

Figure 12-3: iTunes lets you know when the iPod finishes updating.

Eject button

Updating playlists

If you share an iPod with someone else, you can keep track of the music that you use in the iPod by including those songs or albums in playlists in your iTunes library and then updating the iPod automatically with your playlists, deleting whatever was in the iPod before. To do this, set up the iPod to update only selected playlists automatically.

Before using this update option, create the playlists in iTunes (see Chapter 10 of Book III) that you want to copy to the iPod. Then, to update your playlist, follow these steps:

1. **Connect the iPod to your Mac through the Mac's FireWire connection.**

2. **Select the iPod name in the iTunes Source list.**

3. **Click the iPod Options button.**

 The iPod Preferences window appears (see Figure 12-4).

4. **Select the Automatically Update Selected Playlists Only option button.**

5. **In the list box, select the check box next to each playlist that you want to copy in the update, and then click the OK button.**

 iTunes automatically updates the iPod by erasing its contents and copying only the playlists that you select.

 When updating finishes, the iTunes status view tells you that the iPod update is complete.

6. **Click the iPod Eject button, which appears in the lower-right corner of the iTunes window.**

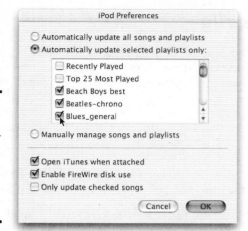

Figure 12-4:
Set up the iPod to auto-matically update with only the selected playlists.

Updating selected songs

You may want to update the iPod automatically, but only with selected songs — songs that are selected with a check mark. To use this method, you must first deselect the songs that you don't want to transfer. To dese-lect a song, click the check box so that the check mark disappears (clicking the check box again makes it reappear, reselecting the song).

You can quickly select or deselect an entire album by selecting an album in Browse view and holding down the ⌘ key.

After deselecting the songs that you don't want to transfer, and making sure that the songs you *do* want to transfer are selected, follow these steps:

1. **Connect the iPod to your Mac through the Mac's FireWire connection.**

2. **Select the iPod name in the iTunes Source list.**

 You can select the iPod name even when it is grayed out.

3. **Click the iPod Options button.**

 The iPod Preferences window appears (refer to Figure 12-1).

4. **Select the Automatically Update All Songs and Playlists option button, and click the OK button when the** Are you sure you want to enable automatic updating **message appears.**

5. **Select the Only Update Checked Songs check box, and click the OK button.**

 iTunes automatically updates the iPod by erasing its contents and copy-ing only the songs in the iTunes library that are selected.

 When updating finishes, the iTunes status view tells you that the iPod update is complete.

6. **Click the iPod Eject button, which appears in the lower-right corner of the iTunes window.**

Book III
Chapter 12

Syncing an iPod
to Your Mac

Updating Your iPod Manually

With manual updating, you can add music to your iPod directly using iTunes, and you can delete music from your iPod as well. The iPod name appears in the iTunes Source list, and you can double-click to open it, displaying the iPod playlists.

You may have one or more reasons for updating manually, but some obvious ones are as follows:

✦ Your entire music library may be too big for your iPod, and therefore you want to copy individual albums, songs, or playlists to the iPod directly.

✦ You want to share a single music library with several iPods, and you have different playlists that you want to copy to each iPod directly.

✦ You want to copy some music from another computer's music library, without deleting any music from your iPod.

✦ You want to edit the playlists and song information directly on your iPod without changing anything in your computer's library. See Book III, Chapter 10, to discover how to edit playlists and song information on your iPod.

✦ You want to play the songs on your iPod using iTunes on the Mac, playing through the Mac's speakers.

When you set your iPod to update manually, the entire contents of the iPod are active and available in iTunes. You can copy music directly to your iPod, delete songs on the iPod, and edit the iPod playlists directly.

To set your iPod to update manually, follow these steps:

1. **Connect the iPod to your Mac, holding down ⌘ and Option to prevent automatic updating.**

Continue holding down these keys until the iPod name appears in the iTunes Source list.

2. **Select the iPod name in the iTunes Source list.**

3. **Click the iPod Options button.**

The iPod Preferences window appears (refer to Figure 12-1).

4. **Select the Manually Manage Songs and Playlists option button.**

iTunes displays the `Disabling automatic update requires manually unmounting the iPod before each disconnect` message.

5. **Click the OK button to accept the new iPod preferences.**

The iPod contents now appear active in iTunes, and not grayed out.

Copying music directly

To copy music to your iPod directly, follow these steps (with your iPod connected to your Mac):

1. **Select the iTunes music library in the Source list.**

The library's songs appear in a list view or in Browse view.

2. **Drag items directly from your iTunes music library over the iPod name in the Source list, as shown in Figure 12-5.**

When you copy a playlist, all the songs that are associated with the playlist are copied along with the playlist itself. When you copy an album, all the songs in the album are copied.

When updating finishes, the iTunes status view tells you that the iPod update is complete.

3. **Click the iPod Eject button, which appears in the lower-right corner of the iTunes window.**

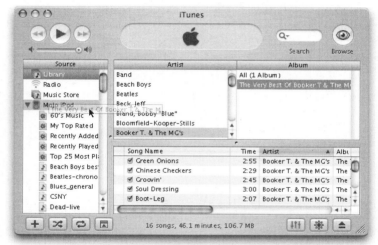

Figure 12-5:
Copy an album of songs directly from the iTunes library to the iPod.

Deleting music from your iPod

With manual updating, you can delete songs from the iPod directly. While an automatic update adds and deletes songs, manual deletion is a nice feature if you just want to go in and delete a song or an album to make room for more music.

To delete any song in the song list with your iPod set to manual updating, follow these steps:

1. **Select the iPod in the iTunes Source list.**

2. **Open the iPod's contents in iTunes.**

3. **Select a song or album on the iPod in iTunes, and press Delete or choose Edit⇨Clear.**

4. **When iTunes displays a warning to make sure that you want to do this, click the OK button to go ahead or click the Cancel button to stop.**

To delete a playlist, select the playlist and press Delete or choose Edit⇨Clear.

As in the iTunes library, if you delete a playlist, the songs themselves are not deleted — they are still on your iPod unless you delete them from the iPod song list or update the iPod automatically with other songs or playlists.

Book IV

CD & DVD Recording

The 5th Wave By Rich Tennant

JERRY AND LYLE ATTEMPT TO LOAD THE NEWEST VERSION OF "TOAST," CD-BURNING SOFTWARE

OK, I got the Sunbeam firewired to the iMac. Try putting the CD in the slot again.

Book IV: CD & DVD Recording

Chapter 1: Optical Storage (Or It's All in the Pits)

In This Chapter

- Defining the disc
- Understanding how stuff is saved on a disc
- Examining the insides of CD and DVD drives
- Understanding the different types of optical media
- Comparing tape, disks, and hard drives with CD and DVD
- Checking your system requirements
- Saving different types of stuff
- Taking care of your discs

When was the last time you really looked at a CD? I mean *really* stared at it, in rapt fascination? Believe it or not, CDs used to be enthralling!

CDs are now a staple of the technical wonderland that you and I live in. Unless you're older and you were around long before 1980 — in the days of disco, *Charlie's Angels,* and Rubik's Cube — you won't remember the lure of the compact disc. In those dark times, before the introduction of CDs, music lived on huge, clunky vinyl albums. Computer software was loaded on floppy disks. Movies? They were kept on videotape (and still are, but not for long).

At first, this situation wasn't a bad one — at least until you kept these old-fashioned storage media for a year or two. Suddenly, you would find that those records had picked up scratches and pops. Computer programs were growing so large that they would span five or six floppies. And sooner or later, those floppy disks and movie videotapes could no longer be read reliably; after a mere 100 viewings or so, you would end up buying another copy of *Enter the Dragon.* (Okay, so I'm a big Bruce Lee fan. Substitute your favorite movie instead.)

Like a circular knight in shining armor, the CD arrived, heralding the beginning of the digital consumer age. I'm not kidding; I can remember an entire room of technotypes jumping with excitement just to *see* their first compact disc! (None of us could afford an audio CD player, and computer CD-ROM drives hadn't arrived yet, but it was great just to see a real, live CD.) In the beginning, audio CDs brought us crystal-clear sound and the convenience of jumping instantly from track to track. Then computer software suddenly fit on one CD, and the software could always be read reliably. Now, with the advent of DVD, movies are accompanied by luxuries like alternative soundtracks and interviews with the cast and director. Would you go back to anything less?

In this chapter, I introduce you to the basics of the compact disc. You certainly don't have to know *all* this stuff before you jump into recording your own discs, but if you understand the basics of what's going on, you avoid mistakes. (Always be prepared.) I promise to tell you along the way about what you absolutely need to know. You find out how discs store information, video, and music as well as what components are inside your CD or DVD recorder. I cover what types of media you can use and what you can store. Finally, I show you how to properly care for your optical pets. (You may not stare at CDs like I used to, but you still have to keep them clean.)

Always Begin with a Definition

In this case, let me start by defining the now-familiar term *CD-ROM* — short for *compact disc-read-only memory.* (I've shortened this to "CD" throughout this book, which will save about 200 trees by the time I've finished.) This high-tech description simply means that a CD stores information of some sort that your computer or audio CD player can read from but can't write to (which makes the CD-ROM drive different from a hard drive, for example, which you can both read from and write to). In general, I use the word *disc* to describe both CD-ROM and DVD-ROM discs; both are similar, and they both look very much alike.

Keep that in mind: Whenever someone refers to just a CD-ROM or DVD-ROM drive (without using the word *recordable*), they're talking about the drives that just read discs and can't record on them.

The basic specifications of both audio CDs and data CDs (those discs that you use in your computer) are the same: They are 12 centimeters in diameter and a millimeter thick, and they have an opaque top and reflective bottom. Such is the Tao of the disc.

As shown in Figure 1-1, however, the structure of a mass-produced disc isn't a single piece of plastic. The disc is made up of a number of layers, each of which has something special to add to the mix, as follows:

Figure 1-1: And you thought that a CD was just a piece of plastic!

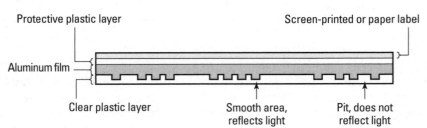

Protective plastic layer — Screen-printed or paper label — Aluminum film — Clear plastic layer — Smooth area, reflects light — Pit, does not reflect light

✦ **A label:** Commercially manufactured discs that you buy in the store have screen-printed labels; these graphics are created from layers of ink applied one on top of the other (like that Metallica t-shirt you may be wearing).

What's that, you say? You don't have $1,000 or so to spend on a special CD screen printer? (Come to think of it, neither do I!) In that case, do what I do, and use your ink-jet or laser printer to create a fancy paper label, complete with the graphics and text that you choose. Or, you can

opt to buy an inexpensive ink-jet printer that also prints on special "print-able" CD and DVD blank discs — we're talking about $150 or less. These are far less expensive than a dedicated CD screen printer, and the discs look almost as good.

"Do I really need a label?" To be honest, no. A disc that you've recorded works fine without one. However, if you've ever dug through a 6-inch stack of unlabeled CDs to find that *Andy Williams Greatest Hits* disc that you burned a month ago for Aunt Harriet, I *guarantee* that you will understand. If you don't need a professional look and you're not into appearances, just use a CD marking pen and scribble a quick title on the top. Most recordable discs have blank lines printed on them just for this purpose. You can pick up one of these handy pens at any office supply store, but make sure that you buy a pen that's designed especially for marking CDs.

✦ **Opaque plastic:** You need something to protect the top of the disc. I suppose that you could use steel, but then a disc would weigh two pounds and cost much more — therefore, you find a layer of scratch-resistant plastic.

✦ **Aluminum film:** Mass-produced CDs use a thin layer of aluminum that's covered with microscopic indentations called *pits*. These pits are arranged in a single, tiny groove that spirals around the disc, just like the groove on one of those antique record albums. (If something works, why mess with it?) However, the groove on a CD starts at the center and spirals to the outside of the disc, so it goes in the opposite direction.

✦ **More plastic:** Again, you have to protect that shiny aluminum — however, in this case, the plastic must be crystal-clear (for reasons that soon become apparent). Here's a hint: It has to do with the passage of laser light.

As I mention at the beginning of this list, this yummy sandwich is a cross section of a commercial CD that's produced at a factory — but the discs that you record on are different in one important way, which I cover in a minute.

Dig that crazy acronym!

I have to use a truckload of acronyms in this book — luckily, each one has only one meaning, right? Almost! One strange exception applies: You may be wondering what DVD stands for, and as the mondo author expert, I *should* be able to tell you.

When DVD-ROM technology was first introduced, everyone agreed that it stood for *digital versatile disc-read-only memory* because it could store so many types of data. Although a CD can store music and computer files, it doesn't have the room for a full-length movie at the highest quality level. You find out later in this chapter that you can cram a huge amount of cool stuff on a DVD-ROM, so it was

the first optical media to hold all the different types of digital information that we use today. Hence, the word *versatile,* and everyone seemed happy.

At some point, however, those first owners of DVD-ROM players who weren't acronym aficionados decided that DVD stood for *digital video disc* — and for a time that was true because DVDs were first used for only movies. This name situation leaves us in a quandary because more and more folks think *video* rather than *versatile.* Naturally, it doesn't matter a hoot because everyone just uses the acronym anyway, but it does make a killer trivia question!

**Book IV
Chapter 1**

Optical Storage (Or It's All in the Pits)

How Is Data Recorded on CDs and DVDs?

Consider just how audio, video, and computer files are stored on a CD. Although these three types of information are different, they are stored in the same way: digitally. But what does that word really mean?

Programmers, technotypes, and hardware jockeys use the word *digital* when they're talking about *binary,* the language that's used by computers around the world. Unlike the imprecise languages that are spoken and written by mere mortals, binary data is built from only two values — 0 and 1. These values are often referred to as *off* and *on,* respectively, as shown in Figure 1-2. (In fact, a computer is only a huge collection of switches, but that's another story.) Therefore, computer files and digital music are a long line of 0s and 1s. If you sat next to a light switch for 100 years and flipped it off and on in the proper sequence, you would have the visual version of a digital song from a CD (and a bad headache along with incredibly sore fingers).

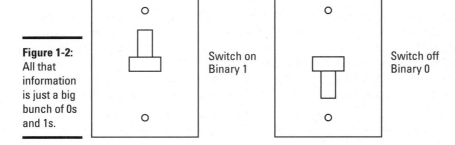

Figure 1-2: All that information is just a big bunch of 0s and 1s.

Switch on
Binary 1

Switch off
Binary 0

Now that you're privy to the binary master plan, you can see how the absence and presence of light perfectly represent binary data — things in a room are either dark or bright. The geniuses who developed CD technology took this concept one step further! They had the great idea of using a laser beam to read the binary data that's stored on a disc, and that's where those pits in the aluminum layer that I mention in the preceding section take center stage.

Figure 1-3 shows how the binary data is read: When the laser beam hits a pit on the surface of the CD, the beam scatters, so most of it isn't reflected (hence, darkness, which in this case stands for a 0 in binary data). If the laser beam hits one of the flat surfaces — they're called *lands,* by the way — the beam is cleanly reflected back, and the drive senses that reflected light. (This is a 1 in binary format.) And, ladies and gentlemen, that is why the bottom of a CD shines like a mirror; the rainbow effect is caused by the microscopic groove that runs across the surface. Naturally, the process of reading data from a disc happens very fast (I talk about speed in Book IV, Chapter 2), but that's really all there is to it.

Essentially, DVD technology works the same way — with a difference or two. A DVD-ROM disc can hold the approximate equivalent of seven CDs, and Figure 1-4 shows why: The pits on a DVD-ROM are much smaller and are packed closer together on the surface of the disc, and the drive uses a much more powerful laser beam to read them. DVDs can also have multiple reflective layers, so data can be stored on both sides.

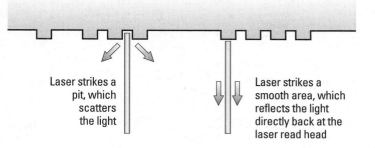

Figure 1-3:
The surface of a CD, as read by your friendly neighborhood laser beam.

Laser strikes a pit, which scatters the light

Laser strikes a smooth area, which reflects the light directly back at the laser read head

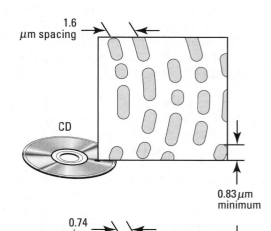

1.6 μm spacing

CD

0.83 μm minimum

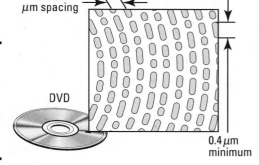

0.74 μm spacing

DVD

0.4 μm minimum

Figure 1-4:
Compared to a CD, you don't find much elbow room on a DVD-ROM.

Believe it or not, the DVD specification standard provides for two-sided DVD-ROM discs that have *two* layers on each side, for more than 27 CDs' worth of storage space on a single DVD-ROM! However, these discs are so hard to manufacture that they're on the endangered species list, and you may never see one.

It's All in the Dye

Consider the structure of recordable discs, which includes both recordable CDs and recordable DVDs. Remember the aluminum film? Sounds permanent, doesn't it? Indeed it is, which is why you can't use commercially manufactured discs to record your own data. Your recorder has to be able to create the equivalent of pits and lands in some other way. (Not even Bill Gates has a CD-R manufacturing plant in his house.)

Figure 1-5 shows how you create a CD — as well as a really bad pun. The CD-R (short for *compact disc-recordable*) disc, which can be recorded once, uses a layer of green or blue reactive dye under a smooth reflective surface of either aluminum or gold. The groove is still there, but until the disc has been recorded, the groove is empty. This dye permanently melts or darkens when hit by a laser beam of a certain frequency; this melting (or darkening) results in a pit.

So, you say, "Hang on, Mark — wouldn't the beam from my regular read-only CD-ROM drive cause problems?" That's a good question, but the designers of recordable CD and DVD drives have you covered. The laser beam that is used to read a CD is far less powerful than the beam used to record one. Therefore, when the beam from the laser in your CD-ROM drive hits one of these dark spots, the beam isn't reflected — instead, the beam is "swallowed" like an apple pie at a state fair, so the dark spot acts just like a pit in a mass-produced CD. In fact, your CD-ROM drive can't tell the difference.

The inside of your CD or DVD recorder sounds like it's getting a little crowded with all these different laser beams, but it's really not. A recorder has a beam that can be set at two levels: a lower power setting that can read a disc and a higher setting to record it. Slick, eh?

A CD-RW (which is short for *compact disc-rewritable*) disc is another story. (Get ready: You're going to *love* this description. It honestly sounds like something out of *Star Trek* — the original series, not any of those later failures that don't have Captain Kirk.) Here goes: A CD-RW disc uses a "phase-change recording process" using a "crystalline layer with amorphous properties" rather than a dye layer. Didn't I tell you? It sounds like something Spock would say! You can promptly forget that stuff because nobody cares and no one gives a test afterward.

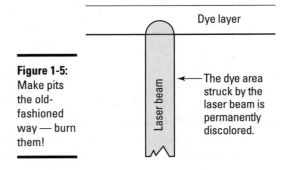

Figure 1-5: Make pits the old-fashioned way — burn them!

Dye layer

Laser beam

The dye area struck by the laser beam is permanently discolored.

Why all the different colors?

I get asked this question all the time. Some CD-R discs are gold with a green dye, and others are silver with a blue dye. Everything acts the same: You're just looking at two different recipes for the dye that's used by different manufacturers. Most drives record on either type of disc, but in rare situations, an older drive seems to work better with one or the other color combination. Personally, I think that it has something to do with the alignment of the planets and the phase of the moon, but I must report what I hear.

On the other hand, CD-RW discs and DVDs all use the same type of dye, so they're all colored the same.

Anyway, although the crystalline layer starts out clear, the correct type of laser beam can change it to opaque, creating — you guessed it — a pit. When you're ready to erase the disk, that same beam of laser light "resets" the crystalline layer to clear again, and you're ready to record all over again. Talk about recycling!

Behind the Curtain: Inside CD-RW and DVD Drives

Before I delve into the depths of your CD hardware, I want to make one thing perfectly clear: *You do not have to read this section!* In fact, if raising the hood on your car and just looking at the engine gives you a headache, I encourage you to skip this section. It's definitely not necessary to know what makes your drive tick.

Still here? I didn't scare you away? Good! If you're like I am, and cool machinery like your recorder fascinates you, stick with me and read on! In this section, I show you the guts of your CD-RW (or DVD) recorder.

The motor

Because pits are arranged around the entire disc, something has to turn that CD — in this case, an efficient, high-speed electric motor. (No coal or gas here, Bucko.) The motor turns a spindle, which holds the disc by the hole in the center — yet another similarity to vinyl record albums!

The laser stuff

A read-only CD or DVD drive has a laser read head, and your recorder also has one laser head — remember, it can be toggled to two different power levels. When you read a disc, the laser beam is focused through a lens upward toward the surface of the disc; if the beam is reflected by a land, the light travels through a prism to an optical pickup. In turn, the pickup yells to your computer — in effect — "Hey, I just passed a land back there, so add a 1 to the file."

When the power's cranked up, it's time to burn, baby, burn. As I mention in the section "It's All in the Dye," earlier in this chapter, the higher-power laser beam travels up to the surface of the disc and creates a pit by discoloring or melting the dye layer in one tiny spot.

How does the laser head get around the entire surface of the disc? It's on a track that can move forward and back between the center and outside edge of the disc.

The tray

The tray is self explanatory but still pretty doggone important: You need some method of inserting and ejecting discs. Although most drives use a tray that extends to hold the disc, some integrated CD-RW and DVD drives use a slot with a motor-loading system that draws the disc inside the drive (just like a car audio CD player). Older drives used a thin plastic box called

a *caddy* — you opened the caddy and stuck the disc inside. Although you would be hard pressed to find a new CD-RW recorder that uses a caddy, some high-capacity DVD-RAM recorders still use them to help protect the disc.

The controls

Your recorder is certain to have an Eject button. It probably also has a headphone jack and a volume control for listening to audio CDs. More expensive drives can go a step further with more audio CD controls, like Pause, Play, Next Track, and Previous Track.

The emergency hole

I know that it sounds weird, but every drive has an *emergency disc-eject hole.* Think of it as being similar to the ejection seat in a jet fighter plane or one of those cool emergency airlock controls that crops up in every science-fiction horror movie. (How many times now has Sigourney Weaver blasted something nasty into space by slapping a button?) You can use this microscopic hole on the front of your drive to manually eject a disc whenever your drive has locked up or if a disc is caught inside. To use the emergency-eject hole, push the end of a paper clip or a piece of stiff wire into the hole to eject the disc. This technique usually works even when no power is applied to the drive.

Love Those Discs: CD-R, CD-R/W, DVD-R/W, DVD+R/W, and DVD-RAM

If you've been reading this chapter at a single sitting, you may have a media-induced headache by now. No, I'm not talking about the nightly TV news — I mean the four different kinds of discs that I mention from time to time in this chapter. It's high time that I identify each of the different types and fill in all the details. This section does just that.

"Hey, can't 1 buy just one drive?"

Yes, you certainly can. (And I encourage you to do it.) A *dual-format* DVD recorder can read and write CD-R, CD-RW, DVD-R, DVD-RW, DVD+R, and DVD+RW discs. Now you know why people get splitting headaches when buying a DVD recorder, and why dual-format drives are so popular now: They burn anything that you can load in them (except for DVD-RAM discs, which can be used only in a DVD-RAM drive).

You'll often see kindred write-once and rewritable formats grouped together as a single name: For example, CD-R/W actually stands for CD-R *and* CD-RW. (Remember, a CD-RW drive can also record CD-Rs.) Likewise, DVD-R/W stands for DVD-R and DVD-RW, and — you guessed it — DVD+R/W includes both DVD+R and DVD+RW.

Unfortunately, if you're already the proud owner of a CD-RW drive, I can assure you that it can't be upgraded to record DVDs.

First on the block: CD-R

In the beginning, there was the CD-R disc, and it's still by far the most popular media on the market. A typical CD-R disc can store from 650MB to 700MB of computer data, or 74 to 80 minutes of audio. (The higher numbers are for higher-capacity, 80-minute CD-R discs.) You can also stack more stuff on a CD-R disc using the overburning feature; read more on this rather nasty-sounding feature in Book IV, Chapter 2. As I mention in the section "It's All in the Dye," earlier in this chapter, after you've filled a CD-R to capacity, there's no turning back; the data is permanently recorded and can't be erased.

Other sizes of CDs are indeed available — for example, discs with a diameter of 8 centimeters that can hold 184MB — but they're typically used only in digital cameras and MP3 players.

CD-R discs are the most compatible optical media. Any CD-ROM drive — no matter how old — can read CD-R discs, and they are the only discs that can play in your home or car audio CD player. It's time for the first Mark's Maxim for Book IV:

> If you need complete compatibility, think CD-R.

In other words, use a CD-R disc in the following situations:

✦ When you're recording a disc to send to someone else

✦ When you're recording an audio CD for playing on anything other than your recorder

✦ When you're not sure whether a drive reads a CD-RW disc

Reusable and loving it: CD-RW

The CD-RW disc is currently the most common rewritable media on the market. It can store 650MB or 74 minutes of audio. A CD-RW disc must be formatted before you use it, just like a floppy disk or your hard drive; most discs come preformatted from the manufacturer. You also have to reformat the disc if you want to erase its contents.

Did you read about the amorphous crystalline stuff that I mention in the section "It's All in the Dye," earlier in this chapter? On the positive side, that's what allows your CD-RW drive to erase the disc and use it again. On the downside, however, most CD-ROM drives that are more than 4 or 5 years old can't read a CD-RW disc, and a CD-RW disc can't be used in older audio CD players. (Check the manual for your audio CD player to see whether it can read CD-RW discs.) Use CD-RW discs in the following situations:

✦ When you're recording a disc for use on your computer, such as for a backup

✦ When you're sure that another CD-ROM drive can read a CD-RW disc

How can you tell whether a CD-ROM drive can read CD-RW discs? Many manufacturers add a MultiRead symbol to their faceplates. If you're still unsure, try reading a recorded CD-RW disc in the drive (don't worry — you can't hurt the hardware). If you can load files from the CD-RW disc, you have a MultiRead drive.

Ready for stardom: DVD-R/W

Perhaps I shouldn't say "ready for stardom" — heck, in the video world, the DVD-ROM disc is already quickly overtaking the traditional VHS tape. (I don't suppose that makes Betamax VCR owners feel any better, but every dog has his day.) The DVD-ROM disc is also poised to take over the reign of CD as the media of choice for virtually every new computer on the planet. But what about recordable DVDs?

Unfortunately, things are still a little tenuous in the world of recordable DVD standards. Luckily, the two competing formats correspond pretty closely to the world of recordable CDs, so most of this will sound very familiar.

The first of these standards is DVD-R, which is short for — you guessed it — *DVD-recordable.* (Note the dash before the R; it becomes pretty important in a page or two.) Like your old friend the CD-R disc, a DVD-R disc can be recorded only once. However, the DVD-R can hold a whopping 4.7GB (that's gigabytes, friends and neighbors) per side of the disc, for a total of 9.4GB of data on a double-sided disc. DVD-R is the darling of the video-editing crowd, because it allows you to record a disc that can be used in a standard DVD player. Naturally, the DVDs that you create with a DVD-R drive can't be read on a standard CD-ROM drive (but you can burn regular CD-R and CD-RW discs).

On the rewritable side, the DVD-R disc format is called DVD-RW. These discs can also store 4.7GB, and you format them much like you format a CD-RW disc. Any DVD-ROM drive should be able to read a DVD-RW disc. Unfortunately, not all DVD players can read DVD-RWs, so if you're an up-and-coming Hollywood type that's interested in producing your own movie discs, you should stick with the DVD-R standard (which is compatible with all DVD players).

Oh joy, what confusion: DVD+R/W

Okay, here's where things gets a little hairy. No, that plus sign isn't a typo: The other independent DVD standard, DVD+R/W, is widely available as well. This more recent format is being touted by an entirely different group of computer hardware manufacturers. (I suppose that they needed different names — but couldn't they have chosen something *easier* to remember? Whatever happened to the guy who chose the name *Microsoft Bob* for an operating system? By the way, I still have my copy.)

Anyway, DVD+R discs and DVD+RW discs can store 4.7GB, and a DVD-ROM player can read both types of discs. Again, however, you run into the same problem — DVD+R discs are compatible with most DVD players, but DVD+RW discs aren't widely supported by DVD players. Plus, DVD-R/W and DVD+R/W are incompatible. (Insert sound of my hand slapping my forehead here.)

In fact, these two disc formats are roughly equivalent — DVD+R/W discs are cheaper to manufacture, though, and DVD+R/W recorders are significantly faster, so the DVD+R/W format may eventually get the nod. (Of course, if you buy a dual-format drive like mine, you don't really give a darn about that plus or minus sign. I can record both DVD-R/W and DVD+R/W discs, smiling quietly to myself all the while.)

If your DVD recorder is limited to one format or the other, take care when you're buying DVD media! Make *doggone* sure that you remember which type of discs your recorder can burn — you'll be deluged by the choices on store shelves, and it's easy to mistake DVD-R discs for DVD+R discs if you're not careful. (Some readers have told me that they are considering getting a tattoo to help them keep things straight.)

The rewritable warehouse: DVD-RAM

Finally, you have good old DVD-RAM — a rewritable disc that can store as much as 9.4GB of data by using both sides. (Remember, a double-sided DVD doesn't have a standard label; printing can appear only around the spindle hole.)

DVD-RAM is well established, and no "plus" format is competing for fame and fortune. DVD-RAM is a great option for storing those huge digital video files, and because DVD-RAM discs are reusable, I find them to be the best media for backing up my hard drives. Note, however, that most DVD-ROM players can't read DVD-RAM discs, so use one of the other DVD formats if you're recording something to distribute to others.

What's Wrong with Tape, Disks, and Removable Media?

Nothing, really! It's just that they're antique technologies compared to rewritable CDs and DVDs. In this section, I list the most important reasons that optical beats magnetic hands down.

I strongly recommend that you *never keep any data of value stored exclusively on floppy disks!* They are the most unreliable media on the planet — they're easily demagnetized, they don't hold much, and they often can't be read by other computers.

More reliable

First (and to many folks, most importantly), a CD-RW, DVD-RW, DVD+RW, or DVD-RAM disc provides permanent storage with a high degree of reliability. Unlike magnetic media — including tape cartridges, floppy disks, and even Zip disks and hard drives — a CD or DVD doesn't stretch or demagnetize. As long as you keep your discs clean, reasonably cool, and free from scratches, you should be able to read them without error for a century or more. (I don't know about you, but my tax returns just won't be that important in 100 years. Then again, I want my priceless family photographs to last as long as possible!) A disc has no moving parts to wear out, and it can't rust.

Higher capacity

Forget about storing 700MB of data on a floppy disk! Even the latest Zip disks are simply no match for the 9.4GB capacity of a double-sided DVD-RAM disc. All that room comes in handy for backing up your system's hard drive, too.

Cheaper

Have you priced a stack of 50 blank, 700MB CD-R discs recently? At the time I wrote this book, I could find that 50-pack all over the Internet at $15; a 50-pack of 650MB CD-RW discs is about $30. DVD-RAM prices are hovering around $15 for a 9.4GB disc, and 50-packs of 4.7GB DVD-R and DVD+R discs are selling for about $35.

As you can imagine, the lower the cost per megabyte for a storage method, the better, and no other type of media can beat recordable CDs and DVDs. And, if the current trend continues, prices will continue to drop. Ain't life grand?

Faster and more convenient

If you've ever waited for a tape to rewind or a floppy disk to load, you've wished for a faster method of loading your stuff — CDs and DVDs feature fast access time, and there's no rewinding. To put it another way, even if something did fit in the tight space of a floppy disk, would you want to run that program from that floppy? Unlike tape drives — which must move linearly from one section of the tape to another — you can jump directly from one part of a disc to another instantly. Take my word for it, it makes restoring files from a backup *much* faster!

Compatibility

Virtually every PC that's still running these days has a CD-ROM drive, so compatibility is a big advantage to recordable CDs for folks like software developers, network administrators, and your Uncle Milton. To put it another way: Ever tried to stick a Zip disk into your car audio player? 'Nuff said.

What Do I Need in Order to Record?

You knew that there would be a catch, didn't you? You're probably thinking, "I bet that I have to have a $1,000 software program and a cutting-edge computer to record discs." Not true, good reader, not true! It used to be that way in the ancient mid-1990s, but CD and DVD recorders are now tame and lovable creatures. They ask for only the basics — in fact, if your computer came with a CD-RW drive already installed, you can skip this section, because you're likely to have everything you need.

What you need for Windows

The basic minimum requirements for CD and DVD recording on a PC that's running Windows 98 or Me are as follows:

✦ **A Pentium II PC (or better):** You need at least 64MB RAM and 1GB of free hard drive space (for a CD recorder). If you're recording DVDs, you need up to 6GB of free space.

✦ **A CD or DVD recorder:** Of course, you also need the proper connection. Internal recorders use Enhanced Integrated Drive Electronics (EIDE) or

Small Computer System Interface (SCSI) connections. External recorders can use SCSI, Universal Serial Bus (USB), or FireWire connections. If you're using an external drive, it should come with the cables that you need.

✦ **Recording software:** Most recorders come bundled with some sort of software. If your computer already has a recorder, it probably also came with the programs that you need to burn your discs.

✦ **Blank media:** Naturally.

The basic minimum requirements for CD and DVD recording on a PC that's running Windows 2000 or XP are as follows:

✦ **A Pentium III PC (or better):** You need at least 128MB RAM and 1GB of free hard drive space (for a CD recorder) or up to 6GB of free space (for a DVD recorder).

✦ **A CD or DVD recorder:** Again, your internal choices are EIDE and SCSI, while external recorders can use SCSI, USB, or FireWire connections.

✦ **Recording software:** Whether your software is bundled with your drive or provided with your computer, you'll need a program to burn.

✦ **Blank media:** You can't burn without the raw material.

What you need for the Macintosh

The basic minimum requirements for CD and DVD recording on a Macintosh that's running Mac OS 9 or Mac OS X are as follows:

✦ **A PowerPC Mac of any speed with at least 64MB RAM and 1GB of free hard drive space:** You need up to 6GB of free space if you're recording DVDs.

✦ **A CD or DVD recorder:** Most Macs come with internal CD-RW or DVD-RW drives, but you can also use external recorders with SCSI, USB, or FireWire connections.

✦ **Recording software:** Mac OS X allows you to burn discs from the Finder menu, and you can burn discs from within iTunes as well. Other commercial recording programs are available, like Toast from Roxio.

✦ **Blank media:** Gotta have it.

If all this talk of connections is making you nervous, don't worry: It's all covered in rich detail in Chapters 2 and 3 of Book IV, including what you need to know before you buy and install a drive.

What Kind of Discs Can I Record?

This question is the easiest of all to answer: Everything! If you can use it on a computer, listen to it in your stereo's CD player, or watch it on your DVD player, you can record it using either a CD or DVD recorder.

**Book IV
Chapter 1**

Optical Storage (Or It's All in the Pits)

Later in this book, I take you step by step through the creation of different types of discs; for now, this section gives you an overview.

Briefcase backup

Never heard of that term? It's my own; I always carry a Briefcase backup when I'm traveling with my laptop. Because my computer has a CD-ROM drive (and the notoriously small hard drive that's found on most laptops), I record on a CD-R disc any files that are specific to my trip. PowerPoint presentations, Word files, contracts, and digital audio and video — even an offline copy of my Web site — they all fit on a Briefcase backup. Therefore, my trip-specific data doesn't take up space on my laptop's hard drive, and it's protected from damage. Plus, copying any of that data to my client's computer is a cinch: No cables or network configuration is required — just pop in the disc and read the files and programs directly! (My Mom always said that I had potential.)

Computer files and data of all sorts

If it can be stored on your hard drive, you can store it on a CD or DVD as well. You can store the following information:

✦ Files and programs

✦ Digital images

✦ Sound clips

✦ Web sites

✦ Backups

Digital audio

With a CD-RW drive, you can record standard audio CDs for use in any audio CD player as well as "mixed" CDs, which have both audio and computer data. Plus, you can extract, or *rip,* tracks from existing audio CDs and record them on a new disc in any order that you choose.

Digital video

A CD-RW drive can create standard video CDs for your video CD player, and a DVD-R/W or DVD+R/W drive can create interactive DVDs with your own digital video.

Network storage

If you have data that is accessed often but never changed on your home or office network, record that stuff to a CD-R disc and load it in your file server's CD-ROM drive. (Getting your network administrator's help with this process is a good idea — those folks get very nervous about such initiatives.) Now you can still access every byte of those files, but you're not using precious hard drive space and you don't have to worry about backing up that information.

Photo discs

You can use your CD-RW drive or DVD recorder to create slideshow discs with images from your digital camera or with scanned photographs.

Caring for Your Optical Pets

In the section "What's Wrong with Tape, Disks, and Removable Media?" earlier in this chapter, I tell you how CDs and DVDs are nearly perfect storage media — but notice the word *nearly.* You have two or three outstanding methods of ruining a disc. The trick is not to become proficient at any of them, so in this last section, I cover the best ways to use, clean, and store your discs.

You gotta grip 'em by the rim!

Let me sound like your mother for a second: Take a good, close look at your hands! When was the last time you washed them? Reading data from a disc that's covered in fingerprints and dust is a touch-and-go process at best, because the laser beam has to get through all that crud twice (especially on DVDs, because the data is packed even closer together). Therefore, you must know how to hold a disc properly.

In my travels, I've encountered two methods of comfortably holding a disc for a decent length of time. You can even jog or tap dance using these holds — whatever floats your boat. Either hold the disc by the outside edge, as shown in Figure 1-6, or — if your fingers are small enough — create your own "spindle" using a convenient finger, as shown in Figure 1-7.

The idea behind these holds is simple: Never touch the underside of a disc, and never put a disc down on any surface. Flipping a disc over and setting it label-side down for a second or two is okay, but put the disc back in its case as soon as possible.

Book IV
Chapter 1

Optical Storage (Or It's All in the Pits)

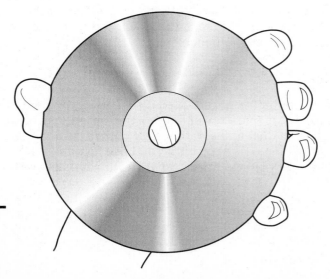

Figure 1-6: I call this the Wilt Chamberlain hold.

Fingers grip on outside edge

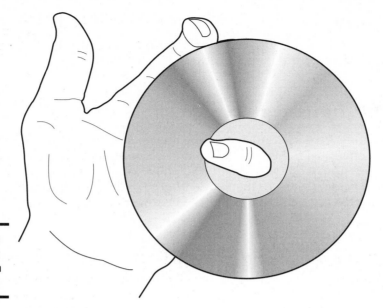

Figure 1-7:
Look, Aunt Harriet, I'm a spindle!

The deadly enemies

To keep your discs safe and avoid skips or data read errors, shelter your discs from these arch-villains:

✦ **Pointed objects:** Scratches are taboo, and that goes for either side of a disc.

✦ **Heat:** How would you like to spend a hot summer afternoon in a closed car, baking on the seat? Underneath that high-tech design, a disc is basically a circle of plastic. Keep your discs cool and out of direct sunlight.

✦ **Surface crud:** This includes liquids, dust, dirt, and peanut butter.

You may have seen one or more CD laser lens cleaners at your local computer store; they usually look something like a disc with a little hairbrush mounted on it. *Never use one of these cleaners on a CD or DVD recorder because it can damage the laser!* In fact, the laser read and write heads inside a recorder need no maintenance.

The Disc Hotel

So where should you put all your recorded discs? Stacking them in a big pile in front of your monitor is one answer, but it's the *wrong* answer. Your discs must be protected from dust and scratches! Of course, storing discs in their jewel boxes is a good idea — that is, until you have an entire 200-disc stand filled and the stand takes up an entire corner of your room! Take a tip from

me: You can save that space and still provide the protection that your discs need with a disc binder, as shown in Figure 1-8. A binder has individual pockets that can hold from 10 to 250 discs, so you can donate your jewel boxes to your friends.

Sometimes you've just gotta wipe

You may say, "I've seen an entire shelfful of CD cleaning stuff at the local GenericMart. Do my discs need cleaning?" If a disc is only dusty, I recommend using a lint-free photographer's lens cloth, which you can pick up at any camera shop. You can also pick up a spray bottle of disc-cleaning fluid for liquid disasters, like those unavoidable soda stains. Other than a cloth and some fluid, however, you can leave all the expensive James Bond contrivances on the shelf at the department store.

To close this chapter on a high note, Figure 1-9 illustrates how to wipe a disc: Start at the center and wipe straight toward the outside of the disc, making sure that you apply no more than fingertip pressure. Wiping harder — or wiping in a circular motion, as shown in Figure 1-10 — can scratch your disc and invite chaos into its ordered world of 0s and 1s.

Figure 1-8:
A true technotype uses a disc binder to save space.

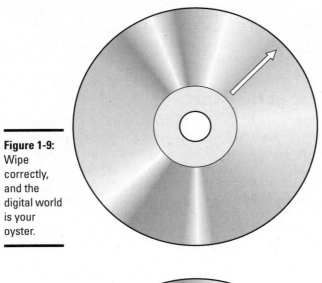

Wipe a CD from the center to the edge in a straight motion.

Figure 1-9:
Wipe correctly, and the digital world is your oyster.

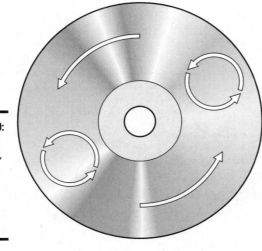

If you wipe a disc like this, you're asking for trouble.

Figure 1-10:
Wipe incorrectly, and your data eventually shows you the door.

Chapter 2: Buying Your Recording Beast

In This Chapter

- ✓ Choosing an internal or external drive
- ✓ Selecting the right interface
- ✓ Understanding recorder read and write speeds
- ✓ Shopping for the right features
- ✓ Understanding CD and DVD formats
- ✓ Selecting the right software
- ✓ Choosing a used recorder
- ✓ Buying your recorder locally
- ✓ Buying your recorder online

Despite the rumors that you may have heard, buying a CD or DVD recorder in the modern world is no longer a dreadful experience (at least, not with this book by your side). In days past, you would be at the mercy of that fast-moving predator of the electronics store — the computer salesperson — who would either turn on the high-pressure hose and sell you the most expensive drive on the planet or stand motionless with hands in pockets, oblivious to the answers to any of your questions. I know friends who still bear the emotional and psychological scars of such an attack.

Today, however, you may never even enter a brick-and-mortar store to buy your drive. If you're on the Web, you can choose from literally hundreds of online stores. You can shop 24 hours a day, at your leisure, and you have all the time you need to compare features and prices. It's paradise for those of us who are ready to purchase online.

If your CD or DVD recorder is already installed and comfortable, you don't need this chapter (although you may still want to read it to brush up on what's available). If your computer came with a CD-RW, DVD-R/W, DVD+R/W, or DVD-RAM drive, feel free to skip to Chapter 5 of Book IV. If, on the other hand, you're shopping for a CD or DVD recorder, you should devour every word to come.

In this chapter, I cover everything that you need to know about buying a CD or DVD drive, including the features that you should covet, the differences between internal and external drives, the type of connection you need, and the formats that your drive should record. Take copious notes or just circle the important stuff directly in this book — whatever floats your boat.

I also provide you with tips on online shopping, which has both its peaks and its pitfalls. Finally, I even cover a few pointers on how to face those sales-sharks head-on at your local store — and *win*. (As my favorite actor, Jack Nicholson, croons in the film *Batman,* "Wait 'til they get a load of me — ooooOOOOooooop.")

Enough talk. It's time to go shopping.

Internal or External: Thinking Outside the Box

Your first choice to make in your trip down Hardware Boulevard is a simple one, yet it has the most effect on the price and performance of a recorder. If you've never run across these terms, an *internal* drive lives inside your computer (just like your floppy drive or your existing CD-ROM and DVD-ROM drives — the latter two are read-only drives). An *external* drive sits outside your computer, using a power cord of its own and a cable of some sort to connect to your computer's case (like the Hewlett-Packard external recorder that's shown in Figure 2-1).

Figure 2-1: An external drive is ready to go solo.

Stay inside with internal

Why pick an internal drive? Most folks do — and for the following reasons:

✦ **Convenience:** Your drive is built in to your computer, without an extra power cord to mess with and some sort of connection cable to boot.

✦ **Speed:** Depending on the interface, most internal drives are faster than their external brethren. (Read more about this party topic in the following section.)

✦ **Cost:** An internal drive is usually less expensive than an external unit, because it's not carrying around its home like a digital hermit crab.

Breathe the open air with external

For some computers (for example, laptops and the stylish Apple iMac), you have to choose an external drive because you have literally no room to install

a second internal drive. (I don't recommend the hacksaw route.) However, the following are good reasons why an external recorder would appeal to even the stodgiest PC owner:

✦ **It saves a bay.** To explain, a *bay* is an internal space inside your PC's case where you can add devices. Most desktop PCs have several of them, but technowizards and power users can easily fill every bay with other gadgets. Because the case has no room inside, an external drive suddenly looks sexy and attractive (at least to them).

✦ **It's easy to install.** Afraid to open your computer's case? Believe me — you are not alone, and you have no reason to be embarrassed. Adding an external drive means that you can leave your desktop alone, and it may even be easier than installing an internal drive. If you choose a USB or FireWire drive, for example, the process is as simple as plugging in a connector and the power cord. (Read more about USB and FireWire in the next section.)

If you want to conquer your fear of computer hardware and delve inside your PC's case, let me recommend another of my books, conveniently titled *Building a PC For Dummies,* 4th Edition (published by Wiley). In the process of showing you how to build an entire Windows-ready PC (yes, the whole ball of wax), in this book, I cover the complete process of adding all sorts of internal hardware, including an internal CD or DVD recorder.

✦ **It's portable.** Everyone in the building can share your recorder, perhaps as a backup device or to carry along with laptops. (By the way, you can also lock up an external drive to keep it from being carried away, if you get my drift.)

Here's the bottom line: Unless your computer simply doesn't have room or you don't want to open it, I recommend saving money and sticking with an internal recorder.

"Edna, He Says We Need an Interface"

Geez, what a word. It sounds like something you would hear from an engineer — ack! — but the word *interface* really has a simple and straightforward meaning: It's the type of connection that you use to unite your computer and your recorder in everlasting friendship (at least until you unplug the two).

In this section, I help you determine which of these exotic connections is right for you.

EIDE

The first connection is the most popular for PC and Mac owners around the world — which, naturally, is why I want to begin with EIDE. Because it's not a freedom-loving English word, it must therefore be one of those furshlugginer acronyms; in this case, EIDE stands for *Enhanced Integrated Drive Electronics.*

Unfortunately, EIDE drives don't come in external form, so if you need an external drive, you can skip to the next interface.

Virtually all desktop PCs built today use EIDE hard drives and CD-ROM and DVD-ROM drives. To handle the workload, your PC likely has both a primary and secondary EIDE connector. Each of these connectors supports two EIDE devices, so you have the capacity for a total of four EIDE drives. If you already have one hard drive and one CD-ROM or DVD-ROM drive in your computer, you're using only two of those four connections.

EIDE drives are simpler and cheaper to install than SCSI units and are a good choice for most home PCs.

SCSI

This time, the evil acronym, SCSI, is short for *Small Computer System Interface*. SCSI is significantly faster and more efficient than a typical EIDE drive, and a single SCSI card can connect from 8 to 14 different devices — which is great if you plan to expand your computer to help NASA with the latest Mars probe. (Seriously, a real power user can add things like scanners and tape drives to a SCSI connection.) SCSI drives are available in both internal and external form. If you have an older Macintosh computer, it likely has an external SCSI port. (And yes, the term is pronounced "skuzzy." Those engineers are real comedians, aren't they?)

Unfortunately, a SCSI drive is harder to configure than an EIDE drive, because a number of settings have to be made correctly. Also, a SCSI recorder is usually significantly more expensive than its EIDE counterpart.

SCSI drives are a good choice for the experienced PC or Mac owner who is willing to spend a little more for better performance and all those extra connections — but be prepared to spend more time configuring and fine-tuning.

USB

At least USB is only three letters long. It stands for *Universal Serial Bus,* a connection type that's used exclusively for external drives. Let me be honest with you: USB is the best thing to happen to PC and Mac owners since the invention of canned air. Believe it or not, the same USB drive can be used by both types of computers, and Figure 2-2 shows how simple it is to connect.

USB is *Plug and Play compatible,* which means that you don't have to reboot your computer when you connect a USB recorder. Plus, your computer automatically recognizes that USB drive, so you have nothing to fiddle with or set. Many USB drives don't even need a separate power supply.

On the downside, a USB 1.1 connection is much slower than an EIDE or SCSI connection, so today's fastest CD and DVD recorders can't use it. You can't burn a DVD using a USB 1.1 connection, and CD burning is limited to 4X or less. USB drives tend to be somewhat more expensive because USB is an external-only connection. Finally, most older computers have only two USB ports, so if you're already using USB devices, you may need a USB *hub;* this little black box converts one of your USB ports into four ports. *Sassy!*

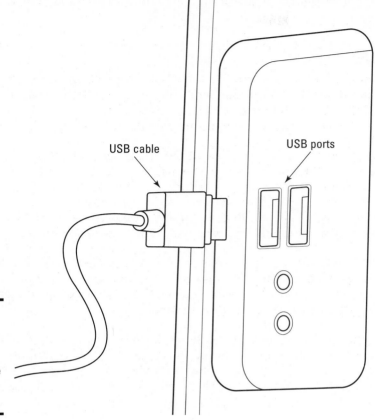

Figure 2-2:
Yes, that USB connector fits only one way. Sheer bliss.

USB cable

USB ports

Although USB 1.1 is too slow for today's recording hardware, I do have some good news: Luckily, those engineers haven't been loafing and resting on their laurels, because the recently introduced USB 2.0 is now quickly becoming standard equipment on today's PCs and Macs. USB 2.0 connections are so speedy that they can easily handle the fastest external CD and DVD recorders that are available today. Naturally, your computer needs USB 2.0 ports to use a USB 2.0 drive. As the Mark's Maxim goes:

> Demand USB 2.0 for your external drive . . . and install new ports if necessary!

Avoid those ancient parallel port drives!

If you're using an older laptop without USB ports, you may hear about parallel port drives, which use the existing parallel printer port that's found on virtually every PC on the planet. (Macintosh computers have no parallel port, so this is not an option for them.)

Visualize a huge, flashing STOP sign: *Stay away from parallel port CD recorders!* These ancient relics are ridiculously slow — think 2X or slower — and more prone to errors, and they often don't work

if you're already using a printer or another external device, like a Zip drive or a scanner, on your printer port.

These days, a parallel port CD recorder isn't even worth scavenging as a doorstop, so avoid such drives like the zombies they are. Instead, see whether your PC can use an adapter to provide a minimum of USB 1.1 connectivity, with USB 2.0 or FireWire 400 preferred.

I heartily recommend USB 2.0 for anyone who wants a typical external CD or DVD recorder.

FireWire

Imagine a — hey, wait a second, FireWire is not an acronym! Anyway, FireWire is also fast enough for today's high-speed drives, and it's been around longer than USB 2.0. (Technoheads also call it the IEEE 1394 standard, and you may see it advertised as such when shopping for digital camcorders.)

FireWire (developed by Apple) has all the advantages of USB, and it also comes in two flavors: FireWire 400, the original standard, and FireWire 800, the new standard that is twice as fast and currently available only in the Mac world. Both types of FireWire connections work great for external CD and DVD recorders. As an additional bonus, you can use a FireWire 400 port for connecting many digital cameras, DV camcorders, scanners, and so on.

What's the catch? Only external drives need apply, and FireWire drives are typically a little more expensive than a USB 2.0 drive. All current Macintosh computers now have FireWire built in (naturally), and PC owners can add FireWire ports by installing an adapter card.

FireWire 400 is the best all-around choice for high-performance external recorders, because it connects far more devices to your computer. (For example, FireWire 400 is the bee's knees for those using digital video camcorders.)

The X Factor Explained

Of all the gobbledygook associated with buying a CD or DVD recorder, nothing is as foreign to a normal human being — or affects the price of a drive as much — as the X factor. You encounter these X numbers in every description of every drive you see, so I cover the X factor thing like a wet blanket (or a new coat of paint).

In plain English, the *X factor* is the speed at which a drive can read and record data. For CD recorders, these speeds are typically expressed as three numbers, like 40X/12X/48X. The order of the numbers is important and is as follows:

✦ The first number indicates the CD-R recording speed.

✦ The second number is the CD-RW recording speed.

✦ The last number provides the read-only speed for all pre-recorded discs (both commercially-manufactured and the discs you've recorded).

Therefore, when you apply these conventions to the example, you're looking at a drive that can record a CD-R at 40X, record a CD-RW at 12X, and read a CD-ROM or CD-R at 48X speed. Naturally, higher numbers are better, so follow this general Mark's Maxim (I really like those):

The faster the X factor, the faster the drive performs at either recording or reading data.

On the DVD side, you typically only see one X number — that's the recording speed for the drive. (Of course, because a DVD recorder can also burn CD-R discs and CD-RW discs, you can see the familiar three-number X-factor combination in the specs as well.)

Most internal CD drives on the market today record a CD-R disc at 24X speed or faster, and most external CD drives record at a minimum of 16X speed.

If you're considering a drive that's slower than 8X, promise me that you won't pay much (if anything) when you buy it. A 2X or 4X recorder is an antique now — of course, it works fine if your Uncle Milton gives it to you for free. Scavengers forever!

For those who care about such arcane measurements, the CD recording X factor is technically a multiplier of the original read-only speed of the first drives that appeared in the early 1980s. (You can call them 1X drives.) These drives could send data to a computer at 150 kilobytes per second. Therefore, a 2X CD-ROM drive can send data to a computer at 300 kilobytes per second. Read-only drives can now reach blinding transfer rates of 52X, or 7,800 kilobytes per second. The same holds true for the DVD recording X factor, which is based on the original 1X DVD recording speed.

The X Factor General Maxim (or, in the acronym-happy world of computers, the XFGM) that I state earlier in this section seems to recommend that you shell out every possible penny for the fastest drive around. If you were Bill Gates, you would be right. However, common folk like you and me have things called *budgets,* so buying the fastest sports car of a recorder may not always be the best road to take. Consider the following examples:

+ If your computer already has a 40X or 48X CD-ROM drive — in the DVD-ROM world, a 16X drive — you don't need to spend anything extra for faster read-only speeds. Play your games and video in the read-only drive, and choose a lower-priced recorder just for burning discs.

+ If you plan to use your new drive exclusively for recording audio CDs, why pay extra for a drive that records CD-RWs, DVD-R/Ws, or DVD+R/Ws faster? A faster rewritable speed is better suited for you if you plan to use the drive to back up your computer's hard drive.

+ If you plan to record once or twice a week and you can wait the extra 4–5 minutes per disc, an 8X CD-RW drive works just as well as a 40X drive that may cost twice as much.

In the end, the drive performance that you should choose depends on how many discs you record, how fast you want to record them, and how much you are willing to pay for a faster drive.

Features on Parade

The earlier sections of this chapter cover the three big features: internal versus external, drive connections, and raw speed figures. Now consider individual features that add convenience, performance, and (coincidentally) cost to a drive. The more of these that you can pack into your purchase, the

happier you will be. Note that I also mention which features are especially important for certain recording tasks. Believe me — it's better to discover that a drive has a tiny recording buffer *before* you buy it.

Make use of every pit: Overburning

Sounds like you're making digital toast, doesn't it? *Overburning* is a fairly recent phenomenon in the world of CD recording; it refers to a drive that can record more than the manufacturer's stated maximum capacity of a CD-R disc. For example, a drive that can overburn to 76 minutes can record 76 minutes of music on a standard 74-minute CD-R disc, or you could use the same drive to store 685MB of data rather than 650MB. The amount that you can overburn depends on your recorder and the specific brand and storage capacity of the discs that you're using. For example, 82-minute discs with more than 700MB of space are now available (but, as you may expect, these new discs aren't compatible with most drives that are more than 3–4 years old).

Overburning is mucho grande, but you must remember the following caveats:

✦ Most CD-ROM drives made in the past 2–3 years have no trouble reading overburned discs, although some older drives spit them back out as unreadable. Therefore, if you distribute your discs, I recommend that you don't overburn them.

✦ Media manufacturers don't guarantee their discs past the 74- or 80-minute rating, so you overburn at your own risk.

How does a drive overburn? It uses the lead-out portion of the disc, which was not originally intended to store data; in fact, the lead-out area is *supposed* to indicate to your drive that it has reached the end of the disc. When you overburn, you're burning past that point. If your CD-ROM drive doesn't care and can read an overburned CD, in effect, you're storing more in the same space. Real 8-bit old-timers like myself who used the early Atari and Commodore computers remember something similar: We used to flip over a 5¼-inch single-density disk and use the other side, which you weren't supposed to do. Shameful, really.

Important: Any CD recorder can use an 80-minute CD-R disc — you're not overburning when you put 80 minutes of music or 700MB of data on this kind of media. Again, however, not every recorder can use these larger-capacity discs. Check the specifications of any recorder that you're considering buying to see whether it can use 80-minute/700MB discs.

Three words: Buffer, buffer, buffer

For today's faster drives, a large *data buffer* (also known as an internal RAM or RAM cache) is indeed an important feature. All recorders have at least some buffer RAM. This memory stores data that your computer has retrieved from your hard drive until your recorder is ready for it. Figure 2-3 tells the tale. The larger the buffer, the more efficient this process becomes, and the less likely your drive is to return an error and ruin a disc because it ran out of data to write.

Figure 2-3:
Think of a
buffer as a
holding tank
for all those
0s and 1s.

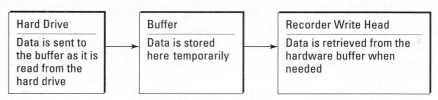

Most modern drives have at least 4MB of buffer memory, and more expensive drives can have 8MB or even 16MB. When comparing drives, always choose a model with a larger buffer.

The ultimate safety net: Burnproof recording

Consider now the hottest-burning feature (horrible pun intended) to come along in several years. Burnproof recorders effectively end problems that folks generally had when they were doing any of the following things:

✦ Recording on slower PCs

✦ Recording in the background under Windows or the Mac operating system (for example, using Word, Photoshop CS, or Internet Explorer while recording)

✦ Recording at high speeds (12X or faster)

Before the arrival of burnproof drives 3–4 years ago, engaging in one of these activities was risky business indeed. As you may have read in earlier sections in this chapter, a recorder had to have a constant flow of data to prevent buffer underrun errors. Any interruption or hiccup in the transfer of data from the computer's hard drive to the recorder was usually disastrous. A larger buffer helped, but that still didn't solve the problem entirely, and your recorder certainly couldn't stop in the middle of a disc — it was now or never.

If your CD-RW drive doesn't support burnproof recording, you should be happy to know that I devote Chapter 6 of Book IV to helping you optimize your computer and recorder to prevent buffer underrun errors. Virtually all DVD recorders support burnproof recording, so fear not.

Burnproof recording eliminates the potential for data errors by interrupting the recording process. The drive monitors the buffer, and when things look dangerous (for example, if you are running Adobe Photoshop CS, which is a notorious disk and memory hog), the recorder takes note of the position of the laser and stops recording. After the buffer has been refilled (which can take a few seconds), the laser write head is automatically repositioned at the point where the recording was interrupted and the recording process continues.

I can't stress how revolutionary burnproof recording is. If you can afford this feature (which is now available on virtually all CD and DVD recorders), by all means, get it.

Disc-at-Once: Funny name, important feature

Here's a strong recommendation: I wouldn't buy a drive that doesn't offer *Disc-at-Once* (also called DAO) recording. (Is that a definite enough recommendation?) Rather than record digital audio or computer data as individual tracks, Disc-at-Once records the entire disc at one time. (You find out all about this subject in Book IV, Chapter 7). Suffice it to say that the audio CDs that you record sound better on some audio CD players, and you can get more music on a single disc if you use Disc-at-Once technology. Again, check a drive's specifications to see whether it offers Disc-at-Once recording.

Sorry, but It's Time to Talk CD and DVD Formats

Formats are tricky things. Any CD-RW drive can create a simple audio CD (which, by definition, conforms to an international set of format standards called the Red Book) or a simple data CD with files on it (which uses the Yellow and Orange Book standards). You don't have to worry about these basic functions; for a CD or DVD recorder, they're like walking and chewing gum.

However, you never know when you may suddenly find yourself needing a Video CD or a CD Extra disc, and if your drive doesn't support them, it can never record those discs. You can't add formats to your drive after you've bought it.

Therefore, this section has two goals: First, I introduce you to each format, and then I help you determine which one you are likely to need later. Here's another Mark's Maxim to chew on:

> Cast your purchasing eye on the drive that can write the largest number of formats.

UDF/packet writing

If you skipped my discussion of burnproof recording earlier in this chapter, flip back to the section "The ultimate safety net: Burnproof recording" and read it. I'll wait for you here.

Anyway, *packet writing* (or, as the format is officially named, UDF) is almost as cool as burnproof recording: It allows you to write files to a CD or DVD just as you would write files to your hard drive, using Windows Explorer, the Mac OS Finder, or any of your other applications. You can add files one at a time or in groups, without having to record the entire disc at one sitting. In effect, packet writing turns your drive into a gigantic, superfast floppy drive that can store more than 600MB (or a whopping 4.6GB).

You can also "erase" data from a disc. Yes, I tell you in Chapter 1 of Book IV that you can't erase data from a CD-R, DVD-R, or DVD+R disc, but I'm stretching the truth a bit. Rather than being physically removed from the disc, the data that you're erasing is being rendered unreadable, so it simply *can't* be retrieved. The data is still there — you just can't access it.

Again, it's time to be blunt: Virtually all modern CD and DVD drives now support the UDF standard, and I wouldn't buy one if it didn't.

Video CD

Although DVD-R and DVD+R are the unequivocal kings of digital video recording, those of you with lowly CD-RW drives can produce your own brand of visual magic: A drive that records in Video CD format can create discs for a Video CD player (and most DVD players can read them, too). Most CD-ROM and DVD-ROM drives can now also read Video CDs — all you need is the right software. I use Windows Media Player.

With a Video CD, you have many of the same features that you would find in a DVD player, including an interactive menu for selecting video clips and freeze-frame or slow-motion effects.

CD Extra

Another new format is CD Extra, which allows you to record a disc with a mixture of audio and data tracks. Why create a mutant disc like this? Most modern computers have high-fidelity audio systems, so many musicians are using CD Extra to add a music video, song lyrics, and other multimedia material to their audio CDs. (Remember that the disc can also be played on your computer's CD-ROM or DVD-ROM drive.) For example, two of my favorite bands — the Squirrel Nut Zippers and the Rolling Stones — have turned out CD Extra discs in the past.

A CD Extra disc doesn't overlook the folks who just want to listen to the disc in an audio CD player. The audio track on a CD Extra disc is recorded first, so it's compatible with any audio CD player — in fact, the player doesn't know the difference. The only restriction, naturally, is the amount of audio that you can record on a CD Extra disc: Because you're adding data as well, you don't get a full 74 or 80 minutes of audio elbowroom.

Digging deep for specifications

I admit that I'm letting loose a landslide of features and formats in this chapter, but I have a reason: I don't know how you will use your drive, so I can't tell you what features and formats are most important for *you*. Instead, I explain all the relevant stuff, and you can pick and choose what's necessary for your Dream Drive.

Unfortunately, the Feature Fairy doesn't drop in to tell you what formats and features are supported by a drive, or what software ships with it. To buy the best drive, you have to roll up your sleeves and do the research. First, visit the manufacturer's Web site and look for that all-important specification sheet. (This is also a good time to check on the quality of the manufacturer's support, like driver updates, firmware upgrades, and FAQ files.) In many cases, the specification list should tell you everything you need to know.

Next, try visiting www.buy.com or www. pricewatch.com, where product features can

be compared side by side among different drives. These sites are great for asking questions like "Which 12X CD-RW drives are under $300 and have burnproof recording?"

If you have an Internet connection and you're familiar with newsgroups, I recommend comp. publish.cdrom.hardware and alt.comp. hardware. Someone in one of these groups may know the features of a particular drive (although you may get opinions mixed in liberally with your answers).

Most computer magazines have online Web editions, and they often cover CD and DVD recorders with hardware comparisons and performance evaluations. Finally, use a search engine, such as www.google.com, to locate information about a specific make and model of drive; you may be surprised at what turns up.

Multisession/CD-ROM XA

I can't discuss CD-ROM XA format without first introducing you to the idea of a *session,* so here goes: In effect, a session is a self-contained dataset that is recorded on a disc. In English, think of it as a single track on an audio CD. You can store multiple tracks on one disc and access each of them individually as you like. As an example, think of one year's tax returns recorded in one session, followed by the next year's returns in the next session; it's a way to update the existing data on a CD without losing the old data. Each of the sessions on a multisession-mode CD-ROM XA disc can be read, but only one at a time.

CD-ROM XA isn't nearly as popular as it once was because of the following gotchas:

✦ **Not all CD-ROM drives can read CD-ROM XA.** Truly antique CD-ROM drives may be able to read only the last session that was recorded or may not even be able to read the disc.

✦ **Software is required to change sessions.** Some sort of session-selection program or function is necessary; it comes with most CD recording programs. But if you're sending a disc to someone else and that person doesn't have the session-changing software (or a CD or DVD recorder), she's out of luck.

✦ **Packet writing is better.** The availability of the UDF standard on most drives has made multisession recording as outmoded as the Model T. Packet writing is far easier than recording multiple sessions.

Software You Just Gotta Have

I really shouldn't say that: Of course, the software that you receive with your recorder isn't as important as the hardware itself. After all, you can always add software later or upgrade what you have. Hardware is, well, *hard.* Other than a firmware upgrade, your drive's features and performance are fixed, so the software should take a back seat (not too far back, though).

One drive that you're considering may have a much better selection of software than another. If the two drives' prices, features, and speeds are similar, a superior software selection can tip the scales. However, every CD recorder that you consider should ship with basic recording software that does the following:

✦ Allows you to burn discs in all supported formats

✦ Erases and formats CD-RW discs

✦ Tests for proper installation and configuration of your drive

My favorite recording software is Easy Media Creator, from Roxio, and I use it throughout much of this mini-book. I'm also fond of Nero Burning ROM, from Ahead Software (visit www.nero.com and see Figure 2-4), and the great shareware program CDRWIN, from Golden Hawk Software (visit

www.goldenhawk.com and see Figure 2-5). On the Macintosh, my recording program of choice is Roxio Toast (www.roxio.com), which I also use later in Book IV, Chapter 9.

Figure 2-4:
Nero
Burning
ROM —
great
recording
program,
funny name.

Figure 2-5:
Gaze upon
the
simplicity
of the
shareware
classic
CDRWIN.

After you've taken care of the basics, you find that some drives offer additional software that can save you money and — as the marketing types would say — "enhances your recording experience." (In other words, the more of this nifty software you get, the better off you are.) I cover this extra stuff in the following three sections.

A sharp-dressed disc

Can you imagine Fred Astaire in a leisure suit? No way! The tuxedo was practically made for him. Many people feel the same way about the discs that they record: They want those discs to look as professional as possible. One way to do this is to spend anywhere from $500 to a couple thousand dollars on a disc label screen printer. If you would rather save the cash and put your ink-jet printer to work, the following programs can spruce up the appearance of a CD or DVD:

✦ **Label-printing software:** Print labels with everything from simple text to line art or full-color photographs. Labels are particularly nice for audio CDs.

✦ **Jewel box-printing software:** You can print custom front and back inserts for a disc's *jewel box* (that plastic whatchamacallit that stores the disc) or DVD snap-case. I think that it completes the look of a recorded disc. Again, audio CDs benefit from track listings, and computer discs can use the space for file descriptions or installation instructions.

Slick recording add-ons

As I mention in the section "Sorry, but It's Time to Talk CD and DVD Formats," earlier in this chapter, any self-respecting recording program should be able to take care of basic recording tasks all by itself, although separate add-on programs can take care of specialized recording jobs. Consider the following add-ons:

✦ **Packet-writing software:** Why run that big, stodgy recording program each time you want to write a UDF disc? With this thought in mind, most software developers spin off packet writing into a separate program that can run in the background under Windows or the Mac operating system. The perfect example is Drag-to-Disc, from Roxio: It runs automatically when you start your PC and doesn't require you to run Easy Media Creator first. (Read more about this program in Book IV, Chapter 10.)

✦ **Backup and disaster-recovery software:** Call these programs digital peace of mind — use your CD-RW drive to back up either part or all of your system, and you can rest easy at night. I use Retrospect, from Dantz Development (see Figure 2-6), which can even format your rewritable media for you.

I've said it before in most of my books, and I say it again (this time as the King of All Maxims):

If you value your data, back it up.

Are you already using a backup program with a tape drive or Zip disks? If so, check to see whether it already supports the use of a rewritable CD or DVD drive. If so, you can keep original backup sets, avoiding a hole in your backup schedule while you switch to the optical world.

Device	Status	Location
Sony CD-RW	No media	ATAPI 0:1
(Empty)		
HP CD-RW	No media	ATAPI 1:0
(Empty)		

Eject

Device Status

Figure 2-6: I'm backed up. *Are you?*

Tools to organize and play your stuff

I go into the organization of your recording projects in complete detail in Chapter 7 of Book IV. For now, suffice it to say that some of the following programs make finding stuff on your finished discs easier, and other software is required to play the digital video and audio that you've recorded:

✦ **Image- and video-editing software:** Many drives are bundled with an image editor for digital photographs and a simple video editor for chopping Uncle Milton out of this year's Christmas video. This feature makes sense because the majority of recorder owners probably burn digital images and video all the time.

✦ **Multimedia filing software:** Think of these programs as organizers for your audio, video, and images. The programs can help you locate and retrieve a single clip or image for your next presentation or Office document from thousands that are stored on a single disc. Plus, you can play or view those images from within the program to make sure that you've found the right one. My favorite multimedia filing program is Media Center Plus, from Jasc Software, as shown in Figure 2-7. (Roxio's Easy Media Creator now comes with its own multimedia organization tool, called Media Manager.)

✦ **Audio CD/MP3/WAV player:** If you don't get an audio media player with your recorder, you will need one eventually. My favorite is Winamp (see Figure 2-8), from Nullsoft, Inc., which can handle almost anything you encounter: audio in MP3 format, audio CDs themselves, Windows WAV files, and Macintosh AIFF files. Plus, it marks you as being technokeen. You can find Winamp at www.winamp.com.

✦ **Video CD/MPEG player:** The counterpart to your audio media player, a video player is a welcome addition to any recorder's software bundle. My favorite is PowerDVD from CyberLink, which can play Video CDs on any CD-ROM drive. If you have a DVD-ROM or DVD-R drive, PowerDVD can

Book IV Chapter 2

Buying Your Recording Beast

765

also turn your computer into your own personal DVD theater. Figure 2-9 shows PowerDVD playing one of the episodes in my *Batman* collection: Go, Adam West!

Figure 2-7: Finding a needle in a haystack (and retrieving it) is what Media Center Plus is all about.

Figure 2-8: Winamp can rock the socks off your llama. (Don't ask — private joke.)

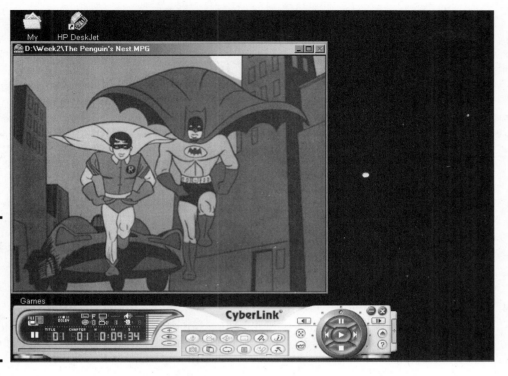

Figure 2-9: PowerDVD is great for watching my favorite TV series of all time on Video CD. Sweet!

Scavenging Fossilized CD and DVD Drives

The vulture may not be the prettiest scavenger on the planet, but it gets the job done. In the world of computer hardware, a scavenged component can often bring you and your computer a world of new possibilities, for little or no cost. This is a good thing, and I'm proud to say that I've been scavenging for many years.

Fate can present a number of different ways to acquire a used recorder: You may inherit one from a family member or friend who is upgrading, or you may stumble across one at a garage sale. The most popular place to find a used drive, however, is probably one of the online auction centers; eBay is the prime location (www.eBay.com). If you're looking for a used drive, keep the following recommendations in mind:

✦ **Don't settle for less than 8X speed for a CD-RW drive.** Unless someone flat out gives you a 2X drive for free, ignore the deal and move on. These drives are just too slow, and any drive with such poor performance probably doesn't have features like burnproof recording, Disc-at-Once recording or a decent-size buffer. (Any DVD recorder is still worth scavenging if it's free, no matter what the speed!)

✦ **Get those drivers.** Nothing is quite as frustrating as searching the world over for CD recorder device drivers, especially when the drive is 5 years old or older. If you're running Windows 98 or later, the process is easier because the operating system comes with a host of drivers built in. The

moral? Whenever possible, get the original software and manual for a drive, and check the manufacturer's Web site to see whether you can still find software and support.

✦ **Buy from recognized sellers.** The seller feedback ratings on eBay make it easy to see who has a good track record, so use these ratings. If a seller has a feedback rating of less than 5 or has a number of negative feedback entries, be wary. Don't be shy about asking questions through e-mail, and keep an eye out for exorbitant handling charges. (I do lots of selling on eBay myself, and I've never charged someone for the overwhelmingly difficult act of slipping something into an envelope or packing it in a box.)

✦ **Consider new versus used.** Finally, consider the current prices for a new drive: At the time this book was written, I could pick up a 40X/12X/48X CD-RW drive for less than $50. Before you spend more than $25 on a used drive, make sure that you're really getting a bargain.

Buying Your Drive at the Maze o' Wires Mall

Let me set one thing straight: You should feel no shame in buying locally. In the following section, I harp away on the advantages of buying online, and I admit that I buy most of my hardware on the Web these days. However, where you buy your drive is your business, and I don't try to push you into shoving dollars through your modem.

Besides the help from a salesperson (hopefully one who really knows the ins and outs of recording), a local store offers three things that no Web store can ever match: immediate delivery, hands-on shopping, and a fast, friendly return policy. (No matter how good Internet Explorer becomes, you can't use your mouse to open a box that's 2,000 miles away.) No waiting is involved to either receive your drive or to bring it back if you find that you're the proud owner of a lemon.

Watch out, however, for pressure tactics from a sales thug. Ask plenty of questions, request a demo, and bring along a knowledgeable friend to help you shop. Check out several stores before settling on a drive.

Considering buying returned (or refurbished) hardware? Have the salesperson connect the drive and give it a thorough check before you take it home. Also, don't forget to ask what kind of warranty you receive on your purchase.

Your drive costs you more, and you pay local sales tax, but if you're nervous about buying online or you want to install that drive tonight, jump in the car and head to your local computer marketplace.

Buying Your Drive on That Web Thing

"Okay, I need to save money, and I've got a credit card — plus, it's hurricane season, I have nothing clean to wear, and my favorite episode of *My Three Sons* is starting in 5 minutes. Can I buy a drive online?" Indeed, you can — in fact, in a situation like that, it's sheer madness to buy locally.

No lock, no sale

If you're ready to buy a recorder online and the Web store doesn't offer a secure connection, tell 'em to take a hike. A secure connection is encrypted to protect your credit card number and personal information, which makes it challenging for the online criminal element to intercept your data as it's sent to the Web site.

If you're using Internet Explorer or Netscape Navigator, look for a closed padlock icon in the status bar at the bottom of the browser's screen. (For Mac owners using Safari, the lock appears at the upper-right corner of the window.) If you see the lock, the connection is secure, and you can enter your information. If you don't see a locked padlock icon (or the lock is open and not closed) and you're being asked for your personal information and card number, I would immediately move on to the next online store.

It really does take only 5 minutes to buy your recorder on the Web (after, of course, you've done your thorough research). The Web offers the widest selection of drives at the lowest prices, and you can use sites like www. pricewatch.com to search for the best deal. Depending on the state that you're in (pun not intended that time), you may be exempt from local sales taxes, too.

Why pay for next-day or second-day shipping if you're not itching for the fastest delivery? Many sites select next-day shipping as a default option, and you're stuck paying twice or three times the cost of 5-day shipping. Don't fall for this old trick: Choose the shipping option that suits your pocketbook.

One final word about ordering on the Web: Most mail-order companies charge a virtual arm and a leg for restocking your drive if you decide to return it. Make sure that you're not charged if you have to return a defective recorder.

Chapter 3: DVD Is the Cat's Meow

In This Chapter

✔ **Comparing recordable DVD media**

✔ **Understanding DVD copy protection**

✔ **Choosing a DVD recording format**

✔ **Shopping for additional hardware and software**

*I*n the early '80s, the acceptance of CD-ROM by the general public was painfully slow but perfectly understandable. For example, John T. Everyman had listened to vinyl albums all his life and had just begun to mesh with the psychology of the cassette tape. Along came the audio CD, and many folks couldn't help but ask, "Is this just a flash in the pan, like my Betamax VCR?" Because only a handful of plants initially manufactured CDs, CD-ROMs started out prohibitively expensive, and the first year or two saw only a pitiful selection.

What was worse, recording your own CD was science fiction for more than a decade. Developing the technology took several years, and then when the first CD-R drives appeared, they were priced so high that technotypes like myself got nosebleeds just reading the advertisements. I can remember wishing that I had $6,000 — that's right; six *thousand* dollars — so that I could become an optical alchemist and burn like professional musicians and video editors. Only around 1995 or so did CD recorders descend from the heavens to less than $1,000, and it took three more years for the typical CD recorder to drop to less than $500. Recording software? You may as well have written it yourself because what was available was almost as expensive as the drive.

Thank goodness, we have all learned our lesson. Things have changed so dramatically that the introduction of DVD a few years ago was a complete mirror image of the early years of the compact disc. First, the CD-ROM has become so common that DVD was immediately accepted as "the next step in optical media." No uncertainty, wailing, or gnashing of teeth this time. We all want the storage space and convenience of DVD. A large number of well-established factories were already ready and waiting to produce DVDs, and the selection of films has mushroomed quickly. Prices on many popular DVD movies are less than $10, and the selection grows every day.

Finally, DVD recording is light-years ahead of where CD recording was at this stage of the game. Drives have reached rock-bottom prices, and software abounds to help you produce your own interactive discs. Many computers are already shipping with DVD-R/W and DVD+R/W drives, and prices continue to drop across the board for all types of recordable DVD blank media.

Many features that I cover in Chapter 2 of Book IV apply in this chapter as well, such as internal versus external drives and the connections you can

use. Therefore, I focus more on the important questions you need to ask before you plunk down your hard-earned greenbacks for a new DVD drive. I also include a discussion of additional hardware and software that comes in handy for recording, as well as information on those pesky DVD formats.

"Do 1 Need DVD-R/W, DVD+R/W, or DVD-RAM?"

Do you need a rewritable DVD-R/W drive or a DVD-RAM model? Why not get all three? (Oh, brother.) Unless you've been hanging out with the good folks at the lottery commission, that's probably not an option. You can, however, find many drives on the market that can use both DVD-R/W and DVD+R/W, like the Sony DRU-510. (Talk about alphabet soup! For the definition of each acronym that I'm tossing around, visit Chapter 1 of Book IV.)

However, I still have good news: The relative strengths of all three types of recordable DVD media make it easy to decide which one you need. Check out Table 3-1 for the scoop.

Table 3-1	Will DVD-R/W, DVD+R/W, or DVD-RAM Escort You to the Ball?		
Media Type	*Can Be Read in DVD Players*	*Reusable/Rewritable?*	*Media Cost*
DVD-R	Almost always	No	$2 per disc (4.7GB)
DVD+R	Almost always	No	$2 per disc (4.7GB)
DVD-RW	Usually not	Yes	$4 per disc (4.7GB)
DVD+RW	Usually not	Yes	$3 per disc (4.7GB)
DVD-RAM	Usually not	Yes	$15 per disc (4.7–9.4GB)

Although I break DVD-R and DVD-RW into separate categories in the table, it's getting harder and harder to find a drive that records *only* DVD-R — and the same holds true for DVD+R/W. This trend mirrors the development of CD-RW technology. Try finding a drive that burns *only* CD-Rs these days! (I dare you.)

I should point out something else about Table 3-1: Besides being incredibly informative, it uses the words *almost* and *usually,* which don't show up in many definitive tables. Why? The answer lies not in today's recorders, but rather in yesterday's DVD-ROM players: *Four* distinct generations of DVD-ROM players have existed since their introduction in late 1997, and each succeeding generation has a better chance of reading DVD-Rs, DVD+Rs, and DVD-RAMs.

The result is a big question mark. Because of the wide disparity in manufacturers, I honestly can't tell you whether the DVD-ROM player you have now reads *any* type of burned disc. If you're using a DVD+R or DVD-RAM, you have the best chance with a DVD-ROM player manufactured since early 2001. If you're using DVD-R, you have the best chance with a DVD-ROM player made after late 1999. Thoroughly confused now? Sorry about that. This alphabet soup of different standards and rapidly evolving hardware can turn a computer book author's hair very gray very quickly.

Anyway, here are my recommendations. First, pick DVD-R/W if

✦ You're looking for the highest level of compatibility with all DVD-ROM drives.

✦ You're distributing discs to others.

Pick DVD+R/W if

✦ You're looking for compatibility with the latest DVD-ROM drives.

✦ You want to spend a little less on media.

Choose DVD-RAM if

✦ Compatibility with DVD-ROM drives is not an issue, such as when you're creating backups or discs that you read only on your computer.

✦ You want to rewrite the largest amount of data on an existing disc.

Oh, and yes, Virginia: You can read a commercially manufactured DVD-ROM movie disc in either type of recorder. At least I can guarantee you the extra bonus of adding a DVD-ROM drive to your computer when you install a DVD recorder.

"Hey — 1 Can't Copy 'Curse of the Mollusk People'!"

Man, of all the clunkers that Hollywood has turned out, why would you possibly want to copy a movie about mobile glowing clams that enslave the minds of simple townsfolk? (I've bought titles like *Robot Monster, Nude on the Moon,* and *Blood Feast* for my collection. Perhaps I shouldn't be too proud.)

Anyway, you can't just copy a DVD-ROM movie for good reason: Lots of smart engineers, software developers, and designers worked hard to make sure that you can't. Some discs are protected by the addition of unreadable areas on the disc during manufacturing, and other protection schemes involve encrypted key codes that must be present on the disc for it to be recognized by either your player or your computer's DVD-ROM drive.

Sure, some programs on the market purport to create direct copies of DVD movies, but most DVD movies hold more than 4.7GB — in fact, many now cram a whopping 8GB onto a single disc. (After all, commercial DVDs can be mastered with more than one data layer. Turn to Chapter 1 of Book IV for details.) Because current DVD technology can burn only 4.7GB on a DVD-R or DVD+R, those pirating programs have two options:

✦ Spread a single movie across two or more recordable discs, with a nasty pause involved (while you or your significant other is banished from the couch to change the discs).

✦ Compress the digital video on the disc up to 50 percent so that it can be stored on a single disc, which typically results in a noticeable loss in picture quality.

This stuff gets really technical really quickly, so I don't go into it here in any great detail. Suffice it to say that buying a DVD-R/W, DVD+R/W, or DVD-RAM drive is not a free ticket to a shelf of cheap movies.

(And no, I didn't think that you would do such a thing. Copyrights are important — ask any book author.)

Weird, Wild DVD Format Stuff

Close the windows, bar the door: You can't escape them. I have two more acronyms to discuss, and I do the best I can to make sure that we all make it out of this section in one piece.

DVD-V

If you've been perusing the DVD movie aisle at your local discount store, you may have thought that you were looking at DVD-ROM — and you would be right. However, I can be even more specific than that: A *DVD-V* (short for DVD-Video, of all things) is a DVD-ROM that holds broadcast-quality digital video in a special compressed format named MPEG-2. (You find out a little more about MPEG in the section, "MPEG card: Aye, Matey, 'tis indeed a tiny file," later in this chapter.) You also get niceties like Dolby audio, surround sound, subtitles, and different aspect ratios with a DVD-V. You can even run programs from a DVD-V if you're playing it in a computer DVD-ROM drive.

You may ask, "Can I burn a commercial-quality DVD-V with my new DVD recorder?" Technically, yes. However, lots of work is involved in compressing digital video, creating interactive menus, and adding a quality audio track. It's nowhere near as simple as recording something on comfortable old VHS tape.

DVD-A

I know that this might break your heart, but even your friend the audio CD is eventually going out to pasture. The likely replacement is a format standard named *DVD-A,* or DVD-Audio. Imagine a standard audio CD that has been to the gym four nights a week for the past ten years, and you get some idea of what DVD-A is like: either two or four hours of stereo music (depending on the type of media); interactive menus, like with the current crop of DVD-Vs; and even the ability to store video clips. Plus, DVD-As store music at a higher quality than standard audio CDs and with an even higher dynamic range . . . in other words, they sound even better than your rusty old CDs.

For me, however, the most exciting new feature of DVD-A is the addition of surround sound support. If you're enjoying a surround sound system, you know how realistic it is. If not, try out this type of system the next time you're in a stereo and video store. Although the extra data needed for surround sound cuts the capacity of a DVD-A in half, you're still talking about an hour or two of incredible music.

Additional Toys You May Need

Before the sun sets on this introductory discussion of DVD recording, I would be remiss if I didn't tell you that you're likely to need a little additional hardware and software. Why? To make the most of the expanded features of DVD, you need to import video, edit those video clips, convert them to different

formats, and design your menu system — not necessarily in that order — and there just isn't the need to do most of those things when you're recording a CD-R or CD-RW.

In this section of your palatial mansion, allow me to show you some of the extras you're likely to use.

MPEG card: Aye, Matey, 'tis indeed a tiny file

If you're serious about creating your own DVD-Vs — or even experimenting with simple video CDs and digital video clips — you should consider an MPEG-2 adapter card for your computer. As I mention earlier in this chapter, MPEG-2 is a compression format; it's somewhat similar to the space you save when you use Zip compression to shrink a folder full of files on your hard drive. And, boy, do you need it: High-quality digital video that's bigger than a postage stamp on your screen takes up an incredible amount of space. Without compressing (or *encoding*) the video, you're likely to run out of room on even the highest-capacity DVD media.

If you're wondering about that term *digital video* (also called DV, for short), indeed, no film or magnetism is involved. Digital video is composed of the same familiar 1s and 0s (zeros) that are written to a recordable CD or DVD. Unlike a traditional videotape (which can stretch and lose its magnetic properties), you can edit, copy, and play digital video as many times as you like without losing quality.

Most MPEG-2 cards have two functions: They can encode video to shrink it, and they can also *decode* it so that you can watch it on your computer screen. (If you receive an MPEG-2 card with a DVD-ROM drive, however, it likely just decodes so that you can watch DVD movies.)

Software programs can take care of both these chores, but I always recommend a hardware solution for folks who want to do any serious MPEG-2 video work. The advantages of the card over software include

✦ **Speed:** Software encoding and decoding programs are nowhere near as fast as an MPEG-2 card, so a process that can take minutes with a card can take hours with a program. The encoding speed depends on the raw power and performance of your computer's processor.

✦ **Efficiency:** An MPEG-2 card does all the heavy thinking about MPEG-2, so even an older PC with a Pentium II brain can keep up.

✦ **Convenience:** Most MPEG-2 cards offer connectors so that you can plug your TV directly into your computer and pipe your DVD movies to the tube. These connectors are handy little beavers to possess.

FireWire port: The real information superhighway

No ifs, ands, or buts with this one: If you work with digital video recording, you need one or two high-speed FireWire ports on your computer. Virtually every piece of machinery on the planet that works with DV uses FireWire to connect to everything else, including digital video camcorders and external DVD recorders. Many high-resolution digital cameras and scanners are now using FireWire as their connection of choice as well.

Some manufacturers seem determined to call a FireWire port an i.LINK connection, for some reason. Heck, if you want to be perfectly accurate, the full international title for the original FireWire standard is IEEE-1394. You may see several of these names on the same box.

If you're using a late-model Macintosh, you're probably doing the Technological Twist right now, dancing in front of your monitor like a Druid partying around Stonehenge. That's because Apple developed FireWire, and all current Macintosh computers include built-in FireWire ports. However, if you're using a PC that didn't come graced with the Wire of Fire, be reassured that you can party just as well by installing a PCI card in your computer. PCI cards average about $100 on the Web, and they provide you with two FireWire ports and all the software and drivers. You need an open PCI slot in your PC, naturally.

A new FireWire standard — called FireWire 800 or FireWire B, depending on whom you talk to — started appearing on high-end Macintosh models in 2003. This Speed Racer delivers twice the data of the original FireWire port, but it hasn't become popular yet in the PC world. Luckily, the original FireWire 400 still does the trick and is compatible with just about everything.

Digital camcorder: Your digital muse

By law (it's written down somewhere, I know it), you can't record digital video without a *digital camcorder* (sometimes also called a DV camcorder). Note that a DV camcorder is not the same as the VHS-C or Hi-8 camcorder that you already own. Oh, no, things couldn't be that simple, right? Yesterday's typical video camcorder records an *analog* signal (which doesn't use the precise 1s and 0s of the digital world that we love so well), so you can't use that video feed with your computer and your editing software. (The next toy I show you, however, helps you get around this problem.)

Virtually all digital camcorders download their video directly through a FireWire port to your computer, where you can have fun with it to your heart's content. DV camcorders are more expensive than their traditional analog brethren, but they're much more versatile: You can take still photographs with most digital camcorders, and most models allow you to perform simple editing jobs onboard ("Can you *please* get the police out of our wedding video?") before you download the video to your computer. For the George Lucas in you, most digital camcorders now allow you to shoot footage in a 16:9 widescreen aspect ratio.

You now shell out anywhere from $300 to $3,000 or more for a digital camcorder. (Chapter 2 of Book II can help you find the digital camcorder to fit your needs.) For example, Figure 3-1 illustrates the Panasonic PV-DV401, which sells for about $400 online. It looks deceptively like a typical VHS-C analog camcorder, but it sports both FireWire and USB ports and a digital camera mode for taking still photographs. You can add special effects during recording or playback, and it can even record in near darkness.

A-D converter: A bridge to the past

If you're shaking your head and mumbling, "I can't possibly afford that kind of cash right now for a digital camcorder," I've got a card up my sleeve that

may set things straight. This joker is called an *analog-to-digital converter* — usually called an A-D converter by those who dislike $5 words. The A-D converter freshens up the signal from a prehistoric analog TV, VCR, or camcorder, and — voilà! — you've turned that analog signal into digital video.

Figure 3-2 shows one of the most popular A-D converters on the market, the Hollywood DV-Bridge, from Pinnacle Systems, Inc. (www.dazzle.com). This alchemist's magic box costs a mere $200 or so on the Web, yet it can

✦ Connect your computer, your analog devices, and your DV devices in perfect harmony with a full set of ports (including a FireWire port)

✦ Convert digital video to an analog signal so that you can use your VCR to create tapes from a DV source

✦ Monitor your DV feed on a TV while it's being converted

✦ Mix both DV and analog material in one production

Figure 3-1: A digital camcorder like the Panasonic PV-DV401 turns you into a walking film crew.

Figure 3-2: The Hollywood DV-Bridge just plain rocks your analog world.

It also comes with two types of Windows video-editing software. I highly recommend the Hollywood DV-Bridge if you're itching to try your hand at digital video, but you want to spend as little as possible and use the analog equipment you already have.

Video-editing software

Speaking of software, I end this opening gambit in the world of DVD recording by describing the typical software you use. In fact, two of these three programs ship as part of the computer's operating system. (Is DV mainstream these days or what?)

Video-editing software now offers a basic set of tools that take care of all common tasks, such as

- ✦ Importing and arranging video clips
- ✦ Removing unwanted footage
- ✦ Adding basic transitions between clips, like fade-ins and dissolves
- ✦ Adding and synchronizing audio

Figures 3-3, 3-4, and 3-5 illustrate three great examples of these multidimensional DV tools: iDVD 3, which ships with new Macintosh computers (you may be familiar with its little brother, iMovie 3), Microsoft Movie Maker (Windows Me and XP), and Adobe Premiere (both platforms). Any of these programs can deliver a quality digital video production.

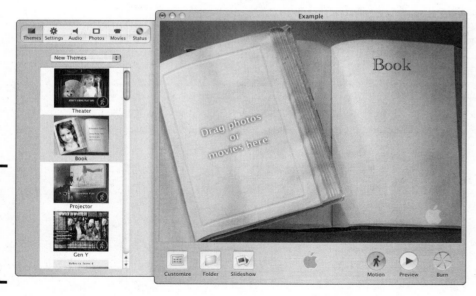

Figure 3-3: iDVD is my favorite basic DV editor for the Macintosh.

Granted, you can spend a heinous amount of money on high-end editing software that toots your car horn and makes doughnuts, but it typically starts at $1,000 (and that's for the cheap seats, my friend). Most programs I cover in this book are free or under $200, and even the commercial version of Adobe Premiere costs less than $500 on the Web at www.adobe.com. Other

programs, like Adobe After Effects, can add everything from a flaming hoop to a scrolling marquee underneath the video. Check out Chapters 8 through 12 of Book II for more details about video-editing software.

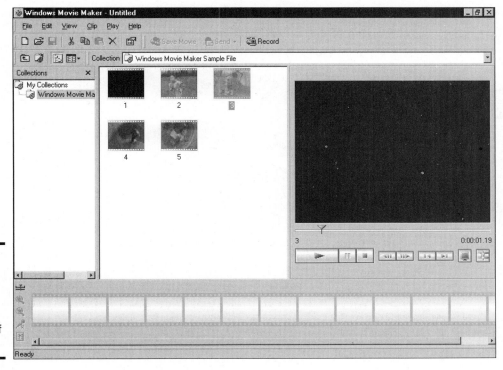

Figure 3-4:
Movie
Maker
follows in
the
footsteps of
iMovie.

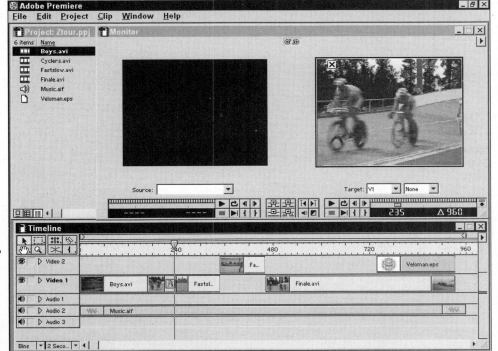

Figure 3-5:
Adobe
Premiere
ships with
many digital
camcorders.

Chapter 4: Poof! You're a Computer Technician

In This Chapter

- ✔ Preparing for the installation
- ✔ Installing an EIDE drive
- ✔ Adding a USB drive
- ✔ Installing a SCSI drive
- ✔ Adding a FireWire drive
- ✔ Troubleshooting installation problems

A certain mystique surrounds today's professional computer technicians: Most folks think that we're one part James Bond, one part Merlin the Magician, and one part Barney Fife. (Quite the visual picture, right?) Armed with nothing more than a pair of taped glasses, a Phillips screwdriver, and a spare power cord, techies are supposed to be able to work hardware miracles beyond the reach of the mere computer owner. (The pocket protector is no longer required equipment; in fact, I've never used one.)

If that nerdy stereotype is still your impression of a typical computer technician, this chapter should open your eyes — because *you* can be your own tech. Sure, you can pay someone at your local computer shop to install your new recorder, but why not save that cash and apply it to something else, like your rent? Come to think of it, that $50 you would have paid someone can buy you a stack of 100 blank DVD-R discs.

This chapter focuses exclusively on the installation and troubleshooting of CD and DVD recorders — consider it the one-chapter, abridged version of my book *Building a PC For Dummies,* 4th Edition (published by Wiley), which shows that you can assemble an entire PC from the ground up. And yes, I cover possible solutions when the worst things happen, such as when your new drive sits there silently like a bump on a log.

Preparation Is the Key

Ever made a complex dish with a dozen ingredients without first reading the recipe? Or how about climbing on your roof to fix a few shingles and discover that you didn't bring your hammer? Preparation makes all the difference when you're installing computer hardware as well, and in this section, I describe the things that you need to know before you get started.

Read the instructions

The steps that I cover in this chapter apply to 99.9 percent of the computers and recorders on the planet — but guess who may have bought the drive that was specifically designed for the other .1 percent of the population? That's right: The Fates may have chosen *you* as the person who has to cut the blue wire, not the red wire. Certain software may need to be loaded first, or you may need to flip switches to configure your drive correctly, which I don't cover in these generic procedures.

Here's a Mark's Maxim that applies to all computer hardware:

> You must read the installation instructions for your recorder!

(And yes, that includes external recorders.) If the installation process that's described by the manufacturer is significantly different, follow the general steps I provide in this chapter and then jump ship to follow the manufacturer's steps instead.

Collect what you need

No surgeon (or car mechanic) wants to operate without the tools at hand, and you should follow their lead by using these guidelines:

✦ **Gather the stuff that you need.** Most installations require just a screwdriver, but bring along your drive's installation instructions and any extra parts.

✦ **Prepare your work surface.** If you're installing an internal drive, prepare a flat, soft, well-lighted surface — several sheets of newspaper on a table work fine, or you can use an antistatic mat.

✦ **Take your time.** No one's looking over your shoulder with a stopwatch, so relax and follow the steps the right way the first time.

✦ **Keep those parts.** You're likely to remove small parts, like screws and a bay cover, when installing an internal recorder; keep a bowl handy that can hold everything you remove. You need some of the parts when you reassemble your computer, and anything left over should be saved as spare parts for future upgrades and repairs.

Ask for help

Do you have a friend or loved one — in fact, *anyone* other than your mortal enemy — who has installed a recorder already or who is experienced with computer hardware? If so, buy that person a meal and ask for assistance while you're installing your drive. If this is your first time working on the innards of your computer, you can probably benefit from the moral support, too.

By the way, as soon as you've successfully installed an internal drive, don't be surprised if someone you know asks for *your* help with a computer.

Choose a spot to be external

If you're adding an external recorder to your computer, take a few moments beforehand to select the right space for your new drive. The best spot is described as follows:

✦ **A minimum of 6 inches away from your computer:** This space helps minimize interference from your computer's power supply and monitor.

✦ **Well ventilated:** An external drive can give off a significant amount of heat, so make sure that your recorder has room on all four sides.

✦ **Free of vibration:** For example, don't park your recorder next to your computer's subwoofer (that big speaker box that delivers the deep bass for your computer's sound system). Vibration can ruin a recording and eventually damage your drive.

Installing an EIDE Drive

Enhanced Integrated Drive Electronics (EIDE) drives are internal, inexpensive, and fast — no wonder they're the internal drive of choice for most PC owners. If you've bought an EIDE CD or DVD recorder, now is the time to get down to business and get your new toy installed.

What you need

First, make sure that your PC has the following items:

✦ **An unoccupied drive bay:** Your computer needs to have a 5¼-inch drive bay that can be opened to the front of your case. Most PC cases have at least two or three of these bays (although a hard drive may be hogging one, even though it doesn't need an opening to the outside world).

✦ **An unused EIDE connector with a cable:** Most PCs made in the past 2–3 years have four available EIDE device connectors (a primary master and slave and a secondary master and slave). You need at least one unused connector for your new recorder. You may also need to buy a cable if you're using your secondary EIDE connector, because many PC manufacturers don't provide a cable if the connector isn't being used.

✦ **An unused power connector:** No recorder works without a power supply. An internal drive uses a connector like the one that's shown in Figure 4-1. You can also buy a power splitter (or a Y connector) that can convert one power cable into two.

**Book IV
Chapter 4**

**Poof! You're a
Computer Technician**

Figure 4-1:
Your internal
drive needs
a connector
to supply
the juice.

Cable from
power supply

Connector on a
component

The EIDE dance, step by step

This section covers the installation process for an EIDE drive. Follow the steps in this section (and yes, you have to follow the steps in the order that I list them).

Static electricity is not fun, is not amusing, and is *not* your friend. It's the sworn enemy of anyone who has ever installed computer hardware. Static can damage an electronic component in the blink of an eye, and you may not be able to spot the damage until you discover that you have a dead drive on your hands. Therefore, you *must* discharge static electricity that's on your body before you touch the drive, your PC's motherboard, or any of the PC's internal parts. Touch a metal surface before you open your computer's case — usually, you can just touch the case itself — and touch the internal *chassis* (that's the metal framework) often during the installation process.

Follow these steps to install an EIDE drive:

1. **Turn off your computer, and unplug it from the AC power outlet.**

2. **Remove the screws that hold your computer's cover in place, and set the cover aside.**

 Don't forget to put those screws in that high-tech bowl that I mention earlier in this chapter.

3. **Set the EIDE drive configuration.**

 Every EIDE drive uses a specific configuration that allows your new recorder to peacefully cohabitate with your existing EIDE hard drive(s) or CD/DVD-ROM drive.

 Setting up your recorder is not an overwhelming task, although the exact settings for your jumpers vary among brands and models. (If you've never handled a *jumper,* it's the workhorse of the computer hardware world. It's a tiny, metal-and-plastic crossover that allows you to make connections on the drive's circuit board.) Check your drive's manual for the correct set of pins, and use a pair of tweezers to add or remove jumpers to match that pattern. If you're working with a scavenged drive or you don't have the manual, check the manufacturer's Web site or call its technical support number. Set the jumper as follows:

 - **One hard drive:** Configure the jumper on the hard drive as "multiple drive, master unit," and configure the jumper on your recorder as "multiple drive, slave unit."

 - **One hard drive and one CD-ROM drive on the same cable:** Set the jumper on your recorder as "single drive, master unit," and connect the recorder to the secondary EIDE cable. Leave the existing drives alone.

 - **One hard drive and one CD-ROM drive on different cables:** Configure the jumper on your recorder as "multiple drive, slave unit," and connect the recorder to the EIDE cable that the hard drive is using. Then set the jumper on the hard drive to "multiple drive, master unit." Don't change your existing CD/DVD-ROM drive settings.

You may have to change the jumper settings on your existing EIDE devices to get things working. For example, if you're adding a DVD recorder on your primary EIDE connector and you already have an EIDE hard drive on that cable, you have to switch the hard drive from "single drive, master unit" to "multiple drive, master unit." In this situation, your new DVD recorder is set to "multiple drive, slave unit."

4. **Check the bay that is to hold your recorder.**

 If a plastic insert is covering the bay, you should be able to remove the insert by removing the screws that hold it or by carefully prying off the insert with a screwdriver.

5. **Align the drive into the bay, and slide it into the front of the case, with the rear of the drive (the end with the plugs and connectors) going in first.**

 The faceplate and buttons should be visible from the front of the case, as shown in Figure 4-2.

 Naturally, the printing and logo on the front should be facing right side up.

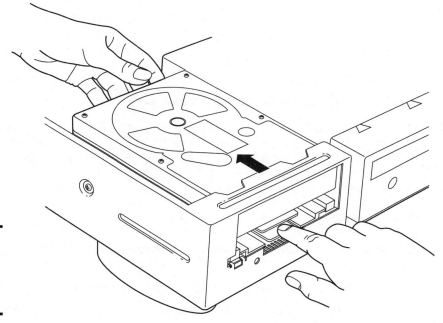

Figure 4-2: Showing your recorder its new home.

6. **Move the drive forward and backward until the screw holes are aligned with the screw holes in the side of the case, and then attach the recorder.**

7. **Connect a power cable to the drive, and make sure that you press it in firmly.**

 Notice that it goes on only one way, so don't try to force it on backward.

8. **Connect the ribbon cable that comes from the EIDE connector on the motherboard to the EIDE connector on the back of the recorder.**

 No need to worry about this connector either, because it's notched to fit in only one way. Press it on firmly after it's correctly aligned.

9. **Because pulling and tugging on things inside your computer can result in an unplugged cable, take a moment to check all your connections — even the ones that don't lead to your recorder.**

10. **Replace the cover on your PC with the original screws.**

 Did you read about that parts bowl earlier in this chapter?

11. **Plug in the PC's power cable.**

12. **Turn on your PC, and allow it to boot up normally.**

 I love that phrase — like your computer will suddenly grow wings and a tail, leap off your desk, and fly around the room like a dragon. I would say that that would be an *abnormal* boot — wouldn't you?

13. **Uh-oh. I hope that you're not superstitious and that you don't mind my ending on Step 13. Anyway, install the software that accompanied your recorder.**

To verify that the installation was successful, jump to Chapter 8 of Book IV and try your first recording. If things don't fly, read the troubleshooting section at the end of this chapter.

Plugging and Playing with a USB Drive

Made the Universal Serial Bus (USB) external choice, did you? (Hopefully, you settled on a USB 2.0 drive, but older USB 1.1 drives are installed the same way.) Notice that this step-by-step section is much shorter than the internal EIDE drive installation in the preceding section; that's part of the beauty (and the popularity) of USB.

Follow these steps to install a USB drive:

1. **Plug the power cord from your new drive into the AC wall socket.**

 Note that some USB drives are powered through the USB connection itself, so they don't require an external power supply.

2. **Connect the USB cable to the drive (don't connect the cable to the computer's port yet), and turn on the drive.**

3. **Turn on your computer, and allow it to boot up normally. (There I go again.)**

4. **Plug the USB cable from your drive into the USB port on your computer, as shown in Figure 4-3.**

 Your next step depends on the software and the operating system that you're using. You may see a dialog box that prompts you to insert the driver disc that came with your drive, or you may have to install the drive's software separately.

5. **Check your drive's installation instructions to see which path you take.**

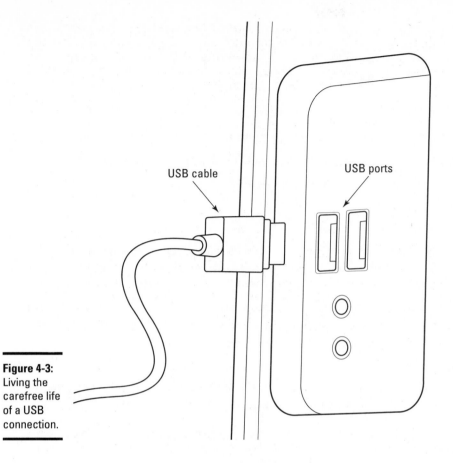

USB cable

USB ports

Figure 4-3:
Living the
carefree life
of a USB
connection.

That's it. Follow the steps in Book IV, Chapter 8 to record your first disc and make sure that everything's working well. If your drive isn't working, visit the troubleshooting section at the end of this chapter.

Running the SCSI Gauntlet

Decided on an internal or external Small Computer System Interface (SCSI) recorder? Memorize these two important commandments (add them to the original ten):

✦ Thou shalt assign no two devices the same SCSI ID number.

✦ Thou shalt terminate both ends of your SCSI device chain.

In this section, I explain exactly what I just said — in modern English, without technobabble — and help you install your drive.

IDs 'R' Us

Think of a SCSI *device chain* as a neighborhood on a cable — to be precise, a chain is at least one SCSI adapter (which may be built in to your computer's motherboard) and at least one device, which could be your recorder. For your computer to transfer data to or from your drive, it has to know the

"address" of your recorder in the SCSI neighborhood. In other words, every SCSI device in your computer needs a unique *SCSI ID number* for identification, as you can see in Figure 4-4. This sample SCSI device chain has a SCSI card and three devices.

Figure 4-4:
Everyone have your own, unique ID number? Good!

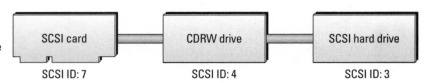

SCSI card CDRW drive SCSI hard drive

SCSI ID: 7 SCSI ID: 4 SCSI ID: 3

Typical SCSI devices can use ID numbers from 0 to 7, with ID number 7 usually the default for your SCSI adapter. (Your SCSI card manual tells you which number the card uses.) Manufacturers of SCSI hardware use different methods of configuring the ID number; most drives use a jumper, which you can set on the correct pins with a pair of tweezers. Again, your drive's manual shows you which jumpers to move when setting the ID number. Some drives also use a thumbwheel that you can turn to choose the number.

By the way, you don't have to assign SCSI ID numbers in sequence; as long as all the device IDs are unique, it doesn't matter what order they're in.

If your SCSI adapter and your SCSI devices are all SCAM ready (man, what an acronym!), you can forget about assigning numbers manually. That's because SCAM stands for *SCSI Configured Automatically.* Enabling this feature on your SCSI adapter allows it to automatically set SCSI ID numbers each time you boot your PC.

Coming to grips with termination

No, I'm not talking about the Donald Trump kind of termination, where another hapless apprentice ends up without a job (again). In the SCSI world, a chain must be correctly *terminated* on each end to tell your SCSI adapter where the chain ends. Without termination, your poor SCSI adapter continues to scan the horizon in vain, looking for straggling SCSI devices that aren't there — and your computer either locks up or fails to recognize the last device on the chain. If the termination is set on a device that *isn't* on the end of the chain, that device becomes the end anyway, leaving at least one SCSI device out in the cold. The device that is really at the end of the chain either refuses to work or locks your computer. In short, without proper termination, you never get your SCSI devices to work.

Consider the simplest installation of a CD or DVD recorder on a SCSI chain. As you can see in Figure 4-5, this is just the SCSI adapter and the drive, and the drive could be internal or external. Both these devices naturally indicate the ends of the SCSI chain, so both need to be terminated. When your SCSI adapter looks for terminators, it finds that one device is on one end and the card itself is terminated on the other.

Figure 4-5:
May all your
SCSI chains
be this
simple.

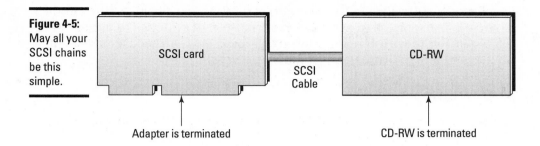

Adapter is terminated CD-RW is terminated

However, what if you want to install an internal recorder into an existing SCSI chain that already has a hard drive? If no changes are made and you just added your spiffy new CD-RW drive to the end of the cable, you would invite the disaster that is shown in Figure 4-6. Because the hard drive is still terminated, your new toy is useless, and it can't be recognized within Windows or the Mac operating system.

Figure 4-6:
With
improper
termination,
your
recorder is
out to lunch.

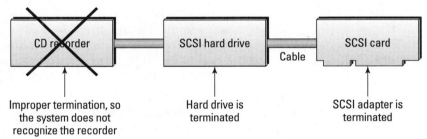

Improper termination, so Hard drive is SCSI adapter is
the system does not terminated terminated
recognize the recorder

For this reason, heed this Mark's Maxim carefully:

> Always review all your termination settings when installing a new SCSI device chain or adding a new device to an existing chain.

Figure 4-7 shows how the same chain *should* be terminated. Now the SCSI adapter can "see" and communicate with the recorder, and all is well.

**Book IV
Chapter 4**

**Poof! You're a
Computer Technician**

Figure 4-7:
Setting the
termination
correctly
solves the
problem.

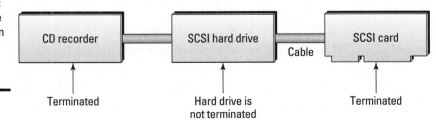

Terminated Hard drive is Terminated
 not terminated

Depending on the manufacturer, setting the SCSI termination usually involves your old friends, the Jumper family. You may also encounter a *resistor pack,* which you plug in to add termination and remove to drop termination. Finally, you may set termination by flipping the tiny plastic

toggles on a *DIP switch* (a tiny switchbox that's wired as part of the circuit board) — use a pencil to set the correct pattern of switches to either On or Off. Again, all these interesting settings appear in your recorder's manual, so keep it handy during the installation process.

What you need

If you're installing an internal SCSI recorder, you need the following items:

✦ **An open drive bay:** Look for a 5¼-inch drive bay that's accessible from the front of your case.

✦ **A SCSI connector:** Your SCSI adapter should come with a cable, and you should use the first open connector that's closest to the SCSI adapter. If you're adding a drive to an existing chain, select the next open connector on the cable after the last existing device.

I've always recommended this technique of adding devices to the end of the cable (instead of trying to stick them in the middle of a SCSI chain). Why? You have less to worry about come termination time: You simply remove the termination on the last existing device on the cable, and make sure that your new device is terminated. Because it's now the last device on the cable, you always know that it marks the end of the chain. Sometimes, this process isn't possible (for example, if you have only one open drive bay and the end of the SCSI cable doesn't reach it), but whenever you can, adding devices to the end of the cable is a good idea.

✦ **An open power connector:** Most PCs come with a veritable forest of available power connectors. If you've used them all, buy a Y connector that splits one power cable into two. 'Nuff said.

Your step-by-step guide to internal SCSI happiness

Ready to dive in? Follow these steps to install a SCSI drive:

1. **Turn off your computer, and unplug it from the AC power outlet.**

2. **Touch a metal surface to dissipate static electricity that may be stowed away on your person.**

Usually, your PC's case suffices just fine.

3. **Remove the screws that attach your computer's cover, and place the cover out of harm's way.**

Put the removed screws in your parts bowl.

4. **Set the SCSI device ID on your drive to a unique number.**

Refer to the drive's manual to determine where the ID control is located, and then configure the drive with a unique number that's not used on any other SCSI device in your system.

5. **Determine the correct termination — don't forget that the correct termination includes *all* existing SCSI devices on the chain.**

Check the position of the SCSI connector that you want to use. If the recorder is on the end of your SCSI cable, make sure that the device is terminated (and all intervening devices have had their termination removed).

6. **If necessary, remove the plastic insert that covers the drive bay.**

 If the cover is the snap-on type, you can carefully pry it off with a screwdriver.

7. **Slide the drive into the front of the case, with the rear of the drive (the end with the plugs and connectors) going in first.**

 The tray and buttons should be facing the front of the case, as shown in Figure 4-2, and any printing or logos on the front should be facing right side up.

8. **Move the drive forward and backward to align the screw holes on the side of the drive and the case, and then attach the recorder with the manufacturer's screws.**

9. **Connect a power cable to the drive, and make sure that you press it in firmly.**

10. **Connect the SCSI ribbon cable to the SCSI connector on the back of the recorder.**

 Note that the connector is notched to fit only one way. Press it on firmly after it's correctly aligned.

11. **Take a moment to check all your power and cable connections — even the ones that don't lead to your recorder.**

12. **Replace the cover on your PC with the original screws.**

13. **Plug in the PC's power cable.**

14. **Turn on your PC, and allow it to boot up normally. (Snicker.)**

 You should see the SCSI adapter verifying each of the devices on the chain, including your new recorder.

15. **Install the software that accompanied your recorder.**

Sweet! It's time to test things out by taking a quick detour to Chapter 8 of Book IV. If you can't record, remain calm and turn to the troubleshooting section at the end of this chapter.

External SCSI stuff

Like USB and FireWire external drives, an external SCSI recorder carries its house along with it — however, you still have to select a unique SCSI ID and correctly terminate that external recorder before everything starts humming. Use your SCSI adapter's external SCSI port to connect your recorder. A number of different SCSI port configurations are possible, so if your card didn't come with a cable, make sure that you're buying the right type with the right connections.

All external SCSI devices come with two connectors, so you can add more than one external device with additional cables — a classic example is a SCSI system with an external SCSI recorder and a SCSI scanner. The same termination rules that you followed for internal drives apply when you're installing multiple external SCSI devices. As shown in Figure 4-8, make sure to terminate the last external device in the chain.

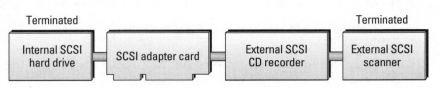

Figure 4-8:
Feel free to hang more than one SCSI device outside your computer.

Remember that your SCSI adapter should never be terminated if you've connected both internal and external SCSI devices (in fact, it's now at the *center* of your chain).

Installing a FireWire Drive

As is the case with USB, installing an external FireWire recorder is an easy process. Granted, producing microwave popcorn is easier, but everyone can do that, and it doesn't sound nearly as impressive for the uninitiated. (Remember, let others *think* this stuff is complex . . . technotypes have been doing it for decades now.)

Anyway, follow these steps to install your FireWire drive:

1. **Plug the power cord from your recorder into the AC wall socket.**

2. **Connect the FireWire cable to the drive, and turn on the drive.**

3. **Plug the cable from your drive into the FireWire port on your computer.**

4. **Turn on your computer, and allow it to boot up normally.**

Your next step depends on the software and the operating system that you're using. You may see a dialog box that prompts you to insert the driver disc that came with your drive, or you may have to install the drive's software separately.

5. **Check your drive's installation instructions to see which path you take.**

To double-check your work, rush to Book IV, Chapter 8 and try burning your first disc. If your drive appears to be suffering from rigor mortis, jump to the following troubleshooting section.

"Um, It's Just Sitting There"

I *really* hope that you're not reading this — I hope that your recorder installation was as smooth as butter, it lit up like a Christmas tree when you turned things on, and it perfectly burned that first disc of Liberace tunes. Therefore, I assume that you're skipping this section completely. Or, perhaps you've reached this section and you're just curious about what *could* have happened. Perhaps you're just generally interested in *troubleshooting* (the art of figuring out what's wrong with your computer and knowing how to fix it).

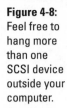

On the other hand, you may have reached this section with a hunk of hardware that's just sitting there like a dead weight. If so, these sentences are pure gold, because they can help you diagnose the problem with your recorder installation and solve it quickly.

EIDE troubleshooting

If you've installed an EIDE drive and it appears to be acting persnickety, the following are some problems that folks often encounter along with some tips on how to solve these problems.

The drive doesn't eject the tray, and the power light doesn't turn on.

The culprit behind this problem is usually an unplugged, loose, or broken power connector. Unfortunately, this means that it's time to crack open your PC's case and check your connections.

I tried to play an audio CD with my recorder, and I can't hear any music.

This problem is common and easy to fix: You forgot to connect the Audio Out cable from the recorder to your PC's sound card. The manufacturer of your drive should provide this cable (and it's often also supplied with a sound card). Consult the manual for your sound card to determine where you should plug in the Audio Out cable from your new drive.

My drive ejects the tray, but I can't find the drive symbol in Windows, and my software says that it can't recognize the recorder.

The simplest explanation for this problem is an unplugged data cable. Check to make sure that you've plugged the flat ribbon cable from the EIDE connector firmly into the drive. Next, you may have the master and slave jumpers on your recorder configured incorrectly, so check them against the configurations that are listed in the recorder's manual. Finally — and this is the tricky one — you may have set the jumpers on the recorder correctly but forgotten to configure the new multiple drive setting on the drive that's already on that EIDE cable.

SCSI troubleshooting

I think that even Scotty on the original *Star Trek* TV series would have thought twice before sticking one of those silver penlights into a recalcitrant SCSI setup. (Just kidding.) Although you have more to troubleshoot with a SCSI installation, all it takes to solve a problem is time and patience. Check out the following problems and tips for solutions.

My computer locks up every time I boot after the installation, and I have to turn it off manually.

I bet that you already suspect that your SCSI termination or ID numbers are configured incorrectly — and if so, you're right. Double-check all your termination settings and make sure that they're correct, and then verify that each SCSI device on your chain has a unique SCSI ID number.

I can't get my SCSI drive to eject the tray, and the power light doesn't turn on.

On an internal drive, check your power cable — if you've added an external SCSI drive, the external power supply is the likely culprit.

The drive ejects the tray, but my computer acts like the recorder isn't there. (Alternatively, the recorder works, but my existing SCSI scanner is now broken.)

Poke your drive with a finger to make sure that it's there. (Sorry, I couldn't resist that one.) The real problem is probably your old friends: two or more devices trying to share the same SCSI ID number, or termination that's incorrectly configured for your new drive. Also, make sure that all other SCSI devices on the chain are powered up and connected, and wiggle your data cable to make sure that it's firmly connected.

If your SCSI adapter card came with SCSI diagnostics programs, run them now and see what error messages the programs display. Also, check your SCSI adapter manual to see whether you can run a self-test mode.

USB and FireWire troubleshooting

Although both USB and FireWire are Plug and Play compatible (meaning that you can simply connect and disconnect them without rebooting your computer), that doesn't mean that they're trouble-free. If your external recorder isn't working, check out the following possible solutions.

My computer complains that it doesn't have a "USB (or FireWire) device driver" when I plug in my recorder.

This message is a clear cry for help from your computer: You either need to install the manufacturer's driver from the disc, or the driver that you installed has been corrupted. To fix this problem, reinstall the recorder's software. Check the manufacturer's Web site to see whether an updated USB driver is available. If you're using a Macintosh computer under Mac OS 9.2 and a FireWire recorder, check your Extensions list for the device's FireWire extension. To do so, click the Apple icon in the Finder menu and choose the Extensions Manager from the Control Panel list. (Mac owners running Mac OS X don't have to worry with extensions.)

My recorder has no power. The tray doesn't eject, and no power light turns on.

Your first thought is probably to check the drive's power supply, and if the drive has an external power supply, you're probably right. If you bought your drive locally, take it to the salesperson and ask that person to check it out with another power supply. However, if your USB drive is designed to be powered from the computer's USB port, it doesn't have a separate power supply. In this case, the port is probably not providing enough power to meet the USB standard. (This problem happens frequently with USB hubs and keyboards and/or auxiliary USB ports.) Plug your recorder into another computer's USB port, and see whether it jumps into action.

My drive has power, but my computer doesn't recognize the drive.

If the recorder's software installation ran without a hitch and the driver is present, this problem is usually caused by a faulty cable, a faulty USB or FireWire hub, or a USB cable that's too long (it shouldn't be more than 10 feet long). Try connecting your drive to your computer with a different standard cable and without an intervening hub. Most USB and FireWire devices don't pass a signal when they're turned off, either — this can cause any daisy-chained peripherals that may be connected to suddenly go silent as well. Make sure that all the external devices that connect your recorder to your computer are turned on.

Chapter 5: Choosing Recording Software

In This Chapter

↳ **Introducing Easy Media Creator 7**

↳ **Presenting Roxio Toast 6 Titanium**

↳ **Introducing Drag-to-Disc**

↳ **Getting acquainted with iDVD, iMovie, and Premiere Pro**

Hardware. Are you up to your gills in it? I devote the entire first portion of this minibook to describing your CD or DVD recorder, buying it, and installing it. Sure, I admit that your drive is the most important part of your computer-based Optical Recording Studio (ORS), but does it run itself? Can it do anything by itself besides blink a light or two and stick out its tray?

The answer, of course, is a big, fat *No.* You need software to tame your recording beast. It's like Santa at the North Pole: The old guy gets all the credit, and his elves are constantly toiling away behind the scenes year-round while he's watching marathon reruns of *The Andy Griffith Show* and eating leftover popcorn balls. Without the elves, who would load the sleigh, make the toys, and feed the reindeer? Not to mention the work that Mrs. Claus must be doing to keep everyone fed and clothed. (Sorry, I tend to get a little carried away — I have three kids.)

In this chapter, doggone it, I change all that. I cover the highlights and special talents of each elf — whoops, I mean *program* — that I mention in this minibook. This information comes in handy if you're considering a shareware or commercial recording package to replace the lame program that came with your recorder. If you decide to buy a different program from the favorites I recommend in this chapter (insert look of shock and chagrin here), make sure that the program you're buying has at least most of these primo features.

The Windows Tool of Choice: Roxio's Easy Media Creator 7

For PC owners running Windows, the choice is clear: Easy Media Creator 7 (which I call Creator 7, for short) from Roxio (www.roxio.com), shown in Figure 5-1. This showpiece has been the solid, reliable Swiss army knife of CD and DVD burning for many years. It has the widest range of features of any recording software I've ever used in my travels, it can burn a host of different formats and disc types, and it's simple enough for a novice to use.

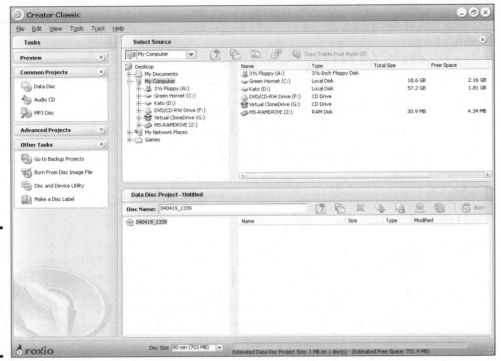

Figure 5-1:
Creator 7
is the
recording
software of
choice for
most PC
owners.

Formats and disc types out the wazoo

If you're likely to need just about any specific type of disc on planet Earth, this program can do it. Of course, Creator 7 can burn simple data discs and audio CDs using Track-at-Once or Disc-at-Once without even lifting an eyebrow, but it can also pump out

✦ CD-ROM XA (multisession) discs

✦ DVD-Video discs

✦ Video CDs

✦ Mixed-mode discs

✦ CD Extra discs

✦ Photo slideshow discs

This lineup also includes two types of discs that deserve special attention: the *bootable* CD-ROM and the *MP3 music* disc. As you may have already guessed, you can boot most PCs by using a bootable CD-ROM, so you can even run your PC without a hard drive — after a fashion, anyway. A bootable disc can also carry other programs and data besides a basic operating system. A Microsoft Windows XP CD-ROM is a good example of a bootable CD: It uses DOS as a basic operating system to display simple prompts, but after your computer is up and running, you can install Windows from it and *really* screw up your system. (Sorry, Mr. Gates, I didn't mean that. Please don't pull the plug.)

An MP3 music disc, on the other hand, is a specialized data CD-ROM. Although it carries music in MP3 (MPEG Audio Layer 3) format, its songs

are not recorded in the Red Book digital audio format (refer to Chapter 2 of Book IV), so you can't play the disc in an older audio CD player. MP3 discs are meant to be played exclusively on either your computer, using a program like Winamp, or on specially designed MP3 CD players. (Many of the current crop of audio CD players now support MP3 music discs; check your player's manual to see whether your model can use them.) You'll find more on MP3 music discs in Chapter 7 of Book IV — these CDs are called *MP3 discs* in Creator 7.

Wolfgang woulda loved this

Interested in burning hot music on a compact disc? Whether those songs are in MP3 format or stored on older cassettes and vinyl albums or you're collecting tracks from a number of existing audio CDs, Creator 7 can do it in style. Although I've tried many different programs that record audio CDs, Creator Classic (the primary recording application included with Easy Media Creator 7) continues to be my favorite; it's the easiest to understand and the fastest to use. On the audio side, the program can

✦ Automatically convert songs in MP3 and WMA (Windows Media Audio) formats and prepare them for recording

✦ Extract tracks from existing audio CDs and save them as MP3 files on your hard drive

✦ Store CD text for display on many CD players with digital readouts

✦ Add transition effects, like fade in, fade out, and cross-fading

✦ Preview WAV and MP3 songs before you record them

I especially like how Creator Classic can venture onto the Internet to check online music databases and download all the track names for CDs it finds. This feature can save you both time and sore fingers because you avoid typing all those track names by hand.

Extra stuff they give you (without even asking)

If the Creator 7 feature list ended in the preceding section, most folks would be satisfied. But, wait — what if I told you that you also get these great standalone (separate) programs to boot?

Disc Copier

Disc Copier makes it easy to produce a duplicate of an existing data CD, data DVD, or audio CD (without requiring you to start Creator 7 and produce a disc image, which is a much longer process that accomplishes the same thing). Folks who date back to the glory days of floppies should remember programs that allowed you to copy a disk read from one drive to another. If you have both a read-only CD-ROM or DVD-ROM drive and a recorder in the same PC, you can use the read-only drive as the source (as I'm doing in Figure 5-2) — no swapping required. If you have only a recorder, however, you can still use Disc Copier — you just have to eject the original disc and load a blank. I show you how to use Disc Copier in Chapter 8 of Book IV.

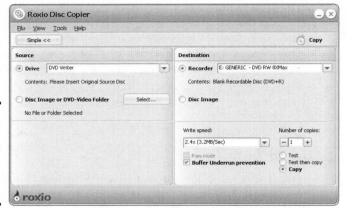

Figure 5-2:
Copying an audio disc is child's play with Disc Copier.

Roxio Retrieve

How many times in this book do I harp about backing up your hard drive? Would you mind losing every file you've ever known if your hard drive crashes? If you don't have a current backup, I'll nag you like your mother until you make one. (There's a scary thought, eh?)

With the combination of Creator Classic and Roxio Retrieve (shown in Figure 5-3), you no longer have any excuse. You can back up a drive to multiple CD-RWs, DVD+RWs, or DVD-RWs as fast as your drive can shovel ones and zeros.

Figure 5-3:
Use Roxio Retrieve! Back up! Do it!

Capture

Capture (shown in Figure 5-4) is an exciting program for anyone interested in recording music: You can copy your favorite old cassettes and albums to audio CDs. Those of us with extensive piles of vinyl and tape still occupying

the corners of a room know the heartbreak of losing an old favorite that hasn't been released in compact disc format. Scratches and stretched tape can ruin your treasures, but after you use Capture to transfer them to CD, you can keep them for their cover art. The program can also play your digital audio files and includes an editor that can modify tracks before you burn them to disc.

Label Creator

Let me be honest: I like a labeled disc, but I don't label everything I burn. For example, if I'm going on a business trip and I've just recorded a disc of material for a book I'm writing, I don't go to the trouble of printing a label — I just use my trusty CD/DVD-marking pen and write a short title right on the disc.

On the other hand, Label Creator (shown in Figure 5-5) is the program you want to use when a disc needs to look its best — if you're giving it to someone else or you're particularly proud of that DVD-Video disc you made at your cousin's wedding. The program can also produce front and back jewel box inserts and DVD box inserts, with classy clip art, photographs, and different fonts. You can even choose one of the themes that's already set up in the program, which can produce a matching set with a label and a complete set of inserts. Neat!

Figure 5-4:
Capture is a complete analog-to-digital music solution.

**Book IV
Chapter 5**

Choosing Recording Software

Figure 5-5:
Puttin' on
the Ritz with
Label
Creator.

Burning Up Your Macintosh with Roxio Toast 6 Titanium

As you can see from Figure 5-6, those Mac folks look different again: This time, it's Toast 6 Titanium, from Roxio, the king of recording programs on the Macintosh. (Don't ask how the program got its name — I'm sure that a funny story is in there, but I don't know it.)

Figure 5-6:
No butter,
no jelly —
just Toast.

Besides the standard formats — audio, data, mixed-mode, Video CD, and CD Extra — that we all expect, Toast 6 can produce a couple of nifty extras:

✦ **Hybrid discs:** These strange beasts can be read under both Windows and Mac operating systems — they're often used for cross-platform applications that have both a Mac and Windows version. Games are often shipped on hybrid discs for the same reason.

✦ **Super Video CD:** Also called SVCDs for short, Super Video CDs can store digital video files just like standard Video CDs. As the name suggests, however, Super Video CDs provide significantly better video quality (at the expense of disc space, so SVCDs typically hold only about 45 minutes of video). Standard Video CDs can usually store up to 60 minutes of digital video.

✦ **MP3 music discs:** As I discuss in earlier chapters, these discs store music files in MP3 format.

✦ **DVDs:** Toast can burn both DVD data and DVD-Video discs on supported drives.

If you're burning discs for older Mac operating systems, you can use the Mac standard format. However, if your disc is used on a newer machine running Mac OS 9.0 or later, you should use the enhanced Mac OS Extended mode.

As any Mac technotype can tell you, the Mac operating system can mount a disk image as a virtual drive on your desktop. Toast can both create and mount these images for you, so you can store multiple images on a single CD or DVD and use them rather than hunt for a physical disc. (I leap headlong into the subject of disc images in Chapter 8 of Book IV.) I also like the Compare feature in Toast, where you can compare two folders or files and view the differences — usually one folder or file on your hard drive and another on a CD or DVD disc.

Chapter 9 of Book IV is devoted to burning with Toast. (I'm sorry — that one just slipped in subconsciously.)

Packet Writing Made Easy with Drag-to-Disc

Packet writing is *almost* as foolproof as a burnproof recording: You simply format the disc, write to it just like it's a huge floppy or Zip disk, and then finalize it for reading just like an ordinary CD-ROM or DVD-ROM. Teamed with a CD-RW or DVD rewritable drive, packet-writing software can produce the nearly perfect, reusable, low-cost storage solution that everyone has been chasing since the first 1GB hard drive appeared way back when. Figure 5-7 illustrates Roxio Drag-to-Disc hard at work.

You can find a complete rundown on Drag-to-Disc in Chapter 10 of Book IV.

Figure 5-7:
Drag-to-Disc is the key to oneness with your CD or DVD recorder.

Introducing the Editors: iMovie, iDVD, and Premiere Pro

Not one of these three programs — iMovie 4, iDVD 4, and Premiere Pro — counts as true disc-recording software. Instead, they're programs for digital video editing, disc design, and the creation of special effects that just happen to have recording features built-in. (As you can tell, these programs cross a number of boundaries when it comes to genre.) Because I use iDVD 4 in Chapter 13 of Book IV and iMovie and Premiere Pro in Chapters 8 through 12 of Book II, I thought I'd tell you a little something about each one here.

iMovie, shown in Figure 5-8, was a groundbreaking arrival for both Apple and the world of digital video. iMovie marked a revolution where practically anyone who could connect a FireWire cable, drag and drop video clips, and select a transition or two could develop their own professional-looking movies. For the first time, you didn't need several hundred dollars to spend just on editing software. The software has been shipping free with iMacs since the program was first introduced. iMovie was simple enough to appeal to novices, who definitely didn't want to spend hours understanding the basics of a more powerful, traditional editor. Unfortunately for Windows folks, iMovie 4 runs on only Mac OS X. However, Windows Movie Maker is *very* much like it.

iDVD 4 is the recently released big brother to iMovie 4. At the time I wrote this book, it was available only on Macintosh computers that offered the CD-RW/DVD-RW SuperDrive. With iDVD, you can master your own DVD-ROM titles, complete with basic menu and submenu interaction. For example, viewers can select a video clip to watch or view a slideshow of digital photographs. While designing your disc, you can use a prepared theme to automatically set the appearance of your buttons and background, or you can add your own. Finally, iDVD allows you to preview your work and burn the DVD within the program itself. Figure 5-9 shows iDVD in action.

The excellent Adobe digital video editor Premiere Pro (shown in Figure 5-10) is available for both Windows and Mac OS. Premiere is much more powerful than either iMovie 4 or iDVD 4, offering professional special effects, better

control over audio and timing, output as streaming Web video, storyboarding, and the ability to handle more formats of digital video. However, it's not anywhere near as simple to use as iMovie or iDVD. Because it's a commercial program, you're likely to spend around $700 or so for a copy. Premiere Pro is the right choice for those folks who know that they're in digital video to stay, want to grow into a professional package, and want its tight integration with other Adobe products, like After Effects.

Figure 5-8:
If you buy a Macintosh these days, you pick up iMovie for free.

Figure 5-9:
Deciding on a theme for my newest hit DVD title.

Figure 5-10:
You pay for it, but Adobe Premiere Pro is the classic digital video editor.

Chapter 6: Preparing Your Computer for CD and DVD Recording

In This Chapter

↙ **Reclaiming space on your hard drive**

↙ **Checking for hard drive errors**

↙ **Defragmenting your hard drive**

↙ **Disabling programs that can ruin a recording**

↙ **Fine-tuning Windows and Mac OS for better recording**

"In the beginning, there were Windows 3.1 and the 486 processor, and many tried to record their first CD-ROMs and fell by the wayside. For buffer underruns roamed the land, ruining those early discs because the computer could not keep up with the recorder. And many threw up their hands in anger and frustration, and they knew then that they must optimize their systems."

Such tales are few and far between these days because you're probably using a PC or Macintosh that performs much better than the 486-based computers of old. The latest hard drives can deliver data much faster than a recorder can burn it, and today's burnproof recorders no longer fear multitasking and disk-intensive applications. So why do I dedicate a chapter to optimization and fine-tuning? I have two important reasons (besides the fact that I needed a topic for Chapter 6).

First, you may not be lucky enough to own only the cutting edge in hardware. I own and use seven computers, and only one of them is state of the art (meaning that it's less than a year old). If both your computer and your drive have been hanging around for 3 years or more, optimization is just as important as ever.

Second, optimization helps your entire system run like the Six Million Dollar Man: better, faster, and farther. I recommend many of these steps even if your computer doesn't sport a CD or DVD recorder right now — you'll thank me the next time you open Microsoft Word or Adobe Photoshop.

Therefore, this chapter is designed to help you tinker and tune. Just hand me a wrench and the proper screwdriver from time to time, and your computer will soon be running at its best.

Creating Elbowroom

No matter how you cut it, 700MB of data takes up a fair chunk of hard drive territory — and that's just what you store on a CD-R or CD-RW disc. As you may have read in earlier chapters, a DVD-R or DVD+R disc can hold 4.7GB, and a double-sided DVD-RAM disc can store as much as 9.4GB! You can see how hard drive space can become important very quickly, and you never seem to have enough. You find that your data expands to fill your drive, regardless of the size (rather like The Blob). In this section, I cover a number of tips and tricks that can help you clear space for your next burning session.

'Course, you could just buy a bigger hard drive

Although a bigger hard drive is the likely option for the fine folks living in the Gates mansion, I bet that you would rather conserve space, reduce clutter, and just keep your current drive. Besides the space that you need to temporarily store the data or audio that you want to record, the following two other important temporary files take up space behind the scenes:

✦ **Temp files that are used by your recording software:** If you're recording in Disc-at-Once mode, for example, your software is likely to create a temporary image file of the entire disc — this process typically takes as much space as the data itself!

✦ **Virtual memory:** All versions of Windows (as well as Mac OS 9.2 and Mac OS X) use territory on your hard drive as *virtual memory,* which is storage space for all those 0s and 1s that don't fit into the physical RAM that's installed in your system. (Ever wonder how a computer with 64MB RAM can run a 10MB program that opens 256MB files? That's virtual memory at work.) Figure 6-1 shows how limited your system becomes if virtual memory is disabled. I talk more about virtual memory throughout the rest of this chapter.

As you may have guessed from the word *temporary,* these files are deleted after the recording has finished or the additional virtual memory space is no longer needed. (Insert ominous chord here.) However, good people, not all programs are as tidy in cleaning up behind themselves. Shame!

Figure 6-1: Need more RAM for your programs? Virtual memory is the ticket to wide-open spaces.

Without virtual memory = 64MB system RAM

64MB of RAM

With virtual memory + = 128MB system RAM

64MB of RAM

64MB of hard drive space

Locate unnecessary stuff

If you've ever deleted programs and data files manually from your computer, you know that you're waltzing in a potential minefield, and you're a prime candidate for this important Mark's Maxim:

> Never — *never* — delete files willy-nilly!

(By the way, "willy-nilly" is a nontechnical term for opening Windows Explorer and simply deleting some files or an entire folder.) Luckily, programs that are both built into your operating system and are available separately at your neighborhood computer store can help you remove accumulated hard drive crud safely.

First, though, you can kiss the following files goodbye without sending your computer into a coma:

✦ **Demos, samples, and Aunt Harriet's fruitcake recipe:** First things first: Get rid of those 10-year-old game demos and one-shot software installations that you'll never need again! Naturally, you should drag any unnecessary documents that you have created to the Recycle Bin or Trash — I mean, how many Top Ten joke listings should you save? Anyway, after you decide what to trash, choose Start➪Settings➪Control Panel➪Add/Remove Programs to display the dialog box that is shown in Figure 6-2. (You should always use this method to delete a program in Windows!) Click the program that you want to delete from the list, and click the Remove button to start things moving.

Figure 6-2:
Deleting a
program
(the right
way).

✦ **The contents of your Trash or Recycle Bin:** Hey, you didn't want these files anyway, and they already have one foot in the Great Beyond! To clear the space in Windows, right-click the Recycle Bin icon and select Empty Recycle Bin from the menu that appears. In Mac OS 9.2, choose Special⇨Empty Trash; in Mac OS X, choose Finder⇨Empty Trash.

✦ **TBR:** That's an acronym of my own — I guess I just snapped from all these silly technobabble terms. It stands for *typical browser refuse:* the images, Web pages, and sound files that your browser stores in its cache to speed things along when you reload a page. Luckily, shoveling this stuff out the door is easy because both Internet Explorer and Netscape Navigator allow you to purge their cache directories. (In Internet Explorer, click Tools⇨Internet Options, click the Delete Files button, and click the OK button to confirm that you want to sweep up the place.) If you're a big-time Web walker, you may be surprised at the sheer amount of space you can reclaim!

Let the wizard do it!

Fans of J.R.R. Tolkien's classic *The Hobbit* will agree: Dwarves would much rather leave the heavy work to the burglar or the wizard! If your system is running Windows 98 or later, you can turn to the Disk Cleanup Wizard to help you automate the removal of accumulated disk gunk.

To run the Disk Cleanup Wizard in Windows XP, follow these steps:

1. **Choose Start⇨All Programs⇨Accessories⇨System Tools⇨Disk Cleanup.**

 Geez, can the friendly folks in Redmond hide useful stuff like this any farther under the rug?

2. **If you have more than one hard drive on your system, select Drive C: from the drop-down list box and click the OK button.**

3. **Windows displays the Disk Cleanup dialog box, as shown in Figure 6-3.**

 As you can see, you save quite a bit of space here! Click the OK button to begin the cleanup.

4. **Click the Yes button to assure Windows (which is often slightly paranoid) that you do indeed want to delete files.**

Sit back and watch while the wizard safely sweeps your system clean. Neat! (And yes, Virginia, I bet Dumbledore could do just as good a job.)

Call in the professionals

I heartily recommend two commercial programs that can help you clean up either a PC running Windows or a Macintosh running Mac OS 9.2/Mac OS X. Figure 6-4 illustrates Norton CleanSweep for the PC, from Symantec (www. symantec.com) — it offers a high level of safety. I especially like the feature that locates and deletes temporary, zero-length, and duplicate files that can nibble away at your free space.

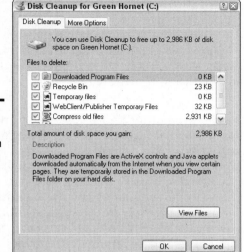

Figure 6-3:
Not even
Gandalf can
clear space
as fast
as the
Windows
Disk
Cleanup
Wizard!

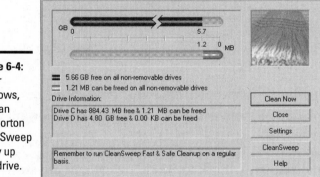

Figure 6-4:
Under
Windows,
you can
use Norton
CleanSweep
to tidy up
your drive.

On the Macintosh side, I recommend Spring Cleaning, from Aladdin Systems (www.aladdinsys.com), which does everything from uninstalling old programs to zapping browser cache files.

Checking under the Rug

Your computer may be hiding something from you: No, I'm not talking about a winning lottery ticket or a love affair with a coffee machine, but rather nasty errors on your hard drive that may be robbing you of both free space and performance. If you don't look for these errors, I can guarantee that they won't leap up and identify themselves (except, of course, those errors that continue to grow worse and eventually cause you to lose files and data *permanently*). Before you burn a disc — or, for that matter, once every couple of days — running your computer's disk diagnostics program takes care of anything that may be hiding under the rug.

These errors fall into the following categories:

✦ **Logical errors:** These are the most common file problems, and they're usually caused by improper shutdowns, power outages, and misbehaving programs. If you have already encountered lost clusters and cross-linked files, you have already met (and hopefully fixed) logical errors on your hard drive. Most logical errors can be solved with the right software.

✦ **Physical errors:** These errors, on the other hand, are caused by a malfunction in the hard drive itself. The classic cause of physical errors is the infamous and frightening hard drive crash, where either your entire drive croaks or the magnetic platters inside are damaged. Physical errors usually can't be corrected by the layman. If you're willing to spend a rather unbelievable amount of money, some companies can fix the innards of your hard drive, but in most cases, it's simply not worth the effort. Therefore, if your drive is acting up and returning physical errors, I strongly recommend that you back up now — this second! — and buy a replacement drive.

Fixing your drive the Windows way

Checking a drive in Windows 98 and Windows Me is child's play, thanks to a program named ScanDisk; use it at least once a day to fix any logical errors that may appear on your drive. Follow these steps to put ScanDisk through its paces:

1. **Choose Start⇨Programs⇨Accessories⇨System Tools⇨ScanDisk.**

2. **Use the drop-down list box to select the hard drive that you want to scan.**

3. **Select the Standard radio button to check for logical errors, or select the Thorough radio button to check for both logical and physical errors.**

 Be prepared for a long haul if you choose Thorough, especially on today's huge hard drives.

4. **Click the Start button to begin the scanning process.**

5. **After the disk has been checked and any logical errors squashed, ScanDisk displays the results.**

6. **Click the Close button to return to Windows and your work.**

In Windows 2000 and Windows XP, ScanDisk has been integrated into the operating system, so you can check a disk for errors from the drive's Properties dialog box. Follow these steps to do so:

1. **Double-click the My Computer icon on your desktop.**

2. **Right-click the icon for the hard drive that you want to scan, and choose Properties from the menu that appears.**

3. **Click the Tools tab to display the panel that is shown in Figure 6-5.**

4. **Click the Check Now button to display the Check dialog box.**

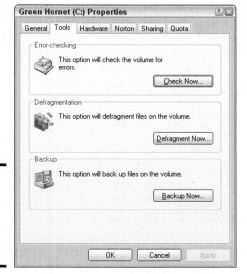

Figure 6-5:
Scanning
for pesky
errors in
Windows
XP.

5. **Select the Automatically Fix File System Errors check box.**

6. **For a full scan, select the Scan for and Attempt Recovery of Bad Sectors check box to check for both logical and physical errors.**

Because a full scan takes so much longer, I perform bad-sector testing only every 6 months or so. Otherwise, I leave the Scan for and Attempt Recovery of Bad Sectors check box deselected.

7. **Click the Start button to begin the scanning process.**

8. **After the disk has been checked, ScanDisk displays the results.**

9. **Click the Close button to return to Windows.**

Fixing things with Mac OS 9.2

In the Macintosh world, with Mac OS 9.2, Apple includes a drive checkup program named Disk First Aid. Follow these steps to use it:

1. **From the Mac OS 9.2 desktop, double-click your hard drive and then choose Applications (Mac OS 9)⇨Utilities⇨Disk First Aid to launch the application (see Figure 6-6).**

2. **Click the icon for the hard drive that you want to scan.**

3. **Click the Repair button.**

Disk First Aid automatically checks the selected drive and repairs any errors.

To repair some errors on your startup disk, you may have to boot your Macintosh by using your Mac OS 9.2 CD-ROM. To do this, insert the CD-ROM, restart your Mac, and hold down C throughout the boot process.

4. **Done? Choose File⇨Quit to return to the Mac OS desktop.**

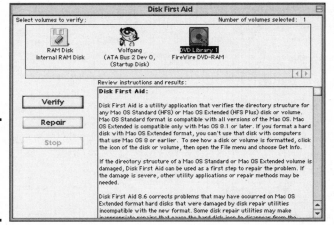

Figure 6-6:
Should I call this iPreventive iDisk iMaintenance?

Fixing things in Mac OS X

If you're running Apple's Mac OS X 10.3 — or *Panther* to the In Crowd — don't feel left out! You have an application called Disk Utility that can repair drive problems. To use Disk Utility, follow these steps:

1. **From the desktop, double-click your hard drive and then choose Applications⇨Utilities⇨Disk Utility to launch the application, as shown in Figure 6-7.**

2. **Click the icon for the hard drive that you want to scan.**

3. **Click the Repair Disk button.**

 Disk First Aid automatically checks the selected drive and repairs any errors.

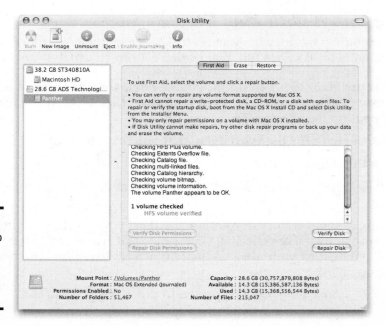

Figure 6-7:
Preparing to pulverize disk problems in Panther.

If the Repair Disk button is disabled, you have to reboot your Macintosh by using your Mac OS X Installation CD-ROM. To do this, insert the CD-ROM, restart your Mac, and hold down C throughout the boot process. After the first installation screen appears, click the Installer button and click the Open Disk Utility button, and you should be able to repair your hard drive.

4. **Done? Choose File⇨Quit to return to the Mac OS X desktop.**

Most commercial disk utility programs can also check your drive. One example is Disk Doctor, which comes with Symantec Norton Utilities for both Windows and the Macintosh.

Avoiding Fragments

It's time to cover another insidious problem that can rob your computer of the performance that you need for recording: *hard drive fragmentation*. Geez, more buzzwords.

I could get into a convoluted description of sectors, files, and your computer's operating system — but this is a *For Dummies* book, so I distill all that hoorah into a sidebar. If you're interested about what you're doing and why fragmentation occurs, read the sidebar "Defragmenting For Dummies." Otherwise, just remember this important truth: Defragmenting your hard drive is A Good Thing to do once a month or so, and it increases the overall performance of your computer (including, naturally, your recording projects).

Windows 98/Me, Windows 2000, and Windows XP all come with a defragmenting program named (strangely enough) Disk Defragmenter, but Mac OS 9.2 and Mac OS X don't have a defragmenting program. Mac owners, I feel your pain, and I recommend using a commercial program like Speed Disk (another part of Norton Utilities, from Symantec), which works under both Mac OS 9.2 and Mac OS X.

Therefore, follow these steps to defragment your drive in Windows XP:

1. **Choose Start⇨All Programs⇨Accessories⇨System Tools⇨Disk Defragmenter.**

2. **The Disk Defragmenter displays the window that is shown in Figure 6-8. Click the target drive in the list to select it.**

 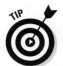

 Do you have more than one hard drive? If so, defragmenting all of them is a good idea (especially if you want to record files from multiple locations). If you're pressed for time, however, always choose Drive C because this drive usually holds both Windows and your virtual memory swap file.

3. **Click the Defragment button to begin the defragmentation process.**

 You can continue to work on other things, but defragmenting takes much less time if you can leave your PC alone while it's defragmenting. (For this reason, I always defragment during the night, when I'm generally not using my computers.)

Defragmenting For Dummies

No matter how cool I think defragmenting is, I just don't have enough material to write a *For Dummies* book about it. I know for sure because I pitched that idea to the publisher before I wrote this book. So consider this sidebar your personal copy of *Defragmenting For Dummies* (definitely the shortest book in the famous series). It has no table of contents, no Part of Tens, no index, and not a single figure or table — but I *do* tell you what's happening behind the curtain.

Why do files fragment? Well, when you delete files from and move files around on your computer, you open areas on your hard drive for new files. However, these open areas aren't always big enough to hold a new file in one piece, so your computer and hard drive work together to save files in pieces called *segments.* For example, if you're copying a 200MB video clip to your hard drive so that you can record it later, your drive may not have 200MB worth of contiguous, unbroken open space on it — that's when the file is broken up into segments. Perhaps 20MB can fit in one place on your drive, 100MB can fit in another, and so on. When the time comes to read the file, Windows or Mac OS X automatically and invisibly reassembles the file and sends it to the proper place. All is well, right?

It is until your drive becomes badly fragmented and little chunks of thousands of different files are spread across the surface of your hard drive! If a file is saved as a contiguous whole, your drive can read it efficiently and quickly. On the other hand, it takes a significantly longer time for Windows or the Mac operating system to rebuild a file that's made up of dozens of segments in several different locations. We humans see this lag time in the form of decreased performance and a delay of a second or two. When you're burning a disc, however (especially on an older computer with a fast CD or DVD recorder), that drop in performance can result in creating a coaster. Scratch another disc, unless you're using a burnproof drive.

You can solve this problem by running your defragmenting program. This slick piece of software reads each file on your hard drive, combines the segments to form a contiguous file, and then saves the reassembled file to the drive in one piece. Plus, most defragmenting programs can also rearrange the locations of your files so that the programs and data that you use most often load the fastest. When the program is finished, your hard drive is a smooth, efficient vista — a storage wonderland. (I think perhaps I need to stop now before I wax too enthusiastic.)

Figure 6-8: Defragmenting is an ugly word, but it can really speed up your computer.

Avoiding the Unexpected

"Okay, Mark, how am I supposed to predict the unpredictable?" Good point — I don't mean the *really* unexpected things in life, like a hard drive crash or an honest politician. Instead, I'm talking about that doggone screen saver that pops up while you're burning or that silly guy in the next office who bothers you with constant network messages. Things like these are also unexpected, and they can easily trash a disc.

In this section, I talk about a number of automatic features and functions of Windows, Mac OS 9.2, and Mac OS X that you can disable before you start recording. These items can help you avoid these irritating interruptions.

Scheduled events and scripts

Windows allows you to set up scheduled events that run automatically at a certain time or periodically during the day. Although this feature can be a great convenience, I recommend that you disable any scripted or scheduled tasks if you're set to record.

Windows 98/Me, Windows 2000, and Windows XP allow you to temporarily pause scheduled tasks by pausing the Task Scheduler. In Windows XP, choose Start➪All Programs➪Accessories➪System Tools➪Scheduled Tasks to display the Task Scheduler, as shown in Figure 6-9. Choose Advanced➪Pause Task Scheduler. After you have finished recording, you can display the Task Scheduler again and restart the schedule: Choose Advanced➪Continue Task Scheduler, and click the Close button in the upper-right corner to banish the Scheduler from your screen.

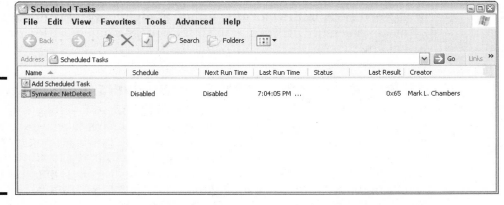

Figure 6-9: Pause any scheduled tasks that might interrupt a recording.

Although the Mac operating systems don't have a built-in task scheduler, you should disable any scheduling software that you may have added before you record; check the program's documentation to determine how to disable or pause automatic events.

Network access

Planning on using your recorder on your office or home network? All that network hard drive space makes this idea appealing, but I don't recommend recording a CD or DVD from a network source unless you have no other

choice. Depending on the traffic your network carries, your file transfer rate may slow to a crawl, and your recording may be interrupted by network messages from your administrator and other users. Someone halfway across the building may decide to copy that unabridged electronic text of *Beowulf* that you have stored on your hard drive.

Worst of all, you may hit a number of hidden snags: restricted or password-protected file access, network drives that suddenly disappear because they were brought down, and so on. When the network suddenly displays a "dropped connection" dialog box in the middle of your recording session, you have (to put it delicately) hosed a disc.

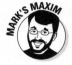

I'll anchor this warning with a Mark's Maxim:

> Rebooting and recording directly from your local computer's hard drive is the best idea; don't log on to your network unless you're sure of its stability.

However, if you *absolutely* have to use network storage for your recording (for example, if you have a discless workstation at your desk), follow these suggestions:

✦ **Buy a burnproof recorder.** Burnproof technology prevents a ruined recording that's caused by a sluggish network and usually avoids optical tragedy even if the recording program is interrupted with a network message. (Naturally, though, it can't fix a disconnected network drive!)

✦ **Record by using packet writing.** I recommend Roxio Drag-to-Disc for packet writing, and I cover it in Chapter 10 of Book IV. Even older recorders that don't offer burnproof protection can successfully burn a disc on a busy network when you use Drag-to-Disc.

✦ **Record early in the morning or late at night.** An empty office generally means an empty network, with far fewer delays and intrusions from other network users.

Power-saving mode and screen savers

Computers are now sophisticated pieces of equipment — they can even fall asleep or switch to standby mode if their lazy humans take a soda or coffee break. Allowing your computer to switch to these power-saving modes is normally a great idea: You save electricity without having to shut down your machine. When you're burning a disc, though, your computer may not recognize the activity — after all, you're not moving your mouse — and a switch to a power-saving mode can be disastrous! I recommend that you either disable your computer's power-saving or standby mode (especially if you're recording on a laptop computer) or allow 30 minutes (for CDs) or 60 minutes (for DVDs) to elapse before it kicks in.

The same is true of those cool screen savers that keep boredom at bay. They're neat, and I have more than 50 on my own machine, but whenever I use a screen saver, I set it for at least a 60-minute period of inactivity before it starts. This period allows me to complete any recording session before the light show starts and the fun begins.

In Windows XP, you can configure both your power-saving mode and your screen saver activity delay from the Control Panel. First, click the Power Options Control Panel icon to display the settings that are shown in Figure 6-10 and set both the Turn Off Hard Disks and System Standby drop-down list boxes to Never. To change the inactivity delay for your screen saver, open the Display Control Panel and click the Screen Saver tab. Click in the Wait text box and type **30** or **60** for the number of minutes.

Figure 6-10: You can change your power-saving settings.

If you find that you are continually using the Power Options Control Panel, set up two power schemes. You can then switch back and forth between power-saving and recording modes.

For Macintosh owners who use Mac OS 9.2, click the Apple menu and choose Control Panels. Then, click the Energy Saver menu item to display the dialog box that's shown in Figure 6-11. Move all the sliders to Never, and click the Close button in the upper-left corner.

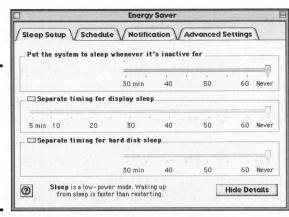

Figure 6-11: Mac owners — saving energy while burning a disc is not a good idea!

Book IV Chapter 6

Preparing Your Computer for CD and DVD Recording

If you're using Mac OS X, click the Apple menu and choose System Preferences. Then, click the Energy Saver icon to display the panel that's shown in Figure 6-12. Move the Put the Computer to Sleep When It Is Inactive For slider to Never, and deselect the Put the Hard Disk(s) to Sleep When Possible check box. Click the Close button in the upper-left corner.

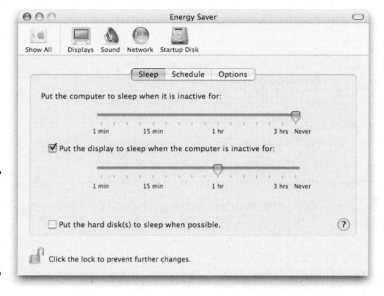

Figure 6-12: Setting up uninterrupted recording in Mac OS X.

Remember, these energy-saving features in Windows and Mac OS are quite beneficial — just not when you're recording. Don't forget to restore your energy-saving settings when you're done burning!

Terrific Tips and Tweaks

Although I get into specific recording tips throughout the rest of this book, I beseech you to pay heed to these general tricks that apply to all types of recordings.

Avoid disk-intensive, memory-hungry behemoths

Follow this advice while you're recording, anyway. In other words, if you don't have a burnproof drive, launching programs like Microsoft Outlook, Adobe Photoshop, or Macromedia Flash during that burn is *not* A Good Idea. They simply consume too much system memory and thrash your hard drive too actively to cooperate well with optical storage.

Give your recording software some elbowroom

Is Mac OS 9.2 your recording environment of choice? Do you have at least 64MB RAM? Then I strongly recommend that you reserve additional application memory for your recording software, which can use the memory for all sorts of good things.

If you're using Mac OS 9.2, follow these steps to increase the memory that is allocated to your recording program:

1. **From the Finder, click the recording program's icon once to highlight it.**

2. **Choose File⇨Get Info.**

3. **Click Show, and choose Memory to display the dialog box that's shown in Figure 6-13.**

Figure 6-13:
Make room!
In Mac
OS 9.2,
allocating
extra
memory is
A Good
Idea.

4. **In the Preferred Size text box, enter a larger amount of RAM.**

As a rule, I tend to double the figure, but you should add at least 1024KB, or 1MB, of extra memory.

5. **Click the Close button to close the dialog box and save your changes.**

Speed up your hard drive

Here's a great tweak for PC owners running Windows 98 and Windows Me. As explained in the following steps, this tweak can increase your hard drive's performance:

1. **Right-click the My Computer icon on your desktop, and choose Properties from the menu that appears.**

2. **Click the Performance tab, and click the File System button to display the File System Properties dialog box (see Figure 6-14).**

3. **Select Network Server from the Typical Role of This Computer drop-down list box. Drag the Read-Ahead Optimization slider to Full (if it's not there already).**

4. **To save your changes, click the OK button to exit the File System Properties dialog box and click the OK button again to return to the desktop.**

Note that you may have to reboot your system after this step.

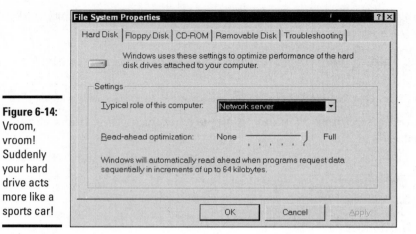

Figure 6-14:
Vroom,
vroom!
Suddenly
your hard
drive acts
more like a
sports car!

Beware the flagged-out laptop

Laptop owners can be proud of their computers, but a loss of battery power has caused the premature demise of many a recording session. If you're using a laptop to burn a CD or DVD while you're on the road, use your AC adapter if at all possible — and if not, make doggone sure that your battery is fully charged and can last for at least 30 minutes. Also, remember that most laptops automatically switch to standby mode if their battery power levels drop below a certain point, so don't cut things too closely!

Chapter 7: Making Choices Before Your Recording Session

In This Chapter

- ✓ Selecting the proper format
- ✓ Using the correct recording mode
- ✓ Choosing the right file system
- ✓ Organizing your material properly
- ✓ Adding thumbnails to a disc
- ✓ Converting files between formats

*A*t this point, you may be ready to throw caution to the wind and start burning ones and zeros — and I can't say that I blame you because I cover a huge amount of ground in this minibook, and you may not have even recorded a single disc yet! However, I want to devote just one more chapter to preparations: in this case, steps you should take to make your finished discs

- ✦ Faster during loading and reading
- ✦ Better organized
- ✦ Easier to use
- ✦ Easier to search

See? This stuff is worth another chapter's wait. I promise! I especially recommend that you take care to follow the guidelines in this chapter when you're creating a disc for distribution or creating an archive disc that you will use often over the next decade or two.

Picking a Jazzy Format

The *formats* that a recorder can burn are criteria you could use to tell just how high a particular recorder ranks on the evolutionary scale. In this section, I show you how best to use those different formats. Remember: Certain formats are the right choice for certain jobs.

Data, lovely data

Data — pure binary ones and zeroes. Your computer lives on the stuff, and that's what data CDs and DVDs are for. If you're storing only data or program files — no digital audio — this is the disc format for you. These discs fall into one of two standards: the Yellow Book (for data CD-ROMs manufactured in a

factory) and the Orange Book (for data CD-ROMs burned with your CD recorder). Some specialized types of discs I briefly mention in Chapter 5 of Book IV — for example, DVD movies, Video CDs, and photo slideshow CD-ROMs — are specialized types of data discs.

Use a data CD or DVD when you want to

✦ Store computer files and programs in the same folder or directory hierarchy as on your hard drive.

✦ Take advantage of the maximum storage space for data.

✦ Run programs directly from the disc.

✦ Load data (like a Word document or a spreadsheet) directly from the disc.

✦ Save multimedia files, like digital video and digital photographs, as pure data.

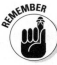

In case you're wondering, your computer's CD-ROM or DVD-ROM drive is the best playback solution for *any* kind of disc because it can read both audio CDs and data CD-ROMs (or DVD-ROMs) without blinking. Your audio CD player can't return the favor, though. Don't try to read a standard data CD-ROM in an audio CD player: If you hear anything, it's likely to be a screeching wail that will drive away every living thing within a square mile. I'm not kidding; even plants try to escape.

Sweet audio for the ears

Unlike a data disc, a disc recorded in audio CD format — also called *Red Book* — can store only one type of material (in this case, digital audio). However, it does this really, *really* well — so well, in fact, that an audio CD player doesn't recognize anything unless it's either Red Book or a subset of Red Book, like a CD Extra disc.

You can use a number of different sources for audio tracks, including

✦ MP3 files

✦ WAV files (a Microsoft Windows standard)

✦ AIFF or AAC files (Macintosh standards)

✦ WMA files (another Windows standard)

Unlike with a tape cassette, however, you can't record your voice directly onto an audio CD. Instead, you have to record your material (usually as an MP3 or WAV file) and then record that disc in audio CD format later.

Are you a musician who uses a Musical Instrument Digital Interface (or MIDI for short) instrument or composes in MIDI format? You can record your compositions on an audio CD as well, but you still have to create an MP3 or a WAV digital audio file on your hard drive with your MIDI software. After the music is in one of these digital formats, you can burn it to an audio CD just like any other MP3 or WAV audio. (Of course, the latest MIDI composition programs can do all this work behind the scenes, allowing you to record your masterpiece to an audio CD from a menu command.)

Man, this band is *horrible!*

Okay, let me get this straight: You have just recorded your first audio CD from that huge selection of Slim Whitman MP3 files you're so proud of, and the burn seemed to go like butter. You got no error messages, the songs sounded perfect when you previewed them, and your new drive churned the disc out in less than three minutes. Excellent! Hold on, though — when you try playing your new disc in your car's CD player, you get either a screeching wail that sounds like a catfight under an outhouse, or nothing. I mean, absolutely *zip.* What went wrong?

This is the classic of all classic problems: You mistakenly recorded a data disc format rather than the audio CD (Red Book) format! Those files are still in MP3 format, and they can be played by using Winamp or another MP3 player program — but *only* on your computer. To play those songs with your audio CD player, you have to record them again. This time, make sure that you choose Red Book or digital audio or audio CD format (whatever your recording software calls it) when you set up the recording.

Alternatively, you may have recorded an *MP3 music disc,* which is very similar in format to the data disc I just described. However, these discs are now supported by many personal CD players, home stereo systems, and car audio systems. The advantage to an MP3 music disc is the storage space you get. Because the songs are recorded in their existing MP3 form, they take up a lot less space than the same songs recorded in Red Book (digital audio) format. Unfortunately, if the audio CD player you're using doesn't support MP3 music discs, the effect is usually the same as trying to play a regular computer data disc.

Oh, one other possibility exists: If your audio CD player doesn't recognize your new CD but your computer's CD-ROM drive (or your recorder) *does* play it, you have rebelled against tradition and used a CD-RW rather than a CD-R. Of course, this particular rebellion is in vain if you're using an older audio CD player because a player that's four years old or older probably can't read a CD-RW. However, that same disc should play fine in a newer audio CD player that *does* support CD-RW media. (And come to think of it, you haven't really wasted a disc because you can reformat that CD-RW and use it again. Whew!)

Remember that older standard audio CD players can't read CD-RWs. Use only CD-R media when you're recording Red Book CDs unless you're sure that the finished discs will be played only on an audio CD player that supports CD-RW media! Time for a Mark's Maxim that can save you time and trouble:

> Use an old-fashioned CD-R whenever you want to record a disc for a standard audio CD player!

Straddle the line with mixed mode

There's always an exception, right? (Just like those spelling rules you used to memorize.) In this case, you *do* have a way to record both data and digital Red Book audio on the same recordable CD. I'm talking about *mixed-mode* format, which is used for multimedia discs and games that need programs, digital video, and high-quality audio on the same compact disc. As shown in Figure 7-1, mixed-mode discs have two tracks: The first contains data, and the successive tracks are digital audio. Pretty sassy, don't you think?

Because that first track is a data track, however, you still can't play a mixed-mode disc in your audio CD player. This is the opposite of another type of dual-purpose wonder, the *CD Extra disc,* where the audio tracks come first in a separate session (think of a chapter in a book), followed by data tracks in another session. You *can* play a CD Extra disc in your audio CD player.

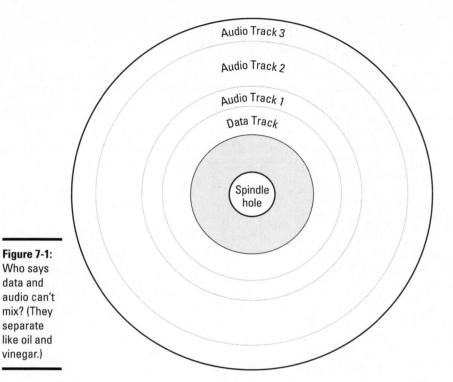

Figure 7-1:
Who says data and audio can't mix? (They separate like oil and vinegar.)

Why aren't all discs recorded in mixed-mode format? Of course, there's not much point in it if you're recording only files and programs or recording only digital audio. Other caveats apply:

✦ **They're less operating system-friendly.** Older versions of DOS, Windows, the Mac operating system, and UNIX can't read mixed-mode discs. (Then again, DOS is fading into an indistinct memory for most of us; I use a command line only for Linux these days.)

✦ **They're less compatible.** Older, read-only CD-ROM drives may be able to read only the first or last track on a mixed-mode disc.

✦ **They have decreased capacity.** Working the magic of mixed mode takes anywhere from 3MB to 19MB of wasted space. Most of that space is required to separate the data track from the first audio track. Therefore, don't use mixed-mode format if you need to squeeze every possible bit from your recorded CD.

Use a mixed-mode CD-ROM when you want to

✦ Store both computer files and digital audio on the same disc.

✦ Run programs and load files directly from the data track.

Throw caution utterly to the wind with packet writing

I crow enough about packet writing — or, as it's more properly called, *Universal Disk Format* (UDF) — in this minibook that you may already know that it's one of my favorite topics. Packet writing makes it easy to record

what you want, when you want it, using any recordable CD or DVD (rewritable or not). Heck, you don't even need to open Easy Media Creator first to write a UDF disc with Drag-to-Disc. Just drag and drop as you always do, or save directly to the disc from within your applications. If you can do it with a floppy disk or a hard drive, you can do it with packet writing.

Packet writing even allows you to delete files you have written — in a fashion, anyway. The directory entries for the files you're deleting are overwritten, after which the unwanted files effectively vanish. This situation can make it appear that you've erased them completely and regained that space, like you would with your hard drive, but that's not the case. They still take up space on the disc; you simply can't reach them. (Of course, if you're using a rewritable disc — that's CD-RW, DVD+RW, DVD-RW, or DVD-RAM — you can always erase the entire disc and start over.)

Also, you should remember that all recordable media must be formatted before you can use it with a UDF program, like Drag-to-Disc. Naturally, after you've filled up a CD-R, you can't reformat it and use it over again, but (as I mention earlier) you can reformat a rewritable CD or DVD recorded with packet writing. You lose all the data on the disc, of course, but that makes packet writing a great choice for one-shot discs.

Drawbacks to packet writing? Only a couple exist: You can't record a Red Book audio CD by using packet writing, and older operating systems (before Windows 98 and Mac OS 8) can't read UDF discs without a separate loader program.

"Disc-at-Once? Track-at-Once? Why Not All-at-Once?"

If you really want to act like a computer technotype at your next party, walk over to a group of your friends and jovially inquire, "So, folks, which recording mode do you use with your audio CDs?" It always gets me a laugh. (I don't get invited to many parties.)

Anyway, this question is indeed a valid one. The recording mode you use helps determine the compatibility of your finished disc and how much data or audio it can contain. Therefore, I cover the three common recording modes now so that you're ready to answer my question if we attend the same gala bash.

Meet you at the track

In *Track-at-Once* recording mode (or, as it's technically known, CD-ROM Mode 1), each data or audio track is kept primly separate from the others: No co-ed mingling here! As shown in Figure 7-2, your recorder turns off the laser write head between tracks.

On the positive side, Track-at-Once mode is supported on every recorder, no matter how old, and can be read on any CD-ROM or DVD-ROM drive. That's why it's the default recording mode used by most recording programs.

Unfortunately, those gaps left by the laser when it toggles off can cause a distinctive *click* noise between each track on an audio CD — whether you hear it depends on the audio CD player, but it can be excruciatingly irritating. Therefore, Track-at-Once is best used for data CD-ROMs.

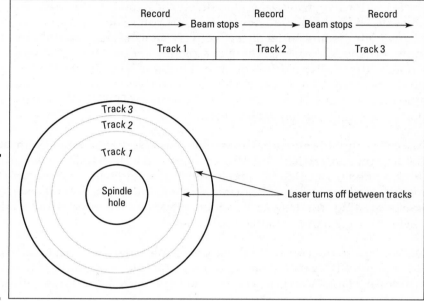

Figure 7-2: Track-at-Once mode is somewhat like the stop-and-start traffic in town.

Do it all at once

Disc-at-Once recording mode is the best pick for audio CDs because your recorder's laser is never turned off, and the entire disc is written at once (as illustrated in Figure 7-3). You don't hear a click between tracks, no matter what type of audio CD player you use.

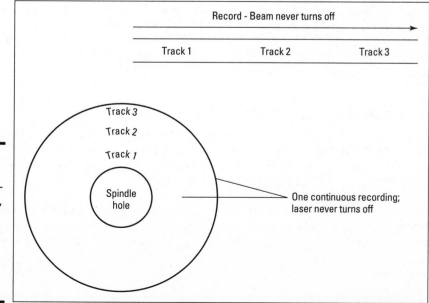

Figure 7-3: When you use Disc-at-Once mode, it's like interstate driving — you're in it for the long haul.

Disc-at-Once mode has three drawbacks:

✦ Truly antique CD recorders (ones that are older than five years or so) can't write in Disc-at-Once mode, so if you own an older drive and you try to select Disc-at-Once in your recording software, you will probably find that you can't select it.

✦ Your disc takes longer to record in Disc-at-Once mode.

✦ Disc-at-Once recording may occupy more temporary hard drive space because — depending on your recording software — your computer may have to create an image file of the entire disc before it can begin burning.

Multipurpose multisession

Multisession recording (or to be technically correct, CD-ROM/XA Mode 2) allows you to add more than one separate session to a disc, each of which can be read just like a different CD, as shown in Figure 7-4. You can record sessions at different times, too, which makes multisession recording particularly handy for incremental recordings over weeks or months.

Again, compatibility is an issue: Multisession mode is not supported on many older, read-only CD-ROM drives, and you need a separate program that can switch between sessions to read all the material on the disc. Also, multisession discs can't be properly read in audio CD players.

Only Session 1, 2, or 3 can be active at one time

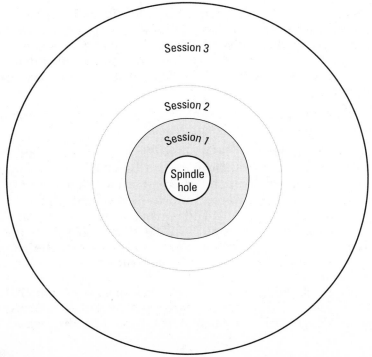

Session 3

Session 2

Session 1

Spindle hole

Figure 7-4:
Use multisession when you want a gaggle of virtual discs.

Long Filenames Are Your Friends

While I'm discussing the decisions you must make before recording a data CD-ROM or DVD-ROM, I think that now is the right time to mention the five major file systems. A *file system* is a specific set of naming conventions and a data layout that . . . whoops, there I go again, letting loose the programmer technical troll within me. (Sorry about that.)

To keep this simple, a file system determines

✦ What type of computer can read your disc

✦ The allowable filenames and their length

✦ The total number of subdirectories (or folders) that can appear on the disc and what arrangement they can take

The five major file systems are

✦ **Microsoft Joliet:** Supported since Windows 95, Joliet is now by far the most common file system used on PC CD-ROMs. Joliet provides the long filenames and folder names that the Windows crowd now finds indispensable, and those names can include niceties like periods, spaces, and most of the characters on your keyboard. A notable exception is the \ (backslash) key, so don't try to use it. If you're burning a disc on a PC for a PC running Windows, you have little reason to use anything else.

✦ **UDF:** Universal Disk Format is a fancier name for packet writing, but it's also a file system. UDF is usually the file system of choice for burning data DVDs and DVD-Video discs because it can handle individual files over 1GB with aplomb.

✦ **HFS:** If you own a Macintosh, most of your Mac-only discs use the Hierarchical File System (HFS). Some programs allow a Windows system to recognize and read HFS discs (and, in the same vein, you can find Mac extensions that allow Mac OS 8 and earlier to read Joliet discs). Both Mac OS 9.2 and Mac OS X can read Joliet discs without any help, thank you very much.

✦ **Hybrid:** Hybrid discs contain both a Joliet session and an HFS session and can be read on both PCs and Macs.

✦ **ISO 9660:** Finally, I come to the oldest file system still in use. ISO 9660 has been around since the dawn of the CD-ROM, and virtually every operating system ever shipped can read it (including heretics like UNIX, Linux, Solaris, and OS/2 Warp). Unfortunately, this high level of compatibility is caused by a strict file and folder naming convention, so you don't find long filenames on an ISO 9660 disc. (You're back to the DOS standard of eight-character filenames and three-character extensions.) Also, you can store far fewer files in each directory.

Which file system should you use? Luckily, this question is one that basically decides itself. For a PC disc, I strongly recommend Joliet; Mac owners can rely on HFS. Folks recording cross-platform PC or Mac discs should use the

Hybrid file system. Hollywood types recording DVD-Video discs should choose UDF. Finally, if you're looking for the widest possible distribution among the largest number of different computers and operating systems, go with the perennial favorite, ISO 9660.

The Right Way to Organize Files

Yes, Virginia, there is indeed a right way to add files to a data, mixed-mode, multisession, or UDF CD-ROM! Smart organization makes finding that certain data file for your tax return easier — which is especially useful if you're being audited tomorrow. No matter what sort of data you're recording, I urge you to heed this oft-repeated Mark's Maxim:

Take the time to think things through!

Believe me. I have spent many years — numbering in the decades now — organizing my data. As an author and consultant, I can't afford to waste time digging through an entire binder of 250 discs, trying to figure out what was burned where. Therefore, heed my words when I say

✦ **Use every character of those long filenames!** The ability to use long filenames is the primary reason why you should use the Joliet file system whenever possible. You may know now that the file named AHARCAKE you just burned is Aunt Harriet's fruitcake recipe, but will you remember that after five or ten years?

✦ **Put your files in folders!** This problem is a common one with hard drives, too. Storing all your files in the root directory (like the C drive) results in the worst kind of anarchy — the computer kind! Also, file systems such as ISO 9660 can handle only a certain number of files in any directory or folder, including the root directory. The solution is simple: Create new folders in the root directory of your CD layout and give the new arrivals logical names, and then organize the files within the folders (more on this in a second).

✦ **Use a logical file arrangement.** You can help yourself in years to come when you're searching for files by organizing them in a Spock-like fashion. That is, stick files of the same type or files that relate to the same topic together in one folder. Or, if you have enough files and you have the time, you can do both with folder names like Pictures of Fluffy in 2002. Think of the fun you can have! (Okay, I need another Diet Coke.) Anyway, when you combine a folder arrangement like this with long filenames, you can suddenly locate that needle in a haystack — and you can still find it three years from now.

✦ **Use file-cataloging software.** Some shareware and commercial disc cataloging programs can store the names and locations of every file on a drive. These programs create indexed databases of each CD-ROM you record. With one of these utilities, searching for a single file among 20 of your personal library discs is as simple as using the Windows Search feature. Your operating system may also allow you to search an entire disc.

For example, Mac OS 9.2 features Sherlock, and Mac OS X includes the powerful Find feature, shown in Figure 7-5. You can use both to search not only for filenames but also for strings of text *inside* documents!

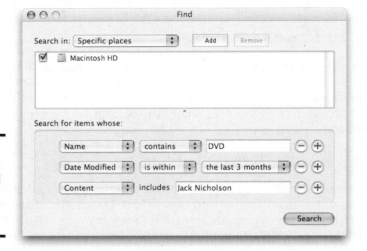

Figure 7-5: I use Mac OS X to find everything but my socks.

Of course, you may not want to spend this kind of time if your disc holds two or three 200MB video clips and nothing else — but it sure helps when you have 300 files to store on one CD-ROM.

"Thumbnails? You're Kidding, Right?"

Not the human body kind of thumbnails! I mean the postage-stamp-size pictures that represent larger JPEG, TIFF, and bitmap images stored inside a folder. (You may have seen thumbnails in Windows XP, which can be set to show image thumbnails within Windows Explorer.) When you use a program like Paint Shop Pro (www.jasc.com) to generate these munchkins, you can build a catalog of thumbnails that makes it easy to scan dozens of images in seconds (using the most sophisticated optical hardware ever designed, the Human Eye . . . patent pending, I'm sure). After you find the right image, just double-click the thumbnail to load it. Figure 7-6 shows a screen chock-full of thumbnails that I'm searching through with Paint Shop Pro.

If you also want to catalog your other multimedia files — like sound files and video clips — you can use Jasc Media Center Plus at www.jasc.com. Like digital images, the multimedia thumbnails in this program allow you to preview your stuff by just clicking the icons.

No matter what program you use, the trick to remember is that you must generate the program's catalog and add it to the disc layout so that it can be recorded along with the rest of the material. (No sense in keeping the catalog file on your hard drive for 100 years, unless, of course, you use this disc every day.)

Figure 7-6:
Scanning more than 100 images takes only a few seconds with thumbnails!

Converting Files for Fun and Profit

Before I end this chapter, here's a riddle for you: If you have burned a CD-ROM or DVD-ROM of photographs from your digital camera in JPEG format (which most cameras produce) and you're using a Macintosh, what have you done wrong? (Because this chapter is about convenience and ease of use, consider that a clue.)

Technically, the answer is "nothing" — until you try to use those images in many Macintosh applications. You see, some Mac programs that use graphics favor images in TIFF format. Of course, you can use an image editor like Photoshop to open those JPEG images and convert them to TIFF format each time you use them, but talk about a time-wasting hassle! In this case, you would have made a wise decision if you converted all those files to TIFF format *before* you recorded them so that you can simply pop the disc into your computer and load photos directly from it. (Don't worry if you didn't get that one — it was extra credit.)

With this example in mind, I devote this last section to format conversions: which common formats work best in what situations and which programs work best when converting files to other formats. The idea is twofold: You want your material in the form you use it in most, and you also want that material to be recognizable and usable in years to come.

What exactly is a *format?* A computer programmer would tell you that a file format is an arrangement of data that corresponds to specific byte positions and data element lengths. (Whew. Thank goodness my days of writing COBOL are over.) We flesh-and-blood humans can simply think of a *format*

as a language that's recognized by a program for storing and reading files. For example, although an image may look exactly the same when it's displayed in two different formats, one file may be 100K, and another may be 1MB! The difference in size is caused by the format, which determines the way the image data is saved.

You're likely to encounter four major species of formats when you're recording CDs:

✦ **Audio:** Without a doubt, the two most popular — and usable — audio formats for saving your recordings are MP3 and Windows WAV. Between the two, MP3 is probably the best choice because WAV files can reach colossal sizes when recording longer songs at higher-quality sampling rates. Also, Macintosh owners have far more support on their systems for MP3 than for WAV. To convert other sound formats to MP3, I use Musicmatch Jukebox Plus (`www.musicmatch.com`), shown in Figure 7-7. You can download the basic version for free.

Figure 7-7:
I use Musicmatch Jukebox Plus to convert audio between formats.

✦ **Video:** Digital video now generally resides in QuickTime MOV format, Microsoft AVI format, or MPEG format — and surprisingly enough, I'm again not recommending the Microsoft standard. Instead, I archive my video clips in MPEG format, which is recognized by just about every editor on the planet. You can be certain that future versions of your editor will be able to import your clips for new projects. For conversion, I use Adobe Premiere on the PC, which can import all these formats. More expensive commercial programs can handle a wider range of less popular formats, but because I use only the Big Three, Premiere works fine in my case.

✦ **Images:** For archival purposes, select JPEG, TIFF, or Windows bitmap; the latter two don't use compression that degrades the image, so they offer better quality, but both TIFF and Windows bitmap images are much larger than their JPEG counterparts. JPEG is recognized by most image editors (and because JPEG is the format of choice for Web pages, you have the advantage of being able to copy your archived images directly to your Web site). On the PC side, either Paint Shop Pro (from Jasc) or Adobe Photoshop does the conversion trick. On the Macintosh side, use Photoshop or the classic GraphicConverter from Lemke Software, at `www.lemkesoft.de/en/index.htm` (see Figure 7-8).

Figure 7-8:
Putting Graphic-Converter through its paces on the Mac.

✦ **Documents:** I can't think of a better set of tools for importing, converting, and exporting all sorts of document formats than Microsoft Office (www.microsoft.com). On both the PC and Macintosh, it can read most of your ancient, hoary document formats for spreadsheets, word processing files, presentations, and databases. For archival purposes, it's a safe bet that saving your documents in one of the standard Microsoft formats from the Office suite of applications is a good idea.

Don't forget that virus check!

As a final preparation before burning, I always run Norton AntiVirus (see the Downloads page at www.symantec.com) and check the contents of those folders that contain the files I have selected — especially for a disc I'm giving to someone else. Can you think of anything more antisocial than sending your friend a virus in a Word document or a program file?

**Book IV
Chapter 7**

Making Choices
Before Your
Recording Session

835

Chapter 8: Taking Easy Media Creator for a Spin

In This Chapter

✔ **Recording data discs**

✔ **Recording audio CDs**

✔ **Copying an existing disc**

✔ **Using disc images**

✔ **Erasing a rewritable disc**

*I*t's time to crank up Easy Media Creator on your PC and find out how to make basic data discs and audio CDs! You can consider this chapter the bread and butter of optical recording: These types of discs are likely to make up 90 percent of the recordings that are burned by most PCs. First, I describe the basic steps for each procedure, and I close this chapter with step-by-step procedures that illustrate specific tasks.

Interested in recording data and audio discs on a Macintosh? I fill in the details on recording with Toast in Chapter 9 of Book IV.

Recording Data: Putting Files on a Disc

The first disc I ever recorded was a data CD-ROM — ah, the memories! In fact, the first version of Easy Media Creator hadn't been released yet, and the primitive software that I used was anything but automatic or easy to use. In fact, I burned a couple of useless coasters before I finally got everything to work.

Just about everything has changed for the better. Easy Media Creator shields you from as much of the drudgery of burning a disc as possible. Follow these steps to record a basic data disc with folders and files from your PC's hard drive:

1. **Load a blank disc into your recorder.**

If you're using a CD-RW, DVD-RW, DVD+RW, or DVD-RAM disc, it should be formatted. (See the section "Erasing a Rewritable Disc," later in this chapter.) Easy Media Creator detects that you have loaded a blank disc and automatically displays the rather sexy-looking Home window (as shown in Figure 8-1).

To run the Home window from the Start menu, choose Start⇨All Programs⇨Roxio⇨Roxio Easy Media Creator Home.

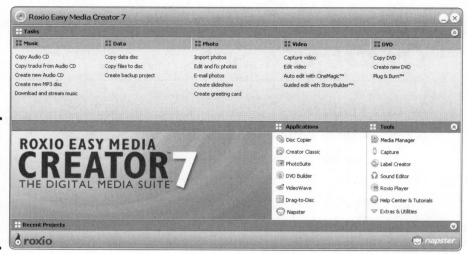

Figure 8-1:
Hey, the
Home
window
almost
looks like a
Macintosh
program!

2. Click the funky button marked Creator Classic.

The Home program runs Creator Classic, which is the main recording application within Easy Media Creator.

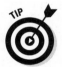

Alternately, you can click the Copy Files to Disc button under the Data section of the Home window; this performs the same actions as Steps 2 and 3. Hey, I use either method, depending on my mood!

3. Choose File⇨New Project⇨Data Disc.

Easy Media Creator opens an empty data disc layout, like the one that's shown in Figure 8-2.

Figure 8-2:
An empty
data disc
layout, just
waiting
for your
selections.

If you would rather run Creator Classic directly from the Start menu, choose Start➪All Programs➪Roxio➪Creator Classic.

See the folder tree that fills the top portion of the window? It operates just like Windows Explorer, and you use it to select the folders and files to include in your layout.

4. To open a folder and display the contents, double-click it. To move up to the preceding directory, click the Up One Level button (which looks like a folder with an up arrow on it).

You can also use the Select Source drop-down list box to navigate to a specific drive or top-level folder on your system. Highlight a folder or file that you want to add by clicking once on the name — you can highlight several by holding down Ctrl while you click.

5. After you have highlighted the folders and files that you want to add in the current directory, click the Add Selected Files Above to Project button in the center of the screen.

Alternatively, you can click and hold the mouse to drag the selected icons from the Explorer tree to the project layout display that fills the bottom half of the window. Oh, and if you look at the bottom of the window, you see a truly nifty bar display that tells you how many megabytes you have used in your layout and how much space remains — programs like this one make me proud to be a technonerd. To switch between different CD and DVD capacities, click the Disc Size drop-down list, which is conveniently placed to the left of the bar display.

6. If necessary, repeat Steps 4 and 5 with other folders until all the files that you want to add appear in the layout display (as shown in Figure 8-3).

The great file and folder hunt

"I know I put that file somewhere on this drive!" Brothers and sisters, I feel your pain — searching for one document in the midst of 50 directories and 30,000 files is not my idea of a fun way to spend an afternoon. If you agree, click the Search for Files button (the button with the folder and the magnifying glass) next to the Select Source Files list box to call for help from Easy Media Creator.

First, choose the drive that you want to search by clicking the Look In drop-down list box. (Boy, those Windows programmers in Redmond sure know how to label their fields.) Then, select your search criteria, as follows:

The filename: Even if you know only a part of the filename, you can enter the part that you know in the Named field. (Don't forget to select the Include Subfolders check box if you want to search the folders below the specified location.)

A word or phrase in a file: Search for all files that contain a certain string of text by entering the text in the Containing Text field.

The file's time and date stamp: Click the When Was It Modified tab. You can specify a search for files that were created or modified within the last week, month, or year — alternately, click the Specify Dates button and type the beginning and ending dates in the From and To fields.

The size of the file: Click the What Size Is It tab, and choose its minimum or maximum size. You can select one of the predefined sizes (less than 100KB, less than 1MB, or more than 1MB) or click the Specify Size in KB button and type the target file size yourself.

When you're ready to go, click the Search button. Good luck, Mighty Hunter!

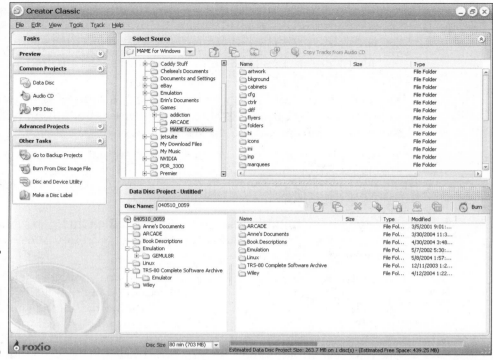

Figure 8-3:
The Data
Disc project
layout is
rapidly
getting full.

You can drag and drop in the Project layout display, too, so it's easy to arrange files in different folders or in the root directory of the disc if necessary.

Arrgh! It never fails: You're almost finished designing your Project layout, and your mom calls (either on the phone or from the kitchen). Luckily, you can save your current project within Easy Media Creator. Choose File⇨Save Project, enter a filename in the File Name field, and click the Save button. (To copy the current project under another name, choose File⇨Save Project As instead.) When you're ready to continue with your project, run Easy Media Creator, run Creator Classic, and then choose File⇨Open Project; highlight the project file and click the Open button to load it.

You probably won't be satisfied with a name like 010803_0203 for your disc — I don't blame you! Therefore, why not change it? Click once on the disc name, and then change the name just like you would rename a file on the Windows desktop. Remember that you are limited to a certain number of letters, depending on the file system that you're using, so keep your name short.

7. **Everything squared and ready? Houston, you're go for recording! Click the Big Red Flaming Disc-on-Fire Burn Button on the project layout toolbar.**

The program presents the Burn Progress dialog box. For a simple data disc, the program's default hardware settings should work just fine.

8. **Check to make sure that the correct drive and recording speed are listed.**

9. **Click the Details button (to display the advanced settings that are shown in Figure 8-4). Then click the Record Options drop-down list box and choose Test and Write. Although it takes twice as long, Easy Media Creator performs a test recording first, and if the test is successful, you can perform the recording.**

 If a problem occurs, you save a blank disc from becoming a coaster. After you have become comfortable with your recorder, however, I recommend that you choose Write Only and press onward.

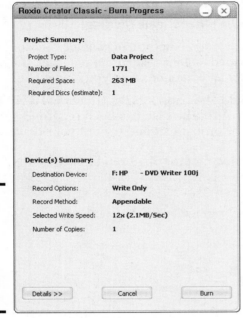

Figure 8-4: Don't let these settings scare you — this is a walk in the park!

10. **You can make more than one copy of your disc by specifying the number in the Number of Copies field on the Detailed version of the dialog box.**

11. **If you can select the Buffer Underrun Prevention check box, do so with all haste — this action turns on your drive's support for burn-proof recording.**

How do you "test" a CD-R?

"Hang on, there — you said that I could use a CD-R, DVD-R, or DVD+R disc only once. How can my recorder test the disc without messing it up?"

It's easy! If you read my discussion of lasers in Chapter 1 of Book IV, you remember that your recorder can toggle between two power levels. When you test a layout, your recorder acts like it's burning the disc, when in fact the laser is toggled

to the lower power setting. At this lower setting, the beam doesn't affect the dye layer (or the crystalline layer, if you're using a rewritable disc).

The result is a safe test: Easy Media Creator can still detect whether it would encounter an error while recording, but if errors are detected, you don't lose your blank disc!

12. **Select or deselect the Read-Only Disc check box to specify the recording method, as follows:**

- Deselecting the check box leaves the disc open so that you can record more data later. The current session is closed so that the disc can be read in any CD-ROM or DVD-ROM drive. However, the disc itself is not finalized, so you can write additional sessions later. If this field is grayed out, either your drive or the file system that you chose doesn't support this option.

- Selecting the check box closes the disc, so you can't write any more data. (You can consider it as "write-protecting" the disc.)

13. **Click the Burn button to start the wheels turning!**

If you used the Windows Start menu method of running the Home window and you haven't already loaded a blank disc in the recorder, the program automatically ejects the tray and demands that you feed it one.

The Burn Disc Progress dialog box appears, as shown in Figure 8-5, and you can watch the fun. After the disc has been recorded, you can optionally run Label Creator or just exit and try out your new toy.

Congratulations! You're the proud creator of a brand-new data disc.

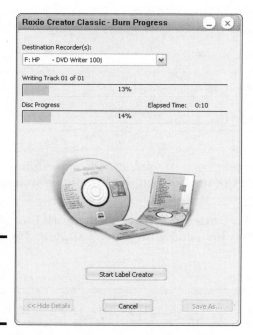

Figure 8-5:
This is it,
Bucko!
You're
burnin'!

Recording Your Music

Remember to rip and record only what you've bought — or what's legally available on the Internet. Likewise, don't copy commercial software and blithely hand it over to those who didn't pay a penny for it. I won't turn into a lawyer and start talking unintelligible legalese, but honor the copyrights of the musicians and software developers that worked the long hours. Please.

These days, I find myself recording audio CDs primarily from MP3 files — however, Easy Media Creator can also do the following:

✦ Copy individual tracks from existing CDs (in a process sweetly called *ripping*).

✦ Copy an entire existing audio CD. (Find out more on this in the next section, where I show you how to clone things with Disc Copier.)

With your permission, then, I show you how to create the Ultimate Motorhead Mix CD (or, if you prefer, the Absolute Best of Alvin and the Chipmunks):

1. **Load a blank disc into your recorder, which automatically displays the Home screen.**

Yes, I'm saying it again: *Do not use a CD-RW disc when recording a standard audio CD for use in a stereo system unless the player is designed to play CD-RW discs!* Are you getting tired of that sentence yet? (How about these italicized sentences?) Anyway, you can't say that I didn't warn you.

2. **Click the Creator Classic button in the Home window.**

Again, you can skip this foolishness by clicking the Create New Audio CD button under the Music section of the Home window. This performs the same actions as Steps 2 and 3.

3. **Choose File⇨New Project⇨Audio CD.**

If you would rather create an MP3 music CD (and your audio CD player supports MP3 music discs), choose File⇨New Project⇨MP3 Disc instead. You can add up to 700MB of MP3 files from your hard drive — that's because an MP3 music disc is actually a data disc (and not a true audio CD). MP3 music discs store MP3 songs in their native format, so you can get several hours of listening pleasure on a single CD! (Remember, however, that you can't play an MP3 music disc in an audio CD player that doesn't support the format — you'll hear absolutely zilch.)

4. **Now it's time to add tracks from the Easy Media Creator screen that's shown in Figure 8-6. You can select one of the following options:**

• **Add MP3, WAV, or WMF files:** Use the Explorer view in the upper-left portion of the screen to locate folders where your audio files are stored.

• **Rip tracks from another CD:** Load a disc into either your CD-ROM or DVD-ROM drive, and then select that drive from the Select Source drop-down list box to display the tracks. To load other tracks from other audio CDs, repeat the process.

If you don't have a track listing for the disc that you have loaded, just double-click a track in the Explorer view in the upper-right portion of the screen. Easy Media Creator displays the Preview player, and you can listen to the track before you add it to your layout.

5. **Click once on each track that you want to add.**

To choose more than one track from the same source, hold down Ctrl as you select each track name.

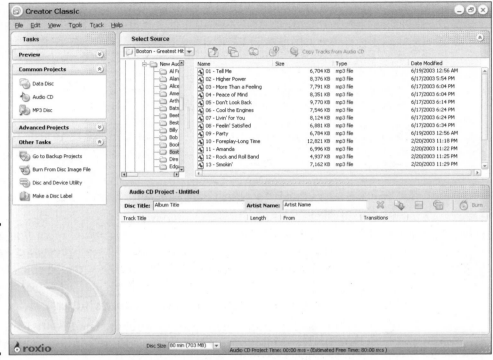

Figure 8-6:
New music CDs get their start on this Easy Media Creator screen.

6. **After you have selected your tracks from the source folder or disc, click the Add Selected Files Above to Project button (which looks like a document with an arrow pointing downward) in the center of the window to add the tracks to your project layout. (Alternately, you can drag the music files from the Explorer view and drop them on the layout at the bottom of the screen.)**

7. **Repeat Steps 4 through 6 until your track layout is complete — or until you have packed every second of your blank disc!**

 You can tell how much time you have used on your disc by checking the Estimated Time bar at the bottom of the screen. This bar tells you how much time the current track list needs and the remaining time that you can fill on both a 74-minute and 80-minute CD-R disc.

8. **Arrange the tracks in your layout as you like by clicking a track name to highlight it and dragging it to the new position in the track list.**

9. **Although it's not necessary, I recommend that you enter both a name for your new disc in the New Disc Title field and the artist's name in the Artist Name field.**

 Need to change or add a name for a track? Just click the entry to highlight it, and click again to edit the New Disc Title field.

10. **Ready to burn those hip 0s and 1s? Click the Big Red Flaming Disc-on-Fire Button on the project layout toolbar.**

 If you're loading tracks from an audio CD, Easy Media Creator prompts you to load the pesky CD when necessary so that the tracks can be copied and converted.

The program displays the Burn Progress dialog box. Click the Details button to see all the settings that you can fiddle with.

11. **If necessary, select your recorder and select the fastest possible recording speed.**

12. **You can clone multiple copies of your new music disc by clicking the arrows next to the Number of Copies field.**

13. **Select the Buffer Underrun Protection check box if your drive supports burnproof recording.**

14. **Unless you plan to add music to the disc in the future (or if you want to use CD-Text), select the Read-Only Disc check box.**

 Many audio CD players (and most CD-player programs for your computer) display CD-Text while the disc is playing. This includes the disc name, artist name, and each track's name.

15. **Click the Burn button, you music-producing mogul! If your recorder is empty, Easy Media Creator yells for you to load a blank disc.**

 The program displays the Burn Progress dialog box (which has already popped up in Figure 8-5), allowing you to monitor the 0s and 1s as they're shoveled into the furnace and onto your disc. When the recording is done, you have the choice of running Label Creator if you want to print a fancy-looking label or a set of jewel box inserts.

Time to grab your headphones and jam to your latest creation!

Copying a Disc

In this section, I describe how you can copy an existing data disc (both CD-ROM discs and unprotected DVD-ROM discs) or an audio CD. Rather than take the time to crank up Easy Media Creator, Roxio provides you with a separate program named Disc Copier; it can clone a disc by using just the recorder. If you're lucky enough to have either a CD-ROM or DVD-ROM drive or a second recorder in the same system, you can even copy drive to drive and whip out a copy in record time!

Follow these steps to copy a disc:

1. **Choose Start⇨All Programs⇨Roxio⇨Disc Copier to display what's shown in Figure 8-7.**

Figure 8-7:
You're on the road to Duplication City with Disc Copier.

2. Click the Source drop-down list box, and select the drive in which you have loaded the disc that you want to copy.

It can be any drive on your system that can read a disc, including your recorder.

3. Click the Destination drop-down list box, and select the recorder that is to burn the disc.

Remember that it can be the same as the Source drive.

4. It's a good idea to check the advanced settings before you begin the copy, so click the Advanced button to display the settings shown in Figure 8-8.

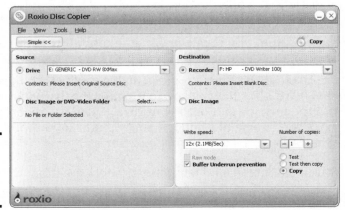

Figure 8-8: Preparing to tweak Disc Copier.

5. You can select the Test, Test then Copy, or Copy radio button. Because I'm familiar with my equipment, I skip any testing and jump right to the real thing. However, the Test then Copy radio button does the trick as well (it just takes twice as long), and you won't lose a blank disc if something is SNAFU.

6. If you want more than one copy of the original disc, click the arrows next to the Number of Copies field and select, well, the number of copies!

7. Instead of burning immediately, you can also create a disc image on your hard drive that you can use later to record the actual disc. To do so, click the Disc Image radio button.

This is a neat trick for those with external CD or DVD recorders who have "lent" their drive to someone else. To burn a disc from the image in the future, run Disc Copier again and choose Disc Image or DVD-Video Folder as your source. You find out more about disc images in the next section (including another way to record 'em).

8. Select the Buffer Underrun Prevention check box if your drive supports burnproof recording.

9. Click the Red Disc-on-Fire button at the right end of the toolbar to unleash the fearsome power of your laser, and be prepared to load a blank disc if you're using one drive to copy.

Using a Disc Image

From time to time, you may find that you need multiple copies of a disc but don't want to produce all the copies at one time. Perhaps the data will change within a few weeks or you're preparing discs for sale or distribution, but you don't know how many copies you need.

This situation is where a *disc image* comes in handy. Think of it as a complete CD or DVD that's saved as a single file to your hard drive. In fact, you can even create a disc image for later burning without a recorder! I know that sounds screwy, but when you're on the road with your laptop or you're at the office and you don't have your external recorder with you, you can create a disc image file instead. After your computer and external recorder are reunited, recording that disc is a snap.

However, you have to look at the downside: The disc image takes up all the space of its optical sibling, so each disc image that you save on your hard drive takes up the space that the data occupies on the recorded disc. Therefore, it's wise to save from 800MB to 5GB of free space on your drive (depending on the type of disc that you're burning) if you think that you need to create a disc image.

Follow these steps to create a disc image with Easy Media Creator:

1. **Choose Start⇨All Programs⇨Roxio⇨Creator Classic.**

2. **Choose File⇨New Project, and select the type of disc that you need from the pop-up menu.**

3. **Build your project layout as you normally would.**

4. **Click the Burn button as usual, but this time click the Details button and click the Disk Image File button in the Destinations panel.**

5. **Click the Save As button, navigate to the folder on your hard drive where the image should be saved, type a name for your image file, and then click the Save button.**

Sit back and watch the fun as the disc image is recorded. The image filename carries a C2D extension.

Later, when you're ready to record the disc, the process is just as easy. You can use Disc Copier, as I showed you in the previous section, or you can follow these steps to use Creator Classic:

1. **Choose Start⇨All Programs⇨Roxio⇨Creator Classic to run the program.**

2. **Choose File⇨Burn from Disc Image File.**

The Burn from Disc Image File dialog box appears, as shown in Figure 8-9.

3. **Navigate to the location of the disc image that you want to record. Highlight the image, and click the Open button.**

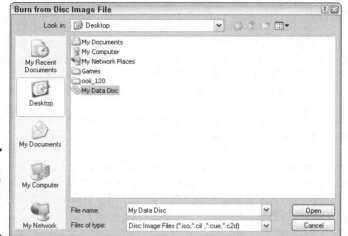

Figure 8-9:
Selecting an existing disc image to record.

4. **Make any necessary settings changes (as I show you earlier in this chapter), and click the Burn button.**

5. **Load a blank disc, and the recorder does its stuff.**

Erasing a Rewritable Disc

After you have finished with a CD-RW, DVD-RW, DVD+RW, or DVD-RAM disc, do you simply chuck it in the nearest wastebasket? No! Instead, you can erase the entire disc at one time (you have no way to erase only part of the disc — it's either all or nothing) and use it all over again.

To erase a rewritable disc with Creator Classic follow these steps:

1. **Load the offending rewritable disc into your recorder.**

2. **Right-click the drive in the folder tree, and choose Erase from the pop-up menu that appears.**

3. **If Creator Classic prompts you for confirmation, answer in the affirmative.**

You can choose a quick erase or a full erase. I agree with the good folks at Roxio and recommend a quick erase in most cases.

When do you use the Full Erase option? Sometimes you may want to be absolutely sure that your data is erased. However, if you're trying to record by using a rewritable disc and Easy Media Creator reports errors with the disc's formatting or TOC (table of contents) information, you probably have to erase the disc to make it usable again. This can happen if a recording session is interrupted by a power failure or if Easy Media Creator should — perish the thought — crash on you.

Click the Start button to begin the process — and take a break for a soda or a cup of java if you have selected the Full Erase option.

Project: Developing MP3 Fever

Friends, I have a hankerin' to hear the King — that's right, Elvis Aaron Presley himself. The trouble is, I have all my Elvis songs in MP3 format on my hard drive and I want to listen to them in my '64 Cadillac's audio CD player! If you're in the same boat (I don't mean the Caddy), you have come to the right project: burning a *Best of Elvis* audio CD. (And yes, neighbors, I own the original commercial CDs for the music that I use in this project! I just ripped the tracks into MP3 format for this demonstration.)

Follow these steps to record a standard audio CD from a passel of MP3 files:

1. **Choose Start⇨All Programs⇨Roxio⇨Roxio Easy Media Creator Home.**

2. **Click the Create New Audio CD button in the Home window.**

3. **Click the Select Source drop-down list box, and select the drive where your MP3 files are living. Use the Explorer view in the upper-left portion of the screen to navigate to the right folder.**

4. **Hold down Ctrl, and in the right pane of the Explorer view, click the MP3 files that you want to add.**

5. **Click the Add to Project button in the center of the screen — it looks like an arrow pointing downward.**

6. **To add songs from another folder, repeat Steps 3 through 5.**

 Personally, I think that these eight are the King's best songs, so let me stop here.

7. **You can click and drag the track names to rearrange them. I want my disc to start out with "Jailhouse Rock," so I click and drag the entry from Slot 5 to Slot 1.**

8. **Click in the New Disc Title field, and enter a name for your disc.**

9. **Click in the Artist Name field, and enter the name of the performer or band.**

10. **The disc layout is ready to record, so click the Big Red Disc-on-Fire Burn Button.**

 The Burn Progress dialog box appears, and I click the Details button to see all the settings.

11. **I need only one copy of this disc, so I leave the Number of Copies field set to 1.**

12. **Even if your audio CD player doesn't display CD-Text, you may encounter one in the future. Therefore, I always recommend that you select the Read-Only Disc option and burn things permanently.**

13. **Click the Burn button to start the wheels turning, and then load a blank disc.**

14. **When the recording is finished, you can run Label Creator. Otherwise, eject your disc and enjoy your Elvis!**

CHECK IT OUT

Archiving Digital Photographs

Have a number of family photos that you have taken with your digital camera? Why not burn them to a data CD and free that hard drive space for other programs? Follow these steps to burn a basic archive of digital images:

1. Choose Start⇨All Programs⇨Roxio⇨ Creator Classic.

2. Click the Data Disc button in the Common Projects task pane in the left side of the window.

3. Click the Select Source drop-down list box, and navigate to the drive where your images are stored. To move to another folder, use the Explorer view in the upper-left portion of the screen.

4. Click one or more filenames while you hold down Ctrl.

5. Click the Add to Project button in the center of the screen — that's the one with the arrow pointing down — or drag the highlighted files to the bottom window.

6. To select more images, just repeat Steps 3 through 5 until you have added all the photos that you want (or, of course, until the disc is full). Use the bar display at the bottom of the screen to keep track of how much space remains.

7. To create a new folder in your project layout, right-click the disc title in the Layout window in the lower-left corner and choose New Folder from the pop-up menu that appears. The new folder appears with the name highlighted; type a name for the new folder and press Enter to save the name. To move images in and out of folders, click and drag the filenames wherever you want them.

8. Click the disc title to highlight it, and click it again to type a new name.

9. When you're ready, click the Big Red Burn Button!

 The Burn Progress dialog box appears, so click the Details button to verify all your settings.

10. If you don't want multiple copies, leave the Number of Copies field set to 1.

11. Choose whether you want to finalize the disc or add files and folders later. Because I'm archiving, I select the Read-Only Disc check box.

12. Click the Burn button to start the wheels turning, and then load a blank disc.

13. When the recording is finished, you can run Label Creator. Otherwise, eject your disc and hand your photo archive to Grandma!

Because you finalized this disc, you can't write to it again. If your drive supports packet writing, Chapter 10 of Book IV shows you how to create a UDF disc with Drag-to-Disc — which I prefer rather than creating a multisession disc. With Drag-to-Disc, you can add files later, and it's much easier than using Creator Classic. (Don't forget to check out Book I to find out all about digital photography.)

Chapter 9: Toasting Mac Discs

In This Chapter

✓ Recording HFS data CD-ROMs

✓ Recording audio CDs on the Macintosh

✓ Creating a hybrid Mac/PC disc

✓ Burning video on CDs and DVDs

✓ Creating a temporary partition

✓ Recording DVD-R backups with Toast

I don't even own a toaster, but I use my Toast to burn all the time! (Try explaining that to your friends.) In the Macintosh world, however, that sentence makes perfect sense. Compared to Roxio's Easy Media Creator, Toast 6 Titanium for the Macintosh (also from Roxio) is a lean, mean, and exceptionally attractive recording machine. As you may guess, the program's menu system and appearance are radically different from its Windows sibling, and it has a number of Mac-specific features. (If you're running Mac OS 9.2, you're out of luck. Toast 6 Titanium runs only under Mac OS X — progress marches on.)

In this chapter, you take a look at both the basics of recording and many of the advanced options that are available within Toast.

Putting Files on a Disc

Toast can create the following types of Hierarchical File System (HFS) discs:

✦ **Mac OS Standard CD:** If your disc will be used on older Macs using System 7 or earlier — those before Mac OS 8.1 — you should use this standard disc.

✦ **Mac OS Extended CD:** Macs running Mac OS 8.1 or later can take advantage of the Extended file system, which allows faster performance and provides a bit more room on the disc for your data.

Therefore, if compatibility is in question, always use the Mac OS Standard CD version of HFS because both older and newer Macintosh operating systems can read it. (Also, as you see later in this chapter, some types of discs require the Mac OS Standard CD file system.)

To record a simple data disc with files from your Macintosh's hard drive, follow these steps:

1. **Double-click the Toast icon on the desktop to launch the program and display the stylish Toast screen, as shown in Figure 9-1. (Talk about classy!)**

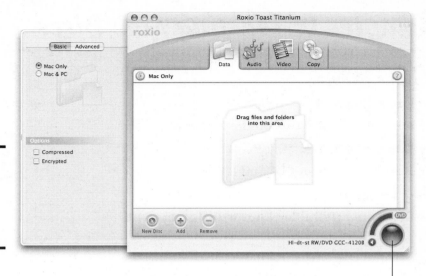

Figure 9-1:
Didn't I tell
you that
Toast is a
spiffy
program?

The Record button

2. **Click the Data tab at the top of the screen.**

3. **To select the type of data disc that you want to record, click the Advanced button on the Disc Options drawer (in the upper-left corner).**

Toast displays the different types of discs that you can record in the selected category. For a basic Macintosh-only data disc, you should select the Mac Only option. By default, Toast records a Mac OS Extended CD. To record a Standard HFS CD, select the HFS Standard check box to enable HFS.

To hide or display the Disc Options drawer, click the button to the left of the Data tab. (In Figure 9-1, this button appears to the left of the words `Mac Only`.)

4. **Drag and drop files and folders from the Finder window into the Toast main window.**

Note that the program keeps track of both the number of files in your layout and the approximate amount of space that these files use on the disc. (Check out that nifty gas gauge bar graph that encircles the Record button!) You can toggle between CD and DVD displays on the usage bar graph display by clicking the CD or DVD button that's next to the Record button.

5. **Repeat Step 4 until you have added all your files and folders or until the disc layout is filled to capacity.**

You can click and drag filenames to move them into and out of folders, just as you would in the Mac OS X Finder window when you're using List view. To add a new folder, highlight the parent folder (or the CD itself) and click the New Folder button at the bottom of the screen. To remove a file or folder — just from the layout, mind you, *not* from your drive — highlight the unwanted item and click the Remove button at the bottom of the screen. Figure 9-2 illustrates a typical disc layout that I have created on my system.

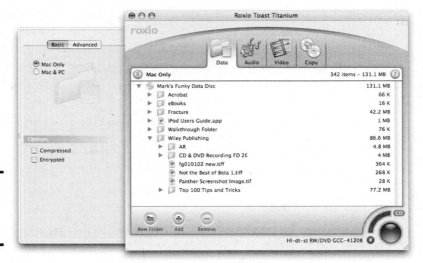

Figure 9-2:
Ready to
record
with Toast!

6. **Load a blank CD into your recorder.**

7. **Click the big red Record button.**

8. **The Record dialog box appears, as shown in Figure 9-3.**

 To make more than one copy of the disc, click in the Number of Copies field and type the desired number. By default, Toast selects the highest recording speed that your drive supports.

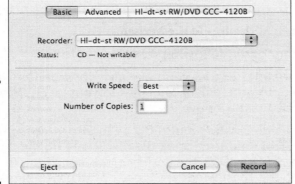

Figure 9-3:
To write one
copy or a
thousand —
that is the
question.

9. **Click the Advanced button at the top of the dialog box.**

 Here, you determine whether you want to finalize (or close) the disc, as follows:

 • To write a single session and leave the disc open for later recordings, deselect the Close Disc check box. (This action is the same as selecting the Finalize Session, Don't Finalize CD check box in Roxio's Easy Media Creator.) You can read the disc in your Mac's CD-ROM drive, and you can create a multisession disc by using this disc in the future.

- Select the Close Disc check box to write the session and finalize the disc so that it can't be written to again. This action corresponds to selecting the Finalize CD check box in Roxio's Easy Media Creator.

You can choose to test the recording by selecting the Simulation Mode check box, but note that this selection does not automatically record the disc if the test completes successfully.

If your Mac's recorder supports burnproof recording — and all Macs made in the last 3 years or so do — make sure that you select the Buffer Underrun Prevention check box. With buffer underrun prevention turned on, you can continue to use your Mac while it's burning without fear of ruining the disc. *Sassy!*

10. **Click the Record button.**

While recording, Toast displays a progress bar. After the recording is complete, the program automatically verifies the finished disc against the original files on your hard drive. Because this process takes several minutes, you have the option of ejecting the disc immediately and skipping the verification step.

Recording an Audio CD

Although Apple has released programs like iTunes that can burn audio discs, I still prefer to record audio CDs on the Macintosh with Toast; it provides more choices and more control over the finished disc. To record an audio CD from files on your hard drive and existing audio CDs, follow these steps:

1. **Double-click the Toast icon on the desktop to launch the program.**

2. **Click the Audio tab at the top of the screen.**

3. **Add tracks in either of the following ways:**

 - **Add existing sound files that you have already saved to your hard drive.** For example, add AIFF or MP3 files to your layout by dragging the files into the Toast window.

 - **Add tracks from an existing audio CD by loading it into your CD-ROM drive and double-clicking the disc's icon on the desktop to display the track icons.** Drag the desired track icons from the audio CD window into the Toast window. (These tracks have a tiny CD icon to indicate that they're being ripped from an existing audio CD.)

If you plan to copy the majority of tracks from an existing CD, just drag the entire disc icon to the Toast window and load all the tracks at one time.

4. **To create an MP3 music disc with the MP3 files that you've added, select the MP3 Disc option in the Disc Options drawer.**

If the Disc Options drawer is hidden, click the button to the left of the Data tab. Naturally, you can add only MP3 files to an MP3 music disc project.

5. **You can rearrange the tracks to any order that you want by dragging them to their new positions. To rename a track, click the track name to highlight it and click again to open an edit box. Type the new name. To hear a track, highlight the track name and click the eminently familiar-looking Play button at the bottom of the screen. To remove a track, select the offending track and click the Remove button. Finally, you can change the length of the pause before a track by clicking the current value — by default, it's 2 seconds — and choosing a new value from the menu.**

If you're using files from an existing audio CD and you have only one optical drive on your Mac system, you have to *export* (a more dignified word for rip) any tracks that you're copying from other discs before you record your new audio CD. This export step eliminates any possible problems that your drive may encounter if you try recording directly from the discs themselves.

6. **Highlight each track that you have added from another disc, and click the Export button in the lower-left corner of the Toast window.**

Toast displays a Save As dialog box that allows you to choose the folder where the extracted audio is saved. The tracks are saved as AIFF files.

7. **Load a blank CD-R disc into your recorder.**

8. **Click the big red Record button, which displays our old friend, the Record dialog box.**

9. **For a standard audio CD, click the Advanced button and make sure that the Close Disc and DAO (short for Disc-at-Once) options are both selected.**

10. **Click the Record button.**

I swear that this is the last time I'll say this — it really is, folks — *Do not use a CD-RW disc when recording a standard audio CD unless you're sure that the audio CD player supports rewritable media!* Using a CD-RW disc in an older audio CD player that doesn't support rewritable media will probably result in stark silence (and a blinking error message from your CD player). If you do hear anything, your CD player will probably produce something that sounds like an enraged moose. (And yes, for you Monty Python fans, a moose once bit my sister . . .)

After your audio CD has been recorded, you can regain hard drive space by deleting the extracted audio tracks that you saved. Or, if the notion is attractive to you, keep the tracks for another recording or use them with your iPod.

Ooh! It's a Hybrid!

Next, turn your attention to an important type of disc that's easily recorded with Toast: a PC/Macintosh hybrid disc, that is, a disc that can be read on both systems. The Mac portion of the disc uses the HFS standard, and the PC portion uses either Joliet or ISO 9660. This disc type is a perfect way to

distribute files and programs to a wide audience — especially games, educational material, clip-art libraries, multimedia files, and fonts (all of which are often shared between PCs and Macs).

Note that unless you're running special software, only the native format portion of the disc can be read by either operating system. (Geez, I need a soda. In plain English: The Macintosh can read only the Mac information on the disc, and the PC can read only the PC portion. Sorry about that.)

To create a hybrid disc, follow these steps:

1. **Gather the Mac-only files that you want to record, and move them to a separate volume.**

 (This volume can be a separate hard drive partition, a removable disk like a USB flash drive, or a temporary partition, which I show you how to create at the end of the chapter.)

 If you have any files that should be visible on both Macs and PCs, copy them to the volume as well.

2. **Double-click the Toast icon on the desktop to launch the program.**

3. **Click the Data button at the top of the screen.**

4. **Click the Advanced button in the Disc Options drawer, and then select the Custom Hybrid option.**

 Toast displays the screen that is shown in Figure 9-4.

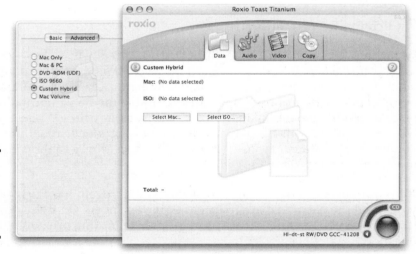

Figure 9-4:
The beginnings of a Mac/PC hybrid disc.

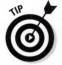

If you're just looking for a single disc that offers one set of files that both types of computers can read, eschew the Custom Hybrid format. Instead, click the Basic button on the Disc Options drawer and select the Mac & PC option. This format creates a simple cross-platform disc that can be read on both Macs and PCs. A Mac & PC format disc is suitable only for

sharing simple data files. Unlike a true hybrid disc, a Mac & PC format disc doesn't support any operating system-specific features for either type of computer.

5. **Click the Select Mac button.**

6. **From the Select Volume dialog box, click the volume that you created in Step 1 in the list and select the Optimize On-the-Fly check box. Click the OK button to return to the main screen.**

7. **Click the Select ISO button to display the ISO 9660 dialog box, as shown in Figure 9-5.**

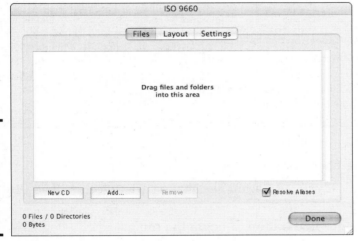

Figure 9-5:
Yes, Mac folks can communi-cate with PC folks — sometimes.

8. **Drag and drop the files that should be read on the PC to the ISO 9660 dialog box.**

 You can click the CD title or a folder name to rename it — files are auto-matically renamed to conform to the ISO standard. Click the New Folder button to add a new folder, and feel free to drag files and folders around to rearrange your ISO layout.

9. **After you're finished adding ISO files, click the Settings tab. From the Naming drop-down list box, select Joliet (MS-DOS + Windows), which allows long filenames. Click the Done button.**

10. **Okay, let's burn this puppy! Choose File⇨Save As Disc Image. Toast prompts you for a location to save the image file. (I generally pick the desktop because it's easy to find.) Click the Save button to create the image.**

11. **Click the Copy button at the top of the screen. This time, select the Image File option from the Disc Options drawer.**

12. **Click the Select button, choose the image that you created in Step 10, and click the Open button.**

13. **Load a blank disc into your recorder.**

Mounting an image (and not on the wall)

From time to time, you may want to take advantage of the absolutely nifty ability to mount a disc image on the Mac OS 9.2/X desktop, just like it was a gen-u-wine piece of CD-ROM hardware. You can open the mounted disc and even run programs and load files from it. Your Mac applications can't tell the difference, and you don't have to dig through dozens of CDs to find the one that holds the files that you need. (You're likely to use a mounted disc image only for data discs because you can listen to audio tracks just by extracting them as AIFF or MP3 files.) As long as you have the available hard drive territory, you can keep a disc image on tap for any contingency.

To create a disc image, build your data CD layout as usual, as I describe in the section "Putting Files on a Disc," earlier in this chapter. (Make sure that you have at least 800MB to 900MB of free hard drive space if your image will reflect a full disc.) Then, rather than burn the layout, choose File⇨Save As Disc Image. From the Save Disc Image As dialog box, click the target folder in the list to select it, type a new name (if necessary), and click the Save button. Toast acts just as though it's writing to a disc; when it's done, however, you have a brand-spanking-new disc image file.

To mount the file, double-click it. Toast automatically launches and presents you with two buttons: Select and Mount. Click the Mount button, and you're ready to go. (After the volume icon appears on the desktop, you can exit Toast.) The mounted volume stays on your desktop until you reboot your Macintosh or drag the volume icon to the Trash. Enjoy!

14. **Click the big red Record button.**

15. **Click the Advanced button and make sure that the Close Disc option is selected.**

16. **Click the Record button to begin the fun.**

17. **After the recording has finished, you have the choice of verifying the disc or ejecting the disc immediately and skipping the verification step.**

Let Your Video Do the Talking

Toast 6 Titanium allows you to create your own Video CDs, Super Video CDs and DVD-Video discs — after a fashion, that is. Unlike iDVD, you don't have creative control over menu creation and what goes where — Toast does it automatically — but if you're looking for basic transportation for your digital video clips and digital photographs, you can't get much easier than this application!

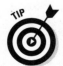

Video CDs (commonly called VCDs) can be shown on your computer with the proper VCD player application; most standalone DVD players can also handle Video CDs. Super Video CDs (or SVCDs), on the other hand, display significantly better video quality, but there's a caveat or two: An SVCD stores less information than a VCD, and most older DVD players don't recognize the format. Therefore, use the Video CD format whenever possible to ensure the best possible compatibility.

To create a Video CD or Super Video CD, follow these steps:

1. **Double-click the Toast icon on the desktop to launch the program.**

2. **Click the Video button at the top of the screen.**

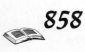

3. **Click the Advanced button in the Disc Options drawer, and select the Video CD or Super Video CD option.**

 If you're creating a disc for use in the United States, make sure that you select the NTSC option.

4. **To add basic menus to the disc automatically, select the Create VCD Menu check box.**

 Personally, I leave this option deselected and simply allow the video clips to run sequentially. Remember, the more video clips you add, the more cumbersome (and harder to navigate) your menus become.

 I always recommend that you click the Video Quality drop-down list box and select High quality. You get less recording time on the disc, but the video on the finished disc looks much better.

5. **Drag and drop video clips to the content window (see Figure 9-6).**

 Alternatively, you can click the Add button to select the video clips from a standard Open dialog box. To remove a clip that arrived by accident, select the clip and click the Remove button.

 To import digital video directly from your DV camcorder, plug it in — Toast displays a DV camcorder icon in the content window. Click the Import button, and sit back while Toast creates the video clip! (Just make sure that you have enough hard drive space to hold the imported clip — the digital world can get cumbersome.)

Figure 9-6: Adding the hottest video clips to my new SVCD project.

6. **Add photographs (or an entire folder of photographs) from your hard drive by dragging them into the content window.**

 You can drag images from a Finder or iPhoto window; Toast labels a folder as a slideshow and displays the number of images that each slideshow contains.

Book IV
Chapter 9

Toasting Mac Discs

Can I burn DVD-Video discs with Toast?

Yes, Virginia, Toast can handle basic DVD projects — however, don't expect many frills. (Forget creating fancy animated menus and embedded content.) I recommend that you take the easy route, and follow the same steps that I used for VCDs and SVCDs. You'll end up with a DVD-Video disc that plays video clips and slideshows on your computer and DVD player — but you won't be able to directly manipulate the contents of the VIDEO_TS folder. A DVD movie must conform to the DVD-Video standard, which uses a very specific set of directories (and is recorded using the UDF standard). If that sounds like ancient Sumerian to you, you don't need to read any more of this sidebar!

Hey, you. Yeah, you, the DVD wizard who wants to burn a DVD-Video disc. Actually, you *can* hot-wire Toast to produce a bona fide DVD-Video disc with

your own VIDEO_TS files. (Forgive me if I get a bit technical here for the DVD wizards.) You need to burn the project as a data disc instead, and you have to prepare the contents of the VIDEO_TS folder separately because Toast doesn't allow you to directly author DVD content.

To create the necessary layout, click the Data tab, click the Advanced button in the Disc Options drawer — choose the DVD-ROM (UDF) option, and then drag your prebuilt VIDEO_TS folder into the content window. (Remember, most older DVD players also require an AUDIO_TS folder for everything to work, even if the AUDIO_TS folder doesn't contain anything.) Now you can burn the disc. Naturally, I recommend that you use a DVD-R disc for the best possible compatibility with all DVD players.

Here's a neat trick: Click the Advanced button in the Disc Options drawer, and select the Add Original Photos check box. Toast creates a separate folder on the final disc that contains all the photos that you add to your VCD/SVCD project. When you load the disc into a computer, you can copy those images directly from the disc to the computer's hard drive. (If you use this feature, your discs will both display *and* store your images!)

7. **Load a blank disc into your recorder.**

8. **Click the big bed Record button . . . and wait.**

 Unfortunately, digital video takes time to *encode* (a fancy-pants term that describes the conversion of your digital video into a form that can be recorded). How much time? Well, pardner, that depends on the size of the video clips, the quality setting that you've chosen, and the speed of your Mac — but don't be surprised if you can take a break for lunch before the Record dialog box appears.

9. **Finally! Click the Advanced button, and select the Close Disc option.**

10. **Click the Record button, and relax.**

Project: Recording a Backup DVD-ROM Disc

Toast can burn with DVD-R/W and DVD+R/W drives, so it makes a good quick-and-dirty recording program for creating backups. The storage space on a DVD-R disc makes backing up a decent-size drive easy, using only three or four discs. You don't get a full 4.7GB — a 4.7GB disc provides only about 4.25GB when you use the Mac OS Extended format — but it's still nothing to sneeze at.

You, too, can burn a simple DVD-ROM backup disc for your hard drive files. Follow these steps to do so:

1. **Double-click the Toast icon on the desktop to launch the program.**

2. **Click the Data tab.**

3. **Click the Advanced button in the Disc Options drawer, and select the Mac Only radio button.**

When you're backing up data, compatibility with other computers usually isn't a big deal. Therefore, I heartily recommend that you select the Compressed check box in the Disc Options drawer. To safeguard your data, you can also select the Encrypted option, which will prompt you for a password. Security is a good thing, but here's a stern Mark's Maxim:

> Brothers and sisters, if you can't supply that password, you won't be able to read anything from the disc!

4. **Click and drag the desired files and folders into the content window.**

5. **Load a blank DVD-R disc into your DVD recorder.**

6. **Click the big red Record button, which presents our old friend, the Record dialog box.**

7. **Click the Advanced button, and make sure that the Close Disc option is selected.**

Because a backup is such an important procedure, I also recommend that you select the Verify Data check box. Toast takes additional time to check the disc after the recording is complete, but isn't your peace of mind worth that extra step?

8. **Click the Record button, and grab another soda.**

Note that Toast can also write a data layout to a DVD-RAM disc, but the entire disc is automatically reformatted first, and the data is recorded as a read-only disc. If you want to record data to the disc again using Toast, you lose the current contents of the disc when it's reformatted. Sorry about that. But then, if you're using a DVD-RAM drive for backups, like I do, automatic reformatting probably isn't a problem!

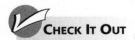

CHECK IT OUT

Creating a Temporary Partition

As I mention in the section "Ooh! It's a Hybrid!," earlier in this chapter, recording with Toast sometimes requires you to create a temporary partition as a separate volume on your Mac desktop. In fact, you can use the Mac Volume disc type to record the contents of a temporary partition as a complete disc.

In the following steps, I show you how to create a temporary partition to store the Macintosh files for a hybrid disc:

1. **Double-click the Toast icon on the desktop to launch the program.**

2. **Choose Utilities⇨Create Temporary Partition to display the Create Temporary Partition dialog box, as shown in the following figure.**

CONTINUED

CONTINUED

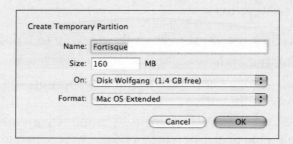

Create Temporary Partition

Name: Fortisque

Size: 160 MB

On: Disk Wolfgang (1.4 GB free)

Format: Mac OS Extended

Cancel OK

3. Click the Name field, and enter a volume name for the partition.

In this example, I chose Fortisque. (I have my reasons.)

4. Click the Size field, and enter a partition size in megabytes (the default is 650MB).

Naturally, this size can't be larger than the amount of free space on the drive that you select in the On drop-down list box. I have only about 150MB of Mac files to record on this hybrid disc, so I show you how to create a 160MB partition on my hard drive. Leaving about 10MB of breathing space on your temporary partition is always a good

idea. This allows you to add a forgotten file or two later without running out of room.

5. If you need a Mac OS Standard disc, select it from the Format drop-down list box.

6. Click the OK button.

As shown in the following figure, Fortisque has suddenly appeared on my Mac desktop.

Don't you wish that it was that easy to add permanent storage space to your system?

After the partition has been created, you're ready to drag your Mac files into it.

After you're done with the partition, you can delete it by dragging it to the Trash.

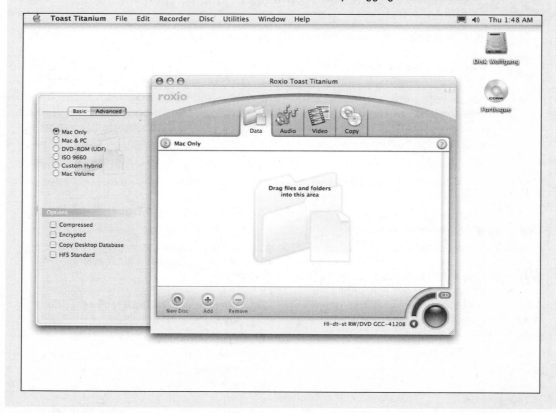

Chapter 10: Burning Data with Drag-to-Disc

In This Chapter

✔ **Formatting discs for use with Drag-to-Disc**

✔ **Adding files to a Drag-to-Disc project**

✔ **Ejecting and using Drag-to-Disc discs**

✔ **Adding new files to a Drag-to-Disc project**

✔ **Restoring Drag-to-Disc files**

✔ **Recording an employee disc with Drag-to-Disc**

Okay, I trumpet the advantages of Roxio Drag-to-Disc throughout much of Book IV, and it's time to deliver the goods. What makes Drag-to-Disc so hot? Here are the facts:

✦ You don't need to open any recording software ahead of time. Just drop a Drag-to-Disc disc in your drive, and everything's taken care of for you automatically.

✦ The Universal Disk Format (UDF) recording mode — also known as *packet writing* — that's used by Drag-to-Disc is almost as reliable and foolproof as burnproof recording. You can safely record data on a Drag-to-Disc disc while you're working in another application under Windows.

✦ You can add files at any time without creating a multisession disc.

✦ Drag-to-Disc works with CD-R, CD-RW, DVD-R/W, DVD+R/W, and DVD-RAM discs. In other words, you can forget the ASH Syndrome (an acronym of my personal invention, short for *Alphabet Soup Hassle*).

✦ Although Drag-to-Disc itself is a Windows-only program, all popular operating systems can read a UDF disc produced by Drag-to-Disc.

Eager to find out more? This is the chapter for you — I put Drag-to-Disc through its paces.

"Whaddya Mean, I Have to Format?"

Hey, I didn't say that Drag-to-Disc is perfect, did I? This program has only two drawbacks, as follows:

✦ You have to format a disc before you can use it.

✦ You can't create mixed-mode or standard audio CDs with Drag-to-Disc.

I can't do anything about the latter — Drag-to-Disc prompts you to launch Creator Classic if you're moving digital audio files to your disc — but the program automatically formats a disc for use with Drag-to-Disc when you drag files to it within Windows Explorer.

If your drive doesn't support this automatic formatting option (or if you want to use compression, which I cover in a paragraph or two), you can follow these steps to manually format a blank disc in Windows XP:

1. **Load a blank CD-R or CD-RW disc into your recorder.**

2. **Choose Start➪All Programs➪Roxio➪Drag-to-Disc to display the Drag-to-Disc window, as shown in Figure 10-1.**

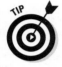

You can also double-click the Drag-to-Disc icon in the system tray to display this screen.

Figure 10-1: All roads to Drag-to-Disc start here.

3. **Press Alt+F to display the Format Options dialog box, as shown in Figure 10-2.**

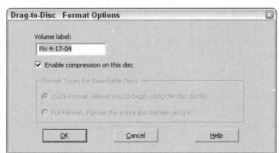

Figure 10-2: Choosing a volume name and enabling compression for a disc.

4. **It's time to give your disc a name: In the Volume Label field, enter a descriptive volume name that has 11 characters or fewer.**

You see this label displayed in the same places as your hard drive names, including Windows applications, within Windows Explorer and within My Computer.

If you suddenly decide to rename your Drag-to-Disc disc later — if you change your significant other, for example — click in the Drag-to-Disc window, press Alt+R, and then type the new name.

You can also choose to use compression on your Drag-to-Disc disc, which means that files can be reduced in size and you can pack additional stuff on the disc. Woohoo! Roxio says that the compression ranges from 1.5:1

to 3:1. As with a Zip archive, the compression that you achieve depends on the data that you're adding to the disc. I like to select this check box because the more space I have to add files, the better. However, this action can limit the number of computers that can read the disc, as you find out from my description of the Eject options in the section "Eject, Buckaroo, Eject!," later in this chapter. Don't use compression if you want any computer to be able to read the disc!

To read a compressed Drag-to-Disc disc on another computer, you must have either Drag-to-Disc installed or you have to install UDF support (which is already included on most PCs that are running Windows 2000 and Windows XP).

5. **If you're formatting a rewritable disc, select the Format type by clicking the desired button.**

 Drag-to-Disc offers two types of formatting for rewritable media. *Quick formatting* takes only a few minutes, but you must have Drag-to-Disc installed to read the disc. *Full formatting* can take up to 90 minutes (depending on the speed of your drive and the capacity of the disc), but the resulting disc can be read on any PC that's running Windows 2000 or Windows XP, even if Drag-to-Disc is not installed on that machine.

6. **Click the OK button to set the wheels in motion.**

 Drag-to-Disc displays the dialog box that's shown in Figure 10-3 while it's working.

Figure 10-3: I'm formatting as fast as I can!

When the disc has been formatted, Drag-to-Disc displays the volume name in the Drag-to-Disc window, which is shown in Figure 10-4.

Figure 10-4: You're ready to use Drag-to-Disc!

Double-click My Computer, and you can see your new drive. Although it appears to be a CD-ROM or DVD-ROM drive, it's ready to store data and read it. The Drag-to-Disc icon in the Windows system tray now sports a fashionable miniature red padlock, which tells you that you have loaded a Drag-to-Disc disc.

Burning Data with Drag-to-Disc

TIP

Depending on the brand and model of your recorder, you may not be able to eject a Drag-to-Disc disc using your drive's Eject button like you can with a regular read-only disc. Don't worry, though; I cover the procedure for safely ejecting a Drag-to-Disc disc in the section "Eject, Buckaroo, Eject!"

Just Add Files and Stir

"So what programs do I run to use a Drag-to-Disc disc?" Programs? You don't need 'em! Drag-to-Disc works behind the scenes, so you can forget that it's there. Just read, create, copy, and move files to your Drag-to-Disc disc in the same way that you use your hard drive or a floppy disk. You can save to the disc within your applications, drag and drop files, or use a file-management program like Windows Explorer.

You can also keep tabs on the status of your Drag-to-Disc disc by checking its Properties page: Double-click My Computer to display your drives, right-click the Drag-to-Disc drive icon, and choose Properties from the pop-up menu that appears. Figure 10-5 shows the Properties window for the disc that I showed you how to format in the preceding section.

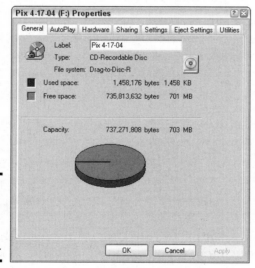

Figure 10-5:
Viewing the properties for a Drag-to-Disc disc.

As you can see, the file system is listed as Drag-to-Disc-R, with compression enabled. You can see that this disc has approximately 701MB of free space remaining. (However, if you use compression, remember that the total capacity of your disc is a guesstimate because the rate of compression can vary depending on the type of data that you're storing.)

That's it! Of all the recording programs I cover, Drag-to-Disc is definitely the easiest to master. There's literally nothing to it.

"Wait — I Didn't Mean to Trash That!"

When you delete files from a Drag-to-Disc CD-RW, DVD-RW, DVD+RW, or DVD-RAM disc, the files are deleted and you recover the space that those files used. When you delete files from a CD-R, DVD-R, or DVD+R Drag-to-Disc disc, the files are no longer accessible, but you don't regain the space.

Unfortunately, you can't undelete files from a Drag-to-Disc project by using the Windows Recycle Bin — after they've been deleted, those files are long gone, pardner. If a Drag-to-Disc project disc is damaged or corrupted, however, you can use ScanDisc to attempt to recover the files from it. Read more about that in the section "Whoops, I Can't Read This Disc," later in this chapter.

Eject, Buckaroo, Eject!

A Drag-to-Disc disc has one feature that's a little tricky: You may not be able to simply eject a Drag-to-Disc disc like any other mundane CD-ROM or DVD-ROM disc. (In fact, the Eject button on your recorder may be disabled!) Drag-to-Disc has to take care of a few housekeeping tasks, like updating directory entries and preparing the disc for reading, before it lets you eject the disc.

Go ahead and give the Eject button a poke, but if it doesn't work, you can always follow these steps to eject a disc by using the Drag-to-Disc window:

1. **Right-click the Drag-to-Disc icon in the system tray, and choose Eject Disc from the pop-up menu that appears.**

 Alternately, display the Drag-to-Disc window (as I show you in the section "Whaddya Mean, I Have to Format?" earlier in this chapter) and click the Eject button. You can also right-click the drive icon in the My Computer window and select Eject from the menu that appears.

 If you're using a nonrewritable disc, Drag-to-Disc displays the Eject Disc dialog box that's shown in Figure 10-6. You can select or deselect the options in this dialog box (along with the options on the Advanced Eject Settings dialog box) to determine how the disc is prepared when it's ejected. These options are as follows:

 - **To read the disc on a computer with UDF support (or Drag-to-Disc installed):** Select the This Disc Will Be Used on Other Computers or Devices option, click the Advanced button, and select UDF version 1.02. Click the OK button to return to the Eject Options dialog box. The disc is closed so that computers that can read UDF version 1.5 can read the disc — this includes Windows Me, Windows 2000, Windows XP, Mac OS 9.2, and Mac OS X. With this option, you can either leave the disc open so that you can write more to it later, or you can select the Protect Disc So That It Cannot Be Written to Again check box (which I describe in a second) to finalize the disc permanently.

 - **To read the disc on any computer:** Select the This Disc Will Be Used on Other Computers or Devices option, click the Advanced button, select UDF version 1.02, and then select the Also Use ISO/Joliet check

box. Click the OK button to return to the Eject Options dialog box. These choices create a Joliet/ISO 9660 disc that can be read on just about any computer. (Note, however, that you can't use this option if you have elected to compress the data on the disc.) Again, you can leave the disc open and write to it again later, or you can select the Protect Disc So That It Cannot Be Written to Again check box to finalize the disc.

- **To allow further recording:** If you want to continue recording later (for example, if you need to read something else or record an audio disc with Creator Classic and you need the drive), *deselect* the Protect Disc So That It Cannot Be Written to Again check box. You can't read the disc on anything other than a recorder that's running Drag-to-Disc, however, so it's effectively out of commission until you reload it.

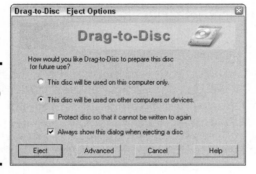

Figure 10-6: Preparing to give your Drag-to-Disc disc the boot.

2. **Click the Eject button to eject the disc.**

 Depending on the option that you choose in Step 1, you may have to wait while the disc is finalized, but Drag-to-Disc shows you a progress dialog box to let you know how things are going.

Do you usually choose the same Eject options for your CD-R, DVD-R, and DVD+R discs? If so, you can choose an Eject setting that Drag-to-Disc will apply to all discs in the future. Click the Drag-to-Disc window, and press Alt+S to display the Settings dialog box; then choose the desired Eject settings. Click the Advanced Eject Settings button to specify whether non-rewritable discs should be prepared with the UDF or ISO/Joliet file format, as I describe earlier in this section.

Adding Files to an Existing Disc

If you have ejected a nonrewritable disc, you can reload it and write additional data if the following two conditions apply:

- ✦ You didn't select the Protect Disc So That It Cannot Be Written to Again check box.
- ✦ Additional space remains on the disc.

When you reload a nonrewritable Drag-to-Disc disc, the program may have to open a new session and read the files that it already contains. This process can take a few moments, depending on whether you decided to close the disc or leave it as is. However, after the disc is back in the drive, you can use it normally.

Erasing a Drag-to-Disc Disc

Like Creator Classic (which I explore like Jacques Cousteau in Chapter 8 of Book IV), Drag-to-Disc allows you to completely erase CD-RW, DVD-RW, DVD+RW, or DVD-RAM media. To erase a disc, follow these steps:

1. **Click in the Drag-to-Disc window, or right-click the Drag-to-Disc icon in the system tray.**

2. **Choose Erase Disc from the pop-up menu that appears.**

 Drag-to-Disc requests confirmation that you really want to erase the disc.

3. **Click the Yes button.**

Sit back while the disc is erased, or go grab yourself another soda.

"Whoops, I Can't Read This Disc"

In case something nasty occurs and you encounter problems with a Drag-to-Disc disc (for example, if you're hit with a power failure while copying files to the disc), the program offers a ScanDisc feature that can recover files and fix some errors. Note that this program should not be confused with Windows ScanDisk, which is used only with hard drives and floppy disks.

To scan a Drag-to-Disc disc for errors, follow these steps:

1. **Click in the Drag-to-Disc window, or right-click the Drag-to-Disc icon in the system tray.**

2. **Choose Launch ScanDisc from the pop-up menu that appears.**

 Drag-to-Disc prompts you to select the drive where you've loaded the Drag-to-Disc disc.

3. **Click the correct drive, and click the OK button.**

 Drag-to-Disc displays the dialog box that's shown in Figure 10-7.

4. **Click the Scan button to begin.**

 Drag-to-Disc provides a progress bar while it works. If the program finds problems, you're prompted for confirmation before the program gathers recovery information.

5. **Click the Yes button to continue. (Naturally, this is a definite choice.)**

 If files can be recovered, ScanDisc allows you to copy them to another drive.

Figure 10-7:
Running
ScanDisc
on an ill
Drag-to-
Disc disc.

6. **Select the target drive from the Destination Drive drop-down list, and then specify the target folder in the Destination Folder list.**

7. **Click the Copy button to attempt to recover all files and folders.**

Each recovered file is renamed with a generic filename, so you have to open each file manually to determine what it is and to know whether it was recovered successfully. (I know this stinks worse than an angry skunk in a closet if you have dozens of files, but you have no other choice. Such is technology.)

Project: Creating a New Employee Disc

Here's the deal: Suppose that you work in the Human Resources division of your company, and it's your job to provide new employees with all the information they need. However, your office doesn't have an intranet (that's another book entirely), so you hit on the idea of a New Employee CD-ROM that contains all sorts of company clip art, press releases, document templates, and the company president's recipe for Heavenly Hash Browns. Your coworkers often take these discs on business trips, too. Your discs are popular because they save plenty of hard drive space on laptops.

That's a great idea, but it has one problem: Your company is continually requesting that new material be added to the discs, and some information is soon out of date and needs to be deleted to make sure that it doesn't accidentally get included in a company document. You need a way to add more data to a disc and be able to selectively delete information whenever you want. Hey, that's the definition of a CD-RW Drag-to-Disc disc! Follow these steps to create the perfect employee disc:

1. **Choose Start➪All Programs➪Roxio➪Drag-to-Disc to run Drag-to-Disc.**

2. **Load a blank rewriteable CD-RW disc into your recorder.**

3. **Press Alt+F to format the disc (as I demonstrate in the section "Whaddya Mean, I Have to Format?" earlier in the chapter).**

 Depending on your recorder, you could do this automatically . . . but this disc may need compression to hold that huge hash browns recipe.

4. **Name the disc (ACMECO, for example), and because you're assuming that all computers in your company are running Drag-to-Disc or are using an operating system that recognizes UDF discs, enable compression to make room for as much data as possible.**

5. **Click the OK button.**

6. **After the disc is formatted, double-click the My Computer icon on your desktop. Drag to the recorder icon all the company files that you want to add to the disc to copy them.**

 After all the files have been recorded, eject the disc.

7. **Right-click the Drag-to-Disc icon in the system tray, and choose Eject from the pop-up menu that appears.**

Pass the disc with pride to your next new employee. Whenever you need to update the contents of the disc, just pop it back in the drive and start copying and deleting files!

Chapter 11: Heavy-Duty Recording

In This Chapter

✔ **Creating a mixed-mode disc**

✔ **Designing a video CD**

✔ **Recording a standard mixed-mode disc**

✔ **Recording an enhanced CD Extra disc**

✔ **Recording video with DVD Builder**

A ll right, troops — if you've been following along in this minibook, you know that I've been easy on you. I've covered the simple stuff, and you can burn simple data discs and audio CDs until the cows come home. But what if you need to burn a mixed-mode disc? Or a CD Extra disc? Or even record a DVD for use in your DVD player? Those are heavy-duty recording jobs, Private. Have *you* got what it takes?"

Of course, you do. Luckily, those are the specialized discs that I cover in this chapter! You may not use them often, but when you do, you can hold your head up high and say, "I know how these are made. Step aside, and let the expert show you how it's done."

It's Data, It's Audio, It's Mixed!

Ever felt like you needed both digital audio and computer data on the same disc? If so, consider mixed-mode format. You can burn two different types of mixed-mode discs — the one you select depends on the material you're recording and what device will play it.

Putting data before your audio

Standard mixed-mode discs are great for discs that need to combine both digital audio and computer data, but they aren't meant to be used in a standard audio CD player. These discs can be played only in a computer's CD-ROM or DVD-ROM drive.

Typically, the program is installed from the first track (the data portion), which is closest to the spindle hole. After the program is running, it plays the audio tracks that follow. Most sophisticated computer games now use mixed-mode format because the game program can load movies and data files from the first track and still access the digital audio tracks while you're blasting the aliens from Planet Quark.

Part IV

Meeting Your Data Storage Needs

The extra behind CD Extra

As you can see in Figure 11-1, a CD Extra disc turns regular mixed-mode format on its head: One or more audio tracks come first, followed by a data track. The big attraction here is for musicians; a CD Extra disc can be played in both a standard audio CD player (which really can't tell the difference because the data is at the end) and a computer's read-only CD-ROM or DVD-ROM drive. This, folks, is the definition of neat!

Groups such as the Rolling Stones, the Red Hot Chili Peppers, and the Squirrel Nut Zippers have popularized the CD Extra disc with their fans. Although the format costs a minute or two of disc space (the blank space that's necessary to separate the tracks), the band's music can share the disc with a multimedia presentation of the latest music video or still pictures of a recent concert — or even lyrics to the songs.

Figure 11-1: Is the enhanced CD Extra disc the best of all possible worlds?

Recording That MTV Video

The last advanced specialized disc that I discuss is the *Video CD* (commonly called VCD), which stores digital video in MPEG-1 format. You can watch a Video CD in a Video CD player, a computer CD-ROM drive (with the right software), and most of the latest generation of DVD players. Before the advent of DVD players, Video CDs were the primary method of recording and distributing digital video among computer owners. An enhanced version of the Video CD — called the *Super Video CD*, or SVCD — provides even better video quality, but an SVCD stores less than a VCD, and SVCDs aren't compatible with all DVD players.

Roxio's Easy Media Creator uses a separate program named DVD Builder to help simplify the creation of a Video CD. With DVD Builder, you can burn professional VCD, SVCD, or DVD-Video discs, complete with a basic menu system — I lead you through the process step-by-step in the last project in this chapter.

Project: Recording a Mixed-Mode Disc

Suppose that you need to record a selection of multimedia clips to carry with you on a business trip. Some are video clips that you need to store only for the ride, and some are digital audio that you need to hear to practice your presentation. One solution would be to burn two discs — one, a data CD for the video clips, and the other, a traditional audio CD. A mixed-mode disc, however, allows you to combine both types of content on a single disc.

Follow these steps to create a mixed-mode CD:

1. **Choose Start⇨All Programs⇨Roxio⇨Creator Classic to run the program.**

2. **Choose File⇨New Project⇨Mixed-Mode CD to display a special mixed-mode layout, as shown in Figure 11-2.**

 Make sure that the indented data CD icon is selected under the Mixed-Mode CD Project label in the lower-right pane — the icon looks like a tiny disc with just a file folder, as shown in Figure 11-2. (By default, Creator Classic assigns the data portion of your disc with a string of numbers for a name, but you can change that — more on this in a step or two.)

3. **Locate and highlight the data files by using the same method that you use to select files for a data CD-ROM.**

 (Need a reminder of how this works? Flip to Chapter 8 of Book IV and check out the section that describes how to put files on a disc.)

4. **Click the Add button (the downward-facing arrow shown in Figure 11-2) to add the files and folders to the data portion of the layout.**

5. **Repeat Steps 3 and 4 until your data layout is complete, as shown in Figure 11-3.**

Book IV
Chapter 11

Heavy-Duty Recording

Figure 11-2:
A blank mixed-mode CD layout in Creator Classic.

Data CD icon Labels Add button

Music CD icon Burn button

Figure 11-3:
The data part of this mixed-mode layout is now complete.

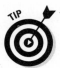

Don't forget to click the data CD label and name the data portion of the CD-ROM something descriptive. (Alternately, you can type the new name directly into the Disc Name text box.) The default name, which is built by using the current date and time, is rarely what you want.

6. **Click the music CD icon next to the Audio Project label to add the digital audio tracks. (The icon looks like a disc with a musical note; refer to Figure 11-2.)**

 As shown in Figure 11-4, the right side of the Mixed-Mode CD Project pane changes to the familiar audio CD track layout.

7. **Locate and highlight the MP3, WAV, or WMF digital audio files that you want to record, just as you do in designing a standard audio CD.**

 Remember to watch the free-space display at the bottom of the screen to make sure that you don't run out of space while adding audio files.

8. **Click the Add button (the down arrow in the middle of the window) to copy the files to your track layout.**

9. **Repeat Steps 7 and 8 until your audio track layout is complete, as illustrated in Figure 11-5.**

10. **Click the Big Orange Disc-on-Fire Burn button (refer to Figure 11-2) and finish the recording, just like with a typical data CD-ROM.**

 (Consult Chapter 8 of Book IV — specifically, the section about putting files on a disc — if you need a refresher course in choosing options for a data CD-ROM.)

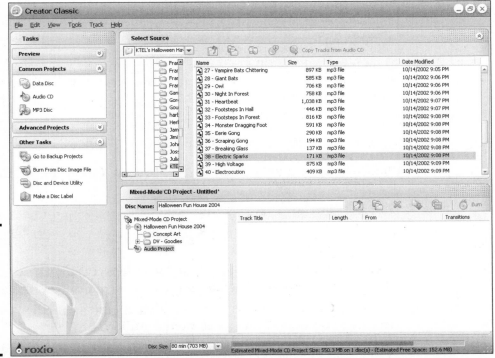

Figure 11-4: Whoa! Now you've switched to digital audio — on the same disc.

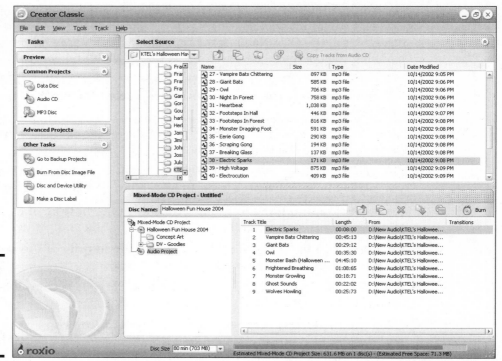

Figure 11-5:
I think this disc is ready to be burned, don't you?

Project: Recording a CD Extra Disc

As you may have guessed, I could also have created the disc described in the preceding project by using a CD Extra disc. Like a mixed-mode disc, a CD Extra (or Enhanced) disc can hold the same unique combination of digital audio tracks and computer data. The big difference is that you can play the audio tracks from a CD Extra disc in your standard audio CD player, and you need a computer's CD-ROM drive to access the digital audio on a mixed-mode disc. That's great for adding that video of your garage band to that *Best of Deep Purple* disc you burned!

Follow these steps to record a CD Extra disc:

1. **Choose Start⇨All Programs⇨Roxio⇨Creator Classic to run the program.**

2. **Choose File⇨New Project⇨Enhanced CD.**

 Again, Creator Classic has a special layout screen for a CD Extra project, as illustrated in Figure 11-6.

3. **In the Enhanced CD Project pane, if the music CD icon next to the empty Audio Project label isn't already selected, select it now.**

4. **Locate and select the MP3, WAV, or WMF digital audio files to record, just as you do in designing a standard audio CD.**

5. **Click Add (that familiar downward-pointing arrow in the middle of the window) to copy the tracks to the audio CD portion of the layout.**

6. **Repeat Steps 3 and 4 until you've added all the audio tracks that you want.**

Documenting your CD Extra discs

CD-Text is a nice feature that allows many audio CD players to display the CD title and the artist and track names while you listen. That's all that most people need. However, a CD Extra disc can store even more reference information describing the audio tracks, including the artist name, CD title, and publisher. If your audio CD player can't show this additional stuff, your computer probably can when you play the disc in your CD-ROM drive.

If you want to store this extra information, you must enter it after you have added your tracks (see Step

5 in the section titled, "Project: Recording a CD Extra Disc"). Choose File⇨Project Settings, which displays the Project Properties dialog box, and click the Advanced tab to display the dialog box shown in the following figure. Click OK to save the information that you entered and return to the CD Extra layout.

Personally, I don't use these fields, and you don't have to enter any of this stuff. But the fields do come in handy when you're recording a disc that will be used as a master for a manufacturing run or a disc that will form part of an ongoing archive.

7. **Click the label for the data CD icon and type a more descriptive label into the Disc Name text box.**

If folders labeled "CDPLUS" and "PICTURES" appear in your data layout, leave them as they are. Don't delete these folders or add files within them because they're used in conjunction with the audio tracks on the disc! (You can find out more about this topic in the nearby sidebar, "Documenting your CD Extra discs.")

8. **Locate the files and folders to add in the usual manner by using the Explorer display in the Select Source pane, and then highlight them.**

9. **Click Add (that handsome arrow pointing down in the middle of the window) to copy the selected files and folders to the data portion of the layout.**

10. **Repeat Steps 7 and 8 until all the files that you want are added.**

Figure 11-7 shows a finished data layout for your CD Extra disc. Note the location of the data files in the layout.

Figure 11-6:
A CD Extra project layout.

11. **Click the Big Orange Disc-on-Fire Burn button and finish the recording as you would with a typical data CD-ROM.**

Figure 11-7:
The finalized audio and data layouts for your CD Extra disc.

Project: Recording a DVD Movie Disc

To end this chapter on advanced recording, I show you how to create a basic DVD-Video of a child's birthday party. Suppose that you edited a series of short video clips with Adobe Premiere and saved them in MPEG format on your hard drive. The DVD should show the clips in order as soon as it's loaded.

Follow these steps:

1. Choose Start⇨All Programs⇨Roxio⇨DVD Builder to load the program.

As shown in Figure 11-8, the wizard runs automatically.

2. Select the DVD option button and click OK to continue.

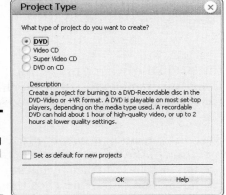

Figure 11-8: The opening gambit used by DVD Builder.

Note that you can also capture a digital video stream from a DV camcorder or analog input (like a VCR). If you're adding still images to your project, you can also include existing images from your hard drive, or capture digital photographs directly from your digital camera. For right now, just add existing video clips, but you can switch to these other sources whenever you like. *Sassy!*

3. Click the Add Intro Title link in the Edit Task Pane on the left side of the window.

The Add Media to Project dialog box appears, as shown in Figure 11-9.

4. Navigate to the folder in which you stored your MPEG files and digital photographs. Click the desired clip or still image that should appear first in your video and then click Add.

DVD Builder adds the clip to your Production Editor pane as a thumbnail-size icon.

5. Add the rest of your clips and still images: Click the Open Media Selector link to choose additional clips and images. To add an item, drag it from the Media Selector dialog box to the empty frame at the end of the sequence.

Figure 11-9:
Choosing
your first
video clip or
still image
for the
project.

If you want to insert an item, drop it in the desired frame, and DVD Builder shifts the rest of the items one frame to the right. To change the order of the items, just drag the offending thumbnail and drop it in its new location.

Note that DVD Builder keeps track of the amount of space that you've used with a bar display at the bottom of the window. You can toggle the estimated space between the different types of discs by clicking the Disc Size drop-down list box at the left end of the bar; click the type of disc that you want to record, and the status bar changes to reflect the capacity of the specified disc type.

Not quite sure about the contents of a video clip? Just double-click the clip's thumbnail icon to watch it in the Preview window, complete with the familiar controls from a typical DVD player program — these include pause and advance/rewind one frame.

If you add a clip or image by mistake, right-click the item to display the pop-up menu and click Delete to remove the element from your project.

6. **To add a transition between items, click the Add Transitions link — DVD Builder displays a spiffy selection of transition thumbnails (see Figure 11-10). Click the desired transition and drag it to the transition box between the two items.**

To view what a transition looks like before you add it, click the tiny Play button at the lower-right corner of any transition thumbnail in the Media Selector dialog box.

7. **Ready to preview your disc? Click the Preview button at the top of the Edit Task Pane.**

The program displays the high-tech control panel shown in Figure 11-11, complete with familiar controls like the buttons on a DVD player. Click the Intro button at the top of the control panel to begin the show.

Click to view the transition.

Figure 11-10: You can pick from a selection of Hollywood-quality transitions.

8. **When you've finished your preview, click the Edit button at the top of the Edit Task pane and click the Big Orange Disc-on-Fire Burn button to continue.**

From the Burn Setup dialog box (shown in Figure 11-12), you can select the drive to use for burning, and erase a rewritable (CD-RW, DVD-RAM, DVD+RW, or DVD-RW) disc. In most cases, you want to burn your project immediately, but you can also create a disc image file for later recording. DVD Builder automatically selects the default advanced settings to match the type of disc you're burning, so you're ready to go!

Figure 11-11: Previewing the goods before you record.

Figure 11-12:
Choosing recording options for a DVD project.

9. **Load the correct type of media (a CD-R, DVD-R, or DVD+R disc — always use a write-once disc if you're burning a disc for an older DVD player), and click OK to start shoveling ones and zeroes to your drive.**

Chapter 12: Burning Large Files to DVD

In This Chapter

✔ Considering the ins and outs of DVD recording

✔ Introducing DVD authoring tools

✔ Recording DVDs with UDF

✔ Designing and burning a DVD-Video disc with iDVD 4

Whether it holds 90 minutes of digital video or it's simply crammed full of backup files, a DVD recordable disc is a wonderful thing. Only current prices are holding most technotypes back from investing in a DVD-R/W, DVD+R/W, or DVD-RAM drive. But those prices have already fallen from $1,000 to less than $200 for a fast DVD-R/W drive, and the cost of blank media has dipped more than 50 percent over the past two years. It's simply a matter of time until DVD recorders pack the shelves at your local discount store; they will replace the CD-RW drives that are now standard equipment on today's PCs and Macs.

My job is clear: I must prepare you for the rigors of DVD recording so that you're ready for the coming wave of new hardware! It's a daunting job, but, well, it's not *really* all that daunting. If you're interested in backing up your system or simply saving 4.7GB of data at once, burning a DVD is a process similar to burning a CD-R or a CD-RW. I show you how in this chapter.

If you're interested in mastering a DVD with digital video for use in your home DVD player or your computer's DVD-ROM drive, you are indeed walking into an unfamiliar land — but this chapter shows you the way there!

Let me be honest with you (as always): This chapter offers only a basic introduction to digital video editing and DVD authoring. For a much more in-depth discussion of these topics, peruse Book II.

What's Involved in Recording a DVD-R or DVD+R?

In short, the same four things required to burn a CD-R are involved in recording a DVD-R or DVD+R:

✦ A recorder

✦ A blank disc

✦ Your source material

✦ The appropriate recording software (either UDF/packet writing, a DVD authoring program with built-in burning capabilities, or a full-blown mastering program similar to Roxio Easy Media Creator or Nero 6)

With this close resemblance to the now-familiar process of CD recording, what gives DVD recording that James Bond feeling — at least at the time this book was written? Here are several reasons:

✦ **Prices are still high.** The painful side of DVD-R/W, DVD+R/W, and DVD-RAM recording simply *starts* with the high cost of the drive. Then you're hit with the cost of the blank media! A single DVD-R or DVD+R sets you back anywhere from $1 to $2, and a typical DVD-RAM is a hefty $15. The higher the cost, the less appealing DVD recording remains to average computer owners.

✦ **DVD standards are still evolving.** "Should I invest in DVD-RW, or is there something just around the bend? Will my DVD player read the discs that I record?" Unfortunately, far too many question marks still surround the different DVD formats, and many computer owners are holding back another six months to a year, hoping for one to become a clear winner.

✦ **Perceived value.** At this point, many folks just don't feel that they *need* the space offered by recordable DVD. DVD is attractive for digital video and system backups, but 700MB per CD-R is still a fair chunk of territory (at a mere pittance of a price, too).

✦ **DV is only just becoming a mainstream technology.** As DV camcorders continue to drop in price and Uncle Milton decides to try out digital video editing, DVD recording is sure to heat up (pun intended). Right now, the analog camcorder and the VHS VCR are still Kings of the Mountain.

The Heavy Stuff: Introducing DVD Authoring

If you've been reading up on DVD technology, you know that DVD *authoring* (that's the process of creating an interactive DVD-ROM title, usually involving digital video, still images, and custom-written programs) and DVD burning go hand in hand.

Authoring a disc involves a little bit of flowchart design (the creation of a logical menu system), a little bit of artistic talent (the development of a distinctive look and feel for the buttons, images, and background), and at least a basic knowledge of digital video. Of course, the DVD video discs that you buy at your local video store are authored by professionals who use hardware and software packages that cost many thousands of dollars. You may be surprised, however, at the results that *you* can achieve with the right software, as you see in the iDVD project at the end of this chapter. (My first DVD amazed my family. After they played with the menu system for several minutes, I was such a hit that I could have sold them oceanfront property in Kansas.)

Although the recording is only a small part of the authoring process, I want to give you a small taste of two authoring programs. iDVD 4 is a free package (with a new Mac) that's exceptionally easy to use, and DVD Studio Pro 3 is a full-blown professional authoring package that sets you back $500. (If that's not a wide price range, I don't know what is.) Both these programs were developed by Apple (www.apple.com) and run exclusively on the Macintosh, but PC folks get about the same treatment at the low-end price point with MyDVD 5 Deluxe from Sonic for $70, at www.sonic.com. Coincidentally — wink, wink — MyDVD works very much like iDVD 4. Go figure.

Welcome to the world of iDVD

iDVD, a Mac OS X application, ships with the current crop of high-end G4 and G5 Macs that offer the DVD-R SuperDrive. Because iDVD is aimed squarely at novices, it has only a small selection of the more powerful features offered by more expensive authoring applications. For example, iDVD automatically creates your disc's menu system, and you're limited to full-screen video. But, friends and neighbors, the kids at the local elementary school are now using iDVD. It's easy — and if it's easy, *normal* people will try it!

DVDs created with iDVD are limited to displaying digital video and still images (using a slideshow format). These displays are organized into media folders (which, in turn, can hold subfolders). I especially like the fact that discs created with iDVD take advantage of the DVD player's remote control (even though you don't have to know anything about how your DVD remote functions). It's all taken care of automatically by iDVD, leaving you free to concentrate on where to put what and how it should look.

An iDVD disc can contain up to about 90 minutes of digital video (DV) or a combination of DV and slides. After you have completed your design, you can use the program's Preview mode to try out your disc before you burn it (complete with a virtual remote).

For a guided tour through the process of creating a DVD-Video disc with iDVD, check out the project at the end of this chapter.

Letting loose with DVD Studio Pro

On the other end of the spectrum, you have a heavyweight of DVD authoring: DVD Studio Pro 2. It includes commercial features like Macrovision copy protection, support for today's popular widescreen aspect ratio, a total of nine possible camera angles, MPEG format support, region coding, and much more. You have complete control over your menu creation, with layered images taken from Adobe Photoshop. Unlike with iDVD, you choose what actions are taken when the different buttons are pressed on the DVD player's remote control. Whereas iDVD can use only one audio track — the audio from the video itself — a high-end package like DVD Studio Pro allows as many as eight tracks, so you can mix music with your DV.

As with iDVD, you get a Preview mode with DVD Studio Pro, so you can double-check all your work before burning. Speaking of recording, that too is supported internally. As extra options, you can also write your completed project to a disc image or DLT tape.

If you're already well-versed in digital video editing, you should feel right at home using DVD Studio Pro 2 (and you should be better prepared for the high prices for DV hardware and software). If you have just bought your Macintosh and you have never shot a frame of DV, I recommend that you pass on both the complexity and the price. This package will likely take you places where you don't want to venture, so stick with iDVD 4 (or, on the Windows side, MyDVD 5).

Book IV
Chapter 12

Burning Large Files to DVD

Letting UDF Do the Work

Here's another of my patented Nuggets o' Knowledge, a Mark's Maxim for rewritable recording:

> What works with CD-RW usually works just as well with DVD-RW or DVD+RW.

(Look out — you could soon see this catchy phrase on bumper stickers and t-shirts.)

In this case, what works is *UDF — Universal Disk Format,* otherwise known as your old friend *packet writing,* which is compatible with Mac OS 9, Mac OS X, and all versions of Windows 98 (and later). A number of great programs are available for both Windows and the Mac operating system (OS) that implement the Holy Grail of UDF. These applications allow you to use your recordable DVD drive as a 4.7GB floppy (isn't *that* a mind-boggling idea?) except that your DVD recorder is much faster and much more reliable and holds a heck of a lot more.

For DVD packet writing, I use Roxio's Drag-to-Disc, which I cover in stunning detail in Chapter 10 of Book IV. Of course, you can also run the full-blown Easy Media Creator to build a DVD from a project layout, as I demonstrate in Chapter 8 . . . but it takes longer, and I'm a creature who craves instant satisfaction. (Really.)

Project: Recording a DVD-R with iDVD

Do you have a DVD-R drive in your Macintosh? Yes? Then you're a self-contained movie studio, and you probably didn't even know it! (Don't worry — you have plenty of time to hit eBay and bid on a beret, a mega-phone, and one of those chalkboards with the clacky thing on top.) On the software end, all you need is iDVD. (And, as you've probably already figured out, this project gives you a good idea of how to handle things under Windows XP with MyDVD 5.)

In this project, I use iDVD to show you how to create a home video DVD-Video disc that you can watch in almost any standard DVD player. You may be amazed at how easy Apple has made the process and how professional your finished DVD looks. The completed disc features

+ An interactive menu system

+ Separate menus for digital video and a slideshow of still photographs

+ Menu music imported from iTunes

+ An automated slideshow

As a first step, you should convert or export your video in QuickTime format. Both iMovie and Final Cut Pro allow you to export QuickTime movies directly, but you can also use QuickTime Pro to convert video from other formats. If you plan to add digital images, I recommend that they be in JPEG format, which takes up far less room than the same images in TIFF format.

One cool feature of iDVD is its ability to use a digital photograph as the background for your DVD menu system. If you want to do this, make sure that the image you're using is 640 x 480 pixels. (If necessary, you can resize it with any image editor; I use Photoshop.)

After your source material has been converted to QuickTime and JPEG, follow these steps:

1. **Double-click the iDVD icon in your Applications folder to launch the program, which displays the iDVD project window shown in Figure 12-1.**

In effect, the project window is the skeleton for your DVD menu, so it's time to put something on those bare bones.

Figure 12-1: The iDVD project window, ready to receive your creative genius.

2. **Choose Project⇨Project Info. Click in the Disc Name field and type the name for your DVD. Click OK to save the change.**

In this case, I entered **Example**. (Just call me Mr. Imagination.)

Next, it's time to choose a theme, which includes preconfigured choices for fonts, button styles, and the background image used in your menu.

3. **Click the Customize button in the main iDVD window, which opens the iDVD Theme drawer.**

4. **Click the Themes button at the top of the drawer and scroll through the choices that appear, as shown in Figure 12-2, to choose a theme.**

For this example, select the Green Linen 2 thumbnail in the list.

5. **To use your own background image, click the Settings button in the Theme drawer (see Figure 12-3), drag an image from a Finder window, and drop it into the Image/Movie thumbnail (or *well*) in the Background section.**

To add a moving background, drag a QuickTime movie into the well instead.

**Book IV
Chapter 12**

**Burning Large
Files to DVD**

Figure 12-2:
Some of
the prebuilt
iDVD
themes
that you
can choose.

Figure 12-3:
Displaying
the settings
for an iDVD
project.

At this point, the blank menu system, shown in Figure 12-4, already looks classier than anything I ever did with my VHS camcorder.

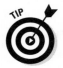

You can also indulge in additional iLife goodness: Click the Photos button in the iDVD drawer and select an image directly from your iPhoto collection.

Figure 12-4:
The menu
after the
theme has
been
applied.

6. Click the title text to change it, type the title for your menu, and press Return to save it.

In Figure 12-5, I've used the title "Our Lazy Crazy Day at the Beach." Man, do I like Apple software!

Figure 12-5:
Changing the title of the menu is child's play.

7. Drag an audio clip into the Audio well in the Settings panel.

What fun is a menu without your favorite background tune? You can drag the audio file from a Finder window, or click the Audio button in the iDVD drawer to choose a song from your iTunes collection (if you're feeling sassy). iDVD recognizes AIFF, MP3, AAC, and WAV sound files.

Next, it's time to add a video clip to the menu. That sounds a tad daunting, but there's nothing to fear with iDVD.

8. Open the folder that contains your QuickTime movies and drag one to the iDVD project window.

As shown in Figure 12-6, the program creates a custom button using a thumbnail image from the video. The button is automatically centered in the screen for you. Definitely not daunting.

Figure 12-6:
The first video clip appears in the iDVD project.

9. **Because the title under the button is less than descriptive, change it: Click once on the text to display the edit box and then type a new name.**

You can also move the slider that appears above the button to choose the thumbnail image from within the clip. (This is great for clips that begin with darkness or something equally as uninteresting.) Figure 12-7 illustrates the slider. If you enable the Movie check box, the Movie button in the menu becomes animated!

Figure 12-7: You can select the image that appears on your button, dude.

You can move a Movie button anywhere you like on your menu. Just click it and drag it to the desired destination; it snaps to the closest position on an imaginary grid. You can turn off this automatic alignment by enabling the Free Position option in the Settings panel.

10. **Add additional clips by repeating Steps 8 and 9.**

You can add a maximum of six buttons to a single DVD menu screen; personally, I avoid overcrowding a menu by adding no more than four buttons.

11. **Add a separate submenu for your slideshow display of digital images: Click the Folder button to add a submenu button to the project window and change the button name to whatever you like (I typed** Slide Show**).**

You can change the look of your menu buttons another way: Click the Settings button in the Theme drawer, and then select any Movie button you've added to your DVD menu layout. Adjust the button's properties in the Button section of the Settings panel, and voilà! You have a new appearance for your buttons!

12. **Double-click the Slideshow button on your iDVD menu to display the submenu screen. Click the title at the top of the submenu screen to open the edit box, type your title text, and press Return to save it.**

13. **It's time to add the Slideshow button itself. Click the Slideshow button at the bottom of the iDVD window, which adds a button to your submenu.**

14. **Double-click the button that you added; this opens the My Slideshow window. Drag the images that you want to add from their locations on your hard drive into the window, as shown in Figure 12-8.**

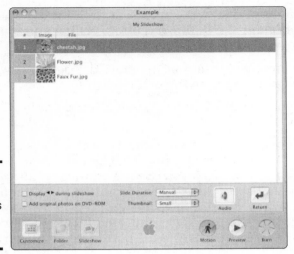

Figure 12-8:
Preparing
the contents
of the
slideshow.

Once again, you can add images to your slideshow in another way: Click
the Photos button at the top of the iDVD drawer, which displays all the
images in your iPhoto Library (as well as the albums that you've defined
there). You can drag images from the Photos tab to the Slideshow
window.

15. **At this point, you need to decide whether you want an automated
slideshow or a manual slideshow. If your parents had a slide projec-
tor like mine did, this step should really interest you:**

- **Manual:** For a manual slideshow, leave the Slide Duration drop-down
list box set to Manual. It's a good idea to enable the Display < > During
Slideshow check box, which superimposes left and right arrows on the
image as appropriate. (Although these arrows are optional, they help
remind Aunt Harriet how to advance through the photos in a manual
slideshow.) The lucky person holding the DVD player remote control
presses the right cursor key to move forward through the images and
the left cursor key to move backward.

- **Automatic:** The DVD player displays the images automatically (but
you can still move forward and backward by using the remote). Click
the Slide Duration drop-down list box and select the number of sec-
onds to delay before switching to the next image. If you like, you can
still enable the Display < > During Slideshow check box.

16. **How about some audio for that slideshow of your cousin's wedding?
Again, you can drag an audio file from a Finder window to the Audio
well in the Slideshow window.**

If you're a fan of iTunes, click the Audio button in the iDVD drawer, and
you can choose that perfect song from your iTunes playlists.

17. **If you want to change the order of the slideshow sequence, click and
drag the image that you want to its new spot on the list. After you've
finished designing your slideshow, click the Return button to return
to the submenu screen.**

Whoops — now that you have added your images, don't forget to cus-
tomize the slideshow button.

18. **Drag the slider to select one of the images in the slideshow as the button image. To change the button's caption, click it and type your new text; press Return to save it.**

(If you're too cool for sliders, drag one of the JPEG images that will make up your slideshow and drop it on top of the button.)

19. **Care to preview your DVD? Click the Preview button at the bottom of the iDVD window.**

iDVD displays a cool-looking virtual remote. Note that the slideshow button in the middle of the screen is now highlighted, just as it would be if you were using your DVD player. Use the buttons on the remote to select menu items, and press Enter on the remote to activate the item that's highlighted. When you're done playing with your DVD-to-be, click the Preview button again to return to editing mode (where you can make changes if you like).

You should save your project to your hard drive before you burn it.

20. **Choose File➪Save Project As to display a standard Mac OS Save dialog box. Navigate to the destination folder, type a new name for your project, and click Save.**

Okay, you film mogul, you — it's time to record your own DVD!

21. **Click the Burn button, which opens to display a glowing fail-safe button. (Kinda nuclear-looking, ain't it?)**

Apple doesn't want you to waste a blank disc with an accidental click of your mouse. (Plus, it's one of the neatest animated controls I've ever used. Let no one say that Steve Jobs has no sense of humor.)

22. **Click the Burn button again to start the recording process, and load a blank DVD-R into your DVD recorder when prompted.**

After the first disc has been burned, you can choose to record additional copies.

23. **When the recording is done, eject the disc and pop it in your DVD player.**

Or, if you like, you can watch your creation on your Mac with the Mac OS X DVD Player, which you can find in the Applications folder.

I should warn you that iDVD has quite a bit of housekeeping to do to prepare your digital video, so you probably have to wait several minutes before the recording starts. (This preparation time depends on the speed of your Mac, the number of movies that you have added, and how long they are.)

Index

A

B

C

M

N

O

T

U

V

W

FOR DUMMIES®

The easy way to get more done and have more fun

FOR DUMMIES®

A world of resources to help you grow

TRAVEL

0-7645-5453-0

0-7645-5438-7

0-7645-5444-1

Also available:

America's National Parks For Dummies
(0-7645-6204-5)

Caribbean For Dummies
(0-7645-5445-X)

Cruise Vacations For Dummies 2003
(0-7645-5459-X)

Europe For Dummies
(0-7645-5456-5)

Ireland For Dummies
(0-7645-6199-5)

France For Dummies
(0-7645-6292-4)

Las Vegas For Dummies
(0-7645-5448-4)

London For Dummies
(0-7645-5416-6)

Mexico's Beach Resorts For Dummies
(0-7645-6262-2)

Paris For Dummies
(0-7645-5494-8)

RV Vacations For Dummies
(0-7645-5443-3)

EDUCATION & TEST PREPARATION

0-7645-5194-9

0-7645-5325-9

0-7645-5249-X

Also available:

The ACT For Dummies
(0-7645-5210-4)

Chemistry For Dummies
(0-7645-5430-1)

English Grammar For Dummies
(0-7645-5322-4)

French For Dummies
(0-7645-5193-0)

GMAT For Dummies
(0-7645-5251-1)

Inglés Para Dummies
(0-7645-5427-1)

Italian For Dummies
(0-7645-5196-5)

Research Papers For Dummies
(0-7645-5426-3)

SAT I For Dummies
(0-7645-5472-7)

U.S. History For Dummies
(0-7645-5249-X)

World History For Dummies
(0-7645-5242-2)

HEALTH, SELF-HELP & SPIRITUALITY

0-7645-5154-X

0-7645-5302-X

0-7645-5418-2

Also available:

The Bible For Dummies
(0-7645-5296-1)

Controlling Cholesterol For Dummies
(0-7645-5440-9)

Dating For Dummies
(0-7645-5072-1)

Dieting For Dummies
(0-7645-5126-4)

High Blood Pressure For Dummies
(0-7645-5424-7)

Judaism For Dummies
(0-7645-5299-6)

Menopause For Dummies
(0-7645-5458-1)

Nutrition For Dummies
(0-7645-5180-9)

Potty Training For Dummies
(0-7645-5417-4)

Pregnancy For Dummies
(0-7645-5074-8)

Rekindling Romance For Dummies
(0-7645-5303-8)

Religion For Dummies
(0-7645-5264-3)

Available wherever books are sold. Go to www.dummies.com or call 1-877-762-2974 to order direct

FOR DUMMIES®

Plain-English solutions for everyday challenges

HOME & BUSINESS COMPUTER BASICS

0-7645-0838-5

0-7645-1663-9

0-7645-1548-9

Also available:

Excel 2002 All-in-One Desk Reference For Dummies (0-7645-1794-5)

Office XP 9-in-1 Desk Reference For Dummies (0-7645-0819-9)

PCs All-in-One Desk Reference For Dummies (0-7645-0791-5)

Troubleshooting Your PC For Dummies (0-7645-1669-8)

Upgrading & Fixing PCs For Dummies (0-7645-1665-5)

Windows XP For Dummies (0-7645-0893-8)

Windows XP For Dummies Quick Reference (0-7645-0897-0)

Word 2002 For Dummies (0-7645-0839-3)

INTERNET & DIGITAL MEDIA

0-7645-0894-6

0-7645-1642-6

0-7645-1664-7

Also available:

CD and DVD Recording For Dummies (0-7645-1627-2)

Digital Photography All-in-One Desk Reference For Dummies (0-7645-1800-3)

eBay For Dummies (0-7645-1642-6)

Genealogy Online For Dummies (0-7645-0807-5)

Internet All-in-One Desk Reference For Dummies (0-7645-1659-0)

Internet For Dummies Quick Reference (0-7645-1645-0)

Internet Privacy For Dummies (0-7645-0846-6)

Paint Shop Pro For Dummies (0-7645-2440-2)

Photo Retouching & Restoration For Dummies (0-7645-1662-0)

Photoshop Elements For Dummies (0-7645-1675-2)

Scanners For Dummies (0-7645-0783-4)

Get smart! Visit www.dummies.com

- **Find listings of even more Dummies titles**

- **Browse online articles, excerpts, and how-to's**

- **Sign up for daily or weekly e-mail tips**

- **Check out Dummies fitness videos and other products**

- **Order from our online bookstore**

Available wherever books are sold. Go to www.dummies.com or call 1-877-762-2974 to order direct

FOR DUMMIES®

GRAPHICS & WEB SITE DEVELOPMENT

Photoshop 7 FOR DUMMIES

0-7645-1651-5

Creating Web Pages FOR DUMMIES

0-7645-1643-4

Macromedia Flash MX FOR DUMMIES

0-7645-0895-4

Also available:

Adobe Acrobat 5 PDF For Dummies
(0-7645-1652-3)

ASP.NET For Dummies
(0-7645-0866-0)

ColdFusion MX For Dummies
(0-7645-1672-8)

Dreamweaver MX For Dummies
(0-7645-1630-2)

FrontPage 2002 For Dummies
(0-7645-0821-0)

HTML 4 For Dummies
(0-7645-0723-0)

Illustrator 10 For Dummies
(0-7645-3636-2)

PowerPoint 2002 For Dummies
(0-7645-0817-2)

Web Design For Dummies
(0-7645-0823-7)

PROGRAMMING & DATABASES

C++ FOR DUMMIES

0-7645-0746-X

Visual Studio .NET ALL-IN-ONE DESK REFERENCE FOR DUMMIES

0-7645-1626-4

XML FOR DUMMIES

0-7645-1657-4

Also available:

Access 2002 For Dummies
(0-7645-0818-0)

Beginning Programming For Dummies
(0-7645-0835-0)

Crystal Reports 9 For Dummies
(0-7645-1641-8)

Java & XML For Dummies
(0-7645-1658-2)

Java 2 For Dummies
(0-7645-0765-6)

JavaScript For Dummies
(0-7645-0633-1)

Oracle9i For Dummies
(0-7645-0880-6)

Perl For Dummies
(0-7645-0776-1)

PHP and MySQL For Dummies
(0-7645-1650-7)

SQL For Dummies
(0-7645-0737-0)

Visual Basic .NET For Dummies
(0-7645-0867-9)

LINUX, NETWORKING & CERTIFICATION

Red Hat Linux 7.3 FOR DUMMIES

0-7645-1545-4

TCP/IP FOR DUMMIES

0-7645-1760-0

Networking FOR DUMMIES

0-7645-0772-9

Also available:

A+ Certification For Dummies
(0-7645-0812-1)

CCNP All-in-One Certification For Dummies
(0-7645-1648-5)

Cisco Networking For Dummies
(0-7645-1668-X)

CISSP For Dummies
(0-7645-1670-1)

CIW Foundations For Dummies
(0-7645-1635-3)

Firewalls For Dummies
(0-7645-0884-9)

Home Networking For Dummies
(0-7645-0857-1)

Red Hat Linux All-in-One Desk Reference For Dummies
(0-7645-2442-9)

UNIX For Dummies
(0-7645-0419-3)

Available wherever books are sold.
Go to www.dummies.com or call 1-877-762-2974 to order direct